New Jersey: A Guide to the State

LIBRARY OF CONGRESS CATALOGING-IN-PUBLICATION DATA Westergaard, Barbara, 1930–

New Jersey, a guide to the state / Barbara Westergaard ; illustrations by Ellie Wyeth ; maps by Margaret Westergaard. — 2nd ed.

p. cm. Includes indexes. ISBN 0-8135-2482-2 (pbk. : alk. paper) 1. New Jersey—Guidebooks. 2. Automobile travel—New Jersey— Guidebooks. I. Title. F132.3.W47 1998 97-23594 917.4904'43—dc21 CIP

British Cataloging-in-Publication Information available

Copyright © 1998 by Barbara Westergaard

All rights reserved

Manufactured in the United States of America

DESIGNED BY: Judith Martin Waterman

To my family

Contents

Note to the Second Edition

I have left unchanged the introduction to the first edition of this guide. Although some of the examples used there may be out of date, the main thrust still holds: New Jersey is a state of striking physical and social contrasts. Generic housing developments continue to eat up land, but the largest piece of open space between Boston and Washington is still in New Jersey, and it occupies almost one-quarter of the state. We may be the country's most densely populated state, but agriculture is still a major contributor to the economy. The turnpike may no longer go straight through an oil refinery, but New Jersey is still a leader in pharmaceuticals, a major exporter (of chemicals and allied products, electronic equipment, and industrial machinery and computers), and home to over 1,500 foreign firms. And tourism remains our second largest industry, in 1996 contributing \$23 billion to the economy.

Some of the changes have been for the better, some not. We now have a highly successful science museum in Liberty State Park, an agriculture museum in New Brunswick, an aquarium in Camden, and a performing arts center in Newark. Despite the loss of open space, the bank of permanently protected land has grown. But with the reduction in state budgets, state historic sites have had to cut back—some have even lost their curators or been forced to share them with other facilities—and state parks have lost staff (not to mention their trash baskets). Many small museums have had a hard time finding the volunteers they need and have had to give up regular hours. I cannot urge too strongly the need to call ahead, even if regular hours are listed.

I have also left unchanged the basic structure of this guide. Except for the turnpike tour, entries are arranged alphabetically by town. If you can't find the town you're interested in, look in the index under towns, for it may be part of another town's entry. If you don't know the location of a museum or park, check the index of museums or the index of parks. At the top of each entry is the town name, the county it's in, its population in the 1990 census, and the roads that lead you there (*I* indicates an interstate, *US* a federal, *NJ* a state, and *C* a county road). If the community is unincorporated and therefore not in the census, the township it is part of is listed instead. The dot on the little state map tells you what part of the state the entry is in, and an asterisk tells you that a building or district is listed in the state and national registers of historic places. The street (not mailing) address of sites you might want to visit is given, with a telephone number you can call for information and an indication of whether there is an admission charge. Dates are inclusive: January–March means January through March. For more practical details, please check the introduction.

Once again I would like to stress that this guide is meant to get you started, not to be all inclusive. I'd like to apologize in advance to those who feel I have neglected their communities and to ask my readers to let me know about the places you think I should have mentioned. As with the first edition, listing by name all the people who have contributed to this revision would consume too much paper. Let me again single out the staff at the Turnpike Authority, in particular Lynn Flieger and Tom Suszka, and then repeat what I said ten years ago: to all those who helped me, to those who accompanied me on my trips around New Jersey, to the members of historical societies, the curators of museums, the park superintendents and rangers, the officials of federal, state, county, and municipal agencies, the librarians, I offer my heartfelt thanks.

Introduction

You will find in this guide information on several hundred of New Jersey's towns and parks. The guide is meant to serve both those who are contemplating a trip to New Jersey and are wondering what they can expect to find there, and those who are already in New Jersey and wondering what there is to look at. It's meant, in other words, to serve not just tourists but those who live in or commute to or through the state, and it's meant to serve the many newcomers—victims of corporate relocation, New York City rents, or economic and political hardship in other parts of the world. The word "guide" is chosen advisedly: this book is meant to get you started on your explorations, not to describe everything you will discover.

New Jersey is a state of unusual diversity, particularly in relation to its size (with c. 7,500 sq. miles, it's the fourth smallest state in the nation). Consider for a moment some of the contrasts it presents. New Jersey is one of the nation's leading industrial states. Its chemical industry, the state's largest, is second only to that of Texas (and actually employs more people), and New Jersey is the country's leading producer of pharmaceuticals, detergents, and toiletries. Yet almost two-thirds of the state's land is in farms and woodlands, and the gross average income per farm is the highest in the nation. It is one of the country's leading producers of blueberries, cranberries, peaches, eggplant, and nursery stock. It is the country's most densely populated state, yet within it is the largest wilderness area east of the Mississippi. It has more helipads than any other state, yet it also has the third largest state-park system. A leader in the high-tech industries (10 percent of the revenue from programming goes to New Jersey; 11 percent of its research budget is spent in the state). New Jersey is one of only four states where you can see 200 species of birds in one day, and the site of the largest annual gathering of migratory shorebirds. It has the third highest number of corporate headquarters, but is also the ninth state in wine production.

The contrasts extend to the landscape as well. The southern tip of Cape May (which is below where the Mason-Dixon Line would have been if it had continued due east) is only 144 miles from the Appalachian mountain ridges of the northwestern corner of the state. The flat and sandy lands of the southern portion of the state (actually, the coastal plain occupies over half the state's area) give way to the rolling hills of the central section, which in turn give way to the mountains of the north (the Kittatinny to the west, the Highlands to the east). In terms of feet above sea level, the mountains may not be high, but for a variety of reasons, including the lack of east-west passes in the Highlands, when you are in them, they look and feel high. This variety in terrain has produced a similar variety in ecosystems, and for that reason you can see an unusual diversity of plants and animals in New Jersey, with many species reaching their southern or northern limit in the state.

The natural contrast between north and south has been reinforced by the

state's history. Early in its development (in 1676) the colony was divided in two, and East Jersey (roughly the same as today's northern New Jersey) and West Jersey (today's southern New Jersey) were owned by separate groups. The settlers in the two areas were different as well: largely Quakers in the south, a mixture of New Englanders, Scots, Dutch, and others in the north. Southern New Jersey was oriented toward Philadelphia, northern New Jersey toward New York. The appearance of many communities still reflects the differences in the way these groups built. The Dutch stone houses of northern New Jersey are perhaps the best known example, but you will also find in central and northern New Jersey many villages that are similar to New England villages, with white frame houses clustered fairly close together. In the southern Quaker towns, on the other hand, the streets are wider, and the color and texture of red brick often dominate your first impression of a town.

And consider the contrast between the past and the future: a state rich in 18th-century historical associations is the site of the laboratory that is developing what may become the world's principal source of energy in the 21st century. New Jersey was not just one of the 13 original colonies, but an important battleground in the Revolution, and on two occasions the capital of the country was here. The United States's first national historical park is in New Jersey. But New Jersey's leadership in the high-tech world is not new: you can visit sites and museums associated with the inventors of the telephone, the telegraph, motion pictures, the electric light, patent leather, submarines, revolvers, streptomycin, commercial blueberries.

Yet, in part because of its long-term division between the Philadelphia- and New York-oriented areas (Benjamin Franklin spoke of New Jersey as a barrel tapped at both ends), the state has had difficulty establishing an identity, and its negative image as an amalgam of oil refineries and toxic waste dumps has been tenacious. It's not as if no one has discovered New Jersey: tourism is in fact the state's second largest industry, generating some \$11 billion a year in revenues, three-quarters of it from the shore. In terms of drawing tourists it is the fifth most popular state. Nevertheless, the New Jersey jokes continue, and the state's poor reputation-derived, many believe, from the fact that much of the world forms its impression of the state from driving through it on the turnpike-is becoming increasingly annoying to many New Jersey residents. At its northern end the turnpike goes right through one of the world's largest oil refineries, but to judge the rest of the state from this portion is clearly unfair. It's also unfair to the turnpike, which as eastern interstate highways go, is a pleasure to ride on: it's one of the safest, and even when the road is crowded, the traffic usually moves. And it's even unfair to the oil refineries, which can be breathtaking to look at, particularly at night. Since presumably every user of this book will have occasion to use the turnpike, the book closes with a tour of the turnpike.

Now, a few words on how to use the guide: Except for the turnpike tour, the entries are arranged alphabetically by town. This means that if you are interested in a particular park, say, but don't know which town it's in, you

should look in the index under parks and find the town you need. Similarly, if you don't find an entry for a town you're interested in, check the index under towns to see if the town you're looking for is part of a larger entry. If you're thinking of planning a trip around a visit to a museum, check the index for museums.

Each entry begins with the name of the town, followed by the county it's in and the major roads that lead to or go through the town. *I* followed by a number is an interstate, *US* a federal highway, *NJ* a state road, and *C* a county road. The dot on the state map at the beginning of each entry is meant to help you find that town on a larger map. The numbers in the entry headings are the population figures from the 1980 census. When no census figures are available for the community in question, the township it is part of appears in brackets. To avoid confusion, I have sometimes indicated whether the figures refer to the borough or the township, or what the census calls a census-designated place (CDP). For the fast-growing areas—and there are many in the state—the 1980 census figures may be far too low. An asterisk tells you that something is listed in the state and national register of historic places.

When a building or other place open to the public is listed, it is generally followed by its actual (not mailing) address and telephone number in parentheses. Times of opening come at the end of the description. (The months or days on either side of a dash are inclusive; that is, October–March means October through March.) Admission charges are noted; exact amounts are not.

Although every attempt has been made to secure accurate and up-to-date information, it is always advisable to call ahead, particularly for smaller museums and historic houses. Hours change, and in many cases the curators have no substitutes to take over when they cannot be on the job. Do not be surprised if you reach the past president of the local historical society, who is no longer involved in the museum you want to visit. He or she will be glad to help you find the current curator. Even the state parks can change their hours as their budgets change. Definitions of summer and winter also vary. For the state parks and many seaside resorts summer usually means Memorial Day to Labor Day, but it is always best to call ahead. Since some admission charges can be high while others are nominal, you might want to check on those too.

Parking fees are usually in effect in the state parks during the summer. For both state and county parks, it's a good idea to call about regulations if you want to camp, boat, fish, horseback ride, or hold group picnics. Also, when an entry says that an area is open to hunting or fishing, please remember that this means open to hunting or fishing with the proper license. For information about hunting and fishing regulations call 609-292-2965 or the number listed for the particular area.

Each entry should contain enough information to allow you to find your way to the place you're looking for, but you may want to call ahead for more detailed directions. The state gives away an excellent road map (available at state tourist centers and some state parks, by calling 609-292-2470, or by writing NJ Department of Commerce and Economic Development, Division of Travel

xii Introduction

and Tourism, CN 826, Trenton, NJ 08625). If, however, you're going to do any real exploring, you should arm yourself with a county map. These are particularly helpful now that most counties are posting numbered signs for most of their routes. (But be warned: some counties mark the roads they maintain with an abundance of signs; others may leave you feeling neglected.)

The state's Division of Travel and Tourism also publishes booklets and brochures useful to those who want to explore the state. There are many specialized guides available, including ones for antiques lovers, bird-watchers, canoists, history buffs, naturalists, and shopping enthusiasts. Tourist centers and chambers of commerce at the major tourist areas have literature you may find useful. There are also wonderful books not specifically intended for tourists on various parts of the state—John McPhee's *The Pine Barrens* and Charles Funnell's *By the Beautiful Sea* simply being among the best known—and most public libraries have large New Jersey collections. Many bookstores have New Jersey material, and the book sections in the larger state park visitor centers, in the Audubon sanctuaries, and in many historical museums are often good sources of local literature.

The preparation of this book has converted mc and my husband into fervent, even proselytizing, patriots. I hope some of this fervor, much of which rubbed off on many who worked with me, will spread to those who use this guide.

I would have liked to thank here by name all the people all over the state who helped me with this guide, but as they number in the hundreds, I am afraid this is not possible. Some of my friends will recognize my unabashed exploitation of their ideas, which I trust they will take as an expression of gratitude. I would also like to single out the authorities at the New Jersey Turnpike, particularly Gordon Hector and Jack Seymour, for their unfailing cooperation and to thank Susan B. Scheuermann for letting me look at the turnpike material put together by the State Council of the Junior Leagues of New Jersey. And to all those who helped me, to those who accompanied me on my trips around New Jersey, to the members of historical societies, the curators of museums, the park superintendents and rangers, the officials of federal, state, county, and municipal agencies, the librarians, I offer my heartfelt thanks.

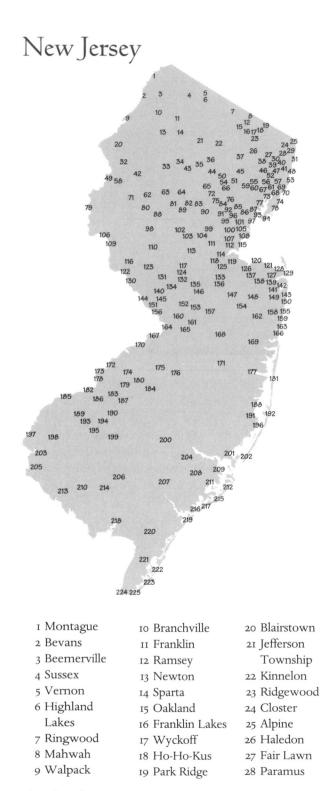

29 Oradell 30 River Edge 31 Tenafly 32 Hope 33 Stanhope 34 Hopatcong 35 Rockaway 36 Boonton 37 Wayne 38 Paterson 39 Hackensack 40 Teaneck 41 Englewood 42 Hackettstown 43 Dover 44 Parsippany-Troy Hills 45 Caldwell 46 Passaic 47 Teterboro 48 Fort Lee 49 Belvidere 50 Whippany 51 Roseland 52 East Rutherford 53 Edgewater 54 East Hanover 55 Bloomfield 56 Nutley 57 Rutherford 58 Oxford 59 West Orange 60 Montclair 61 Lyndhurst 62 Long Valley 63 Chester 64 Mendham 65 Morristown 66 Livingston 67 Kearny 68 Secaucus 69 North Bergen 70 Weehawken 71 Washington 72 Madison 73 Harrison

xiv Introduction

74 Hoboken 75 Chatham 76 Millburn 77 Newark 78 Jersey City 79 Phillipsburg 80 Glen Gardner 81 Peapack and Gladstone 82 Bernardsville 83 Basking Ridge 84 Summit 85 Union 86 Springfield 87 Hillside 88 Oldwick 89 Far Hills 90 Berkeley Heights 91 Scotch Plains 92 Mountainside 93 Elizabeth 94 Bayonne 95 Westfield 96 Cranford 97 Roselle 98 Clinton 99 Plainfield 100 Clark 101 Winfield 102 Bridgewater 103 Somerville 104 Green Brook 105 Rahway 106 Milford 107 Metuchen 108 Woodbridge 109 Frenchtown 110 Flemington 111 Piscataway 112 Edison Township 113 Millstone 114 New Brunswick 115 Perth Amboy 116 Sergeantsville

117 Griggstown 118 Milltown 119 South River 120 Keyport 121 Port Monmouth 122 Stockton 123 Ringoes 124 Rocky Hill 125 East Brunswick 126 Matawan 127 Middletown 128 Atlantic Highlands 129 Highlands 130 Lambertville 131 Hopewell 132 Kingston 133 Helmetta 134 Princeton 135 South Brunswick 136 Jamesburg 137 Holmdel 138 Lincroft 130 Red Bank 140 Pennington 141 Shrewsbury 142 Little Silver 143 Long Branch 144 Titusville 145 Lawrenceville 146 Cranbury 147 Englishtown 148 Colts Ncck 149 Eatontown 150 West Long Branch 151 Ewing Township 152 West Windsor Township 153 Hightstown 154 Freehold 155 Asbury Park 156 Trenton

157 Roosevelt 158 Neptune 159 Ocean Grove 160 Hamilton Township 161 Allentown 162 Farmingdale 163 Spring Lake 164 Bordentown 165 Crosswicks 166 Manasquan 167 Roebling 168 Cassville 169 Lakewood 170 Burlington 171 Lakehurst 172 Riverton 173 Pennsauken 174 Moorestown 175 Mount Holly 176 Pemberton 177 Toms River 178 Camden 179 Cherry Hill 180 Mount Laurel 181 Seaside Park 182 National Park 183 Haddonfield 184 Medford 185 Paulsboro 186 Woodbury 187 Laurel Springs 188 Forked River 189 Swedesboro 190 Blackwood 191 Barnegat 192 Barnegat Light 193 Mullica Hill 194 Pitman 195 Glassboro 196 Manahawkin 197 Pennsville 198 Woodstown 199 Clayton 200 Hammonton 201 Tuckerton 202 Beach Haven

204 Egg Harbor City 205 Hancock's Bridge 206 Vineland 207 Mays Landing 208 Pomona 209 Oceanville 210 Bridgeton 211 Absecon 212 Brigantine 213 Greenwich 214 Millville 215 Atlantic City 216 Somers Point 217 Margate City 218 Mauricetown 219 Ocean City 220 Woodbine 221 Cape May Court House 222 Stone Harbor 223 The Wildwoods 224 Cape May Point 225 Cape May

203 Salem

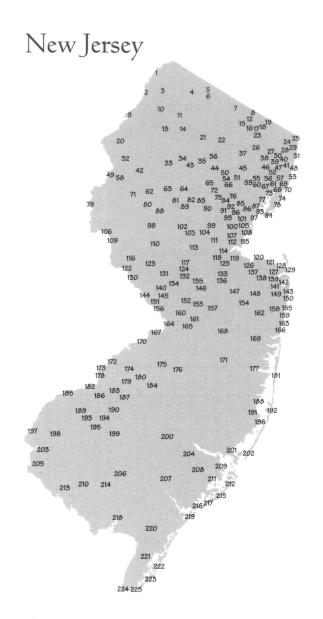

Absecon 211 Allentown 161 Alpine 25 Asbury Park 155 Atlantic City 215 Atlantic Highlands 128 Barnegat 191 Bayonne 94 Beach Haven 202 Beemerville 3 Belvidere 49 Berkeley Heights 90 Bernardsville 82 Bevans 2 Blackwood 190 Blairstown 20 Bloomfield 55 Boonton 36 Bordentown 164 Branchville 10 Bridgeton 210 Bridgewater 102 Brigantine 212 Burlington 170 Caldwell 45 Camden 178

Cape May 225 Cape May Court House 221 Cape May Point 224 Cassville 168 Chatham 75 Cherry Hill 179 Chester 63 Clark 100 Clayton 199 Clinton 98 Closter 24 Colts Neck 148 Cranbury 146 Cranford 96 Crosswicks 165 Dover 43 East Brunswick 125 East Hanover 54 East Rutherford 52 Eatontown 149 Edgewater 53 Edison Township 112 Egg Harbor City 204 Elizabeth 93 Englewood 41 Englishtown 147 Ewing Township 151 Fair Lawn 27 Far Hills 89 Farmingdale 162 Flemington 110 Forked River 188 Fort Lee 48 Franklin II Franklin Lakes 16 Freehold 154 Frenchtown 109 Glassboro 195 Glen Gardner 80 Green Brook 104 Greenwich 213

Basking Ridge 83 xvi Introduction

Barnegat Light 192

Griggstown 117 Hackensack 39 Hackettstown 42 Haddonfield 183 Haledon 26 Hamilton Township 160 Hammonton 200 Hancock's Bridge 205 Harrison 73 Helmetta 133 Highland Lakes 6 Highlands 129 Hightstown 153 Hillside 87 Hoboken 74 Ho-Ho-Kus 18 Holmdel 137 Hopatcong 34 Hope 32 Hopewell 131 Jamesburg 136 Jefferson Township 21 Jersey City 78 Kearny 67 Keyport 120 Kingston 132 Kinnelon 22 Lakehurst 171 Lakewood 169 Lambertville 130 Laurel Springs 187 Lawrenceville 145 Lincroft 138 Little Silver 142 Livingston 66 Long Branch 143 Long Valley 62 Lyndhurst 61 Madison 72 Mahwah 8 Manahawkin 196 Manasquan 166

Margate City 217

Matawan 126

Mauricetown 218 Mays Landing 207 Medford 184 Mendham 64 Metuchen 107 Middletown 127 Milford 106 Millburn 76 Millstone 113 Milltown 118 Millville 214 Montague 1 Montclair 60 Moorestown 174 Morristown 65 Mountainside 92 Mount Holly 175 Mount Laurel 180 Mullica Hill 193 National Park 182 Neptune 158 Newark 77 New Brunswick 114 Newton 13 North Bergen 69 Nutley 56 Oakland 15 Ocean City 219 Ocean Grove 159 Oceanville 200 Oldwick 88 Oradell 29 Oxford 58 Paramus 28 Park Ridge 19 Parsippany-Troy Hills 44 Passaic 46 Paterson 38 Paulsboro 185 Peapack and Gladstone 81 Pemberton 176 Pennington 140 Pennsauken 173 Pennsville 197

Perth Amboy 115 Phillipsburg 79 Piscataway III Pitman 194 Plainfield 99 Pomona 208 Port Monmouth 121 Princeton 134 Rahway 105 Ramsey 12 Red Bank 139 Ridgewood 23 Ringoes 123 Ringwood 7 River Edge 30 Riverton 172 Rockaway 35 Rocky Hill 124 Roebling 167 Roosevelt 157 Roseland 51 Roselle 97 Rutherford 57 Salem 203 Scotch Plains 91 Seaside Park 181 Secaucus 68 Sergeantsville 116 Shrewsbury 141 Somers Point 216 Somerville 103 South Brunswick 135 South River 119 Sparta 14 Springfield 86 Spring Lake 163 Stanhope 33 Stockton 122 Stone Harbor 222 Summit 84 Sussex 4 Swedesboro 189 Teaneck 40 Tenafly 31 Teterboro 47

Titusville 144 Toms River 177 Trenton 156 Tuckerton 201 Union 85 Vernon 5 Vineland 206 Walpack 9 Washington 71 Wayne 37 Weehawken 70 Westfield 95 West Long Branch 150 West Orange 59 West Windsor Township 152 Whippany 50 The Wildwoods 223 Winfield 101 Woodbine 220 Woodbridge 108 Woodbury 186 Woodstown 198 Wyckoff 17

Absecon Atlantic 7,298

US 9, 30, NJ 157, C 585

Although many visitors to the shore may think of Absecon (pronounced Ab-see'-con) as simply the entrance to Atlantic City, the town long predates Atlantic City (it was a stagecoach stop before the Revolution) and in a sense was essential to its development. In 1820, Dr. Jonathan Pitney, the man who more or less

invented Atlantic City (see Atlantic City), moved to Absecon. His house still stands (N. Shore Rd.), as do other older houses on quiet streets away from the busy commercial highways. Known as the Reed house, Pitney's house was built in 1799; his additions date from 1848.

Pitney was also involved in both the Methodist and Presbyterian congregations. Near his home is the brick United Methodist Church (50 W. Church St.), first built in 1823 and rebuilt in 1856. (Methodism had taken hold in Absecon when Francis Asbury visited in 1796–97.) The Presbyterian Church building (New Jersey Ave.) dates from 1867. (The first Presbyterian churchmen to preach in Absecon were also distinguished: John Brainerd in the 1750s, Philip Vickers Fithian in the 1770s.)

Absecon Wildlife Management Area contains over 3,500 acres of salt marsh in Reeds and Absecon bays. This is an excellent area for bird-watching, fishing, boating, and waterfowl hunting. The town has a public boat ramp (Faunce Landing Rd., off us 9), and you can fish from the northern part of the old Brigantine Bridge.

About two miles south of Absecon in Pleasantville is the Firefighters Museum of Southern New Jersey (8 Ryon Ave.; 609-641-9300). The collection includes 11 fire engines, from hand drawn and horse drawn to motorized, as well as old equipment and other items related to fire fighting. Open by appointment. Also in Pleasantville is the county's recycling center (6700 Delilah Rd.). When it opened in 1991, it was the largest in the country, capable of receiving over 300 tons of recyclable material a day. The heated seat used by the National Football League to warm benches in late-season games was invented by a Pleasantville plumber.

Allentown Monmouth 1,828

C 524, 526, 539

First settled by Quakers, Scotch, and Dutch (and known as Allen's Town from the gristmill Nathan Allan built in 1706 near the site of the present mill), Allentown was an active milltown by the mid-18th century. The village today retains many attractive 18th- and 19th-century buildings, both in its historic district* (approximately 24

blocks centered around the mill and N. and S. Main sts.) and along the county roads that radiate out from the center.

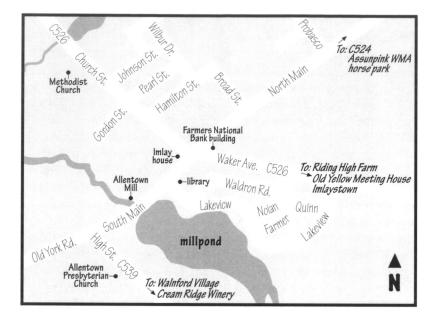

Small as it is, Allentown can claim at least two prominent citizens: Molly Pitcher, the Revolutionary War heroine who carried water to the soldiers during the Battle of Monmouth (see Freehold), and Dr. William A. Newell, founder of the United States Lifesaving Service. In 1848 Newell worked out the principle of throwing a line (Joseph Francis of Toms River improved the system by developing a closed lifeboat). Newell became a congressman in 1848 and again in 1865; he was governor of the state in 1856 and 1858. After serving as governor of the Washington Territory (1880–84), he returned to Allentown and once more took up his medical practice, living until 1901. His house is at the corner of Main and High streets. Allentown can also claim one of the first temperance organizations in the United States: the Allentown Sober Society, started in 1805.

The Allentown Mill* (42 S. Main St.), built in the mid-19th century on the site of earlier mills, now houses several shops and artists' studios. The John Imlay house (28 S. Main St.) was built c. 1790. Some of its imported French wallpaper is in the Metropolitan Museum of Art and at Winterthur. The Allentown Presbyterian Church (20 High St.) was founded in the 18th century; this lovely building dates from the early 19th century. The Methodist Church (23 Church St.) dates from 1810 (enlarged 1830, rebuilt 1936), and the former Baptist church (1879) serves as the town library (14–16 S. Main; 609-259-7565). The local historical society expects to install exhibits in the library before too long. The early-20th-century Farmers National Bank building (9 N. Main St.), listed in the state register of historic places, has become a shop.

One of the nation's largest wholesalers of seedlings, Kube Pak Inc., is located just south of Allentown on c 526. In 12 acres of greenhouses, some 10 million seedlings (this comes to 100,000 flats) are raised each spring.

Two miles east of Allentown, also on 526, is Riding High Farm (609-259-3884), devoted exclusively to handicapped riders. Group and individual lessons are offered year-round to riders of varying ages and disabilities. If you are interested in watching a lesson, call for an appointment. The Horse Park at Stone Tavern, the state equestrian facility, is five miles east of Allentown, off 524, in the Assunpink Wildlife Management Area (see Roosevelt).

Three miles south of Allentown, in Crosswicks Creek Park (c 539 east to Walns Mill Rd., right, or south, on Walns Mill), is Walnford Village* (78 Walnford Rd.; 201-842-4000). Established in 1734 by an Allentown merchant, Walnford was purchased in 1771 by Richard Waln and once included a gristmill, sawmill, dye house, cooper's shop, blacksmith shop, and family mansion. Now part of an 800-acre county park, Walnford Village consists of a homestead surrounded by a gristmill (built in 1872 and in use until 1917), carriage shed, icehouse, and other outbuildings. The mill, one of the finest of its type, will be put back into working order so that demonstrations can be given. The county is restoring the other buildings as well and eventually will install interpretive exhibits. Regular hours should be established soon, but groups will need an appointment.

Also south of Allentown on C 539 (at the point where Polhemustown and Holmes Mill rds. join) is the Cream Ridge Winery (609-259-9797), a family-run winery that opened in 1988. Among the annual events is a grape stomping. Open Monday–Saturday, 11–6, Sunday, 11–5; tours by appointment and at special events (held monthly April–December).

East of Allentown (take c 526 which becomes Red Valley Rd. to Yellow Meeting House Rd.) is the Upper Freehold Baptist Meeting* (609-259-2462), also known as the Old Yellow Meeting House. Built c. 1737, the church is said to be the oldest Baptist church in the state, the third oldest in the country. Tours by appointment. On your way to the meetinghouse note the Imlaystown Historic District* (Implaystown–Davis Station and Red Valley rds.), with its well-preserved 18th- and 19th-century buildings.

Alpine Bergen 1,716

US 9W, C 502

The small, wealthy community of Alpine (in 1989 half the houses sold for at least \$1.2 million, the average house was worth over \$.5 million, and the average annual income per household was \$115,426) is perched on top of the Palisades, which at this point rise abruptly 530 feet above the Hudson River. Volcanically formed,

the Palisades, which were discovered by Verrazano in 1524, are a national natural landmark. Threatened with destruction by quarrying in the late 19th century, they were saved by a federation of women's clubs, and the Palisades Interstate Park was established in 1900.

The park headquarters are at exit 2 of the Palisades Interstate Parkway in an interesting stone building with wonderful views of the river. The Blackledge-

Kearney house* (Closter Dock Rd.; 201-768-1360), a fieldstone and frame mid-18th-century building known as Cornwallis's Headquarters, was used by British Major General Cornwallis during the retreat of the American forces in November 1776, after Cornwallis's surprise attack at Fort Lee. Open May to Labor Day, weekends, 12–5; other times by appointment.

You can hike along the river and on the cliffs, and crabbing and fishing are both allowed. In the northern section of the park, at State Line Lookout, you will find some 7½ miles of ski trails (for information on skiing, call 201-768-1360). Special events, such as nature walks and history hikes, are held throughout the year; for schedules call 201-768-0379. The park commission planted wildflowers along the parkway, hoping to cut down on maintenance costs. The result was so attractive that the plantings are now cited as another reason for using the parkway.

At various times such celebrities as Joe Piscopo, Eddie Murphy, and Stevie Wonder have lived in Alpine, a town that used to do without house numbers and still does without mail delivery (house numbers have been assigned because of the 911 emergency service, but many people choose not to use or post them). After the Civil War millionaires built lavish estates along the

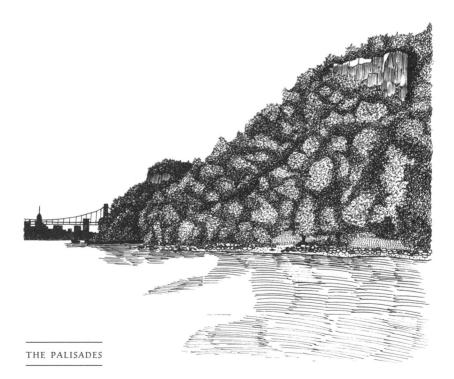

Palisades, most of which were destroyed with the establishment of the park and the building of the parkway. Edwin Armstrong, the developer of FM radio, lived in one of these mansions and sent from his radio tower (still visible from exit 2 of the Palisades Pkwy) the first static-free FM broadcasts. (In 1954 Armstrong killed himself, though not, as legend sometimes has it, by jumping from the tower.) The tower is now used for a microwave dish that relays cable TV. A small Armstrong museum (9W; 201-930-0533), containing, among other things, some of Armstrong's old equipment, is open by appointment.

To the west of Alpine, in Demarest, is the Old Church Cultural Center (561 Piermont Rd.; 201-767-7160). Housed in what was once the Demarest Baptist Church (1875), the center sponsors art shows and jazz concerts and offers classes in fine arts and crafts for children and adults. Exhibits in the gallery change each month; among the regular shows are an invitational pottery exhibit, a New Jersey–artist small-works show, and a faculty show. Open September–July, Monday–Thursday, 9–5:30 and 7–10, Friday, 9–3:30, Saturday, 9–12; further weekend hours by appointment. There are still 18th-century houses to be seen on County Road.

Asbury Park Monmouth 16,799

NJ 33, 66, 71

The seaside resort of Asbury Park, named after the Methodist bishop Francis Asbury, was developed in 1870 by James A. Bradley, a New York brush manufacturer who had been visiting the camp meeting of Ocean Grove. Like Ocean Grove, Asbury Park was intended as a temperance resort, but in other respects it catered to

more worldly tastes. ("Stimulated by the fiery influence of ice cream and ginger-pop, its permanent and floating population may plunge into the vortex of social dissipation afforded by pool, billiards, bowling, smoking, and dancing" was Gustav Kobbé's description in 1889.) The first trolleys in New Jersey ran in Asbury Park in 1877, and Bud Abbott of Abbott and Costello was born here. Stephen Crane, author of *The Red Badge of Courage*, born in Newark to an old New Jersey family, was raised here and as a young man worked as a journalist out of Asbury Park. His house (508 Fourth Ave.; 732 502 9261) is being converted into a museum. The house is open for special events in town; regular hours will be established eventually. Tours by appointment.

One of the country's worst marine disasters occurred off the Asbury Park beach when the *Morro Castle*, a cruise ship, burned under mysterious circumstances in 1934. Many rock-and-roll musicians developed their reputations in Asbury Park, including, of course, Bruce Springsteen; the Stone Pony he made famous reopened in the early 1990s. And the Amerada Hess Company grew out of a two-truck oil delivery company in Asbury Park.

Asbury Park suffered a decline in the 1970s and '80s, but many people are working on bringing it back to something like its early glory. Some of that early splendor can still be seen in the wide streets; the Convention Hall* (Ocean Ave.; 1928); the Paramount Theater (300 Ocean Ave.; 1920); and the Berkeley-Carteret Hotel (Ocean Ave; 1925), now owned by a transcendental meditation group. The Paramount, built as a vaudeville house, converted to a movie theater, and converted back to a performance space, has been restored and now serves as a venue for jazz, light rock, and classical concerts; dance; opera; and multicultural events. Convention Hall is being restored, but is still open for concerts, trade shows, gym shows, carnivals, and the like. For information on programs in both places, call 732-502-4581 or 732-775-2100, ext. 5703. Each July the town holds a jazz festival. Town festivals also take place at Easter and in October; call 732-775-2100 for information. The boardwalk may have fewer concessions, but the beach is still the beach (for information on beach fees, call 732-775-0900).

At 599 Lake Ave. is Marimba Productions Inc., an internationally recognized manufacturer of marimbas (as well as xylophones, glockenspiels, and mallets). The company sponsors summer workshops and occasional contests and festivals. Tours of the factory may be arranged by appointment (732-774-0088).

Atlantic City Atlantic 37,986

US 30, 40, 322, ATLANTIC CITY EXPRESSWAY

Because of the board game Monopoly, the names of Atlantic City's streets—Boardwalk, Park Place, Indiana Avenue—are as familiar to most Americans as those in their own town. That the game depends on buying and selling and developing real estate is peculiarly appropriate, for Atlantic City itself was the creation of a

speculative real estate venture. In 1850 today's resort was simply Absecon Island, an eight-mile stretch of sand with but a handful of inhabitants. For many years Dr. Jonathan Pitney, a doctor and congressman who lived nearby on the mainland (see Absecon), had mulled over the possibilities of building a railroad to the shore and developing the island. Atlantic City does have certain natural advantages as a resort: its particular location moderates the waves, and the position of the Gulf Stream moderates the climate; nearby Philadelphia supplied a ready clientele. The rest was the work of the developers. The railroad was built in 1852, and an engineer named Richard B. Osborne formulated a plan for the new city as grandiose as its name: streets parallel to the ocean were named after seas and oceans (Baltic, Mediterranean, etc.), and streets at right angles were named for the states.

In 1870 Atlantic City built its first boardwalk, probably the first boardwalk anywhere. It was the joint idea of a hotel man and a railroad conductor who, in one version of the tale, didn't like sand in their hallways and corridors, or, in another, saw in the walkway the potential for increasing business. The original boardwalk was eight feet wide and made of wood laid directly on the sand. Today, wood planking is laid on a steel and concrete foundation. Hotels, stores that catered to a wide variety of tastes, restaurants, and the kind of attractions one finds at carnivals were built along the boardwalk, and several entrepre-

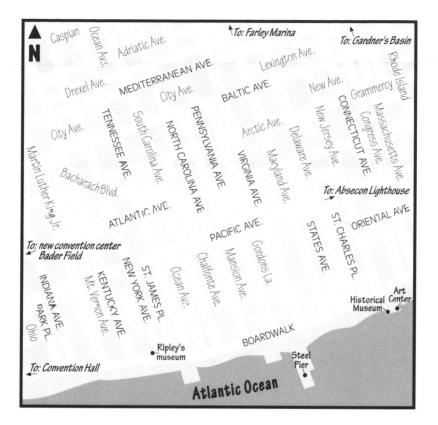

neurs built piers that jutted out into the ocean and featured similar attractions. For those tired of walking there were tram cars and push chairs, and these remain today in a modified form.

Another of Atlantic City's trademarks—salt water taffy—was also invented in the 1870s. And yet another—the Miss America Pageant—resulted, like the city itself, from a deliberate promotion. Begun in 1921, the pageant has been held each fall since 1935. (The first Miss America, Annie Laurie, died in 1985.)

The word "airport" was apparently coined in Atlantic City, when the editor of the *Atlantic City Press* used it in referring to Bader Field. Opened c. 1918 (and sold to the city in 1922), it may have been the country's, perhaps the world's, first official airport. Ironically, airplanes were one of the major factors in Atlantic City's later decline, as lower air fares made it possible for people to vacation farther afield. And the country's first Ferris wheel was built in Atlantic City in 1891, the brainchild of William Somers, not George Ferris.

To a large extent the resort flourished because of day trippers, but gradually, as more and larger hotels were built, it became known as a center for conventions. After World War II, Atlantic City entered a long period of decline, broken only (and only partially) in the 1970s with the advent of state-authorized casino gambling. After 1978, when the first casino opened, there was an upsurge of speculative activity reminiscent of the 1890–1912 boom. Unfortunately, it has not solved the city's problems. Casino operations are approaching a \$4 billion a year business; the casinos employ some 40,000 people and pay 71 percent of the municipal budget; over 33 million people visit Atlantic City each year (compared to 2 million before the casinos), which makes Atlantic City the top tourist destination in the United States. But the unemployment rate is three times the national average, and unless and until all the dreamed-of construction projects are actually completed, visitors will continue to approach the glitter of the casinos across what looks like a bombed-out wasteland—the city has been likened to a collection of "pleasure palaces in the midst of a war zone."

The casinos have, however, changed the appearance of the boardwalk. The trams and wicker push chairs are still there, as are the benches (a few facing the ocean, most facing the crowd) and the candy stores selling fudge and salt water taffy. Many of the piers are gone; the Million Dollar Picr, now called Ocean One, has been converted to a ship-shaped shopping mall. Most of the elegant hotels (including those listed in the national register of historic places) and the seedier of the shops are gone. The beautiful beach is still there, but even in its heyday Atlantic City was rather urban for a seaside resort. Unlike Las Vegas, Atlantic City permits no slot machines in public places other than the casinos (this still allows you over 29,000 opportunities to use a slot machine), and only hotels with 500 rooms can apply for casino status. The idea was to raise the tone of the resort and encourage people to stay longer, but neither goal has been achieved entirely, although over the years hotel occupancy has picked up.

Many visitors to Atlantic City are still day trippers, despite the efforts of the casinos to encourage longer stays (one-quarter of the country's population lives within a few hours' drive of the casinos). Most arrive by car, but a significant portion arrives by bus (the casinos have been credited with changing public attitudes toward motor coaches and leading to a boom in the bus business). Parking can be a problem, but jitney buses run on Pacific Ave. 24 hours a day to get you from casino to casino. Rail service to Atlantic City was reinstituted in 1989, though the service requires a subsidy that amounts to 80 percent of its operating costs.

To protect their customers, the casinos may only use cards or dice for 24 hours, after which they must be destroyed or have holes drilled in them. Over 2 million decks of cards and 160,000 pairs of dice are destroyed or given to charitable organizations each year; some mutilated remains are made into key rings and sold as souvenirs.

For those who like gambling or glitz or observing either of them (the paintings of Hieronymus Bosch may come to mind), Atlantic City is an exciting place. Other options include strolling on the boardwalk and watching the people or shopping. The beach is patrolled by lifeguards in the summer months, and you can visit the Absecon Lighthouse* (Pacific and Rhode Island aves.; 609-449-1360), another project inspired by Dr. Pitney. Built in the 1850s, the lighthouse, like the Barnegat Lighthouse, was designed by George Gordon Meade, later the Union commander at Gettysburg. Decommissioned in 1933, the lighthouse has been closed for repairs and renovations, but the tower is scheduled to be open by the spring of 1998. A replica of the lightkeeper's house,

which will serve as a visitor center and museum, is expected to open at the same time. Long-range plans include reconstructing the lifesaving station and eventually the assistant keeper's house.

The old Convention Hall* (Boardwalk between Mississippi and Florida aves.; 609-348-7000), which once had the world's largest unobstructed room and still has one of the world's largest pipe organs, was recently restored to all its late-1920s glory. A new convention hall (888-228-4748) opened in the spring of 1997; the old one is scheduled to become a venue for sports events, concerts, and family entertainment.

The Atlantic City Art Center on the Garden Pier (Boardwalk and New Jersey Ave.; 609-347-5837) has fine-art exhibits that change every month or two. Across the pier is the Atlantic City Historical Museum (609-347-5839), which features photographs and memorabilia from the city's past. One photographic display changes to reflect topics of current interest, as, for example, Black History Month or the Miss America Pageant. Open daily except major holidays, 10–3:45. A recent addition to the boardwalk is Ripley's Believe It or Not Museum (Boardwalk and New York Ave.; 609-347-2001). Part of a chain, the museum features a variety of what have been described as wacky, far-out exhibits. Open daily, 10–10. Admission charge.

There are still abundant opportunities to fish and boat in the area. The Senator Frank S. Farley Marina (600 Huron Ave.; 609-441-8482) is one of three marinas run by the state.

In the mid-1990s development frenzy picked up again (some say because the state loosened its oversight of gambling), and Atlantic City is likely to continue to change. In addition to the new convention center (and the city's first new shopping center in over 20 years), more casinos, non-casino hotels, and restaurants are being built. A marine education building is planned for Gardner's Basin, and a minor-league baseball team may begin playing in a new stadium at Bader Field before the end of the century.

Annual events, in addition to the Miss America contest, include a dog show in December, an antique-cars show in February, an arts festival in April, a professional fine-arts show in June, and a crafts show in September.

Atlantic Highlands Monmouth 4,629

NJ 36

Formerly known as Portland Poynt, Atlantic Highlands was first settled in 1671. Developed as a Methodist camp meeting in 1881, it was incorporated as a borough six years later and today is more of a residential and less of a tourist community than some of its neighbors along Sandy Hook and Raritan bays. You will find a

downtown movie theater on First Ave., and the Hofbrauhaus on Scenic Dr. is said to feature the oldest Oktoberfest in the state.

The Mt. Mitchill Scenic Overlook (Ocean Blvd.; 732-842-4000) is part of the Monmouth County park system; the mountain itself, at 250 feet, is the highest

natural point along the mid-Atlantic seacoast and the first spot seen by ships coming in from the east. (The Fresh Kills landfill on Staten Island is the highest man-made point.) If you can ignore the high-rise building that adjoins the park, you will be rewarded with a spectacular view of Sandy Hook and New York City from the overlook. There are coin-operated telescopes and picnic facilities at the park. Many fine views can also be had on the drive along Ocean Blvd. (also known as Scenic Dr.) from the center of town to the overlook. Closer to the bay, on Bayside Dr., is Henry Hudson's Spout, a spring frequented by Native Americans, by 19th-century packet steamers, and, according to tradition, by Hudson's crews as well.

The Adolph Strauss house (27 Prospect Circle; 732-291-9454) is a 20-room Victorian mansion built in the 1890s, operated as a house museum by the Atlantic Highlands Historical Society. The house is furnished with period pieces, and a variety of artifacts and memorabilia, most related to the history of the town, is on display. There are steamship memorabilia, a Lenape exhibit, and material on the Shakespearean troupe that used to rehearse its winter program in Atlantic Highlands in the summer. Each year there is a new thematic exhibit, dealing, for example, with subjects like the vocabulary of fans or the roaring twenties (this latter inspired by the town's connection to rum running; there are caves at the beach where liquor was stored, and a tunnel to the beach was found in one of the houses). Open June–September, Sunday, 1–4. The society also sponsors an annual house tour in the fall.

Barnegat Ocean 12,235

US 9, C 554

Located on an inlet of Barnegat Bay, Barnegat (from the Dutch Berende-gat, meaning an inlet with breakers) was regularly visited by Native Americans during the summer months. The spot was observed by Hudson in 1609 (Juet noted in the log that "this is a very good Land to fall with and a pleasant Land to see"). The

village was first settled around 1720, and during the Revolution was the site of an important saltworks. The community has always lived from the water, from the whalers and pirates of colonial days to the shipbuilders and fishermen, both commercial and sport, of more recent times. Although the village of Barnegat has preserved some of its past, the surrounding township is multiplying rapidly, and some of the waterfront growth is causing concern about pollution of the bay. (The township's population in 1990 was almost eight times that of 1970.)

The Barnegat Historical Society Heritage Center (E. Bay Ave.; 609-698-5284) consists of seven buildings moved to the site to save them from destruction. They include the Lippincott-Falkenburg house, a typical bay house, probably from the 18th century, with handmade nails and squared-off tree trunks used for structural members; the Edwards house, traced to 1813 but probably older; a barber shop; the necessary; a corn crib; and a butcher shop (the storage shed was once a motel cabin). Open mid-June–mid-September, weekends, 1–4. Also on E. Bay is the Friends Meeting House, built in 1767; the cemetery has some gravestones that predate the meetinghouse.

On the northwest corner of the intersection of Main St. and Bay Ave. is the Cox Memorial Library (609-698-0080). The Cox house was built in the 1840s and remained in the Cox family until the last owners, publishers of a local newspaper, gave it to the town. The house is furnished as it might have been in the mid-19th century and contains many antiques, portraits, and items of historical interest that belonged to the Cox family. It is opened to the public on special occasions and by appointment, but the town hopes to convert it into a museum with regular hours. Note also the Wright Memorial Presbyterian Church (S. Main St.), acquired by the congregation in 1876, but before that used as an opera house (a later opera house was converted to a movie theater); the United Methodist Church (E. Bay Ave. and Birdsall St.), built in the 1880s (its early-20th-century steeple replaces one blown off in a gale); and the former Tuckerton railroad station (Memorial Dr.), now a private house.

If you continue on E. Bay Ave. past the Heritage Center you will come to the bay and the town's public docks and beach.

North and west of Barnegat (you can take the Garden State Pkwy or us 9 north to c 532 and turn left) is Wells Mills County Park (Wells Mills Rd., C 532; 609-971-3085), the county's largest park. Its 900 acres encompass a variety of environments, and therefore a large variety of plants and animals. Records for this land go back to colonial days, and Atlantic white cedar was once harvested here—the first sawmill was built in the late 18th century—clay was mined, and sphagnum gathered. In the 1930s it was bought as a rustic retreat, and a cabin built then still overlooks the lake. You can fish or boat (electric motors only) on the lake, and there are trails, playgrounds, and a picnic area. Trail maps are available at the Wells Mills Nature Center, where you will also find an exhibit of plants and animals indigenous to the area. The center offers a variety of programs, including canoeing and kayak instruction, Pinelands walks, and weekend video and slide shows. The nature center is open daily, 10–4; the park daily, 8–sunset.

Barnegat Light Ocean 675

C 607

This tiny seaside community at the northern tip of Long Beach Island can be reached only by crossing from the mainland on the Manahawkin Bay Bridge (NJ 72) or by boat. At the very tip of the island is Barnegat Lighthouse State Park (609-494-2016), 31 acres

whose main attraction is the lighthouse* (affectionately referred to as Old Barney), built in the late 1850s after the earlier one (1834) fell into the sea in 1857. Designed by George Gordon Meade, the Union army commander at Gettysburg, and first lit in 1859, the lighthouse was decommissioned in 1927 when a lightship took over its duties. The lighthouse, 27 feet in diameter at the base and 15 feet above the walkway, is built of two concentric cones, which makes it flexible and permits it to sway in the wind. The hollow pipe in the center supports the cast-iron circular stairs and used to enclose the pendulum mechanism that turned the five-ton lens and lamp. There are splendid views for those willing to climb the 217 steps (but watch out for the sand falling from those climbing above you). A protective wall has been built to keep this lighthouse from following its predecessor into the ocean. The park also contains facilities for fishing, swimming, and picnicking.

The lens itself contained over 1,000 prisms, each of which could be individually adjusted, and the lamp was visible more than 30 miles out at sea. It can be seen today at the Barnegat Light Museum* (5th St. and Central Ave.; 609-494-8578), housed in a 1904 one-room schoolhouse. In addition to the lamp, the museum contains memorabilia from the school and the area, including old fishing equipment, school desks and diaries, and old photographs. Around the museum are the Edith Duff Gwinn Gardens, a seashore garden of plants, trees, and herbs that are able to grow on a barrier island. Open June and September, weekends, 2–5; July and August, daily, 2–5. Groups by appointment.

St. Peter's at the Light (7th St. and Central Ave.), c. 1890, has 18th-century pews taken from the Wading River Methodist Church and an antique organ.

Barnegat Light was settled largely by Scandinavian fishermen, and some of their bayside huts, dating from the early 1900s, have been converted into shops and christened Viking Village (20th St. and Bayview Ave.).

South of Barnegat Light in Loveladies is the Long Beach Island Foundation of the Arts and Sciences (120 Long Beach Blvd.; 609-494-1241). The foundation offers classes for adults and children in art and nature and presents lectures, art exhibitions, children's theater, and a film series. Open June–September, weekdays, 9–5, weekends, 10–4.

Basking Ridge Somerset [Bernards Township]

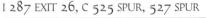

A colonial village, Basking Ridge sits on the western edge of the Great Swamp, the 6,700-acre remains of Glacial Lake Passaic. This was the home of William Alexander, a major general and quartermaster in the Continental army during the Revolution, who had not long before that established his claim to the earldom of Stirling

(but no lands) in Scotland. All that remains of his 18th-century manor house are two small brick structures* intended as slaves' quarters (96 Lord Stirling Rd.), now a national historic site, but his memory has been honored in Lord Stirling Park, 897 acres devoted to an environmental education center, a riding stable, and natural areas.

The Environmental Education Center (190 Lord Stirling Rd.; 908-766-2489), a county facility adjacent to the Great Swamp National Wildlife Refuge, encompasses 430 acres of freshwater marsh, swamp, bog, streams, rivers, fields, and woods. There are more than eight miles of trails, with two miles of boardwalk. Two observation towers and two observation blinds allow a closer look at the

abundant wildlife. There is also a quarter-mile barrier-free special-use trail. The center's education building is said to be the first interpretive center in the nation to rely almost entirely on solar energy: solar heating and cooling supply some 60 percent of the total energy needs and a substantial portion of the hot water (representing a saving of roughly 6,000 gallons of fuel oil a winter). On display in the building are over a dozen exhibits, dealing with the history and natural history of the Great Swamp, from glacial days through the jetport controversy (in the 1960s the Port Authority planned to build a major airport in the Great Swamp, but was thwarted by a massive citizens' campaign) to the present. European settlers arrived here in the mid-17th century, but Native Americans were in this area 12,000 years ago, and several of the exhibits deal with them. Geology, the varied habitats found in Lord Stirling Park, and the ecology of the area are also included. The center offers many educational programs for children and adults, including canoeing, bird walks, and map reading, and sponsors summer programs for children. Open daily, 9-5; closed major holidays. Trails open daily, sunrise to sunset. The hours for the exhibit hall vary; it is best to telephone ahead. Groups (8 or more) by appointment.

The riding stable (S. Maple Ave.; 908-766-5955) offers group lessons and, in the summer, workshops. Experienced riders can rent horses during limited hours every day; trail riding can be arranged when the trails are open. Call for the exact times.

To the east of Lord Stirling Park is the Great Swamp National Wildlife Refuge. Its eastern two-thirds is a wilderness area, with limited access to some 10 miles of trails. There is a wildlife observation center off Long Hill Rd., with a mile of trails, interpretive displays, and blinds. The western third is operated as a wildlife management area. The visitors' areas are open daily year-round, dawn to dusk; tours by appointment. (Morris County runs an environmental center on the eastern edge of the swamp, with one mile of trail and boardwalk and a half-mile barrier-free trail; see Chatham.)

Among the many well kept buildings in town note the Presbyterian Church* (6 W. Oak St.), built in 1839 on the site of two earlier buildings; the oak tree may have been standing for 300 years before the earliest (pre-1731) church. St. Mark's (S. Finley Ave. and Lewis St.), with its vertical siding, was built in 1853; the municipal building (S. Finley Ave. and Collyer La.) was once a summer home on an estate owned by the Astors. The Brick Academy* (15 W. Oak St.; 908-221-1770), built in 1809, has served as a school and a municipal building; it is now the headquarters of the historical society. Inside are various artifacts connected with the history of Somerset Hills. The society also sponsors a series of public lectures. Open Sunday, mid-May–November, 2–4.

If you continue east on Lord Stirling Rd., which becomes White Bridge Rd., you will come to the Raptor Trust (1390 White Bridge Rd.; 908-647-2353), a private, 20-acre refuge devoted to caring for, and when possible releasing, orphaned and injured birds, particularly birds of prey. Some of the center's resident owls have been reproducing (the chicks are shielded from visitors and sent to Canada, where they learn to hunt so they can be released). The center offers public lectures in the winter and engages in educational programs (call for details). Open daily during daylight hours; groups by appointment. The Raptor Trust is actually in Millington, also the home of Garden State Fireworks, a century-old family-run company that is one of the largest in the country.

At 287 Childs Rd. (just west of 202), on a lovely site, is the Van Dorn Mill (908-953-8200). Built in 1842, it is said to have replaced one that supplied George Washington during the Revolution. The building has been converted to office space, but visitors are welcome to come in and look around on the first floor, where they can see the wheel and look at pictures and other items of historical interest relating to the mill. Open weekdays, 8:30–5:30.

Bayonne Hudson 61,444

NJ TNPK EXIT 14A, I 78, NJ 169, 440

Situated on the peninsula separating New York Bay from Newark Bay, the city of Bayonne presents a remarkably solid appearance. Extensive neighborhoods of single- and two-family houses look well tended, no skyscrapers are apparent, the main streets are broad, and the stores seem to be selling things people need rather

than reflecting trends. Bayonne, in fact, has the reputation of being a remarkably stable community, where people remain in the same neighborhoods for generations. First settled by the Dutch in 1646, Bayonne became a resort area in the 18th century and an industrial one in the 19th. Oil companies began their transformation of the waterfront in 1875, and the city became home to a variety of industries.

One of the world's largest military ports, the Military Ocean Terminal, was located on Bayonne's waterfront and was for a time Hudson County's largest employer. Extending into New York Bay, the facility covered over 400 acres of land and 200 acres of water, and had its own apartment complex, movie theater, and restaurant. The facility is scheduled to close completely by 1999, and a commission has been formed to consider what should best be done about the large question mark on Bayonne's waterfront.

Bayonne is considered the birthplace (in 1913) of the manufactured diner: although the idea of modeling a restaurant on the lunch wagon apparently dates to the 1870s, a bar and grill owner named Jerry O'Mahoney is credited with being the first to build the structure we think of today as the original diner. Bayonne has also been the birthplace, or the home, of many entertainers, among them Frank Langella, Sandra Dee, and Mickey Rooney. And a Bayonne company was the first to use ball bearings in an electric motor (in 1903).

At the southeastern tip of the peninsula is Constable Hook, the first area in town to be settled; it is now an industrial enclave and occupied by oil refineries, tank farms, warehouses, trucking terminals. Yet in other parts of the city industrial concerns sit cheek by jowl with well-kept residential neighborhoods. The city has had a rich ethnic mix with significant populations of Irish, Polish, English, Italian, and Jewish background. Some of this diversity is still reflected in the number and variety of religious buildings.

At the southern tip of the peninsula is Kill van Kull Park, where you can watch the river traffic on the Kill van Kull (the narrow waterway separating Staten Island from Bayonne) from the water's edge. This park will form one end of the proposed Hudson River walkway.

Just west of the park is the Bayonne Bridge, which crosses the Kill van Kull to link Bayonne with Staten Island. Opened in 1931, the steel-arch structure carries four lanes of traffic (some 5 million vehicles use the bridge each year) and is one of the world's longest steel arch bridges, with an arch span of 1,675 feet.

Bayonne Park is another waterfront park, this one on Newark Bay. Its 97 acres provide an interesting combination of formal landscaping, natural and open areas, and athletic facilities. You can ice-skate on the pond, and there are picnic grounds, playgrounds, and athletic fields. Much of the park's threequarters of a mile of bay frontage is reclaimed land.

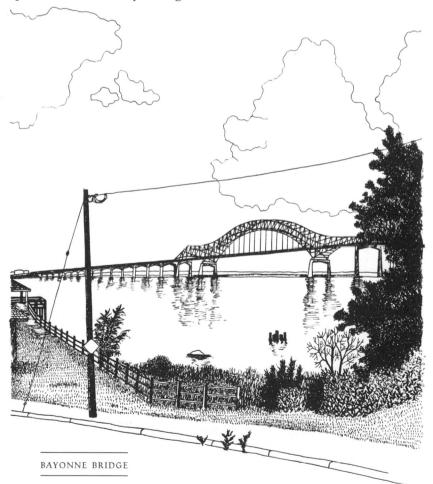

At 10 West 47th St. is the Chief John T. Brennan Fire Museum* (201-858-6017). It contains old equipment, including one of the oldest hose units in the state, photographs, and other paraphernalia. The building itself dates from 1875. Open by appointment only, though the museum hopes to establish regular hours two days a week. The urban park next door is locked on weekends.

Other buildings worth noting are the elegant public library, with its neoclassic wing design (Ave. C and 31st St.); the somewhat Spanish Romanesque Masonic temple (Ave. C at the entrance to Bayonne Park); the First Federated Church (Ave. C between 33d and 34th), built in 1866; Saints Peter and Paul (28th St. between Kennedy Blvd. and Ave. C), a Russian Orthodox church with bronze minarets; Saint Henry's Catholic Church (Ave. C between 28th and 29th), an English Gothic church modeled on Durham Cathedral and dedicated in 1915; the Victorian house on seven lots at Broadway and 3d, unlike other houses in Bayonne; and the red brick mid-19th-century mills used from the 1920s until the mid-1990s by Maidenform (17th St. and Ave. E). In the library (201-858-6980) exhibits, generally put up by local community groups, change roughly once a month. Open Monday, Tuesday, Thursday, Friday, 9–9, Wednesday and Saturday, 9–5.

Beach Haven Ocean 1,475

c 607

Beach Haven is located on Long Beach Island south of the Manahawkin Bay Bridge (NJ 72), the only land route to the island. The town has many Victorian seaside houses (Beach Haven's historic district* includes Atlantic, S. Atlantic, Beach, N. Beach, and Engleside aves. and Amber, Centre, Coral, Pearl, 2d, and 3d

sts.). In the historic district, in the former Holy Innocents' Church (1881), is the Long Beach Historical Society museum (Engleside and Beach aves.; 609-492-0070). Its exhibits, which change periodically, focus on the history of the area. You might see a display of Victorian furniture or clothing or an exhibit showing the type of fishing once practiced in the area. The museum also offers a variety of special programs, including a summer lecture series. Open daily, July–Labor Day, 2–4 and 7–9; Thursday and Friday, 10–12; open weekends Memorial Day– June, and Labor Day–September, 2–4. Groups by appointment. During July and August, the society also sponsors walking tours that leave from the museum, Tuesday and Friday, 10:30.

The Chamber of Commerce (265 W. 9th St.) sponsors an annual chowder cook-off in the fall. For information on the cook-off and on beach fees, call 609-492-7211.

During July and August the Alliance for a Living Ocean (609-492-0222) runs three-hour eco-tours of the island that leave from the Chamber of Commerce on Wednesday and Friday (one trip does the north half of the island, the other trip the south half). The alliance also sponsors field trips and other special programs during the summer. The Historic Preservation Committee (609-494-6828, 609-494-1263) also sponsors three-hour trolley tours of the island. These concentrate on the historic aspects of the island and leave from the Chamber of Commerce 9 A.M. Thursday, mid-July–August.

Beemerville Sussex [Wantage Township]

c 519, 629, 649

A tiny crossroads community in rural Sussex County, Beemerville has long been the home of the Space family. Their farm today occupies over 425 acres, 100 of which are devoted to the Space Farms Zoo and Museum (C 519; 973-875-5800), managed by the third generation of Space-family members (the fourth generation

is learning the business). The zoo has over 500 animals, representing over 100 species, and is involved in programs to restore threatened and endangered species. Goliath, a long-term resident of the zoo who died in the early 1990s, was, at 12 feet and 2,000 pounds, believed to be the largest Kodiak bear in the world.

When the zoo opened in 1927, the family also ran a general store that served the local farm community. During the Depression many of the customers brought in family mementos in lieu of cash, which Mr. and Mrs. Space hung on the wall until the items were redeemed. Out of this collection grew the museum, which in the late 1970s moved into buildings that used to house the Rutgers University cattle research facilities. (At those facilities Sir Mutual Ormsby Jewel Alice in 1938 contributed semen for the country's first cooperative artificial breeding association.) The museum's nine buildings contain a variety of old cars, tools, toys, firearms, sleighs, Native American artifacts, and the like. Open daily, May–October, 9–5. Admission charge (group rates by appointment).

While in Beemerville, note the windows of the First Presbyterian Church (1834).

Belvidere Warren 2,669

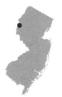

c 620, 623, 624

Located at the confluence of the Delaware and Pequest rivers, Belvidere was settled early in the 18th century and incorporated in 1845. The county seat, Belvidere has grown little over the last 60 years, one of the factors contributing to its special quality.

In the mid-18th century, there had been hopes that the power of the Pequest River could be harnessed and that Belvidere would become a flourishing industrial area. Robert Hoops, whose slaughterhouse supplied Washington's army when it was quartered in Morristown, had conceived the plan but was forced to sell his holdings along the river. The purchaser, Robert Morris (a signer of the Declaration of Independence and financier important to the revolutionary cause), tied up the lands with a restrictive deed that took an act of the legislature to set aside; many believe Morris's deed permanently hobbled Belvidere's development. (The town is not without industry today; Hoffmann–La Roche employs 1,000 people at its vitamin production plant.)

Belvidere's 19th-century historic district* encompasses Market, Race, Greenwich, and Mansfield sts. and the Pequest River, and includes some 200 buildings, but it is worth exploring outside this area as well. Included in the historic district is Belvidere's large green, another factor contributing to the town's appeal. On one side of the green is the red brick county courthouse (Second St. between Mansfield and Hardwick sts.), built in 1827 shortly after Warren County became independent of Sussex County; it has been modified, and the roof line was extended forward some 35 years ago. In the middle of each of the other three sides of the square is a church: the Presbyterian (1861) on Mansfield, the Methodist (1840s) on Hardwick, and the Episcopal (1900) on Third St. The green is known as Garrett Wall Park, named for a state governor who had donated the land for the courthouse, the square, and the churches, stipulating that the green was to remain undeveloped for the use of the county's residents forever. Some of the houses are open to the public during the town's Victorian Days (908-475-2176), held each year the first weekend after Labor Day.

Many of the county's offices are located in Belvidere's old houses; particularly beautiful is the stone Cummins house (1834; Second and Mansfield sts.), now being used by the departments of education and mental health. Among many other attractive and interesting buildings note the county library and courthouse annex (1860s; Hardwick St.); the old mill (Hardwick St.); the Croxall house (1780; Greenwich St.), built by Robert Morris for his daughter; the tiny Robert Hoops stone house (c. 1700; Prospect St.), probably built as servants'

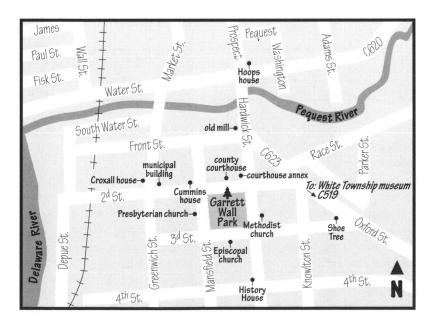

quarters; the Queen Anne house at Second and Greenwich sts.; and the mid-19th-century brick house that serves as the municipal building (Second and Greenwich sts.). At Oxford and Third sts. note the 300-year-old oak tree; it bears the legend "Barefoot folk sat under this tree to put on shoes before going to worship across the village green."

In an elegant 1850s house built of local brick the Warren County Historical and Genealogical Society runs History House (313 Mansfield St.; 908-475-4246), a museum specializing in the history of Warren County. The collection includes a wide variety of artifacts, ranging from the late 1600s (a child's high chair) to the present, from a dungeon door found when the courthouse was remodeled to hand-woven linen sheets made from flax grown in the county. In the Victorian parlor is Eastlake furniture that belonged to the last family to live in the house. Special exhibits change about once a month. Open Sunday, 2–4, and by appointment.

Public access to the Delaware River for bank fishing is available just south of Water Street.

About four miles east of Belvidere, in Bridgeville, is the White Township museum, located on Titman Rd. behind the White Township School at the intersection of NJ 46 and C 519 (908-689-7677, 908-453-2704). The first story dates to the 1770s, the second to the 1830s, when the building was converted from a house to a store. It has been restored as a store with an apartment upstairs and one room devoted to artifacts relating particularly to local history. Open June–October, 2d and 4th Sunday of the month, 2–4, and election days in June and November, 10–4. Open other times between June and November by appointment.

Berkeley Heights Union 11,980

C 512, 527, 531

Located in the Watchung Mountains and possibly named for Lord John Berkeley who, with Sir George Carteret, once owned all of New Jersey, Berkeley Heights was settled by the 18th century (but not so named until 1952). After a railroad spur reached it in the 1870s, Berkeley Heights became popular as a resort and vacation

area. Now a residential suburb, the township experienced a dramatic increase in population after World War II.

In 1910 the community of Free Acres, one of the few attempts in the United States to put into practice the single-tax ideas of Henry George, was founded in Berkeley Heights. (Nineteenth-century philosophical anarchism was also an element in the thinking of Bolton Hall, Free Acres's founder, who saw in the colony a chance to support his principles and perhaps realize something on his investment in land at the same time.) The community, which lies in the southwestern corner of Berkeley Heights (along Emerson La., between Apple Tree Rd. and Beachwood La.), began as a summer retreat for poor New York City intellectuals and artists and gradually evolved into a year-round community. Although it has had to bend some of its original principles to accommodate the demands of the township of Berkeley Heights, within the 80-acre colony itself land is still held not by individuals but by the association, and problems involved in maintaining the roads, water system, public grounds, swimming pool, and the like are still resolved in open meetings at the 18thcentury community farmhouse. James Cagney and MacKinlay Kantor are among the many well-known former residents of Free Acres.

Centered around Cataract Hollow Rd. within the Watchung Reservation (see Mountainside) is Feltville* (908-527-4900), an 1840s mill village, known as the Deserted Village. Intended as a model mill town by its founder, the mill village went through several changes of ownership and in the 1880s was transformed into a resort community known as Glenside Park. Now owned by the county, it is being restored to reflect its appearance as Glenside in 1882– 1916, although it is still easy to imagine what the mill village would have looked like. Montclair State University is doing extensive archaeological investigation of the site through summer field schools; there are hopes that public participation in the work will be possible. For now some 800 fifth graders are at the village each year in a program that teaches them about archaeology both in the classroom and in the context of a site under investigation. The church store is being restored and will eventually function as a small museum, and there may someday be pamphlets for self-guided tours and interpretive signs. In the meantime, tours are offered by Trailside Nature and Science Center (908-789-3670; see Mountainside), and you are free to wander about, on foot, on your own.

The Littell-Lord Farmhouse Museum* (31 Horseshoe Rd.; 908-464-0961), run by the Historical Society of Berkeley Heights, is housed in a farmhouse whose earliest part dates to the mid-18th century (additions were made in the 19th). It is furnished to show what life would have been like in the 18th and 19th centuries. The farm occupies 18 acres, and on the property are several outbuildings, including a mid-19th-century spring house and a Carpenter Gothic house that served for a time as a school. Open September–December and March– June, the 3d Sunday of the month, 2–4, and by appointment. Note also the Erie Lackawanna railroad station (Plainfield and Springfield aves.), c. 1888, an outstanding example of stick style. Off Springfield Ave. is the Passaic River County Park, where you can fish, picnic, and walk on the nature trail.

At the Bell Telephone Laboratories, now part of Lucent Technologies (600 Mountain Ave., at South St.; 908-582-3275; the entrance is actually in New Providence), the transistor was developed and *Telstar*, launched in 1962, was built. The oldest building here dates from the 1940s and marks one of the first cases of a research laboratory moving to the suburbs. Close to 4,000 people work in this seven-building facility. In the lobby is an exhibit dealing with the history of Bell Labs, including the development of the transistor, the laser, and talking movies; the actual computer that was first declared a chess master; and some of the lab's Nobel winners; some of the exhibits are interactive (but not intended for very young children). At the facility is an apple tree said to be grafted from the tree in Newton's orchard, and copper from the building's roof was used to repair the Statue of Liberty. The new corporate structure could result in physical changes to the facility, so it is best to call first. Open daily, 7–7.

Directly northeast of Berkeley Heights is New Providence, once known as Turkey. In the historical society's museum (1350 Springfield Ave.; 908-464-0163) two rooms are furnished to show what a simple late-18th-century house would have been like; other rooms are devoted to changing exhibits. Open the 1st and 3d Sunday of the month, 2–4.

Bernardsville Somerset 6,597

I 287, US 202, C 525

Although Bernardsville's population doubled between the 1930s and the '80s, the borough has not experienced the explosive growth of some of its neighbors in the Somerset Hills. Not only has it not allowed corporations to build on its borders, it has also decided to build low-cost housing itself rather than let a developer

build a large project that would also include some low-cost housing. For many years the town was known for its large estates and wealthy population.

The town is also known as the home of the Gill–St. Bernard's independent school, of Meryl Streep, and of Millicent Fenwick. Fenwick, who entered Congress at 64 and served as the model for the Lacey Davenport character in the comic strip "Doonesbury," began her political career on the Bernardsville Township school board. Near the train station is a statue honoring her, said to be the only statue in the state to honor a female politician.

The front section of the public library building (2 Morristown Rd.) is one of Bernardsville's few remaining 18th-century structures and one of Somerset County's oldest buildings. Built as a farmhouse, the building served as a tavern during the Revolution, and according to local legend is visited by the ghost of the tavern keeper's daughter, who went mad when her fiancé was hanged as a spy.

Not all of Bernardsville's old estates remain in private hands. The Scherman-Hoffman Sanctuaries (11 Hardscrabble Rd.; 908-766-5787), for example, a New Jersey Audubon facility, occupy 260 acres of streams, lush floodplains, hardwood and second-growth forests, and open meadows that were once private. The facility is involved in a wide array of educational programs and field trips. In the imposing 1930s Hoffman house is the Mary K. Roach Birdroom, with a collection of New Jersey birds, as well as an exhibit room, with changing exhibits of bird paintings or photographs, and a bookstore. The sanctuaries are a haven for diverse plants and wildlife, and material for self-guided walks is available at the house. (When the house is closed, consult the map at the Scherman parking lot.) Hour-long guided nature walks take place on Friday and Saturday morning at 8. The office is open Tuesday– Saturday, 9–5, Sunday 12–5; the trails are open daily, 9–5. Groups by appointment. The Hoffman house can be difficult to get to when there is snow on the ground.

22 Berkeley Heights, Bernardsville

If you continue on Hardscrabble Rd. past the Audubon facility toward Jockey Hollow Rd., you will come to a sign for the New Jersey Brigade Area. Here you will find the Cross Estate Gardens (973-539-2016), once part of another of Bernardsville's estates, now within Morristown National Historical Park (see Morristown) and administered by the National Park Commission and the New Jersey Historical Garden Foundation. The gardens include a formal walled garden, a native plant area, shade gardens, and much else. Open 8–sunset. If you drive the other direction on Hardscrabble Rd. until you get to Childs Rd., you will reach the Franklin Corners Historic District,* with its 18th- and 19thcentury buildings.

In the northwest corner of the township is Little Brook Sanctuary (take c 659, Claremont Rd., north out of town to Post La.; left on Post La.; left on Mountain Top Rd.; right on Clark Rd.; right on Stevens La.), a 100-acre natural area of woods, rolling meadows, and mountain streams belonging to the county park system. The area attracts a wide variety of wildlife, and there are hiking trails here.

Bevans Sussex [Sandyston Township]

c 521, 615, 640

A rural crossroads village in the Kittatinny Mountains, Bevans is within the Delaware Water Gap National Recreation Area, and the home of the Peters Valley Craft Center (take c 521 west off us 206 toward Layton and Dingmans Ferry; turn left, or south, on the first road, c 615; 973-948-5200), a crafts community founded in 1970

as an unintended result of the Tocks Island project. The federal government, proposing a massive dam at Tocks Island in the Delaware River, had already bought the houses and evicted the tenants of several communities along the river before the project was stopped. Bevans was one of those communities. At Peters Valley artists in several crafts—among them pottery, woodworking, metalworking and smithing, weaving, and photography—live and work in the community year-round and (except in winter) teach classes open to the public. Among the facilities at Peters Valley is a traditional Japanese wood-fired Anagama kiln, which is fired once a year. (To watch a firing, call the office for the schedule.) The 19th-century Peters Valley historic district* includes an old cemetery, a Dutch Reformed church, a Greek Revival house, farmhouses, and slate-roofed barns; several of the buildings are open to the public. A large, juried outdoor craft show is held the last weekend in July. Gallery and store open daily 10–5, April–December.

Also in Bevans is the popular Flatbrook-Roy Wildlife Management Area, over 2,300 acres of fields and uplands. The area attracts a wide variety of songbirds and migrating waterfowl and is an excellent place for hiking, fishing, bird-watching, and cross-country skiing. Big and Little Flat Brook, both noted trout streams, run through the area, and at the office (on c 521 between Layton and Flatbrookville) you can see the Flatbrook Valley Club clubhouse. This fishermen's club, one of the many that used to line the streams, was formed in 1893; by 1911 it owned 12 miles of stream, which it stocked from its own pond. The club was sold to the state in 1943, and now only two private clubs remain.

Blackwood Camden [Gloucester Township]

NJ 42, 168, C 534

Settled in the early 18th century, Blackwood is the site of Camden County College (Little Gloucester Rd.), founded in 1967. The college's concerts (609-227-7200, ext. 335), theater programs (ext. 377), and lectures (ext. 289) are open to the public. Exhibits in the art gallery (Lincoln Hall; ext. 682) include an annual student show.

Blackwood's historic district* includes over 100 buildings, dating from roughly 1830–1930, along Black Horse Pike, Baptist La., Church and Elm sts., and Central and East Railroad avenues. Older buildings are also to be seen on Good Intent and Asayla roads.

North of Blackwood in Glendora, also part of Gloucester Township, is the Gabreil Daveis Tavern^{*} (Third Ave.; 609-228-4000). This brick and stone building dates to 1756; built as a tavern, it served as a hospital during the Revolutionary War. Concerts are given Thursday evening in July and August; the house is open then. Other times by appointment.

East of Blackwood and north of Pine Hill (which until recently boasted a ski resort), in Clementon, is the Clementon Amusement and Splash World Water parks (144 Berlin Rd.; 609-783-0263), a 90-year-old amusement park with water rides, a wooden roller coaster, a carousel that has been in place since 1915 (although the wooden horses have been removed and replaced by fiberglass ones), and a showboat on the lake. Open 11–8 weekends, mid-May–late May; noon–10, Thursday–Sunday, late May–June; daily, July–Labor Day; weekends by appointment Labor Day–September. Admission charged.

Blairstown Warren 5,331

3

NJ 94, C 521

Situated on the Paulins Kill, Blairstown is the site of Blair Academy,* founded in 1848 by John I. Blair, who made a fortune from the Lackawanna Railroad and other ventures. It opened as a coeducational independent school, became all male in 1915, and in the 1970s reverted to being coeducational. Its 315-acre campus,

atop a hill, is impressive, and the school now owns Blair's former estate. The town is a participant in the Main Street USA program, and the downtown has several buildings of charm, among them the old Blair Waterworks (1889), now apartments for the school. Next door in a former bank building (1891) is the Ridge and Valley Conservancy (16 Main St.; 908-362-7989). The conservancy sponsors various special events, including nature hikes and lectures, and its

exhibits on the history and natural resources of the area change every three to four months. Open Saturday, 11–2.

West of the center of Blairstown is Raccoon Ridge, known as a spot for seeing hawks and, on clear days, the Poconos, Catskills, and Shawangunks. Access is possible through the Yards Creek Pumped Storage Electric Generating Station (908-362-6163; south from Blairstown on NJ 94 c. 4 miles, right on Walnut Valley Rd. to the gates of the station; register here); the trail is steep and rocky in places. At the center there are also a picnic area and a visitor center. The center contains an exhibit on the history of the Delaware and a model of the station, which pumps water to the upper reservoir and sends it down to create electricity for peak times (see Rockaway). Trail maps are available at the security office. Open daylight hours. You can also hike from here into Worthington State Forest.

Worthington State Forest (Old Mine Rd. just off the last New Jersey exit from 1 80; 908-841-9575) is a 5,800-acre tract that was once part of the Worthington estate. In 1912 the Worthington family built a terra cotta pipeline down Mount Kittatinny to tap water from Sunfish Pond, a glacial pond (and a national natural landmark) that sits at 1,380 feet on the top of the mountain, surrounded by hardwood forest. The Douglas trail to the pond honors U.S. Supreme Court Justice William O. Douglas, who helped in the campaign to save Sunfish Pond from being converted into a reservoir. A popular section of the Appalachian Trail goes through the forest, and there are facilities for picnicking, swimming, fishing, skiing, hunting, and (from April through December) camping. Dunnfield Creek, which descends 1,000 feet from Mount Tammany to the Delaware, is one of the few streams in New Jersey to support native brook trout. The 100 acres surrounding it are particularly lovely in mid-June when the mountain laurel are blooming. Trail maps are available at the ranger's station, itself an old house belonging to the Van Campen family, early settlers in this area.

Farther north on the Old Mine Road (c. 7 miles north of 1 80) are the Pahaquarry copper mines. It was once thought by some that these mines were worked in the mid-17th century; it is certain they were worked for a brief time in the mid-19th century, and for the last time in the early 20th. The single bar of ingot produced in the last attempt is in the New Jersey State Museum in Trenton. Be prepared for rugged trails in this area.

The Old Mine Road extended 104 miles from the mines to what is now Kingston, New York (it used to be known as Esopus). Some controversy surrounds the dating of the Old Mine Road, long believed to be the first commercial road of any extent in the colonies. (Parts of the road are no longer maintained and can be rough on a car.)

North of Blairstown in the Delaware Water Gap is the Appalachian Mountain Club's Mohican Outdoor Center (50 Camp Rd.; 908-362-5670). The center, situated near the Appalachian Trail on the shore of Catfish Pond, offers a variety of weekend programs throughout the year (except July and August), which run from CPR workshops to ski instruction to guided hikes. Within the Delaware Water Gap National Recreation Area (see Walpack) you can hike, bike, swim, canoe, rock climb, bird-watch, cross-country ski, snowshoe, and ice-skate.

Bloomfield Essex 45,061

GARDEN STATE PKWY EXIT 148, C 506, 509

Bloomfield in the 18th century was a suburb of Newark. In 1794 some of its residents decided to form their own church and two years after that named the church in honor of Joseph Bloomfield, a Revolutionary War general who was later (1801–12) to become governor of the state. The town, established in 1812, took its name

from the church.

The sandstone church, finished in 1797 but altered several times in the 19th century, is known as the First Presbyterian Church on the Green (Broad St., opposite Park Ave.). According to legend, the deacon moved the surveyor's stakes in the middle of the night to make the church larger. The green itself, thought to be New Jersey's largest, was a Revolutionary War parade ground purchased by the town and converted to a park. The Bloomfield Green historic district* encompasses Montgomery, Spruce, State, Liberty, and Franklin sts. and Belleville Ave. and includes buildings from the 18th to the 20th century. On the green, note the parish house (at Church St.), a brick and sandstone Greek Revival building (1840) of considerable charm; the manse (Park Pl. south of Monroe Pl.), a clapboard building dating from 1800; and Bloomfield College, another Presbyterian institution.

Founded in Newark in 1868 as the German Theological School, what is now Bloomfield College moved to Bloomfield in 1872, growing over the years

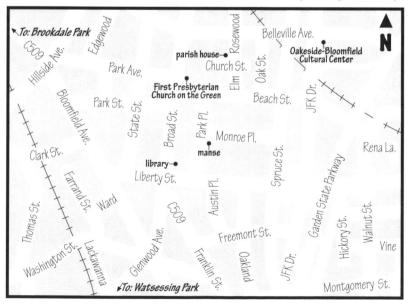

and becoming known as Bloomfield Theological Seminary, Bloomfield College and Seminary, and finally, in 1960, Bloomfield College. The college has continued its tradition of serving different ethnic groups and has developed a nationwide reputation for its multicultural emphasis and programs. Note, on the green, the yellow brick Seibert building, the college's first building, built in 1808 to house the Bloomfield Academy. The Robert V. Van Fossan Theatre, formerly a Presbyterian church dating to 1892, became part of the college in 1966. The Westminster Arts Center (973-748-9000, ext. 343), which was built in 1902 and retains its 75 original stained-glass windows, is part of the same Richardsonian-style complex. Exhibits in its gallery are open Monday– Thursday, 1–5; Friday, 11–2; and by appointment.

On the second floor of the library (90 Broad St.; 973-566-6200) is the museum of the Bloomfield Historical Society. This small museum contains memorabilia from Bloomfield's earlier years, including some examples of items manufactured in town. (The Peloubet-Pelton Organ Company and the Thomas Oakes Woolen Mills were both located in Bloomfield; the museum's Peloubet melodion is said to be the only remaining example in the country.) Some of the exhibits change seasonally. You can pick up the historical society's walking tour of the historic district here. Open Wednesday 2–4:45; other times by appointment.

The Oakes estate,* a 31-room Colonial Revival mansion built in 1895, is the last surviving Oakes building in town. It now serves as the home of the Oakeside-Bloomfield Cultural Center (240 Belleville Ave.; 973-429-0960), which presents a fall (October–December) and spring (March–May) program of lectures, exhibitions, and concerts. Call for a schedule. Tours of the building may be arranged by appointment.

There are two county parks in Bloomfield, both designed by the noted Olmsted firm. To the north is Brookdale Park (Bellevue Ave.; 973-268-3500; go north on Broad St., c 509, to the intersection with Watchung; part of this park is located in Montclair), 121 acres with playgrounds, picnic grounds, playing fields, tennis courts (some with lights), fishing, and fitness and interpretive trails. To the south is Watsessing Park (Glenwood Ave.; 973-268-3500; take Broad St. south to the intersection with Bloomfield Ave., when Broad St. becomes Glenwood; this park is shared with East Orange). This 70-acre park includes playgrounds and playing fields, a network of paths, and a natural ice-skating area.

Boonton Morris 8,343

1 287, US 202, C 511

Situated on a ledge overlooking the Rockaway River, Boonton was a prosperous iron town during much of the 19th century. What may have been the first rolling and slitting mill in the country operated in the 18th century at nearby Old Boonton (since the early 20th century displaced by the Jersey City reservoir), but

Boonton's real prosperity developed after the building of the Morris Canal in

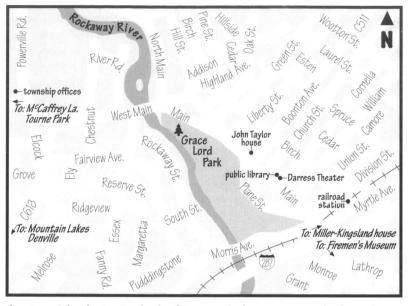

the 1830s. The distinctive look of Boonton's downtown results from the combination of its location on a steep hill with the fact that it was once one of the most important iron centers in the country and did not decline completely after the iron industry went elsewhere (the first plant to manufacture Bakelite was in Boonton). The 19th-century historic district* encompasses Main, Church, Birch, Cornelia, and Cedar streets. Note particularly the public library* (1849; 621 Main St.); the Miller-Kingsland house* (c. 1740, 1808; 445 Vreeland Ave.); the railroad station* (1904; Myrtle Ave.), now converted to commercial use; and the two octagon houses on Cornelia Street. Note also the pre–World War I brick factories along Myrtle Ave. east of the station. Boonton has also preserved attractive older residential districts.

The Darress Theater (615 Main St.; 973-334-9292), built just after World War I, has been restored. Some of the space in the building houses stores and a recording studio, but the auditorium is used for live theater, concerts (the community boasts a resident Baroque orchestra), and films. The John Taylor house (210 Main St.; 973-299-7721) has also been restored and serves as a meeting hall and local history museum, with displays of local historical artifacts. The historical society expects to establish regular hours; call for the schedule. The society also hopes to save a pier that was used to support a mule bridge for the Morris Canal (the bridge can be seen in the town seal).

In the township offices (155 Powerville Rd.) you can see a bust of James Doolittle, remembered for his flying exploits in World War II. Doolittle flew the first instrument-only flight out of Boonton (the equipment was manufactured by the local Radio Frequency Laboratories). Open weekdays, 9–5.

At the New Jersey Firemen's Museum (565 Lathrop Ave.; 973-334-0024), located in a home for the state's retired paid and volunteer fire fighters (said to be the only one of its kind in the country), you can see old equipment, memorabilia, and photographs. Open daily 1–4; groups and other times by appointment.

28 Boonton

A mile or two southwest of Boonton on c 618 is Mountain Lakes (population 3,847). The railroad station (Midvale Rd.) in this wealthy suburb, first built in 1912 and rebuilt in 1919 after a fire, is on land once owned by Hero Bull, a former slave; the cornerstone was laid by Belle de Rivera, a well-known suffragist. The station has been converted to a restaurant. Mountain Lakes was an early-2oth-century planned community; its developer (who built the railroad station) dredged the swamps to create the lakes, and much of the land is parkland. Many of the bridges, walls, and chimneys were built of the colorful local stone, and if you drive in the area of Tower Hill, Sunset, and Lookout rds., you will see many Craftsman-style houses.

Just west of Mountain Lakes and Boonton is Tourne Park (Powerville and Old Denville rds.; 973-829-0474), 545 acres of county land with facilities for softball (to reserve the field call 973-326-7631), picnics, hiking (there is a glacial erratic to be seen and a wildflower trail), cross-country skiing, and sledding. McCaffrey La., the main entrance to the park, was built in 1767 to haul iron to Old Boonton.

Also west of Mountain Lakes (and south of Tourne Park), in Denville, is the Denville Historical Society Museum (Diamond Spring Rd.; 973-625-1165). Exhibits in the museum (a house built in 1832 and moved to its current site next to the library) usually change four times a year; past exhibits have ranged from World War II (Denville is not far from the Picatinny Arsenal; see Dover) to the history of Denville to the history of teapots. The society sponsors a lecture series, a house tour in the fall, and a flea market in the spring. Open weekends, I–4, and by appointment. Also on Diamond Springs Rd. is the New Jersey Foundation for the Blind's training and recreation center, established in 1942, which teaches the blind how to live independently.

Bordentown Burlington 4,341

US 130, 206, C 528, 545

Situated on a bluff overlooking the Delaware River at the confluence of Crosswicks Creek and the Delaware, Bordentown was settled in 1682 by an English Quaker, Thomas Farnsworth, and was originally known as Farnsworth's Landing. It takes its name from Joseph Borden, who arrived 35 years later, organized

travel by stage and boat between New York and Philadelphia, and ended up owning most of the land in present-day Bordentown. A transportation center, Bordentown was for many years an important town, and the list of famous people connected with it is out of all proportion to its size. The historic district* (Farnsworth, Second, and Third aves.; Crosswicks, Prince, Walnut, Burlington, Park, and Spring sts.) takes up a large portion of the town, and despite the heavy loss of notable buildings through arson, an extraordinary amount of the past remains to be explored.

The first American to sculpt in wax, Patience Lovell Wright, grew up in Bordentown in the mid-1700s. After her husband's death, she supported herself doing what had begun as a hobby. In England during the Revolution, she served as a spy for the colonies. Her son Joseph, born in Bordentown, designed the first American coin. The Wright house is at 100 Farnsworth Avenue.

Francis Hopkinson, lawyer, poet, musician, political satirist, designer (he helped design the great seal of New Jersey and the American flag), composer (his "Ode to Music" is said to be the first piece written by someone born in America), member of the Continental Congress, and signer of the Declaration of Independence, married Ann Borden, the daughter of Joseph Borden, and lived at 101 Farnsworth Avenue. The mid-18th-century Farnsworth house is a national historic landmark. Hopkinson's son Joseph wrote the words to "Hail, Columbia" and is buried in the Old Burial Ground (Church St. toward the river).

Thomas Paine, best known perhaps for the stirring pamphlets he wrote supporting the revolutionary cause, lived at 2 W. Church Street. While in Bordentown he developed the single-span iron bridge and worked on other scientific projects. He lived longer in Bordentown than in any other place in North America, and this was the only place in this country in which he bought property. A monument honoring him, designed by Lawrence Holofcener, was unveiled in June 1997. At the foot of Prince St., not far from where Paine lived and worked, the site overlooks the property he owned and a bridge named in his honor.

Clara Barton, who was to found the Red Cross in 1881, opened one of the state's first free public schools in 1852. The schoolhouse stands at 142 Crosswicks Street. Group tours by appointment (609-298-1740).

The 18th-century Gilder house (Crosswicks St. opposite Union St.; 609-298-1740) was the birthplace of Richard Watson Gilder, editor of *Century Magazine*, and home to many of the other distinguished members of his family. Now the Gilder House Museum, it has been furnished with period pieces and artwork by the Bordentown Historical Society. An authentic early- to mid-18th-century kitchen is to be found downstairs, and upstairs the exhibits usually change four times a year. Open every other Saturday and for special events (the cranberry festival, for example) from the first weekend in April to the first weekend in November, 1–3; other times by appointment. Gilder Field, behind the house, is a 15-acre municipal park with picnic facilities, which was built in the mid-1930s by the WPA (Works Progress Administration).

The John Bull, the country's first railroad engine, was shipped in parts from England and assembled in Bordentown, without instructions, by a man who had never seen one. A memorial to him is in the center of town (Farnsworth Ave. by the railroad tracks).

For some 18 years in the early part of the 19th century, Bordentown was the home of Joseph Bonaparte, former king of Naples and Spain and older brother of Napoleon. The only building from his day that remains on his estate at Point Breeze* (us 206 and Park St.), now occupied by a Catholic order, is the garden house, although some of the furnishings are preserved in the Gilder house, and St. Mary's Roman Catholic Church (45 Crosswicks St.) has a Bonaparte chalice that is brought out on special occasions. The row houses at 47–53 Park St. were,

however, once part of a girls' boarding school run by his nephew Prince Lucien Murat and Murat's wife, the former Caroline Frazer of Bordentown.

Since the buildings mentioned here represent only a fraction of what Bordentown has to offer, you might wish to buy a copy of the Bordentown walking tour. These are available at City Hall (324 Farnsworth Ave.) and at various stores throughout the historic district. In the tower of Old City Hall (11 Crosswicks St.), an 1888 building that once housed the police and fire departments and the courtroom, is a Seth Thomas clock dedicated to William F. Allen (1846–1915), the designer of standard time, who was born in Bordentown.

At the end of Farnsworth Ave. you can walk along the bluff; at the end of Prince St. you can go down to the river, where there is another small municipal park with picnic facilities. Some days you may notice the smell of cranberries from the Ocean Spray processing plant, warehouse, and distribution center at the edge of town (the processing plant is Ocean Spray's largest).

South of Bordentown City but within the township is the former Bordentown School (Burlington St.), founded in 1886 as the New Jersey Manual Training Center for Colored Youth and for a time the only publicly funded secondary boarding school for blacks in the northern United States. Established six years after Booker T. Washington's Tuskegee, the school moved to this location in 1902 and at one time had 30 buildings on over 400 acres. A leading educational facility for African Americans in the first half of the century, it was often referred to as the Tuskegee of the North. Today there are some state offices in the complex, and there are plans to use parts of the complex for a museum. Merabash (Museum of Education and Research on the American Black in Art, Science, and History) hopes to have its permanent gallery in place with regular hours by the fall of 1997. Until then, the museum will arrange exhibits at other venues; call 609-877-3177 for information.

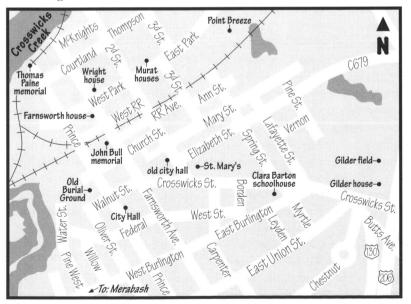

Branchville Sussex 851

US 206, C 519

Unlike some other Sussex County communities, the tiny borough of Branchville, situated near some of the state's most beautiful scenery, has only grown some 28 percent over the last 60 years. At the Garris Center (Broad St.; 973-948-4631) the Culver Brook Restoration Foundation runs a small museum focusing on local

artifacts. Open by appointment.

About a mile west of Branchville is the Bear Swamp Wildlife Management Area (C 52I, 630, and 633; 973-383-0918), 2,000 acres where you can hike, crosscountry ski, mountain-bike, fish, and bird-watch. Continuing west, you will reach Stokes State Forest (US 206, C 519; 973-948-3820), one of six nearly contiguous undeveloped public areas in the western part of Sussex County. The state began purchasing land for this reserve in 1907, buying over 5,000 acres, some of it at \$1.00 an acre. The forest is named in honor of Governor Edward Stokes, who donated the first 500 acres. Much of the original hardwood forest was burned to feed the iron industry and to clear land for farming, but between 1919 and 1942 the state and the CCC (Civilian Conservation Corps) planted over 650,000 trees.

Located within Stokes at the site of one of the largest CCC camps in the country is the New Jersey School of Conservation (973-948-4646), which calls itself "the largest university-operated environmental field center in the world." Here the CCC built barracks, developed the forest's trail network, and created a lake by damming a stream. Since 1949 there has been a field center on the site, and today Montclair State University administers the program, which brings over 10,000 students and teachers a year to the center to stay for 2–5 days and learn about environmental sciences and techniques.

Within Stokes State Forest is a large variety of forest types, of plant and animal life, and of recreational possibilities. The extensive trail network allows many types of hiking, from a stroll to something more strenuous. Tillman's Ravine is a particularly picturesque 500-acre natural area with interesting rock formations and a hemlock forest that has not been cut in more than 100 years. Some of its hemlocks are 150 years old, and the density of the woods so cools the ravine that warblers nest there, unusual this far south. The Tinsley Trail has a geological area, where the record of the last glacier can be read in the rock formations. From Sunrise Mountain there is a spectacular view out over the New Jersey Highlands and the Poconos, and hawks often appear at eye level. (This is a prime site for viewing hawks during the fall migration.) There are bubbling springs, and beavers are active in the streams. The Appalachian Trail goes through Stokes, and dog-sled racing began here in the winter of 1985-86. Camping and picnic facilities are available. Adjacent to Stokes are two wildlife management areas, Hainesville (see Montague) and Flatbrook-Roy (see Bevans).

About a mile east of Branchville on us 206 (turn left at Plains Rd. in Augusta) is the fairgrounds for the 60-year-old Sussex County Farm and Horse Show, a 10-day August event that in 1995 drew 235,000 visitors. Although there is a midway, the fair concentrates on agricultural exhibits and contests.

Also on Plains Rd. is the Frankford Plains Octagon Schoolhouse (99 Plains Rd.; 973-702-0334). Apparently the only wooden octagonal schoolhouse in New Jersey, it was built c. 1850 and used until 1924, when the county closed the one-room schools and regionalized the school system. The building is being restored, and it is hoped that it will be possible to introduce regular hours soon. Until then it is open by appointment.

If you continue south to c 565 (about a half-mile south of Plains Rd.), you will arrive at Skylands Park (94 Champion Pl.; 973-579-7500), a new facility that serves as home park for the New Jersey Cardinals. A baseball museum focusing on amateur and minor-league baseball in New Jersey is open May–October whenever there is an event. During off-season the museum is open Tuesday, Thursday, and weekends, as is the indoor recreation center.

If you continue south to NJ 94 (when 206 intersects with NJ 15, stay straight on NJ 15), and turn left (north) on 94, in about three miles you will come to the Old Monroe Schoolhouse* (973-827-9402, 973-697-8733), which dates back to at least 1819. This restored one-room building is a rare example of a hand-hewn stone schoolhouse. The museum's educational program includes holding classes for visiting school groups in the schoolroom, using McGuffey *Readers*, slates, slate pencils, and the like. There are picnic facilities on the grounds. Open May–October, 1st Sunday of the month, 1–4; groups by appointment.

On your way to the Old Monroe Schoolhouse you will pass through Lafayette, settled in the late 18th century and said to be the first community in the United States to be named for the marquis de Lafayette, who fought on the side of the colonies in the Revolution. Note the mill complex just off NJ 15; the mill is over 150 years old. Within the complex you will find a potter with a studio and gallery who gives classes for children and adults; a general store; a restored carriage house; and many shops. The Lafayette Center Preservation Foundation sponsors a craft and antique show the first weekend in October and maintains the cemetery (NJ 15 south of the town hall), which contains some 18th-century headstones.

About a mile and a half south of Branchville (take 519 to c 655 and turn left) is the Homestead Complex, a group of county buildings built on the site of an old farm. In the 1830s the farmhouse, with a stone addition, became the county almshouse, and another addition was made when the building was converted to a convalescent home in the 1950s. It now houses the county's health department.

Bridgeton Cumberland 18,942

Bridgeton, which celebrated its 300th birthday in 1986, was first settled in 1686 when Richard Hancock built a sawmill at the head of the Cohansey River. The community grew considerably when the river was bridged in 1716 (at which point its name changed to Cohansey Bridge), becoming the county seat in 1749. In the mid-

1760s it became known as Bridge Town and finally (because a bank printed the wrong name on its letterhead), in 1816, as Bridgeton. A raceway was dug in 1814, and the Cumberland Nail and Iron Company became Bridgeton's largest industry until it closed in the 1890s. More recently, Bridgeton was a center for food processing and glass manufacturing. Although these industries are no longer active in Bridgeton, other industries have moved in, and there are plans to revitalize the Cohansey as a low-cost shipping lane. Bridgeton is also faring well as a tourist center. Its symphony orchestra performs regularly at the local high school, in Vineland, and in Pomona.

When the Cumberland Nail Company folded, the city bought its property, an unusual move for 1903, and created the City of Bridgeton Park (609-455-3230). The park's 1,200 wooded acres (one-sixth of Bridgeton's area) contain a lake; an amphitheater; picnic, swimming, and boating areas (the raceway is used by canoeists); sports facilities; nature trails; and the Cohanzick Zoo (609-455-3230, ext. 242), said to be the oldest and largest municipal zoo in New Jersey. Currently engaged in replacing and renovating many of its exhibits, the zoo is also involved in educational programs. Open daily, 8-dusk. Added to the park in 1988 as part of the celebration of the 350th anniversary of the New Sweden colony in America is the New Sweden Farmstead Museum (609-455-9785, 609-455-5529). The farmstead is a faithful re-creation (built mostly by hand) of the 17th-century farmsteads the Swedish-Finnish settlers erected in what became southern New Jersey. The buildings, which include barns, a blacksmith shop, a bathhouse and smokehouse, and a stable, are furnished with artifacts dating to the 17th century. From May through September tours start at 11, with the last tour starting at 4 on Saturday; on Sunday and holidays the first tour is at 12, the last at 4; groups and other times by appointment year round. Admission charged.

Also in the park is the Nail Mill Museum (I Mayor Aitken Dr.; 609-455-4100). This small museum, in what was formerly the office of the Cumberland Nail and Iron Company (1814), features memorabilia from the nail industry, pottery, glasswork, and lanterns; there are special exhibits each month. Open April– December, Tuesday–Friday, 10:30–3:30; weekends, 11–4; groups by appointment. Next to the museum is Dame Howell's School (c. 1830), an example of an early dame's school, which was moved to the park in the 1970s.

Bridgeton's historic district* is New Jersey's largest: its 2,200 colonial, federal, and Victorian buildings make up one-third of the town's structures. Particularly noteworthy is Potter's Tavern* (49–51 W. Broad St.; 609-455-4100), a small, pre-1767 clapboard tavern, which has been restored and furnished as an 18th-century tavern. Here New Jersey's first newspaper, the *Plain Dealer*, a wall sheet, was published weekly between Christmas Day 1775 and March 1776. Open April–October, Saturday, 12–4, Sunday, 1–4. Admission charged.

The Old Broad Street Presbyterian Church* (W. Broad and Lawrence sts.; 609-455-0809), built in the meetinghouse style out of bricks burned on the site on land donated by a Quaker, was begun in 1792. When the builders ran out of money, the state legislature authorized a lottery to provide the necessary funds. The church, open for services in August and the first week of September and for various special events, has two Atsion stoves with their original cast-iron flue pipes in place, made in New Jersey c. 1815, and the whale oil lamps added as an amenity in the early 19th century, as well as the original collection poles, which are still used.

The George Woodruff Indian Museum (150 E. Commerce St.; 609-451-2620), in the Bridgeton Free Public Library, features artifacts relating to the Lenape, all collected within a 30 mile radius of the library. Open Monday– Saturday, 1–4; closed Saturday June–August; other times by appointment. The library's 1816 building originally housed the bank whose mistake on its letterhead led to Bridge Town becoming Bridgeton.

In the county courthouse (Broad and Fayette sts.) is Cumberland County's own liberty bell, cast in 1763 and rung to announce the Declaration of

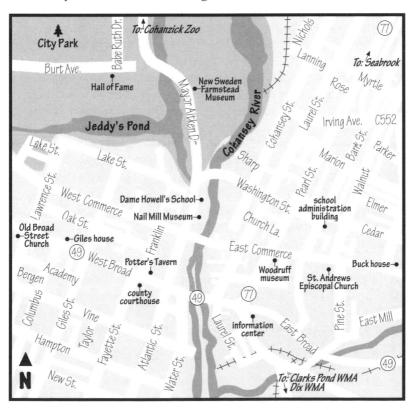

Independence. The town is also proud of its Hall of Fame (Burt Ave.; 609-451-7300), located in the 55-acre Bridgeton Recreation Area across from Alden Field. The museum features local (and other) sports heroes. Open Tuesday–Saturday, 10–12, 1–3. Other noteworthy buildings include St. Andrews Episcopal Church (1864; 186 E. Commerce St.); the Buck house* (297 E. Commerce St.), built for Jeremiah Buck, a mill owner, in 1808; and the Giles house* (143 W. Broad St.), built in 1791 by one of George Washington's generals, perhaps visited by Lafayette, and now used for commercial purposes. What now serves as the administration building for the school system (Bank St.) was built as the city's first public school (1847).

Perhaps the best way to see Bridgeton is to start at the information center, housed in the former railroad station (early 1900s) at the junction of NJ 49 and 77 (609-451-4802, 609-455-3230, ext. 262). You can pick up a free walking-tour map and rent an audio cassette for your walk. Walking, trolley, and escorted motorcoach tours can also be arranged. Open weekdays, 9–4, year-round; weekends, 10–4, May–Labor Day; closed major holidays. Many special events take place along the riverfront promenade, particularly in summer.

Some three miles south of Bridgeton (take 553 or Clarks Pond Rd.) is Clarks Pond Wildlife Management Area, 78 acres with three ponds where you can fish. About four miles northwest of Clarks Pond is Dix Wildlife Management Area with about 2,600 acres. Some three-quarters is marshland, but the rest is divided between hardwood forests and farmland. This is a good spot to view fall foliage, and you can also fish, hike, and hunt.

A few miles north of Bridgeton (take NJ 77) you will come upon the community of Seabrook, once the heart of an agricultural enterprise that for a time was the largest in the state, renowned for its introduction of industrial methods to farming. C. F. Seabrook, referred to by one of his sons as the Henry Ford of agriculture, experimented with overhead irrigation, mechanization, time clocks for farm workers, and cold storage, and dominated the frozenfoods-for-household market—in the 1950s about 2 million packages of frozen vegetables were produced daily. Faced with a labor shortage in World War II, Seabrook brought interned Japanese Americans to live and work on the farm; after the war the farm offered housing and jobs to refugees from the displacedpersons camps in Europe; and many other ethnic groups were part of this community. The Seabrook Educational and Cultural Center, housed on the lower floor of the Upper Deerfield Township Municipal Building (NJ 77; 609-451-8393), tries to preserve something of Seabrook Farms's extraordinary past. The center sponsors publications and various special events (including the traditional Japanese Obon Festival in mid-July, which draws visitors from all over the East Coast), collects oral histories as well as published materials, and has on display artifacts, photographs, and a large diorama of the village in its heyday. Open Monday-Thursday, 9-2.

Bridgewater Somerset 32,509

1 287, US 22, 202, 206, NJ 28, C 525, 616, 620

Although for many, the name Bridgewater Township brings to mind the Somerville traffic circle or the Bridgewater Commons mall, this formerly agricultural area appears in some of the earliest records of land transactions in New Jersey. Washington's troops spent the winter of 1778–79 here at what is now called the

Middlebrook Encampment* (Mountain Ave., c 527); Washington reported to the marquis de Lafayette that they were "in a more agreeable and fertile country than they were last winter at Valley Forge." By special act of Congress, the Betsy Ross flag is flown here 24 hours a day.

During the encampment the Van Veghten house* (Van Veghten Rd.; 908-218-1281), then a working farm, served as headquarters for Nathaniel Greene, Washington's quartermaster general. The earliest section of the house dates to 1720; it was renovated in the mid-19th century. Today it serves as the library for the Somerset County Historical Society. The society also holds an annual open house the 1st Sunday in December, at which time it displays items of historical interest from various local collections. Open mid-March–November, Tuesday, 12–3 and 7–9. The society hopes to open the library some Saturdays as well; call for the schedule. The Vosseller-Castner-Allen Tavern (664 Foothill Rd.), c. 1753, functioned as a store in the 18th century, a tavern and stagecoach stop in the 19th, and a farm and residence in the 20th.

West of the encampment is Washington Valley Park (take Vosseller Ave., a road that appears on a mid-18th-century map, to Miller La.; 908-766-2489), an undeveloped 680-acre preserve with a lake, woodlands, and fields. From the Miller La. parking area you can get to Chimney Rock Overlook; during the spring and fall migrations Chimney Rock is an excellent place to view hawks (and other birds). Unimproved trails wind through the area, and you can also park farther west off Newman's Lane.

Farther west in the township is the Green Knoll golf course (Garretson Rd.; 908-722-1301) and tennis center (908-722-1303). Golf course and courts open daily; pro shop hours are more limited.

In the southwestern corner of the township is Duke Island Park (c 567, the Old York Rd.; 908-722-7779), one of the county's first parks. South of the Old York Road are about 160 developed acres; north of the road is a 100-acre undeveloped portion. The park includes playgrounds and playing fields; a nature trail; and facilities for family and group picnics, fishing, and ice-skating. Concerts are given in the amphitheater in the summer. At the visitor center are a few displays relating to the natural history of the area. On S. Branch Rd. opposite Studdiford Dr. is the Little Red Schoolhouse, said to have been the last one-room schoolhouse operating in the state; closed in the 1950s, it was renovated in the mid-'60s and closed again in 1965.

North of Duke Island Park (take Milltown Rd. off c 567, crossing us 202) is

North Branch Park (908-722-1200), another county facility with frontage on the river (part of the park is in Branchburg Township). The county fairgrounds are here—the county 4-H fair has been going for well over 40 years and draws over 60,000 people each summer—as are horse-show rings, with shows generally scheduled the first Sunday of every month (except in the depth of winter). This is a popular spot for fishing, and there are picnic groves, a playground, and a softball field.

West of North Branch Park in Branchburg Township (take 202 south to Old York Rd., c 637, and head west), the Branchburg Historical Society is restoring the Andrew Ten Eyck house (671 Old York Rd.; 908-722-2124), built in 1790 by a Revolutionary War veteran and a stop on the Swift-Sure Stage. (The house is just west of the intersection with 202, on your left before you get to Evans Way.) If you continue west on the Old York Road but continue straight when it turns south and stay on Dreahook Rd., you will come into Readington and the Solberg Airport (Solberg Rd.; 908-534-4000). Named for and founded by the first man to fly from the United States to Norway, the airport hosts an extremely popular balloon festival in July, with over 100 balloons, some of them over 13 stories high (973-882-5464).

Brigantine Atlantic 11,354

NJ 87

Built on a barrier beach reachable by car only from Atlantic City, Brigantine started as a real estate speculation in the 1920s. A hotel and some 100 houses were built before the crash put an end to the development. Population growth took off after World War II; the opening of the Atlantic City casinos intensified that growth, and

the population, half of which lives on the island year-round, has more than doubled since the 1960s. You can see some of the 1920s flavor in the Brigantine Inn (1400 Ocean Ave.) or in the Byzantine-looking church (1927) on 8th St. S.

At 3625 Brigantine Ave. is the Marine Mammal Stranding Center (609-266-0538), a rehabilitation center devoted to rescuing stranded or injured whales, dolphins, porpoises, and turtles and making it possible for them to return to the sea. Founded in the late 1970s and operated by the only person in New Jersey (and one of only 11 in the Northeast) licensed to work on marine animals, the center has a remarkable success rate with the animals it rescues. It has also been successfully experimenting with solar panels (it has even sold power on occasion) and has installed a special plastic boardwalk. Exhibits in the marinelife museum include products of economic value derived from marine life, fiberglass casts of various species, and a tank containing local marine life. Museum open daily in the summer (Memorial Day to Labor Day), 11–5; in the winter, weekends, 12–4; groups by appointment. By 1996 the museum had outgrown its Brigantine home and was exploring the possibility of finding larger quarters, so be sure to call first.

For beach information (Memorial Day–Labor Day), call 609-266-1122.

Burlington Burlington 9,835

US 130, C 541, 543

"The identifying mark of BURLINGTON (20 alt., 10,844 pop.) is the single track of the Pennsylvania Railroad that runs through the center of the main street without benefit of curb or fence. In many other respects Burlington seems to have changed little from its eighteenth century character as capital of the Province of West

New Jersey." These sentences were written some 60 years ago when the great WPA guide to New Jersey was published. Amazingly, both are still accurate. It is indeed startling to see the tracks in the middle of the city (and trains do tic up traffic, even if they no longer belong to the Pennsylvania Railroad), yet much of Burlington, with its wide streets and heavy use of red brick, has the particular aura of an 18th-century southern New Jersey town.

Settled in 1677 by Quakers from Yorkshirc and London (who divided the area so that the Yorkshiremen lived east of High St. and the Londoners west of it), Burlington became the capital of the Province of West New Jersey in 1681, and when West and East Jersey were joined in 1702, shared the honor of being capital with Perth Amboy. A pottery joined the sawmill and gristmill in the 1680s, other industries followed, and by the 1740s Burlington's port ranked with those of New York, Philadelphia, and Boston. Although the port is no longer active and Burlington went through a period of stagnation common to many eastern cities, it now shows the positive effects of an active redevelopment program.

On W. Broad St. in the small brick Proprietors Office many old documents relating to early transactions in West Jersey are stored, including the original Concessions and Agreements, signed by the Proprietors in England in 1676. The Council of Proprietors has met in Burlington in mid-April each year since 1688, usually on the side walk at Broad and High. A plaque on the side of the bank marks the spot.

Burlington can claim a large number of firsts, among them the oldest educational trust in the country. Burlington Island (Matinicunck Island when the Swedes established a trading post on it in 1624) was given to the town in 1682 with the stipulation that the revenue be used for the schools. The country's first regular public transportation began here, when regular stagecoach service between Burlington and Perth Amboy was initiated in 1733 (there had, of course, been irregular stages between the two cities long before). Although its current sandstone building dates from 1864, the Library Company of Burlington (23 W. Union St.; 609-386-1273), founded in 1757, is the oldest continuously operating library company in New Jersey (Trenton's was founded in 1750 but discontinued operation for many years). It was also the first library in the country to publish its own catalogue. Now a public library, it has on display some of its collection of rare books and other artifacts. You can also see its original 19th-century shelving. Plans include restoring the second floor as an

exhibition space for artwork. Open Monday, Tuesday, Thursday, 2–8; Wednesday, 11–8; Saturday, 10–3 (closed Saturday, July and August).

Burlington can also claim many famous citizens. Captain James Lawrence of "Don't give up the ship" fame (his words as he was dying in a battle in the War of 1812; his men were unable to carry out his command) was born in 1781 at 459 High St.* (c. 1696; front portion added c. 1750). His house has become a historic-house museum, run by the Burlington County Historical Society (609-386-4773). On display here is material relating to Lawrence and the War of 1812, as well as a changing costume exhibit.

40 Burlington

James Fenimore Cooper, the novelist, was born next door* (457 High St., c. 1780) in 1789. Although Cooper did not spend much time in Burlington (the family left for upstate New York shortly after his first birthday but did return occasionally when the father was serving in Congress in Philadelphia), his house is also a museum run by the historical society. Here you can see artifacts relating to Cooper, as well as some that belonged to Joseph Bonaparte (see Bordentown). The society also operates as a museum the Bard-How House* (453 High St., c. 1743), decorated to show how an 18th-century Quaker tradesman would have lived, and the Corson Poley Center (454 Lawrence St., behind the Cooper House). The center contains the society's library and exhibition space; here you can see, for example, quilts, tall case clocks, and samplers. All the society's museums are open Monday–Thursday, 1–4, Sunday 2–4; the library is also open Wednesday, 10–noon.

The cast-iron plow was developed (in 1797) by a Burlington resident, Charles Newbold. In the 1830s, during the silkworm mania that afflicted much of New Jersey and other eastern states, Burlington planted what was probably more mulberry trees (over 300,000 of them) than any other city and in 1838 built a cocoonery. (A cold spring the next year killed thousands of trees, and the mania.) James H. Birch, known as the wagonmaker to the world, began business in Burlington in 1862 on Broad and Liberty streets. His 15-acre plant closed after World War I, but while he was in business, he manufactured some 200 models, shipping out 10,000 carriages in a good year, and even exporting jinrikishas to the Far East.

Ulysses S. Grant had a house here (c. 1813; 309 Wood St.) and may have been on his way to Burlington when he learned the news of Lincoln's assassination. His daughter went to St. Mary's Hall–Doane Academy (south side of Delaware St. at Ellis), an Episcopal girls' school founded in 1837. Now called simply St. Mary's Hall, it has become a coeducational school. (Its Gothic Revival Chapel of the Holy Innocents, 1845–47, was designed by John Notman.) The Edward Shippen family of Philadelphia had a summer home along the Delaware (c. 1756; Talbot St. at the river). Peggy Shippen, who spent summers here and also visited her uncles in Oxford (see Oxford) but apparently didn't like New Jersey, married Benedict Arnold and seems to have had a good deal to do with his eventual betrayal of his country.

Burlington can also claim some interesting churches. Old St. Mary's Episcopal Church* (southwest corner of Wood and W. Broad sts.), a brick church dating to 1703, is one of the oldest church structures in the state. The new St. Mary's (1854) was built from a design of Richard Upjohn, the architect of Trinity Church in New York City. It still uses a silver communion service presented to the congregation by Queen Anne. The two churches and the cemetery between them form a national historic landmark. The Friends Meeting House (west side of High St., near Broad) was built in 1783 to replace one built a century earlier, which the congregation had outgrown. Now a religious retreat and teaching center, it still retains much of its original hardware and many of the original window panes. The Native American king Ockanickon was buried behind the meetinghouse in 1681; a stone commemorating him is under an ancient sycamore tree.

On Wood St. is the Revell house (1685), probably the oldest house in the county. Benjamin Franklin told the story of a kindly woman in the Revell house who gave him gingerbread one day when he missed his ferry back to Philadelphia and of how he wandered about Burlington with the piece of gingerbread in his hand. At the annual Wood St. fair each fall, gingerbread is sold to commemorate the event. On the northeast corner of Broad and York sts. is another house with a connection to Franklin—the Collins-Jones House

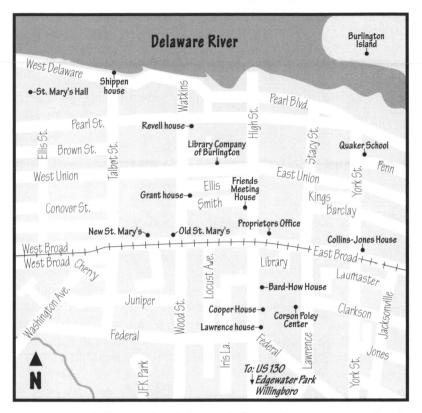

(c. 1750). Isaac Collins produced the state's first modern newspaper, the *New Jersey Gazette* (1777–86), printing it at the same shop Ben Franklin had earlier used to print the country's first currency. The Burlington County Historical Society is working to establish a living history museum at the site.

The city maintains a promenade along the Delaware the length of the city. Another waterfront site to note (in addition to St. Mary's Hall and the Shippen house) is the Grubb estate (Grubb was a Civil War general and ambassador to Spain; the house dates to 1850).

Burlington's 18th- and 19th-century historic district^{*} includes W. Delaware, Wood, and Broad sts., and there are many other buildings of interest not mentioned here. Elias Boudinot, for example, lived on Broad St. when he was superintendent of the Mint in Philadelphia; in a 1730s building is a drugstore that's been there for over 100 years and may well be the oldest continuously operating drugstore in the state; at York and Penn sts. is the Quaker School, which dates from 1792 and has been furnished to reflect a schoolroom of that period (tours by appointment; call 609-386-3993). A walking-tour pamphlet is available at the city hall, and there are walking and bus tours year-round. Call Dr. Kamaras at 609-386-3993 for information.

West of Burlington in Edgewater Park (take 130 west and turn right, or north, on c 630, or Cooper St.) is the Whitebriar farmhouse (1029 Cooper St.; 609-871-3859), part of which dates from 1739, the rest from 1886. Tours (for groups, by appointment only) vary with the season but can include demonstrations of colonial crafts. Admission charge.

If you take 130 west and turn left, or south, on Charleston Rd. you reach the township of Willingboro. For five years (1958–63) Willingboro was known as Levittown, after the post–World War II builder who achieved international fame by building large subdivisions of similar, reasonably priced houses. Each summer the town holds a jazz festival at Millcreek Park (Beverly-Rancocas Rd.; 609-877-2200, ext. 6232).

Caldwell Essex 7,549

C 508, 527

Situated along the Watchung Mountains, Caldwell was named for the Reverend James Caldwell of "Give 'em Watts, boys" fame (see Springfield), who was involved in organizing the Presbyterian congregation in 1779 (the settlement was then known as Horse Neck). Grover Cleveland, the only president of the United States

to be born in New Jersey and the only one to serve two nonconsecutive terms, is probably Caldwell's most famous native son. His birthplace* (207 Bloomfield Ave.; 973-226-1810), a clapboard house dating from 1832 that once served as the Presbyterian manse, has been operated as a memorial since 1913 (Cleveland died in 1908 and is buried in Princeton). Many of Cleveland's personal belongings, including his wooden cradle, the desk he used when he was a lawyer in Buffalo, a chair he used in the White House, and a piece of his wedding cake, are on exhibit. Open Wednesday–Friday, 9–12 and 1–6; Saturday, 9–12 and 1–5; Sunday, 1–6. Call first for a reservation; group tours by appointment.

Caldwell College (Ryerson Ave.; 973-228-4424), founded in 1939, became coeducational in 1986 and in recent years has experienced one of the highest growth rates of any college in the state. Exhibits in the Visceglia Art Gallery change approximately six times a year and feature a wide range of contemporary art, including design, new media, and photography. The gallery (ext. 457) is open weekdays, 9–5. Concerts are also open to the public (call ext. 402 for information). While on campus note the stained-glass windows in the chapel and library; they were created by the former head of the art department.

Camden Camden 87,492

176, 676, US 30, 130, NJ 70, C 537, 543, 551

When Camden was first settled, it functioned as a satellite of Philadelphia, and Philadelphia continued to dominate it until the coming of the Camden and Amboy Railroad in 1834. Camden was settled by Quakers, the first of whom was probably William Cooper who in 1681 built a house on Pyne Poynt. Cooper ran the

ferry to Philadelphia, and as late as the mid-19th century, ferrying goods and

people to Philadelphia was still the town's primary industry. The settlement was long known as Cooper's Ferry despite the fact that it had been renamed to honor the earl of Camden, friend of the colonies. (The name Camden was first used unofficially in 1773 as part of a real estate venture; it became official in 1828.) A few of the houses of William Cooper's descendants remain: Pomona Hall, for example (discussed below); the Benjamin Cooper house (1734; Erie and Point sts.), which served as headquarters for the commander of the British and Hessian outpost during the occupation of Philadelphia and has recently served as the offices of maritime-related companies; the ruins of the Joseph Cooper Jr. house* (c. 1695; Erie and 7th sts. in Pyne Poynt Park); the Samuel Cooper house (1790; 1104 N. 22d St.).

Camden has been the seat of Camden County since the 1840s, although there was a long gap between the formation of the county in 1844 and the building of the first courthouse in 1853, caused by irregularities in the voting on where to place the county seat. Its courthouse (Market and 6th sts.), which houses both city and county offices, dates from 1931 and is one of the tallest in the state. The Benjamin Franklin Bridge, painted a grayish shade of blue and illuminated at night, was the longest suspension bridge in the world when it was opened by President Coolidge in 1926. In 1933, the country's first drive-in movie theater was built in Camden.

Camden became a large industrial city toward the end of the 19th century and reached its peak in the 1950s. During Camden's industrial heyday, a wide range of products was manufactured, the best known being pens, canned foods, phonograph records, and ships. The earliest of these was pens: the Esterbrook company began manufacturing steel pens in 1858; it later switched to fountain pens.

The Campbell Soup Company was set up in 1869 when Joseph Campbell and Abram A. Anderson began packing fancy peas and tomatoes, but the company's growth exploded when John T. Dorrance, who developed the idea of condensing soup, was hired as a chemist in 1897. Dorrance eventually became head of the company and died in the 1930s a very wealthy man. (One story has it that the inheritance tax on his estate was so large that even though it was the Great Depression, for a time the state did not need to worry about funds for relief.) The company's waterfront plant at Market and Front sts. was remarkable for its water towers: four soup cans with hats on. Although the company's headquarters remain in Camden, it no longer manufactures here and has recently threatened to move out completely. When the plant was demolished, one of the towers was rescued; there is hope it can be installed on the waterfront. In 1996 the company's remarkable public museum of tureens and other objects connected with serving and eating soup was also closed.

Eldridge R. Johnson was running a repair shop in Camden when, in 1894, a customer brought in a broken phonograph. Whether Johnson repaired the machine is not clear, but he did develop a way to improve it, moving from Thomas Alva Edison's cylinder to a plate. In 1901 Johnson formed the Victor Talking Machine Company, and in the early years of the 20th century, all the

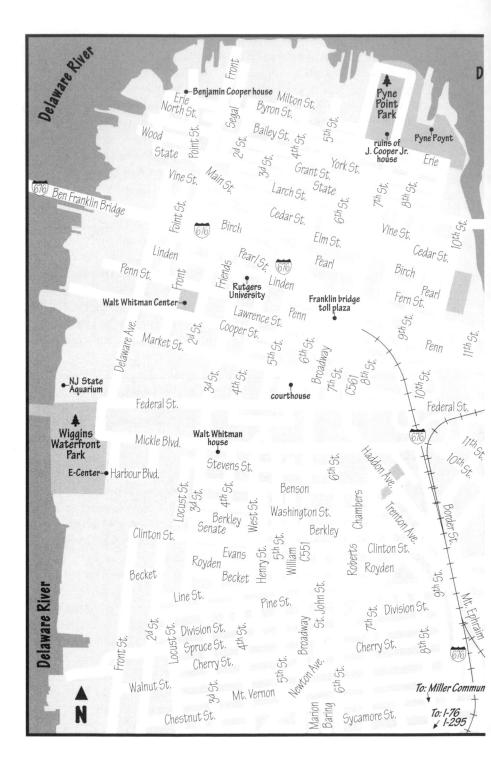

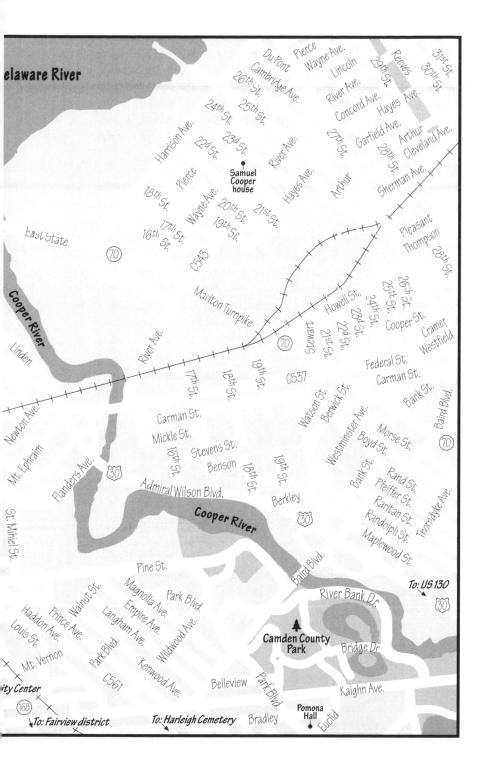

major performers traveled to Camden to record for Victor. In the 1920s he sold the company to what became part of RCA, and he too died a wealthy man. Johnson Park, the site of Cooper Library* (1916–18; Cooper and 2d sts.), now the Walt Whitman Cultural Arts Center (609-964-8300, 609-757-7276), was his personal gift to the city. The center features art exhibits in its Andrew Vitagliano gallery, theater programs (including a children's theater series), poetry readings, and concerts. Exhibits at the gallery change roughly every month. Gallery open weekdays, 10–4.

The last of Camden's major industries was shipbuilding; at their peak the Camden yards had a tremendous capacity and built or refitted many of the warships used in both world wars. The industry's final moment of glory came with the launching of the nuclear-powered steamship *Savannah* in the mid-1950s. Although ships are no longer built in Camden, the port, which occupies over 250 acres at the most navigable part of the Delaware River, is the East Coast's largest exporter of scrap metal and largest importer of plywood. Over 2 million tons move through it annually.

Considered the state's most economically distressed big city (the population has been falling, unemployment has been a problem, and boarded-up buildings are not a rarity), Camden has recently been making a comeback. The New Jersey State Aquarium (I Riverview Dr.; 609-365-3300), part of an ambitious plan to revitalize the waterfront, opened in 1992. At first focusing exclusively on local species, the aquarium remodeled soon after it opened and now includes more interactive exhibits and more tropical species. Among the displays are a 760,000-gallon open-ocean tank that holds some 50 species (divers in the tank can answer questions from the audience), an outdoor seal pool, a touch-the-shark tank, and the seven-foot jaws of a Megalodon shark (this reconstruction contains some 275 real fossilized shark teeth). The terrace gives a spectacular view out over the Delaware, and you can take a ferry to Philadelphia (service was restored 40 years to the day from the last trip). Open daily, 10–5, but the hours do change, so it is best to call ahead. Groups by appointment (800-616-5297). Admission charge.

South of the aquarium is the Sony-Blockbuster Music Entertainment Centre (I Harbour Blvd.; 609-635-I445), which opened in 1995. This entertainment complex, known as the E-Center, can seat 25,000 outdoors, but with almost one-third of its seats under a roof, it can also be closed in for the winter, providing venues for music and theater that range from approximately 1,500 to 6,600 seats. (It takes six people and a crane three working days to effect the conversion.) At the center you can attend concerts ranging from major pop stars to classical musicians, theater, dance, magic, and family shows. This is also the winter home of the South Jersey Performing Arts Center, which uses the smallest configuration, known as the Walter Rand Theatre, and has an educational wing, consisting of a black-box theater and classrooms.

The Campbell manufacturing plant has been replaced by the Lockheed Martin Camden Aerospace Center, an office and manufacturing facility that contains some 575,000 square feet. Other new buildings include a parking

garage, and next to it a Delaware River Port Authority office building designed by Michael Graves.

Both the entertainment center and the aquarium are in Wiggins Park (see below), which eventually will be extended north to the Ben Franklin Bridge. Other plans include a waterfront children's garden, designed to complement the aquarium as an educational facility. The garden will focus on but not be exclusively for children; it is expected to open in the spring of 1998.

Camden's most famous resident was undoubtedly Walt Whitman, who came here to live with his brother, an inspector of pipes at a local foundry. By the time his brother moved to Burlington, Whitman had made enough money from Leaves of Grass to buy his own house at 330 Mickle Street. The house and the building next door are operated by the state as the Whitman House and Library (609-964-5383). (The Walt Whitman Neighborhood* is bounded by Mickle, 3d, and 4th sts.; if you continue on Mickle St. toward the river, you will come to the original section of the Dr. Ulysses S. Wiggins Waterfront Park, where you can get a wonderful view of the river and both the Camden and Philadelphia waterfronts.) Whitman lived in the house, which dates from the 1840s and is now a national historic landmark, from 1884 until his death in 1892, and many of the items he lived with are there to see. The library, established in 1984, contains the Colonel Richard Gimbel collection of rare and out-of-print editions of Whitman's works, as well as writings on Whitman. Open Wednesday–Friday, 9–12 and 1–6; Saturday, 10-12 and 1-6; Sunday, 1-6. Whitman is buried at Harleigh Cemetery (Haddon Ave.), where you can read on his headstone the epitaph he wrote for himself.

Another famous Camden resident was Peter McGuire, commonly credited with having thought up the idea of Labor Day. He moved to Camden in 1884, two years after he first suggested the holiday and two years before he became the first secretary of the American Federation of Labor. Labor Day was first celebrated in New Jersey in 1887.

Rutgers University, Camden (Cooper and 3d sts.), grew out of a small twoyear college that was incorporated into Rutgers in 1950. The campus is a blend of converted Victorian and modern buildings. Shows at its Stedman Art Gallery (609-225-6245) focus on contemporary art. They change five to six times a year. Open Monday–Saturday, 10–4 and two evenings a week. There are fall, spring, and summer concerts at the Fine Arts Center (Linden and 3d sts.; 609-225-6176), as well as occasional theater productions. Call for the exact schedules. Prospective students can arrange tours of the campus by calling 609-225-6104.

Pomona Hall* (Park Blvd. and Euclid Ave.; 609-964-3333), built in 1726 by Joseph Cooper Jr., with an addition by Marmaduke Cooper in 1788, is run as a house museum by the Camden County Historical Society. This lovely Georgian brick building is furnished primarily with objects from the 18th and 19th centuries. At the same site the historical society also operates another museum and a library. The museum's collections include early craft tools, American glass, fire-fighting equipment, and toys, as well as one of the original 14½-footin-diameter stained-glass windows showing Nipper, the His Master's Voice dog, that used to be in the tower of the Victor waterfront plant; there is also an exhibit on the history of industrial Camden. Pomona Hall and the museum are open Tuesday and Thursday, 12:30–4:30, Sunday, 1–5; groups by appointment.

One of Camden's most successful revitalization projects has been a program that encourages children, with the aid of professional artists, to paint murals on buildings, thereby reducing the amount of graffiti. One example can be seen at the Isabelle Miller Community Center (8th and Van Hook sts.).

The Fairview district* (Hull and Olympia rds., Mt. Ephraim Ave., Crescent Blvd.) is a neighborhood of brick houses built in 1917 by the planner and architect Electus Litchfield.

Cape May Cape May 4,668

GARDEN STATE PKWY EXIT O, US 9

Calling itself the oldest seaside resort in the United States, Cape May City^{*} is one of a handful of cities to be designated a national historic landmark. Situated at the southern tip of the state (Cape May would be below the Mason-Dixon Line if the line had continued due east from Pennsylvania), the city is a living mu-

seum of Victorian architecture. Over 600 Victorian buildings, most dating from the 1880s to c. 1910, are preserved in an area of less than two square miles.

Named for (and by) the Dutch explorer Captain Cornelius Mey, who pronounced the area as pleasant as his homeland and claimed it for the Netherlands in the 1620s, the peninsula was first settled early in the 1600s by whalers. Cape May began to become well known as a resort before the Revolution-an advertisement for a house appearing in the Pennsylvania Gazette in 1766 mentioned that the property would be "very convenient for taking in" tourists-but it was not until the early 19th century, with the introduction first of regular steamship connections between Philadelphia and Cape May (1819) and later of train service (1830s) that Cape May achieved its reputation as a fashionable and special place. It was so popular in the 1840s and '50s that ships from Philadelphia to Cape May ran daily and so fashionable that it liked to be known as the "playground of presidents." Abraham Lincoln stayed at the Mansion House in 1849 when he was still a congressman; Franklin Pierce visited in 1855, James Buchanan in 1858, Ulysses S. Grant in 1873, and Chester A. Arthur in 1893. In the summers of 1890 and 1891 President Benjamin Harrison's summer White House was at the Congress Hall Hotel, although he himself stayed in Cape May Point. Other noteworthy visitors included the bandmaster and composer John Philip Sousa, who wrote a "Congress Hall March"; Senator Henry Clay, who came in 1847; and Henry Ford, who in the early 1900s staged an automobile race on the beach against Louis Chevrolet (driving a Fiat) and Alexander Christy (driving a Winton). Ford in his Ford was ahead, but a wave broke over the car and the motor stalled. To pay his hotel bill he offered stock in his company, which was refused, and he finally sold his car to Dan Focer, who opened an agency in Cape May three years later, becoming the country's first Ford dealer.

Tourists at first stayed in private homes, but soon seaside hotels were built. For two seasons Cape May boasted the world's largest hotel—the Mount Vernon, with over 3,000 rooms. It burned in 1856, as did many of Cape May's buildings over the years. In fact, the city's present appearance is largely a result of the rebuilding that took place after a fire in 1878 destroyed most of the city's tourist accommodations. (Cape May's charm also reflects its decline in popularity: after Atlantic City's rise in the early 1900s, new building virtually ceased in Cape May.)

Although the beaches, despite serious problems with erosion, are an obvious attraction (for many beaches it is best to check on tides to make sure you can enjoy both sand and water) and fishing and boating are also popular, most people come to Cape May to spend time in the town. The best way to see the town is on foot or bicycle. The Mid-Atlantic Center for the Arts (609-884-5404, 800-275-4278) sponsors walking tours and trolley tours (daily in season, weekends only the rest of the year; call for the detailed schedule; groups of over 20 can arrange in advance for individualized tours, and in the summer the center also features special tours for children aged 3–12). The center and the city both sponsor many special events: Victorian week, spanning two weekends and featuring tours of many private homes, in October; a tulip festival in April (with plantings of over 100,000 tulips); a music festival in early summer; a Christmas candlelight tour; and many other fairs and tours throughout the year. Call for specific schedules.

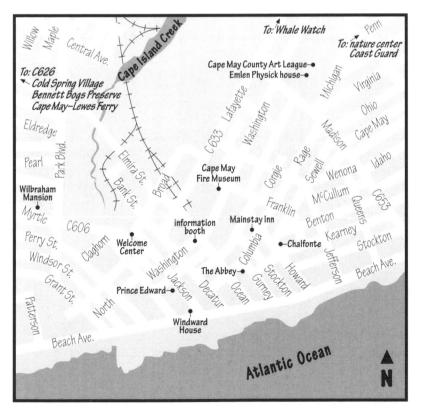

Cape May 51

To tour on your own, stop in at the Welcome Center (407 Lafayette St.; 609-884-9562) or the information booth at the head of the Washington St. pedestrian mall (Ocean St.); maps are available for self-guided walking tours. Built as a Presbyterian church in 1853, the Welcome Center became an Episcopal church in 1903 and now serves as a community center. The information booth was formerly a guardhouse in Philadelphia's Fairmount Park. At both places you can pick up a variety of brochures and information on beach passes. (For information on passes, you can also call 609-884-9525.) The Welcome Center is open daily, 8:30–4:30; off season, the information booth's hours are irregular.

Not to be missed is the Emlen Physick house (1048 Washington St.), a 16room stick-style house designed by Frank Furness, which sits on over eight acres in the center of town. It was built in 1881 for Physick, a member of a prominent Philadelphia medical family (his grandfather is often referred to as the father of surgery). Now open as a house museum, the building contains furniture, toys, clothes, and other Victorian artifacts. Of particular note are the Eastlake-style furniture, much of it designed by Furness, and the papier-mâché (Lincrusta) wall coverings. Also on the property is the Carriage House, now the home of the Cape May County Art League (1050 Washington St.; 609-884-8628). Founded in 1929 and said to be the oldest continuously operating county art league in the country, the league offers classes and lectures and sponsors a variety of special events. Exhibits in the galleries change roughly once a month. Gallery open Tuesday–Saturday, 10–4; Sunday, 11–4.

Almost any street has its rewards. Compared to some other Victorian seaside resorts, Cape May has an unusual variety of buildings. It also sports an unusual abundance of gingerbread and other decorative exuberance. Some of the most interesting private houses have been converted to bed-and-breakfast inns or hotels. The Abbey (Columbia Ave. and Gurney St.), for example, an 1869 Gothic Revival estate built by a Pennsylvania coal baron, has a 60-foot tower and elaborate stained-glass windows. The Mainstay Inn (635 Columbia Ave.) was a gentleman's gambling club. The Wilbraham Mansion (133 Myrtle Ave.) was an 1840s farmhouse expanded in 1900 by Philadelphia industrialists. Windward House (24 Jackson St.), an Edwardian shingle-style house, has unusual stained and beveled glass; the glass is also striking in the Prince Edward (38 Jackson St.). The oldest hotel, the Chalfonte (Sewell and Howard sts.), was built in 1876 as a private home by Colonel Henry Sawyer, who was taken prisoner in the Civil War by the Confederates and exchanged for a son of Robert E. Lee. Volunteers help maintain and restore the Chalfonte on working weekends in fall and spring. Space prohibits listing all the enjoyable buildings here, but the brochures available from the information centers will help identify them.

The Nature Center of Cape May (1600 Delaware Ave.; 609-898-9366) has exhibits focusing on the state's natural environment, particularly the marine environment. The center runs a variety of workshops, field trips, and educational programs, including harbor tours with marine biologists. Open daily, 10– 4, but in winter the hours can be irregular, so it is best to call ahead. The Cape May Fire Museum (Franklin Ave. and Washington St.; 609-884-9512), constructed on the site of an earlier firehouse, features a 1928 LaFrance pumper and other memorabilia; exhibits are also devoted to Cape May's fire history. Open daily, May–October, 8–8; groups and other times by appointment.

The U.S. Coast Guard's only station for training recruits is located on 500 acres northeast of the center of town (609-884-6900), in an area used as a harbor by the Continental navy during the Revolution. The station is open for self-guided tours, 9–3, Monday–Saturday. You can pick up a map at the front gate. Graduation ceremonies take place Friday at 11; May–October they are held outside (weather permitting). At 10, two films, one about life at boot camp, the other the Coast Guard year in review, are shown in the auditorium. Both the graduation ceremonies and the films are open to the public. The Coast Guard also schedules several sunset parades each summer.

Northwest of town (take US 9 to Lincoln Blvd.) is the terminal for the Cape May–Lewes, Delaware, ferry (609-886-2718). The trip takes just over an hour, and the ferries run all winter. From April through December you can also look for whales and dolphins on cruises run by the Cape May Whale Watch and Research Center (1286 Wilson Dr.; 609-898-0055).

North of town is Historic Cold Spring Village (Seashore Rd.; 609-884-1810), intended as a reconstruction of a 19th-century southern New Jersey village. The Cold Spring Grange (1897) serves as a restaurant, and buildings from other sites in the county have been moved here, among them what may be the oldest house in the county, the Spicer Learning house (c. 1702); the Cape May Point jailhouse (c. 1850); the Dennisville Inn (c. 1775); a blacksmith's shop (1865); and two railroad stations. Crafts workers, including a blacksmith, weaver, tinsmith, ropemaker, and potter, demonstrate their crafts and sell their products in the shops. The welcome center and marine museum are housed in a late-19thcentury building that was once a Loyal Order of Mechanics Hall and later the municipal hall for Lower Township. Special programs—antiques and craft shows, sheep-shearing festivals, concerts, colonial and Civil War encampments—take place on weekends. Open daily, Father's Day–Labor Day, 10–4:30; weekends, Memorial Day–Father's Day and September. Admission charge.

Also north of town (take Seashore Rd., c 626, to Tabernacle Rd., turn left, and turn left again on Shunpike Rd.) is Bennett Bogs Preserve, home to 250 species of plants, of which some are at their northern limits and many are rare or endangered. The preserve contains three vernal ponds; these flood in winter and spring and dry out in summer and fall, displaying then an abundance of plant life. Managed jointly by the New Jersey Audubon Society and the Nature Conservancy, the preserve is open for walking, except when the trails are flooded.

Cape May Court House Cape May [Middle Township]

US 9

The seat of Cape May County, Cape May Court House, though still small, saw its population double between 1960 and 1980. Known as Middletown when the first courthouse was built in 1745, the city has kept its mid-19th-century white frame courthouse* for meetings, conducting county business elsewhere.

The Cape May County Historical and Genealogical Society Museum occupies the John Holmes House (504 US 9; 609-465-3535). The house dates to the 18th century, the earliest part to 1755. It contains 18th- and 19th-century period rooms and a wide variety of artifacts, from medical aids to children's toys. In the barn are whaling implements, the lens from the Cape May Point lighthouse, and other maritime-related exhibits, as well as some horse-drawn vehicles. The society is also involved in various outreach programs. Museum open 10–4, Monday–Saturday, mid-June–mid-September; Tuesday–Saturday, mid-September–December and April–mid-June; Saturday, December–March. The last tour begins at 3. Closed Sunday and holidays; groups and other times by appointment. Admission charged. The office is open 8:30–4:30, Monday–Saturday, mid-June–mid-September, Tuesday–Saturday, mid-June; the library is open Wednesday–Friday, 10–4, Saturday by appointment, 10–1.

East of us 9 is the Performing Arts Center of Middle Township (212 Bayberry Dr.; 609-463-1924, 609-463-1925). The center schedules a wide variety of musical, theatrical, and dance events. Exhibits in the lobby art gallery feature work by local artists. Open weekdays 8–4 and during performance intermissions.

Roughly two miles north of town on us 9 is the Cape May County Park (609-465-5271). Its 128 acres include a natural area with jogging, nature, and bicycle trails and a wide variety of facilities for active sports. There is also a small zoo with over 100 species of domestic and exotic animals. Open daily, 10–4:45.

About four miles north of town on us 9 is Learning's Run Gardens and Colonial Farm (1845 us 9 north, one mile north of the Avalon Blvd. intersection; 609-465-5871). There are 25 gardens on 30 acres, each garden constructed with a different theme; paths lead you from one calculated effect to another. This is an unusually peaceful spot in the midst of a busy resort world. Also on the property is a small reproduction of a colonial farm. Open mid-May–mid-October, 9:30–5; the gift shop is open until Christmas. Admission charged.

Just beyond Leaming's Run is Beaver Swamp Wildlife Management Area, 2,800 acres of swamp, dense forest, creeks, and small ponds. Here you can hike, bird-watch, and hunt; this is also a good spot to see muskrats, beavers, and river otters.

Both north and south of Beaver Swamp are parcels of the Cape May National Wildlife Refuge (24 Kimbles Beach Rd.; 609-463-0994). The refuge, which has been described as a work in progress, will eventually contain 16,000 acres and should have foot trails by the late 1990s. West of Cape May Court House is Reeds Beach (take Hand Ave., c 658, to NJ 47, turn right, and turn left on Reeds Beach Rd.). Because horseshoe crabs breed at Reeds Beach, it is a famous spot for viewing migratory shorebirds, who stop here each spring exhausted from their flight from their winter grounds. They stock up on the horseshoe crab eggs, which give them the energy they need for the long journey to their breeding grounds.

Cape May Point Cape May 248

с 606, 629

Ş

Cape May Point was founded as Sea Grove in 1875 by a group of wealthy Philadelphia Presbyterians, including John Wanamaker of the department store family, later postmaster general under Benjamin Harrison (Harrison spent his summers at the point in the 1890s). Apparently their aim was to establish a beach commu-

nity like the successful Methodist ones at Ocean Grove and Ocean City. (Visitors journeying to Cape May by boat used to dock here and travel overland the three miles to Cape May City.)

Still primarily a summer community, Cape May Point has some typical seaside resort architecture. Saint Peter's-by-the-Sea, a gray wooden church with white gingerbread trim, was taken from the Philadelphia centennial exhibition in 1880 and moved to Cape May Point by train. The erosion problem at the point is extreme: this is the church's fourth location; the last one, two blocks away, is now in the ocean. With an artificial reef in place, a dune-replenishment program, and constant vigilance, the town is optimistic that it is at least not losing the battle.

Even before the community was founded, there was a lighthouse at the point. The current one* (Lighthouse Ave.; 609-884-5404, 609-884-8656), built in 1859, is the third, the land the previous two stood on now being underwater. It is still being used, and on a clear night you can see its light for 19 miles. Restored by the Mid-Atlantic Center for the Arts (see Cape May), the lighthouse offers a spectacular view from the top, and on the landings are exhibit panels dealing with the history of the area you can see from the window, the structure of the building, and the functioning of the light. Open weekends, mid-October–March; daily the rest of the year, with extended hours mid-June–Labor Day; the schedule varies so it is best to call before visiting. Admission fee.

This is prime territory for bird-watchers, one of the best spots in the country for observing migratory birds, particularly raptors (birds of prey). On the Atlantic Flyway, it is the last stop on the southern journey before the 18-mile flight over the open water of Delaware Bay. Birds congregate here, resting, eating, and waiting for good weather. At its Cape May Bird Observatory (707 E. Lake Ave.; 609-884-2736) the New Jersey Audubon Society has been studying migration at the point since 1975. The center sponsors birding weekends in spring and fall, weeklong workshops on shorebirds and raptors, and a variety of walks and educational programs. The observatory and research

center are open daily, 9–5 (hotline 609-884-2626). Lily Lake is across the street from the observatory; it is home to geese, ducks, and swans, and you can ice-skate there in the winter.

The Cape May Migratory Bird Refuge (Sunset Blvd. opposite S. Bay Shore Rd.; 908-879-7262) is a 271-acre reserve between Cape May and Cape May Point, owned by the Nature Conservancy. A well-marked trail goes through the meadow to the beach and back by another route. This was land that used to belong to South Cape May, a resort town destroyed in the 1950s by a storm. Open daily dawn to dusk.

Cape May Point State Park (Lighthouse Ave.; 609-884-2159) consists of some 190 acres of sand dune and freshwater marsh used during World War II as a coastal defense base. In 1942 bunkers were built here (and across the bay at Lewes, Delaware) 900 feet from the sea. Today you can see them at low tide. The dunes were blown away by Hurricane Gloria in 1985 and have been replaced by a smaller system, but the park is losing land to erosion at the rate of 30 feet a year. At the visitor center (once a military building) you can pick up trail guides. From Memorial Day to Labor Day the visitor center contains an aquarium filled with local marine life, and there are a few other exhibits of local wildlife. The park has facilities for picnicking and fishing, observation decks for watching the birds, and over three miles of hiking and nature trails, including several stretches of boardwalk; there is also a half-mile trail for the handicapped. Open daily, 8–8, in the summer (Memorial Day–Labor Day); Wednesday–Sunday, 8–3:30, the rest of the year.

At the end of Sunset Blvd. (c 606) is Sunset Beach, a good spot to find Cape May diamonds. These are pebbles of clear quartz smoothed and rounded by weathering, which, when polished, take the light like a precious stone. At Sunset Beach you can also see the remains of an experimental concrete ship, used in World War I. It was apparently being towed to be used as part of a wharf but broke loose in a storm and sank.

North of Sunset Beach is Higbee Beach, a wildlife management area containing roughly 900 acres of beach front, dunes, marsh, woodlands, fields, and ponds. Higbee Beach is another good place to look for Cape May diamonds (in fact, it used to be called Diamond Beach) and for birds. The area is important as a nesting and resting station since Pond Creek Meadow is the last freshwater area before the flight across Delaware Bay. Seventeen endangered species of birds frequent the area, over 250 species are around at some time during the year, and millions of songbirds and over 50,000 raptors migrate through this area each year. Millions of monarch butterflies stop here each fall during their southwestern migration. It is also very popular with people, some tens of thousands from many countries visiting each year, and between Memorial Day and Labor Day the parking lots can be closed (write the Division of Fish, Game, and Wildlife in Trenton to find out about the parking lot schedule). Some of the visitors swim, sunbathe, picnic, hike the trails (a trail map and brochure can be picked up at the head of the trail), watch the spectacular sunsets, and, in season, hunt, but the main attraction is the birds.

Cassville Ocean [Jackson Township]

C 528, 571

Ş

The crossroads community of Cassville* was important to the development of cranberry cultivation in the Pinelands. John Webb began growing cultivated berries in the 1840s and also developed the idea for the mechanical berry sorter; his success encouraged others to follow his example. Today, what is most noticeable

about Cassville is its Russian settlement. If you drive into the village on C 571 from the north, you cannot miss the gilt onion domes of two Russian Orthodox churches. St Vladimir, the one to the south, is modeled on an 11th-century Russian church; for tours, call 732-928-1337. The trees that 40 years ago surrounded all the houses (and made them look like Russian dachas) have been giving way over the years to American lawns, and you are less likely to see women in babushkas than you once were. Rova Farms, founded in 1934 under the auspices of a Russian mutual aid society, was a cooperative community on 1,400 acres with 3,000 shareholders (the Rova Farms district is listed in the state register of historic places). The children of the original members are evidently losing interest in the venture, but Rova Farms (732-928-0928) is still open for old-style Russian meals Tuesday, 6 A.M.–4 P.M., and weekends, 10 A.M.–6 P.M.; there is also a flea market on Tuesday, 6 A.M.–4 P.M..

Jackson Township itself (population 33,233) is a large township that has seen its population more than quintuple over the last 30 years. Ocean County as a whole is one of the fastest-growing counties in the state, and because of the striking number of retirement colonies has been dubbed the St. Petersburg of

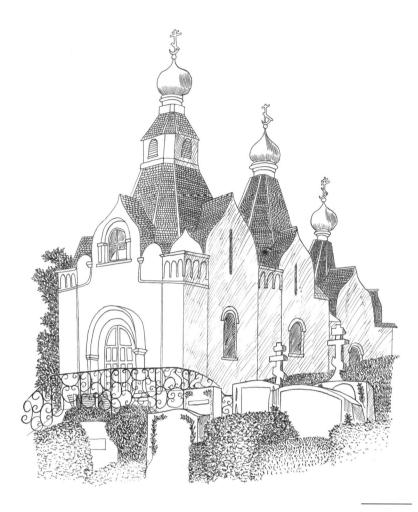

CASSVILLE

the North. Jackson Township has its share of retirement colonies, but it also has large tracts that remain undeveloped. One of these is the 450-acre state seedling nursery, moved here from Washington Crossing State Park in 1982 and located on the site of the state's former quail farm (C 527, 528, between the Meadowbrook and South Wind retirement communities c. 4 miles south of 1 195 exit 17; 732-928-0029). Ten of the acres are devoted to the seed orchards, and trees used in large-scale reforestation projects around the state are grown at the nursery, now known as the Forest Resource Education Center. Longrange plans call for eventually turning some of the woodlands into demonstration areas. For now the center runs a variety of hands-on educational tours. Its resources include a 20 x 30 foot New Jersey–shaped deck to help teach the natural history and geography of the state, an ABC arboretum with one tree for each letter of the alphabet to help teach tree identification, and an interpretive nature trail. You can hike here and fish in the Toms River, which flows through the tract and is stocked with trout. The nursery is open to the public, weekdays, 8–4; groups and tours by appointment. Across 527, 528 from the nursery is the Butterfly Bogs Wildlife Management Area (Bennetts Mill Rd.), 103 acres of pitch pine and scrub oak with three lakes suitable for fishing.

Farther west is Colliers Mills Wildlife Management Area (accessible from 528 and 571), more than 12,000 acres of both pitch pine and scrub oak uplands and white cedar swamp lowlands, with fields, wetlands, and six major impoundments. One of the most heavily hunted areas in the state, Colliers Mills offers opportunities for hikers and bird-watchers on its sandy roads. The Pine Barrens tree frog and bluebirds are some of the unusual animals to be seen here. Prospertown Lake Wildlife Management Area (access road off c 537 just north of Prospertown) consists of 125 acres with facilities for fishing and boating.

Between Butterfly Bogs and Colliers Mills is Patriots County Park (Bowman Rd.; 732-296-9090), more than 200 acres with open playing fields; softball and soccer fields; bocce, horseshoes, and shuffleboard courts; picnic facilities; and bicycle, hiking, and fitness trails.

North of Butterfly Bogs (take Butterfly Rd. to Frank Applegate Rd. and continue until you are almost at c 638) is the Schulman tract, an 80-acre natural area where you can walk and bird-watch.

Behind the Jackson municipal building (c 528 and Coventry Rd.) is a restored (and expanded) one-room schoolhouse now functioning as a museum (732-928-1200). One of the exhibits re-creates a classroom atmosphere from the 1920s, when the building was last used as a school, and the collection features local artifacts, including memorabilia related to cranberry and blueberry cultivation and to the Lakehurst Naval Air Engineering Station, site of the explosion of the dirigible *Hindenburg* in 1937 (see Lakehurst). Open weekdays, 9–5, by appointment.

Just north of Prospertown Lake is Six Flags Great Adventure (c 537; 732-928-1821), an amusement park and safari that hopes to transform itself into a yearround resort. Open daily, June–August; more limited schedule April, May, September, and October. Hours vary; call for the exact schedule. Admission charge.

Chatham Morris 8,007

NJ 24, 124

A colonial town that in the mid-19th century attracted commuters and in the late 19th century became, with Madison, a center for rose growing, Chatham has converted many of its older buildings to modern uses. This is particularly apparent on Main St., which, incidentally, follows the old Minisink Trail; in other parts of the

Chatham historic district (listed in the state register of historic places), which also includes Parrot Mill and Tallmadge rds. and Summit, Hedges, Hillside, and University aves., the older buildings are sometimes less apparent. Prerevolutionary houses are to be seen on Watchung Ave. overlooking the Passaic River and on Kings Street.

South of the center of town (take Fairmount Ave., c 638, to Southern Blvd., c 647, and turn left) is the Great Swamp Outdoor Education Center (247 Southern Blvd.; 973-635-6629). Located at the eastern border of the Great Swamp National Wildlife Refuge, the center is run by the Morris County Park Commission. (Somerset County's Lord Stirling Environmental Education Center is located at the western edge of the refuge; see Basking Ridge.) At the education center is a one-mile path of trail and boardwalk and a half-mile barrier-free trail. The center has an active educational program for children and adults, including weekend nature walks. Open daily, September–June, 9–4:30. In July and August (the buggy months) the center continues its programs at the Kay Outdoor Education Center (see Chester).

Cherry Hill Camden 69,348

I 295, NJ 70

The township of Cherry Hill, which remained rural until the 1950s, has seen its population increase almost twelvefold since the 1940s. Known as Delaware Township until 1961, Cherry Hill is now largely a commuter town with many big hotels, housing developments, and shopping malls. The Cherry Hill Mall (NJ 38 at

Haddonfield and Church rds.), in fact, was one of the country's first enclosed malls, and its skylit corridors, fountains, courts, plantings, and sculpture were frequently published as examples of good design.

The township attracted national attention when the Garden State Park racetrack (NJ 70; 609-488-8400) was somehow built here in 1942. After a fire in 1977, the track reopened in 1985 as a state-of-the-art facility; its glassed-in paddock and mahogany sculpture of a horse's head caused considerable comment. In 1985, after almost 100 years in the outskirts of Trenton (now the site of the Johnson Atelier and Grounds for Sculpture; see Hamilton Township), the New Jersey State Fair moved to the Garden State Park. In 1995 it moved again, but in 1996 was back at the racetrack. Boasting the biggest midway in North America, the fair, which predates statehood—it was first held in Burlington County in 1745—lasts 11 days.

Barclay Farmstead* (209 Barclay La., off NJ 70 east between the Kings Highway, NJ 4I, and I 295; 609-795-6225) is a living-history museum showing early farm life in the southern portion of New Jersey. The land first changed hands in 1684; after that, only three families held title to the property before it was purchased by the township in 1974. The present house, built by the second owner, Joseph Thorn, dates to 1816; in the 1820s it was bought by a member of the Cooper family, a descendant of the founder of Camden, as a summer retreat. (The Barclay Farm housing development is on land that belonged to the original Barclay farmstead; within the development is a wooden covered bridge built in the 1950s, the first wooden covered bridge to be built in the state in over 90 years.) The house is decorated as it would have appeared in the early 1800s when the Thorns lived in it. Also on the property, which is liberally supplied with interpretive signs, are an herb garden, a forge barn with an 1830s blacksmith's shop, a corn crib, and a Victorian springhouse. Some of the land is rented to members of the community who farm it. A footbridge leads over the pond and connects with a nature trail along the north branch of the Cooper River. The farmstead sponsors a variety of programs and special events, including a December open house, concerts, a pumpkin festival, a quilting program, and a spinning and weaving show. Open Tuesday–Friday, 9–4, year-round except for major holidays; group tours by appointment. Admission fee except for residents of Cherry Hill.

Although most of Cherry Hill's buildings are of relatively recent vintage, on Old Cuthbert Rd. is the Samuel Coles House* (1743), and at the intersection of Kings Highway and Church Rd., note the gatehouse at the Colestown Cemetery* (1858).

Located in a former industrial building in an area of similar buildings is the Garden State Discovery Museum (16 N. Springdale Rd.; 609-424-1233). Focusing on children aged two to ten, the museum features hands-on exhibits that may be educational and hosts a variety of special events. Open Tuesday–Friday and Sunday, 9:30–5:30; Saturday, 9:30–8:30. Admission charge.

Northwest of Cherry Hill is the borough of Merchantville, said to be the only town in the United States bearing that name. In Victorian days the town was a fashionable commuting suburb of Philadelphia. Note in particular the stick-style Centennial House* (17–19 E. Chestnut St.), Collins and Pancoast Hall* (1887, 1893; 4–8 S. Centre St.), and the Cattell Tract Historic District* (parts of Chestnut, Walnut, Cedar, Gilmore, and Leslie aves.; Cove Rd.; and N. Centre St.). The Merchantville Historical Society's archives and costume collection are at the Community Center (Somerset Ave. and Greenleigh Ct.; 609-663-1819). Open by appointment. The historical society also sponsors annual events, including a spring art fair and a holiday tree festival.

Chester Morris 1,214 (borough) 5,958 (township)

US 206, NJ 24, C 510, 513

Chester, originally Black River, is a popular tourist town, which was settled early in the 18th century, primarily by immigrants from Long Island. By 1740 the community was known as an iron village, its mills supplying munitions to the revolutionary army. The iron industry flourished in the second half of the 19th century, and many of the

town's handsome buildings date from that prosperous period. By the 1890s the discovery of the Mesabi Range in Minnesota had ended local iron mining.

A walk along Main St., Hillside Rd., Budd Ave., and Grove St. will reveal many restored and converted buildings, often with plaques giving their builders' names and the dates they were built. At the northwest corner of Main St. and Hillside Rd. stands the Brick Hotel (now the Black River and Raritan

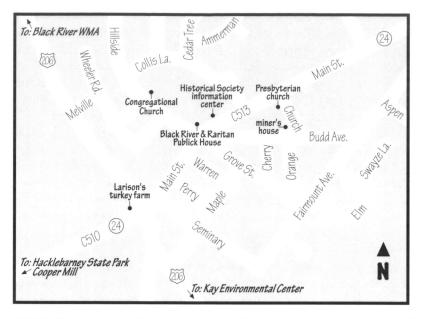

Publick House), whose brick portion dates from c. 1810. A stagecoach stop for many years, it was used for a while in the mid-19th century as a school. The Congregational Church (Hillside Rd.) dates from 1856, the Presbyterian (Main St.) from 1852. An example of a two-family miner's house can be found at 60 Budd Ave., an 18th-century house at 50 Budd. Many of the roads leading into the center of town are lined with attractive houses; at the intersection of us 206 and NJ 24 is Larison's Turkey Farm, housed in an early-19th-century building.

About 300 feet north of the Publick House on Main St., in a late-19thcentury Gothic Revival building, is the Historical Society's information center (908-879-2761). Here you can pick up a copy of the society's walking tour. The society also has a library in the carriage house at 41 North Rd. and presents an annual house tour.

Two miles west of Chester on NJ 24 (formerly the Washington Turnpike, opened early in the 19th century) stands the Cooper Mill (908-879-5463), the last surviving building from a community known as Milltown or Milldale. It is a working mill with two sets of grinding stones, which is run by the Morris County Park Commission. The current mill was built in 1826 by Nathan Cooper, but a flour mill had been on the site in the 1760s and a sawmill and gristmill in the 1780s. The wooden water wheels were replaced by metal ones in the 1850s, and the mill incorporated the latest in 19th-century technological improvements. It is set up now to represent a typical gristmill of the 1880s. Open 10–5, weekends, May–October; Friday–Tuesday, July and August; last tour at 4. Visitors can purchase stone-ground whole-wheat, oat, rye, buck-wheat, and corn flours made at the mill, though not all kinds are always available. Group tours by appointment (973-326-7645). At any time of year you can hike on the fairly undeveloped trails that start from the mill's parking area and go along the Black River. Trail maps are available, and it is important that

you stay on the trails because not all the mines that were once worked in the area have been fenced off.

About three miles southwest of Chester is Hacklebarney State Park (take Hacklebarney State Park Rd. off 24 or Pottersville Rd. off 206; 908-879-5677). Established in 1924, when Adolphe E. Borie donated 32 acres to the state in memory of his mother and granddaughter, the park now contains 890 acres. Much of the park lies in a beautiful gorge along the Black River, and the footing is rugged on some of the trails. The Black River is stocked with trout, there are beautiful picnic sites, and in winter you can sled and cross-country ski. The park also contains playgrounds, a scenic overlook, and an area open for hunting in season. Open daily, 8 A.M.; closing hours vary with the season. In the summer there is an admission fee on weekends and holidays.

Also off Pottersville Rd. (southwest of Chester but north of Hacklebarney) is the Elizabeth D. Kay Environmental Center (200 Pottersville Rd.; 908-879-7262), the New Jersey field office for the Nature Conservancy. The center, jointly with the county park system, sponsors a variety of educational programs, hikes, and workshops. A self-guided brochure is available for a loop trail at the center, and if you want to hike to the gorge, you should get a permit at the center. Open daily, 9–4:30; closed major holidays.

Also along the Black River, about two miles northeast of Chester, is the Black River Wildlife Management Area (North Rd. or c 513), some 3,000 acres open to hikers, bird-watchers, and hunters.

Clark Union 14,629

GARDEN STATE PKWY EXITS 135, 136, C 509

Named for Abraham Clark, a signer of the Declaration of Independence, what is now the township of Clark was settled late in the 17th century. The first mill was built on the Rahway River in the late 1700s, and for a time in the 19th century the American Felt Company was active in Clark. One of the first to buy land in the

area was Dr. William Robinson, who arrived in 1686. His small red farmhouse, c. 1690, now known as Dr. Robinson's plantation* (593 Madison Hill Rd.; 732-388-3600, ext. 3025), has been restored. Decorated to show what a 17th-century farmhouse would look like, the house also has on display a collection of historical artifacts and an exhibit on early medical practice and the influence of Native American lore on medicine. Period craft demonstrations are given, and school tours can be arranged (call Ethel Tuder, 732-388-6330). Open April– December, 1st Sunday in the month, 1–4; groups by appointment other times.

The Polish Cultural Foundation sponsors exhibits at its Skulski Art Gallery (177 Broadway; 732-382-7197). The shows, which change monthly, feature works in a variety of media by artists from a variety of ethnic backgrounds. Open Tuesday–Friday, 10–3 and 5:30–10:30; Saturday, 10–2; Monday 10–3. The foundation also sponsors concerts, lectures, and educational activities.

The Oak Ridge golf course (Oak Ridge Rd.; 732-574-0139) is a county facility

located on land that belonged to a later Robinson, and the clubhouse uses the former Robinson homestead. Its kitchen wing is prerevolutionary; the central section dates to the early 19th century, the library wing to the Civil War. Directly adjacent, and also part of the county system, is the Ash Brook Reservation, 650 acres that have been described as a haven for golfers and birdwatchers. (The Ash Brook golf course is off Raritan Rd. in Scotch Plains: 908-756-0414; pitch and putt: 908-756-0550.)

Clayton Gloucester 6,155

NJ 47

During the Depression the Clevenger brothers set up a glassworks in the family stables (E. Linden and Vine sts.; 609-881-6795). Over the years they acquired many of the old South Jersey molds and began reproducing old South Jersey bottles (see Millville). Open weekdays, 9–3 (public tours were discontinued many years ago,

but the company hopes to be able to reinstate them soon).

East of town is Scotland Run Park (Clayton-Williamstown Rd., c 610, and Fries Mill Rd., c 655; 609-881-0845), a county facility of over 940 acres. You can boat, fish, and swim on Wilson Lake, and on the other side of c 610 from the lake is a nature center. Behind the center is a nature trail; you can pick up maps in the center or at the beginning of the trail. Also in the park are an arboretum, a bog garden, and a picnic grove. Before you get to the park you will skirt the Glassboro Wildlife Management Area (see Glassboro).

Clinton Hunterdon 2,054

178, US 22, NJ 31, C 173, 513

Clinton, situated at the confluence of Spruce Run and the South Branch of the Raritan River, is remarkable for the beauty of its site. The entire town, which lies on the migratory route of many bird species, is a bird and wildlife sanctuary.

At the junction of the two rivers are two mills separated by a 200-foot waterfall. The red mill, now part of the Hunterdon Historical Museum* (56 Main St.; 908-735-4101), was built c. 1810 and has been used as a fulling mill, to make flour, and, from 1903 to 1920, to make talc and graphite. Described as the most photographed building in New Jersey, it even appeared on the cover of a national edition of a New York State map. The museum, which opened in 1963, displays a wide variety of artifacts dealing with daily life, focusing on the period from 1880 to 1910—farm tools, clothing, machinery, spinning wheels and looms, and furnishings. Also part of the museum is the former Mulligan's Quarry, where fertilizer was produced from 1844 to 1964. Still to be seen are the limestone cliffs, the quarry office, the stone crusher, the kilns, and the tenant house, which now contains a turn-of-the-century general

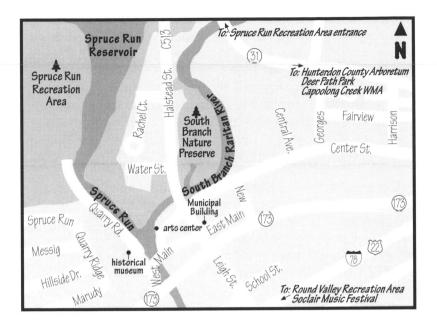

store and the interior of the old Lebanon post office. Also on the grounds are a schoolhouse dating from the 1860s, church sheds (used by parishioners to park their wagons during services) from two of Clinton's churches, and a log cabin built as a bicentennial project. Many educational programs and special events take place at the museum, including concerts, a Civil War encampment, and Jack Russell Terrier trials. The museum is open April–October, Tuesday–Sunday, 10–4; the office is open year-round; groups by appointment. Admission charged.

Across an 1870 iron bridge is the old stone mill,* an early-19th-century stone gristmill in use until the 1950s. Now the home of the Hunterdon Arts Center (7 Center St.; 908-735-8415), it has been restored to its 1836 appearance (the original gray fieldstone and red brick arches were stuccoed over in the late 19th century) and converted into a beautiful building containing galleries, studios, and a sales room. The galleries feature changing exhibits, often focusing on New Jersey artists. The center also sponsors educational programs, a children's summer camp, and various special events. The galleries are open Wednesday–Sunday, 11–5; the shop Tuesday–Sunday, 10–5; and the office Tuesday–Friday, 9–5, and Saturday, 9–1.

It is worth walking along Main, Center, and Water streets. The Clinton House dates from c. 1736, and there are many buildings from the Civil War period. (See, for example, the Municipal Building, c. 1865, on Leigh St. off Main.)

Three miles north of Clinton, on Van Syckels Rd. off NJ 31, is the entrance to Spruce Run Recreation Area (908-638-8572). This park, which includes New Jersey's third-largest reservoir (1,290 acres of surface and 15 miles of shoreline), offers abundant opportunities for swimming (between Memorial Day and Labor Day; on nice weekends it is advisable to get to the swimming area early), boating, fishing, and, in winter, ice-boating, ice-skating, and ice-fishing. The camping and picnicking areas are in particularly lovely spots. Call for details on facilities and regulations. Adjacent to the western end of the park is the Clinton Wildlife Management Area, a heavily used area of fields and woodland, which is open for fishing, hunting, and hiking. Camping area open April–October. Office open daily at 8; closing hours vary with the season. Parking fee in summer.

About eight miles east of Clinton (off us 22) is another, larger (3,600 acres) state park, Round Valley Recreation Area (Stanton-Lebanon Rd., c 629; 908-236-6355), with a large (1 mile by 3 miles) reservoir surrounded by hilly, wooded land. This park, too, has abundant opportunities for swimming, boating, and fishing (particularly trout—24-pound lake trout and 21-pound brown trout have been caught here), and there is a special area for scuba diving. There are wilderness campsites accessible only by foot or boat. In winter you can iceboat, ice-skate, ice-fish, and cross-country ski. The hiking and bridle trails can be rugged, but they offer beautiful views, and there are gentler paths as well. Open year-round, but hours vary with the season. Parking fee for day-use area Memorial Day–Labor Day.

North of Round Valley on a 100-acre farm dating to the 1840s is the home of the Soclair Music Festival (19 Haytown Rd.; 908-236-6476). From the lawns there are beautiful views over the reservoir. Each summer the festival offers chamber music concerts in a 150-year-old horse barn.

Some six miles south of Clinton on NJ 31 is the Hunterdon County Arboretum, a 100-acre special-purpose park and the headquarters of the Hunterdon County park system (908-782-1158). Conceived as an educational and experimental resource, the facility contains a greenhouse, composting toilets, and a gray-water filtration system. The plantings include homestead, herb, and butterfly gardens, and all-American selection varieties are included. There is an 1893 gazebo in the garden, another gazebo by the pond, and a mile and a half of nature trails, including a boardwalk trail through a wetland study area.

Another three miles south on 31, turn left (east) on W. Woodchurch Rd. for Deer Path Park (908-782-1158). There are woods, meadows, a pond, and playing fields, with places to fish and picnic, and trails for hiking, riding, jogging, and cross-country skiing. The parks department presents its summer concerts here. Future plans include setting up a portable pond suitable for ice-skating.

One of the few streams in New Jersey that can support trout naturally can be found about three miles south of Clinton. Take 513 to 617 and continue to the Capoolong Creek Wildlife Management Area, which runs along an old railroad right-of-way.

Closter Bergen 8,094

C 502, 505

Known locally as the "hub of the Northern Valley," Closter (pronounced with a long *o*) was an early settlement—the first individual purchases found in the records date to 1701—and many of its Dutch stone houses remain (try Hickory La. and Piermont Rd.). The town also has a large stock of 19th- and early-20th-

century buildings. The Closter Historical Society (201-767-7974) sponsors a variety of tours and other special events.

Among the older houses is the Abram Demaree Homestead* (Old Hook and Schraalenburgh rds.; 201-784-9618, 201-385-7309). The west wing dates to 1769; additions were made in 1809 and in the late 19th and early 20th centuries. Artifacts are on view in both the house and barn; the collection is rich in handcrafted items from all over the country. Open mid-September–mid-December and February–May, Thursday–Sunday, 10–5. The food grown on the 14-acre farm next to the house is distributed to charities.

The Closter Nature Center (Ruckman Rd.; 201-768-1442) encompasses 135 acres of ponds, woods, and meadows. There are hiking trails here, and you can fish in the pond (trail maps are available at the house). The center offers monthly lectures September–June and summer programs for children. Educational programs for groups during the rest of the year by appointment.

The Belskie Museum of Art and Science (280 High St.; 201-768-0286), opened in 1994, displays the work of Abram Belskie, sculptor, medal designer, and pioneer in the construction of three-dimensional medical models. Belskie was a long term resident of Closter, which has had a sculptors colony since the early years of the century. The museum also has changing exhibits, concentrating on local art and culture. Past exhibits have included material from the local historical society and a local art school. Open Wednesday–Sunday, 2–5.

Colts Neck Monmouth 8,559

NJ 34, C 537

One of Monmouth County's fastest-growing townships (the population has almost quadrupled in the last 35 years), and one of the most expensive (a zoning law in the 1980s required 10-acre lots for most houses, and the housing market has the reputation of being one of the most expensive in the United States), Colts Neck

has long been known for its horse farms. New Jersey has more horses per square mile than any other state, and the horse industry brings to the state as much as \$6.5 billion a year in revenues. More standardbreds are bred in New Jersey than in any other state, and quarter horses and thoroughbreds are also well represented in the 60-odd varieties to be found on 120,000 acres of horse facilities. Although some of Colts Neck's farms have been sold to developers,

Closter, Colts Neck 67

there are still enough left to make a drive along c 537 and the smaller roads off of it a treat to horse lovers, especially in the spring. There are also some older houses to be seen (try Bucks Mills Rd.) as well as the Colts Neck Inn, built in the early 18th century by a member of the Laird family (see below).

Dorbrook Recreation Area (on both sides of c 537 between Laird and Hockhockson rds.; 732-542-1642) contains a playground, a horseshoes pitching area, tennis courts, and areas where you can cross-country ski. The house on the property has been converted into an activity center, at which a wide variety of programs and events takes place.

Also in this Scobeyville section of Colts Neck is the bottling facility of Laird & Company, makers of applejack. The distillery has moved to Virginia, but the company bottles some 2 million cases a year locally. Established in 1780, Laird is the oldest distillery in the country. Before Prohibition there were over 350 cider distilleries in the country; Laird's, run by a family that began making apple brandy in Monmouth County in the 17th century, is the only remaining firm to make aged apple brandy.

The Montrose Schoolhouse (Cedar Dr. and Montrose Ave.; 732-462-1378), a museum run by the local historical society, is open by appointment.

Cranbury Middlesex 2,500

^C 535, 539

First settled in the late 17th century, the village of Cranbury* today presents a striking concentration of 19th-century architecture with a few 18th-century buildings as well. David Brainerd preached to the Native Americans here in the 1740s; Brainerd Lake and the Brainerd Institute (an 1860s school at 96 N. Main St., now serving

as an apartment building) are named for him. Cranbury's first inn was built in 1686, and the current one (S. Main St., north of Station Rd.) dates from 1780; Aaron Burr changed horses here in 1804 after his duel with Alexander Hamilton. (Another inn, this one c. 1850, used to be on Main St. but was moved to Maplewood and Scott aves. and has been converted to apartments.) Farther south on Main St. is the site of the Dr. Hezekiah Stites house, where George Washington, the marquis de Lafayette, and Hamilton were entertained en route to the Battle of Monmouth (see Freehold).

Both the United Methodist Church (1848; N. Main St.) and the First Presbyterian Church (1839, 1859, though some of the foundation of the 1788 church may still remain; S. Main St.) look like picture-book examples of traditional American church architecture. Note also the old schoolhouse* (1896; 23 N. Main St.; 609-395-0544), now used by the township and the board of education.

The Cranbury Museum (4 Park Pl. E.; 609-655-2611) is in a 19th-century house (c. 1834, with additions 1850–62) that still has its wide pine floors, cooking fireplace with crane, and an original window. The museum, which has a permanent collection of Native American artifacts, early farm implements, tools, china, pottery, and glass, is furnished to give a sense of what a 19thcentury small-town home would be like; there are also special exhibits (past ones have included cut glass, quilts, and Victorian clothing) that change every three to four months. Open Sunday, 1–4, and by appointment.

In the Gristmiller's House (6 S. Main St.; 609-860-1889) is the Cranbury History Center, run by the Cranbury Historical and Preservation Society, which also runs the museum and sponsors a biennial house tour. The house dates to c. 1860, but a gristmill had been on the site since early in the 18th century. The society keeps all its historical records at the center, as well as its textile collection and other holdings not currently on exhibit. Open the 1st and 3d Tuesday of the month, 10–1, and by appointment.

Although there is some industry in the township outside the village— Carter-Wallace, for example, is a major employer and Cranbury is facing development pressures, 15 percent of the land surrounding the village (eight working farms) has been preserved permanently for agricultural purposes potatoes, grain, and soybeans are major crops—and in 1990 Cranbury was the least densely populated municipality in Middlesex County.

Cranford Union 22,633

GARDEN STATE PKWY EXIT 137, C 509

The Minisink Trail once went across the area now occupied by this attractive town, which takes its name from Stephen Crane, one of the original associates who laid the town out in 1699 (and a forebear of the novelist). At one time there were 11 mills on the Rahway River, and during the Revolution, grain for George

Washington's army was ground here and woolen blankets for the soldiers manufactured in the Williams-Droescher Mill* (347 Lincoln Ave. E.). This 18thcentury structure, the only one of the original 11 to survive, has been converted to an office building. It is worth taking a look at this lovely corner. It is also worth looking at the brown shingle First Presbyterian Church (Springfield and N. Union aves.) and driving out N. Union to see some of the large houses.

The Crane-Phillips house (124 N. Union Ave.; 908-276-0082) is maintained by the Cranford Historical Society as a museum. The earliest records of the house are from the 1840s, but parts may be older, and other parts were added in the 1860s and 1960s. The museum concentrates on Cranford history and has many early photographs, but it also has an extensive collection of Native American artifacts. Open September–June, Sunday, 2–4; groups and other times by appointment. The historical society also maintains a library nearby in the 19th-century Hanson House (38 Springfield Ave.; 908-276-0082). The society's costume collection here can be seen by appointment. Library and office open September–June, Tuesday morning, 9:30–11:30, or by appointment.

Union County College's main campus is in Cranford (1033 Springfield Ave.; 908-709-7000). Exhibits at the Tomasulo Gallery in the Kenneth Campbell Mackay Library building (908-709-7155) usually change every five to six weeks and feature a variety of media, including folk art. Open September–June, Monday–Thursday and Saturday, 1–4; Monday–Thursday evening, 6–9; Friday, 10–12. Plays at the school's theater are also open to the public; call for the schedule. Also on campus is the Sperry Observatory (908-276-7827). Every Friday evening, 7:30–10:30, the observatory is open to the public: a slide or video program is followed, weather permitting, by a viewing with the observatory's two telescopes, two of the largest on the East Coast. If you call the observatory when it is closed, you'll hear a few minutes of current astronomical news.

At Nomahegan Park (Springfield Ave.) you can fish, ice-skate, bicycle, and picnic. The park also has athletic fields, a two-mile fitness course, and a playground. Other points along the river where you can fish include McConnell Park (Eastman St.) and Sperry Park (Riverside Dr.).

Crosswicks Burlington [Chesterfield Township]

c 660, 672, 677

Crosswicks, settled in the late 1670s by English Quakers, is said to be the only community in the United States to bear that name. Although the land around Crosswicks is being developed, the village center, which makes up the Crosswicks historic district* and includes 18th- and 19th-century buildings on the Chesterfield-

Crosswicks Rd. (C 677) and Front St., preserves a strong flavor of the past.

David Brainerd first preached to the Native Americans here in 1745; his attempts to teach them trades that would enable them to fare better in the colonial world were thwarted by his failing health. Crosswicks claims to be the home of Taylor's Pork Roll, named for John Taylor, a descendant of one of Crosswick's earliest settlers, who ground ham for the market in 1856.

The Chesterfield Friends' Meeting House (just northeast of the intersection of Front and Church sts.), a large two-story brick building, dates from 1773. Built partly with bricks from an older structure, the building still has its original flooring and one of the few Atsion stoves (purchased in 1772 and made in Atsion of New Jersey bog iron) to be found in New Jersey. In the revolutionary battle of 23 June 1778, Hessian troops used the meetinghouse as a barracks and hospital, and one of the cannonballs fired during that battle (by Continentals) is still to be seen in the north wall (secured with cement). After the Battle of Trenton, Continental troops occupied the building.

The former Orthodox Meeting House, built in the 1850s (Ward Ave. across from Buttonwood St.; 609-298-1651, 609-298-3857), now houses the Chesterfield Township Historical Society Museum. Included in the collection are artifacts and memorabilia related to local people and history, from 18th-century furniture and pottery to a model of the older meetinghouse made by Crosswicks schoolchildren in 1934. Open May–October, last Sunday of the month, 2–4; other times and groups by appointment.

The oldest house in the area, the Singleton-Latham-Large House* (c. 1700; Bordentown-Chesterfield Rd. near the turnpike), is being restored by the historical society, which hopes to turn it into a living history farm museum.

Dover Morris 15,115

US 46

Dover was formerly an iron town and for a time the shipping center for New Jersey's iron industry. The iron industry was active in this area more or less steadily from the 18th century, and the Dover mines continued in operation until the late 1950s. Dover's Blackwell St. historic district* (including portions of Blackwell,

Dickerson, Sussex, Bergen, Essex, Morris, Warren, Prospect, and Dewey sts.), a mixture of 19th- and 20th-century buildings, is of interest; note, in particular, the Baker building* (16 W. Blackwell St.), dating from 1884. and the former Delaware, Lackawanna and Western Railroad station* (N. Dickerson St.), dating from 1901. The Old Stone Academy* (25–27 E. Dickerson St.), c. 1827, once housed the state's first coeducational boarding school. The Baker The-ater* (W. Blackwell St. between Warren St. and Towpath Sq.; 973-366-8982), used by Woody Allen for scenes in *The Purple Rose of Cairo*, was built in 1905 as a vaudeville house. Among those who appeared at the theater were Houdini and George Burns. The theater was converted to a movie theater and also used for rock concerts; plans are under way now to restore it for use as a multipurpose house: a venue for plays and concerts as well as for conferences and trade shows. Every Sunday from mid-May to mid-December, Dover closes off a fair number of its downtown streets for a street-fair-style flea market (908-879-4408).

Dover has a large and relatively prosperous Hispanic community, which makes up some 40 percent of the town's population. Almost half come from, or are descendants of people coming from, one town in Puerto Rico. The original Hispanic settlers were recruited as farmers by the federal government in the 1940s. A Hispanic Festival is held every year on Labor Day.

One mile north of town on NJ 15 (in part occupying the former village of Spicertown) is the U.S. Army Armament Research, Development and Engineering Center (ARDEC), also known as the Picatinny Arsenal. Although there is no more manufacturing at the facility, it is still a large operation (6,500 acres, some 4,000 civilian and 100 military employees), and much of the army's research and development of nuclear weapons takes place here. In Building 2 is the ARDEC Museum, with displays of weapons, munitions, and other military items from the Revolutionary War to the present. There are also displays relating to this post in particular and to the surrounding communities, as well as films, an outdoor display, and a videotape theater. Open weekdays, 9-3; groups by appointment (973-724-3222). You can also take a walking tour of parts of the arsenal, which dates from the 19th century but includes a revolutionary graveyard and an 18th-century forge. The post was struck by lightning in 1926, which resulted in a spectacular series of explosions. The flames could be seen from New York City, and evidence of the explosion can still be found today. A self-guiding tour brochure is available at the museum.

West of Dover, in Mine Hill, is a well-preserved 19th-century miner's house, the Bridget Smith–Ida McConnell House (124 Randolph Ave.; 973-366-9031). This two-family house, which was once one of many like it, has remained basically unaltered. It is being restored and will eventually be furnished to show what 19th-century working-class life was like in a Morris County mining town. The house will also include exhibits of artifacts, photographs, and documents relating to the history of the local area. For now, you can see a lot from looking at the outside; there is an interpretive sign out front and a garden in the back. Regular hours will be established soon; tours can be arranged by appointment.

Also in Mine Hill (and in Dover and Randolph townships) is Hedden County Park (Concord Rd., Reservoir Ave., and Ford St.; 973-326-7600), 285 acres with facilities for hiking, bicycling, boating, fishing, picnicking, and, in winter, cross-country skiing and ice-skating.

East Brunswick Middlesex 43,548

NJ TNPK EXIT 9, NJ 18, C 527

In the southeastern corner of the rapidly growing township of East Brunswick (in 1960 the population was not quite 20,000), along the South River, is the historic district of Old Bridge* (Emerson, Squire, Oak, Maple, Kossman, Pine, Chestnut, and Main sts., Rutgers and River rds.). The district encompasses some

42 acres with about 80 structures, roughly one-fifth of them shops. The soil here led to the early development of the pottery and ceramics industry; potters are known to have worked in this area by the mid-18th century (the first settlers came toward the end of the 17th century). This is also an area of rich fossil finds; in the mid-1990s, 90-million-year-old insects and mushrooms were found in a large piece of amber, by far the oldest mushrooms yet discovered.

In what was formerly the Simpson Methodist church (c. 1860) is the East Brunswick Museum (16 Maple St.; 732-257-1508). The museum's permanent collection features local history, a Victorian kitchen and parlor, a sewing room, farm equipment, and the Governor Hoffman room (with memorabilia and the thousands of elephants collected by Harold Hoffman, governor of the state 1935–38). There are also changing exhibits. Open weekends, 1:30–4; group tours other times by appointment.

Some 3¹/₂ miles west of Old Bridge, between the Middlesex County Fairgrounds and the Jamesburg County Conservation Area, is the Quietude Sculpture Garden (24 Fern Rd.; 732-257-4340). A one-mile trail, arranged to give you the sensation of being in a forest, wanders through four acres of woods, gardens, and outdoor sculpture. The exhibits change each season. There is also a small exhibit hall. There is no sign at the entrance; watch for the two stone Great Danes flanking the driveway. Open May–October, Friday and Saturday, 12–5, and by appointment.

In the western part of the township is the Discovery House (152 Tices La.; 732-254-3770), a hands-on museum for children, with games that illustrate

scientific principles. The museum also sponsors summer science and drama workshops. Open Tuesday–Sunday, 9:30–5:30. Admission charged.

At Dunhams Corner Rd. is the East Brunswick Community Park (732-390-6806), 102 acres with tennis courts, basketball, and the Crystal Springs water park. Just west of Community Park (off Church La.) are the Tamarack Golf Course (732-821-8881) and Ireland Brook Park, both county facilities. Ireland Brook Park, which will eventually be linked to the golf course and Davidson's Mill Pond Park (see South Brunswick), is as yet undeveloped; some of its 385 acres will be designated conservation areas, and some hiking trails will be developed. East of East Brunswick Park are the Middlesex County fairgrounds (Cranbury Rd.); among the regular events taking place at the fairgrounds is the historic car festival, held in the fall.

East Hanover Morris 9,926

NJ 10

The rapidly growing township of East Hanover has seen its population more than double in the last 30 years. Within the village of Hanover (part of East Hanover, not Hanover, Township) note the First Presbyterian Church* (Mt. Pleasant Ave. opposite Hanover Ave.), from the 1830s, and the mid-18th-century

Halfway House* (174 Mt. Pleasant Ave.). In the Nabisco Company headquarters (De Forest Ave. and River Rd.; 973-503-3238), built on the site of a golf course, is an art gallery. The group shows held in this large space have varying themes but try to emphasize New Jersey artists. Shows change roughly every month. The annual holiday show in December, however, is an edible-edifice contest (at least five Nabisco products must be used), with separate prizes awarded for youths and adults. Open daily, 12–4.

West of the Nabisco gallery (take De Forest back to Ridgedale Ave., turn right or north, and continue to Klinger Rd.) is Troy Meadows (973-962-7031), 350 acres of marshy land created by the last glacier. This natural area is the largest remaining cattail marsh in New Jersey, one of the few places in the state where you can see bog turtles, and an excellent spot for bird-watchers.

East Rutherford Bergen 7,902

NJ TNPK EXIT 16W, NJ 3, 120

Much of East Rutherford's land is taken up by the Meadowlands Sports Complex (201-935-8500), a project begun by the New Jersey Sports and Exposition Authority in the 1970s. The concrete complex, which was erected on the marshlands of the Hackensack Meadowlands (see Lyndhurst), contains a racetrack, stadium, and

indoor arena (formerly the Brendan Byrne Arena, now the Continental Airlines Arena), all protected against flooding by a system of dikes, lagoons, and pumps.

Over 7 million visitors a year come to watch thoroughbred and harness racing; professional football, soccer, basketball, and hockey; college sports; the circus; ice shows; auto racing; and concerts. Plans include adding a private "entertainment pavilion" to the complex, with a football-field-size simulated rain forest, movie theaters, stores, restaurants, and perhaps indoor skiing. The racetrack makes a little extra money by selling manure to mushroom growers, and the complex supports programs designed to help compulsive gamblers. Admission charges.

Eatontown Monmouth 13,800

NJ 35, 7I, C I3, 537, 547

The borough of Eatontown is named for Thomas Eaton, an Englishman from Rhode Island who in 1670 built a mill at what is now Wampum Lake. A village thrived here in 1730, the township was incorporated in 1873, and the borough was formed in 1925, after two communities in the township—West Long Branch (in

1908) and Oceanport (in 1919)—broke off and went their own ways.

In the Read house, one of the oldest in town, is the Eatontown Museum (75 Broad St.; 732-542-4026, 732-542-5445). The earliest part is believed to date from 1730, with additions in the 19th and early 20th centuries. The parlor, dining room (the original house), kitchen, and one upstairs bedroom are furnished with 19th-century pieces; the other two bedrooms are devoted to exhibits of artifacts and memorabilia relating to the history of Eatontown. Among the items on display are historic clothing, maps, ledgers, and photographs. Out back is a shed with farm implements, including a hand-carved shovel. Open last Sunday of the month, 12–3, for the annual December open house, and by appointment.

Other buildings to keep an eye out for in Eatontown include the Saint James Memorial Episcopal Church* (1866; 69 Broad St.); the community center (58 Broad St.), housed in the former Presbyterian Church in a building that had once served the Little Church around the Corner in New York City and was brought to Eatontown by barge and reassembled there in the 1870s; and the oldest church in town, the African Methodist Episcopal Church (1845; 271 South St.).

Just north of town on NJ 35 is the main entrance to Fort Monmouth, the headquarters for the army communications and electronics command and (in 1996) the second largest employer in Monmouth County. Built during World War I on the 128-acre site of the old Monmouth Park racetrack, the camp, until 1925, was known as Camp Vail, after Alfred Vail, who helped Samuel Morse develop the telegraph (see Morristown). Many advances in communication technology were developed here—the first radio-equipped weather balloon to be sent into the upper atmosphere was launched at Fort Monmouth in 1928, and in 1946 radar signals from the base were bounced off the moon. In the mid-1990s almost 1,000 military and over 6,000 civilian employees worked at the

74 East Rutherford, Eatontown

1,500-acre base. In Kaplan Hall (Building 275) is the Army Communications– Electronic Museum (732-532-2440), devoted to the development of communications and electronic equipment within the army and to the history of Fort Monmouth itself. Among its collections are memorabilia from the days when the base served as headquarters for the Carrier Pigeon Service. Some exhibits change periodically, and there is also an outdoor exhibit that includes satellite dishes, mortar-locating radar sets, and a tank carrying equipment developed at the fort. Open weekdays, 12–4.

Edgewater Bergen 5,001

NJ 5, C 505

A long, narrow borough situated on the Hudson River, Edgewater was a popular resort for Manhattanites in the late 19th century, and a center of shad fishing from colonial times until the disappearance of the shad. (From about 300 commercial shad fishers in the 1930s, the number declined to about 100 in the '80s;

today they are not to be seen on the New Jersey side of the Hudson.) Edgewater became an industrial city late in the 19th century, attracting, among major companies, Ford Motor Company, Alcoa, Jack Frost Sugar, Hess Oil, and Hills Brothers Coffee, but when trucking replaced the railroad, Edgewater's factories closed. The 25-acre Ford Motor Company assembly plant* (309 River Rd.), built in 1929-31 to the design of Albert Kahn Associates, has been converted to condominiums (the assembly-line floor is now a parking area). Plans to convert the Alcoa Edgewater Works* (700 River Rd.), which closed in 1964, to apartments were stalled for many years by problems with PCBs and other industrial contaminants-once the factory shell was demolished, the site would have to be cleaned—but demolition of the landmark building was scheduled to begin in July 1997. The Sugar Factory apartments (840 River Rd.) were once part of the Jack Frost Sugar Company's local complex. Upscale shopping centers as well as housing now line the waterfront, including Yaohan Waterside Plaza, said to be the largest Japanese shopping center on the East Coast.

At one time, more than 100 decommissioned and abandoned barges dotted the northern section of Edgewater's riverfront, many of them serving as clubhouses for various groups, including the Knickerbocker Canoe Club, the country's oldest (founded 1880). They are gone now, and only the Lehigh Valley Railroad's barge #79,* built in 1914, was saved; it functions as a museum in Brooklyn.

Docked near the former Alcoa plant is the *Binghampton** (725 River Rd.), a ferryboat built in 1904–5 in Newport News. The only double-ender ferryboat still floating in the Hudson, the *Binghampton* was in continuous service between Hoboken and New York City from 1905 to 1967 and carried some 125 million passengers. It is now used as a restaurant.

Edison Township Middlesex 88,680

US I, NJ 27, C 501, 514

Edison is, of course, named for Thomas Alva Edison (see West Orange), who from 1876 to 1886 had a laboratory in the Menlo Park section of the township. During those 10 years Edison took out over 400 patents and invented the incandescent lamp, a method of distributing electricity, the phonograph, the carbon telephone

transmitter, the dynamo, the magnetic separator, and the electric traction railway. The laboratory and its contents (not to mention a considerable quantity of Middlesex County soil) were transported by Henry Ford to his Greenfield Village in Michigan, and on the exact spot of the laboratory was erected in 1937 the art deco Thomas A. Edison Memorial Tower* (Christie St. off NJ 27; 732-549-3299), a cement tower 131 feet high with an amber glass replica of an incandescent light at the top. Within the tower and the outlying buildings are some of the machines Edison invented, memorabilia, and an eternal light that commemorates the first practical incandescent bulb. Open Memorial Day–Labor Day, Tuesday–Friday, 12:30–4, weekends, 12:30–4:30; Labor Day–Memorial Day, Wednesday–Friday, 12:30–4, weekends, 12:30–4:30. Groups by appointment.

A large (32 square miles) and rapidly growing (the population has almost doubled since 1960 and increased by a quarter between 1980 and 1990) township, Edison has become home to a wide variety of ethnic groups. Seventy-five languages are spoken in the public schools, and the township boasts the largest Chinese and Taiwanese population, the second largest Filipino, and the second largest Asian population in the state. The annual Indian harvest festival draws some 100,000 people and is the largest festival of its type outside India.

Like many other New Jersey townships, Edison is made up of several older communities. In Piscatawaytown (in the western section of the township) the Episcopal congregation was established in the late 17th century. The present St. James Episcopal Church (2136 Woodbridge Ave., c 514), a white frame building with a Doric portico, dates from the 1830s. The congregation's 1724 building was occupied by British troops during the American Revolution (British soldiers are buried in the churchyard; there are also some 17th-century headstones, including one that is probably the oldest marked grave in the county). A late-18th-century replacement was destroyed by a tornado in the 1830s, and the pulpit is supposed to have washed up on Staten Island. Many of the materials from the old church were used in constructing the church you see today. If you turn off onto Park Way (south off Woodbridge Ave.), you will see some older houses and the Edison Commons with the Old Town Hall.

At the eastern edge of the township, in Bonhampton, note the late-18thcentury Grace Reformed Church (Woodbridge Ave. and Grace St.) and the Bonhampton School (2825 Woodbridge Ave.), built in 1908 and now a commercial building.

The township is home to many corporate headquarters, research facilities,

and factories. The Mobil Company's laboratory was the first in the nation to win a safety award from OSHA (Occupational Safety and Health Administration). Since the Ford Motor Company's assembly plant (US I) was built in the late 1940s, over 5 million cars have been assembled there; the plant recently added a state-of-the-art painting facility. Tours for groups can be arranged (call 732-632-5930, ext. 5306). The Frigidaire plant on NJ 27 is the largest industrial employer in the county, turning out one of every three air conditioners and dehumidifiers sold in the United States; the four-square-mile Raritan Center (NJ Tnpk exit 10), carved out of the old Raritan Arsenal, is the largest business park in the state, with 13 million square feet of office space and 100 buildings, including a convention center, retail outlets, restaurants, and a child-care center. (For the *New York Times*'s color printing plant and distribution facility, see the turnpike tour, 87 N.)

On the northwest side of US I is the 217-acre Roosevelt Park (732-548-2648), the county's oldest park. Plays and concerts are given in the summer, and there are nature and hiking trails, tennis courts, playing fields, a cross-country running course, fishing ponds, and places to ice-skate in the winter.

Also on the site of the Raritan Arsenal are Middlesex County College (Woodbridge Ave.; 732-548-6000) and Thomas A. Edison Park (Mill Rd.; 732-548-2648), formerly Raritan Arsenal Park. The college, founded in the 1960s, occupies 200 acres, and the campus presents an interesting juxtaposition of modern campus buildings with reused army buildings. When there are exhibits, the College Center and Presidential Galleries are open to the public weekdays, 9–5; events at the performing arts center are also open to the public. (For information on exhibits and events, call 732-906-2566.) The park consists of 161 acres on the flatlands to the north of the Raritan River estuary; it has a hiking trail, a fitness trail, a bike path, tennis courts, and playing fields.

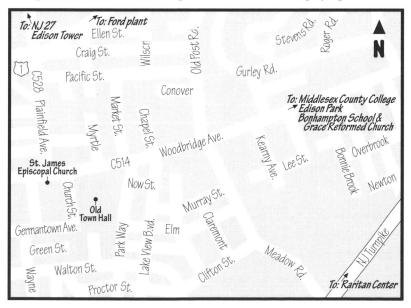

Edison Township 77

Egg Harbor City Atlantic 4,583

C 561 ALT., 563

Settled by Germans in the 1850s, Egg Harbor City (which is not the same as Egg Harbor Township, and is not on Egg Harbor) derives its name from a never-realized scheme to connect the town by canal to the Mullica River. After the discovery in 1858 that the land was extremely well suited for growing grapes, more

Germans emigrated to Egg Harbor City. (Note the street names in the area: Bremen, Frankfurt, Darmstadt, Heidelberg, Hamburg, among others.) Yet it was a Frenchman from Rheims, Louis Nicholas Renault, who established the best-known venture, the Renault Winery (72 N. Bremen Ave., three-quarters of a mile northeast of the intersection of Bremen and c 561 Alt., Moss Mill Rd.; 609-965-2111), listed on the state register of historic places. The oldest continuously operating winery in the United States (during Prohibition the winery produced its "medicinal" Renault tonic with an alcohol content of 22 percent), it was at one time the country's largest producer of champagne and may now be the country's only producer of blueberry champagne. Occasionally on a back road in South Jersey, you will come across one of the company's old 20foot promotional champagne bottles, now a little dingy, standing in front of a liquor store. At the winery there is a small collection of wine and champagne glasses, including some medieval ones, and you can tour the facilities. Special events are regularly scheduled, including a wine stomping in the fall. The winery is open Monday–Saturday, 10–5, Sunday, 11–5; the glass museum is open daily, 10-4, and tours can be taken daily, 10-4. Admission charge for tour. Closed New Year's Day, Easter, Thanksgiving, and Christmas.

Bear Creek Reserve (Lower Bank Rd., c 652), over 100 acres of freshwater wetlands and fresh and tidewater marshes along the Mullica River, is open for birding and wildlife observation.

Elizabeth Union 110,002

NJ TNPK EXITS 13, 13A, US 1, 9, NJ 27, C 514

Elizabeth is Union County's oldest and largest community. Elizabeth, in fact, is one of the state's first permanent European settlements (going back to 1664), its oldest English-speaking settlement, and its first colonial capital (from the mid-1660s to 1686). For many years a busy industrial and commercial town,

Elizabeth today serves as the county seat of New Jersey's youngest county (Union County was founded in 1857).

As in other industrial cities that lost much of their manufacturing base, Elizabeth's population declined for a time, but the loss was not as extreme as in some other urban areas, and many revitalization plans are in place. For over 100 years (1873–1982) Elizabeth was the home of the Singer Sewing Machine

Company's oldest plant, which at its peak employed 10,000 people; the site (Trumbull and First sts.) is listed on the state register of historic buildings. Some of the former Singer buildings are being used by various smaller manufacturers; others have been incorporated into the Elizabethport Industrial Park. Near Port Elizabeth (not the same as Elizabethport), two large retailing centers are being developed on either side of North Avenue. The Jersey Central Railroad station* (Julian Pl.), built in the 1890s and closed in 1976, has been restored and is being converted to commercial uses; the area around the station will become a pedestrian plaza. The city's midtown historic district* includes Broad St. in the area bounded roughly by Rahway, Westfield, Union, and Jefferson avenues. Brochures for self-guided walking tours (in English or Spanish) are available from the Union County Office of Cultural and Heritage Affairs (633 Pearl St.; 908-558-2550).

The city's role as a transportation center goes back to the 18th century, when it was an important ferry link to New York City; regular steam service began in 1808 (the city expects service to be restored before too long). The railroad lines running along the water were important to the city's industrial development. In the late 1950s, the Port Authority of New York and New Jersey developed a new terminal at Port Elizabeth, which has since become a major containership port (almost 11 million long tons were handled there in 1993; see Turnpike tour, 103 N,S). The Goethals Bridge, which crosses Arthur Kill to reach Staten Island, was opened in 1928. There is talk of adding a second span, perhaps one that could accommodate light-rail cars, to this cantilevered structure, which carries close to 12 million vehicles to Staten Island annually.

The list of Elizabeth's famous residents is long. James Caldwell, known as the fighting parson (see Springfield), became minister of one of the oldest English-speaking congregations in New Jersey, the First Presbyterian, in 1761. During the Revolution he often preached with loaded pistols on either side of the Bible and with armed sentries guarding the church, and he preached the Sunday after the British burned the parsonage. The church itself was burned in 1780, and the present building^{*} (Broad St. and Caldwell Pl.) dates from 1784. Caldwell, killed by an American sentry in 1781 (see Westfield), is buried in the graveyard. In 1946 another fire destroyed most of the interior, and today's church has been rebuilt inside the 18th-century walls. (The restoration took the church back to its colonial interior, rather than reconstructing its 19th-century Gothic one.) Upstairs is a small museum of colonial artifacts. Tours can be arranged on request; call 908-353-1518.

Among Caldwell's famous parishioners at First Presbyterian were William Livingston, the state's popular first governor (he was reelected until his death in 1790; his house, Liberty Hall, at Morris and North aves., is a national historic landmark; see Union); Elias Boudinot, a lawyer and president of the Continental Congress (and as such the signer of the peace treaty with Britain), member

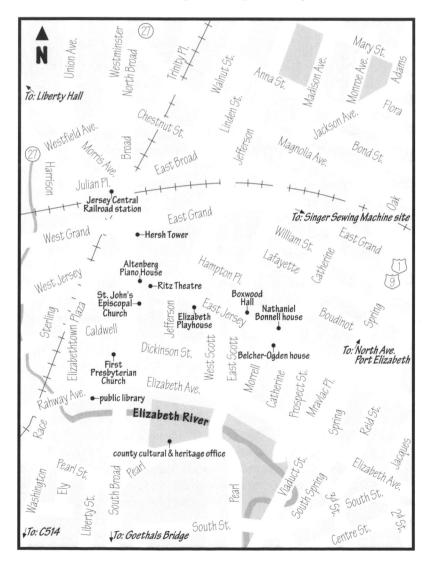

80 Elizabeth

of the U.S. Congress, initiator in Congress of the resolution leading to the establishment of Thanksgiving Day, and superintendent of the Mint at Philadelphia; Jonathan Dayton, Continental army general, congressman, and developer of Dayton, Ohio; and Abraham Clark, one of New Jersey's five signers of the Declaration of Independence. Princeton University was founded in Elizabeth, in 1746 (it was known then as the College of New Jersey), by one of Caldwell's successors at First Presbyterian, Jonathan Dickinson.

Other prominent residents of Elizabeth include Lorenzo Da Ponte, librettist for Mozart's *The Marriage of Figaro*, *Don Giovanni*, and *Così fan tutte*, and Admiral William F. Halsey (his birthplace at 134 W. Jersey St. is no longer standing).

Boudinot's house, Boxwood Hall* (1073 E. Jersey St.; 973-648-4540, 908-820-4000), built c. 1750 by Samuel Woodruff, the mayor of Elizabeth, and purchased by Boudinot in 1772, is a national historic landmark. Boudinot gave a funeral oration over Caldwell's body from its steps; George Washington visited the house en route to his inauguration as the country's first president; Alexander Hamilton lived with the Boudinots while attending school in town. When Boudinot became superintendent of the Mint, he sold the house to Jonathan Dayton; during the time Dayton lived there, the marquis de Lafayette was a guest (early in the 20th century, Lafayette's great-grandson visited Boxwood). Boxwood Hall, operated as a state historic-house museum, retains some of its original moldings and is furnished with period pieces. Open May–October, Monday–Saturday, 9–5; November–April, weekdays only, 9–5 (it is always a good idea to call ahead in case there are school groups in the house).

In the same block is the Belcher-Ogden House* (1046 E. Jersey St.; 908-351-2500). This historic-house museum is run by the Elizabethtown Historical Foundation. Dating from c. 1742, the house was owned for a time by Jonathan Belcher, royal governor first of Massachusetts and New Hampshire and then of New Jersey (from 1747 until his death in 1757), who was also active in promoting the College of New Jersey. The house was later occupied by Colonel Aaron Ogden, a senator from New Jersey in 1801–3 and the state's governor in 1812. Open by appointment.

Across the street is the Nathaniel Bonnell house (1045 E. Jersey St.), which dates from c. 1682 and is probably now the town's oldest house. It is currently being used for offices. The Elizabeth Playhouse (1110 E. Jersey St.), a community theater, is housed in the Italianate former Third Presbyterian Church (1855); apartments and offices are also in the building. The Ritz Theatre (1148 E. Jersey St.) dates to the turn of the century; musical, dance, and theatrical events are presented here. Note also the art deco Altenberg Piano House (1150 E. Jersey St.).

St. John's Episcopal Church (Broad St.; 908-352-1218), founded in 1705, was once the largest Episcopal congregation in the state, but like many other innercity churches, has a much smaller congregation today. Anna Seton's parents were married in St. John's, Winfield Scott was a member, the Kean family vault is in the churchyard, and Jonathan Dayton is buried under the church. The splendid Gothic building, dating from 1859, has five Tiffany windows; an Italian font is the church's only colonial possession. A large population from the Caribbean Islands migrated to Elizabeth after the French Revolution (Elizabeth at one time had the state's largest concentration of Haitians); note the fleurs de lis on the gravestone of a lady from Martinique (1799). Tours by appointment.

North of St. John's on Broad is the Hersh Tower (125 Broad St.). This striking 14-story art deco building, recently restored, was the tallest building in the county when it was built. South of St. John's is the public library (11 S. Broad St.), built in 1912 on the site of the Red Lion Inn.

Englewood Bergen 24,850

NJ 4, C 501, 505

Once known as a bedroom community for wealthy commuters, Englewood now has a large number of multifamily houses and low-income housing projects, as well as a large commercial center. John Travolta was born here, and since the late 1960s the painter Richard Anuskiewicz has lived here. In 1951 Englewood was the

site of the first customer-dialed long-distance telephone call in the United States, when Englewood's mayor called the mayor of Alameda, California. (Through windows of the telephone building at Bergen and Engle sts. you can even see some of the circuitry, not possible in later windowless telephone buildings.) Vince Lombardi coached at St. Cecilia's High School (Demarest St.; the former school building is part of a large stone complex with some interesting buildings) before moving on to college and professional teams. Englewood was also the site of Helicon Hall, Upton Sinclair's ill-fated experiment in communal living. Built with the royalties from Sinclair's exposé of the meat-packing industry, *The Jungle* (1906), Helicon Hall burned after six months. The 20-room house built on its site was occupied for many years by Victor Wallace Farris, inventor of the paper milk carton and the paper clip.

Gloria Swanson was another Englewood resident. She lived in the 32-room Italian villa of the Gloria Crest estate (N. Woodlawn Ave.), built in 1926 by a member of the Polish royal family (and named for his wife, not Swanson). To see some of the houses that gave Englewood its reputation, drive up the hill on N. Woodlawn Ave. (east off Palisade Ave.); as you start note on your left the Dwight-Englewood preparatory school (northeast corner of N. Woodlawn and Palisade; among its graduates are George Schultz and Brooke Shields). Gloria Crest is farther up the hill, on your right.

Also in Englewood is the Actors' Fund retirement home (155 W. Hudson Ave.). The fund was started in the late 19th century and a home early in the 20th. In 1928 the fund purchased a house in Englewood that Stanford White had designed; the grand piano in the sitting room was donated by Enrico Caruso. In 1959 the house was demolished and the current building erected (a nursing home was added later); the antique grand piano in the lounge was donated by Harold Prince.

The John Harms Center for the Arts (30 N. Van Brunt St.; 201-567-3600) in

downtown Englewood occupies a 1926 building, unprepossessing on the outside but reflecting on the inside its origin as a "movie vaudeville emporium." From September through May the center presents a wide variety of theater, musical events (popular, classical, jazz, opera), and dance. Art exhibits are hung in the Intermission Gallery from September through May; the shows change monthly. Box office open year-round, Monday–Saturday, 11–6.

Many of Englewood's older downtown buildings have been converted to new uses. The Renaissance Office Court (northeast corner of Bergen and Engle), for example, built in 1917, was once the well-known Englewood High School. It became a junior high and then a grade school before being converted to its present use. Note also the former Citizen's National Bank building (71 E. Palisade) and the former railroad station, now a restaurant.

Even in this built-up area you can still see some early Dutch stone houses. Many are on Grand Ave.; the Red Cross, for example, is in the early-18thcentury John G. Benson house* (60 Grand Ave.), and others are farther south on Grand (at 228,* 285,* 370,* and 488).

In the midst of this densely populated area is the Flat Rock Brook Center (443 Van Nostrand Ave., the eastern end of Van Nostrand; 201-567-1265), 150 acres of woodland, with wetlands, two ponds, a stream, meadows, and a stone quarry. One area is devoted to native plants, designed to provide habitat and serve as a model for home gardeners. There is a large greenhouse at the nature center and over three miles of trails, a boardwalk at the quarry, and picnic facilities. You can pick up trail maps at the center or the picnic area. The center also offers a wide range of educational programs. Grounds open dawn to dusk; office weekdays, 9–5; groups by appointment.

Englishtown Monmouth 1,268

US 9, C 522, 527

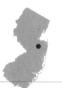

Englishtown is known today primarily because of its huge weekend flea market, but it also has historical interest because of its connections with the Battle of Monmouth. Washington and his men spent the night here before the battle, eating at the Village Inn* (Main and Water sts.; 732-446-9061). After the battle Washing-

ton and Lord Stirling sat in the dining room of the inn and drew up the charges that were used in General Charles Lee's court-martial. Lee also sat in the dining room to write some of the letters that sealed his guilt. Built in 1726 (the eastern portion was added in 1820), the inn was for a long time one of the oldest continuously operating taverns in the state. It has been restored and is being furnished with period pieces. The inn serves as the headquarters for the Battleground Historical Society. A variety of events is scheduled throughout the year, and tours can be arranged by appointment.

The flea market (90 Wilson Ave.; 732-446-9644), known as the Englishtown Auction Sales (it is actually in Manalapan Township), began in 1929 as a

farmers' auction and is being run by the third generation of the same family. There hasn't been an auctioneer since 1980 (though there are plans to reintroduce one), but over 1,000 merchants and craftspeople set up on its 50 acres on weekends.

Ewing Township Mercer 34,185

195, NJ 29, 31

Ş

Ewing, which developed primarily as a suburb of Trenton, is home to what used to be known as Trenton State College (in 1996 the trustees decided, not without controversy, to change the college's name to the College of New Jersey, Princeton University's name for its first 150 years). The college moved to its

250-acre Hillwood Lake campus over 60 years ago, when many of its red brick buildings were built. The William Green house,* however, dates from the 18th century and is being restored by the college and the township. The College of New Jersey began as a normal school in the 1850s (it was then located in Trenton); it now has five undergraduate schools, over 5,000 students, and a reputation for quality. Tours of the campus start from the Admissions Reception Center in Bliss Hall, Friday at 11. The Holman Hall Art Gallery (609-771-2652) presents six exhibits a year; these are open to the public September–June, weekdays, 1–3, Thursday evening, 7–9, Sunday, 1–3. The music department (609-771-2775) puts on concerts of classical music almost every week, and theater productions take place in Kendall Hall (609-771-3100). Call for the schedules.

In Ewing the state makes all the signs used on state-maintained roads (in the Department of Transportation Fernwood complex) and raises useful bugs. The Philip Alampi Beneficial Insect Rearing Laboratory (State Police Dr.; 609-530-4192) looks into ways that bugs can replace pesticides for control of agricultural pests. The lab also raises in quantity beneficial bugs that cannot survive the winter. Tours can be arranged for groups.

The state police, which celebrated their 75th anniversary in 1996 (their first superintendent was Col. H. Norman Schwarzkopf, father of the Gen. H. Norman Schwarzkopf made famous by the Gulf War), have a museum and learning center in the West Trenton area of the township (River Rd. between 195 and W. Upper Ferry Rd.; 609-882-2000, ext. 6402). The exhibits are in a log cabin built in 1934 to house recruits and include material relating to the Lindbergh trial (see Flemington) as well as equipment, both old and new, used by the troopers. Many of the exhibits are hands-on or interactive. Open Monday–Saturday, 10–4; group tours by appointment. In this area is the Trenton bathhouse* (999 Lower Ferry Rd.), Louis Kahn's landmark building, unfortunately not in the best condition.

The Benjamin Temple house* (27 Federal City Rd.; 609-530-1220) is a mid-18th-century house with a mid-19th-century addition, which was moved to its present location in the 1970s. The 27-acre park in which it sits formed part of the tract that James Monroe suggested would be suitable for the country's capital (which, of course, is how Federal City Rd. got its name). Exhibits in the house change periodically and feature artifacts related to local history as well as decorative arts, textiles, and the like. Open Monday and Friday, 10–4, but it is best to call first; other times by appointment.

Paul Whiteman, the famous bandleader, is buried in the Ewing Church Cemetery (100 Scotch Rd.; 609-882-0273); open daily sunrise-sunset.

Fair Lawn Bergen 30,548

NJ 4, 208, C 507

Fair Lawn, an old Dutch settlement, gained attention as the site of Radburn,* a world-famous experiment in postautomobile city planning. The concepts behind Radburn, which was built in 1929 by Clarence Stein and Henry Wright, have been widely influential in British and continental town planning. Organized in super

blocks, Radburn segregated cars from people and had the fronts of the houses face common greens. Parking was close enough to a house to enable a shopper to carry groceries easily, but children could walk to school without ever crossing a street. The Depression interfered with completion of the original plan, and many post–World War II houses coexist with the 1929 buildings. To

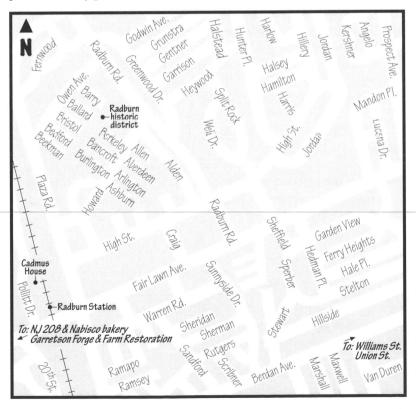

get a better sense of the original flavor, look at the photographs in the lobby of the commercial building at Plaza Rd. and High Street. The Radburn historic district* includes Fair Lawn, Berdan, and Prospect aves. and Plaza and Radburn roads. (For information, write or call the Radburn Association, 29-20 Fair Lawn Ave., 07410; 201-796-1300.)

Just west of Plaza Rd. on Pollitt Dr. is the Cadmus House^{*} (201-796-7692), an early-19th-century Dutch stone house, moved to its present site (it weighed 50 tons). Once part of a farm that covered half of present-day Fair Lawn, the house has been converted to a museum. One room is furnished with Victorian pieces, another with old fire-fighting equipment, another with artifacts from a farmhouse destroyed to build a highway interchange. The collection also includes a variety of local memorabilia. Open March–December, 3d Sunday of the month, 2–4; it is best to call ahead, though, as the opening times can change (in May, for example, the house is open on Memorial Day). Other early stone houses can be seen on River and Dunderhook roads.

West of Radburn near the Passaic River is the Garretson Forge and Farm Restoration* (4-02 River Rd.; 201-797-1775, 201-796-2387). The Garretson family left the Netherlands in 1660 and bought this land in 1668. Six generations lived on the farm until Mary Garretson died in 1950. The property was rescued from a developer and is gradually being restored. The main section of the 18th-century house was made of dressed stone; the sandstone blocks were held together with mortar made of river mud mixed with straw and hogs' hair (the kitchen wing used undressed stone). The carriage shed and the kitchen wing with its beehive oven have also been restored. Among the furnishings are a rope bed and a *kas*, and there are periodic displays of 19th- and 20th-century artifacts, including some from the Garretson family; early iron work; and antique farming tools, as well as cooking demonstrations, sheep-shearing festivals, and harvest festivals. Open Sunday, 1–4, September–November and February–June; groups and other times by appointment.

One of the county's bicycle-pedestrian paths starts from Williams and Union streets.

Oreos, the country's most popular cookie (if all the Oreos eaten since 1912 were stacked on end, they would reach to the moon and back more than five times), are manufactured at the Nabisco Fair Lawn Bakery (NJ 208 at McBride Ave.), as are animal crackers (12,000 animals a minute) and Newtons.

Far Hills Somerset 657

US 202, C 512, 523

Situated on the east bank of the North Branch of the Raritan River, Far Hills is part of Somerset County's estate and hunt country. South off us 202 on Far Hills Rd. (C 512) is the Leonard J. Buck Garden (Layton Rd.; 908-234-2677). Now part of the county park system, the garden was once the private rock garden of a

wealthy mining engineer. The rock formations on its 33 acres are covered with

rare plants from Europe, Asia, and North America. In 1986 an extensive collection of ferns was added to the garden. Open weekdays, 10–4; Saturday, 10–5; Sunday, 12–5. Closed weekends and major holidays, December–February. Groups by appointment (fee charged for guided group tours). Just north of the garden is Moggy Hollow, a national natural landmark. This is a narrow ravine walled off at one end by a ledge of basaltic rock that was once the spillway of the Glacial Lake Passaic. From the ledge, you can see terraces of glacial debris.

If you continue south on 512, crossing I 287 and Douglas Rd., you will come to the headquarters, museum, and library of the United States Golf Association, located on the grounds of a 62-acre 1919 estate, whose main house was designed by John Russell Pope. Recently renovated, the museum displays its permanent collection chronologically. Included are artifacts from ancient Scottish, Flemish, and Dutch games that were the ancestors of today's golf. There is also a gallery with changing exhibitions. Open weekdays, 9–5; weekends, 10–4. Closed holidays.

On the west bank of the North Branch, directly across from the center of Far Hills, is Bedminster (population 7,086), another hunt-country village that attracted some attention as the site of the state's first Mount Laurel housing. The Hills housing development (us 202) is noticeable in a town that used to have five-acre zoning for single-family houses (it also was part of the reason the population almost tripled between 1980 and 1990). The Somerset Art Association (2020 Burnt Mills Rd.; 908-234-2345), housed in the old Pluckemin school (c. 1907), offers a wide range of classes for children and adults year-round. Its exhibits, lectures, and other programs are open to the public, and the association usually sponsors a large outdoor show the end of September. Open weekdays, 9:30–2; Saturday, 9:30–12. The Pluckemin Village Historic District,* concentrated on us 206 and Burnt Mills Rd., contains many 18th- and 19th-century buildings.

At Fairview Farms (2121 Larger Cross Rd.; 908-234-1852) the Upper Raritan Watershed Association sponsors a natural area of 150 acres with four miles of trails. Open daily during daylight hours.

Farmingdale Monmouth 1,462

C 35, 524, 547

A village with interesting 18th- and 19th-century buildings, Farmingdale was once known as Marsh's Bog and then as Upper Squankum. The historic district runs along Main St. from Asbury Ave. to the W. Main St.–N. Main St. fork.

About three miles south of Farmingdale (take Main St.) is Allaire State Park (c 524, 2 miles west of Garden State Pkwy exit 98, 1 mile east of 1 195 exit 31; 732-938-2371). The park itself is lovely—with hiking, cross-country skiing, and nature trails (the red nature trail crosses an excellent example of a swamp forest); bridle paths; a nature center; and facilities for picnicking, canoeing, and camping—but what sets it off from other parks is Allaire Village.*

Allaire Village was once a flourishing part of New Jersey's bog-iron

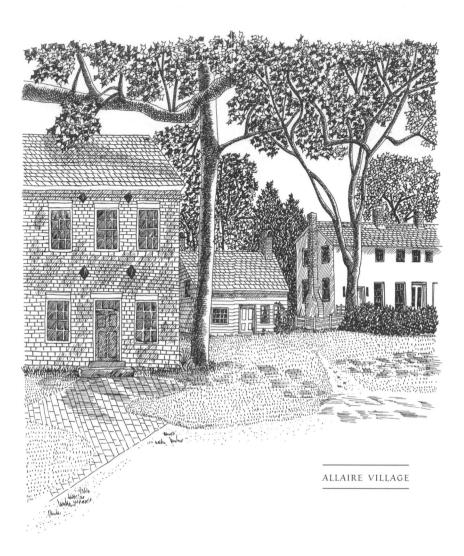

industry. A sawmill operated on this site in 1750, and an ironworks was here in 1813. In 1822 James Allaire, who operated a foundry in New York City and had cast the brass air chamber for Robert Fulton's steamboat the *Clermont* and the iron cylinder of the *Savannah*, the first steamship to cross the Atlantic, bought the property (then known as Howell Furnace or Howell Works). Presumably he saw it as a source of iron for his New York foundry. The community he built at Allaire (it took this name after his death in 1858) was not just selfsufficient, common enough in the 1830s, but contained a church and school as well. Stoves, pots, screws, some pipe, and hand irons were cast here before the works stopped operating in 1846. Allaire's son lived on in the village until 1901, apparently resisting any offers to make use of its facilities. Arthur Brisbane, a noted editor with the Hearst newspapers, bought the property in 1907, building himself a home across from the village. Starting in 1927 he leased the village to the Monmouth Council Boy Scouts for \$1 a year, and they began the work of restoring the village. In 1941 Brisbane's widow deeded the village to the state.

Because so much of the village was left, restoration was relatively easy. Of particular note is the furnace stack, but all the buildings-the general store, the farmhouse, the blacksmith shop, the tenant's house, the enameling shop, and more—are of interest. The church (c. 1831), with its unusually placed steeple (at the rear, not the front), is still used for services in the summer. The village sponsors many special events: there are craft demonstrations, a re-creation of St. Nicholas Day as it would have been in 1823, a farmers' market, a theater on the green, and the like (for information about special programs, call 732-938-2253). Children (and only children) may fish in the millpond, and the Pine Creek Railroad runs a steam train on a short loop through the park, weekends and holidays, April-October (diesel trains run weekdays in July and August). At the nature center (732-938-2003) you will find displays relating to the natural history of the area. Nature tours are given every afternoon the center is open (groups by appointment), and loctures are often given on Sunday afternoon. The center is open Memorial Day weekend–Labor Day, Wednesday–Sunday, 9–5. The village is open Mav-Labor Day, Monday-Saturday, 10-5, Sundays, 12-5; September and October, Saturday, 10-4, Sunday, 12-4. The railroad operates daily July and August, weekends April-June and September and October, 12-5. Admission charged for village and railroad. Brochures are available in the visitor center.

Two miles south of Farmingdale on Preventorium Rd. is the Howell Park and Golf Course (732-938-4771), a county facility consisting of 300 acres of gently rolling land bordering the Manasquan River. You can also hike here and canoe and fish in the river. To the west of the park is the Manasquan Reservoir (Windler Rd.; 732-938-4771). Swamplands were drained to form this reservoir, built to serve the growing population in the area. This 1,100-acre county park has an activity center, facilities for boating, fishing, and ice-skating, and a fivemile trail around the reservoir. The woods are attractive, but when the trail is on the perimeter of the park, the traffic noise can be obtrusive.

Between Allaire and Howell Park is the MacKenzie Museum and Library (C 547 between Herbertsville Rd. and I 195; 732-938-2212), run by the Howell Historical Society. This was a miller's house, started early in the 19th century and expanded in mid-century. Some of the rooms have been decorated to reflect a typical miller's house of the period, and there are period artifacts on display. There is also an outhouse out back and a barn that was originally a horse shed at the Old Tennent church (see Freehold); farm implements are on display in the barn. Open Saturday, 9:30–12:30, and by appointment.

Continuing south on Preventorium Rd. from Howell Park to Old Tavern Rd. brings you to the Old Ardena Schoolhouse (732-938-2212), also run as a museum by the Howell Historical Society. The schoolhouse, in use from 1855 to 1938, is one room. It has old desks, the original blackboards, an old stove, and the bell. Open May–September, the last Sunday of the month, 1–4, and by appointment (during the summer only because it is not heated except for the stove). It is always advisable to call ahead.

Flemington Hunterdon 4,047

NJ 12, 31, C 523

Since 1785 the county seat of Hunterdon County, Flemington takes its name from Samuel Fleming, who bought land from William Penn and Daniel Coxe and in 1756 built the house now known as Fleming Castle. Flemington's first industries depended on agricultural products, but gradually poultry and cattle became

more important than crops. The Flemington Auction Market, in fact, was considered the first successful cooperative egg and livestock market. (Its building has been converted to office space.) Known as an important center for flour milling, Flemington also had iron foundries, and the first of its wellknown potteries dates to the early 19th century. The Flemington Cut Glass Co. (156 Main St.; 908-782-3017) opened in 1908 (in 1920 it began selling seconds from the front of its factory, thus presaging today's factory outlets; see below). Bill Healy Crystal (110 Broad St.; Feedmill Plaza; 732-806-2100) is run by one of the country's six master glass cutters. Demonstrations by appointment. The Stangl company's old kilns can still be seen at the Pfaltzgraff outlet (Mine St.), but except for the cut glass, all these earlier industries are gone.

Some 65 percent of Flemington's structures are listed in the state and national historic registers, and the historic district* includes Broad, Main, E. Main, N. Main, Spring, Court, Bonnell, Mine, William, Brown, Academy, Capner, and Church sts.; Park, Bloomfield, Emery, Maple, Grant, Dewey, Hopewell, Pennsylvania, New York, Central, and Lloyd aves.; and Chorister Place. The old county courthouse (northwest corner of Main and Court), with its Greek Revival details, dates to the late 1820s and uses some of the walls from the burned-out courthouse of 1791–93. This building received international attention in 1935 when the trial of Bruno Hauptmann for kidnapping and murdering the aviation hero Charles Lindbergh's baby son was held there. Memorabilia from the Lindbergh trial are on display in the lobby of the courthouse. In 1996 the county opened a new courthouse (Park Ave. and Capner St.). Plans for the future of the old courthouse are under discussion, but in the meantime the display remains in the lobby (call 908-788-1168 to make sure it is still there).

Across the street from the old courthouse is the Union Hotel (76 Main St.), rebuilt in 1862 after a fire. (There has been a hotel on this site since the early 19th century.) The hotel was altered again in 1877–78 to produce today's mansard-roofed extravaganza with its towers and deep front porch. Baron Renfrew, later England's George VII, is among the celebrities who have signed the Union Hotel's guest register, and during the Lindbergh trial the reporters all congregated here.

Also across the street from the old courthouse is the Doric House (114 Main St.; 908-782-1091), a Greek Revival structure built by Mahlon Fisher (responsible for many of Flemington's mid-19th-century houses). Formerly a residence, a restaurant, and a church school, it is now the home of the Hunterdon County

Historical Society and contains a museum and a library. Among the items in the museum are Empire furniture, pier glass mirrors, a tall case clock made by a Flemington craftsman, and a collection of Fulper pottery. Open by appointment. Library open Thursday, 1–3, 7–9, and by appointment.

Fleming Castle (5 Bonnell St.; 908-782-4655, 908-782-6472), now owned by the Daughters of the American Revolution, has served as an inn and a stage depot. Tours by appointment.

You may enjoy wandering about the downtown streets, for there are many interesting buildings. Note the Calvary Church (Broad St. and New York Ave.), built in the 1880s. Henry Beck, the well-known New Jersey popular historian, was rector here from 1949 to 1956. The county building at 65 Main St. was once used by the Flemington Children's Choir School, which trained children to sing in choirs from early in this century until 1958. Memorabilia from the choir school can be seen upstairs by appointment weekdays, 8:30–4:30; call 908-788-1256.

In 1965 a development began that has changed Flemington considerably. A post–Revolutionary War version of colonial Williamsburg, known as Turntable Junction (Mine St.), was assembled on the site of a former railroad turntable and brickyard. It was followed by Liberty Village (Church St.), which featured weavers, candlemakers, glassblowers, and the like dressed in period costumes, giving public demonstrations of their craft. Although Turntable Junction and Liberty Village both still exist, they changed owners in the late 1970s, and they

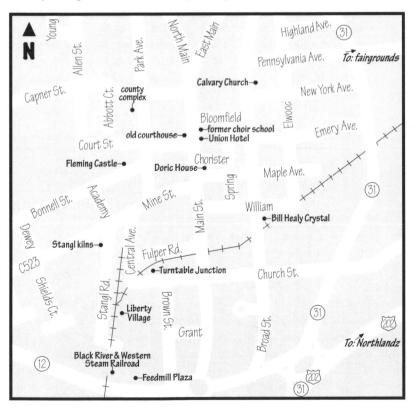

now no longer operate as late-18th-century reconstructions but as outlet areas. In fact, since 1980 or so, Flemington has become widely known as an upscale discount center, and on weekends the influx of shoppers can be impressive.

Flemington's agricultural heritage can be appreciated at the county fair, where agriculture is still the major focus. Hunterdon County had its first fair in the fall of 1745, and the Flemington Agricultural Fair (NJ 31; 908-782-2413) is now the state's biggest and oldest. On grounds built for it in 1846, the fair generally runs from the Tuesday before Labor Day until Labor Day. The fairgrounds are also the site of the Flemington Speedway, where horses raced from 1856 to 1914 and cars have raced since. On the site is a racing museum (908-782-2413), with displays on the history of automobile racing and plaques and pictures of entrants in the National Racing Hall of Fame. Open when there are races (Saturday from the end of April to mid-October; call for the exact schedule). Once a month antique automobiles are run on the track (call 908-782-7885 for the schedule).

From April through December the Black River & Western Steam Railroad (908-782-6622; see Ringoes) runs passenger trains between Flemington (from Turntable Junction) and Ringoes, with connections to Lambertville on Sunday, May–October (freight trains run year-round). Trains run Thursday–Sunday, July and August; weekends, April–June and September–December. Fee charged.

One mile north of the Flemington circle is Northlandz (495 US 202; 908-782-4022), "home of the Great American Railway," a model railroad setup said to be the world's largest. With some eight miles of track and over 100 trains running through a variety of realistic and fanciful scenery, all made by hand, the exhibit has an idiosyncratic quality attributable to its being the creation of a single person. Also at Northlandz are a theater with a 2,000-pipe organ, changing art displays, and a doll collection. Open daily, 10–6. Admission charge.

Forked River Ocean [Lacey Township]

US 9

Located at the head of the Forked River, which empties into Barnegat Bay, the village of Forked (pronounced For-ked) River, like many of the nearby bay towns, was settled before the Revolution and lived off fishing and shipbuilding. Boating and fishing are still important, but the fishing tends to be sport fishing,

and the boating tends to center around the Forked River state marina (311 Main St.; 609-693-5045).

Many of Forked River's older buildings are still standing, some being restored, others showing evidence of the various functions they have served over the years. The mid-19th-century Worden House at the corner of us 9 and Jones Rd. now houses the chamber of commerce; the late-19th-century Methodist Church (Main St.) stands next to the site of the Forked River House, built in 1820 and destroyed by an arson fire in the early 1990s. The building had been frequented by Captain Joshua Huddy during his patrols (Huddy was looking for loyalists; his capture and execution by the British caused a minor incident toward the end of the Revolution). The Captain's Inn (Lacey Rd.) dates to 1813 and at one time was a state-licensed gambling casino. North of the marina, off Us 9, is the state game farm, which is run by the Corrections Department on an 18th-century estate; the manor house is being restored by the township school department as part of an alternative school program. Not open to visitors.

Across from the site of the Forked River House is the Old Schoolhouse Museum (Main St.; 609-971-8429), run by the Lacey Township Historical Society. The building dates to 1860, and the collection features local tools and other artifacts relating to the history of Forked River. The society also sponsors an apple festival in September. Open 15 June–Labor Day, Monday, Wednesday, Friday, 1–3, Saturday, 10–12; groups by appointment other times.

South of the center of town is the Jersey Central Power & Light's Oyster Creek Nuclear Generating Station (US 9; 609-971-2180). Tours of the facility may be arranged by appointment.

North of Forked River (take 9 north about 5 miles to c 618, Central Pkwy, turn left, and continue past the Garden State Pkwy) is Double Trouble State Park* (Double Trouble Rd.; 732-341-6662), presently undeveloped. Double Trouble's 5,000 acres lie in the eastern edge of the Pinelands National Reserve. A sawmill was first built on this stretch of the Cedar Creek in the 1760s, and the name Double Trouble was in use by the 1800s. Cranberries were harvested here in the 1830s, and the state, having restored the sawmill, is working on the cranberry workers' houses, the packing house, and other buildings. Plans for the future direction of the park have been under consideration for some time and should be in place soon. In the meantime, you can walk on a short trail built by the Youth Conservation Corps, which takes you through typical Pinelands terrain past an old cranberry bog, or on the nature trail. Plans also call for developing a 20-mile hiking trail westward from here into Lebanon State Forest (see Pemberton), where it will connect with the Batona Trail. It has been said that the Cedar Creek trail will run along the most pristine watershed in the state.

West of Forked River (take Lacey Rd. c. 6½ miles from exit 74 of the Garden State Pkwy and turn right on Humane Way), within the Greenwood Forest and Pasadena Wildlife Management Area, is Popcorn Park Zoo (609-693-1900). The zoo started as a refuge for wildlife that could not exist on its own and now provides a home for both wild and exotic species that have been abandoned, neglected, or mistreated. Many animals are free to wander about, and the Pinelands vegetation has been left as it was. There is also an animal hospital on the property. Open daily, 11–5, April–October; 1–5, November–March.

The rest of the Greenwood Forest and Pasadena Wildlife Management Area (609-292-2965) consists of over 27,000 acres of pitch pine, white oak, and white cedar scrub. This is a good place to see Pine Barrens frogs, and at Webb's Mill Bog Cedar Swamp (toward the northern end of the area, just off c 539), a boardwalk and trail give you a good vantage point from which to observe the local plants and animals.

Fort Lee Bergen 31,997

1 95, US 9W, 46, NJ 4, 5, 67, C 505

Known to many commuters simply as one end of the George Washington Bridge, Fort Lee sits on the cliffs of the Palisades overlooking the Hudson River. It takes its name from the fort George Washington located there during the Revolution to prevent the British from sailing up the Hudson. Washington was forced to

abandon Fort Lee when Fort Washington across the river fell to the British.

From about 1903 to 1920, Fort Lee was the national center of the young motion-picture industry; the adventures of Pearl White were filmed here, and D. W. Griffith, Fatty Arbuckle, and Theda Bara, among others, began their film careers in Fort Lee. Altogether some 900 movies were shot in Fort Lee, and folk etymology has it that the word "cliffhanger" derives from the serials that were shot on the Palisades.

In 1931 the George Washington Bridge, considered by many one of the most beautiful suspension bridges in the world, was opened; a second level was added in 1962. A key link in the system of roads bypassing the metropolitan area, the bridge, with 14 lanes and a river span of roughly 3,500 feet, connects with the New Jersey Turnpike and many other major roads. The only 14-lane suspension bridge in the world and the busiest bridge in the state, it is used by over 46 million vehicles a year. The riverwalk that may someday extend along the Hudson to Bayonne will start at the George Washington Bridge.

Since the building of the bridge, Fort Lee's population has increased significantly. In 1962, Horizon Houses, a group of award-winning high-rise apartments, created the first silhouette on the Palisades skyline. There are many more such buildings now. The bridge has also caused the borough some financial concerns: apparently one-quarter of the land in Fort Lee is taken up by the bridge or belongs to the Port Authority, and to deal with the traffic the bridge generates, the town has a much larger police force than most towns its size.

One-quarter mile east of the original Fort Lee, in Fort Lee Historic Park (Hudson Terrace; 201-461-1776), are reconstructed revolutionary gun batteries. Cornwallis's assault path up the Palisades in 1776 can be seen, and at the visitor center exhibits and films explain the British assault. The park, which is run by the Palisades Interstate Park Commission, also sponsors educational programs and special events; picnic facilities are available. Grounds open daily, yearround 8 to sunset; visitor center open March–November, Wednesday–Sunday, 10–5. Parking fee charged mid-April–November. Groups by appointment.

The art gallery at the public library (320 Main St.; 201-592-3615) highlights the work of local artists, but others from the metropolitan area are also shown. Exhibits change once a month. Open Monday–Thursday, 9:30–9; Friday and Saturday, 9:30–5; Sunday (except in July and August), 1–5. The library is expanding, and plans call for one room in the new wing (which it is hoped will be ready late in 1997) to be devoted to exhibits of local history.

About two miles west of Fort Lee (in the communities of Leonia, Palisades Park, and Teaneck) is Overpeck County Park (Fort Lee Rd., Cedar La., Roosevelt St.; 201-944-3249, 201-944-7474, 201-807-0201), over 800 acres with a golf course (201-837-3020), tennis courts, playing fields, hiking and bicycle paths, picnic areas, a year-round horseback riding center (201-944-7111), and a wildlife refuge. You can also fish from the lake shore.

Franklin Sussex 4,977

NJ 23, C 517

Franklin was once the leading zinc-mining town in the United States. In the early 19th century, Dr. Samuel Fowler, a physician and member of Congress, who was largely responsible for the settlement of Franklin, found zinc ores on his land. Having perfected a process for making zinc-based paint in the 1830s, he

tried to persuade New York City to ban the use of lead-based paints. He also helped persuade Congress, when it passed a weights and measures law in 1836, to stipulate that the brass used in the weights must contain New Jersey red oxide zinc. Fowler did not profit from these developments, however, for by the time an inexpensive method of extracting zinc from the ore was developed (in 1848), he had died. The New Jersey Zinc Company, which operated the mine on what had been his property, continued to work it for over 100 years, until it was depleted in 1954.

The Franklin area is rich in minerals (over 300 have been found here). Many of them are fluorescent, and some are not found anyplace else. On the site of the old zinc mine is the Franklin Mineral Museum (Evans St. between Main St. and Buckwheat Rd.; 973-827-3481). I lerc you can see exhibits of the minerals found at Franklin, in various stages of refinement; an exhibit of fluorescent minerals that lets you see how they glow under ultraviolet light; and, in the old engine house, a replica of a mine, built entirely from materials used in Franklin zinc mines. This is a popular goal of school trips in the spring. The museum also administers the slag heap, known as the Buckwheat Dump, where collectors can look for their own rocks. Picnic sites are available. Each fall the museum sponsors a mineral show, with lectures, exhibits, and sales tables. Open March–December, Monday–Saturday, 10–4, Sunday, 12:30–4:30; groups by appointment. Admission charged.

In the same mineral-rich area, about two miles south of Franklin (take 517), is the Sterling Hill Mining Museum (30 Plant St.; 973-209-7212). Located in Ogdensburg on the site of the Sterling Hill Mine,* the last operating zinc mine in the state, the museum emphasizes the history of mining and the history of the area. You can take the only underground mine tour in the state, which includes an underground fluorescent display. Open 10–5, daily, with the last tour at 3, April–November; weekends, weather permitting, December and March.

Also in Ogdensburg is the Old Schoolhouse and Firehouse Museum

(6 Passaic Ave.; 973-827-7874). The building, which dates to 1910, was put up as an addition to a 19th-century school building. In 1930, the older part of the school was demolished, and this building was moved and turned into the borough's first firehouse. Exhibits include old fire equipment, memorabilia relating to the school and to the Sterling Mine, material on Thomas Edison's nearby iron mine (a few of the houses from Edison's mining town are now in Ogdensburg), and other artifacts and documents relating to Ogdensburg's past. Open by appointment.

Franklin Lakes Bergen 9,873

I 287, US 202, NJ 208, C 502

This rapidly growing suburbanized area still has a large number of early Dutch stone houses (drive along Franklin, Pulis, Woodside, Circle, Summit, Mabel Ann, and Ewing aves., Franklin Lake Rd., and Vee Dr.). On Ewing Ave. about one mile south of NJ 208 are the New Jersey Audubon Society's headquarters and its Lorrimer

Sanctuary and Nature Center (790 Ewing Ave.; 201-891-2185). In the sanctuary are self-guided nature trails and a butterfly and hummingbird garden. The center has both permanent and changing exhibits, some of them hands-on, and the society offers many educational programs and tours. Open Tuesday–Friday, 9–5; Saturday, 10–5; Sunday, 1–5. High Mountain just south of the sanctuary is a good spot for viewing hawks.

The Saddle Ridge horseback riding area (Pulis Ave.; 201-848-0844), operated for the county park system, offers lessons daily, April–October. The area, a former Nike missile site high on Campgaw Mountain, adjoins the Campgaw Reservation (see Mahwah).

Freehold Monmouth 10,742 (borough) 24,710 (township)

US 9, NJ 33, 79, C 522, 537

The seat of Monmouth County, Freehold was settled in 1715 by a group of Scottish immigrants who had traveled inland from Matawan. The center of a rich agricultural area, Freehold Township was also the scene of one of the major battles of the American Revolution, the Battle of Monmouth (28 June 1778). Although this

was not a clear-cut victory for the Continental army, it did establish the fact that the newly trained troops could hold their own in conventional open-field fighting. It also created a folk heroine, Molly Pitcher; bringing water to the troops throughout the hot day (102°F.), she, according to tradition, took over her husband's position at his cannon when he was wounded. (It is likely the water was actually intended for the cannons, not the soldiers.) And because Major General Charles Lee unexpectedly ordered a retreat (Washington arrived in time to countermand the order and rally the troops, giving vent to

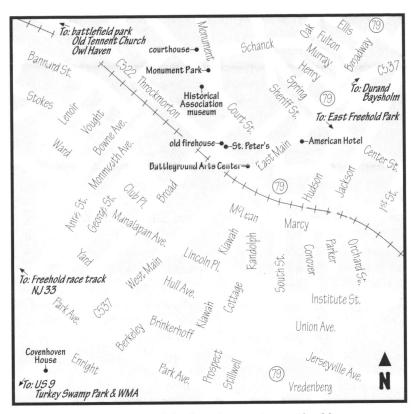

what was for him an unusual display of temper), considerable controversy surrounds the battle.

At Monument Park in the center of town, near the spot where the fighting first broke out, a 100-foot tower commemorates the battle. On the top of the monument, which was dedicated in 1884, is a statue of Columbia, and, near the hase, there are five bas-relief plaques, one of which shows Molly Pitcher at work during the battle. At 70 Court St. (732-462-1466) near the monument, in a Georgian-style building built especially for the purpose in 1931, are the headquarters and library of the Monmouth County Historical Association (founded in 1898). The museum has exceptional collections of furniture, clothing, paintings, and decorative arts, much of which was made in New Jersey or owned by New Jersey residents. Changing exhibits from the collection also include folk art and military objects, and the museum owns Emanuel Leutze's painting of the Battle of Monmouth (Leutze painted the familiar picture of Washington crossing the Delaware, which hangs in the Metropolitan Museum in New York City). Open Tuesday–Saturday, 10–4, Sunday, 1–4. Admission fee.

The association also runs several historic houses, including, in Freehold, the early-18th-century Covenhoven House* (150 W. Main St.; 732-780-3765), a national historic landmark, which was used by Sir Henry Clinton (the British general) as his headquarters the day before the Battle of Monmouth. Using an inventory from 1790, the association has furnished the house to illustrate how a

successful farmer lived in the last years of the 18th century. Open May– October, Tuesday, Thursday, Sunday, 1–4, Saturday, 10–4. Closed 4 July. Groups by appointment other times. Admission fee.

The courthouse dates from the 1950s and replaces four earlier buildings. St. Peter's Episcopal Church (29 Throckmorton St.; 732-431-8383) is a mid-18thcentury church that was used as an army storehouse and a hospital during the Battle of Monmouth. Near it (51–53 Throckmorton) is the volunteer fire department's first building (1874)—now used for shops and offices. The American Hotel (1824) is at 20 E. Main St. (732-462-8019), the offices of the Battleground Arts Center at 35 W. Main Street. The center presents theatrical, dance, musical, and educational programs at various venues; call 732-462-8811 for information.

The main battleground for the Battle of Monmouth remains practically as it was in June 1778. A national historic landmark, it lies northwest of the village and forms part of Monmouth Battlefield State Park (347 Freehold-Englishtown Rd.; c 522, the extension of Throckmorton St., just west of us 9; 732-462-9616). The visitor center (off NJ 33) has exhibits explaining the battle and other interpretive displays. The park's 1,500 acres include a variety of habitats and some 25 miles of trails (many of them unmarked). You can pick up trail maps at the visitor center. About one-quarter of the park is cultivated by local farmers to whom the state leases land. Visitor center open daily, summer (Memorial Day weekend–Labor Day), 9–5; winter, 9–4. Park open daily summer, 8–8, winter, 8–4:30.

On park property is Craig House (turn west off us 9, at Schibanoff Rd., north of the intersection with c 522; 732-462-9616). This house, which was built in 1710 and has chunks of local bog iron in its foundation, belonged to John Craig, paymaster for the local militia, and may have been used as a British hospital during the Battle of Monmouth. It has been restored to its 18th-century appearance. Open Sunday, 12:30–4:30.

At the northwestern corner of the park (Craig and Tennent rds.) is the Old Tennent Church (1751). The congregation was founded in the 1690s, and the church still has its original 17th-century weather vane. In its cemetery are buried many who fell in the Battle of Monmouth. The church sponsors an annual drive-through Christmas pageant the first weekend in December (732-446-6299).

Also on park property is Owl Haven (C 522, C. 1¹/2 miles west of us 9 on the north side of the road; 732-780-7007), a nature center and licensed raptor rehabilitation center run by the New Jersey Audubon Society. The nature center features displays of live and stuffed animals, and a marked trail begins behind the center. Open Tuesday–Sunday, 12–5; groups and other hours by appointment.

Future plans for the park include setting up the country's first museum "dedicated to the role of women in the American Revolution." The Sutfin house, which belonged to a prominent Dutch colonial family, witnessed the Battle of Monmouth. It will be stabilized, restored, and become, with an outbuilding that was part of the Sutfin farm, the home of the Museum of Women in the American Revolution.

At the intersection of us 9 and NJ 33 is the Freehold racetrack (732-462-3800). The oldest pari-mutuel harness track in the country, it was established in the 1850s by the Monmouth County Agricultural Society (it has not run continuously).

Several county parks are in the area. The East Frééhold Park (Kozloski Rd.; take Center St. east about 2 miles from the center of town; 732-842-4000) is a showground, the site of the county fair held each July, and the Monmouth County Horse Show, held in mid-August and over 100 years old.

The Durand Conservation Area (east on c 537 about 3 miles; turn left or north on Randolf Rd.; 732-294-2000) is a county reservation currently being leased to Freehold Township. Its 90 acres are being left undeveloped as a conservation nature-study area. South of Durand across c 537 (on Burlington Rd.) is the Baysholm Conservation Area (732-842-4000), 70 acres that are also undeveloped and used for nature observation.

Some six miles southwest of the center of Freehold (within Freehold Township) are Turkey Swamp Park (Georgia Rd.; turn west off us 9; 732-462-7286) and Turkey Swamp Wildlife Management Area. Within the park's 800 acres are areas devoted to family and group camping; there are also open recreation areas, hiking and nature trails, a fitness trail, and facilities for boating, canoeing, fishing, skating, and picnicking. Camping March–November. Registration for group use. The wildlife area (west of the park) consists of some 2,400 acres of noncontiguous parcels that include upland woodlands, lowlands, swampy areas, and fields. It is used for birding, hiking, archery (access to the archery area is through Turkey Swamp Park), and hunting.

Frenchtown Hunterdon 1,528

NJ 12, 29, C 513, 610, 619

Located on the Delaware River between Milford and Stockton, Frenchtown began as a ferry town in the mid-18th century; its strategic importance was considered sufficient to exempt the ferry operator from service in the Revolutionary War. In the 1790s the land was bought by a French-speaking Swiss aristocrat, Paul Henri

Mallet-Prevost, wanted by the French for having saved his countrymen in the French Revolution. The town came to be called French's Town, then Frenchtown, after Mallet-Prevost.

Thomas Lowrey, from whom Mallet-Prevost had bought his land, had already erected a gristmill and sawmill, both of which continued to operate into the 20th century, grinding corn into feed for the area's poultry industry. (One hatchery in Frenchtown was producing between 5 and 6 million chicks annually in the 1880s; by the 1930s it was up to some 15 million chicks a year.) Today many of Frenchtown's renovated and restored buildings house artists, antiques dealers, and restaurants.

Mallet-Prevost experimented with growing grapes on his land, and the Delaware grape is the result of crossing some of his vines with native American grapes. In a return to local viticulture, one of the state's first farm wineries (in 1982 licensing arrangements for wineries were relaxed to allow the establishment of wineries that used New Jersey grapes; the requirement was further relaxed to allow farm wineries to purchase up to 49 percent of their grapes outside the state for the first five years) opened on the site of one of the chicken hatcheries. It has since closed, but Poor Richard's Winery (220 Ridge Rd.; 908-996-6480) continues the Frenchtown tradition. Located on the site of an old farm, Poor Richard's offers tours of the underground winery and provides picnic facilities. Open Thursday–Sunday, 11–6; other times by appointment.

The Oak Summit School (190 Oak Summit Rd.; continue east on Ridge Rd. to 519, turn left, or north, and continue to the first right; 908-996-4633) is a oneroom schoolhouse built c. 1849. Closed in 1953, the school has been restored and looks as it did in the 1920s and '30s, outhouses and all; inside are slate blackboards, old textbooks, and a wood-burning stove. Tours by appointment. On the same corner is an old cemetery and a stone church built in the 1830s.

Glassboro Gloucester 15,614

US 322, NJ 47, C 536, 553

Glassboro was founded in 1775 by a family of German glassblowers, the widow Stanger and her seven sons, who had worked at the Casper Wistar works in Salem County. Although the town derived its name from its glass factories, cheaper production methods elsewhere have forced all the works to shut down. The

Stangers did not themselves prosper from their glassworks, but the works survived, reaching their peak of production in the 1840s, when they were under the control of Thomas and Samuel Whitney. The Stangers, were, however, highly influential and took the style of South Jersey glass they developed to other glass factories throughout the East. You will find many examples of their work in museums that collect decorative arts. In the 1840s the Whitney Glassworks produced an enormously popular bottle, shaped like a log cabin and supposedly modeled on William Henry Harrison's house, which was filled by a Philadelphia liquor distiller named E. C. Booz, leading to the spread of the word "booze" in this country (the use of the word to mean "drink," however, can be dated at least as far back as 1732).

In 1849 the Whitney brothers built themselves a mansion* (Whitney Ave.) on a 55-acre estate called Holly Bush. Of native Jersey sandstone, the mansion may have been designed by John Notman. Now the administration building for Rowan University, it became internationally famous in June 1967 when it served as the site of a three-day summit meeting between President Lyndon B. Johnson and Soviet Premier Aleksei Kosygin. A second presidential visit to Glassboro occurred in June 1986, when President Ronald Reagan delivered the high school graduation address. Most of the campus buildings are new, but the university grew out of a state teachers' college founded in 1923. Formerly known as Glassboro State College, it changed its name in the early 1990s when Henry and Betty Rowan, the owners of a Rancocas firm that is the country's largest manufacturer of industrial furnaces, gave the institution \$100 million, at the time the largest single gift ever given to a public college. The Glassboro Center for the Arts (609-256-4547) presents a wide variety of professional theater, concerts, opera, and dance. Productions by the School of Fine and Performing Arts are also open to the public, and there is a regular children's matinee series, as well as outreach programs for children. At the Westby Art Gallery (609-256-4521) exhibits tend to focus on regional artists, and each year there is a student and faculty show and a print and pot sale, all done by students and alumni. Exhibits change roughly every six weeks, but there is not necessarily an exhibit during vacation periods. Open weekdays, 9–4.

Another 1840s building of native sandstone with Gothic Revival details, St. Thomas' Episcopal Church* (Main and Focer sts.), is also tentatively attributed to Notman. It supersedes a frame church that may have been located at Main and Broadway, where many members of the Stanger family are buried.

At the corner of High and Center sts., on land that was once the site of the Whitney Glassworks, is the Heritage Class Museum (609-881-7468). Housed in a 1926 bank building (when the bank closed in 1931, two of its directors faced embezzlement charges), the museum preserves and exhibits historic bottles, glass, and related items. Open Saturday, 11–2.

Other buildings of interest include the Franklin House (Main and West); the first tavern on this site was built by Solomon Stanger in the late 18th century. The Whitney-Capie house (29 West St.) is a Victorian house built by a member of the Whitney family during the Civil War; enclosed in one of its clapboard wings is an earlier brick house that stood on the site.

South of the city (access lies off NJ 47) is the Glassboro Wildlife Management Area, one of the earliest such areas (it was started in 1935). The 2,300 acres of woodlands and fields are open to hikers, photographers, bird-watchers, and hunters.

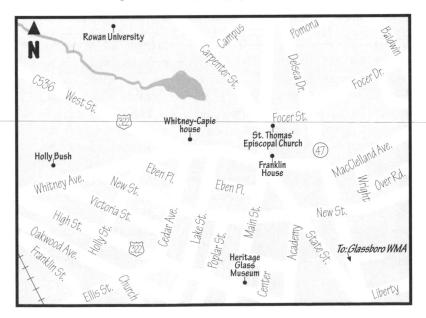

Glassboro 101

Glen Gardner Hunterdon 1,665

NJ 31

Situated on the Spruce Run and once known as Sodom (Sodom La. still appears on maps), Glen Gardner was an iron-mining town in the 19th century, and although the population doubled between 1980 and 1990, much of the part of the town lying east of NJ 3I preserves the look of another era, with the houses and balconies

right up against the street. Of architectural interest are the Masonic Temple (converted to commercial purposes) and, coming into town on School St., the iron bridge* (1870). If you climb Mt. Kipp on Sanatorium Rd., you will come to a state-run psychiatric center, formerly a tuberculosis sanatorium. The road runs through a game refuge and pine forests with wonderful views; some of the buildings at the center have the look of a European spa or Adirondack sanatorium.

Some two miles east of Glen Gardner is Voorhees State Park (off 31; 908-638-6969), whose 630 wooded acres are particularly lovely in fall. There are picnic sites here, as well as hiking trails and facilities for camping; in winter you can cross-country ski. Stop by at the office for maps of the park. The office is open 8–4, the park 8–dusk.

Also within the park is the New Jersey Astronomical Association's Paul Robinson Observatory (Lower Park Rd.; 908-638-8500). The public is welcome for talks, tours, and viewing through the telescope Saturday, 8–11 P.M., Sunday, 2–5, May–October; one Saturday each month, November–April. Additional hours may be scheduled for special events. Groups by appointment, usually on Friday.

West of Voorhees is the Ken Lockwood Gorge Wildlife Management Area (Raritan River Rd.; 973-383-0918), 260 particularly beautiful acres of mixed hardwood forest with varied understory and ground cover bisected by the South Branch of the Raritan River. It is highly recommended for hikers, birdwatchers, and photographers.

Northwest of Glen Gardner in New Hampton (57 Musconetcong River Rd.; take 31 north about 2 miles to Musconetcong River Rd. and turn right) is the Township of Lebanon Museum (908-537-6464). Built as a one-room school-house in 1823, the building was enlarged in the 1870s. A 19th-century school-room has been re-created on the first floor; on the second are a gallery and a lecture hall. Permanent exhibits include a Lenape collection and farm tools. Other exhibits, which change roughly every two months, have featured such collections as poison bottles, clothespin dolls, or Stangl pottery; there are also art shows, quilt shows, regular lecture series, and craft classes. School groups frequently come to experience a day in a 19th-century one-room school. Open Tuesday and Thursday, 9:30–5; Saturday, 1–5; groups by appointment.

Green Brook Somerset 4,460

US 22, C 529

According to tradition George Washington in 1777 stood at the site that is now Washington Rock State Park (C 529; 201-915-3401) and watched the British troops on the plain below. At this 45-acre park are an overview, woods to walk in, and facilities for picnicking. North of Green Brook, in Watchung, is the Watchung Arts

Center (18 Stirling Rd.; 908-753-0190). Housed in a former schoolhouse dating to 1860, the center sponsors jazz, folk, and classical concerts, art shows, and theater, and offers classes for children and adults as well as a children's summer art camp. Shows in the center's two art galleries change every month. Open Monday–Saturday, 1–4.

Southeast of Watchung in the borough of North Plainfield is the Fleetwood Museum of Art and Photographica (614 Greenbrook Ave. at Clinton Ave.; 900-756-7810). Housed in an early-19th-century mansion, the museum features a large collection of antique and classical cameras as well as more modern specialized cameras. Open Saturday, 10–4, Sunday, 1–4 (except major holidays); groups by appointment. The North Plainfield Exempt Firemen's Museum (300 Somerset St.; 908-757-5720) contains antique fire equipment, including horseand hand-drawn pieces and a silver hose cart from New York City. Open April– November, Sunday, 10–3; groups by appointment. The Washington Park historic district,* most of which dates from 1868 to 1917, contains a variety of Victorian architecture and landscaping. The district includes Rockview Terrace, Park Pl., and Linden, Mercer, Myrtle, Orchard, Rockview, Sycamore, Washington, and Willow avenues. The high school, which celebrated its 100th birthday in 1995, is said to be the oldest in Somerset County.

Greenwich Cumberland 911

c 602, 623

Situated on the Cohansey River in the tidewater country of southern New Jersey, Greenwich (pronounced Green-witch by many old-timers) reached its apogee before the Revolution. For a time it was the largest town in Cumberland County, and for some 10 or 11 months in 1748, it served as the county seat. It is now one

of New Jersey's most Brigadoon-like communities. The town was laid out by John Fenwick, the English Quaker who founded Salem. He envisioned a main street two miles long and 100 feet wide, and by 1684 (the year after his death) Quakers, Presbyterians, and Baptists had begun buying 16-acre lots. Today the Greate St. is indeed 100 feet wide and tree lined, and the Greenwich Historic District,* with its 17th-, 18th-, and 19th-century buildings, extends along the Greate St. from the Cohansey River north to Othello.

So prosperous was the shipping at Greenwich that in 1687 the village was

named the official port of entry for all ships traveling on the Delaware River, and in 1695 it was chosen as a market town. Market fairs were held twice yearly in Greenwich until the mid-1760s. It was a blow to Greenwich when Bridgeton was chosen as the county seat in late 1748, and by 1800 road travel had become so much easier that Greenwich's position as a transportation center declined. The town's remarkable 18th-century appearance was discovered after World War II, but although it now attracts many tourists, it has not become a tourist town.

In 1774, when the colonists were boycotting tea as a protest against import duties, a British captain unloaded his cargo of tea in Greenwich, believing it would be safer in the basement of a loyalist merchant there than in Philadelphia, its ultimate destination. The plan was to smuggle it overland to Philadelphia. Ten days later a group of Greenwich men dressed as Native Americans entered the merchant's shop at night, took the tea, and burned it in a giant bonfire in town. Although seven of them were brought to trial, they were never convicted. Like the participants in the Boston Tea Party, these "Native Americans" were among the most responsible citizens in town. The sheriff who selected the jury (he later became one of New Jersey's first two senators) was the brother of one of the tea burners and the nephew of the foreman. It is claimed that the ringleader was the Reverend Philip Vickers Fithian, a recent Princeton graduate, whose journals were used in the Williamsburg, Virginia, restoration. Other participants included the Reverend Andrew Hunter, who founded Woodbury Academy, and two future governors of the state, Richard Howell and Joseph Bloomfield. In 1908 the state erected a monument commemorating the event.

On the northeast side of the Greate St., just west of the intersection with the Bridgeton-Greenwich Rd., is the Gibbon house (609-455-4055, 609-451-8454), headquarters of the Cumberland County Historical Society. Built in 1730 by Nicholas Gibbon, a shipowner and merchant, the house is operated as a museum. On display are the famous Ware chairs (made just north of Greenwich, in Roadstown), children's toys, 19th-century clothing, Canton china, and mementos of Reverend Fithian. Behind the Gibbon house is the Swedish granary, a c. 1650 cabin built of notched cedar logs (moved to the site from a nearby township) that is an extremely rare example of this early type of building. Also behind the Gibbon house is the Red Barn Museum, housing 19th-century tools, implements, and artifacts used by farmers, shipbuilders, and homemakers. Open April–November, Tuesday–Saturday, 12–4, Sunday, 2–5 (closed Sundays in August). Tours by appointment. Admission fee for nonmembers. The Warren Lummis Library is across the street from the Gibbon house (609-455-8580, 609-455-4055, 609-455-0415, 609-451-8455). It serves as the society's library; a former bank building, its vault has proved extremely convenient for climate-controlled storage of delicate items. The library is open April–November, Wednesday, 10–4, Friday, 1–4, Sunday, 2–5. With two weeks' notice, the historical society will arrange tours of Greenwich (call 609-451-8454). Children's programs can be arranged by appointment on Monday, Wednesday, and Friday in April, May, and October (call 609-455-3024). The society also

sponsors many special events, including an annual craft show, farm day, and antiques show.

Also across the street from the Gibbon house, in the former lecture room built by the congregation of the Greenwich Presbyterian church in 1852, is the John Dubois Maritime Museum (609-451-8454), named for a Mauricetown shipyard owner who donated most of the artifacts. Among the items on display are models of some of the boats that sailed out of Greenwich, shipbuilding tools, and a pole boat. Open Sunday, 1:30–4:30, April–mid-November; weekday tours for groups by appointment, April–October.

Among the many other buildings of interest are the Richard Wood house (1785, 1795; northwest corner of Greate and Bacon's Neck rds.) and, on the southwest corner, the Wood store—this late-18th-century store is reputed to be one of the oldest in the country—and across from these the Old Stone Tavern (c. 1730), built of fieldstone from Pennsylvania and Maine that had been carried as ballast; the Friends Meetinghouse (1770s; northeast side of Greate St., toward the river); the old schoolhouse (1810; southwest side of Greate St., just southeast of Sheppard's Mill Rd.), possibly the oldest in the country; and the First Presbyterian Church (1835; north on the Greate St., toward Othello), whose grounds were once planted with seeds from Boston Commons elms.

At the end of Bayside Rd. (take Bacon's Neck Rd. to Tindall Island Rd., turn right, and then left) is Caviar Tower, an observation deck that looks out over the bay. This area was once full of sturgeon, hence the name.

Griggstown Somerset [Franklin Township]

ACROSS MILLSTONE RIVER FROM C 533

Named for the Griggs brothers, who migrated to the area from Long Island in the early 18th century, this idyllic village sits on the eastern side of the Delaware and Raritan Canal* and the Millstone River, separated by a causeway from River Rd. (C 533). Benjamin Griggs built the first gristmill on the Millstone River before 1733.

George Washington marched his troops through the Millstone River Valley after the Battle of Princeton, and John Honeyman, a Continental spy who is given a large part of the credit for the successful surprise attack at Trenton, lived in Griggstown. Honeyman's house still stands on Canal Rd. across from Bunker Hill Rd., and there are many other 18th- and 19th-century houses along Canal Rd. in the Griggstown Historic District.* The Griggstown Reformed Church (1261 Canal Rd.) was dedicated in 1843; its bell dates from 1858 and its stained-glass windows from the 1870s. Behind the church is a one-room schoolhouse moved to this location. Built in the mid-19th century, it closed in 1932 and has been maintained by the Griggstown Historical Society. Open by appointment (908-359-3589). Note also the locktender's station and the barracks used by mule drivers on the canal. The Griggstown Mule Tenders Barracks Museum (732-873-3050) is usually open weekends, April–October, 10–4, but it is best to call first.

In the 1920s Griggstown became a summer resort for Norwegians living in Brooklyn. Their subdivision, which included Lincoln, Washington, and Leif Eriksson rds., was followed by another subdivision, Sunset Hill, in which other Scandinavians also participated. After World War II, these summer homes became a year-round settlement, and a large portion of today's population is of Norwegian descent. Until the mid-1980s Griggstown boasted a Scandinavian delicatessen with a considerable reputation.

Griggstown is adjacent to the Delaware and Raritan Canal State Park (see Kingston). This is a particularly lovely stretch of park suitable for walking, fishing, canoeing, and riding. To the north, the next bridge across the canal is at Blackwells Mills. The Blackwells Mills Canal House (732-873-2958, 732-297-2641), maintained by the Meadows Foundation (see Millstone), is open the 2d Saturday of the month, 1–3, for special events and by appointment.

Hackensack Bergen 37,049

180, NJ 4, 17, C 503

Situated on the Hackensack River and once a busy ocean port, Hackensack was first settled by Dutch traders in the 1640s. The seat of Bergen County, it was until 1921 officially known as New Barbadoes (two of its early landholders came from Barbados). During the Revolution, the Hackensack green was used as a

camping ground for both Continental and British regiments. The courthouse complex* (Main and Essex sts.; 201-646-2472) includes buildings dating from 1910 to 1933. The courthouse is neoclassic, but the jail (designed by the same architect) has medieval turreting. The Administrative Building dates from the 1930s. The public buildings are open weekdays, 8:30–4:30; limited tours by appointment.

Also on the green is the First Reformed Church* (42 Court St.), built in 1791 and altered in the mid-19th century. The congregation, organized in 1686, had its first building by 1696, and stones from this and the next church (built in 1728) are worked into the present building. Many revolutionary soldiers are buried in the graveyard, as is General Enoch Poor (a monument to him is just east of the green). George Washington and the marquis de Lafayette attended Poor's funeral. On the northwest corner of Church St. and Washington Pl. is the Bank House, built in the 1830s for the first bank in Bergen County. Traffic makes it hard to appreciate the green unless you leave your car. Farther west on Essex St. (at 2d) is the Hackensack Medical Center, founded in 1888 and in the mid-1990s the largest in the state. For a look at an earlier Hackensack, drive by the John Hopper house* (1812; 231 Polifly Ave.), which stayed in the same family until 1937; it is now a restaurant.

A big treat in Hackensack is the New Jersey Naval Museum (Court and River sts.; 201-342-3268). There you can visit the USS *Ling*,* a diesel-electricpowered World War II submarine commissioned in 1945. After one patrol run, the *Ling* was decommissioned (in 1946), and from 1962 to 1971 it was used as a training vessel at the Brooklyn Navy Yard. Since 1973 the *Ling* has been berthed at the Hackensack River. Renovated, it is open for tours. Inside the museum are exhibits dealing with the science and history of submarines; models, including a working model of a German U-boat; and submarine-related memorabilia. Outside are missiles, a mine, and an experimental fiberglass sail. Open Wednesday–Sunday, 10–4; groups by appointment. The *Ling* can also be reserved weekdays for birthday parties.

Much of Hackensack's downtown has a 1920s or 1930s flavor. Note the stone Johnson Free Public Library (174 Main St.), built in 1901 and enlarged in 1915 and 1967; the Oritani Field Club (1887; 18 E. Camden); and the group of 1930s Sears Roebuck stores (436 Main St.), a prototype of post–World War II shopping centers.

The Hackensack River county park (NJ 4 and Hackensack Ave.; 201-646-

2680) consists of 30 acres along the river behind the Riverside Square Mall. Trails go through a tidal marsh and forested wetlands, and there are overlooks, bird blinds, and interpretive signs. Parking on lower level of mall parking deck.

At the Bergen County Technical School (200 Hackensack Ave.; 201-343-6000, ext. 2234) is a steam-engine museum, recognized by the American Society of Mechanical Engineers as a regional historical mechanical-engineering landmark. The collection includes operating stationary steam engines and steam-powered equipment, and the museum is restoring two steam locomotives. At midnight on New Year's Eve there is an annual whistle blast. Tours by appointment.

Recitals sponsored by the Center for Modern Dance Education (84 Euclid Ave.; 201-342-2989), a school founded in the early 1960s, are open to the public. Call for the schedule.

Hackettstown Warren 8,120

US 46, NJ 57, 182, C 517

Situated in the Musconetcong Valley between Schooley's and Scott's mountains, Hackettstown was known as Helm's Mills until, in the mid-18th century, according to local legend, Judge Samuel Hackett served free drinks to the local citizenry.

(Hackettstown is reputed to be the only town in the United States with this name.) Hackettstown grew as the center for the surrounding agricultural area, as a service town for those vacationing on Schooley's Mountain (see Long Valley), and as a center for carriage manufacturing. One of the oldest nudist establishments in the United States (founded in the early 1930s) is to be found in Hackettstown, as is M&M Mars, which has been making M&Ms for over 50 years.

In the mid-19th century, the Newark Methodist Conference located its Centenary Collegiate Institute, now Centenary College (400 Jefferson St.; 908-852-1400), in Hackettstown. Because of a fire, the campus was rebuilt; many of the imposing buildings you see today date from the late 19th century. Note particularly the parlors and chapel in Seay Hall. You are welcome to wander about the campus; to arrange a tour, call the admissions office. The Centenary College Performing Arts Guild sponsors programs of theater, dance, and music as well as a young performers' workshop. For specific schedules, call the box office (908-979-0900). At the Ferry Gallery shows change roughly every two months. Gallery open weekdays, 8–6, weekends, 12–4:30.

Hackettstown's old commercial district is well preserved; note particularly the handsome buildings on Main, High, and Washington sts. and on Grand Avenue. The state trout hatcheries, once located here, used to attract many visitors; although the Hackettstown Hatchery is still operating, the trout hatchery open to the public is in Pequest (see Oxford). At 106 Church St., in a 1915 house, is the Hackettstown Historical Society museum (908-852-8797), with a collection focusing on local and state history. Exhibits in the display case in the main room change roughly once a month. Open Wednesday, Friday, and Saturday, 2–4. Groups and other times by appointment.

In the northeastern corner of Hackettstown is the Stephens section of Allamuchy Mountain Park (c 604; 908-852-3790); Allamuchy Mountain Park itself is just north on 604. The two areas combined contain over 9,000 acres. The smaller Stephens section (200-plus acres) has picnic facilities, playgrounds, campsites, and hiking trails. In season you can also fish, cross-country ski, and sled. The Allamuchy section has a natural area with untouched, undeveloped hardwood forest, old fields in various stages of succession, northern marshlands, and Deer Park and Allamuchy ponds. There are extensive trails where you can hike, jog, ride horses and mountain bikes, and cross-country ski. Both ponds are rich in bass and pickerel, and at Saxton Falls, upstream from the Stephens section, you can see the remains of one of the Morris Canal locks.

About two miles south of Hackettstown, on Grand Ave., is the state's Rockport Pheasant Farm (908-852-3461). Children, particularly, might enjoy looking at the deer and the unusual birds to be seen in pens here. A hiking loop goes around the breeder yards. Also on the property is a memorial to those who died in a train wreck at Rockport in 1925. Open daily, 7:30–dusk. Across the road from the pens is one of the few remaining segments of the Morris Canal (the port in the name Rockport dates to canal days). You can take a short walk along the towpath in this beautiful spot.

Haddonfield Camden 11,628

C 551, 561, 573

Haddonfield is perhaps the only colonial town to be directly founded by a woman. Elizabeth Haddon, a Quaker, who had come to the colonies to develop a large tract bought by her father in 1698, built a house on Cooper's Creek in 1701. In 1702, she married John Estaugh, a Quaker missionary (to whom, it is said,

she had proposed), and in 1713 they moved to the site of Haddonfield. They had no children, and the name died out. Even their house is gone; the so-called Elizabeth Haddon house now on the site (201 Wood La.) was built in the 1840s, theirs having burned some 100 years before. Their story, though, has been immortalized by Longfellow in *Tales of a Wayside Inn*.

The town's location on the main road from Burlington to Salem (the Kings Highway, laid out in 1686 and still the main street) gave it a place in revolutionary history. The Indian King Tavern House Museum* (233 Kings Highway; 609-429-6792) served as a tavern, an inn, a temporary statehouse, and a stop on the Underground Railroad. In it the Continental Congress, the New Jersey legislature, and the Council of Safety all met. Both the great seal of New Jersey and a law substituting the word "state" for "colony" in all official papers were adopted in legislative sessions here. Among those who stopped at the inn were Light-Horse Harry Lee, Mad Anthony Wayne, and Lord Cornwallis, and the future Dolley Madison was the innkeeper's niece. Built as a home in 1750 by a wealthy Philadelphia merchant, the inn was bought by the state in 1903, the first such historic structure to be managed by the state. It is being furnished with authentic reproductions to show what an 18th-century tavern would have been like. Plans include a gala celebration of the building's 250th birthday in 2000, with working demonstrations of 18thcentury crafts throughout the year. Open Wednesday–Saturday, 9–4; Sunday 1–4; groups by appointment.

Although Haddonfield is today primarily a suburb of Philadelphia, and a prosperous one at that, it has the feel of a town that had its own identity before it became a suburb. Over 450 colonial, federal, Victorian, and in other ways significant structures are included in its historic district,* which covers almost half the borough's total area. In 1858, on a farm near Haddonfield, the first major dinosaur discovery in North America was made. The dinosaur is now in Philadelphia, but there is a reproduction of it in the State Museum in Trenton, and the place in which it was discovered (end of Maple Ave.) is a national historic landmark. A plaque marks the spot.

The Haddonfield Historical Society has its headquarters in Greenfield Hall* (343 Kings Highway E.; 609-429-7375); Lafayette and General Howe are both supposed to have stayed here. Most of the building dates from 1841, though the oldest part was built in 1747. Four rooms on the first floor are furnished to

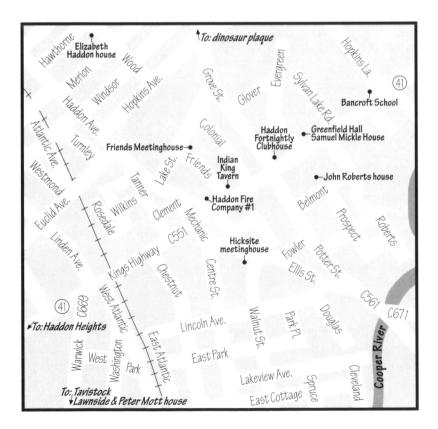

110 Haddonfield

reflect four distinct architectural periods from colonial times through Victorian. Included in the society's collection are Elizabeth Haddon's Queen Anne table and mirror. Open Monday, Tuesday, and Thursday, 9:30–11:30 A.M.; groups by appointment. On the same property is the Samuel Mickle House, * often called the hip-roof house (though it actually has a gambrel roof), dated variously 1710 and 1742; it houses the society's library. Open Tuesday and Thursday, 9:30–11:30 A.M.; 1st Sunday of the month, 1–3. The museum and library are closed in August.

There are many other interesting buildings in town, many of them with identifying plaques. In addition to Kings Highway, you may want to walk or drive along Tanner, Lake, Grove, Chestnut, Centre, Potter, Clement, and Mechanics sts., Warwick Rd., and Washington, Colonial, Friends, Lincoln, W. Park, E. Park, E. Atlantic, and W. Cottage avenues.

The Friends Meetinghouse (Friends Ave.) dates from 1851, and the cemetery wall was built of bricks from the old meetinghouse. Dolley Madison may have worshipped here. In the cemetery is a plaque honoring Elizabeth Haddon as a woman remarkable for "resolution, prudence, and charity." There is a little park around the lake below the meetinghouse.

During the period the Friends were split into two factions, this meetinghouse was used by the Orthodox group. The Hicksite building also dates to 1851 and can be found at Ellis and Haddon sts., entirely incorporated into a supermarket building.

At the corner of Kings Highway and Haddon Ave. is Haddon Fire Company # I (609-429-4308), formed in 1764 and the second oldest fire company in continuous operation in the United States. (Mount Holly claims to have documents proving that it is the oldest; the Haddonfield company does not accept this claim but has decided not to fight it.) There is a small museum at the firehouse, organized to suggest what a firehouse would have looked like 200 years ago. In the museum are two old pumpers, one dating from 1818 (it can be seen spraying water on Independence Hall in the movie *Cinerama*), the other from 1873. The collection also includes the fire company's original banner, a window from the company's original building (this building dates to 1952), helmets and uniforms, and a marvelous collection of old metal toy fire equipment. The museum is open weekdays, 9–5, but you must call for an appointment first (the tour also includes the more modern equipment).

The so-called Elizabeth Haddon house at 201 Wood La. (between Merion Ave. and Hawthorne St.) dates from 1844 and is built of local bricks taken from an earlier house on the site. A two-story brick still, built in 1713 and used by Elizabeth Haddon to produce medicinal whiskey, still stands, possibly the oldest building in Haddonfield.

Among the large houses on the Kings Highway heading north is the splendid Queen Anne–style building of the Bancroft School (at Hopkins La.), a private school specializing in children with mental and physical disabilities. Closer in town note also the former Third Methodist Church* (301 Kings Highway E.), now the Haddon Fortnightly clubhouse, and the John Roberts house (344 Kings Highway E.).

Directly south of Haddonfield (take Warwick Rd., c 669) is Tavistock, which, with its 1990 population of 35, is one of New Jersey's smallest municipalities. Basically a country club and a few houses, Tavistock managed to incorporate itself as a borough in the 1920s after the members of a country club in Haddonfield, dissatisfied because the club could not sell liquor on Sundays, moved their activities to a new site.

Directly south of Tavistock is the borough of Lawnside. Established as an African American community in 1840, and formerly known as Free Haven, Lawnside remains primarily African American today. The Peter Mott house (Gloucester and Moore aves.; 609-546-8172), built in 1845, was an important stop on the Underground Railroad. The Mott house is being restored and turned into a museum of African American history. In the meantime, it is possible to arrange tours of the site.

In the Haddon Heights Public Library (608 Station Ave.; 609-547-7132) is a "corner museum" run by the Haddon Heights Historical Society (Haddon Heights is southwest of Haddonfield; you can pick up Station Ave. in Haddonfield off Chews Landing Rd., c 573). On display are various artifacts connected with the history of Haddon Heights, including the wooden turbine from a 1740 fulling mill; the library also has a good collection of photographs of Haddon Heights from about 1890–1930. Open weekdays, 10–5 and 6:30–9; Saturday, 10–2. The library is in the Station Ave. historic district,* an area of commercial buildings dating from c. 1890–1925. The nearby White Horse Pike Historic District,* with buildings from the same era, also includes parts of Station Ave. as well as White Horse Pike, Garden, Green, and High sts., and E. Atlantic and 4th avenues. You can also find a few prerevolutionary houses scattered about town on Sycamore St., New Jersey and N. Park aves., and Sylvan Dr.

Haledon Passaic 6,951

C 504, 509

An excellent example of a streetcar suburb, Haledon developed as a satellite of industrial Paterson after trolley lines from the city were laid in the 1870s. What had been a small rural village became not only a working- and upper-middle-class suburb but a late-Victorian resort as well.

Haledon is the site of the American Labor Museum* (83 Norwood St.; 973-595-7953), one of the few museums in the country devoted to presenting postindustrial-revolution history from the point of view of the worker. The museum is located in the house* (1908, 1913), now a national historic landmark, of Pietro and Maria Botto, immigrants from northern Italy who came to work in the Paterson silk mills in the 1890s and built their house in 1908. The house is important to American labor history because it served as headquarters for the famous 1913 Paterson silk strike. For seven months in 1913, some 24,000 workers in Paterson, known then as Silk City, stayed off their jobs in a drive for improved working conditions, an eight-hour day, and a minimum wage. Because of legal harassment, the workers were unable to meet in Paterson; the mayor of Haledon offered them a refuge in his city, and the Bottos offered their house as a meeting place. Every Sunday some 20,000 workers would gather on the front lawn and listen to speeches by members of the I.W.W. (International Workers of the World, known as the Wobblies, who were coordinating the strike), including Elizabeth Gurley Flynn, as well as by the journalist John Reed and the writer Upton Sinclair.

Four rooms of the museum are furnished to reflect the living conditions of immigrants in 1913, other rooms have been converted to galleries, and the Old World gardens, including the grape arbor and bocce court, have been restored. There is a permanent exhibit on the silk strike, and the upstairs rooms feature exhibits that change roughly three times a year. The museum's extraordinary collection of photographs and other documents from the peak years of American immigration vividly re-create an important period of American history. The museum sponsors a variety of special programs and educational projects as well as an annual Labor Day parade, which starts at the museum and ends at the Great Falls in Paterson (see Paterson) with a Great Falls festival. Open Wednesday–Saturday, 1–4; groups and other times by appointment. Closed major holidays.

Just north of Norwood St., off Belmont Ave., is the Kossuth Street School* (47 Kossuth St.), built at the turn of the century.

Hamilton Township Mercer 86,553

I 295, US 206, NJ 33, C 533

Though often thought of as a suburb of Trenton, Hamilton Township is actually one of the state's 10 most populous cities. Much of this growth has been recent, and although parts of the township were settled long ago (some so long ago that Hamilton has been called the richest archaeological site east of the

Mississippi; see below), this large (40 sq. mi.) township is a city without a center. (Occasionally, though, you may come across reminders of an early crossroads village.)

Celebrating the Native American settlements of Hamilton is the Civil War and Native American Museum (Kuser Rd.; 609-275-0143). Two rooms of the joint museum are dedicated to the memory of the Lenape Indians, who frequented the area between the Delaware River and Gropps Lake; on display are artifacts that until recently were readily found by anyone walking through that area. The Civil War portion, said to be the largest museum in the state dedicated to that war, includes memorabilia as well as changing exhibits dealing with New Jersey residents involved in the war. The museum is housed in a building that once was used to dry vegetables on the Abbott farm (see below). Jim Thorpe lived there for a year as a migrant worker, and reports of his ghost surface from time to time. Open weekends, 12–5. The museum is located in Veterans Park (between Kuser and Klockner rds., east of 1 295; 609-890-3684) behind the 1730s Abbott House* (2200 Kuser Rd.; 609-585-1686), where New Jersey tried to sequester the state treasury during the Revolution. Restored and furnished as a house museum by the Historical Society of Hamilton Township, the house retains some of its original hinges and buttermilk paint. Open weekends, 12–5; groups by appointment. In the 300acre park are formal gardens, two greenhouses where the flowers used by the township are grown, meadows, woodlands, and a stream and lake where you can fish. There are also athletic fields and what is reputed to be the largest tennis complex in the country. Open daily, dawn to dusk.

West of Veterans Park is the Kuser Farm Mansion and Park (390 Newkirk Ave. or Kuser Ave; 609-890-3630). The mansion was built as a summer home in 1892 and became the Kusers' winter home in the 1920s. The family pioneered in several businesses (Fred Kuser helped finance the forerunner of 20th Century– Fox and was involved with the Roebling family in producing the Mercer car) and sports (tennis and flying), and the furnishings in the lavishly built house reflect their interests. A brochure is available for a self-guided tour of the grounds. A Victorian Christmas is celebrated in December, and the Jersey Valley Model Railroad Club, which houses its displays in the basement, has an annual open house one weekend in early December. Open Thursday–Sunday, May–November, weekends, February–April, 11–3 (last tour, 2:30); groups by appointment.

Closer to the river is John A. Roebling Park (just south of S. Broad St.; access from Sewell or Wescott aves.; 609-989-6530), 250 acres of freshwater marsh and a lake. The park is beloved of bird-watchers, and you can fish in the lake. There is also a small picnic area, and there are walking paths through the woods and among the shrubs near the picnic area. The oldest house in Mercer County, the Isaac Watson house* (151 Wescott Ave.; 609-882-2062), built in 1708, is the state headquarters for the D.A.R. and can be seen by appointment.

This land falls within the boundaries of the Hamilton-Trenton marsh, the northernmost freshwater tidal marsh on the Delaware River, boundaries that are almost the same as those of the Abbott Farm National Historic district,* a national historic landmark. The Abbott district is the largest Middle Woodland site east of the Mississippi, and much older artifacts (as far back as 6000 B.C.) have been found as well. The marsh also contains an extraordinary diversity of species: some 700 varieties of plants, some 235 varieties of birds. Guided tours of the area are given frequently by the Delaware & Raritan Greenway (609-924-4646).

Sayen Park Botanical Gardens (155 Hughes Dr.; 609-890-3874) is a 27-acre garden noteworthy for its naturalized plantings of rhododendrons and azaleas. Narrow trails wind through the property, making this spot an oasis in one of the more built-up parts of the township. Open dawn–dusk.

On the old New Jersey State Fair grounds is the Johnson Atelier, the Technical Institute of Sculpture (60 Ward Ave. Ext.; 609-890-7777). This is a technologically advanced working foundry where artists can maintain control of their work. The atelier casts works by Seward Johnson, who set it up, and others, including George Segal, Isaac Witkin, and the late Georgia O'Keeffe. The apprentices can use the facilities for their own pieces after hours. Tours of the facility can be arranged for art students and sculptors interested in using the foundry. The Extension Gallery, which has widely varied exhibits, is open to the public Monday–Thursday, 10–4.

Also on the old grounds is a 22-acre sculpture park, Grounds for Sculpture (18 Fairgrounds Rd.; 609-586-0616). Landscaping and courtyards highlight the outdoor exhibits, and a shell of one of the old animal buildings has been converted to a 10,000-square-foot indoor museum. Shows change three times a year. Open Friday and Saturday, 10–4, Tuesday–Thursday, by appointment. A restaurant, office, and museum shops are scheduled to open on the old fairgrounds in the spring of 1998.

Hammonton Atlantic 12,208

US 30, 206, NJ 54, C 542, 559, 56T Named for John Hammond Coffin,

Named for John Hammond Coffin, the son of an early-19thcentury glass manufacturer, Hammonton was developed in the late 1850s by Charles K. Landis (see Vineland). Landis encouraged New Englanders and Italians to settle in Hammonton, and the Italian Carnival held on N. 3d St. in mid-July has been a major

ethnic and religious festival for over 100 years. Fruit growing is important in the area around Hammonton, and the town serves as a center for the blueberry industry (see Pemberton). The world's largest cultivated-blueberry plantation is here: 50 employees work on its 1,300 acres of berries year-round, 2,000 in season. New Jersey in fact leads all other states in the production of blueberries for consumption fresh (Michigan is first in total production; see Pemberton). The Hammonton Historical Society's museum is located behind the town hall on Vine Street. On exhibit are photographs and artifacts connected to local history, particularly from the Victorian era. Open by appointment only (call 609-561-4830). In the old Hammonton railroad station (1904), recently restored, the Chamber of Commerce runs a visitor center (10 S. Egg Harbor Rd.; 609-561-9080). Stop here for maps and guides to the area. Open weekdays, 8:30-4. Also in Hammonton is the Tomasello Winery (225 White Horse Pike; 800-666-9463), a 60-year-old family-run winery. Open daily, 9-8; groups by appointment. Some Jerseyites who live north of Hammonton may be interested to know that us 206 begins here.

Hammonton lies just south of Wharton State Forest (609-561-3262), New Jersey's largest state forest (over 100,000 acres) and the largest tract of public land in the Pinelands. The Pinelands are a unique New Jersey treasure: 2,000 square miles unlike those anywhere else, the largest wilderness east of the Mississippi in the nation's most densely populated state. Because of the Pinelands' particular geological and human history, they contain an unusual variety of rare plants and animals—the Pinelands represent the southern limit for many northern species and the northern limit for many southern species.

Beneath the ground surface lies an enormous reservoir (17 trillion gallons) of pure water. The land is generally sandy, and much of it is forested with pine and oak, particularly pitch pine, which is better able than other species to withstand the frequent fires. There are cedar swamps and bogs here; there are forests of pygmy pine; and the rivers are often the color of tea. Seen from a car, the Pinelands often look featureless-mile after mile of sand and scrubby trees-but once you leave the paved roads and walk or canoe, you will be struck by the mysterious quiet and beauty. (It is important when hiking, though, to pay close attention to landmarks until you know the area well-it is easy to get lost.) Although much of the Pinelands seems devoid of people, there once was considerable industrial activity here: the iron found in the bogs was processed (cannons, cannonballs, firebacks, and water pipes were manufactured here); there were paper mills and glassworks; and sphagnum moss (used by nursery owners to protect plants) and salt hay were gathered. Today, cultivation of cranberries and blueberries is the major economic activity, but what is perhaps most unusual about the Pinelands economy is that so many of those who live in the region have chosen not to enter the economic mainstream, supporting themselves by seasonal work related to the Pinelands' natural resources. Although the various grandiose schemes to develop the Pinelands as a resort area came to naught, large segments are now being used for retirement communities. Remains of old forges and villages are still apparent, varying from those noticeable only to a trained eye to the completely restored iron village of Batsto* (see below). The fact that sand quickly obliterates traces of the past has suggested that the Pinelands might be serving as a criminal burial ground.

Batsto is now a historic museum village. That it still exists we probably owe to Joseph Wharton, a Philadelphia industrialist, who purchased large tracts of land in this area in the 1870s. His land included the village, which he partially restored. The first furnace in this area was erected in the 1760s; the last was dismantled in 1858. In between, munitions had been manufactured for the Revolution and the War of 1812, and for a short time the furnace had been used by a glassworks. Among the many schemes Wharton was involved in was one to export the Pinelands' pure water to Philadelphia, but he failed to stir up much interest, and in any case the New Jersey legislature eventually forbade the exportation of water. He also experimented with growing and processing sugar beets. His large holdings remained intact after his death in 1909 and were sold to the state of New Jersey in the 1950s. The ironmaster's mansion has been restored, as have many of the workers' houses and various outbuildings, and craft demonstrations are given in some of the houses during the summer. The Wharton park headquarters are here, as are a nature center and nature trails; there is also a picnic area. The Batsto grounds are open year-round, the buildings Memorial Day–Labor Day, 10–5; call about winter hours, which vary according to the budget. Closed New Year's Day, Thanksgiving, and Christmas.

Within the forest are many miles of hiking trails (including a stretch of the Batona Trail) and bridle paths. The lakes and rivers provide opportunities to

swim, fish, and boat. Canoeing the Pinelands rivers, among them the Mullica, Batsto, Wading, and Oswego, is very popular. The Oswego River goes by the former paper-manufacturing town of Harrisville; there are ruins to explore here. Campsites range from the primitive to screened cabins; some are accessible only by foot or canoe. All require permits. The forest also has picnic areas, and in the winter you can ice-skate and fish. For information and maps, stop at the park headquarters in Batsto or at the ranger's station at Atsion* (Us 206), also a former iron town. Both are open daily (except New Year's Day, Thanksgiving, and Christmas), 8–4:30; April–October, Friday and Saturday evenings, for campers only, until 9. At the Wharton Forest Nature Center (609-561-3170) you will find a few exhibits related to the natural history of the area; guided nature tours can be arranged. Open Memorial Day–Labor Day.

A short distance east of Wharton State Forest is Penn State Forest (east off c 563; 609-296-1114), 3,000 acres with hiking trails and bridle paths, a picnic area, and Lake Oswego, where you can fish and boat.

To the east of the northern end of Whorton 16 the village of Chatsworth (C 532, C 563), often referred to as the capital of the Pinelands. Each October the village hosts a cranberry festival, which is attended by over 50,000 people; the proceeds go toward the restoration of the mid-19th-century White Horse Inn.* New Jersey is the country's third-most-important grower of cranberries (behind Wisconsin and Massachusetts), which in 1995 contributed almost \$21 million to the state's economy. Many field guides are available to help you explore the Pinelands (see also Pemberton, Tuckerton, Vineland, and Woodbine).

West of Hammonton is the Winslow Wildlife Management Area (access from us 322 and Piney Hollow, New Brooklyn–Blue Anchor, Malaga, and Folsom rds.), over 6,500 acres of woodland bisected by the Egg Harbor River (and the Atlantic City Expressway). These woods are open for hiking, birdwatching, hunting, and fishing.

Hancock's Bridge Salem [Lower Alloways Creek Township]

C 658

Hancock's Bridge is a tiny hamlet now, but the drawbridge over Lower Alloways Creek was considered so important during the Revolution that the militia was stationed there to guard it. In the early morning of 21 March 1778, 300 British troops under Colonel Charles Mawhood massacred some 30 militiamen asleep in Judge

William Hancock's house* (Main St.; 609-935-4373). This was the only time during the Revolution that a massacre occurred in a house; the building is now a historic-house museum run by the state. Built in 1743 of brick in a Flemishbond pattern, it is notable for the design on one side: the date and the initials of Judge Hancock and his wife, Sarah, are worked into the brick, with a zigzag pattern below. Also on the property is a Swedish cedar plank house (1640–45) moved to the site from the Tyler tract just south of Salem. The planks are of swamp cedar, shaped with an adze and dovetailed at the corners. The house

has been closed for restoration since 1991; the work is progressing, and the hope is that the house will reopen soon.

About a half-mile west of the Hancock house, on Poplar St., are the John Maddox Denn house (1725) and the Ware-Shourds house* (1730), both of which served as hospitals after the massacre. South on Main St. a short way is the Lower Alloways Creek Friends Meeting House. It still has the original glass in many of its windows and early-19th-century cast-iron stoves made of New Jersey bog iron.

Buried in the local cemetery is Cornelia Hancock, who, as a very young woman, served as a nurse in the Civil War. Much beloved of the troops, she was the first woman to reach the battlefield at Gettysburg.

For an unsettling contrast, continue from Hancock's Bridge south and west on Alloway Creek Neck Rd., following the signs to the Salem Generating Station, an atomic energy installation. The distant sight of the reactor tower rising out of the tideland marshes would probably be striking in any context, but following so close on an 18th-century hamlet, it is eerie. Occasional open houses are held at the generating facility.

South of Hancock's Bridge (off Alloway Creek Neck and Canton rds.) is the Mad Horse Creek Wildlife Management Area, over 7,600 acres, mostly tidal marsh. The area, which is rich in waterfowl and frequented by migratory birds including Canada geese, snow geese, hawks, and eagles, is open for birdwatching, hiking, fishing, and hunting.

South and east of Hancock's Bridge, in the village of Canton (take Hancock's Bridge–Harmersville Rd., 658, to Harmersville–Canton Rd., 623; turn right to Smick Rd., 652, and turn left), is the Lower Alloway Historical Museum (736 Smick Rd.; 609-935-1549). This is a reconstructed log house (one interior wall is original) probably built in the late 18th century and known to have been on the spot since the 1870s. Exhibits in the museum, which change periodically, feature displays relating to local crafts and occupations. The museum also sponsors a variety of special events. Open April–November, 3d Sunday of the month, 2–4.

Harrison Hudson 13,425

1 280, C 508

The population density of this small (just over 1 sq. mi.) industrial town is relieved by West Hudson Park (Davis Ave.; 201-915-1391), a 43-acre county park whose rustic trails are designed to make the rolling land seem rural. In addition to playgrounds, the park contains wooded groves, grassy lawns, three lakes, and wading

pools. The abundance of hardwood trees makes the fall colors noteworthy. Although many of the industries for which it was once known have left, Harrison has kept as its motto, "the beehive of industry," a designation bestowed on it by William Howard Taft before World War I. When its mayor retired in 1995, he had been in office longer (since 1947) than any other mayor in the country.

Helmetta Middlesex 1,211

C 615

In the center of Helmetta is a large brick complex, until 1993 the oldest snuff factory operating in the United States. The present C. W. Helme Snuff Mill district* (Main St., Helmetta Pond, and the area between it and Manalapan Brook) dates from the 1880s, but the operation descends directly from a factory built in 1812.

This complex, set directly along the tracks of the old Camden and Amboy Railroad, dominates the western end of the town.

East of the factory, on Main St., note St. George's Church (1894) and the municipal building (1909), once a public school. Note also the plantings along the railroad. The Helmetta Historical Society holds an annual museum day each spring, exhibiting its collection of papers, artifacts, and photographs, as well as collections on loan from others, in Holy Trinity Church (100 Main St.). It also sponsors a fall walking tour and occasional other special events. For information call 732-521-0386.

The undeveloped 1,500-acre Jamesburg County Park is an island of Pinelands vegetation in a densely populated area. The park is being maintained as a conservation area, but nobody knows what will happen to the Pinelands species without the genetic variety of a larger population. You can fish and boat on the lake, and hike along the trails and fire roads; two endangered species live in the area, and the birding is considered excellent. Tours can be arranged by calling the Middlesex County Citizens' Conservation Council (732-846-1825).

Highland Lakes Sussex [Vernon Township]

C 638

This community, centered on Highland Lake, abuts Wawayanda State Park (973-853-4462), 14,000 acres of wilderness, mountains, lakes, and streams. Here you can picnic, fish, swim, hike, and, in season, cross-country ski, sled, and hunt. The several miles of bicycle and hiking trails include a section of the Appalachian Trail.

In the park are some natural curiosities, among them the oldest rock to be seen in the Middle Atlantic states and northern white cedar rarely seen elsewhere in the state (here it is at the extreme southern limit of its habitat). The park is known for its display of rhododendron bloom in late June and early July, and for the quality of the fishing in Wawayanda Lake. Three natural areas— Wawayanda Hemlock Ravine, Wawayanda Swamp, and Bearfort Mountain occupy over 3,500 acres of the park. The hours vary with the season, so it is a good idea to call the office. Memorial Day–Labor Day, open half-hour before sunrise to half-hour after sunset (a parking fee is charged during these months); during daylight savings, 7:30 A.M.–8:30 P.M.; during standard time, 8–4:30.

Included in Wawayanda is High Breeze Farm* (Barrett Rd.; 973-853-4462),

described as a "high-mountain subsistence farm" that remained in the same family from the mid-19th century to the 1980s. On the property is a federal farmhouse, dating to 1815, and 14 outbuildings. The farm is still being worked, and the state is hoping that once the buildings are stabilized, the farm could become a living history museum, an illustration of 19th-century farming. Because so little on the property was changed (the house was minimally electrified in 1948), and because the Barretts continued to farm with traditional methods, the task should be easier.

East of Wawayanda is the 2,000-acre Abram S. Hewitt State Forest (c 513; 973-853-4462), with extensive hiking trails and some spectacular views; crosscountry skiing is also possible in season. East of Hewitt is the Wanaque Wildlife Management Area, some 2,200 acres just to the east of Greenwood Lake and including Green Turtle Pond. The area is open for fishing, hiking, and hunting.

Directly south of Highland Lakes is Newark's 35,000-acre Pequannock Watershed (accessible from NJ 23 and c 515 and 638), much of it open for recreation. The necessary permits for hiking, fishing (there are five reservoirs), horseback riding, and hunting can be obtained from the Newark Watershed Conservation and Development Corporation (40 Clinton St., Suite 2105, Newark 07102; 973-622-4521, or, within the reserve, 223 Echo Lake Rd., Newfoundland 07435; 973-697-2850).

Highlands Monmouth 4,849

NJ 36

Highlands takes its name from the bluffs that rise 200 feet above the Atlantic Ocean, said to be the first land sighted by ships sailing from the east. On the promontory between the Navesink River and Sandy Hook Bay is the Twin Lights Historic Site* (Hillside Ave.; 732-872-1814), a twin-towered lighthouse decommissioned

in 1949. The first twin towers of the Navesink Light Station were built in 1828, although a light was probably operating at this point in the mid-18th century; the present brownstone and brick buildings date from 1862. This was the first lighthouse in the United States to be equipped with Fresnel lenses (1841), and the first to be electrically powered (1898). When electrified, it was the strongest maritime light in the country, visible 22 miles out to sea. At Twin Lights, Marconi demonstrated that wireless telegraphy was commercially feasible: in 1899 he wired the results of the America's Cup yacht race from a ship 15 miles offshore to a receiving mast erected at Twin Lights. Twin Lights is now a museum; the recently remodeled exhibits focus on maritime history as it relates to Twin Lights, with an emphasis on lighthouses and lifesaving. In the former garage of this popular site (80,000 visitors a year) is a display of the lens with the equipment used to generate electricity. Also on the property is the lifesaving station from Sandy Hook, built in 1849 (the lifesaving service resulted from the initiative of a New Jersey congressman, William A. Newell; see Allentown). There is an overlook in front of the museum as well as in the

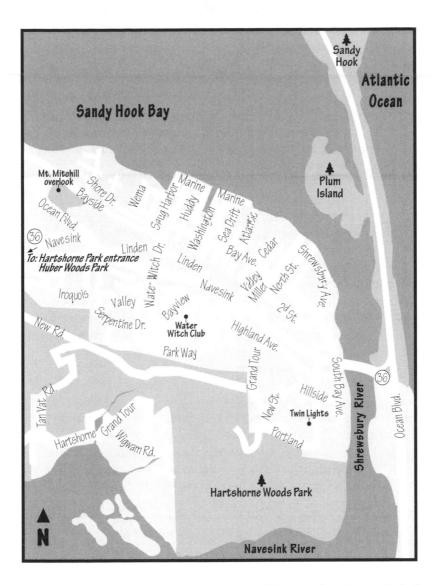

towers, and on a clear day you have a wonderful view of Sandy Hook, the bay, the ocean, and the New York City skyline. Picnic sites available. Memorial Day–Labor Day, open daily, 10–5; the rest of the year, Wednesday–Sunday, 9–5. Group tours by appointment.

Beautiful views can also be had by driving along Scenic Dr. (Ocean Blvd.) and from Mt. Mitchill overlook (see Atlantic Highlands). For information on beach fees, call 732-872-1959.

Off Navesink Rd. is Hartshorne Woods Park (732-842-4000), a 736-acre county facility with woods that once belonged to Richard Hartshorne, who acquired the land from the proprietors of New Jersey in the mid-17th century. Some of the woods have remained undisturbed, and many of the trees are very old. Multiuse trails for hikers, bikers, riders, and cross-country skiers wind through this undeveloped area. Part of the park was once an army missile center, and in that part there are almost two miles of paved trails and a pier from which you can fish.

Between Navesink Rd. and Hartshorne is the former Water Witch Club, a late-19th-century summer community frequented by business and professional people from New York City. The shingle-style clubhouse, originally a casino, survives, as do many of the original houses, now winterized. Among the roads with interesting houses are Sea View and Bay View terraces, Bluff View, and Water Witch and Serpentine drives.

About three miles west of Highlands is Huber Woods Park (take Navesink Ave. west to Locust or Monmouth Ave.; from either of these turn on Browns Dock Rd.; 732-872-2670), with over 250 acres of county woods, primarily oak, beech, and tulip trees, which once formed part of the Huber family's estate. The Huber house, a 1930s Tudor, now serves as an environmental center. The center's programs are geared toward children, and exhibits include an active beehive, a bird-viewing area (the outside plantings are geared to attract birds, which can be watched through glasses inside), and a weather station. Open daily, 10–4. The Monmouth County Park System riding program, including its program for handicapped riders (run by SPUR), is located here (732-842-4000, ext. 297). Bridle paths and hiking and cross-country ski trails go through the woods. Groups and guided tours by appointment.

To the north of Highlands is Sandy Hook, a six-mile-long sandspit extending into the Atlantic Ocean and the lower New York Bay (to get there take NJ 36 east across the Shrewsbury River and turn left). On this spit are long stretches of open beach, salt- and freshwater marshes, back-dune forests, and a spectacular holly forest (the largest stand of holly on the East Coast), as well as the Sandy Hook unit of the Gateway National Recreation Area, Fort Hancock, and the oldest original operating lighthouse in the United States. The lighthouse,* a national historic landmark, was first lit on 11 June 1764. It was built by a group of New York merchants who were appalled at the losses suffered by ships coming into New York harbor (until 1907 the Sandy Hook channel was the only entrance for large ships) and sponsored two lotteries to raise funds for its construction. The first use of a steam-powered fog signal took place at Sandy Hook in 1868. When the lighthouse, a 103-foot octagon tower, was built, it stood some 500 feet from the water; it is now a mile and a half away.

One of the first U.S. Lifesaving Service boat stations was built at Sandy Hook in 1849 (it can be seen at Twin Lights). A Coast Guard unit at the point operates a loran monitoring station for the northeast chain of command. Nineteenth-century lifesaving techniques are demonstrated during the summer; you are welcome to watch the practices as well as the drills. Call 732-872-5970 for the schedule.

Because of its strategic position, Sandy Hook has always been of military interest. The British and Continental troops fought over it during the Revolution, and the federal government began building a fort there before the Civil War. Fort Hancock,* a national historic landmark, dates from the 1890s, and for many years Sandy Hook was a proving ground. (It was also a Nike missile site, which the army left looking like a dump.) You can still see the massive concrete batteries of the seacoast guns used to fire on ships at sea.

The Fort Hancock buildings,* one of which was designed by Robert E. Lee. have an air of deserted elegance. In the 1899 guardhouse and jail is a museum that concentrates on the history of the armaments used at the fort. Open daily, July and August, 1-5; the rest of the year, weekends only, 1-5. The history house, once an officer's house, is also a museum; it concentrates on what it was like to live at the fort. Usually open weekends, 1-5. Tours of the Battery Potter, housing for a gun that rose up like the Radio City orchestra to fire and then sank back out of sight, are arranged by the visitor center, Thursday during July and August. Some Fort Hancock buildings are being used for various environmental and educational programs. In the James J. Howard Marine Sciences Laboratory building, completed in the mid-1990s, research is conducted by the National Marine Fisheries Service and others (in 1985, 20 years of research were destroyed when the Marine Fisheries building—the old Fort Hancock hospital—burned in what was probably an arson fire). The 300-seat theater has been restored and is used year-round by the local high school; various schemes to restore more of the old buildings are afoot. An experimental ferry service to other New Jersey cities and to New York City was scheduled to start in the summer of 1997.

Sandy Hook is heavily used for recreational purposes in the summer (some 2.2–2.5 million visitors a year), but although well over half of the visitors come to use the beaches, the area is also beloved of bird-watchers and other naturalists. The park service uses horses to patrol. At the Spermaceti Cove visitor center,* housed in an 1894 lifesaving station, are displays relating to the area. You can see a short film at the center, and maps and other material to help you tour Sandy Hook on your own are available. A wide range of tours and special events is offered at Sandy Hook, some dealing with the natural aspects of the spit, others with Fort Hancock or the Coast Guard facility. Many of them start from the visitor center; to find out what is available and whether reservations are required, call 732-872-5970 or 732-872-5971. Visitor center open daily, 10–5. A self-guided nature tour, the Old Dune trail, leaves from the center. Notice the prickly pears, the state's only native cactus (often seen with the leaves trimmed by rabbits), and the holly forest with 150-year-old trees that are 50 to 70 feet tall. Parking fee Memorial Day weekend–Labor Day.

Hightstown Mercer 5,126

3

NJ 33, C 539, 571

Settled in the 1720s by John and Mary Hight, Hightstown owed its period of greatest prosperity to the railroads. After the Camden and Amboy arrived in 1831, Hightstown became the transportation hub for the surrounding agricultural country, shipping produce to New York and Philadelphia. Growth stopped when the railroad

was rerouted farther north to connect with Trenton, but not before the welloff farmers had built the splendid Victorian homes that today distinguish Hightstown. The last passenger train went through in 1939, but considerable railroading interest was generated when, some 30 years later, stone sleepers that had supported the tracks on which the John Bull, the country's first steam locomotive, had come into Hightstown were discovered. Some of those sleepers line Railroad Ave.; others are to be found behind the Ely house (see below).

Peddie Lake, in the center of town, is a popular fishing lake. For a few years there was no fishing—construction of the New Jersey Turnpike and Twin Rivers had filled the lake with silt, and it had to be dredged and stocked before it could once again be used for fishing.

The Peddie School (S. Main St. between E. Ward St. and Etra Rd., c 571), a preparatory school founded in 1864, has a handsome campus; note particularly the white octagonal house. The recipient of the largest gift ever given by an individual to an independent school in the United States, Peddie has an active cultural program that is open to the public. Exhibits at the Mariboe Art Gallery (609-490-7550) change roughly every two months and feature exhibits by faculty and area artists; there is also an annual small-works show. Open Monday, Tuesday, Thursday, and Friday, 9–12 and 1:15–3; closed August. At the William Mount-Burke Theatre (609-490-7550) professional music, dance, and theater performances are presented, as are student productions, lecture series, a summer theater season, and summer arts programs for children.

Across the street from the campus are some splendid houses, among them the Samuel Sloan house* (1856; 238 S. Main). A characteristic feature of Hightstown architecture is the grillwork on many of the houses; this is particularly in evidence on Stockton St. (C 571) near the intersection with Main Street.

The Ely house (164 N. Main St.; 609-371-9580) is the headquarters and museum of the Hightstown–East Windsor Historical Society. The house, which dates from the 1840s, features Native American artifacts, a candlestick holder and other objects

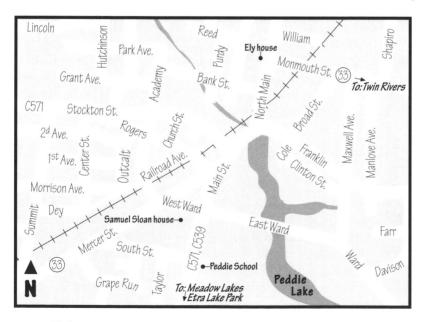

124 Hightstown

belonging to John and Mary Hight, relics from the John Bull locomotive, and period furnishings. Behind the house is the Camden and Amboy's old freight house (1869), which the society is renovating to serve as a meeting room, gallery, and museum. Every other fall, the society sponsors a historic-house tour; Ely house is open then and on other special occasions, as well as for the society's meetings and programs, and by appointment. Call for details.

Just east of town on c 571, on the site of a former estate, is Meadow Lakes, a 103-acre community for 400 senior citizens with a completely staffed medical facility. Farther east on 571 is Etra Lake Park, an East Windsor Township facility with a two-mile running trail, picnic tables, play areas, a pavilion, and 80 open acres. Concerts are held there during the summer.

A mile or two cast of Hightstown, on NJ 33, is Twin Rivers, New Jersey's first planned-unit development. At one time nearly half the population of East Windsor Township lived on its 700-plus acres. The community has its own schools and shopping center and a mix of apartments, single-family houses, and townhouses, and has attracted the scrutiny of countless researchers, from sociologists and anthropologists to specialists in energy conservation.

Hillside Union 21,044

1 78, GARDEN STATE PKWY EXIT 142, US 22, C 509

Part of Union Township until 1913, Hillside has for 50 years been the home of baseball's Phil Rizzuto. Lionel trains were once manufactured here, and today the Atlas Company produces HOgauge track (enough, it is said, to have wrapped the world several times). On the site of a tract purchased by John Woodruff in 1666,

the Hillside Historical Society maintains the Woodruff House* (111–113 Conant St.; 908-352-9270) as a "museum of three centuries." The earliest part of the house, which remained in the Woodruff family until 1978, dates to 1735. The central section was built in 1790, and there are also an 1890s kitchen and a 1900–1930 store. The museum has restored the store to reflect a general or neighborhood store of the early 20th century. In the central section the furnishings are generally mid-19th century, but the house also contains 18th-century items, and there is a smokehouse in the attic. Outside is a barn in which farm artifacts are displayed, as well as a memorial garden and a 1913 garage recently converted into an archival center. Open the 3d Sunday of the month, 2–4; groups and other times by appointment.

East of the Woodruff House is Evergreen Cemetery^{*} (1137 N. Broad St.; 908-352-7940; the cemetery extends into Newark and Elizabeth), one of only two in New Jersey to be on the national register (the other is Mount Pleasant in Newark). Started in 1853, Evergreen spreads out over 100 acres. Influenced in its design by the rural cemetery movement, it is beautifully landscaped, and some of the trees are believed to be over 350 years old. The writers Stephen Crane and Mary Mapes Dodge are buried here; there is also a section of Gypsy graves. You can pick up a map at the office, which is open weekdays, 8:30–4, Saturday, 9–12.

Hoboken Hudson 33,397

HUDSON RIVER BETWEEN HOLLAND AND LINCOLN TUNNELS

The country's first brewery was established in Hoboken, a community first settled by Dutch from New Amsterdam, in 1642. But beer is no longer brewed in Hoboken, and the city's current character was shaped more by the Stevens family than by the earlier settlers. Colonel John Stevens, a Revolutionary War officer

and a famous inventor, in 1784 purchased an estate known as Hobuck Island, which had been confiscated from its Tory owner, and auctioned off lots in what he referred to as the New City of Hoboken. Stevens has been called the father of American railroading, and he and his sons can take credit for many of the events that happened first in Hoboken. Stevens inaugurated the world's first regular steam ferry service (in 1811). He was responsible for the first successful American run of a locomotive (the tracks were near Newark and Washington sts.) and the invention of the T-rail and the ironclad ship. His son John Cox Stevens founded the first yacht club in the United States (in 1844); it was located near 12th Street. John Cox Stevens also originated the first America's Cup race. His brother Edwin made possible the founding (in 1870) of Stevens Institute of Technology, one of the first colleges in the country to offer a degree in mechanical engineering (and, many years later, one of the first to require freshmen to have personal computers). Together the two sons built New Jersey's first railroad.

Other Hoboken firsts include the first organized game of what has become modern baseball. Controversy still surrounds this claim, but in 1846, a uniformed team (only one of the teams wore uniforms) played with stipulated rules on the cricket fields known as the Elysian Fields. What remains of the Elysian Fields can be seen at 10th St. and Hudson, and a commemorative plaque is to be found at 11th and Washington streets. (There are plans afoot to establish a baseball museum on the waterfront.) The first international cricket match in which the United States took part was played in 1859 (the United States was badly beaten). And in 1984 Hoboken was the first city in New Jersey to declare itself a nuclear-free zone.

In the early years of the 19th century Hoboken was a popular resort. Visitors came by ferry from New York to frequent the beer gardens, taverns, and boarding houses and to enjoy the river walks. (Sybil's Cave by the river was a popular meeting place for lovers until a New York salesclerk was murdered there; newspaper accounts of her death are said to have inspired Edgar Allan Poe's "The Mystery of Marie Roget.") Washington Irving and Martin Van Buren were among those who visited John Jacob Astor at his villa at 2d and Washington streets.

By the mid-19th century Hoboken was an active manufacturing center, but of the many industrial firms once in Hoboken, none remains. The last—the Maxwell House coffee plant, whose aroma often permeated the town—closed in 1992. The old Keuffel and Esser complex* (3d St., Jefferson, and Grand), part of which dates to the 1880s, has been converted to apartments. Keuffel and Esser, which produced a variety of precision instruments, was the first company in the country to manufacture slide rules, and during World War II it raised spiders in Hoboken to supply webs for telescope crosshairs.

At the beginning of the 20th century Hoboken was an important shipping center, and during World War I it was a major port of embarkation for American troops (40 percent of the American soldiers who were sent to Europe apparently passed through Hoboken). There were taverns along River St., and like many other port cities, Hoboken had a reputation as a wide-open town, even during Prohibition. *On the Waterfront* was filmed in Hoboken, and in the 1950s the Port Authority spent considerable sums to refurbish piers, but with

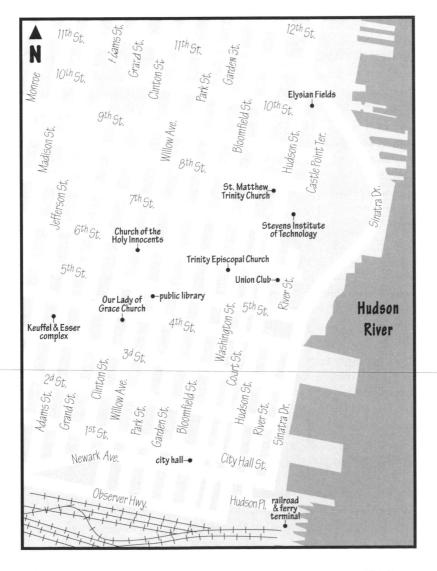

Hoboken 127

the rise in container shipping, Hoboken's shipping activity inevitably declined. After many years of wrangling over how much development the town wanted, ground was finally broken in 1996 on a mixed-use development, which includes 10 acres of open space on two piers, at the former port.

The trans-Hudson train tubes were opened in 1904, and the Erie-Lackawanna's railroad and ferry terminal* (Hudson Pl. at the river), which also served as a warehouse, was built in 1907. This wonderful building with its striking copper roof is said to have been the first American building with platform train sheds. In 1930, one of the early electric trains left from this terminal, with Thomas Alva Edison at the controls. Ferry service continued until 1966; it started up again in 1989 using a temporary dock, and when the restoration of the terminal is complete—this is a long-term project—the ferries will return to their slips at the terminal. Some 30,000 commuters use the terminal every day, making it the second-busiest passenger terminal in the state, and a festival celebrating it and the city is held each year on a Saturday in September.

For a time Hoboken was a wealthy suburb. In the late 1920s it was considered bohemian. At one point there were 20 legitimate theaters in operation, and Christopher Morley, who ran a highly successful theater season in Hoboken, called it "the last seacoast of Bohemia."

The Stevens Institute of Technology demolished John Stevens's mid-19thcentury house in 1959, but the view from the building that replaced it makes clear why he built his house on that spot. The gatehouse (1853) from the Stevens estate remains, as does the college's first building (5th and Hudson), designed by Richard Upjohn. At the northern end of the 55-acre campus, the fraternities occupy what were once the homes of wealthy commuters. At the college's Davidson Laboratory, named for a Stevens Institute faculty member who towed model ships in the swimming pool to learn how they worked, scientists have worked on the design of America's Cup ships and nuclear submarines. From time to time they build an artificial beach in the lab to study wave erosion at the New Jersey shore. Volunteers from the school help inflate the balloons for the Macy's Thanksgiving Day parade, which can turn into a party for the children in town the day before the parade. In 1985 Stevens Institute made national nonscientific news when it awarded an honorary degree to Hoboken native son Frank Sinatra, to the displeasure of many students and members of the faculty.

Although the charms of Hoboken have been discovered by New York commuters—one often hears Hoboken referred to as Manhattan West—and many old-timers worry about overgentrification (signs saying "Speculators, keep out" used to appear with some frequency), the wide main street (Washington) still has an old-time, small-town air. There are no tall buildings on it (tall buildings are, however, gradually appearing, particularly at the northern edge of town and the waterfront), and although the boutiques and coffeehouses have arrived, you can still find shoe repair shops and dry cleaners.

Almost every street in Hoboken has interesting buildings, from rows of

brownstones to mid-19th-century churches to late-19th-century firehouses to early-20th-century public buildings and hotels. There are also a large number of restaurants for the size of the town. The southern Hoboken historic district includes parts of Bloomfield, Hudson, Newark, River, Washington, 1st, 2d, 3d, and 4th sts. and Observer Highway, but you should also take in Willow Ave., Court, Garden, Jefferson, Park, Clinton, and Grand sts., and the rest of the numbered streets. Particularly interesting are the city hall* (Washington and 1st); the Church of the Holy Innocents (Willow and 6th); the Trinity Episcopal Church (Washington and 6th), another Upjohn design; the public library (Park and 5th); and Our Lady of Grace Roman Catholic Church (Willow and 4th), featured in *On the Waterfront*. The strong German influence on Hoboken (the 1880 census called it "the most German city" in the country) is apparent along Hudson St.: at St. Matthew Trinity Church (8th St.), the words "gerichtet 1877" can be seen; the Union Club (6th St.), now condominiums, was the Deutsche Club until World War I.

On the first and second floor of the city hall are exhibits of the Holoken Historical Museum (201-656-2240), featuring memorabilia relating to the history of the city. Open weekdays, 8:30–4:30.

Ho-Ho-Kus Bergen 3,935

GARDEN STATE PKWY EXIT 168S, NJ 17, C 502

Ho-Ho-Kus, an early Dutch settlement, has a Lenape name, which you will see printed with and without the hyphens. Some of the older buildings remain: along E. Saddle River Rd., for example, are three 18th-century stone houses (at 745,* 825,* and 933*). At 335 N. Franklin Turnpike is the Hermitage* (201-445-8311), a national

historic landmark building operated as a house museum. Also known as the Colonel Marc Prevost house, it has associations with George Washington, Aaron Burr (he married Theodosia Prevost), and the marquis de Lafayette. The nucleus of the house was built in the early 18th century, but in the mid-19th century it was expanded and altered to become the Gothic Revival house you see today. From 1807 until 1970, when it was willed to the state, it was occupied by only one family, the Rosencrantzes. The house is being slowly restored, and the intention is to stress the late-19th-century part of its history. The museum offers lectures and other educational programs, mystery evenings, and clothing and textile exhibits; it also takes programs into the schools. Two crafts boutiques are held each year, one four weeks before Easter, the other four weeks before Thanksgiving. The John Rosencrantz house (1892), a family house moved to the property from down the street on what was once part of the estate's original 100 acres, contains display cases with changing exhibits, as well as the offices. The Hermitage is open June–August, Wednesday and Sunday, 1– 4, with other times and groups by appointment; the office is open daily, 9-5.

Holmdel Monmouth 11,532

GARDEN STATE PKWY EXIT 114, C 520

One of the oldest settlements in Monmouth County, the township of Holmdel was named for the Holmes family, Baptists who came to this area in the mid-1660s to escape religious persecution in Massachusetts. The first Baptist sermon in New Jersey was preached here in the late 1660s. The township has been growing

rapidly, almost quadrupling its population over the last 35 years. (In the village note the 19th-century Dutch Reformed church* at 41 Main St.)

About two miles north of Holmdel village is Holmdel Park (take NJ 34 or Holmdel Rd. north to Longstreet Rd; turn right on Longstreet; 732-946-2669). Within this 330-acre county park is the mid-18th-century Longstreet Farm,* which is being run by the county parks system as an 1890s working farm. Many of the furnishings in the house, the first part of which dates to the 1700s, were the Longstreet family's original belongings and reflect several periods. You can watch as the park workers go about the regular activities of the farm, and there are self-guided tours. Many special events, such as sheep days and wool days, are scheduled. Open daily except Christmas; call for the exact schedule. On weekends and holidays, you can tour the house. Groups by appointment.

Also within the park is the 20-acre Holmdel Arboretum, with specimen trees, bushes, and plants suitable for growing in Monmouth County. In the park there are mature stands of American beech, hickory, and white, red, and chestnut oaks; over five miles of trails (because the terrain is rolling, not all the walks are easy); a fitness trail; tennis courts; an activity center for scheduled programs (732-842-4000); picnic areas (group areas by appointment); play-grounds, shuffleboard courts; and, in winter, opportunities for cross-country skiing, sledding, and skating. This is a popular park (over 1 million visitors a year), and in spring and fall access to the parking lots is sometimes cut off for an hour or so because they are full. Guided nature walks by appointment.

On the edge of the park is the Holmes-Hendrickson house* (Longstreet and Robert rds.; 732-462-1466), a mid-18th-century house run as a museum by the Monmouth County Historical Association. Unusually well preserved when the association acquired it, the house contains excellent examples of mid-18thcentury furnishings and working tools of 18th-century farm life. Open May– October, Tuesday, Thursday, Sunday, 1–4, Saturday, 10–4. Admission fee.

Southeast of the park are the Bell Laboratories where *Telstar* was developed (now part of Lucent Technologies). Over 4,000 people work in the Saarinendesigned building, where in 1962 the first telecast from a satellite was received and in 1964 traces of cosmic energy presumed to have originated in the big bang with which the universe began were recorded for the first time. The 20foot horn antenna* used in this work is now a national historic landmark.

South of the laboratories, at Stillwell and Middletown rds., is the former Harding estate. The historical society hopes to use a room in the house to establish a museum (64 Stillwell Rd.; 732-946-8571). The house dates to the 1730s, with additions from the 1930s. The historical society also hopes to set up in an 1820s medical building, the Dr. Robert W. Cooke office (intersection of McCampbell and Middletown rds.), a late-19th-century doctor's office and a genealogy room.

North of Holmdel Park is Telegraph Hill Park (Garden State Pkwy exit 116; 732-888-2034; 732-888-5000). The park is home to the former Garden State Arts Center, now the PNC Bank Arts Center (732-442-9200), owned and formerly run by the New Jersey Highway Authority (the legislation establishing the Garden State Parkway required that recreation be provided along the route). Recently enlarged to seat over 17,500 people, this open shell is the scene of concerts in the summer, mostly popular but some classical. The plaza is also used for special events, particularly ethnic celebrations. The park provides limited opportunities for picnicking and hiking and a nice view from Telegraph Hill. Maps are available at the main arts complex; trails open daily, 9–dusk.

On a slope overlooking the parkway is the state's Vietnam War Memorial, dedicated in 1995. A Vietnam Era Educational Center (800-648-8387), said to be the only one of its kind in the country, is scheduled to open in the summer of 1998. The facility will feature exhibits exploring the history and significance of the Vietnam conflict as well as a library and meeting room. Open Tuesday–Friday, 10–6; weekends, 10–5, but it is probably advisable to call first. Groups by appointment.

Hopatcong Sussex 15,586

c 602, 607, 631

The borough of Hopatcong lies on the western shore of Lake Hopatcong, the largest lake to fall entirely within New Jersey. Reports of monsters in the lake can be found as far back as the 17th century, although until the mid-18th century there were actually two smaller lakes on the site. In the 1750s ironmakers constructed

a dam, which raised the water level and made the two lakes into one; in the 1830s, construction of the Morris Canal, which ran from Newark to Phillipsburg and used the lake as a water source, raised the level again. The lake was also an important source of ice, with several icehouses located on its shore.

Situated over 900 feet above sea level, with some 50 miles of shoreline and clear water, the lake became a popular summer resort. Before World War I it was known as a haven for burlesque performers—Bert Lahr, for example, was a regular visitor. With the arrival of excursion trains in 1882, hotels were built on the lake; there were 3 in 1882 and 40 by 1900. Most are gone, victims of the Depression, the automobile, and World War II, but the Windlass, formerly Allan's Pavilion, dates from the 1880s and still has some of its original docks. The Sunnyside Hotel, above the Windlass, which also dates from the 1880s, is being converted to a bed and breakfast. The Lake Hopatcong Yacht Club,

founded in 1905, is said to be the second-oldest inland yacht club in the country. Its building, which dates from 1910, remains almost unaltered (it has no air conditioning). The amusement park on Bertrand Island, which closed in the early 1980s, boasted the first roller coaster in northern New Jersey. Between 1960 and 1980, as summer cottages were winterized and new developments built, Hopatcong saw its year-round population increase by over 350 percent (in 1990 it was over 23 times what it had been before World War II), and there is some concern about traffic congestion and speeding on the lake, as well as the need to control eutrophication.

At the southwestern end of the lake is the popular Hopatcong State Park (973-398-7010), over 110 acres with facilities for picnicking, swimming, and fishing (a small-boat launch is also available, though not on weekends in high season). The lake is considered one of the best spots in the state for ice-fishing. Also part of the park is Lake Musconetcong, four miles west of Lake Hopatcong, also created as a water source for the Morris Canal. It too is a popular spot for boating and fishing. Toward the southern end of the park you can see some reminders of the Morris Canal, including the dam, gatehouse, and one of the water turbines that lifted canal boats up the inclined planes. In the former locktender's house (next to the park administration building) the Lake Hopatcong Historical Society runs a small museum (973-398-2616). Permanent exhibits deal with the history of the area-from the Lenape who inhabited the area, to the transformation caused by the canal, to the railroads, to the lake's glory days as a resort, to Bertrand Island Amusement Park. Open Sunday, 12-4, March-May and September-November. The park is open daylight hours throughout the year; in the summer an admission fee is charged.

Hope Warren 1,719

C 519, 521

Although the nearness of 1 80 may one day change Hope's appearance radically, the town today presents a striking concentration of 18th- and early-19th-century buildings, many of them of local bluestone, with little intrusion from later periods. Settled by Moravians from Pennsylvania in 1769, it may represent one of the

country's first planned communities. The Moravians bought 1,000 acres from Samuel Green, who had been their host when they passed through the area on missionary trips up the Delaware. Green had become interested in their church (he even tried to give them the land). The town plan was devised in 1774, and in 1775 the community's name was changed from the original Greenland to Hope. The community began to decline in the 1790s, and in 1807 the inhabitants were ordered by the mother church to sell it; the last Moravian service in Hope took place in April 1808.

The first building to be erected (c. 1769–70) was the gristmill (north side of High St., east of the bridge). It has burned twice but still retains its original walls. Flour was produced here for George Washington's troops when they were quartered at Jockey Hollow, and the mill continued to operate well into

the 20th century. At the rear of the mill is the original millrace, cut through solid slate to a depth of 22 feet. The stone bridge that crosses Beaver Brook, although not built by the Moravians, dates to 1807. The little building by the bridge was once the tollhouse. It is now a local museum, which is open irregular hours on weekends, Memorial Day–Labor Day, and for special events; inquire locally.

If the museum is not open, you can pick up a leaflet that describes a walking tour of the town at many of the local stores. Rye whiskey and beer were made at the distillery (1773), and services were held at the Gemeinhaus, or community house (1781), on the southwest corner of High St. and C 519-521. Now a bank, the building has also been a tavern and a hotel, and in 1824 it served as Warren County's first courthouse. The Moravian cemetery (off High St.) dates to 1773; the graves are arranged according to the date of death, and the numbers on the slabs correspond to a chronological list of burials in the Moravian Archives in Pennsylvania. The earliest residence in town (1775) is across from the distillery, the farm manager lived in the house and stored the farm produce in the barn. This farm has been in continuous use since Moravian days. At the northeast corner of Union St. and Moravian Alley is the American House Hotel (c. 1799–1803), originally a schoolhouse. It has recently been restored and is being used for offices. There are several other 18th-century houses and stores in the center of Hope (the historic district* encompasses Union, High, Hickory, and Walnut sts., C 519, 521, Beaver Brook, and the millrace) and on the outskirts as well-for example, the Israel Swayze house and outkitchen, dating from 1759, on C 519 a little over a mile south of town, and what is often called the Moravian Farmhouse on the west side of the Hope-Blairstown Rd., three-quarters of a mile north of town. In addition, both St. John's United Methodist Church and St. Luke's Episcopal Church (High St. south of the intersection with Hickory St.) are worth a glance; both date to 1832. Walking tours of the town (908-459-5381, 908-459-9177) leave at 10 from the Inn at Millrace Pond, Saturday, June October; groups by appointment.

Roughly 5¹/₂ miles south of Hope, on the west side of c 519, is the Four Sisters Winery (908-475-3671). Associated with a 400-acre fruit and vegetable farm, the winery sponsors a variety of special events, including a Native American Powwow and grape stomping. Regularly scheduled tours are given on weekends and by appointment other times. Open daily, 9–6.

West of Hope (take c 655 to Locust Lake Rd., turn left, and turn right on Cemetery Rd.; 908-459-5878) are the Tamuzza Vineyards. The winery is open weekdays, 9–5; weekends 11–5; closed major holidays. Tours are available weekends, 11–5, and there are picnic facilities on the grounds.

Northeast of Hope is Jenny Jump State Forest (take c 519 northeast to Shiloh Rd. and turn right; 908-459-4366), 1,300 acres with facilities for picnicking, camping, fishing, boating, and hunting, a playground, a lookout point, hiking trails, and an astronomy center. The center is open during the camping season (April–October), with programs on Saturday night, 8–10. Jenny Jump is a good place to look at fall foliage. A mile or two southeast of Hope (take 519 east to C 611 and turn right) is the Land of Make Believe (Great Meadows Rd.; 908-459-5100), a 40-year-old commercial theme park for children. Open daily, 3d Saturday in June to Labor Day, weekdays, 10–5, weekends, 10–6; Memorial Day weekend, weekends in June, and Sundays in September, 10–6. Admission charge.

Farther south on 611 is Hemknoll Farm (908-459-5778), one of the largest display gardens of hybrid daylilies in the East. The farm grows over 865 varieties, and although the period of peak display can vary with the weather, July and August are always safe. Visitors are welcome, but you must make an appointment first.

Hopewell Mercer 1,968 (borough) 11,590 (township)

C 518, 569

An attractive small town in the midst of a rapidly growing township, Hopewell was settled in the 17th century. One of its first residents was a son of Richard and Penelope Stout (see Middletown). On the north side of the main street, in a handsome mansard-roofed 19th-century house (with a 20th-century addi-

tion), is the Hopewell Museum (28 E. Broad St.; 609-466-0103). Its collection is made up almost entirely of items donated over the last 80 years by Hopewell residents, and rotating exhibits focus on local life from colonial times to the present. One room is devoted to a notable collection of Native American artifacts. Open Monday, Wednesday, and Saturday, 2–5. A little farther west is the Old School Baptist Church (north side of W. Broad St.), a brick and stucco structure first built c. 1747 and rebuilt c. 1825. John Hart, one of the signers of the Declaration of Independence, is buried in the cemetery.

Across the street (19 W. Broad St.) is a pre-1756 (but much altered) clapboard building that housed the first Baptist school of higher education in the state, founded in 1756 by the Reverend Isaac Eaton, the pastor of the Baptist church in Hopewell. Eaton's first pupil was James Manning, the founder of Brown University. Other buildings of interest include the railroad station* (Railroad Pl.), built in 1876 and currently owned by the borough, which is working on plans for its future use, and the Second Empire–style Valley Inn (E. Broad St.).

Highfields* (Van Dyke Rd.), in the township, was the home of Charles and Anne Lindbergh when their young son was kidnapped (see Flemington). It now belongs to the state, which uses it as a home for boys.

There are many lovely places to walk in and about the township. The Cedar Ridge Trail (Van Dyke Rd. north of c 518) and the McBurney Woods Preserve (Mountain Rd. east of Runyons Mill Rd. in East Amwell) are both preservation projects of the Delaware & Raritan Greenway (609-924-4646). The former is a modest trail through an area that was a lake; bordering Stony Brook, the trail takes you through varied vegetation and wildlife. The McBurney Woods Preserve consists of 178 acres in the Sourland Mountains and forms part of a chain of woods unbroken for 60 miles. A two-mile trail takes

134 Hope, Hopewell

you through mature forest and along a field of wildflowers. If you continue east on Mountain Rd. and turn right on Rileyville Rd. (c 607) you will come to the Sourland Mountain Reservation (908-782-1158), a Hunterdon County preserve of some 200-plus hilly, wooded acres. The reservation is rich in forest birds and a good place to look for early spring wildflowers. Most of the woods are wet, but there are also some interesting rock formations to be seen. The park system hopes to have a system of marked trails in place by the end of 1998. Open for hiking and hunting.

At the western end of Hopewell Township, a battle rages to save Kuser Mountain from being destroyed by a traprock company or turned into housing developments. Some 300 acres have been protected, and there is hope that eventually the whole mountain can be saved and become Mercer County Park land. In the meantime, you can walk on the trails by entering at Pleasant Valley Open Spaces (Pleasant Valley–Harbourton Rd. c. 1 mi. east of the intersection with Trenton-Harbourton Rd., c 579; 609-989-6530).

Jamesburg Middlesex 5,294

522

Jamesburg's first settlers, Scots fleeing religious persecution, arrived in the late 17th century, and its first mill dates to 1734, but the town's period of greatest prosperity began 100 years later when the railroad came through. Jamesburg eventually had two railroad lines and three depots and became the commercial and

social center for the township and the surrounding agricultural area. This prosperity continued until after World War II.

Much of the town's growth can be attributed to James Buckelew, whose greatgrandfather had arrived in the area around 1715. In 1832 Buckelew purchased Lakeview* (203 Buckelew Ave.; 732-521-0068), originally a small 17th-century farmhouse overlooking the millpond (now Lake Manalapan), and enlarged it into a 23-room mansion with a colonnaded porch overlooking the lake.

Buckelew farmed some 4,000 acres (and was the first in the area to use marl on his land), supplied 700 mules for the Delaware and Raritan Canal, established the Freehold and Jamesburg Agricultural Railroad, and helped establish the First National Bank. Because an African American child was excluded from the existing school, Buckelew built another school, open to all, which, at the dedication ceremony was referred to as the James B. School; James B. eventually became Jamesburg. When President-elect Lincoln was in Trenton on his way to his inauguration, he rode in Buckelew's coach from the Clinton St. station to the capitol. The house, also known as Buckelew's Mansion, is now open as a house museum, and Lincoln's coach is one of the items on display. Among those who helped restore the mansion were students from the New Jersey Training School for Boys, a school built in 1867 as the New Jersey State Reform School on a large farm owned by Buckelew, which may have been the site of a mid-18th-century French and Indian War stockade. The museum has some period furnishings, items relating to local history, and a high school memento room. In one room the Jamesburg Historical Railroad Society has set up a model of Jamesburg at its industrial prime, 1900–1930, which includes all three of the town's turn-of-the-century railroad stations. Out back are a blacksmith's shop and a smokehouse, and the museum has a large collection of old farm implements and tools and anvils used by blacksmiths. In the front yard are some track from the Camden and Amboy Railroad and several anchoring stones. Open Sunday, 1–3; groups, other times, and guided tours by appointment.

The Fourteenth Regiment New Jersey Volunteers also has its headquarters in Lakeview, and on the annual Buckelew Day in August does a Civil War reenactment. The Buckelew birthday celebration includes crafts demonstrations, and the town also has a holiday festival in December.

Although Jamesburg is one of Middlesex County's more densely populated communities (more than 6,000 people in less than one square mile), it abuts a county park that is larger than the borough (675 acres). Thompson Park (732-521-1150) includes Lake Manalapan, where you can fish, boat, and skate; there are also athletic fields, hiking trails (including one accessible to the handi-capped), picnic areas, tennis courts, playgrounds, and a small zoo. Part of the park has been designated a bird sanctuary. Several horse and dog shows, as well as two concerts, take place in the summer.

Just west of Jamesburg is the Forsgate Country Club (Forsgate Dr.); each hole on the east course is modeled on a famous hole from a British course. South of the club is Rossmoor (Rossmoor Dr.), a retirement community built around a golf course. The land was once an early-20th-century estate and dairy farm; the clubhouse was formerly a residence.

East of Jamesburg, in Monroe Township (take Buckelew Rd., c 522, to Hoffman–Mounts Mill Rd., turn left and turn left again on Spotswood-Englishtown Rd., c 613; there are plenty of signs), is the Displayworld Stone Museum (476 Spotswood-Englishtown Rd., c 613; 732-521-2232). Part of a landscaping business, this picturesque (there are five waterfalls and a lake) and idiosyncratic collection of stones, including two tons of fluorescent rock, also contains exhibits on the past and present techniques of masonry. Open mid-March–December, weekdays, 8–4:30, Sunday, 10–4:30.

Jefferson Township Morris 17,825

NJ 15, C 699

Located in Jefferson Township, the northwesternmost township of Morris County, is the Mahlon Dickerson Reservation (Weldon Rd.; 973-326-7600). Dickerson, a Morris County native, served as governor of the state, as U.S. senator, and as secretary of the navy under Presidents Jackson and Van Buren. This large (3,200 acres)

county park contains the Saffin–Rock Rill Reservation; you can fish and skate on Saffin Pond. There are also facilities for camping and picnicking, as well as

hiking, riding, mountain-biking, and cross-country ski trails and a ball field. From Headley Overlook, 1,300 feet above sea level, you can see the surrounding area, including the northern end of Lake Hopatcong.

Jersey City Hudson 228,537

NJ TNPK EXITS 14A, B, C, US 1, 9, NJ 440

Jersey City, the state's second most populous city, has been the state's first in other ways: the site of the state's first permanent settlement (1660), the first place to be occupied by the enemy in the Revolution (1776). It was one of the first to declare itself a nuclear free zone, and it can boast a variety of other, perhaps less

significant, firsts: the first automobile tunnel under a river has one end in Jersey City; the first woman elected to the House of Representatives in the eastern United States and the first native-born American to fly a balloon in the continental United States came from Jersey City; the first professional heavyweight fight to produce \$1 million in gate receipts and the first mass production of a modern wood-and-graphite pencil took place in Jersey City.

Although there were sporadic settlements in the early years of the 17th century, disputes with the local Native Americans caused the early residents to leave, and it was not until 1660 that a permanent settlement, known as Bergen (or Bergan), was formed. You can still trace the outline of the original town square—the area bounded by Newkirk, Van Reypen, and Vroom sts. and Tuers Ave., surrounding Bergen Square, south of Journal Square. Alexander Hamilton saw the potential for developing Jersey City as a transportation center and formed an association similar to the one he had established for Paterson. I lis plans never materialized: he was killed in 1804; until 1834, New York asserted its right to control the Hudson to the low-water mark on the west bank, thus preventing Jersey City from developing its own waterfront; and the railroads came to own the association's waterfront land.

The city nevertheless developed as a transportation and manufacturing center, and some sense of its former prosperity can be seen in the abundance of extravagant architecture: there are any number of architecturally exuberant churches and public buildings to be seen in Jersey City. Like many of the state's other cities, Jersey City suffered an economic decline, but in the 1970s New Yorkers and others rediscovered it as a desirable place to live; many of the city's brownstones and row houses have been rehabilitated and many of the commercial buildings converted into condominiums; the process continues today. At the same time, developers have been working on ambitious plans for the waterfront. Although not all the grand schemes of the '80s have come to pass, the waterfront has totally changed. Like other rediscovered cities, Jersey City has become involved in the "cargo versus quiche" controversy, the commercial equivalent to the displacement of long-time residents in the gentrification of a neighborhood: many of the few shipping-related businesses that have managed to survive along the waterfront are being forced to relocate by the more glamorous developments.

Jefferson Township, Jersey City 137

There are many different neighborhoods to explore, and within many neighborhoods there are great contrasts between buildings in different states of renovation. The Paulus Hook historic district* is a 19th-century area that includes portions of York, Grand, Sussex, Morris, Essex, Greene, Washington, Warren, Henderson, and Van Vorst streets. It is bounded on the east by the Colgate Center, formerly the site of the Colgate factory. Colgate began manufacturing in Jersey City in 1847, and its unusual clock tower was long a landmark along the river; the clock now rises from ground level and is still visible from the river. Within Colgate Center is the state's tallest building (101 Hudson St.).

To the west of the Paulus Hook area is the Van Vorst Park historic district,* with both 19th- and 20th-century structures; it includes Jersey Ave. and Varick, Barrow, Grove, Wayne, Mercer, Montgomery, York, Bright, and Grand streets. The Hamilton Park historic district* includes a 19th-century residential square and 19th- and 20th-century buildings around Hamilton Park, Jersey Ave., and 6–10th streets. Just east of Hamilton Square is Manila Ave., once Grove St. but renamed in honor of Jersey City's large Filipino population.

Journal Square in the heart of the city boasts many striking buildings. Loew's Jersey Theater (54 Journal Sq.; 201-798-6055), an art deco theater, with a terra cotta facade and an ornate Spanish Baroque interior, was built in the late 1920s. It was one of the first theaters to be engineered expressly for the new talking pictures. Listed on the state register of historic buildings, it was rescued from demolition by concerned citizens and is now being renovated. The hope is that it can be reopened as a "combination of the Beacon Theater, Carnegie Hall, and Radio City" before the turn of the century. The Stanley Theater (2932 J. F. Kennedy Blvd.) is another art deco building, also listed on the state register of historic buildings. Built in 1928, it now belongs to the Jehovah's Witnesses (some of the classical statues have been removed); open for tours weekdays, 8:30-5. Potential visitors should ring the doorbell (groups larger than 30 should write the Watchtower Society, 25 Columbia Heights, Brooklyn, NY 11201, to set up an appointment). At 26 Journal Square is the Labor Bank Building, a 15-story office building with a marble lobby, molded ceiling designs, and ornamental frieze. Just north of Journal Square (Newark Ave. between Kennedy and Tonnelle) is an Indian enclave.

The William J. Brennan Court House* (Newark Ave. at Central), a large Beaux Arts building completed in 1910, dominates a city block. Inside are murals painted by Howard Pyle, F. D. Millet, Kenyon Cox, Charles Turner, and Edwin Howland Blashfield. Closed in 1966, the courthouse was rescued and restored; it now houses civil courts and the offices of the county executive. Open for self-guided tours weekdays, 9–4. The city hall (1896; Montgomery and Grove sts.), the post office building (Montgomery and Washington sts.), and the main library (1899; 472 Jersey Ave. at Montgomery) all testify to the size and former wealth of Jersey City. The Old Bergen Church* (the west side of Bergen Ave. at Highland Ave.) belongs to the oldest organized congregation west of the Hudson (it received its charter in 1660). The present building, which dates

138 Jersey City

from 1741 and was built with stones taken from earlier buildings, seems unusually sedate in the context of Jersey City's architectural exuberance—for example, directly across Bergen Ave. is the fanciful brickwork of St. Aedans.

On the top floor of the main library is the Jersey City Museum (201-547-4514), a small museum with three rooms devoted to changing exhibits. Works of new and emerging artists are featured as well as material relating to local history; an exhibit of works by students in the city's public schools is an annual event. Open Thursday–Saturday, 11:30–4:30; Wednesday, 11:30–8; closed on Saturday in the summer. If possible, use the stairs rather than the elevator to get to or from the museum; note the swinging gate that can close off upper floors. The museum expects to move into its own building, a remodeled 1920s commercial building at 350 Montgomery St., in 1999.

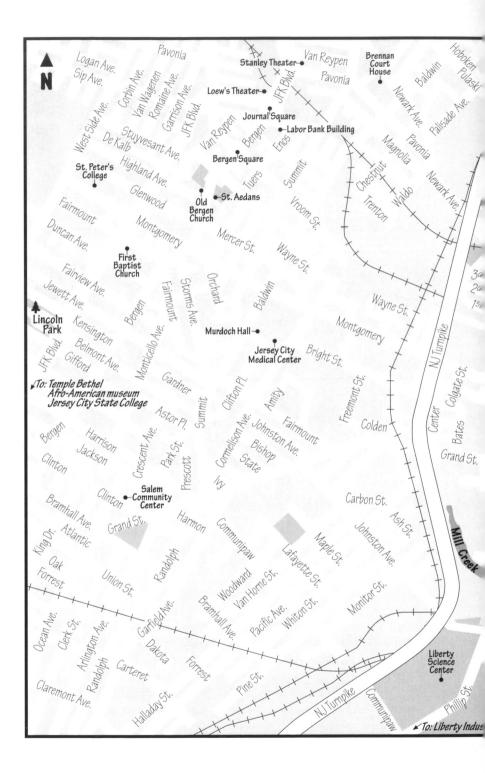

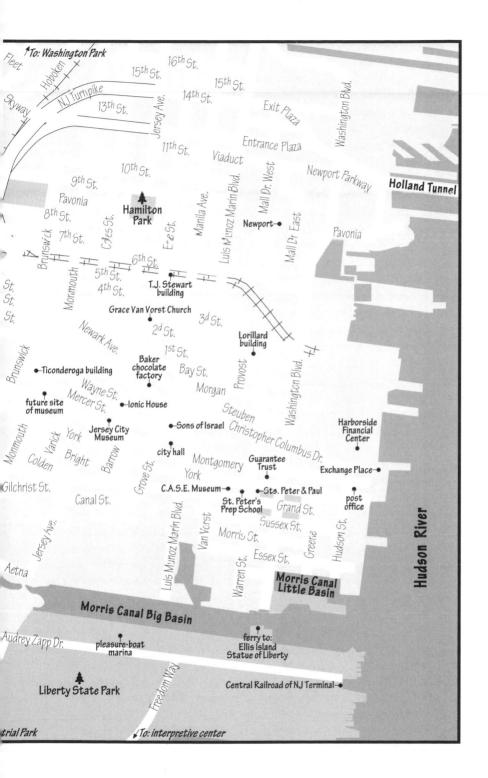

The Afro-American Historical and Cultural Museum (1841 J. F. Kennedy Blvd.; 201-547-5262) has a wide range of exhibits. The history of African Americans in New Jersey, particularly in relation to civil rights and the development of black churches, is one thread; also on display are musical instruments and dolls from the West Indies and Africa; a reconstructed 1930s kitchen; African sculpture; and busts of major black figures. Open Monday–Saturday, 10–5.

The C.A.S.E. Museum of Russian Contemporary Art in Exile (80 Grand St.; 20I-332-5200) is housed in a brownstone once used by the city (across the street from the Ukrainian National Center, also an interesting building, now condominiums). Run by the Committee for the Absorption of Soviet Emigrees, the museum features paintings by artists from former eastern-bloc countries living both here and in Europe. Open Friday and Saturday, 12–5, and by appointment.

At Jersey City State College (2039 J. F. Kennedy Blvd.; 201-200-2000), art exhibits can be seen at Artspace, the Courtney Gallery, and the Michael Gilligan Student Union Building Gallery. These feature contemporary works as well as annual student, faculty, and alumni shows. Open weekdays, 11–4; weekends and other times by appointment (201-200-3441). The college has been involved with running the Black Maria Film and Video Festival for many years; for information call 201-200-2043. Music, dance, and theater programs are also open to the public (201-200-3151), as are an annual lecture series (201-200-3426) and a variety of programs for children.

The Jersey City Medical Center* (Baldwin Ave. and Montgomery St.) is a large art deco complex built in the 1920s. The city removed some exterior ornamental grillwork, but the interiors, with their marble, terrazzo, and bronze elevators, remain. Murdoch Hall (114 Clifton Pl.), now a county office building, may be one of the most striking in the complex. Note also 79 Clifton Pl.; this house was a stop on the Underground Railroad.

Here are some other buildings you might want to look out for: near the Paulus Hook and Van Vorst districts are St. Peter's Preparatory School, which is over 100 years old; the New Jersey Guarantee Trust Company (Montgomery St.), a splendid late-19th-century extravaganza with the relief of a dog guarding the entrance, now converted to condominiums; Sts. Peter and Paul (near Grand St.); the Congregation of the Sons of Israel (Grove St.), with its lions; the 1888 building at 133 Grand St., with its decorative red tiles (the T. J. Stewart building at 88-92 Erie St. also dates from 1888 and has tiles produced by the Perth Amboy Terra Cotta Company); the Ionic House* (1835–40) at 83 Wayne St.; the Grace Van Vorst Church* (1850–53; 268 2d St.); the Salem Community Center (northwest corner of Clinton and Crescent aves.), formerly the home of the Jersey City Athletic Club (1886). On J. F. Kennedy Blvd. you will find the First Baptist Church (at Fairmount), a small stone castle; Temple Bethel (at Harrison); St. Peter's College (at Montgomery), from which Will Durant received a bachelor's and a master's degree; and Jersey City State College (at Audubon), founded in the late 1920s as a teachers' college. The former Lorillard snuff factory (111 1st St.), opened in 1870, has been converted to artists' studios (the city has become something of a mecca for area artists); the Dixon

Ticonderoga Company administrative office building (167 Wayne St.), a Romanesque Revival building from the 1890s, is now a condominium; Pohlmann's Hall* (154 Ogden Ave.), the Joseph Dixon Crucible Company complex, and the former Baker Chocolate factory (Barrow St.) have also been converted to housing. The Lembeck & Betz Eagle Brewing Co. district* (9th, 10th, and Henderson sts. and Manila Ave.) is where "the beer that made Milwaukee jealous" was brewed. You may also find your eye caught by many of the fire houses; in any case, this list only skims the surface of Jersey City's interesting buildings.

Liberty State Park (Morris Pesin Dr.; take exit 14B from the northern extension of the New Jersey Tnpk; Henderson St. and Johnston and Jersey aves. out of Jersey City; 201-915-3400) consists of over 1,100 acres with 21/2 miles of shoreline, land that in the early 1970s was an industrial wasteland. Opened in 1976, the park is a tribute to the perseverance of Morris Pesin. A Jersey City native who had fought to save the trees along the J. F. Kennedy Blvd. and to save the county courthouse from demolition, Pesin was appalled by how long it took to travel to the Statue of Liberty, which, like Ellis Island, is much closer to Jersey City than to New York City, and spearheaded the drive to create Liberty State Park. At the northern end of the park is the Central Railroad of New Jersey Terminal* (1889), a national landmark French chateau with neo-Romanesque details. Historically important because of its connection to Ellis Island (for some 8 million immigrants this was the first U.S. soil they set foot on), it now contains exhibits on the history of the area. In July and August there are concerts in the terminal on Sunday afternoon and Tuesday evening and historical lectures on Sunday afternoon; it is also used for special events. Because the building has no heating it is open only in the summer (daily, Memorial Dav–Labor Dav, 10–5). Group tours of the historic areas of the park can, however, be arranged throughout the year by calling 201-915-3411. Also at this site are a shed for 20 trains (1913–14) and a ferry slip. During the summer (Memorial Day-Labor Day) ferries run from here to Liberty and Ellis islands every half to three-quarters of an hour, 9:15-4:30; the rest of the year the schedule is reduced (call 201-435-9499). The Morris Canal basin (Jersey City formed one end of the Morris Canal) still exists at the northern end of the park; a 100-slip pleasure-boat marina (201-985-8000) has been constructed here.

An interpretive program, revolving around the park's salt marsh and mud flats, was instituted in 1985; the interpretive center (Freedom Way; 201-915-3409) is toward the southern end of the park just north of the Liberty Park Natural Area. Within the center are displays dealing with the natural history and environment of the area. The 60 acres of the natural area are predominantly salt marsh, one of the few remaining salt marshes along New York Bay. Since the Clean Water Act of 1972, the area has seen the gradual return of the wildlife driven away by the pollution of the river. The intertidal area serves as a natural nursery for fish; this is also a good area to see canvasback ducks. The interpretive center offers educational programs, and group tours may be arranged by calling 201-915-3409. There is a brochure for a self-guided tour of the nature walk. The interpretive center is open 9–4 daily July and August, Monday–Saturday the rest of the year, but it is always good to call ahead, as budget changes can affect staffing.

At the southern end of the park are picnic tables, a swimming pool, tennis courts, a boat-launching site, a display of the flags of all the states, and the Liberation Monument (designed by the sculptor Natan Rappaport). The park is open 6 A.M.–IO P.M. daily; the visitor center (Morris Pesin Dr.) is open 6 A.M.–6 P.M. in summer (Memorial Day–Labor Day) and 8–4 the rest of the year.

At the northwestern corner of the park is Liberty Science Center (251 Phillip St.; 201-200-1000), a four-story museum filled with interactive exhibits. Three of the floors are thematically organized: the lower floor is the invention floor, the second the health floor, and the third the environment floor. Live demonstrations take place daily, and traveling exhibits change frequently. The museum also includes the world's largest OMNIMAX theater. There is something here to interest people of almost any age, and the museum can be noisy when it is full. Views from the terrace are spectacular. Open Labor Day–March, Tuesday–Sunday, 9:30–5:30; April–Labor Day, daily, 9:30–5:30.

Lincoln Park is Hudson County's oldest and largest. (It is also one of the most popular: an estimated 25,000 people use it each summer weekend.) The principal entrance, on J. F. Kennedy Blvd. at Belmont Ave., is a formal plaza with a statue of Lincoln, designed by James Earle Fraser, who designed the buffalo nickel. The plaza is the highest point in the park and offers good views to the west. It is particularly lovely in spring when the bulbs and flowering shrubs are in bloom. Note also the Saint Aloysius complex north of the entrance and the fountain at the circle that ends the formal entrance (the fountain, requiring 365 tons of concrete, is said to be the world's largest concrete monument; it was finished in 1911). The plaza is particularly popular with mothers of young children. In the less formal parts of the park are athletic fields, a playground, a lake for sailing model boats, a driving range, and places to walk and drive. There are plans to develop the underused 100-odd acres between US I and the Hackensack River. Jersey City also shares Washington Park (North St. and Central Ave.) with Union City. This smaller park contains tennis courts and other athletic facilities, a children's playground, and an outdoor swimming pool.

Jersey City has continued to be important as a transportation center: the Holland Tunnel,* a national historic landmark, starts (or ends) here. Opened in 1927, the tunnel was taken over by the Port Authority of New York and New Jersey in 1931. It is named for its first chief engineer, Clifford M. Holland, who developed its giant ventilating system (the air is completely changed every 90 seconds) and more or less lived in the tunnel, dying in 1924 at the age of 41. When the ceiling was replaced in the mid-'80s, over 4 million blue and white tiles (weighing more than 1,200 tons) were needed. Over 15 million cars go eastbound through the tunnel each year. Jersey City is also a stop on the Path trains, which are used by roughly 45 million passengers each year, and weekday ferry service to New York City has been restored at Colgate pier near Exchange Place, weekend service from Liberty State Park.

Harborside Financial Center (north of Exchange Pl.) is an office complex with a mix of companies. Converted railroad warehouses dating from the late 1920s, these buildings were designed with ground floors strong enough to hold railroad cars and upper floors heavy enough to hold trucks; when the center first opened, its sales pitch was directed toward companies specializing in finance and trade, as the buildings were especially suited to mainframe computers.

North of Harborside on what were once Erie railroad yards is Newport, a large complex containing housing, office buildings, and the county's first mall. Another office building is under construction by the Lefrak Organization (Samuel Lefrak built more apartment units in New York City than any other private developer). Plans are also being pursued to develop public transportation to cope with the traffic generated by all the waterfront construction.

To the west of Newport is the Harismus Cove Historic District^{*} (Jersey Ave.; Bay, Cole, Erie, and 1–5th sts.; and Manila Ave.). This is one of the oldest communities in Jersey City, but most of the 400-plus buildings in the district are late-19th-century three-story brick Italianate row houses.

On the Hudson River side of the city a condominium complex, Society Hill (Society Hill Dr.), occupies the site of Roosevelt Stadium. Here, a year before he joined the Brooklyn Dodgers, Jackie Robinson, then on the Montreal Royals, became the first African American to play on a previously all-white team.

Within Liberty Industrial Park (just north of Morris Pesin Dr. in Liberty State Park) is the site of the Black Tom explosion, possibly the only successful act of sabotage in the United States in World War I. The Germans blew up an ammunition train, resulting in an explosion that was felt as far away as Connecticut and Maryland.

Kearny Hudson 34,874

NJ 17

An industrial town with a large Scots population—Robert Burns's birthday is still celebrated here each year—Kearny (pronounced car-knee) was settled in the 17th century. It is named for Philip Kearny, a one-armed American general who fought in five wars, including the Civil War, and was the first American to receive the

Legion d'honneur. A statue of Kearny, a replica of the Borglum statue in Military Park in Newark, was recently erected on Midland Ave. just west of Kearny Ave. in front of the main post office.

Kearny Marsh, a flood area in the midst of the Hackensack meadowlands that is owned by the town, contains one of the largest breeding populations of American coots and pied-billed grebes in New Jersey. It is also one of the few nesting sites in New Jersey for the ruddy duck, and one European species of ladybug is reputed to be so abundant here that it is captured for use by gardeners in less-fortunate areas. Kearny is also the home of the world's largest manufacturer of aluminum baseball bats.

The Kearny Museum (318 Kearny Ave.; 201-997-6911, 201-991-2235), housed

on the second floor of the library, features displays relating to local history, including Kearny memorabilia, period clothes, and household items. Open mid-September–mid-June, Wednesday and Thursday, 1–4, Saturday, 10–12:30.

Keyport Monmouth 7,586

NJ 35, 36

Situated on an inlet of Raritan Bay, Keyport was once known for its oyster and shipbuilding industries. (Oysters were being planted in nearby creeks as far back as the early 18th century, and the *River Queen*, built at the Terry shipyards where Terry Park now stands, was active in the Civil War.) Some shipbuilding continues, and

there are signs that the oyster industry may have turned the corner, but recreational fishing and boating are more important now. Along American Legion Dr. there are lovely views of the waterfront (which in 1889 Gustav Kobbé described as "a very animated scene"), a fishing dock, a bulkhead used for fishing and crabbing, and a launching ramp. Fred and Adele Astaire made their debut in Keyport, P. T. Barnum had a house here (still to be seen on Main St.), and the old opera house, which once attracted leading singers, still stands.

At the corner of American Legion Dr. and Broad St. is the Steamboat Dock Museum (732-739-6390, 732-264-2102, 732-264-7822, 732-264-6119), devoted to Keyport history. Located in a building once used by the Keansburg Steamboat Co. as a machine shop and winter quarters for the crew, the museum features a variety of exhibits. Among them are a working printing exhibit; artifacts, including a partially refurbished wing section, from the Aeromarine Corporation, one of the country's first aircraft factories, once located in Keyport; 19thcentury clothing; exhibits on the oyster and shipbuilding industries; and many other items related to Keyport's early history. Open June–September, Sunday, 1–4, Monday, 10–12; groups and other times by appointment. While in Keyport note also St. Mary's Church (E. Front St.), built in the late 1870s.

In a sea captain's house from the 1860s is Master's Octave (80 W. Front St.; 732-264-2445), an art gallery with informal exhibits. Open Saturday and holidays, 1–4, or by appointment.

Kingston Middlesex [South Brunswick Township]

3

NJ 27, C 522

Settled early in the 18th century, Kingston was a stop on the stage route between New York and Philadelphia. George Washington paused in Kingston after the Battle of Princeton, making the decision not to go on to New Brunswick and continue the battle but to retire to winter quarters instead. The Kingston Village

Historic District* includes portions of NJ 27, Laurel and Euclid aves., Church, Union, and Academy sts., Shaw Dr., Sycamore Pl., and Kingston–Rocky Hill

and Heathcote Brook rds.; the buildings date from the 1730s to the 1930s. Many of the houses lining the attractive main street (Lincoln Highway, NJ 27) date from the 19th century (look for the beehives on the porch roof on the north side of 27). Cook Natural Area (Heathcote Brook Rd.; 732-873-3050), 22 acres of freshwater marsh habitat, is a good place to hike.

The Kingston Mill historic district* includes the area where 27 crosses the Millstone River and the Delaware and Raritan Canal.* The present mill (which is actually in Princeton Township) was built in 1888 (and continued in operation until 1942), but there has been a mill on this site since 1755. The stone bridge dates to 1798. The dam, which backs up the river to form Lake Carnegie, was created in 1911, financed by a gift from Andrew Carnegie. It is used for Princeton University and national crew races and by local sailors and windsurfers.

At this point there is access to the Delaware and Raritan Canal State Park (732-873-3050), a 67-mile linear park that follows the Delaware and Raritan main canal and feeder line through central New Jersey. Opened in 1834, the canal went from Bordentown to Trenton to New Brunswick, the feeder from Raven Rock to Trenton, thereby linking Philadelphia and New York. One of the world's busiest waterways, the canal in its best year (1871) carried more tonnage, much of it coal, than the much longer Erie Canal ever did. Profits began to fall toward the end of the century, and the canal was officially closed in the 1930s. Some parts have been filled in (one mile under US I in Trenton and another under NI 18 in New Brunswick; six miles between Trenton and Bordentown were lost in the 1930s), but unlike the Morris Canal, most of the Delaware and Raritan Canal still exists. It provides water for several communities in central New Jersey, and its towpath is much beloved of boaters, hikers, joggers, bicycle and horseback riders, bird-watchers, cross-country skiers, and those who like to fish. In fact, you can walk, ride a horse or bicycle, and canoe from the US I crossing in Lawrence Township all the way to New Brunswick; you can canoe from the west end of Trenton to Bull's Island and walk or ride a bicycle from the Battle Monument in Trenton to north of Frenchtown (part of this walk is on an old railroad right-of-way). The trail system has been designated a National Recreation Trail. You are welcome to picnic informally along the path, but more formal picnic areas with tables or fireplaces can be found at Bull's Island (across from Raven Rock, about 4 miles upriver of Stockton), Lambertville, Titusville (at Washington Crossing State Park), Trenton (in Cadwalader Park), Princeton (Basin Park off Alexander St.), Griggstown, and Blackwells Mills (about 3 miles north of Griggstown). Many of the historic buildings along the canal, which include locktenders' houses and a muledrivers' barracks, have been or are being restored (see Griggstown, Lawrenceville, Stockton). For most of its length the park is narrow (its total area is only five square miles), but at Bull's Island it widens out, and you can camp on the island. Future plans for the park include instituting a canal-boat ride.

At the Hasty Acres Farm (121 Laurel Ave.; 609-921-8389), the Heads Up Special Riders program gives lessons to handicapped riders once a week, weather permitting. You are welcome to observe a lesson if you call first.

Kinnelon Morris 8,470

C 618

In Kinnelon, a rapidly growing borough in the northern section of Morris County (just south of NJ 23), is Silas Condict Park (Kinnelon Rd.; 973-326-7600), a 265-acre county park with scenic overlooks, hiking trails, picnic sites, a playing field, and a seven-acre lake. Silas Condict was a Morris County farmer and surveyor who was a

member of the Continental Congress and was elected to the New Jersey Assembly eight times, serving as its speaker in 1792–94 and 1797. The park has facilities for fishing and boating, and in the winter you can skate, ice-fish, and cross-country ski. The casino at the lake, a 1920s stone building recently restored and available for private functions, once housed a large still and hidden storerooms where, it is said, up to 16,000 gallons of illegal liquor could be kept.

Also in Kinnelon is Pyramid Mountain Historic Area (Boonton Ave.; 973-334-3130, 973-326-7600). This extraordinary geological area, threatened until quite recently with development, includes land on Pyramid, Stony Brook, Turkey, and Rock Pear mountains. These 2,000 acres contain a rich diversity of flora and fauna—some 400 plant species, more than 100 bird species, 20 mammals. The extraordinary glacial rock formations, which include Tripod Rock, a large boulder somehow perched on three smaller boulders, and Bear Rock, one of the largest glacial erratics in the state, were once sacred to the Lenape. There are breathtaking views, and the many miles of hiking trails are beautiful, though some can be rugged. You can pick up trail maps at the visitor center, which has a small exhibit of local and historical artifacts and photographs. Open Friday–Sunday, 10–4:30.

Lakehurst Ocean 3,078

NJ 37, 70, C 547

Lakehurst has the misfortune of being primarily known to the rest of the world as the site of the naval station where the dirigible *Hindenburg* burned in 1937. The station specialized in lighter-thanair ships, which had many advantages over today's airplanes, but the *Hindenburg* disaster put an end to serious consideration of

dirigibles. At the Naval Air Engineering Station (732-323-2620), the visitor center has a small display connected with the station's past and present. You can also view the exterior of Hangar No. 1 (c. 1921), now a national historic landmark, and visit the field where the *Hindenburg* crashed; a small monument is on the site. Open weekdays, 8–4; to arrange a tour you must apply in writing.

Lakehurst was settled in the 18th century; its iron forge supplied cannonballs to the Continental army. In the mid-19th century it became an industrial center, with a rope factory and railroad shops and a roundhouse; in the late 19th and early 20th centuries it was known as a winter resort. The rope factory burned, and most of the railroad buildings and the Pine Tree Inn, a large resort building, were demolished in the 1940s, but some of the older buildings remain.

At the former St. John's Roman Catholic Church, the oldest Catholic church in the county (c. 1874), which was built by Irish railway workers, is the historical society's museum (300 Center St.; 732-657-8864). Displays include memorabilia relating to the railroad, the fire department, and airships (including charred remains of the *Hindenburg*). Open Wednesday and Sunday, 12–3; groups by appointment.

The Ocean County Parks Department arranges tours of Lakehurst, which include the naval station; call 609-971-3085 for information.

Lakewood Ocean 45,048

US 9, NJ 88, C 526, 528, 547

One of the first areas in the United States to be developed as a winter health resort, Lakewood reaped from its fresh pine air and proximity to New York and Philadelphia a long reign as a leading resort. Described in the 1880s as "a little winter paradise created by good taste and sound judgment backed by the necessary capital,"

its golden period lasted from the 1880s to the 1930s, and for most of those years the socially prominent flocked to the hotels and estates of this former mill and iron town situated on the northern edges of the Pinelands.

The abundant forests had drawn sawmills in the late 18th century. The discovery that the soil was rich in iron led to the establishment in the early 19th century of ironworks, first by Jesse Richards, whose family was involved in the Batsto ironworks (see Hammonton), and then in 1832 by Joseph W. Brick. First called Three Partners Mill, then Washington's Furnace, then Bergen Iron Works, on Brick's death the town was renamed Bricksburg in his honor.

The discovery in the 1860s of hard coal close to iron deposits in Pennsylvania put an end to the Pinelands' iron industry, but by then Lakewood had begun to build hotels. When in 1879 two New York stockbrokers bought 19,000 acres of land, Lakewood's career as a resort took off. In 1880 the town's name was changed from Bricksburg to Lakewood, but Brick's family is still memorialized in the names of the two lakes: Carasaljo (for Brick's three daughters, Caroline, Sally, and Josephine) and Manetta (for his wife).

Many of the hotels were large and lavish, akin to Old World alpine hotels. The Lakewood, for example, covered 14 acres and was used by the federal government as a hospital during World War I. (It was also for a time the winter headquarters of Tammany Hall.) The Laurel House, built in 1880, counted among its guests the Goulds, the Rockefellers, the Vanderbilts, the Astors, the Claflins; Rudyard Kipling and Oliver Wendell Holmes were frequent visitors. Emma Calvé and Mark Twain spent time in Lakewood; Grover Cleveland built a cottage in town; the Goulds, Rockefellers, and Claflins, among others, built large estates. By the end of World War I, Lakewood had over 100 hotels.

The Depression, the automobile, and inexpensive airline travel combined

to end Lakewood's golden years. World War II brought some prosperity, for the town served as a center for nearby military camps. There was a considerable migration of people from the city, and an influx of refugees from eastern and central Europe (including Kalmuks, who built a Chinese temple in nearby Howell Township). The refugees built up an egg-and-poultry business; for many years Lakewood was a leading egg center.

The egg-and-poultry business has also declined, and many of Lakewood's citizens are now commuters. The town fathers have been successful in attracting light industry, and the town is home to several educational establishments, among them Georgian Court College (see below) and the internationally known Beth Medrash Govoha of America (Forest Ave.), a yeshiva founded in 1943 by Rabbi Aaron Kotler, who, with a few students, had arrived in Lakewood the year before as a refugee from Poland. After World War II there was a boom in building: housing developments, particularly retirement communities, sprang up, perhaps attracted by some of the same features that brought vacationers, and now a significant portion of Lakewood's citizens are retired. The Orthodox Jewish population has also increased dramatically—by some estimates it now makes up 40 percent of the population.

The grand old hotels are gone—some burned, others were replaced by motels—but it is still possible to get some idea of what Lakewood must once have been like. One way is to drive around Lake Carasaljo. The area occupied by the Laurel in the Pines (S. Lake Dr.), for example, is now occupied by condominiums, but the scale of the hotel is apparent from that of the condos. Note also the Georgian Court College Music Center (Sixth St. and Lakewood Ave.) and the Castle (Forest Ave.), once a house, which has been converted to apartments. The Strand Theatre* (400 Clifton Ave.; 732-367-9595), now the Ocean County Center for the Arts and a national historic landmark, dates from the early 1920s and the heyday of art deco theaters. Pearl Bailey was at its reopening in 1983. Its renovation and the new town plaza at Clifton Ave. and Third St. are part of a program to improve the downtown area and restore it to a late-19th-century appearance.

The best way to recapture Lakewood's past, though, is to visit Georgian Court College* (Lakewood Ave. and Ninth St.). The college is run by the Sisters of Mercy, who, having outgrown their quarters in Plainfield, in 1924 purchased the estate of George Jay Gould (a son of Jay Gould). The sisters have added buildings, and in 1950 they sold some 30 acres along the road, but what they have managed to preserve is remarkable. Reservations are necessary to tour the college; for an appointment, call 732-364-2200. Allow at least an hour.

Four of the estate's original buildings remain: the mansion, the stable, the casino, and the small building now used as the chaplain's house. (In addition, Hamilton House, the administration building, which is off the campus proper, occupies a house Gould built for his son.) Started in 1898, the entire estate, grounds and buildings alike, was designed by Bruce Price, the architect of Tuxedo Park and Château Frontenac. The mansion, built with an extraordinary attention to detail, is an imposing reflection of the styles and characters of

several types of European country houses. The casino was the Goulds' recreation building and boasted an indoor polo field, a swimming pool, a bowling alley, and squash and tennis courts. The polo field has been converted to a gymnasium that is also used as an auditorium, but the students still bowl in the 1899 bowling alley and swim in the 1899 pool, with its marble diving platform. The stable area has been converted into a dining room and offices.

Included on the grounds are an Italian garden, a sunken garden, and a lovely Japanese tea garden. The statuary and the fountains are noteworthy; unfortunately the fountains can only be turned on for special occasions.

Other old estates have been preserved in parks. Ocean County Park* (Ocean Ave., NJ 88, at the east end of town; 732-506-9090) was formerly the John D. Rockefeller estate. Most of the buildings are gone, but included in its 323

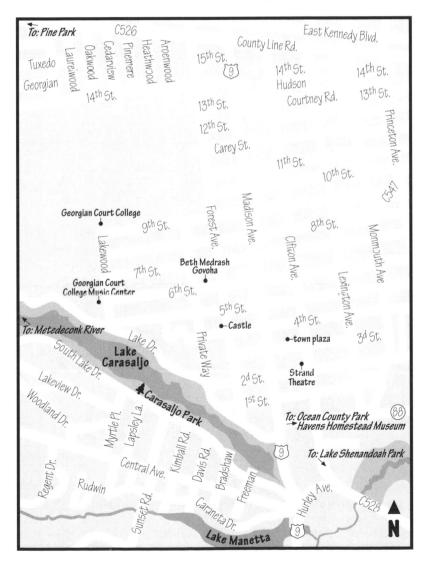

acres are magnificent stands of trees planted by the Rockefellers. The park has facilities for hiking, swimming, tennis, fishing, cross-country skiing, skating, games, and picnics.

Pine Park, a municipal park at the west end of town (500 Country Club Dr.; take County Line Rd., C 526; 732-367-6737), is on the site of the Claflin estate, once the Newman School. Kuser Hall now houses administrative offices, but most of the buildings are not being used.

Also in Lakewood is Lake Shenandoah Park (Clover St.; 732-506-9090), more than 200 acres with hiking trails, a field-sports complex, and facilities for picnicking and fishing. Fishing is also possible in the Metedeconk River (in Carasaljo Park) and in both Lake Manetta and Lake Carasaljo.

East of Lakewood (take NJ 88 to NJ 70 and turn left on Herbertsville Rd.; continue until you cross Sawmill Creek) is the Havens Homestead Museum (521 Herbertsville Rd.; 732-785-2500). The Brick Township Historical Society is restoring this building, the oldest part of which is pre-1820, to a house museum that will reflect life in the area in the mid-19th century. The house is open by appointment, but regular hours will be established eventually.

Lambertville Hunterdon 3,927

NJ 29, 179, C 518

One of Hunterdon County's oldest communities and its only city (Flemington, the county seat, which in 1990 was a little larger, is a borough), Lambertville has seen its fortunes wax and wane. Once a thriving industrial town, it has become a magnet for artists, restaurateurs, and those interested in historic renovation.

Situated on the banks of the Delaware River directly across from New Hope, Pennsylvania, Lambertville prospered because of its location. It began as a ferry town; the arrival of the Delaware and Raritan Canal in the 1830s and the Belvidere and Delaware Railroad in the 1850s helped turn it into a flourishing regional industrial and commercial center. Settled in 1705 by John Holcombe, who managed to make sure that the main road from Philadelphia to New York City passed through his land, the town took the name of Coryell's Ferry after Emmanuel Coryell established his ferry service. In 1814 the name was changed to Lambertville when U.S. Senator John Lambert set his nephew up as postmaster. That same year saw the ferry replaced by a wooden bridge; its masonry piers still support today's bridge, built in 1904. (Under that bridge nests a large colony of cliff swallows, an endangered species. When the nests had to be removed so that the bridge could be repaired, artificial nests were supplied for the birds.)

George Washington twice (July 1777 and June 1778) made his headquarters in Coryell's Ferry, staying both times at the mid-18th-century Richard Holcombe house (NJ 29, north of the center). At least two other presidents have visited Lambertville: Andrew Johnson and Ulysses S. Grant were both guests at the Lambertville House* (32 Bridge St.), built by Senator Lambert in 1812. Closed for some years, it was recently restored and reopened in the early summer of 1997.

With ready waterpower at Wells Falls, gristmills, paper mills, cotton mills, and lumber mills were established. Other industrial enterprises included a railroad machine shop, rubber plants, ironworks, and a sausage factory. The population peaked (at 5,100) in the early years of the 20th century, and there has been little new construction since then (in 1985 a new hotel was built along the river). Now the older buildings are being renovated and used for new purposes: the sausage factory houses restaurants and art galleries; the Pennsylvania Railroad station has been restored and converted to a restaurant; old warehouse buildings serve as artists' studios; a private home, which had been converted to a church, has been converted to an art gallery; former mansions have become bed-and-breakfasts. In the factory where Trenton oyster crackers

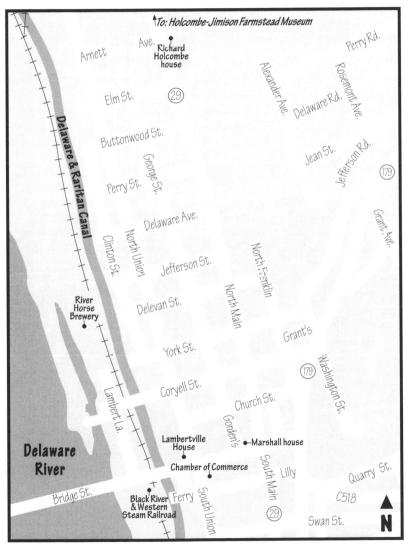

Lambertville 153

were once made, the River Horse Brewery (80 Lambert La.; 609-397-7776) brews, kegs, and bottles beer. Open for tours daily, 10:30–5.

Another part of Lambertville's past that is reviving is the shad industry. In 1896 some 19 million pounds of shad were caught in the Delaware River and Bay; by the 1960s none were to be found in the river. Although only one commercial shad fisherman remains in business in the nontidal parts of the Delaware (established in the 1880s, this family business is now run by the fourth generation), enough fish have returned to the cleaned-up Delaware that Lambertville in 1981 decided to celebrate the rebirth of an old industry and held its first annual shad festival. In 1995 the event attracted some 30,000 visitors. Look for the festival in late April, early May.

Lambertville was the home of James Wilson Marshall, who set off the 1849 Gold Rush, called by some the largest migration in U.S. history, when he discovered gold at Sutter's Mill in California in 1848. His house* (62 Bridge St.; 609-397-0770), built in 1816 by his father, is operated as a museum by the Lambertville Historical Society. Open some weekends from the end of April through October, but since the hours vary, it is necessary to call first and check the message on the telephone. The society also sponsors a juried art show each winter and will arrange guided walking tours of the town.

Lambertville's historic district* includes the area around NJ 29 (Main St.)

and NJ 179. Some of the remnants of Lambertville's importance as a transportation center now serve recreational purposes. There is access to the Delaware and Raritan Canal* at Lambertville, and the Black River & Western Steam Railroad (908-782-6622) runs to Ringoes and Flemington on Sundays, May– October, and on Saturday evening (with a 2½-hour stay), June–Labor Day. Brochures for a self-guided walking tour are available at the Chamber of Commerce (4 S. Union St.; 908-397-0055) and at various businesses around town.

North of town on NJ 29 is the Holcombe-Jimison Farmstead Museum (609-397-2752, 609-397-1810), dedicated to depicting Hunterdon County rural life in the past. There is an early-18th-century house on the property, and in the bank barn, which probably also dates from the early 18th century, is a large collection of agricultural tools and equipment (both hand- and machine-made), items used for spinning and weaving, and items used in the kitchen. On display on the second floor of the barn is a large collection of pieces, including plows, stoves, and corn shellers, made at Hiram Deats's foundry. Deats was a wealthy late-18th-century Hunterdon County foundryman who had forges at Stockton and Pittstown. A blacksmith works on the property; there is a woodworking shop in the carriage house; and a printing shop, a country doctor's office, and a post office. Open Sunday, May–October, 1–4; groups and other times by appointment. Admission charged.

LAMBERTVILLE

Laurel Springs Camden 2,341

US 30

This densely populated small borough is perhaps best known because it is where Walt Whitman spent his summers between 1876 and 1881. Indeed, according to one legend, the borough was formed (in 1893) because some of its citizens decided that their connection to Whitman was a marketable commodity. The

Whitman-Stafford Farmhouse (315 Maple Ave.; 609-784-1105), an 18th- and 19thcentury farmhouse where Whitman stayed, has been restored and is furnished with pieces from Whitman's time. Exhibits include New Jersey glass, local photographs, tools, and old toys, and the South Jersey Organic Gardeners' Club maintains an attractive herb garden. In July and August concerts are given regularly on Wednesday evening, and a special event is scheduled for each March (every other year it is a quilting show). Open by appointment.

Lawrenceville Mercer [Lawrence Township]

US 206, C 546

First settled in 1660 in an area that had been a Native American camp and known until 1816 as Maidenhead, Lawrenceville is perhaps familiar today primarily because it is the home of the Lawrenceville School, one of the country's best-known independent preparatory schools. Much of the school and the town

directly across from it on Main St., once the Kings Highway and now part of us 206, form Lawrence Township's historic district,* a national historic district. (The school itself has been designated a national historic landmark.) For two miles along both sides of 206, from the southwest corner of Franklin Corner Rd. (c 546) to just north of Carter Rd., are well-preserved structures from the 18th and 19th centuries. One of the oldest houses, Old Brick (1706), is on the east side of the road in the school's golf course. Wayside (the school side of Main St. opposite Phillips Ave.) is perhaps some 30-40 years older and was once a tavern. The Presbyterian Church (Main St. north of Gordon St.) dates to 1764, although it was enlarged and altered in the mid-19th century. The 1815 Richard Montgomery Green house (2549 Main St.) was built from stones from the nearby Cherry Grove quarry. Lord Cornwallis was quartered in Lawrenceville in 1776 (and apparently recorded in his journal later that "one night in Maidenhead was more than enough"). On 2 January 1777, Colonel Edward Hand stalled Cornwallis at Lawrence Rd. (US 206) near Darrah La., thereby preventing Cornwallis from reaching Trenton before dark and thus giving George Washington his chance to escape to Princeton. This event is reenacted every January.

In 1810 the Reverend Isaac Van Arsdale Brown of the Presbyterian church founded the Academy of Maidenhead; Brown was also a leader in the move to change the town's name, "for reasons of delicacy," from Maidenhead to Lawrenceville in honor of the 1812 naval hero, Captain James Lawrence, of "Don't give up the ship" fame (see Burlington). Brown was a victim of the silkworm craze (also see Burlington), and although his house on Main St. was torn down in the 1940s to make room for the post office, some of the mulberry trees he planted remain. Much of the present appearance of the school dates from the 1880s, when a legacy from one of the original graduates made it possible to convert the academy into a boarding school (the trustees looked to the best schools of England for inspiration). Frederick Law Olmsted drew up the overall plan (which included planting more than 300 species of trees and shrubs), and the circle, with its nine Richardsonian buildings, dates from that expansion. Thornton Wilder taught at the school in the 1920s and wrote *The Bridge of San Luis Rey* during his years there. In 1987, the school became coeducational. In the summer, the Opera Festival of New Jersey (609-936-1505) presents its season at the school's Kirby Arts Center.

The township, which celebrated its tricentennial in 1997, is expanding rapidly, attracting corporate headquarters and research facilities. Long established in the area is the world-famous Educational Testing Service (entrances on Rosedale and Carter rds.; 609-921-9000), best known for its standardized college-admission tests. (Although ETS has a Princeton address, its campus actually lies within Lawrence Township.) There are art exhibits in Lounge B of Conant Hall (open weekdays, 8:30–4:30) and in the Henry T. Chauncy Conference Center (open daily, 9–9). Shows change every six to eight weeks.

Southwest of ETS (take Rosedale Rd. to Carter Rd., turn left, and take the first right) is Terhune Orchards (330 Cold Soil Rd.; 609-924-2310), the first farm in Lawrence Township to enter the state and county farmland preservation programs. The friendly farm animals make this a favorite spot for families with children, and there is a mile-long farm trail that wanders through a meadow and along a pond. Terhune's sponsors three special events: a kite day in May, an apple festival in September, and a Halloween party in October. Open daily, 9–6, though weekend hours may be shortened in the depths of the winter.

Among the more striking headquarters buildings are those of Lenox (US 206 south of the village) and Bristol-Myers Squibb (US 206, c. 2 miles north of the village; 609-252-6275). At Bristol-Myers Squibb there is an art gallery with exhibits that change every six to eight weeks. There is also a permanent exhibit on the history of the company. Open weekdays, 9–5; Thursday evening until 7; weekends and holidays, 1–5. Like many other corporations with ponds on their lawns, Bristol-Myers Squibb has been plagued by a superfluity of Canada geese (some 60,000 Canada geese are year-round residents). The company's attempt to scare off the geese by establishing live swans on the property apparently failed.

Another art gallery open to the public is in the Rider University Student Center (US 206; 609-896-5325); exhibits here feature professional artists and students and change roughly every two months. Open Monday–Thursday, 1– 10; Friday–Sunday, 1–5. Rider University developed out of Trenton Business College, founded in Trenton in 1865. Its present campus dates from 1965. On Lawrence Station Rd. (take 546 east from Lawrenceville past US I and I 295) is the 50-acre John Dempster fire service training center for Mercer County's 24 volunteer fire departments. Most responsible for the center's surreal look is the concrete tower built to resemble a high-rise apartment building. At the center firefighters can also gain experience with chemical fires and simulated airplane crashes and house fires. The water used in the exercises is recycled.

The Port Mercer Canal house (Quaker Bridge Rd. at Quaker and Province Line rds.), operated as a house museum by the Lawrence Historical Society, dates to the 1830s (the kitchen was added later in the 19th century). Run as a house museum by the Lawrence Historical Society, the building was the first bridgetender's house along the Delaware and Raritan Canal to be completely restored. Also on the property is a pre–Civil War outhouse, moved from Dutch Neck in the 1990s. The society holds an annual Christmas open house and crafts sale, and the house is also open on other special occasions. Tours by appointment (call 609-896-9181).

The Baker-Brearley House* (Meadow Rd. off the Princeton Pike), was built in 1761 from bricks brought from England; in the cellar an 18 x 12 inch oak timber supports the first floor. Once the home of John Brearley, the house is now owned by the township. There are plans to restore the house and turn the surrounding 40 acres, which border the Delaware and Raritan Canal and the Shipetauken Creek, into a passive park.

Lincroft Monmouth [Middletown Township]

GARDEN STATE PKWY EXIT 109, C 520

The village of Lincroft dates back to the late 17th century. From 1901 to 1932 it was the site of Harry Payne Whitney's racing stable, where the first filly to win the Kentucky Derby was foaled and trained. The Brookdale Breeding and Stock Farm, where Whitney kept his horses, dated to the late 1880s; in the 1890s it became the

property of William Payne Thompson, who built a mansion on the farm and founded the Monmouth Park Jockey Club. After 1932 the facilities (which included an indoor track) were leased by independent trainers. When Geraldine Livingston Thompson, Thompson's daughter-in-law died, the 700acre estate was put to a variety of uses. On this land you will now find Thompson Park, Brookdale Community College, the Lincroft Elementary School, and the Monmouth Museum and Cultural Center.

The Thompson mansion (1893), now in Thompson Park (C 520, Newman Springs Rd.; 732-842-4000), houses a visitor center. The exhibit area shows the work of local artists and features painting and photography shows, which change every four to six weeks. Open weekdays, 10–4; weekends, 10–2. There is summer theater in a former barn, and one of the horse tracks is now used as a jogging track; there are also athletic fields, a fitness trail, tennis courts, pottery and ceramics studios, and a formal rose garden.

The Monmouth Museum and Cultural Center (Newman Springs Rd.;

732-747-2266) is located on the Brookdale Community College campus (use parking lots 1 and 2). The small museum contains an attractive gallery, with shows that change four or five times a year, and the Becker Children's Wing, with a large hands-on exhibit that changes every two years. Until September 1998 this wing will deal with the change in culture from the Lenape to the urban age. Open Tuesday– Saturday, 10–4:30; Sunday, 1–5. On school days the children's wing is open to the public 2–4:30. Tours by appointment. Admission charge for nonmembers.

The college's performing arts center is in the same part of the campus; dance, music, theater, and children's series are presented there. During reconstruction in 1997–98, performances may be relocated. Box office (732-842-3335) open weekdays, 10–4. Phalanx Rd., which cuts through the campus, takes its name from the North American Phalanx, a mid-19th-century Fourierinspired experiment in communal living. The community, built on over 600 acres, was founded in 1843 and lasted until 1855. Its last remaining building burned in the 1970s. Albert Brisbane, the father of the Hearst writer and editor Arthur Brisbane and one of the prime movers in the colony, interested Horace Greeley (the journalist and political leader, perhaps best remembered for having told a young clergyman, "Go west, young man, go west") in the project, and Greeley wrote a regular column about it in the *New York Tribune*. Alexander Woolcott, the man of letters and model for Sheridan Whiteside in *The Man Who Came to Dinner*, was born in the phalanx.

Little Silver Monmouth 5,721

C 520

Settled in the late 1660s, Little Silver was apparently named for Silverton, the Rhode Island estate of a Mr. Parker, the father of two of the town's founders (Silverton itself may have been named after the town of Little Silver in England). Descendants of these Parkers lived at the 17th- and 18th-century Parker Homestead (235

Rumson Rd.), listed in the state register of historic places, until 1995. The last Parker deeded the house and several acres to the borough, which is working on a plan to open it to the public as a small working farm, to be known as the Parker Homestead 1665.

In the late 1800s a steamboat dock was built, adding vacationers to the farmers, fishermen, and nurserymen, who until then made up most of Little Silver's population. The Post Office Museum (480 Prospect Ave.; 732-842-2400, 732-741-3137) is located in Little Silver's first post office building (1875), and the original post office has been re-created in the front of the museum. There are other exhibits of historical interest, and the museum is used for lectures and other community activities. Open by appointment and in conjunction with town events, like parades or Sunday evening concerts in the summer. Other buildings of interest in town include the Embury United Methodist Church (1869; 25 Church St.), St. John's Episcopal Church* (1876; Point Rd.), and the railroad station* (1890; Sycamore and Branch aves.).

Livingston Essex 26,609

NJ 10, C 508, 527

Livingston is named for William Livingston, New Jersey's first governor after the Revolution. Settled early in the 18th century, the village for a time supported a considerable shoe industry, supplying many of what shoes the revolutionary army did wear (these shoes, incidentally, fit either foot). One of Livingston's

remaining 18th-century houses, the Force Homestead (366 S. Livingston Ave.; 973-535-4378), is maintained as a museum by the Livingston Historical Society. The house dates from 1745, with later-18th-century additions, and contains, among other attractions, a buttery, a museum room, and an authentically furnished lower kitchen. Among the Victorian pieces on display is a clothes rack that belonged to General George McClellan, Civil War general, governor of New Jersey (1878–81), and inventor of the notorious McClellan army saddle. Also on the property is a barn museum containing old tools and farm implements and the Condit family cookhouse, which was moved from the Ira Condit farm where the Livingston Mall now stands and is probably one of the oldest buildings in Livingston. Open October–November and April–June, 2d Sunday, 2–4. Tours by appointment (call Helen Shumsky at 973-992-3017).

Livingston is also home to Newark Academy (91 S. Orange Ave.), the state's second-oldest independent day school (founded in 1774), which moved to Livingston in the 1960s. The New Jersey architects Bernard and Howard Grad and former U.S. Treasury Secretary William Simon are among its graduates.

Livingston is the hometown of former Governor Thomas Kean, a descendant of Governor Livingston. On the family estate you will now find a housing development.

On the site of a former regional missile command center in the heart of the Watchung Mountains is Riker Hill Art Park (take Eisenhower to Beaufort and watch for signs; 973-992-8806), named for a family that lived in the area before the Revolution. The county leases space in the habitable buildings to working artists, occasional special events are open to the public, and plans for the park have included establishing a gallery in which the work being produced in these studios can be exhibited. There are also trails in the park, although little is left of the dinosaur remains that used to be a feature of the park.

The state's oldest hospital, St. Barnabas Medical Center (Short Hills Rd.), is also one of its largest (over 600 beds and 3,000 employees in 1995). St. Barnabas was founded in Newark in 1865; its burn center, the only one in New Jersey that is state certified, is reputed to be the largest of its kind in North America.

Long Branch Monmouth 28,658

NJ 36, 71, C 537

Although Long Branch, one of the largest cities on the shore, is enjoying a rebirth, it is hard to realize, looking at it today, that from roughly the 1860s to the First World War it was one of the most glamorous resorts in the country. It was also one of the earliest—a boarding house for summer visitors opened in 1788. At

first the resort's clientele came from Philadelphia, then, particularly after the Civil War, from New York as well. Mrs. Lincoln visited in 1861, but it was President Grant's first visit in 1869 that gave Long Branch its cachet. Grant was to visit every summer he was president, and many summers after that. A racetrack opened in 1870, gambling casinos soon thereafter, and during the 1880s and '90s Long Branch's reputation as a fashionable place was at its height. (It was described at the time as "not a place whither a circumspect parent would take his family for a quiet summer by the sea," and "an object-lesson in certain extreme phases of American life.") A partial list of the people who frequented Long Branch includes such members of society as the Astors, Fiskes, Goulds, Biddles, and Drexels; high-liver Diamond Jim Brady; General Winfield Scott; actors Edwin Booth, Lillie Langtry, and Lillian Russell; painter Winslow Homer; and writers Bret Harte and R. L. Stevenson.

Grant was not the only president associated with Long Branch. James Garfield was a frequent visitor, and after the attempt on his life he was taken here (a half-mile railroad spur from the main line to a borrowed cottage was built overnight so that his journey could be more comfortable) in the vain hope that the sea air would help him recover. Chester A. Arthur, Rutherford Hayes, Benjamin Harrison, William McKinley, and Woodrow Wilson also spent some time at Long Branch.

Although not much of Long Branch's former elegance remains, you can still see the church at which these seven presidents worshipped. Built in 1879 as St. James Episcopal Church, it is now known as the Church of the Presidents* (1260 Ocean Ave.; 732-229-0600, 732-222-7000) and is a museum run by the Long Branch Historical Society. The collection focuses on Long Branch's relation to the national scene. Open by appointment.

Seven Presidents Oceanfront Park (Ocean and Joline aves.; 732-229-0924), a 33-acre county park, has facilities for swimming, fishing, boating, and picnicking. Long Branch is working to transform itself into a year-round community, and high-rise hotels and condominiums have replaced some of the summer cottages. A stretch of the wooden boardwalk has been replaced by a cement promenade, but you can still walk on "boardwalk" from Brighton Ave. in West End to Sea View Ave. in Long Branch, and along part of the way is an exercise walk with fitness stations.

Long Branch once boasted the longest pier in New Jersey, from which visitors could fish all day long the year-round. The pier, built in 1902, burned in

the '80s, but there are hopes that it will soon be rebuilt. Other plans include converting the old armory into a sports complex, which would include an ice-skating rink. For beach information, call 732-222-0400.

North of Long Branch, in Monmouth Beach (take Ocean Avenue to Seacrest Rd.), the New Jersey Historical Divers Association is at work on a museum dedicated to the history of shipwrecks and to preserving the rich historical record to be found off the Jersey shore. The museum will be housed in a former lifesaving station that dates to the 1890s. For information, call John Bandstra at 201-445-2515 or Dan Lieb at 732-776-6261.

Long Valley Morris [Washington Township]

NJ 24, C 510, 513, 517

Settled by Dutch and Germans at the turn of the 18th century, Long Valley was known as German Valley until the United States entered the First World War and anti-German sentiment inspired the change of name. The German Valley historic district* includes portions of Fairview, E. Maple, and W. Maple aves., and

Fairmount, E. Mill, and W. Mill roads. The mid-18th-century Long Valley Inn (r W. Mill Rd., c 513) was identified by the WPA guide in the 1930s as serving "liquor longer than any other tavern in the State N. of Trenton." The 18thcentury stone barn behind the inn has been converted to a brew pub. On Fairview Ave. note the remains of the Old Stone Union Church, built in 1774 to replace an earlier log church and abandoned in 1832 by the two congregations (Dutch Reformed and Lutheran) that used it. Many of the tombstones in the cemetery are inscribed in German; the oldest goes back to 1865. Next door to the church walls, in an 1830s schoolhouse, is the Washington Township Historical Society museum (908-876-9696). In one section of this local history museum is a replica of an old schoolroom; other exhibits change every two to three months. Open Sunday, 2–4, except on holiday weekends; other times by appointment.

A bit farther up Fairview Ave. is Welsh Farms, a dairy founded in 1891, which still has a major home-delivery business. The last dairy in the state to use glass bottles, it finally abandoned them late in 1985.

Southwest of Long Valley, on c 513, is Middle Valley, settled early in the 18th century. Its historic district* includes some 40 buildings from the mid-18th to the 20th century on Beacon Hill, Middle Valley, and W. Mill roads.

Northwest of Long Valley (take 24 west and turn north on Springtown Rd.) is Schooley's Mountain Park (908-876-4294, 973-326-7600), a 782-acre county park. Schooley's Mountain was a popular and fashionable health resort in the 19th century (General Grant was a visitor): not only is the mountain 1,000 feet above sea level, but there are springs there, known to the Native Americans for the supposed healing qualities of the water, and famous among the colonists at least since the 1770s. The back roads around Schooley's Mountain are worth exploring: the scenery is lovely, occasionally you will see reminders of the

elegant resort of the past, and old buildings line many of the roads. The Schooley's Mountain Historic District* includes Schooley's Mountain, Pleasant Grove, and Flocktown rds. and Heath Lane. The park itself has facilities for hiking, picnicking, boating, swimming, fishing, softball, and many winter activities.

Lyndhurst Bergen 18,262

NJ TNPK EXIT 16W, NJ 3, 17, C 507

Situated on the eastern bank of the Passaic River, Lyndhurst is bounded on the east by the Hackensack Meadowlands, some 19,000 acres of salt- and freshwater marshes, tidal pools, and uplands that were once thought of as wasteland, suitable only for dumping garbage. (Many travelers on the New Jersey Turnpike

have been aware of the dumps as the only hills in an otherwise almost flat landscape.) These now-protected wetlands are recovering from past abuse, and some 2,000 acres of them, including the Saw Mill Creek Wildlife Management Area, make up the not-yet-completed Richard W. DeKorte State Park. All but one of the dumps are now closed, and the county landfill is being landscaped and integrated into the park. This is not a simple task because the decaying garbage generates heat, which makes it hard for plants to establish themselves

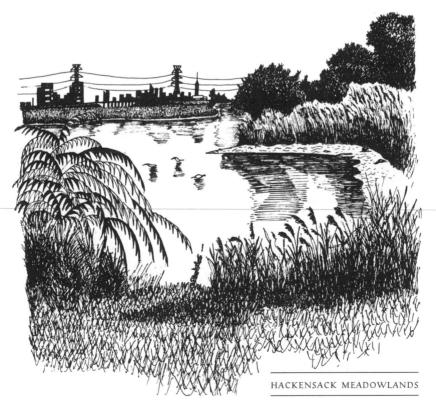

unless moisture is increased. If too much moisture is added, though, there is a risk of pollutants leaching into the marsh.

Already in place is the Hackensack Meadowlands Development Commission's Environment Center (2 DeKorte Park Plaza; 201-460-8300), a museum and nature center that focuses on environmental problems, which the New Jersey Sports and Exposition Authority, as part of its proposal to build the Meadowlands Sports Complex (see East Rutherford), agreed to help build, finance, and maintain. The road to the center first passes corporate warehouses and offices, and as you get close to the center, you will still see an occasional dump truck, but the mountains of garbage and the steady stream of dump trucks still visible in the mid-'80s are no longer apparent.

In working to reclaim the landfills without causing adverse environmental effects, the center has been pursuing a variety of approaches that may serve as models for others. In some cases methane collection wells are placed in the dumps, and the methane gas is sold to local utility companies. The center has also been able to establish a garden of local plants, and as water quality improves, fish that have not been seen in the area for many years are reappearing. An environmental laboratory at the center conducts research and monitors progress (the closed landfills must be monitored for 30 years).

The center, which provides programs for some 10,000 students and handles perhaps 40,000 general visitors a year, is solar heated and sits on stilts out over the Kingsland Creek marsh. A variety of trails is available, some around the marshes and some in upland areas, some of them handicapped accessible. The area attracts many birds, particularly in May, late August, and early September, and there are observation decks on the trails (trail maps are available at the center). The boardwalk used on the marsh trail is made of an environmentally friendly (and bouncy) synthetic material. The Lyndhurst Nature Reserve, two and one-half acres devoted to serving as an educational example, has been designed to show how natural succession works; it also contains bird blinds and wildlife observation areas. Meadows Path, which goes along the road, will eventually link the entire area, from Little Ferry in the north to Kearny in the south. For now, you can see corporate workers in shirtsleeves and ties walking toward or away from the center during lunch break.

Exhibits in the museum, many of which are interactive, focus on trash disposal, the nature of urban salt marshes, and the history of the Meadowlands area. Best known is the trash museum, oriented toward children but interesting to all. Open weekdays, 9–5; Saturday, 10–3; groups by appointment.

Lyndhurst's downtown has some interesting buildings, among them the town hall (Valley Brook Ave.), the library (Valley Brook Ave.), and the railroad station (Stuyvesant Ave.). The Little Red Schoolhouse Museum* (400 Riverside Ave.; 201-804-2513), dating from the 1890s, functions as the Lyndhurst Historical Society museum. Focusing on local history, it contains a c. 1912 schoolroom, artifacts and local memorabilia, and changing exhibits. Open September–June, 2d and 4th Sunday of the month, 2–4; groups and other times by appointment.

One block north of the museum, at 316 Riverside Ave., is the 18th-century

stone Jacob van Winkle house*; in 1804 van Winkle donated the property for the first schoolhouse on the Little Red Schoolhouse Museum site. Just south of the schoolhouse, at 410 Riverside Ave., is the mid-19th-century Jeremiah Yeareance house,* where teachers at the school often boarded. Across Riverside Ave. is a section of Riverside County Park (201-939-9339), with tennis courts, picnic groves, playing fields, and a pedestrian and bicycling path.

Madison Morris 15,850

NJ 124

A colonial town (Mad Anthony Wayne had his headquarters here when the revolutionary army was quartered in the Loantaka Valley), Madison became a spot favored by wealthy commuters in the 19th century. For many years it was known as the rose capital of the country, a huge industry having developed out of what had

begun as a hobby of the rich. By the turn of the century, 50,000 roses were shipped from Madison to New York City alone, and at the height of production 25 million roses a year were being grown under 1 million square feet of glass. Advances in refrigeration ended Madison's rose industry; although there are still 3 rose growers in New Jersey (down from 17 in the '60s), most roses today are flown in from South America.

The Museum of Early Trades and Crafts* (Main St. and Green Village Rd.; 973-377-2982) is housed in the former public library, a gift of Willis James, a Wall Street commuter. The small stone Gothic building, built in 1900, has an imported-tile roof, leaded handblown-glass windows, forged bronze chandeliers, stenciled walls and ceilings, and many other remarkable details. The museum was created in 1970 and is devoted to encouraging better understanding of the state's heritage by preserving and exhibiting artifacts showing how people have lived and worked since New Jersey was first settled. The museum is popular with schools—some 5,000 school tours go through each year—and the exhibits generally change monthly. Open Monday–Saturday, 8:30–5; Sundays, 2–5. Closed New Year's Day, Easter, 4 July, Thanksgiving, and Christmas Day.

At 36 Madison Ave. (NJ 124) is Mead Hall,* also known as the Gibbons Mansion. This 1830s building forms part of the Drew University campus. Founded in 1866 as a Methodist seminary on land donated by Daniel Drew, a stock-market speculator, Drew has since become a liberal arts college with a graduate school as well. On its wooded 186 acres are two other buildings from the Gibbons estate, a red-brick carriage house and Embury Hall, the former granary. The library is the official depository for the United Methodist Archives. The Korn Gallery (Brother College Building; 973-408-3553) mounts six shows a year. Two are student shows; the others tend to emphasize contemporary works by metropolitan-area artists, but ethnographic and photography shows are also featured. Open Tuesday–Friday, 12:30–4, and by appointment. The New Jersey Shakespeare Festival (973-408-5600), a professional repertory

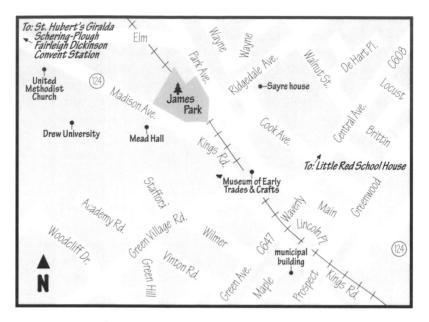

company in residence at Drew, expects to open its 1998–99 season in a remodeled and rebuilt theater and to move gradually to a year-round schedule.

Farther west on Madison is the Florham Park–Madison campus of Fairleigh Dickinson University. Built on 180 acres from the 1,000-acre Twombly estate (the Esso Research Laboratories are also on the grounds of the estate), Fairleigh Dickinson has as its main building a 100-room mansion designed by Stanford White and modeled on one wing of Hampton Court.

Directly northwest of Fairleigh Dickinson's campus, in Convent Station, is the campus of the College of St. Elizabeth (2 Convent Rd.; 201-292-6300), the oldest four-year college for women in the state (men have been enrolled in the continuing education program, known as the weekend college though classes also meet during the week, since the 1970s). Convent Station's name dates to the 1870s, when the Sisters of Charity financed the establishment of a train station to serve their Academy of St. Elizabeth, a school they had founded 10 years earlier. In the 1890s the nuns gave the town the road to the station (the station building dates to 1913). The order's motherhouse is also here; the college itself dates to 1899. Although some of the handsome Victorian buildings have been demolished, the main building remains, and this is still an extraordinary campus. The Shakespeare garden is a particular treat. Located next to the conservatory (Seton Dr. and Midway), where many winter plants are grown, the garden is planted with the flowers grouped according to the play in which they are mentioned. The Greek theater, modeled on the one at the bottom of the Acropolis, was built in the 1930s as a way to employ out-of-work laborers.

There are many other buildings of interest in Madison, including several Queen Anne buildings on NJ 124 as you come into town from the east. Note also the United Methodist Church (1730; 120 Madison Ave.); the Daniel Sayre house* (c. 1740–45; 31 Ridgedale Ave.), possibly Wayne's headquarters; and the

elaborate municipal building (Maple Ave.), donated in 1935 by Mrs. Geraldine R. Dodge. Madison has worked to preserve the classic small-town look of its shopping streets; its Commercial Historic District,* roughly centered on Main St. and Waverly Pl., includes some 60 buildings dating from about 1870 to 1936 on Green Ave., Central, Lincoln, and Waverly pls., Green Village and Kings rds., and Main Street.

Giralda Farms, Mrs. Dodge's former estate, has been subdivided and now contains offices (Schering-Plough and Prudential) and, in a former cow barn, St. Hubert's Giralda, an animal shelter actively engaged in placement, rehabilitation, and educational efforts. Schering-Plough (I Giralda Farms; 973-822-7000) presents art exhibits in its lobby; these change about every three months. Open weekdays, 8:30–4:30.

North of Madison (take Central Ave., c 608, to Ridgedale Ave.), in Florham Park, is the Little Red School House Museum* (Ridgedale Ave. and Columbia Tnpk, c 510; 973-377-5345). Originally a one-room schoolhouse (the basement is a later addition), the mid-19th-century red-brick Gothic building is now a museum of local history, with exhibits of artifacts and period clothes that change three times a year. Open mid-September–mid-December and April– July, Sunday, 2–4; groups and other times by appointment.

Mahwah Bergen 17,905

I 287, US 202, NJ 17

Located along the northern border of the state, the township of Mahwah includes within its boundaries both extensive undeveloped areas and many corporate complexes. (The superhighways that go through town can make it difficult to get from one part to another.) Bergen County runs two large reservations in the

township, the 2,100-acre Ramapo Valley County Reservation (US 202; 201-825-1388) and the 1,300-acre Campgaw Mountain County Reservation (Campgaw Rd.; 201-327-7804). Both are wildlife reservations, and both are open year-round for hiking and camping (permits are necessary for camping), with marked and rough trails. Guided public hikes and walks are scheduled some weekends, and both parks run nature programs. Fishing is available in a mountain pond in Ramapo Valley; Campgaw has a ski area (201-327-7800). For information on trail maps and guided tours, call 201-891-5771. Adjacent to Campgaw is Darlington County Park (Darlington Ave.; 201-327-3500), which has two lakes for swimming and a third for fishing. Open daily, Memorial Day weekend–Labor Day (admission is charged); open limited hours, April–Memorial Day and Labor Day–October. There is also a county golf course (201-327-8770).

In Mahwah's first railroad station (1871 Old Station La.; 201-891-9049), which dates from 1871, is the Old Station Museum (the new station dates from the early 1900s). A caboose is also part of the museum. Displays feature railroad memorabilia and items of local history. Open June–October, Sunday, 3–5; groups by appointment.

For over 25 years Ford Motor Company had an assembly plant here (near NJ 17), which closed in 1980 after turning out close to 6 million cars and trucks. Its 172-acre site is now home to a hotel, offices, and corporate headquarters. In fact, most manufacturing in Mahwah has been replaced by housing and corporate headquarters, and the population has increased by almost 50 percent since the Ford closing threw 5,000 people out of work.

There are many 18th- and 19th-century Dutch stone houses to be seen in Mahwah, particularly along Ramapo Valley Rd. (US 202). George Washington is believed to have stayed in one of these houses, and Joyce Kilmer lived for a time on the southwest corner of Airmount and Armour rds., commuting to his job at the *New York Times*. For many years Mahwah has been home to Les Paul, who developed the electric guitar when patrons of a barbecue stand where he was performing complained they couldn't hear the guitar; in 1996 he was inducted into the New Jersey Inventors Hall of Fame.

The art gallery at Ramapo College of New Jersey (505 Ramapo Valley Rd.; 20I-529-7368), located in the college library, houses two to three one-artist shows each semester, most lasting roughly a month. Open weekdays, II–2; Wednesday, also 5–7. The college was founded in the late 1960s. Its campus, formerly the Stephen Birch estate, lies on 300 wooded acres in the foothills of the Ramapo Mountains. The college's original building, the late-19th-century Havemeyer mansion, has been augmented by award-winning contemporary buildings.

At the Bergen County's Life Safety Complex (281 Campgaw Rd.; 201-818-7800) is a state-of-the-art training facility for firefighters (and police). The simulations, which include residential buildings, retail stores, hotel hallways and guest rooms, movie theaters, elevators, and a commercial kitchen, are set up so that firefighters can learn to battle blazes in the cluttered situations and poor visibility they are likely to encounter in real fires. Tours for all ages can be arranged by appointment (the tours include safety instruction).

Southeast of Mahwah, in Upper Saddle River, is the Hopper-Goetschius house* (363 E. Saddle River Rd. at Lake Ave.; 201-327-2236), run as a house museum by the Upper Saddle River Historical Society. On the property are a Dutch sandstone house, built c. 1739 and lived in by only two families, a Dutch barn (moved from another property), an outkitchen, and a privy. Furnishings in the house are those of the original families and date from the 18th to the early 20th century. Changing exhibits display items of local historical interest. Open Sunday, June–September, 2–4, and by appointment. The New North Reformed Low Dutch Church* (E. Saddle River Rd. at Old Stone Church Rd.) dates from c. 1789, and there are 18th-century houses to be seen at 54 Pleasant Ave.,* 72 Hopper Farm Rd.,* and 349 W. Saddle River Rd.*

Manahawkin Ocean [Stafford Township]

GARDEN STATE PKWY EXITS 63, 63A, US 9, NJ 72, C 180

The last town before the bridge to Long Beach Island, Manahawkin, whose name means "land good for growing corn," was formerly the site of a Native American village. It was here that William A. Newell, living with his uncle on Main St. for a time, developed the idea that led him to found the United States

Lifesaving Service (see Allentown).

In the Stafford Township Historical Society Heritage Park (Bay Ave., just west of Main St.; 609-597-3076), you will find the Stone Store and Museum and the old Railroad Station. The Stone Store, built in 1838, houses a museum of local history and a museum shop that specializes in the work of local craftspeople. On display at the station, which dates from 1872, are memorabilia from the old Tuckerton Railroad line, which used to run through Manahawkin. The society also sponsors various annual events, including a holiday tour in December. Open weekends, 1–5, May–mid-December, and by appointment. The former Baptist church* (N. Main St.; 609-597-8099), started in 1758 and enlarged in the 19th century, now serves as the Old Baptist Church Cultural Center and is used for concerts and lectures as well as private events. You can swim and fish in Manahawkin Lake. At the lake is the 60-acre A. Paul King County Park (609-971-3085), which also has playing fields.

East of town (take Stafford Ave. off Main St.) is the Manahawkin Wildlife Management Area, one of the oldest in the state. Begun in 1933, it now contains almost 1,000 acres of woodlands, fields, and salt marsh and is a good place for fishing, crabbing, and bird-watching (raptors are common in the winter).

Manasquan Monmouth 5,369

NJ 71, C 524

A seaside community near the outlet of the Manasquan River at the southern end of Monmouth County, Manasquan retains in its downtown much of the flavor of another era. Native Americans frequented this area, and the name is said to mean "enclosed area with a house in it," referring to the practice of leaving the women

behind when the men went hunting. The settlement began to grow early in the 19th century. In 1888, before embarking for the South Seas, Robert Louis Stevenson stayed here for six weeks and wrote part of *The Master of Ballantrae*. Note the Holy Trinity Lutheran Church (Main St.), built in 1848.

The town has the reputation for being a family resort in the summer; for information on beach fees, call 201-223-0544. This characteristic is recognized in the historical society's Big Sea Day, a local festival that remembers the early-19th-century custom of families from all around gathering for one day at the

Manasquan beach. Held the second Saturday in August, the event ends with fireworks on the beach.

Thirty-five acres on the north shore of the Manasquan Inlet (across from Point Pleasant Beach) that once belonged to the American Timber Company, and whose ownership was recently contested by the Board of Proprietors of Eastern New Jersey, now form the Fisherman's Cove Conservation Area. The land is open for passive recreation.

The Squan Village Historical Society's museum was destroyed by fire in 1996. For information on the society's plans to establish a new museum, call 732-223-6770.

About three miles northwest of Manasquan is the Manasquan River Wildlife Management Area (go south from Manasquan to NJ 35, west on 35 to NJ 34, west on 34 to Ramshorn Dr.), 753 acres open for hiking, fishing, and limited hunting.

Margate City Atlantic 8,431

C 563

A shore community south of Atlantic City (and Ventnor City), Margate City is known today as the home of Lucy,* the Margate elephant (9200 Atlantic Ave.; 609-823-6473, 609-822-6519). Built in 1881 by a real estate developer as a gimmick to attract potential customers, Lucy is now a national historic landmark. She appears

frequently in tourist promotions and is visited by some 25,000 people every summer. Six stories tall and weighing 90 tons, Lucy was built of wood and covered with a tin skin; she cost about \$33,000. Lucy's builder constructed two other elephants, one of which, the Colossus, was 18 stories tall. It burned in 1897. Sold in 1887, Lucy continued her career as a tourist attraction, even serving for a while as a hotel. She began to decline after World War II and was nearly destroyed in the 1960s. Rescued by a citizens committee in the 1970s, she has been relocated; she has also been given a new steel frame, and her exterior has been restored. Also relocated was a Camden and Atlantic Railroad depot from 1881, which houses the ticket office and a gift shop. An antique show is held the last Saturday in August to raise money to continue the restoration of her interior and to landscape the grounds she stands on. There is a fine view from her howdah, which was recently rebuilt. Band concerts are held Thursday evening in July and August at 7. Open for visits daily, mid-June-Labor Day, 10-8; weekends, April-mid-June, September, and October, 10-4:30. Group tours by appointment. Admission charged.

There are some splendid houses to be seen in Margate. The Marvin Gardens historic district* lies between Ventor, Fredericksburg, Winchester, and Brunswick avenues. For information on beach fees, call 609-822-0424 or 609-822-2508.

Matawan Monmouth 9,270

GARDEN STATE PKWY EXIT 117, NJ 34

Matawan, originally settled by Scots and known variously as New Aberdeen and Middletown Point, has seen its population quadruple over the last 60 years. It was the home of Major John Burrowes, who organized the first New Jersey company of militia. His scalloped-shingle house,* built in 1723, has become the

Burrowes Mansion Museum (94 Main St.; 732-566-5605). Having also served as a hotel and a restaurant, the house is now operated as a local-history museum by the Matawan Historical Society. Furnished with period furniture, it contains a permanent exhibit of locally made pottery and tile, as well as exhibits relating to the history of the local brickmakers. There are also changing exhibits and a special December musicale. Open March–December, 1st and 3d Sunday of the month, 2–4. Tours by appointment.

West of Matawan is Cheesequake State Park (Garden State Pkwy exit 120; 732-566-2161), 1,300 acres of rolling land, 380 acres of which are a natural area. The park exhibits a wide diversity of plant communities, including Pinelands vegetation typical of the southern part of the state, deciduous forests typical of the northern part, a cedar swamp, white pine stand, freshwater swamp, and flood plain. In the spring the display of wildflowers, particularly the pink lady's slippers, is spectacular. This is also a good place for bird-watchers. The extensive trail system goes into the marsh to an abandoned landing on the Cheesequake River, where once bricks made from local clay, salt hay harvested from the marsh, and agricultural products from nearby farms were loaded for transportation elsewhere. The park also has facilities for swimming, camping, fishing (the lake is stocked with trout), and cross-country skiing, as well as a trail open to mountain bikes. A naturalist at the interpretive center offers a mix of programs, and in the center are various exhibits and displays relating to the natural history of the area, as well as an aquarium containing snapping turtles and various fish. The park can be crowded in the summer. The interpretive center is open Wednesday–Sunday, 10–3, year-round; the park daily, 8–8, in summer (Memorial Day-Labor Day), 8-dusk in winter. Parking fee in summer.

Also west of Matawan, in Old Bridge Township (take Old Bridge Rd., c 516), is the Thomas Warne Historical Museum and Library (c 516, between Morganville and John Partridge rds.; 732-566-0348). This was a one-room schoolhouse, built in 1885, which still has its original wainscoting and slate blackboards. The collection includes artifacts from the area, as well as documents, photographs, and research files. Open Wednesday, 9:30–12, and the first Sunday of the month, 1–4; guided tours by appointment.

Mauricetown Cumberland [Commercial Township]

с 670, 676, 744

Although the first settlers arrived in what is now Mauricetown in the early 18th century, the town was not really developed until the early 1800s. It thrived as a fishing port during the 19th century, when fleets of boats worked the Delaware River, and in the mid-1800s attracted captains of three-masted schooners, who built

houses in town. Mauricetown is an unusually well-preserved entity, with most of the houses dating from 1815 to 1870 (but note the Caesar Hoskins house at the foot of 2d St., which dates at least to 1714 and possibly to 1680). Today most of the residents commute to nearby jobs, although there is a sand works outside town. There are plaques on many of the houses, giving their dates and often identifying them as captains' houses. The Greek Revival Mauricetown Academy (High St.), a two-room elementary school from 1860, was used as a school for over 100 years. The Elizabeth Compton house (Front St.; 609-785-1137, 609-785-1391), built in 1862, is being restored by the Mauricetown Historical Society as a house museum and library. On the second floor you can see the river room and the children's room. Tours by appointment. The Methodist Church (Noble and 2d sts.) dates from 1880; its high spire once served as a navigational aid. At the foot of High St., where the 1888 drawbridge used to be, is Riverside Park; you can sit here and watch the river go by. One of the benches is placed on the remaining fragment of the bridge. The Maurice River, together with its tributaries the Manumuskin and Menantico rivers and Muskee Creek, is part of the Wild and Scenic River project, unusual in that almost all the land along the river is privately owned.

The historical society sponsors an annual house tour, usually in December, and various other special events. The fire company sponsors three antiques shows each year (the first weekends in March, June, and December), as well as an annual crafts show in November and a seafood festival in October that draws some 2,500 people. Statewide oyster-shucking contests have been among the events taking place at the seafood festival, and if you continue on to Bivalve (take High St. west to c 649 and turn left; at Port Norris, turn right on Main St. and left on c 631), you will come to the heart of New Jersey's oyster industry, now devastated by a parasite that has drastically reduced yields. Before the parasite hit Delaware Bay in the late 1950s, 2 million bushels of oysters a year were harvested, but the industry's biggest crop today is quahog clams. The Rutgers Shellfish Research Laboratory in Bivalve is actively engaged in research that it hopes will find a way to overcome the parasite.

In the meantime you can visit a restored Delaware Bay oyster schooner, the *A. J. Meerwald*, which often docks in Bivalve. Built in 1928, the *Meerwald*, after a career as an oyster schooner, a fireboat, an oyster dredger, and a surf clammer, sank; she was raised and restored by the Delaware Bay Schooner Project (2800 High St.; 609-785-2060), which uses the boat in many ways, all

geared toward raising people's awareness of the history, culture, and environment of Delaware Bay. The project sponsors hands-on educational sails and workshops, dockside tours (when the sailing schedule permits), public sails, and various land-based programs. Call to find out where the boat is docked and to arrange a tour. The Maritime Traditions of Delaware Bay Museum, now located in Port Norris (18 E. Main St.; 609-785-2060), will eventually move to the Bivalve waterfront. Open weekends, April–October, 1–4:30.

The schooner project is one of the sponsors and the host of Bay Day (609-785-2060), a June event that includes an oyster shucking contest, a blue-crab race, river tours, family games revolving around fish and shellfish, traditional crafts, local seafood, educational displays, folk music, and evening fireworks.

At the mouth of the Maurice River is the East Point Lighthouse* (C 616: 609-327-3714). Built in 1849, the lighthouse is the second oldest still standing in New Jersey (Sandy Hook is older) and the only remaining one on the Jersey side of Delaware Bay. The light was extinguished on 7 December 1941 but reinstalled in 1980, and the Maurice River Historical Society has been working on restoring the building. Long-range plans call for setting up a museum in the lighthouse. Open the first Saturday in August and on Bay Day; groups by appointment. In this area is the Heislerville Wildlife Management Area, 5,700 acres of diked and tidal marshes, impoundments, and uplands. To the east of East Point are Thornpsons Beach and Moores Beach, where horseshoe crabs spawn and attract migrating shorebirds. The impoundments also attract wintering snow geese. This is prime territory for bird-watchers, but you can also fish and hunt.

Mays Landing Atlantic [Hamilton Township]

US 40, NJ 50, C 552, 559

Located at the head of Great Egg Harbor River, Mays Landing has been the county seat since Atlantic County was formed in 1837. The original red brick courthouse (1838) remains the center of the greatly expanded county buildings. The smallest county seat in the state, Mays Landing was founded in 1760 by George May, a

trader from Philadelphia. It is an attractive spot, with large trees and a common. Note the Presbyterian Church* (1841) at the corner of Main St. and Cape May Avenue. The Mays Landing Historic District* includes over 250 buildings along E. and W. Main St. and the intersecting streets. Along the river in the heart of town is Gaskill Park (609-645-5960), a 10-acre county facility where you can fish, boat, and picnic. In the summer the shell is used for concerts.

Northwest of the center of town (on US 322) is Atlantic Community College (609-343-4900). Shows at the campus art gallery change monthly except in the summer; there are faculty and student shows and shows focusing on black history, women's history, the Holocaust, and contemporary trends in fabrics. For hours, call 609-343-4900, ext. 5346. From September through May the college sponsors occasional open houses and tours; call the admissions office

for the schedule. During those same months the college's Academy of Culinary Arts runs a restaurant that is open to the public by reservation (609-343-4940). The college's active performing-arts program includes contemporary folk concerts, student theater productions, and authors' lectures; these events, which take place at the Walter Edge Theater, are open to the public (call 609-343-5040 for the schedule). There is also a folk series at the restaurant.

North of the center of town is Lenape Park, 2,000 acres that are open for camping (call 609-645-5960 for information). The park also includes Lake Lenape, the end point in a 12-mile canoe trip through the Pinelands along the Great Egg Harbor River that begins in Penny Pot County Park in Folsom (spur 561 and us 322), where you can also fish and picnic. A shorter version starts at Weymouth County Park (US 322 and c 559), in the early 1850s a flourishing community and the site of the Weymouth iron forge (1802–62) and paper mills (1866–97). Some foundations remain, and you can find interpretive signs here as well as picnic tables and grills.

Three miles south of Mays Landing, on NJ 50, is Estell Manor Park (609-625-1897), a county facility with 1,700 acres located primarily on the site of the World War I Bethlehem Loading Company plant. Built in 1918, the plant ceased operations in 1919. All the usable steel and iron was removed, and all that remains now are concrete foundations and rail beds (the nature trail goes along the rail bed, and chunks of coal, slag, and cinders can be seen, although the forest has almost reclaimed the site). Also in the park are the remains of the Estellville Glassworks, which dates from the 1830s and is remarkable for being built of local sandstone. The works operated until the late 1870s; window glass was the principal product. The Estellville Glassworks Industrial Historic District* includes Estell Manor Park, Stevens Creek, Maple Ave., Walkers Forge Rd., and NJ 50.

The park has a nature education center with a passive-solar envelope design. Inside are exhibits focusing on the history and the plant and animal life of the Pinelands. The park also has facilities for fishing, boating, picnicking, hiking, biking, and cross-country skiing, as well as a fitness trail and a nature trail (a brochure describing the nature trail is available at the center). Many special programs are offered for school groups and the general public, including orienteering and environmental education programs. Guided nature and history tours are available by appointment to groups of 10 or more. The park is open daily, 7:30–dusk; the nature center weekdays, 7:30–4, weekends, 11–3.

Among New Jersey cities, Estell Manor is second in area only to Vineland. Over the years the city has supported a wide variety of trades, from shipbuilding to glassmaking to piracy. The historical society is hoping to restore the 1913 Risley schoolhouse (Cape May and Cumberland aves.) to serve as a research library and museum of local history.

Medford Burlington [Medford Township]

NJ 70, C 541

The village of Medford is a tiny dot at the edge of what used to be pinelands in the midst of an extremely fast-growing township. (The population of Medford Township, 20,526 in 1990, more than quadrupled between 1960 and 1990, more than doubled between 1970 and 1990.) This was Native American territory before the first

settlers began arriving, possibly late in the 17th century, more definitely early in the 18th, and the excavations for the many housing developments keep turning up artifacts. C 541, in fact, follows an old Native American path to the sea (NJ 70 follows an old Camden and Atlantic Railway route).

The first real community probably didn't develop until the mid-18th century (the oldest gravestone reads "M. S. 1759"), and from the 1760s to the 1780s Medford profited from the nearby Etna and Taunton bog-iron furnaces. The first machine to manufacture cut nails was built in Medford by Mark Reeve, who arrived in town in 1800; however, he did not patent his invention. According to tradition, he was so impressed with Medford, Massachusetts, that he urged changing his adopted town's name from Upper Evesham to Medford. His former factory, now a private home, can be seen on Jennings Rd. off NJ 70.

When the railroad arrived in 1869, Medford was a prosperous village with sawmills, a gristmill, and a glass factory. The area was an important cranberrygrowing region, and the many lakes that have made it into something of a resort area result from damming the streams and draining cranberry bogs.

A famous native son was James Still, known as the Doctor of the Pines. Born in 1812 to freed slaves from Maryland, he managed somehow to educate himself and, surmounting incredible obstacles, built up a practice, based mainly on herbal remedies, that enabled him to die (in 1882) the largest property holder in the area. A modern housing development sits where his house once sat, but his office,* with its double fireplaces in the basement for boiling syrups, is still standing (Church Rd., just east of 541, north of the village).

Many of the village's buildings date from the 19th century (and some from the 18th). The Stage Coach Inn (Main and Union sts.), which now houses shops and a luncheonette, was built in 1810. Braddock's Tavern (Main St.) is on the site of the old Medford House, which had pillars cast at Batsto. Until recently the Quakers used both their meetinghouses, the Hicksite (1842; off Main St. at South St.), and the Orthodox (1814; Union St.); unfortunately, the former was put up for sale. The former St. Peter's Episcopal Church (Union St.), a 19thcentury Gothic structure, served for a time as a doctor's office. The former Methodist Episcopal Church (1854; 1896; Branch and Filbert sts.) is being used by another group; the First Baptist Church (Bank St.) dates from 1893. Note also the Reily house (53 S. Main St.) and the Braddock house (70 S. Main). The Medford Historical Society (609-654-2608, 609-254-1629, 609-254-7102) sponsors house tours the first Saturday in December as well as a quilt show the first weekend in June and an apple festival the second Saturday in October.

The Kirby's Mill Museum* (Church and Fostertown rds.; take 541 north out of the village to Church, c 616; 609-654-7767) is in an old gristmill (the foundations date to 1788, and a sawmill was on the site before that) that operated with water power until 1961 and with combined water power and electricity for a short period more. The historical society has been restoring the mill and returning it to working condition. A blacksmith's shop on the property will also be restored. In the museum are the mill's old stones and wheels, farm tools, woodworking equipment, and a collection of period clothes and costumes. Both the quilt show and the apple festival are held at the mill. Open July and August, Sunday, 1–4; other times by appointment.

Close by the mill is the oldest house in the county still on its original foundations (the Revell house was moved; see Burlington). The first part of the John Haines house* (26 Fostertown Rd.) was built c. 1690; the Flemish-bond brick section dates to 1720, and alterations and additions were made in 1810 and c. 1850. The house remained in the Haines family until early in the century; today it is once again lived in by a descendant of the original builder.

If you continue east from Kirby's Mill on c 616 about three miles, you will come to Vincentown. In this small village are four museums: the Vincentown-Tabernacle Telephone Museum (17 Mill St.), a one-room schoolhouse (Race St. at the millpond), a two-cell lock-up (Plum St. behind the town hall), and the Old Vincentown Town Hall (Plum St.). The telephone museum, in a c. 1898 building, has an exhibit showing what the telephone company was like in 1908 and a working switchboard that enables you to see what happens when a call goes through. The collection also includes numerous old telephones and other artifacts. The schoolhouse, c. 1860, is furnished as an 1860s schoolroom, and

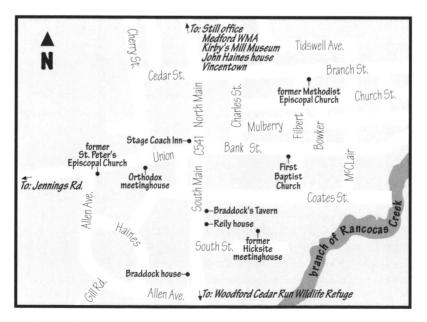

176 Medford

visiting schoolchildren are treated to lessons using the materials and methods of the 19th century. In the Old Vincentown Town Hall, you can see the Southampton Historical Society's exhibits; these change four times a year. All four museums are open by appointment (609-859-2602, 609-859-3683). The Sally Stretch Keen Memorial Library (94 Main St.; 609-859-3598) offers a variety of programs, particularly for children.

About two miles north of the village (take 541 to Brace Rd. and turn left, or west) is the Medford Wildlife Management Area, 200 acres of fields and hedgerows open for hiking, bird-watching, and hunting.

Seven miles southwest of the village (6 Sawmill Rd., 609-983-3329) is the Woodford Cedar Run Wildlife Refuge. The refuge's 180 acres of pinelands also support a rehabilitation center for wounded animals, bird studies, and an environmental education center. Special programs, including, for example, night hikes, bird-walks, wilderness survival courses, summer canoe classes, and guided walks along the one-mile nature trail that circles Cedar Lake, are offered for adults and children. For program information call 609-983-0326. Open weekends, 12–4, and, for members, other times by appointment.

Mendham Morris 4,890 (borough) 4,537 (township)

NJ 24, C 510, 525

A region of rich soil and abundant water power, the Mendham area was first settled in the early 18th century. At least three stories have grown up to explain its name: it derived from a Native American word, from a town in England, or from a clergyman who, when apprised of the settlers' bad habits, said, "Don't worry,

I'll mend 'em." Although like much of Morris County it grew considerably between 1960 and 1980 (the borough and the township each doubled its population over those 20 years), a lot remains from the 18th and 19th centuries. The Mendham Historic District,* with buildings dating from the 18th to the 20th century, includes Bridge, Halstead, E. and W. Main, New, Orchard, and Prospect sts.; Talmadge and Hampton rds.; and Mountain and Hillcrest avenues. The Black Horse Inn (Main St.) has been in continuous operation since 1742, and on the other side of the street another 18th-century hotel, the Phoenix House* (Main St. and Hilltop Rd.), now contains borough offices. On Hilltop Rd. is the First Presbyterian Church (1860), the third church built by a congregation that goes back to the 1730s. When the church celebrated its 150th anniversary in 1888, it is supposed to have coined the word "sesquicentennial," used later by Princeton University to celebrate its 150th anniversary (the OED, however, does cite an example from 1880).

The Patriots' Path, Morris County's linear path to Hanover Township, starts here. You can enter at Ironia or Pitney rds. and Mountain Avenue.

About one mile west of Mendham is the historic district of Ralston* (NJ 24 and Roxiticus Rd.; the community was formerly known as Rocksitious or Roxiticus). At this corner are the general store and manor house, both dating

from the 1780s. The general store was still in business in the 1920s, and the building served as the Ralston post office from 1892 to 1941 (at which point it was reputed to be the oldest building in the United States to house a post office). The store is now operated as a small museum and contains household and other items of historical interest. Open Sundays and holidays, Memorial Day–Labor Day, 2–5. Tours by appointment (973-543-4347).

Another mile or so southwest off 24 is Mount Paul Memorial Park (East Fox Chase Rd.), an undeveloped county park of 251 acres where you are welcome to hike. East of Mount Paul off Pleasant Valley Rd. in the former Mortimer Schiff estate is a 300-acre natural area open for hiking.

About three miles east of the town center (take 24 east to Tempe Wick Rd., c 646, and turn right) is the Jockey Hollow Environmental Studies Center (Leddell Rd.; 973-927-7722), run by the Morris Area Girl Scout Council. Here are 200 acres, with woods and a river running through the property. Although the center is primarily designed to offer environmental education programs to groups on weekends, individuals are welcome to hike on the property except during the summer day camp (mid-July–mid-August; call for the exact sched-ule). Hiking is also possible at the nearby Mendham Township Buck Hill (or Dos Passos) Park (north of Tempe Wick Rd., west of Corey La.); at the Dismal-Harmony Natural Area (Woodland and Mt. Pleasant rds.), a 150-acre township preserve about three miles east of the town center (take 24 east to Cherry La. and turn left, or north; Cherry La. turns into Woodland Rd.); and at Buttermilk Falls (take Mountain Ave. north out of town until it becomes Calais Rd; continue to Combs Hollow Rd.).

Metuchen Middlesex 12,804

NJ 27, C 501, 531

Settled in the late 17th century by Dutch and English settlers, Metuchen became a commuters' town in the 1830s. It remained rather an exclusive community until the rapid growth of neighboring Edison Township after World War II. Because it attracted many literary and intellectual figures, Metuchen gained the

nickname "Brainy Borough." Its older buildings are generally well preserved. Note in particular the Franklin Meeting House (291 Middlesex Ave.), built in 1805, used as a school from 1807 to 1872, and since then serving a variety of civic purposes; and the railroad station (off Main St.), dating from 1888. St. Luke's Episcopal Church (Middlesex and Oak aves.), a charming frame building with vertical siding and Gothic Revival details, dates from 1868 and was designed by Richard Upjohn. Joyce Kilmer was married in St. Luke's, and Mark Twain, William Dean Howells, Helen Keller, and Ogden Nash have been among its visitors. Continuing the Brainy Borough tradition, the writer and critic John Ciardi lived his adult life here. The pianist Robert Taub is a Metuchen native.

In the center of town is the Forum Theatre (314 Main St.; 732-548-4670), built as a vaudeville house in 1928 and later converted to a movie house. It is

now used by the Forum Theatre Group, which puts on some four to five plays and musicals each year.

The 10-acre Dismal Swamp in the northwestern corner of the borough is being preserved as open space. Access to the trail is from an unpaved road off Durham Ave. between Weston Ave. and Lisa Lane.

Middletown Monmouth 68,183

NJ 35

The village of Middletown, set in the middle of a rapidly growing and densely populated township, is one of the state's oldest continuously settled communities. Dutch settlers were among the first, followed in the 1660s by Baptists seeking freedom from the religious intolerance they had experienced on Long Island. Among

the early settlers were Richard and Penelope Stout. He was one of the founders of the Middletown Baptist Church and a recipient of the Monmouth Patent; she was a Dutch immigrant who early in the 17th century had been attacked by Native Americans, who left her for dead. Nursed to health by other Native Americans, she found her way to New York (then New Amsterdam), where she met and married Stout. Eventually they settled in Middletown and had 10 children; at her death at 90, she reputedly had 492 descendants.

The Kings Highway historic district* (the intersection of Kings Highway with NJ 35) is an 18th- and 19th-century neighborhood, and it is even possible to find a 17th-century structure or two by wandering about the village. (The Kings Highway was supposedly built wide so that horses could be raced along it, and there is a record of a race being run as early as 1699.) The best known is Marlpit Hall (137 Kings Highway), a one-room Dutch cottage (1685), which was "enlarged in the English taste" (c. 1740) by John Taylor, a Tory merchant. The house remained in the Taylor family until 1936, when it became the property of the Monmouth County Historical Association. The house retains most of its original paneling, hardware, and doors, one of which has bull's-eye panes, and has been furnished to reflect life in Middletown over several generations. The dining room is particularly gracious. Closed for structural repairs, the house is expected to reopen in 1998 for the centennial of the historical association.

Middletown's Baptist Church was the first in the state. The congregation was organized in 1668; the present building (69 Kings Highway) dates from 1832. Christ Episcopal Church* (92 Kings Highway at Church St.) was organized in 1702; this building dates from 1835. Part of the church's funds derive from money left to it by William Leeds, a convert who had been a member of Captain Kidd's pirate crew. Note the octagon house (1885) on Church St. and the blacksmith's shop (1825).

On Leonardville Rd., between Chamone and Bellvue aves. (in the Leonardo section of the township), is Croydon Hall (732-671-2645), once the home of Melvin A. Rice, a gentleman dairy farmer who served as a roving ambassador for Woodrow Wilson. The turn-of-the-century building, which may actually incorporate an older small farmhouse, for many years housed a private school and is now the Middletown Township Historical Society's local history museum. Both the changing and permanent exhibits feature local history, and the library has many items going back to the 1660s. Open most Sundays, 1–4.

South of the Kings Highway on Red Hill Rd. (or c. 1½ miles east of Garden State Pkwy exit 114) are two county parks. Deep Cut Park (732-671-6050) consists of 50 acres of greenhouses and gardens that have been planned to serve as "a living catalogue of cultivated and native plant material." The park is on property that was under cultivation during the Revolution, though the old house burned in 1948, and the house that serves as the activity center dates from 1954. The park sponsors educational programs and has a reference library devoted to horticultural materials, classrooms, and a shop that features rare horticultural items.

Directly across Red Hill Rd. is the entrance to Tatum Park (732-671-9283), 365 acres of rolling hills, open fields, and woods. There are hiking trails and open play areas, and the activity center (formerly a radio-wave generation center for the U.S. Army) features cultural programs open to the public.

South of the village on Oak Hill Rd. (east off NJ 35) is Poricy Park Nature Center (732-842-5966). On the property are an 18th-century farm listed in the state historic register, a 250-acre nature preserve, a 65-million-year-old fossil bed, a 20-acre pond, and four miles of trails that wander through fields, forests, and marshlands. Educational programs concentrate on the environment and colonial history. Nature center open weekdays, 9–4; Sunday, 12:30–3:30; groups by appointment.

For over 25 years, the Visiting Nurse Association of Central New Jersey (732-747-1204) has been sponsoring a December holiday house tour, concentrating on houses in the Middletown-Rumson-Locust area, which includes some of the most affluent parts of the county. Not all the houses are historic, but in past years buildings on the tour have included restorations of 19th-century mills and farmhouses, converted turn-of-the-century riverside luxury cottages, and converted garages from large estates.

Milford Hunterdon 1,273

C 519, 627

Like many other Delaware River towns, Milford began as a ferry location. Although there was a sawmill here in the mid-18th century, real development came toward the end of the century with the establishment of three mills and the ferry. The town was known first as Burnt Mills (after fire destroyed an early mill), then

Burnt Mills Ferry, then Mill-ford Ferry. Milford lost its ferry in 1842 when the first bridge was built. Today's bridge, dating from 1933, was built on the concrete and rubble abutments from the original wooden bridge.

Today Milford is a lovely river town with many old buildings, antique

shops, inns, and restaurants. It has attracted artists, among them Clarence Holbrook Carter and Wanda Gag, the children's book writer and illustrator. Many of the old buildings have been converted to other uses: the railroad station, for example, has shops and a restaurant; other old houses have been converted to restaurants or bed-and-breakfasts. The Riegel Paper Company, which began operations up the river in a converted gristmill in Finesville in 1862, had one of its largest plants in Milford; in 1995 the plant was being run by Crown Bantage.

The last two miles of 627 heading into Milford are particularly beautiful, though this is not the route to take if you are in a hurry. The road, in many places only wide enough for one car, goes right along the Conrail tracks and the Delaware River.

The Volendam Windmill Museum (231 Adamic Hill Rd.; 908-995-4365) can be reached off 627 about 3¹/₂ miles northwest of Milford. (Take Crabapple Hill Rd. to Alfalfa Hill Rd. and watch for signs. You can also take Mt. Joy Rd., farther north on 627, to Adamic Hill Rd., or approach from 519 and go west on Anderson Rd., jog left when it ends, and turn right on Adamic I Iill Rd.) The roads climb through lovely woods that have become increasingly developed. The windmill, which stands near a splendid 18th-century house, is a replica of a Dutch or Danish wind-driven grain mill. Open May–September, weekends, weather permitting, 12–4:30. Admission fec.

Continuing north on 627 will bring you to Finesville. Situated on the Musconetcong River, considered one of the state's finest trout streams, this attractive village has many lovely stone buildings. The church dates from 1879. The Alba Vineyard (c 627, slightly over 2 miles south of Warren Glen and north of the bridge at Riegelsville; 908-995-7800) grows grapes on the slopes of the Musconetcong Valley above a 100-year-old cut-limestone dairy barn and outbuildings. Open for tours, tasting, and picnics, Saturday, 10–6, Sunday, 12–5; groups and other times by appointment.

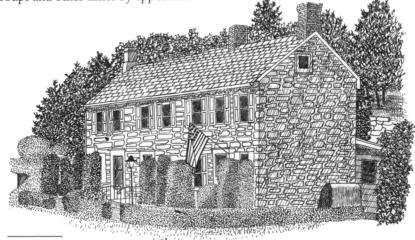

FINESVILLE

About two miles north of Finesville (take 627 north to Warren Glen and turn south on 519 to the intersection with Dennis Rd.) is the Musconetcong Gorge Nature Preserve, part of the Hunterdon County park system. This is a rugged area of over 400 acres, with steeply wooded terrain overlooking the Musconetcong River. There are many small streams and a variety of plant and wildlife, and you can hike, fish, and hunt.

Northeast of Milford, near Pattenburg, is the King's Road Winery (C 579 just north of the intersection with 614; 800-479-6479, 908-479-6611), operating out of a late-19th-century barn with stone cellars. There is a picnic area on the grounds, and the winery is open for tasting Wednesday–Sunday, 12–5; tours by appointment.

Millburn Essex 18,630

NJ 24, 124, C 527

Settled early in the 18th century, Millburn became a wealthy commuter town in the 19th. Within the township is Short Hills, established in 1877, which for many typifies the affluent suburb. The Short Hills Park historic district* encompasses 19th- and 20thcentury buildings in the area roughly between Hobart Ave. and

Parsonage Hill Road. At the eastern edge is the Wyoming historic district, listed in the state register of historic places, also with 19th- and 20th-century buildings, roughly bounded by Sagamore Rd. and Wyoming Avenue. Walking-tour brochures are available at the Millburn public library (200 Glen Ave.; 973-376-1006). Open Monday–Thursday, 9:30 A.M.–8:45 P.M.; Friday and Saturday, 9:30– 5:15; Sunday, 1–4:45; closed Saturday, Memorial Day–Labor Day.

At the westbound waiting room of the Short Hills railroad station (I Station Plaza; 973-376-7048) is a museum run by the Millburn–Short Hills Historical Society. The station, built in 1907 of brick with glazed clay tile roofing and mahogany detailing, has recently been restored and contains artifacts and photographs relating to the history of the town and the area. The society also uses the building for educational programs. Open Wednesday, 2–4, and one Sunday a month; groups and other times by appointment.

Just east of the station is the Cora Hartshorn Arboretum and Bird Sanctuary (324 Forest Dr. S.; 973-376-3587), over 16 acres of natural woodlands with three miles of trails. The arboretum was founded in 1923 by Cora Hartshorn, the daughter of the founder of Short Hills (and inventor of the spring-loaded window shade), on land given her by her father. Stone House, built with traprock and oak from Hartshorn property, houses a small museum with changing nature exhibits and a small collection of live animals; there is also a library. The grounds and trails are open daily, dawn–dusk. The museum is open Monday and Friday, 9–3; Tuesday–Thursday, 9–4:30; Saturday, 9:30–3:30; if, however, a class is using the museum, it is not open to the public, so it is best to call ahead; tours by appointment. Closed during school vacations and state holidays.

Part of the South Mountain Reservation is in Millburn. This 2,000-acre park has many miles of trails, many lookout points, picnic areas, and a wildlife preserve (see also West Orange). At the entrance to the reservation is the Paper Mill Playhouse (Brookside Dr.; 973-376-4343). The theater takes its name from its original house, a converted 18th-century mill that had continued to produce paper until after World War I. After a fire in 1980 destroyed all but a few fragments of the mill, the theater built a new house on the site (and incorporated some of the fragments). The company puts on six shows a year, specializing in musicals; it also hangs art exhibits that change with each production. Each year there are shows from the New Jersey Watercolor Society, from the Millburn–Short Hills Art Center, and of miniature art; other shows have included prints, soft sculpture, and oriental rugs. Open September–July, Friday, 12–3, and one hour before performance through intermission (for information on the exhibits, call 973-379-3636, ext. 2272).

Millstone Somerset 450

C 514, 533

Tiny in area as well as population (it occupies 0.6 sq. mi.), this picture-book village and former agricultural center situated on the Millstone River and the Delaware and Raritan Canal* was once called Somerset Courthouse because for almost 50 years in the mid-18th century it was important enough to be the county seat.

(After the British burned the courthouse in 1779, the seat was moved to Somerville.) Millstone's 19th-century historic district* includes Ann, S. River, West, and Main sts., Alley Way, and Amwell Road. Set back from the road in the midst of these 19th-century houses, but not visible from it, is one of Frank Lloyd Wright's Usonian houses.

In what was once a blacksmith shop is the Old Millstone Forge Association's blacksmith museum (c 533; 732-873-2803). The building probably dates to the mid-18th century, and the collection of old blacksmiths' tools, both hand- and machine-made, includes some late-17th-century Dutch pieces. There are also wheelwrights' tools on display. Demonstrations are given. Open Sunday, 1–4, April through June and October to the 2d Sunday in December; groups by appointment.

The Millstone Dutch Reformed Church (Main St. and Amwell Rd.) dates from 1828. Troops came through Millstone during the Revolution, and George Washington stopped at the John van Duren house (1754; W. River Rd., 1 mile south of Amwell Rd.) after the Battle of Princeton; he may also have made it his headquarters on other occasions.

Across the water is East Millstone, even smaller but also picturesque. Its 18th- and 19th-century historic district* includes the area along Amwell Rd. and the canal. Just beyond the bridge is the Franklin Inn (2371 Amwell Rd.; 908-873-2958, 908-297-2641, 908-873-5244). Built in 1734 it served as Cornwallis's headquarters for a week. It was an important stagecoach stop and active during the life of the canal; maintained by the Meadows Foundation (see below), it is being restored and now houses a bookstore. Note also, closer to the canal, the locktender's house.

About a mile east of the village, on the south side of Amwell Rd., is the Hutcheson Memorial Forest, formerly Mettler's Woods, a national natural landmark. This is one of the oldest undisturbed stands of oak-hickory forest remaining in the United States. Although not virgin forest, it has apparently never been cut over and has not burned since the early 18th century. The original 90-acre tract (it is now over 300 acres) was bought by the United Brotherhood of Carpenters and Joiners of America and given to Rutgers University, which uses it as a laboratory for ecological and biological research. The woods have been described as a living museum of the eastern United States as it was 200 years ago, and "the most intensively studied primeval woods on the continent." Open for guided tours by appointment only (write Director, Hutcheson Memorial Forest, Department of Biological Sciences, Rutgers University, Piscataway 08903).

On the north side of Amwell Rd. is Somerset County's 467-acre Colonial Park (Mettlers Rd., with access from Amwell Rd. and Elizabeth Ave.; 908-234-2677). In the western section are a 5½-acre arboretum and the Rudolf van der Goot Rose Garden, with over 4,000 plants and a sensory and fragrance section for the handicapped. The western boundary of the park includes frontage on the canal and the river. Park facilities include a canoe-launching ramp as well as family and group picnic sites, playgrounds, fishing ponds, open playing fields, a bicycle path, hiking and bridle trails, and tennis courts (732-873-8716). The Spooky Brook Golf Course (Elizabeth Rd.; 732-873-2241) is at the eastern end of the park. Both open daily, dawn–dusk.

North and east of Colonial Park in the town of South Bound Brook (take Elizabeth Ave., c 621, to New Brunswick Rd., turn right, and then left on Davidson Ave.) is the Ukrainian Orthodox Memorial Church Museum (135 Davidson Ave.; 732-356-9105). The museum, located in the basement of the church, is part of a large complex that forms the administrative center of the Ukrainian Orthodox Church and includes, in addition to the church and museum, a cultural center, a store, a library, and a cemetery. In the 18th century this was the Henry Fisher farm. At least one of the remaining houses dates to the 18th century, and the cemetery, which serves as a burial place for Ukrainians from a wide area, is attached to the old Fisher family cemetery. Much of the material in the museum is church-related, and among the items on view are paintings, books, and a striking collection of embroidery. Open Wednesday, Friday, Saturday, 9–3 or by appointment. The Revolutionary War affected South Bound Brook, too, for Baron von Steuben (see River Edge) was on duty here in the winter of 1778–79.

The New Jersey Flower and Garden Show, a spring event, in the 1990s moved from the Morristown National Guard Armory to the Garden State Exhibit Center (50 Atrium Dr.; 732-469-4000), off Davidson Ave. southwest of the Ukrainian complex.

If you continue east on Amwell Rd. from East Millstone and turn right on S. Middlebush Rd., you will come to three of the houses preserved by the Meadows Foundation (1289 Easton Ave.; 732-828-7418). Hageman farm (209 S. Middlebush Rd.; 732-873-8718) is just south of Bennetts Lane. The house was started in the mid-18th century, but the main portion of today's house and the barns were built in the 19th. The Wyckoff-Garretson (215 S. Middlebush Rd.; 732-873-1792) and the Van Liew-Suydam houses (280 S. Middlebush Rd.; 732-873-3417) are south of the farm; the Van Liew is set back from the road. Both date to the 18th century, and the earliest portion of the Wyckoff house is probably the oldest structure in Franklin Township. Taking Amwell Rd. east until Demott La. and Demott to the end brings you to the Van Wickle house* (1722), headquarters for the foundation, which also maintains the Blackwells Mills Canal House (see Griggstown). All the properties managed by the foundation are open the second Sunday of the month, 1-3, and for special occasions; the foundation also sponsors concerts at its headquarters and at the First Reformed Church in New Brunswick, and tours can be arranged by appointment (732-246-2184).

Milltown Middlesex 6,968

OFF US I

Known in the early 19th century as Bergen's Mill after Jacob I. Bergen, who built a gristmill on Lawrence Brook, Milltown for a time was the center of the nation's rubber industry (at the end of the 19th century the industry shifted to Trenton and in the 20th century to the Midwest). In 1843 the Meyer Rubber Company

built a plant* on Bergen's mill site (Main St. at Mill Pond); the plant was later run by the India Rubber Company and the International Rubber Company before the Michelin Tire Company bought and expanded it in 1907. At peak production the Michelin plant employed as many as 3,000 people. The company stopped producing rubber in Milltown in the 1930s, and parts of the large complex have been converted to other uses.

The Milltown Museum (116 S. Main St.; 732-545-3497, 732-828-0249, 732-828-6987) occupies two mid-19th-century farmhouses, one of which may be the second-oldest house in town. The rooms are furnished with period furniture; the exhibits include the town's original post office, a schoolroom, a general store, a sewing room, a doll collection, and memorabilia and photographs relating to local history. There are also changing exhibits. Open 1st Sunday of the month, March–June and September–December, 1–3; groups and other times by appointment.

Next door to the museum and behind the red, fish-scale-shingle firehouse is the Eureka Fire Museum (732-828-7207). In a converted 1899 barn the museum has a large collection of early fire-fighting equipment, with rotating exhibits of old apparatus, extinguishers, helmets, hand-pulled hoses, and the like. The museum has plans to expand into a second building. Guided tours by appointment. A walk along Main St. will reveal many mid- and late-19th-century buildings. Some, like the hardware store at Main and W. Church St. or the funeral home at 170 Main, have been converted from homes to other uses. On Washington Ave. the old Russell Playing Card factory* has been converted to condominiums.

Millville Cumberland 25,992

NJ 47, 49, C 555

Situated at the head of the tidewater of the Maurice River, Millville was settled as a shipping center around 1720. Word of vast sand deposits led to the establishment, in 1739, of Millville's first successful glassworks. Over the years glassmaking became Millville's major industry; it remains that today, followed by

aircraft repair.

Wheaton Industries, once the largest family-owned glassworks in the world, descends from a firm founded in 1888 by Dr. T. C. Wheaton, who arrived in Millville in the 1880s intending to establish both a medical practice and a pharmaceutical business. The need for pharmaceutical bottles led him to buy into a recently established glassworks. Although Wheaton Industries was sold in the mid-1990s, it still employs 2,500 people in Millville alone.

In Millville's first bank,* built in 1857 (E. Main and 2d sts.; 609-825-7000, ext. 275 weekdays, 609-327-4944 weekends), is the museum of the Millville Historical Society. The collection contains a variety of artifacts and old records, including a display of Millville glass and a ship's bell alleged to have come from Spain on Columbus's last voyage. Open Wednesday and Sunday, 1–4; groups by appointment.

Wheaton Village (Glasstown Rd., off Coombs and Valley rds. between NJ 55 and Wheaton Ave; 609-825-6800) is a re-creation of an 1880s South Jersey town. Founded in 1970 by Frank H. Wheaton Jr., T. C. Wheaton's grandson, it centers on the Wheaton Museum of American Glass and a replica of his grandfather's first factory. The museum contains one of the world's largest collections of American glass, with the style of the rooms designed to reflect the era of the glass on display. The museum has rescued chandeliers from the Roxy Theater in New York City and the Traymore Hotel in Atlantic City. Bottles, decorative glass, paperweights, and lighting devices are some of the items on display.

The glass factory has been re-created following early photographs and partial blueprints (but with modern precautions against the fires that plagued 19th-century glassworks). You can watch the glassblowers while they work; at certain times of the day they give a set talk explaining what they are doing. Ask at the gatehouse for the day's demonstration schedule. You can also arrange in advance to blow your own paperweights.

The Down Jersey Folklife Center opened in the village in the summer of 1995. Devoted to preserving the folk traditions of southern New Jersey, the

center contains a small museum and sponsors a variety of programs featuring folk traditions from boat-building to origami. Also in the village are a Crafts and Trades Row, where potters, a decoy carver, and a lampworker demonstrate their crafts; a miniature railroad; a playground; and various old buildings, shops, and restaurants. The village sponsors a large variety of special events, many focusing on antiques, collectibles, and cars. Open 10–5, daily, April– December; Wednesday–Sunday, January–March (the last glass demonstration is at 3:30); the Crafts and Trades Row is not open in the winter except for special occasions; closed Easter, Thanksgiving, and Christmas. Admission charge (except for the stores and restaurants). Group tours by appointment.

Millville is also the home of what at one time was the largest Americanholly farm in the United States (the English-holly farms in Oregon are bigger). Millville Holly Orchard and Ornamental Tree Nursery grew out of the aversion the president of the New Jersey Silica Sand Company had to sending liquor as a Christmas gift to his customers and employees. In 1926 he began sending boughs of holly, and in 1939, after frost had killed the native trees, he planted 2,800 trees. The farm has passed through various hands and various modes of operation (at one time a holly-motif museum was open to the public); today there are 40 varieties and some 3,300 trees planted on 50 acres. Also on the property is a conference center, and some electricity is generated by solar panels.

At the Millville Municipal Airport (southwest of town off Cedar St., c 610) is the Millville Army Airfield Museum (609-327-2347). Said to be the first airfield constructed for defense in World War II, it retains many of its original buildings. Plaques identify the functions once served by the look-alike bare-bones buildings. Open Wednesday evening, 7–9; weekends, 10–4.

Several wildlife management areas lie close to Millville. Northwest of the center of town is Union Lake, the largest freshwater lake in southern Jersey. Created in the 1860s (by damming the Maurice River), the lake has long had a reputation as a good place to fish (in 1978 a 27-pound striped bass was caught here), and you can hike in the surrounding area. At the head of the lake is Union House, which dates at least to the early 18th century. The first known record of the house is on a 1709 deed. Roughly 40 years later William Penn's sons added the main structure you see today. The house is furnished with period pieces. Tours can be arranged through the Millville Historical Society (call 609-825-0789); donation requested.

South of Millville, on c 555, is the Edward G. Bevan Wildlife Management Area (formerly the Millville Wildlife Management Area). One of the oldest such areas in the state (it was started in 1932), it contains over 12,000 acres of woodlands and fields and is a good place for hiking, fishing, and hunting. You can also fish in the Menantico Ponds Wildlife Management Area, just east of Millville off NJ 49. The access road, just after the Menantico Creek crossing, is suitable for walking. Some seven miles east of Millville, on NJ 49, is the Peaslee Wildlife Management Area. Its 20,000 acres make it one of the largest such areas in the state. It consists of pine-oak woodlands and lowlands, and it is

bordered on the east by the upper reaches of the Tuckahoe River. It has a field-trial course and is open for hiking, fishing, and hunting.

Montague Sussex 2,832

US 206, C 521, 650

Ş

A stagecoach stop on the Hoboken-Buffalo route in the 18th century, Montague is now within the Delaware Water Gap Recreation Area (see Bevans and Walpack). The Foster-Armstrong house* (Old Mine Rd.) dates from the 1790s (with a post-1812 addition) and served as a hotel for many years. According to local

legend, rafters taking logs from the north to the Trenton sawmills used to stay here. The Neldon-Roberts Schoolhouse (US 206; 973-293-7854) was probably built in the early 1800s and was used as a schoolhouse before it became a private residence. It is now run by the Montague Association for the Restoration of Community History and contains a 19th-century schoolroom; paintings showing the history of the area; an exhibit on quilting, spinning, and weaving; and changing exhibits and craft demonstrations. On the grounds is a colonial herb garden. Open weekends, mid-June–September, 1–4, and for two weekends in late November or early December for holiday events. The association also sponsors weaving classes in the Foster-Armstrong house. Group tours of both sites by appointment.

South of Montague (off us 206) is the Hainesville Wildlife Management Area, almost 300 acres of fields, hedgerows, and woodlands, with a 30-acre pond. You can fish here and in the Little Flat Brook.

East of Montague and surrounded by Stokes State Forest and High Point State Park (take Deckertown Rd., c 650) is Mashipacong Bogs, 1,000 acres formerly owned by Doris Duke (see Somerville), now a Nature Conservancy preserve (908-879-7262). Part of the land, described as one of the state's last boreal forests, is leased to a camp for inner-city youth; the rest is undeveloped. A short loop trail goes into the preserve roughly a quarter of a mile before the intersection of Deckertown and Grigger roads.

Montclair Essex 37,729

GARDEN STATE PKWY EXIT 148, C 506, 509

Although Montclair was first settled in the 1660s, today's community took shape in the 1860s, when Montclair broke away from Bloomfield in a dispute over the routing of a railroad line. Frank and Lillian Gilbreth, the efficiency experts about whom *Cheaper by the Dozen* was written, raised their large family (12 children) on

Eagle Rock Way; a junior high school is named after the painter George Inness, who lived in Montclair for a time; the noted golf course designer Robert Trent Jones was a long-time Montclair resident; Yogi Berra has been a Montclair resident.

Like many of the early suburbs, Montclair suffered a period of population decline, but the community engaged in a vigorous program to revitalize its downtown. The Montclair railroad station* (Lackawanna Plaza), for example, designed in 1913 by William H. Botsford, who also designed the railroad terminal in Hoboken, has been converted to commercial purposes. A nearby school from the same era (Baldwin St. and Glen Ridge Ave.), with its 12-foothigh windows and all, has been converted into apartments.

The Israel Crane House* (110 Orange Rd.; 973-744-1796) was built in 1796 by Israel Crane. A direct descendant of one Montclair's original settlers (part of today's Montclair was once called Cranetown), Crane was a highly successful businessman who engaged in a wide variety of enterprises from cider, cotton, and woolen mills to turnpikes and quarries; the writer Stephen Crane (1871-1900) was a descendant of this family. The house, which was altered in the mid-19th century, is now run as a house museum by the Montclair Historical Society. The only building remaining in Montclair with connections to the carly settlers, and a rare example of a North Jersey federal mansion, it has been furnished to reflect the period 1796–1840. Demonstrations of open hearth cooking are given on the Sunday tours. The house is specially decorated at Christmas, and the hours are expanded then (call for the exact schedule); the society also offers a variety of "historic-skills classes" in the winter and spring. Open mid-September-mid-June, Sunday, 2-5, Wednesday by appointment; groups by appointment. Also on the property is a c. 1820 house, in which you will find the contents of an actual country store and a post office. A library focusing on local history, Montclair authors, and the colonial period is housed in a Victorian home next to the Crane house at 108 Orange Rd. (call for the library schedule).

The Montclair Art Museum* (3 S. Mountain Ave.; 973-746-5555), housed in a Greek Revival 1914 building, has an unusually fine permanent collection for a town the size of Montclair. The collection specializes in American painting and sculpture from the mid-18th century to the present and includes Native American art. The museum puts on changing exhibitions and sponsors classes, workshops, lectures, and other special events; gallery talks take place most Sunday afternoons. The museum's grounds, known as the Howard A. Van Vleck Arboretum, are of particular interest. The trees are all labeled, and a guide to the grounds is available at the museum shop. Open Tuesday, Wednesday, Friday, and Saturday, 11–5, Thursday and Sunday, 1–5; during the summer (usually defined as early July through early September), Wednesday–Sunday, 12–5. Admission charge.

The grounds at Van Vleck's own house (21 Van Vleck St.; 973-744-4752) are also noteworthy; built in 1916, the house is now a center for nonprofit activities. The gardens include many of the varieties developed by Van Vleck, and include a striking display of rhododendron. The gardens are open to the public each spring on a limited schedule; call for the exact times.

The fine and performing arts are stressed at Montclair State University (Normal Ave. and Valley Rd.; 973-655-4000). The university, established in 1908

on a 200-acre campus, sponsors a variety of programs in theater, music, and dance. Its student programs are open to the public (call 973-655-5112 for information on theater and dance), as are its art galleries (973-655-7640). At both the Main Gallery (Life Hall) and Gallery One (Life Hall Annex), shows focus on contemporary art and change roughly once a month. Open Monday, Wednesday, Friday, 10–4; Tuesday, Thursday, 10–6. The music department offers over 100 concerts a year that are open to the public, including student and faculty recitals, campus groups, and guest performers. The Montclair-Kimberly Academy (Bloomfield Ave. and Lloyd Rd. campus; 973-746-9800) also sponsors a professional summer theater.

For such a densely settled area, the amount of open space is surprising. At the northwestern end of town are Mills Reservation (Reservoir Dr.; 973-268-3500) and Mountainside Park (500 Upper Mountain Ave.; 973-783-5974). The former is a 157-acre county facility with a wildlife reserve, a lookout point, and bridle and hiking trails, the latter a town facility with the world-famous Presby Iris Gardens* (1927). The gardens contain 4,000 kinds of iris (totaling some 30,000 individual plants), each labeled with the year it was first recognized or hybridized; the earliest dates from the 16th century. The display usually reaches its spectacular peak from the last week in May through the first week of June. At the 1870s Walther house next door, there is a wonderful Victorian garden. When the planned carriage house is completed, the educational programs for children will be expanded. The office is open weekdays, 9–12; during bloom season (20 May–10 June), the garden is open 10–8; guided tours by appointment. The park itself is open during daylight hours.

The opportunities for bird-watchers are also remarkable. In the northwestern area is the Montclair Hawk Lookout (Edgecliff Rd.; 201-891-2185; take Upper Mountain north to Bradford, turn left on Bradford, right on Edgecliff), a New Jersey Audubon Society sanctuary and a national natural landmark situated on an outcropping on the first Watchung ridge. Because of the ridge, there are updrafts, essential to hawks on their long migrations. The season runs from mid-September through November, with the peak during the first four weeks. In mid-September you can see as many as 2,000 broad-winged hawks in a few hours, and although it doesn't happen often, there have been days when 10,000 hawks have been spotted. This is the second-oldest continuous hawk watch in the country. Farther east is the town's Alonzo F. Bonzal wildlife preserve (Riverview Dr. off Alexander Ave.), 23 acres of natural area with trails.

On the eastern edge of town is Brookdale Park (Bellevue Ave.; 973-268-3500), which Montclair shares with Bloomfield. This 121-acre park is one of the many Essex County parks to have been designed by the noted Frederick Law Olmsted firm. It has a rose garden, fitness and interpretive trails, playgrounds and playing fields, tennis courts, and facilities for fishing and picnicking.

Moorestown Burlington 16,116

NJ 38, C 537

A Quaker town that was laid out in the 1720s, Moorestown is the home of the well-known Moorestown Friends School.* Founded 200 years ago, the school has grown and now occupies a complex off W. Main St. in the center of town. Several buildings in the town center are of particular interest. Note the old town hall*

(40 E. Main St.) and the First Baptist Church (1877; 19 W. Main St.), connected to a 19th-century brick building, once the parsonage. The Smith-Cadbury Mansion* (12 High St.; 609-234-9087, 609-235-0136), c. 1738, 1766, serves as the headquarters of the Moorestown Historical Society. The house has been furnished almost entirely by donations and concentrates on the period 1830–40. On display are examples from the society's extensive collection of period clothes and some Moorestown memorabilia. Open Tuesday, 1–3, and by appointment. The historical society also publishes walking tours of Moorestown. Taking Main St. (c 537) west out of town takes you through a particularly lovely stretch of houses. At 436 E. Main St. (just west of Poplar Ave.) is the bondsman's house, c. 1780, which is one room wide and two rooms deep, with 12-inch-thick stone walls.

A well-known worshipper in the Friends Meeting House (1802; E. Main between Chester Ave. and Schooley St.) was Samuel Allen, inventor of the hand cultivator, a manure spreader, and the Flexible Flyer sled. The Lutheran Home (E. Main St. between Zelley Ave. and Curtis) was his house, which, according to legend, the meeting considered too ostentatious for a Friend. In 1920 it was bought by Eldridge R. Johnson, founder of the Victor Talking

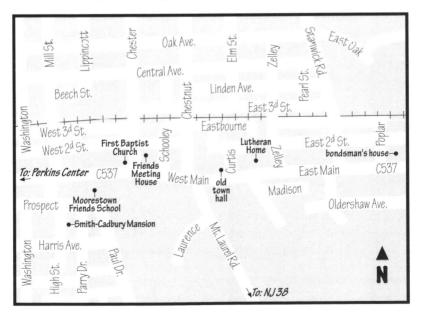

Machine Co. (later part of RCA; see Camden); it was bought by the Lutherans in 1946.

The Perkins Center for the Arts* (Camden Ave. and Kings Highway; 609-235-6488), located in a 1910 Tudor house on the site of a nursery that specialized in ornamental trees as far back as 1815, features fine arts and crafts exhibits, chamber music concerts, special events, and a wide range of classes in the visual and performing arts. There are six shows a year, each lasting three to four weeks; they include an annual juried photography show, a members and faculty show, a works-on-paper show, and a special children's show (Young at Art). The center has a summer day camp for children from Camden and Moorestown, and the parks department puts on a summer concert series at the house. A small arboretum is maintained by the Moorestown Garden Club. Gallery open Thursday and Friday, 10–4, weekends, 1–5.

Morristown Morris 16,189

I 287, US 202, NJ 24, I24, C 510, 511

The county seat of Morris County, Morristown was settled early in the 18th century and developed as an iron town and commercial center. It played an important role in the Revolution: after the victories at Trenton and Princeton in the winter of 1776–77, George Washington brought his tired troops here to spend the

winter. While the troops encamped in the Loantaka Valley, Washington made his headquarters at Arnold Tavern in the center of town. He returned again in 1779–80; this time he stayed at a substantial private house in Morristown while the troops were quartered at Jockey Hollow, some six miles southwest of town. The strategic location of Morristown was such that there were always soldiers stationed here during the war, and the British army never went through Morristown. After 1838, when the Morris and Essex Railroad provided connections to Newark, the town attracted large numbers of wealthy residents, and it developed a reputation for having the densest concentration of millionaires in the state. Because of the Depression, many owners of large estates and houses could no longer maintain them, and you will come across several public buildings in Morristown that once were private homes.

Morristown is at the center of an explosive growth in corporate headquarters that took place in the '70s and '80s. Much of that growth occurred in the surrounding townships, but there are some striking signs of it in town as well, the most obvious being Headquarters Plaza. Despite these taller buildings and the enormous increase in traffic, the look of Morristown is still dominated by its large green, which was laid out in 1715 and is one of the few surviving town greens in the state. It is also interesting that Morristown has the feel of a city rather than of a town; in fact, its population is not that large and has hardly increased at all over the last 60 years.

Morristown's historic district* includes Green, South, DeHart, Elm, Wetmore, Madison, Ann, Court, High, Hill, James, King, Market, Morris, Oak, Prospect, Washington, and Pine sts.; Macculloch, Maple, Ford, Mt. Kemble, Speedwell, Western, Wetmore, and Colles aves.; Altamont Ct.; Catherine La.; Miller Rd.; and Blachley, Franklin, King, Odgen, Park, Schuyler, and Farragut places. This is primarily a 19th- and 20th-century area, but there are still some 18th-century buildings to be seen in town, among them the Condict house* (51 South St.), now the Women's City Club, and the Timothy Mills house* (27 Mills St.), c. 1740. Note also the courthouse* (Washington St. between Court St. and Western Ave.), built in 1827; the Presbyterian Church (65 Park Pl.), from 1895; and the former town hall (South St.), built just after World War I as a private house. At 100 South Street in a 1937 movie house the Community Theater (973-993-1331) features a variety of musical events, including concerts by several orchestras and an international festival of the arts. If you happen to notice an unusual number of Seeing Eye dogs as you wander through the center of town, this is because Seeing Eye Inc., which trains the dogs, has its headquarters on Maple Avenue.

Several sites and buildings related to Washington's second time in Morristown make up the Morristown National Historical Park, the first historical park established by the federal government (in 1933). (Arnold Tavern, where Washington stayed the first time, was moved in 1886 to make way for an office building; it later burned and had to be torn down.) In addition to the Ford Mansion (230 Morris St.; 973-539-2085), where Washington had his headquarters, and the Jockey Hollow Encampment Area, where the troops were quartered, the park includes a museum (located behind the Ford house), the New Jersey Brigade Area, and the site of Fort Nonsense. Jacob Ford Jr. was a wealthy Morristown merchant and powder maker who died early in the Revolution; his widow offered Washington the use of her beautiful Georgian house, built earlier in the 1770s. The house has been furnished to look as it did when Washington was in residence (this means much of it is quite sparsely furnished, as Mrs. Ford was concerned that her belongings not be pilfered by colonial troops). Adjacent to the Ford Mansion is the Historical Museum and Library, with displays relating to the 1779–80 encampment and other artifacts and memorabilia of Washington and the Revolution. Museum open daily, 9-5. Tours of the mansion leave from the museum daily, 10–4. Admission charged. Closed New Year's Day, Thanksgiving, and Christmas.

To reach the Jockey Hollow area take Western Ave. south for about six miles. On your way you will pass the entrance to the site of Fort Nonsense, an earthwork built on a 600-foot hill, fortified on Washington's orders in 1777. Nothing remains of the fortification, but there is an explanatory plaque and a view of the town that will give you a sense of why—situated as it is on a shoulder of Mt. Kemble with the Normandy Heights and the Watchung Mountains to the east, Gillespie Hill to the west, and Horse Hill to the north—Morristown was a strategically advantageous location. The fort's name is supposed to have developed because people forgot why the fort had been built and assumed it must have been created to make work. (Frank Stockton, who lived in Morristown for a while, accepted this theory, and in "The Story of Fort

Nonsense" he offers it as evidence for Washington's astute understanding of the need to keep his troops feeling useful.)

Some 10,000 troops were quartered at Jockey Hollow in 1779–80 and endured a winter worse than the one at Valley Forge. Model huts, like those the soldiers built for themselves, were re-created during the 1930s by the Civilian Conservation Corps, and the various areas used by the troops have been delineated and are clearly marked. Also at Jockey Hollow is the Wick House, a mid-18th-century farmhouse and garden, which have been restored to show how a prosperous farmer would have lived. According to legend, the Wick daughter hid her horse in the house to prevent the soldiers from appropriating it. You can pick up maps at the visitor center and take your own tour of the park, and there is usually someone around to answer questions. The New Jersey Brigade Area is two miles southwest of Jockey Hollow. This site, like Fort Nonsense, is not staffed, but there are interpretive signs. (The Cross Estate Gardens are nearby; see Bernardsville.) The park also has miles of trails for hikers, riders, and cross-country skiers, and there are picnic facilities and a lake for swimming in the adjacent Lewis Morris Park (see below).

The park schedule has been changing because of budgetary problems, so it is best to check before you go (this applies to the museum and mansion as well). The grounds at Jockey Hollow are open daily, dawn–dusk, and the visitor center and Wick House are open 9–5, daily, April–November, Wednesday–Sunday, December–March. Closed New Year's Day, Thanksgiving, and Christmas.

While Alexander Hamilton, who accompanied Washington to Morristown, was staying at the Ford Mansion, he courted and became betrothed to Elizabeth Schuyler, then visiting her aunt at what is now the Schuyler-Hamilton House (5 Olyphant Pl.; 973-267-4039). This colonial clapboard house has been lovingly restored with period furnishings by the D.A.R. and features a recreated colonial garden. Open Tuesday and Sunday, 2–5. Admission charged.

One of the local ironworks was Stephen Vail's Speedwell, which, in the early 19th century, built most of the machinery for the SS *Savannah*, the first transatlantic steamship. The ironworks was converted to a cotton factory in the 1820s. The first public demonstration of the telegraph took place at Speedwell in 1838: Vail's son had worked with Samuel F. B. Morse in developing it. Much of the Vail homestead has been preserved and forms the backbone of Historic Speedwell* (333 Speedwell Ave.; 973-540-0211), a national historic site. On the site are several 18th- and 19th-century buildings, including the Vail factory, now a national historic landmark. Not all the buildings were originally part of the Vail homestead. Exhibits in various of the buildings deal with early ironworks, the development of the telegraph, farm tools, and the like. Open May–October, Thursday and Friday, 12–4; weekends, 1–5; groups by appointment. Admission charge.

Another of Morristown's 19th-century residents who influenced the development of the state was George P. Macculloch, the driving force behind the construction of the Morris Canal. His house, started in 1810, lived in by his

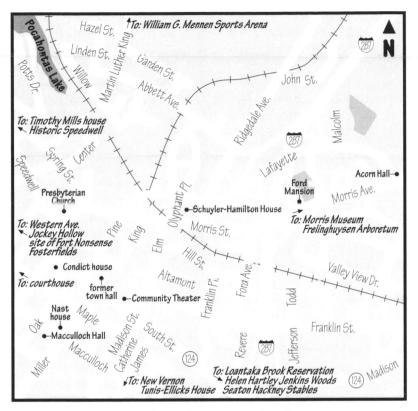

descendants until 1949, and now the Macculloch Hall Historical Museum (45 Macculloch Ave.; 973-538-2404), is furnished with period pieces. The permanent collection focuses on English and American decorative arts of the 18th and 19th centuries and incudes fine china, oriental rugs, and prints and drawings of Thomas Nast (see below). Changing exhibits focus on Morristown and New Jersey history and art. The gardens have been restored; of particular note is the wisteria, apparently brought from Japan by Commodore Matthew C. Perry. Museum open Thursday and Sunday, 1–4; groups by appointment. Admission charged. Gardens open daily until dusk.

One of Morristown's renowned citizens at the turn of the century was Thomas Nast, remembered today for having invented the donkey and elephant as symbols of the Democratic and Republican parties and for popularizing the image of Uncle Sam in striped trousers and tall hat, and, possibly, that of Santa Claus suggested by Clement Moore's "The Night before Christmas." To his contemporaries, however, he was known for his crusade against the corruption of Boss Tweed and Tammany Hall. His house,* known as Villa Fontana (Macculloch Ave. and Miller Rd.), built in the 1860s, is a national historic landmark.

The Morris Museum (6 Normandy Heights Rd.; 973-538-0454) is a general museum with permanent and changing exhibits in the arts and sciences. Among the collections are dolls, toys, early American and Native American artifacts, and dinosaurs and fossils. Located in the former house of Peter H. B.

and Adaline Frelinghuysen, the museum also sponsors concerts and educational programs. Open Tuesday–Saturday, 10–5; Sunday 1–5. Admission charge.

Acorn Hall* (68 Morris Ave; 973-267-3465), an Italianate house built in 1853 and the headquarters of the Morris County Historical Society, is also a museum. Many of the furnishings have been in the house since it was built, and the gardens have been restored to represent a Victorian garden from the 1853– 88 period. Gardens open daily until dusk. House open March–December, Thursday, 11–3 (last tour at 2), Sunday, 1:30–4 (last tour at 3); groups by appointment other days. Closed major holidays. Admission charge.

On Whippany Farm, built in 1891 as a summer home for George Griswold and Sarah Ballantine Frelinghuysen, is the Frelinghuysen Arboretum (973-326-7600). The Morris County Park Commission uses the Colonial Revival house* as its administrative headquarters, but the extensive arboretum (127 acres) is open to the public. Among its attractions are a rose garden, a crabapple collection, a lilac garden, two self-guiding trails, and a braille nature trail. You can pick up maps and guides at the administration building. Tours of the arboretum are given weekends at 2, June–October.

About a mile west of the center of town (take Washington St., NJ 24, to Kahdena Rd.; 973-326-7645) is Fosterfields Living Historical Museum. This museum is actually a working farm, used to demonstrate farming methods from 1880 to 1910. The mid-19th-century main house was built by the grandson of Paul Revere, and for a short time in the 1870s it was rented to Bret Harte. There are several outbuildings and barns, including a recently restored carriage house, which has on display three carriages used by the Fosters. Among the animals are guinea hens (these were raised by the Fosters). Future plans include a transportation museum. Open April–October, Wednesday–Saturday and holidays, 10–5; Sundays, 12–5. In January and February Fosterfields is open on Saturday, 12–4, for demonstrations of ice-cutting, maple-sugaring, and cooking on a wood stove. Groups by appointment. On Labor Day weekend one of the most popular sheepdog trials in the Northeast—attracting some 4,000 spectators—takes place at Fosterfields (call 973-299-9785 for more information).

On a hill with lovely views into town is the campus of the Rabbinical College of America (Sussex Ave., off Speedwell Ave.), said to be the world's largest campus for the study of Hasidic Judaism. The original buildings were once the campus for a Catholic girls' reform school.

Adjacent to Jockey Hollow is Lewis Morris Park (also accessible from NJ 24; 973-326-7600), the oldest park in the Morris County park system. Named for the first governor of New Jersey, the park contains facilities for picnicking, swimming, boating, fishing, and camping. There are also several miles of hiking and cross-country ski trails, fields, open woods, and playing fields. The cultural center is used for occasional public concerts and is available for use by nonprofit groups.

South of town are the Seaton Hackney Stables (South St.; 973-267-1372), part of the Loantaka Brook Reservation (973-326-7600). The park stretches southward to include the Helen Hartley Jenkins Woods, an untouched forest with

trails suitable for bicycling, horseback riding, and hiking. Available in other parts of the reservation are picnic facilities, softball fields, a children's playground, a fitness cluster, and trails suitable for hikers, bicyclers, and crosscountry skiers.

North of the center of town is the William G. Mennen Sports Arena (E. Hanover Ave.; 973-326-7651), a two-rink skating facility with a year-round schedule. Special events are scheduled here, including an annual circus.

The county is also developing Patriots' Path, a network of trails and open spaces linking parks, watersheds, and historic sites in southern Morris County. Within Morristown you can pick it up at the arboretum and near Speedwell Village, among several other places. Running parallel to the New Jersey Transit lines from Morris Ave. to Convent Rd. in Convent Station is the Traction Line recreation trail. This two-mile paved path also has a fitness course.

About four miles south of Morristown (take James St. out of town to c 663) is the village of New Vernon. Its historic district* includes Lee's Hill, Village, Millbrook, and Glen Alpin roads. The Tunis-Ellicks House (Village and Millbrook rds.; 973-292-0161, 973-292-3661), a farmhouse built in 1795, is run as a house museum by the Harding Township Historical Society. Its restored kitchen wing is used for demonstrations of open-hearth cooking, and around the house is a re-created 1800 parlor garden featuring over 100 varieties of herbs and perennials. A tramp house dating to the 1870s has been reconstructed behind the house. Archives and office open Thursday, 10–4; house open by appointment.

Mountainside Union 6,657

US 2,2

First settled in the late 1660s by a group of miners from Cornwall, England, who were looking for mineral deposits in the Watchung Mountains, Mountainside is primarily a residential community. A large portion of Union County's 2,000-acre wooded Watchung Reservation falls within its borders. Within the reservation is the

Trailside Nature and Science Center (452 New Providence Rd.; 908-789-3670), a complex containing a visitor center, museum (built in 1941 and apparently the state's first nature center), and planetarium. The visitor center, a Michael Graves building dating to 1974, has permanent exhibits that focus on the history, both human and natural, of the reservation, pond life, and reptiles, and changing exhibits of artwork and photographs; it also displays various private collections. A bird-attraction area, and herb, wildflower, and fern gardens are here. Open daily (except New Year's Day, Easter, 4 July, Thanksgiving, and Christmas), 1–5. The museum's exhibits include taxidermy, birds of prey, fluorescent minerals, fossils, a weather station, and a butterfly garden. Open daily, 1–5, April to the 4th week of November and during Christmas and other winter school vacations; weekends, 1–5, the 4th week of November through March; closed the same holidays as the visitor center. The planetarium, opened

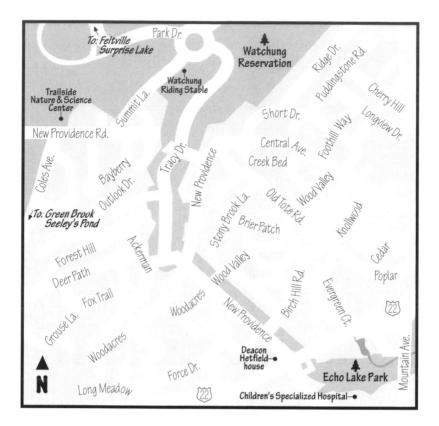

in 1969, has regular Sunday afternoon programs as well as weekday programs during the summer and other school vacations. Groups by appointment. The center supplies information and referrals on plants and animals including injured and orphaned wildlife. In winter all the trails are open for cross-country skiing.

Within the reservation are over 13 miles of marked hiking trails, several nature trails, and nearly 30 miles of bridle trails. Stop at the visitor center for maps. The Watchung Riding Stable (Summit La.; 908-789-3665) offers classes for adults and children and a summer camp for children, sponsors shows and a drill team, and rents horses by the hour. Open Tuesday–Sunday, 9–5 (rental hours are much more limited). Closed Memorial Day, Thanksgiving, and Christmas. You can explore the deserted village of Feltville* (see Berkeley Heights), a factory town dating from the 1840s; fish in Seeley's Pond and Green Brook; and fish and boat (with permission from the parks department) in Surprise Lake. The county nursery is also at the reservation.

Also partially in Mountainside is Echo Lake Park (Mountain Ave; 908-352-8431, 908-232-9819), one of the many parks in Union County designed by Frederick Law Olmsted. Its 140 acres offer opportunities for boating, fishing, and ice-skating. There are athletic fields, a playground, and picnic facilities, as well as a fitness course that includes a 10-station course for people in wheelchairs.

Part of the Children's Specialized Hospital (New Providence Rd. south of 22; 908-233-3720) is in a 1750 farmhouse built by Jonathan Crane. The house was

purchased in 1875 by Thomas Drew, related by marriage to the Barrymore family of actors; according to local legend, John, Ethel, Lionel, and Maurice Barrymore all stayed here. Although the hospital, which purchased the property in 1896, has altered the house considerably, it tries to maintain the look of a late-19th-century mansion in the older section. Call for more information about visiting.

Also on New Providence Rd. (on the westbound side of 22; 908-232-2400, 908-232-1552) is the Deacon Hetfield house* (c. 1760 with 19th-century additions), moved half a mile along 22 in 1985. This house, which retains its original floors, plaster, beams, and mantels, was the writer MacKinlay Kantor's home in the 1930s. The house is being gradually restored to serve as a museum and meeting place; the kitchen, part of the oldest section, has been restored as a colonial kitchen; the parlor is Victorian. Eventually, it will be open on a regular basis, but until then it is open by appointment.

Mount Holly Burlington 10,639

NJ 38, C 537, 541, 628, 630

2

Mount Holly, the Burlington County seat, was settled by Quakers in the 18th century and exhibits the characteristic brick buildings and wide streets of the early Quaker communities. A mill was

established on the north branch of Rancocas Creek in the 1720s and an ironworks and clothing factory in the 1730s. (The clothing

factory was set up by Josiah White, ancestor of the Josiah White who realized the importance of coal as a fuel and formed the Lehigh Coal and Navigation Company, and of Joseph C. White and Elizabeth C. White, who developed New Jersey's cranberry and blueberry industries respectively.) Also in the 1730s Benjamin Franklin published in the *Pennsylvania Gazette* an account of a Mount Holly witch trial in which two witches were accused of making the livestock sing and dance; accusers and accused had to stand trial together, and only the accused sank in the trial by water. Franklin apparently made up the tale out of whole cloth, but what motivated his choice of place is the source of much speculation.

By the late 18th century, Mount Holly was important enough to be made the county seat. The Burlington County Court House (west side of High St. at Union St.), a beautiful two-story brick Georgian building dating from 1796, may be the oldest courthouse in the United States still used for its original purpose. The two flanking buildings date from 1807.

Until its conversion into a museum in 1966, the Burlington County Prison Museum (128 High St.; 609-261-5068) was probably the oldest operating jail in the United States. Designed by the architect of the Washington Monument and built in 1810 according to the most modern principles of penal practice (prisoners had individual cells and could learn a trade in the prison workshop), the stone jail may have been the first fireproof building in the United States. The building is now a national historic landmark. Tours were temporarily canceled while the building underwent an extensive renovation. Call for the schedule.

What is probably the state's oldest surviving schoolhouse* on its original foundations is to be found at 35 Brainerd St. (609-267-0219). The one-room brick building, dating from 1759, is run as a museum by the New Jersey chapter of the Colonial Dames of America. It is furnished as a mid-18th-century school-room, with a schoolmaster's desk and Bible, benches for 15–20 children, old copybooks, period maps, and quill pens. Open by appointment. And what may be the oldest volunteer fire department in the state—it dates from 1752—is to be found at 15 Pine.

John Woolman, the Quaker whom many have credited with beginning the antislavery movement in this country and whose journal remains a well-loved and much-read book (the second book chosen for the Harvard Classics), was born nearby and moved to Mount Holly in 1740. The house he built for his daughter (99 Branch St.; 609-267-3226) in 1771 (the "i. e. w. 1783" visible on the south elevation refers to Jabez Woolman and his wife, who bought the house that year), with two acres surrounding it, once Woolman's orchards, has been

preserved as a memorial. There is a lovely garden, and in the peaceful room (used for the Mount Holly Quaker meetings January–April to save heating the big house in town) are a few mementos of Woolman and his times, among them his chair and a fragment of his handwriting. Open Friday, 10–2; groups and other times by appointment.

Woolman's grandfather Henry Burr in 1695 purchased Peachfield Plantation from the widow of John Skene, the first Freemason resident in America. Burr built a new, ironstone house on the property in 1725; a wing was added in 1732. The property remained in the Burr family until the late 1920s, when the house was severely damaged in a fire. Rebuilt and handsomely furnished with 18th- and 19th-century pieces, Peachfield* (Burr Rd.; 609-267-6996) is run as a house museum by the Colonial Dames of America; the Peachfield land is still being farmed. Open Thursday, 1–4, April–June, September, and October; groups by appointment. Admission charged.

John Brainerd, the famous missionary, was also active in Mount Holly, preaching here from 1767 to 1775, preaching at the Native American reservation in nearby Brotherton (now Indian Mills), and founding the Mount Holly Presbyterian Church. He sold the land on which the Friends Meeting House (1775; Garden and Buttonwood sts.) stands. The house was used by the Hessians as a slaughterhouse in December 1776 (apparently, the marks of their cleavers are still to be seen on the benches) and by the state legislature in 1779.

The Mount Holly Historic District* encompasses much of the town's center and includes 18th- and 19th-century buildings on Mill, Pine, High, Garden, White, Union, Bispham, Madison, Buttonwood, Branch, Church, and Ridgeway sts., as well as Park Dr. and Commerce Place. At 211 Mill St. is the Stephen Girard house (c. 1779). The American financier who was later to be prominent in financing the Revolution and who founded Girard College in

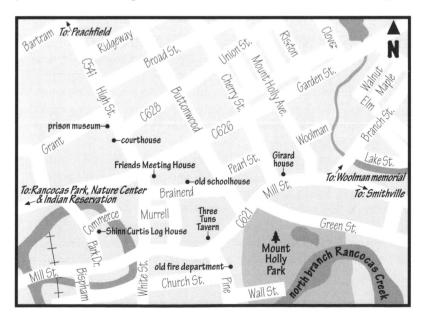

Mount Holly 201

Philadelphia lived here for a year or two. The Three Tuns Tavern (Pine and Mill sts.) dates from 1723. Off Pine St. is Mount Holly Park, situated on the holly-covered hill that gave the town its name. In the municipal parking lot is the Shinn Curtis Log House (Park Dr.; 609-267-9572). Discovered in the 1960s when Rancocas Rd. was being widened, this 1712 house has been moved and restored; it now serves as a visitor center and museum for the local historical society. The exhibits, which change from time to time, feature an eclectic set of artifacts, mainly relating to local and county history. Open Friday, 10–2; the society hopes to add regular Wednesday hours. Groups and other times by appointment.

Two miles east of Mount Holly (C 530 or 621 to the Smithville-Jacksonville Rd.; turn left off 530, right off 621) is Smithville County Park* (609-261-5068, 609-261-3780). In the 1850s Shreveville (as Smithville was then called) was the site of a large industrial complex, where cotton was spun, woven, and printed. The enterprise failed, and between 1858 and 1865 Shreveville lay dormant. In 1865 the complex was purchased by Hezekiah Bradley Smith, a machinery manufacturer from Lowell, Massachusetts. Smith converted the various cotton factories and began producing woodworking machines; eventually, the H. B. Smith Machine Company would produce one-quarter of the country's woodworking machinery. Its Star bicycle also proved highly successful. Smith renovated the workers' houses, built new ones, and added a boardinghouse with a dining room and theater. Three hundred acres of farmland were added to the complex, supplying much of the town's food. He expanded the Shreves' mansion, adding, among other amenities, a billiard room and bowling alley. After Smith's death the company continued, and one of its most remarkable achievements was the Bicycle Railway, intended to carry employees from Mount Holly to Smithville. Workers glided along a rail on special self-propelled bicycles, reaching a maximum speed of 18 miles per hour, but since a second rail was never built, there were always delays when a rider approached from the opposite direction. Although the Smithville company was a victim of the Depression, descendants of the family continued to live in the mansion until 1962. Since 1975 it has belonged to the county, and the facilities currently include the orientation and exhibit center, the Victorian house museum, the casino annex and art gallery, and the formal gardens and grounds. You can also take a self-guided walking tour. Open April-November, Wednesday and Sunday. Groups by appointment.

Northwest of Mount Holly, on the Mount Holly–Rancocas Rd. (C 626) is Rancocas State Park (609-726-1191), 1,200 acres of largely undeveloped land, suitable for fishing, hiking, and informal picnics, with a natural area along the Rancocas Creek. Part of the land north of the river has been leased to the Audubon Society. Its Rancocas Nature Center (794 Rancocas Rd.; 609-261-2495) encompasses 200 acres of fields, woodlands, and freshwater tidal marsh, with self-guiding nature trails. At the center is a small museum of artifacts relating to the natural history of the area; the center also sponsors educational programs and field trips. Open Tuesday–Sunday, 9–5. Just beyond Timbuctoo, off 626, is the Rancocas Indian Reservation (609-26I-4747), 250 acres the Powhatan Renape Nation has leased from the state. At the Indian Heritage Museum you will find some 30 cases containing a variety of exhibits and dioramas, some showing types of settlements or the part played by animals in different Native American cultures, others containing artifacts, ranging from musical instruments to weapons. There is also an art gallery, an outdoor re-creation of a Woodland village, and nature trails that take you down to the river, which splits at this point, one branch going to Millville, the other to the Delaware. Tours also include a look at the reservation's buffalo. An annual juried art show and festival takes place in the fall. Open Saturday, 10–3; Tuesday and Thursday by appointment, 10–3. Admission charged.

Mount Laurel Burlington 30,270

NJ TNPK EXIT 4, I 295, NJ 38, 73

Composed of several old communities, the modern township of Mount Laurel has seen its population increase more than fivefold over the last 30 years. The name of the town is familiar to many in New Jersey because of the 1975 and 1983 court decisions requiring the town to provide a certain amount of middle- and low-income

housing, a decision that has had repercussions in most other growing New Jersey communities.

Mount Laurel was the home of the noted suffragist Alice Paul (1885–1977). Trained as a sociologist, Paul helped revitalize a faltering women's suffrage movement, continuing her fight for women's rights after the 20th Amendment was passed. She drafted what is believed to be the earliest version of the Equal Rights Amendment. Paulsdale,* the Greek Revival farmhouse in which she was born (118 Hooten Rd.; 609-231-1885), was built c. 1840 and is a national historic landmark. Now home to the Alice Paul Centennial Foundation, Paulsdale is being restored; when the restoration is complete, the foundation, which is involved in outreach programs, hopes to use the house as a leadership development center for women and girls.

The Evesham Friends' Meeting House* (Moorestown–Mt. Laurel Rd.) dates to 1760 and replaced the original 17th-century building. The eastern end was built, with the help of Native Americans, from sandstone quarried across the street. The western end was added in 1798. The meetinghouse, which is only used for special occasions now, served as a barracks for the British in 1778. The Thomas Smith House* (also known as the General Clinton House, 1645 Hainesport–Mt. Laurel Rd.), built in 1764 with a second section added 20 years later, served as headquarters for the British commander that same year. Note also Farmers Hall* (Hainesport–Mt. Laurel and Moorestown–Mt. Laurel rds.), built in the 1860s.

PAWS Farm Nature Center (1105 Hainesport–Mt. Laurel Rd., east of Hartford Rd.; 609-778-8795) is an 18th-century farm sheltering wild and domestic animals. The farmhouse, smokehouse, icehouse, and dairy barn are open to visitors, and there are nature displays, an archaeological trail, and a self-guided nature trail. The farm sponsors a visiting-pet program, summer classes and field trips, educational programs, and a variety of special events. Open Wednesday–Sunday, 10–4; groups by appointment. Admission charge.

Mullica Hill Gloucester [Harrison Township]

US 322, NJ 45, 77, C 581

Mullica Hill, located in the center of one of the largest fruitgrowing regions in New Jersey, was settled in the late 17th century by four Finns, the brothers Eric, John, Olaf, and William Mullica. (Because Finland was controlled by Sweden at the time, they are often identified as Swedes.) There were many Quakers among the

early settlers as well, and the town is reputed to have sent an all-Quaker company to the Civil War. The Mullica Hill Historic District* includes over 100 buildings on East Ave., Woodstown Rd., and Church, High, Mill, New, and Union streets. The Friends Meeting House (c. 1806; Main St.) stands on land purchased from the first person to settle on the south side of Raccoon Creek. Many of the older buildings have been converted to crafts and antiques shops, and there are some 80 crafts and antiques dealers in Mullica Hill. The Merchants Association (609-881-6800) sponsors several special events: a juried art show the third weekend in July, a doll and toy show the third Saturday in August, a fall open house the third weekend in October, and a tour of historic houses the first Saturday in December. Because of the orchards, the area is particularly lovely in spring. (The peach blossoms are usually at their peak in early April.)

The Old Town Hall Museum (S. Main St., NJ 77, and Woodstown Rd., NJ 45; 609-478-4949) occupies the former town hall, built in 1871 by a private stock company. The museum, which recently underwent a massive restoration, includes a re-created country store as well as permanent and changing exhibits. The exhibits usually focus on South Jersey; past ones, for example, have dealt with agriculture, Quakerism, and images in art of southern New Jersey. Open March–May and October through the first week in December, Saturday, 11–4, Sunday, 1–4; groups and other times by appointment.

National Park Gloucester 3,413

DELAWARE RIVER, NORTHWEST OF WOODBURY

The site of an important battle in the Revolutionary War, Red Bank Battlefield,* a national historic landmark, is in the borough of National Park (so named because Congress in 1870 authorized the purchase of a portion of the battlefield). Fort Mercer was hastily erected here in the apple orchard of James and Ann Whitall

(he was a wealthy Quaker farmer and merchant) to protect the river approach

to Philadelphia. Troops under Christopher Greene built a trick wall in the earthworks and withheld their fire until the Hessian troops, who outnumbered them more than two to one, were so close that they ended up with wadding in their chests. Most historians believe the American victory helped delay the British navy's entrance into Philadelphia and helped convince the French to enter the war. Count von Donop, the Hessian commander, was fatally wounded in the battle.

After the engagement the James and Ann Whitall house (100 Hessian Ave.; 609-853-5120) was used as a hospital for wounded Hessians and Americans. It is said that during the fighting Ann Whitall, whose nine children had retired to Woodbury for safety, continued her spinning, and when a cannon ball came through the house, she picked up her spinning wheel and resumed spinning in the basement. After the battle she nursed both Hessians and Continentals. A brick building (1748) with a stone wing, the house bears scars from the battle. It now contains a county-run museum. The rooms have period furnishings, and displays change periodically. The museum sponsors a variety of special events, including living-history programs the 3d Sunday of the month. Open April-December, Wednesday–Sunday, 9–12 and 1–4; January–March, Wednesday–Friday only; groups by appointment. The battle is restaged annually on the Sunday closest to 22 October, the date of the battle, and the event includes a craft show and craft demonstrations. You can reach the river in the 20-acre park, which also has a picnic pavilion for groups with reservations. Open daily, 9–dusk.

Nearby (100 Grove Ave.) is the James Whitall Jr. house,* built in 1766 by one of the Whitall sons.

Neptune Monmouth 4,997 (borough) 28,148 (township)

GARDEN STATE PKWY EXIT 100, NJ 18, 33, 35, 66

Ş

The birthplace of actor Jack Nicholson, and home of the world's largest manufacturer of practical jokes and magic tricks, Neptune is the site of Monmouth County's first county park, the 580-acre Shark River Park (Schoolhouse Rd.; 732-922-3868). The park is hilly, and there are pitch pine and oak forests with a dense

understory of sheep laurel, ferns, pepperbush, and blueberries. The Shark River goes through the park, and because of the cedar swamps and sphagnum bogs, the trails can be wet. In addition to its hiking, cross-country skiing, and nature trails, the park contains picnic facilities, a pond for fishing and skating, and shuffleboard courts. A county golf course (Old Corlies Ave.; 732-922-4141), abuts Shark River Park to the east; it is open year-round.

The Neptune Historical Museum (25 Neptune Blvd.; 732-775-8241, ext. 306), housed on the second floor of the public library, contains exhibits concentrating on local history. Open Tuesday–Friday, 1–5:30; other times by appointment.

South of Neptune, in Wall Township (across from Airplane Park), is the Allgor-Barkalow Homestead Museum* (1701 New Bedford Rd.; 732-974-1430, 732-681-3806), run by the Old Wall Historical Society. The museum is housed in an early-19th-century farmhouse, and in one room the society has re-created the country store that had been in the original farmhouse. Period furnishings date to the 1840s, and there are also exhibits that change from time to time. The society sponsors special events each year, including an antiques show in March and a crafts show in September. Open Sunday, 1–4; groups and other times by appointment.

Newark Essex 275,221

1 78, 280, 287, NJ TNPK EXIT 14, US 1, 9, 22, NJ 21

New Jersey's largest city, and one of the first to be settled by the English, Newark was founded in 1666 by a group of about 40 men, women, and children who left Connecticut to seek a place where they could live as they chose, which meant a place where the church would have ascendancy over the state. They settled near

the intersection of Broad and Market sts. and were soon joined by other families from Connecticut. Toward the end of the century the settlement became known for its apple cider, which was thought to be of higher quality than that produced in other colonies.

Eventually the religious monopoly was broken, but the community continued to grow very slowly until the end of the 18th century, when smallscale manufacturing began to appear: hat factories in the 1780s, shoe factories in the 1790s. In the 1830s the coming of the Morris Canal and the railroads connected Newark more readily to raw materials (particularly coal and iron from the west) and markets (particularly in the south). The city became a leading center for all types of leather goods, for jewelry, and for carriages. Brewing, established in Newark in the 1840s, remained one of the city's largest industries until very recently (only one brewery, its copper vats and steaming smokestacks familiar to those who use Newark Airport, is in operation today). Financial services also appeared early-the first bank in 1804, the first insurance company in 1810. Newark's development as a transportation center continued with the opening of Port Newark in 1915 and of Newark Airport in 1927. Although Newark has been losing population since World War II and has suffered most of the problems faced by older cities all over the country, it remains a center for financial services and transportation, it is becoming a center for education, and it is attracting a considerable number of artists. Some of Newark's largest companies are engaged in major construction projects, primarily in the area of Penn Station and on the Passaic River (before the turn of the century a popular spot for recreation). Port Newark, with Port Elizabeth, is a major facility for container ships, and the airport, which already handles some 28 million passengers a year, expects its international traffic to increase rapidly with the opening of a new international terminal. Newark has not conquered all its problems, not the least of which is its financial situation-with all the cultural, medical, and educational facilities, not to mention federal, state, and county courts and offices, as much as 80 percent of Newark's property is off the tax rolls-but most people seem to feel the corner has been turned.

The list of famous people connected with Newark is long. One of the most remarkable is Seth Boyden, who came to Newark around 1815 and, except when he took part in the Gold Rush, spent the rest of his life in the city. Boyden invented the process for making patent leather, developed a way to make malleable iron and to refine zinc from New Jersey ores, designed a train that could go up grades, invented machines to make nails and form hats, improved the daguerreotype process, and, at the end of his life, developed a giant strawberry. He profited from none of his inventions and spent his last days in a small house purchased for him by some of the men who did (he died in 1870). Another Newark resident, Hannibal Goodwin, the pastor of the House of Prayer (407 Broad St.), invented the flexible film used by Edison in the development of motion pictures.

Among the writers Newark can claim are Stephen Crane, best known for *The Red Badge of Courage*, born here in 1871 (his birthplace on Mulberry Pl. was torn down in 1940); Mary Mapes Dodge, the author of *Hans Brinker, or the Silver Skatcs*, described by one Dutch bookseller as the best book ever written about I lolland, although Dodge did not visit the Netherlands until many years after the book was published; Howard Garis, the author of the Uncle Wiggily tales, which first appeared in the *Newark Evening News*; the playwright Imamu Amiri Baraka (LeRoi Jones); the poet Allen Ginsberg, who later lived in Paterson, where his father taught English at the high school; the novelist and dog fancier Albert Payson Terhune; and the novelist Philip Roth.

Musicians and entertainers connected with Newark include the opera singer Maria Jeritza, who moved to Newark in the 1940s; Jerome Kern, who graduated from Newark High School in 1902; and Sarah Vaughan, Jerry Lewis, Samuel Augustus Ward (he wrote the music later used for "America the Beautiful" and is buried in Mt. Pleasant Cemetery; see below), and Dore Schary, who were all born in Newark. Moe Berg, presumably the only professional baseball player who ever served as an undercover agent (in World War II), was raised in Newark, and a more recent home-grown professional athlete, Shaquille O'Neal, has a park in the South Ward named for him.

The state's first daily newspaper, the *Daily Advertiser*, was started in Newark in 1832; the first regular radio station on the eastern seaboard, WJZ, which was the first to broadcast a world series (in 1921), was a Newark station; the first municipally supported summer school was established in Newark in 1886; the first blackout test in World War II took place in Newark.

A tour of Newark's downtown should include the late-18th-century Old First Presbyterian Church* (820 Broad St.), the direct descendant of the church built by Newark's original settlers. From the 1760s until 1986, Old First owned the prime real estate across from it on Broad Street.

North of Old First, at Washington Park, is the Newark Museum (49 Washington St.; 973-596-6550). Its 1920s building was expanded by Michael Graves in the late 1980s. A pioneer in the recognition of folk art, the museum is also known for its collection of American painting and sculpture, its Tibetan

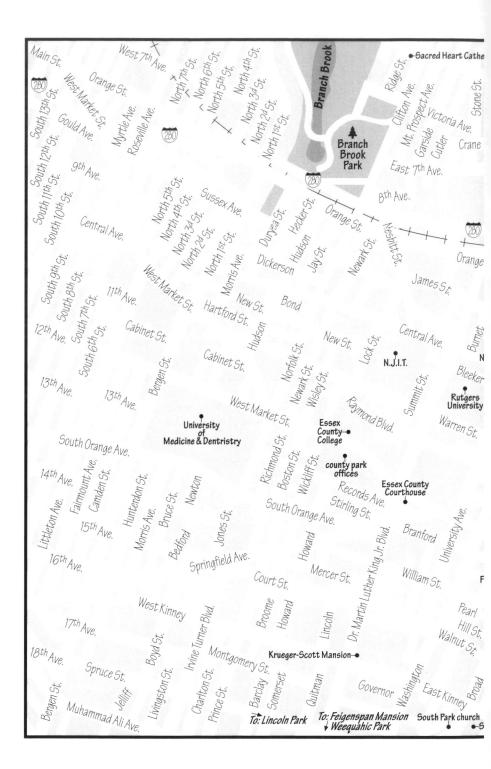

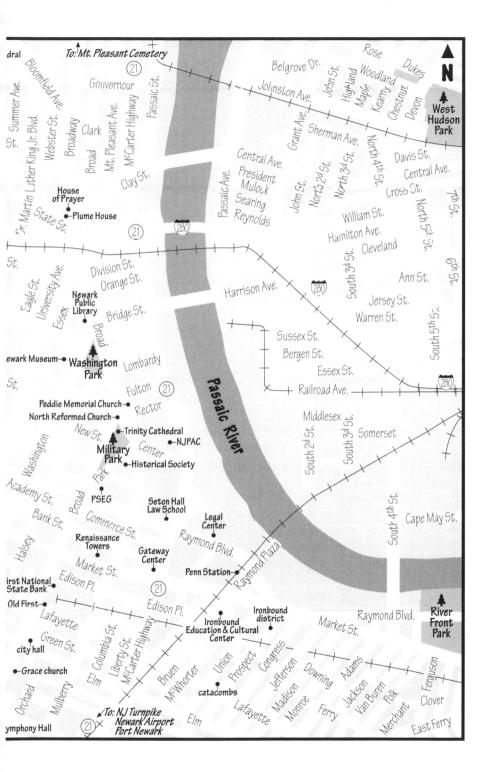

art, its decorative arts, and its educational programs. In its garden is a sculpture collection that includes works by David Smith, George Segal, and Tony Smith, all, incidentally, New Jersey artists. Also in the garden are the Old Stone Schoolhouse,* 1784, one of Newark's oldest buildings, which was moved to the museum grounds, and, in an old carriage house, a small firefighters' museum. Attached to and part of the museum is Ballantine House,* a national historic landmark built in 1885 by John Ballantine, the son of the founder of Ballantine Brewery. Built with Victorian abandon in a variety of styles and with considerable attention to detail, the building is the only mansion remaining around Washington Park (Washington and Broad sts.), once a fashionable residential district. (The park was laid out as a marketplace in 1667; note the statue of Seth Boyden.) The Ballantine House, recently restored, serves as the gallery for the museum's collection of decorative arts, which date from the 17th to the 20th century. The two floors of period rooms also form part of an interpretive scheme that examines the meaning of home in the late 19th century and more generally. Special Christmas holiday exhibits are held in the Ballantine house. Also part of the museum is the planetarium, which offers public programs weekends, September-June, and on an expanded schedule the rest of the year. The planetarium gallery is open when the rest of the museum is open. There is also a junior museum with many special programs and workshops; science galleries are scheduled to open on the third floor in 1999. Museum open Wednesday–Sunday, 12–5; admission charge for planetarium; group tours by appointment (973-596-6615).

Near the museum is the Newark Public Library (5 Washington St.; 973-733-7793). Its splendid early-20th-century Renaissance building houses a large collection, and the Centennial Hall, available for private use, has served as the site of a rump meeting of the state legislature, a Spike Lee preview, a concert by the New Jersey Symphony Orchestra, and corporate dinners. Exhibits in the library's galleries, which change frequently, cover a wide range and focus on showing off the library's collection. Often honoring the varied ethnic communities of Newark, the exhibits include annual African American and Hispanic shows but can range from an exhibit showing you how to research your house to one honoring the 200th anniversary of the newspaper that is today the *Star Ledger*. The library continues its long tradition of civic involvement, with film and lecture series as well as occasional concerts.

Military Park (Broad St. and Park Pl.), once a training ground for the militia, was laid out in 1667 by Newark's original settlers. In 1776 it was used by George Washington's troops as a camping area; it was during that encampment that Thomas Paine wrote "The Crisis" ("These are the times that try men's souls"). The park contains *The Wars of America*, a large bronze group done by Gutzon Borglum, the sculptor of Mt. Rushmore. Also in the park is Trinity Episcopal Cathedral,* 1744–46, possibly the only church in New Jersey to be situated in a public park. This church is said to owe its origins to the decision of one of the stalwarts of Old First to harvest his hay on a Sunday because rain threatened; the ensuing argument with Old First led him to help found Trinity.

In Military Park are the headquarters of the New Jersey Historical Society (52 Park Pl.; 973-483-3939). Founded in 1845 (in Trenton), the society in 1993 was given the 1926 Essex House,* and moved into its new quarters on Friday, 13 June 1997. Its building houses a library (the old one was used by some 11,000 people in 1995), galleries, a museum, and publication and education departments. The society sponsors a variety of exhibits (it inaugurated its new home with an exhibit entitled "Teenage New Jersey, 1941–1975") and educational programs. The museum is open Tuesday–Saturday, 10–5, the library by appointment only until January 1998.

On a 12-acre tract across Park Pl. from Military Park (and, in fact, not far from where the city's settlers landed) is the New Jersey Performing Arts Center (Theater Sq.; 973-648-8989). The first building, containing two performance spaces, one of 2,750 seats, the other 500, opened in October 1997. A 2,400-seat concert hall is next on the schedule; eventually the area may see new retail and office space, housing, and a waterfront park. The center is to be the permanent home of the New Jersey Symphony.

Walking along Broad St. (first paved in 1852) notice (at State St.) the House of Prayer Episcopal Church^{*} and rectory^{*} (Plume House, c. 1740), in which Goodwin invented flexible film; the 19th-century North Reformed Church^{*} (510); the First Baptist Peddie Memorial Church^{*} (at Fulton), from the late 1880s; the Griffith building^{*} (605) from the 1920s; First National State Bank^{*} (810), 1912; Old First and City Hall; and Richard Upjohn's Gothic Revival Grace Church^{*} (at Walnut), a national historic landmark. West of Washington and Military parks, on the way to the concentration of educational institutions, is the James St. Commons historic district^{*} (University, Bleeker, New, Linden, James, Essex, Burnet, Washington, and Summit sts. and Central Ave.).

Among the educational institutions to be found in Newark are Rutgers University, the University of Medicine and Dentistry of New Jersey, the New Jersey Institute of Technology, Seton Hall Law School, and Essex County College. The Rutgers unit was formed in 1946, when the University of Newark, itself an amalgam of several colleges, was incorporated into Rutgers. Its Paul Robeson Center Gallery (350 Martin Luther King Jr. Blvd.; 973-648-5119, 973-648-1610) changes exhibits roughly eight times a year, with three annual exhibits of student works, including one of drawings by New Jersey Institute of Technology architecture students. Open weekdays, 11:30-5; sometimes closed in August. At the Dana Library (973-648-5222) exhibits change roughly every six weeks and cover a wide range; past exhibits have included Ella Fitzgerald, boatmaking, Spanish culture, and painting and sculpture. Open when the library is open (daily, September-April; closed Sunday, May-August). Prospective students can arrange tours of the Rutgers campus by calling 973-648-5205. The New Jersey Institute of Technology, founded in 1881 as the Newark Technical School, has offices in Eberhardt Hall* (323 Martin Luther King Blvd.), once an orphanage and now a national historic landmark. In the dental school building (110 Bergen St.; 973-982-4633) old equipment is on display. Open weekdays, 9–4:30.

Across Market St. from Essex County College is the Essex County Court-

house* (470 High St.), a national historic landmark designed by Cass Gilbert and opened in 1907. On the steps of this impressive marble building, which replaced an earlier Egyptian-style one (1836), is a seated statue of Lincoln, also by Borglum. The informal quality of the figure and the fact that you can sit right down on the bench next to Lincoln caused something of a stir when it was dedicated in 1911; the worry now is whether it can survive its current neglect.

North of the educational cluster, on one of the highest points in the city, is the Krueger-Scott mansion* (1888–89; 601 Martin Luther King Blvd.), built for one of the beer barons and currently being restored as a multipurpose cultural center. Note also the Feigenspan Mansion* (1905; 710 Martin Luther King Blvd.), the last of the mansions to be built on what was then High Street.

Penn Station* (Raymond Plaza W.), built in the 1930s, has recently undergone extensive renovation. The station serves New Jersey Transit, Conrail, Amtrak, and Path trains, and there are plans to link the station to the airport by means of a monorail. Roughly 70,000 people pass through this art deco building every day, some third of them heading for the buses or subways. The subway runs on trolley tracks laid in the 1930s in the old Morris Canal bed; it comes up at Branch Brook Park. Outside the subway entrance note the sculpture of seven life-size figures done by Grigory Gurevich and students at the Newark School of Fine and Industrial Arts.

Near the station is Renaissance Towers (207–215 Market St.), once the Newark News building (the paper folded in 1972), now condominiums. The oldest structure in the complex dates to 1915; some of its ceilings are 12 feet high. Across Market you can see what the scale of this area once was; look toward the station (at 100 Mulberry) for an example of the large structures now dominant in the area.

Also near the station is the Gateway Center office complex, a multibuilding project that the Prudential Life Insurance Company, the nation's largest insurance company (established in a Broad St. storefront in the 1870s), became involved in when a company for which Prudential held the mortgage went bankrupt. The 26-story headquarters of the Public Service Enterprise Group Inc. is on Park Pl., as is the former home office building of the Fireman's Insurance Co.,* which dates from the 1920s.

Also along the river is the Legal Center (I River Front Plaza), a triangularshaped building with high-tech offices. This is an area favored by law firms; the Seton Hall University Law School, for example, occupies several floors at I Newark Center, which also houses many law firms. Pedestrian skywalks connect Penn Station to some of this riverfront development, which also includes offices, a hotel, shops, and a garden.

The Lincoln Park historic district* includes the park and parts of Spruce, Broad, and Washington sts. and Clinton Avenue. The Cathedral Evangelica Reformada* (27 Lincoln Park at Halsey St.) was once the First Reformed Church, dedicated in 1872. The South Park Calvary United Presbyterian Church* (1035 Broad St. at Lincoln Park) was built in 1853.

Just north of Lincoln Park is Symphony Hall* (1020 Broad St.). It was built

as the Salaam Temple in 1925 (at a cost of \$2.5 million, a considerable sum in those days) and later became known as the Mosque Theater. Second in size on the East Coast only to Radio City Music Hall, it was extensively renovated in the mid-'80s. With the opening of the Performing Arts Center, Symphony Hall is expected to serve as a venue for a variety of musical groups.

East of Symphony Hall is the Ironbound section; the name derives from the train tracks that more or less define its borders. Ironbound was once an Italian enclave; today a large portion of its residents are of Portuguese descent, and the annual Portugal Day Festival in June is the largest such festival inside or outside Portugal (some 300,000 people attended in 1995). In the Ironbound section are what are said to be the only catacombs in the United States. Modeled on those in Rome, they are in a former church (now used by the board of education as an annex of the Lafayette St. School) and are run by the Immaculate Heart of Mary Church (212 Lafayette St.; 973-589-8249). Open Monday–Saturday, 9–5, by appointment only. Also in the Ironbound section note the Ironbound Education and Cultural Center* (178–184 Edison Pl.), built in 1848 as the Second Reformed Dutch Church (later Our Lady of Mount Carrnel). Ironbound's Riverfront Park, like several others in Essex County (see Bloomfield, Montclair, West Orange, and the next paragraph), was designed by the Olmsted firm; many of its original plantings survive.

Newark's Branch Brook Park* (Clifton Ave.), dedicated in 1895, is the first county park in the United States. Situated on a marsh once known as Old Blue Jay Swamp and used as an army training camp in the Civil War, the park was designed by the Frederick Law Olmsted firm. The Beaux Arts entrance gate (Lake St.) was a gift from Robert Ballantine, and the turn-of-the-century stone lions at the concert mall once guarded the entrance to the Prudential Building. In 1910 the world's largest water fountain was installed, but it had to be abandoned because it endangered the city's water supply. Branch Brook is perhaps best known for its Japanese cherry trees, first planted in 1929. In the spring, when 3,000 of them are in bloom, the park's display surpasses that in Washington, D.C. Half a million people visit the park in April, and the park commission sponsors various special events, including the 10-kilometer Cherry Blossom Run.

East of Branch Brook is the Gothic Revival Cathedral of the Sacred Heart* (89 Ridge St.; 973-484-4600), started in 1899, but not completed until 1954. This huge cathedral is modeled somewhat on that at Rheims. Among its noteworthy features are 200 stained-glass windows, woodwork of Appalachian white oak, and the angle of the wings of the facade. Near the cathedral is the Essex County Park Commission Administration Building* (115 Clifton Ave.), built in 1914.

East of the cathedral is Newark's oldest continuously operating cemetery. Mt. Pleasant Cemetery* (375 Broadway; 973-483-0288), a national historic landmark, was opened in the 1840s (the Gothic gate and administration building were erected in 1877). Some of the graves are older than the cemetery since headstones and remains uncovered in downtown building projects have been moved here. Among the people buried in Mt. Pleasant are Seth Boyden, Peter Ballantine, and John Dryden, a U.S. senator and founder of the Prudential Insurance Company, whose mausoleum is hard to miss. Note also the fire hydrants at the firemen's lot. Cemetery open daily, 9–4:30; office open weekdays.

South of downtown is Weequahic Park (Elizabeth Ave.; 973-482-6400). The park, also designed by the Olmsted firm, contains a lake for boating and fishing, a rose garden, a trotting track (once known as the Waverly Fair Grounds), and a golf course (973-923-1838). Note the field house (1907) and the Gothic comfort station (1916).

Newark Airport is east of Weequahic Park. Opened in the late 1920s, the airport for a time was the only one serving the New York metropolitan area. For period flavor, note, at the northern end of the airport, the former administration building,* Brewster hangar,* and the medical building,* all dating from the late 1920s. Operated by the Port Authority of New York and New Jersey, the airport currently generates some \$3.5 billion in economic activity each year. Tours of the facilities can be arranged for groups (973-961-6265), but they must provide their own transportation.

Adjacent to the airport on Newark Bay is Port Newark. It and Port Elizabeth, directly to the south, together constitute one of the busiest container ports in the world, handling 17 million tons of cargo annually. With channels dredged to 40 feet, they can accommodate the newest generation of container ships. On the 930 acres are sheds, warehouses, distribution buildings, refrigerated storage (one facility can handle 6.5 million gallons of orange juice concentrate), wharves, cranes, railroad tracks, and roadways; 165 acres are used to store automobiles. Tours of the New Jersey marine terminals can be arranged by appointment (call the facility staff assistant at 973-589-7100), but you must provide your own transportation.

New Brunswick Middlesex 41,711

US 1, NJ 18, 26, 27, 91, 171, 172, C 514

The settlement of New Brunswick goes back to the 1680s, when a group of Englishmen from Long Island, among them John Inian, purchased some 10,000 acres along the Raritan River, described at the time as "the handsomest and pleasantest country that man can behold." Inian established a ferry across the river in 1686, eventu-

ally adding an inn, docks, and a road to Trenton; in 1697 he gained exclusive rights to the crossing. The settlement, originally known as Prigmore's (or Pridmore's) Swamp, came to be called Inian's Ferry, but early in the 18th century it was again renamed, becoming New Brunswick, in honor of the English royal house.

New Brunswick developed as an active shipping center during the 18th century and saw considerable action during the Revolution. The Continental army retreated here after the defeat at Fort Lee, and Alexander Hamilton commanded an artillery battery that stalled the British while George Washington moved south toward the Delaware River. Between 29 November and I December 1776, Washington made his headquarters at Cochrane's Tavern, at the corner of Neilson and Albany streets. In all, Washington visited New Brunswick five times. The third reading of the Declaration of Independence in the colonies took place here on 6 July 1776. Although many from New Brunswick were accused of favoring the loyalists, local merchant shippers successfully harassed British shipping.

New Brunswick continued as a transportation center during the 19th century (and hence its nickname, Hub City), but the coming of the railroads shifted the action from water to land. The city also developed industrially. Its preeminence as a pharmaceutical town dates to c. 1885, when the Johnson brothers moved their adhesive tape and gauze business (founded in 1873) to an old mill in New Brunswick. Incorporating as Johnson & Johnson in 1887, the firm recruited workers from Hungary, giving New Brunswick at the time the largest Hungarian population, proportionally, of any city in the United States. Joyce Kilmer (1886–1918), New Brunswick's best-known poet, was the son of the scientific director at Johnson & Johnson (Kilmer's birthplace is at 17 Jovce Kilmer Ave.). Other industries that have been important to New Brunswick include rubber, hosiery, and musical instruments. The New Jersey Rubber Shoe Company, later part of US Rubber, was founded here in 1839, and the National Musical String Co.* (1898; 120 Georges Rd.), a manufacturer of steel strings, was the first firm in the United States to make harmonicas. Of these only the pharmaceutical industry remains as a major presence (Johnson & Johnson was later joined by E. R. Squibb, now Bristol-Myers Squibb).

Another major presence in the city is, of course, Rutgers University. The eighth college to be founded in the colonies and the only state university to have existed before the Revolution, Rutgers was chartered in 1766 as Queen's College, its mission the training of Dutch Reformed ministers. In 1771 it opened in a New Brunswick tavern, the Sign of the Red Lion, with one instructor (Frederick Frelinghuysen), one sophomore, and a handful of freshmen. In 1774 it graduated its first student, Matthew Leydt, whose clergyman father was a trustee and founder of the college. Its early years were rocky, but in 1825 it changed its name to Rutgers College in honor of Colonel Henry Rutgers, a New York philanthropist who had fought in the Revolution and been a trustee of the college. He gave the college some modest financial assistance and the bell that still hangs in the cupola of Old Queen's (it is the oldest bell in Middlesex County). Rutgers became a land grant institution in 1864, and over the years various colleges-among them agriculture, engineering, pharmacy, Douglass College for women (the largest women's college in the United States), and education—were added. In 1924 Rutgers College became Rutgers University and in 1945 the state university. It now enrolls some 48,000 students in its 26 schools and colleges on three campuses (Camden, Newark, and New Brunswick; the university's general information number is 732-932-1766).

Now considered a major university (its library, for example, is ranked among the top 25 in the country), Rutgers is also widely known for the Rutgers tomato (developed in 1934) and streptomycin, the first broad-spectrum antibiotic (developed by Selman Waksman in 1943). The first intercollegiate football game (Princeton vs. Rutgers) was played at New Brunswick in 1869, the Princeton team arriving by train. Rutgers won, 6–4. The faculty apparently disapproved of football, but the captain of the Princeton team went on to become chief justice of the New Jersey supreme court, the captain of the Rutgers team a leader in the Dutch Reformed church. Rutgers was not to beat Princeton again until 1938 at the game dedicating the new stadium (the new stadium was replaced by a larger one in 1994).

Two other large institutions also shape New Brunswick. As the county seat, it is home to the county courthouse (I John F. Kennedy Sq.) and a host of county agencies. It is also home to two teaching hospitals: St. Peter's Medical Center (254 Easton Ave.) and the R. W. Johnson Medical Center (R. W. Johnson Pl.), founded in 1884 by a group of concerned lay people. New Brunswick, incidentally, had been a leader in colonial medicine—the country's first professional medical association, the Medical Society of New Jersey, was founded here in 1766.

Like many other cities of the Northeast, New Brunswick suffered a decline after World War II, and in 1975 a coalition of business, university, community, and government leaders formed to reverse that decline. In part through their efforts downtown New Brunswick has a new look: the central business district was redesigned by I. M. Pei Associates; Johnson & Johnson built a new headquarters building; there are other new office buildings, a new hotel, and townhouses; and the city has developed a reputation for the quality of its restaurants.

The New Brunswick Cultural Center (19 Livingston Ave.; 732-247-7200) began with four existing buildings (a department store, a 1921 theater, a YMCA building, and a warehouse). The center includes two professional repertory theaters (George Street Playhouse, 732-846-2895, and Crossroads Theatre Company, 732-249-5581); the 2,000-seat State Theatre (built in 1921 and used as a vaudeville house and movie theater; 732-247-7200), presenting classical music, opera, jazz, country music, theater, entertainers, and film; the American Repertory Ballet Company (formerly the Princeton ballet, 732-249-1254); and the New Jersey Designer Craftsmen (see below). The center engages in a wide variety of educational programs. At 33 Livingston the Civic Square Building (on the site of the department store) houses studios of the university's Mason Gross School of the Arts (732-932-7511). Seven galleries on the first floor feature biweekly exhibits of students' and guest artists' work. Open weekdays, September–May, 10–4.

At the New Jersey Designer Craftsmen Gallery (10 Livingston Ave.; 732-246-4066) shows change roughly every two months. The group also organizes shows in other venues and does outreach programs and workshops at its New Brunswick location. Open Wednesday–Saturday, 12–6; groups by appointment.

Along the waterfront there are plans for improving Boyd Park and restoring the historic Delaware and Raritan Canal lock outlet and towpath. First to be completed are the roughly 10 acres between NJ 18 and the river from New St. southeast to Commercial Avenue. The Hungarian Heritage Center (300 Somerset St.; 732-846-5777) offers concerts and lectures; call for information. The museum at the center features changing exhibits of Hungarian fine and folk arts; at the annual Festival of Trees in December and January trees are decorated to reflect other ethnic traditions. Museum open Tuesday–Saturday, 11–4, Sunday, 1–4. A Hungarian festival is held each June; 15,000 people attended in 1995.

Despite all the rebuilding, which has involved considerable demolition, there are still a few historic buildings to be seen in New Brunswick. The old Hiram Market historic district (once listed on the state register of historic places) encompasses parts of Albany, Bayard, Church, Dennis, Hiram, Neilson, Paterson, Peace, and Richmond sts. and Memorial Parkway, but middle-income townhouses have replaced most of the older structures. In the 19th century rubber factories were located here (Daniel Webster won a patent case for one of New Brunswick's firms), and the area includes two old churches (one English, one Dutch, reflecting part of the city's history—Dutch settlers from Albany began arriving in 1730). Middlesex County's oldest church (1812, replacing an early-18th-century stone church; the clock dates to c. 1830, the interior was rebuilt in 1847, 1862, and again in the 1970s after a fire damaged the interior), the First Reformed Church of New Brunswick* (732-545-1005), is on the west side of Neilson St., opposite Hiram Street. In the cemetery are graves going back to 1746. You can visit the church when the office is open (September–

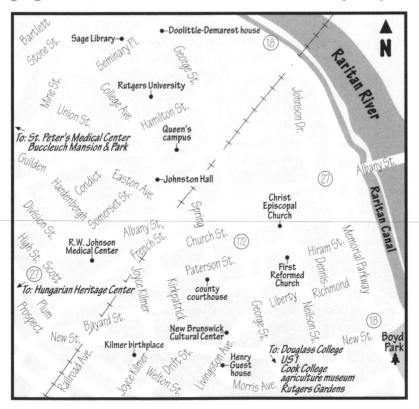

New Brunswick 217

June, Tuesday–Friday, 9–1; July and August, Thursday, 9–1); guided tours by appointment.

Christ Episcopal Church* (5 Paterson St.) is also in the Hiram Market district, and it too has a prerevolutionary cemetery. The building dates from the 1850s (with later alterations and additions) and uses the stone from the original church built 100 years earlier.

Buccleuch Mansion* (Easton Ave. in Buccleuch Park, across the street from St. Peter's Medical Center; 732-745-5094), is an 18th-century house (c. 1739) built by Anthony White, a cavalryman who married Lewis Morris's daughter. In 1821 the house was acquired by Col. Joseph Warren Scott, son of the surgeongeneral of the Continental armies and himself a noted New Jersey lawyer, who named it after a Scottish ancestor, the duke of Buccleuch. His grandchildren gave the house to the city in 1911, and it has been operated as a museum since 1915. The recently renovated house has 16 rooms, which have been furnished to show how styles have changed over its lifetime; particularly noteworthy is the hand-blocked wallpaper, with scenes of Paris and of Indian tiger hunting, dating from c. 1820. The saber and spur marks made by the Enniskillen dragoons, who were quartered in the house in 1776–77, are still visible. Open Sunday, 2–4, June–October; guided tours by appointment. Buccleuch Park itself (George St. and Easton Ave.; 732-745-5112) consists of 78 acres overlooking the Raritan River.

The Henry S. Guest house* (Livingston Ave. and Morris St.; 732-745-5108) was built c. 1760 (the front doorway and porch were added c. 1825 and the house moved to its present location 100 years later). Guest was a whaler and tanner, and among his guests were John Adams, Thomas Paine, and Lafayette. Paine, in fact, was hidden from the British in Guest's house. Collections in the handsome stone house include shawls and old lace and Civil War and Japanese artifacts. To visit the Guest house, ask at the public library next door, week-days, 9–4:30; the house is being renovated, and it may not always be possible to see the interior. Driving south on Livingston Ave. toward us 1, you will see a considerable number of substantial late-19th-, early-20th-century houses.

The university's Queen's campus* (part of the College Ave. campus) combines 18th- and 19th-century buildings, and Old Queen's itself (north side of Somerset St. between George St. and College Ave.) is a national historic landmark. A three-story brownstone built between 1808 and 1825, it was intended to serve the needs of a grammar school, a college, and a theological college of the Dutch Reformed Church, with living quarters for two professors. The architect, John McComb Jr., was also the architect of New York's City Hall, designed at about the same time. University administrative offices are here, including the president's office. One of the fireplaces has a preserved Dutch oven, and some of the windowpanes are handmade.

The College Ave. campus has an unusual sense of space for an urban campus, and many fine old houses are scattered throughout the area. West of Old Queen's is the Rutgers University Geological Museum (732-932-7243). The collection includes dinosaurs, a mastodon, a mummy, and items relating to the natural history of the state. Open Monday, 1–4; Tuesday–Friday, 9–12; Sunday,

12–4; but it is always advisable to call ahead. The Daniel S. Schanck Observatory (c. 1865–66), two octagons connected by a one-story passage, was Rutgers's first building intended exclusively for scientific purposes; it is no longer being used. South of Old Queen's is the Jane Voorhees Zimmerli Art Museum (George and Hamilton sts.; 732-932-7237). Exhibits include both items from the permanent collection and temporary exhibits. The permanent collection includes the largest collection of Russian and former Soviet art in the West and a nationally renowned print collection particularly strong in 19thcentury French prints and 20th-century American graphics. Rotating exhibits from the permanent collection of illustrations for children's literature are exhibited in the lower wing; temporary exhibits are shown in the other galleries. Open Monday, Tuesday, Thursday, Friday, 10–4:30; weekends, 12–5. Tours by appointment (732-932-7096).

At the northern end of the College Ave. campus is the statue of William of Orange, founder of the Netherlands, and the New Brunswick Theological Seminary, founded in 1784. The Gardner A. Sage Library (21 Seminary Pl.; 732-247-5243) was built in 1875; the archives of the Reformed Dutch church (now known as the Reformed Church in America) repose there. There are also changing exhibits. Open Monday–Thursday, 9 A.M.–10 P.M.; Friday, 9–5; Saturday, 11–3; closed Saturday, July and August. Note also the Doolittle-Demarest house (southwest corner of George St. and Seminary Pl.; 1850–70), and the painted Suydam statue. The red brick former headquarters of Johnson & Johnson are visible toward the river.

At 101 Somerset St. is Alexander Johnston Hall (1830, 1870) once the home of Rutgers Preparatory School,* one of the 12 oldest schools in the country. Joyce Kilmer's birthplace (17 Joyce Kilmer Ave.; 732-745-5117), a modest 18th- and 19thcentury farmhouse, is used as an office by New Brunswick Dial-A-Ride. The house contains some period furniture and pictures of members of the Kilmer family. Individuals may stop by the house weekdays, 9–3; group tours by appointment.

On the university's Douglass campus is the Nicholas Music Center, where public concerts are presented from September through July. Also on this campus are two theaters where plays and dance concerts are presented. (Another theater on the Cook campus also presents dance concerts.) For information on all these events, call 732-932-7511.

On the university's Cook campus is the New Jersey Museum of Agriculture (College Farm Rd. just off us 1 south; 732-249-2077), which opened in 1990, 61 years after Hiram Deats had given a plow designed by his grandfather (see Stockton) to the dean of the College of Agriculture in the hopes it would provide the nucleus for just such a museum. The collection, the largest in the mid-Atlantic, covers three centuries of farm implements, and the museum offers a wide variety of interactive history and science programs for children (in 1995 close to 12,000 schoolchildren were involved in museum programs; the total number of visitors was over 24,000). There are also weekend family programs and workshops and a summer camp. Past programs have ranged

from quilting bees and maple-sugaring to studying bats and potatoes. Open Tuesday–Saturday, 10–5; Sunday, 12–5; closed Christmas and Christmas Eve, New Year's and New Year's Eve. Admission charge.

On the east side of US I are the Rutgers Gardens (off Ryders La. about I mile south of NJ 18; 732-932-8451). Here you will find the world's largest collection of American hollies, and in the fall the gardens hold a holly festival, with tours, instructional sessions, and activities for children. Also in the gardens are collections of small trees, shade trees, rhododendrons, and azaleas, as well as a children's garden, a sun and shade garden, and a bamboo forest. Many new and unusual annuals can be seen in the display gardens, and the Native Plant Society also has a garden here. A spring flower festival takes place on Mother's Day weekend, and there is a fall foliage festival as well. Open daily, dawn–dusk.

Newton Sussex 7,521

US 206, NJ 94, C 519

Newton, the seat of Sussex County, was settled in the mid-18th century. Until recently it was the center of a bustling farming community providing the legal, financial, and medical services associated with a county seat, but it is becoming more of a bedroom community for Morris County, and even some New

York City, commuters. It is said that the first beer to be sold in cans was produced in Newton.

Much of Newton retains its 19th-century air, and if you can ignore the cars, you can get a strong sense of earlier times. The Newton Town Plot historic district* includes over 50 buildings along Church, High, Main, Moran, and Spring sts. and Park Pl. and 1 Dunn Place. Try to walk around the central square and Main St., with its well-preserved line of 19th-century shops, and drive along the streets off the square. The county courthouse* (High and Spring sts.), built in 1847, replaces the first one (1765), which burned (though portions of the original building may be contained within the current one). A Greek Revival building with six Doric columns, it is strikingly sited on a steep hill. (The last hanging in New Jersey took place behind this courthouse.) George Washington stopped at the inn at Main and Spring sts. on his way to Newburgh, New York, in 1782. The First Presbyterian church (High and Church sts.) dates from the 1860s and is listed in the state register of historic buildings.

The public gallery in the Judicial Center (43–47 High St.; 973-383-0027) features art exhibits sponsored by the Sussex County Arts and Historical Council; the exhibits are changed quarterly. Open weekdays, 8:30–4:30. Art exhibits are also featured at the administration building of Sussex County Community College (I College Hill; 973-300-2144).

The Hill Memorial Building (1916) at the corner of Church and Main sts. houses the Sussex County Historical Society's headquarters and museum (973-383-6010). The building was built in 1916 specifically for the society; it contains a fireplace with stones taken from various buildings and sites of historic interest. Displays are changed throughout the year. Open Friday, 10–3.

The Newton Fire Museum (150 Spring St.; 973-383-0396) is housed in the department's first station and includes old equipment, much of it from the 19th century (an 1863 hand pumper, an 1873 steamer, hand-drawn hose carts and ladder wagons), memorabilia, and photographs. Tours Friday and Saturday, 9–3; groups other times by appointment. The department, incidentally, gave up its horses in 1923.

The Merriam house* (131 Main St.) is a particularly splendid example of Queen Anne architecture. Built in the 1880s for the founder of the Merriam Shoe Company, it is now a retirement home. The factory itself (75 Sparta Ave.), which once employed some 750 people, now contains apartments, a pub, and a fitness center. (Shoes made at the factory are in the museum.) At the pub (called the Gateway Pub) artworks from the Sussex County Art Society are on display; the exhibits change every three months. About one mile south on 206 note St. Paul's Abbey. The original structure (now the right wing) dates from 1840, the rest from 1932.

Some two miles south of Newton off us 206 (head west on Fredon Rd., 618, across from the Newton Airport) is the Whittingham Wildlife Management Area. Of the area's 1,800 acres, 400 are designated a natural area, in which live beaver, otter, and many species of waterfowl. On the limestone cliffs in this

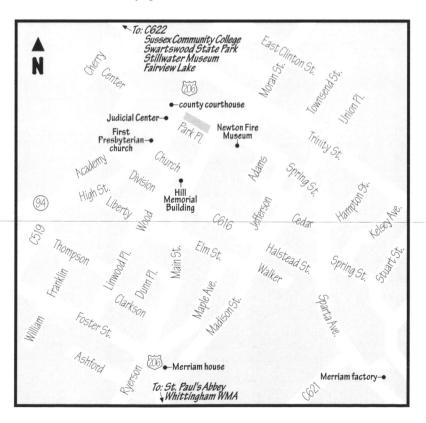

northern swamp and floodplain forest you can see rare species of fern. The open places are kept open, which makes this a good spot for watching butterflies, and there are mowed paths and dirt roads to walk on. You can also hunt and fish here.

About five miles west of Newton on c 622 is Swartswood State Park (973-383-5230), almost 1,750 acres with facilities for picnicking, swimming, boating, hiking, riding, camping, and in season hunting, cross-country skiing, iceboating, snowmobiling, and skating. A popular park, it can see some 250,000 visitors annually. Open 8–sunset in summer (Memorial Day–Labor Day), 8– 4:30 in winter. Parking fee in summer.

About four miles south of Swartswood on C 521, in the community of Stillwater, is the Stillwater Museum (941 Stillwater Rd.; 973-383-4822). Housed in an 18th-century schoolhouse, the museum contains a re-created early-20thcentury country store, farming and household tools, an unusual collection of 19th-century gowns, Native American artifacts, and fluorescent rocks. Open early June–Labor Day, Sunday, 1–4; groups by appointment.

West of Swartswood at Fairview Lake (off Fairview Lake Rd., c 624 at that

point) is the Fairview Lake YMCA camp and conference center (973-383-9282). Trails here are open to the public for cross-country skiing.

North Bergen Hudson 48,414

1495, US 1, 9, C 501

Louis XVI once had a garden here, and it is said that the country's first Lombardy poplar trees were introduced into this garden by André Michaux, the king's official botanist. At the eastern end of the township is North Hudson Park (J. F. Kennedy Blvd. E. and Bergenline Ave.), a 167-acre county park. Part of it lies on the

Palisades, offering views of the Hudson River and New York City, and a scenic path goes down steps to the river valley. West of the boulevard the land is more rolling, and the park contains a lake, with fishing, boating, and skating. Other facilities include a children's playground, athletic fields, picnic areas, and tennis courts. There are also woods, rare in Hudson County.

At Flower Hill Cemetery (J. F. Kennedy Blvd. at 55th St.), there is a splendid view of the wetlands to the west, and the architecture of the gatehouse and the mausoleum with the gray stone windows is worth a look. Note also the mid-19th-century Egyptian-Revival sphinxlike creature guarding a crypt.

Wandering around in North Bergen you will come across many interesting buildings: Schuetzen Park (3167 J. F. Kennedy Blvd.), now used for banquets and weddings but once an opera house, and the Fritz Reuther Altenheim (3161 J. F. Kennedy Blvd.) tell us something of North Bergen's ethnic past. For something from the present, the new firehouse on Tonnelle Ave. between 43d and 44th sts. has been designed not just as a striking backdrop to the adjacent playground but with glass to let the children using the playground see the trucks.

Nutley Essex 27,099

GARDEN STATE PKWY EXITS 150, 151, NJ 7, 21

Settled in the 17th century by colonists from Newark, Nutley was once known as Franklinville after William Franklin, New Jersey's last royal governor (and Benjamin Franklin's natural son; see Perth Amboy). The town still boasts one house dating from the beginning of the 18th century (the Vreeland house,* now used by the Women's Club of Nutley, 216 Chestnut St.; the town hall

across the street was once a textile mill). After the Civil War, it attracted a colony of artists and writers, many of whom lived in the Enclosure historic district* (Enclosure and Calico las.). Mark Twain was a frequent visitor here (the editor of *Puck* was his host), and Frank Stockton wrote his most famous story, "The Lady or the Tiger?", at his home on Walnut Street. Annie Oakley was another famous resident. Near the Enclosure is Memorial Park, a lovely linear park along the Third River.

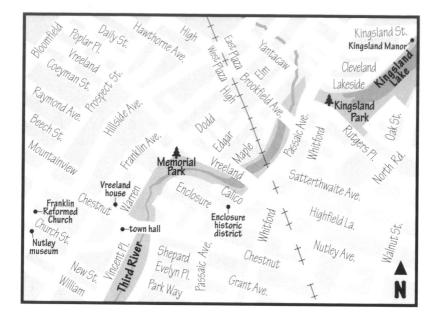

Tradition has it that Mussolini once owned a one-acre tract in Nutley, now the site of the Amvets Memorial Post 30 clubhouse. He was the only creditor of a local bank that tried to pay him before declaring bankruptcy, but the bank didn't wait long enough, and the draft didn't clear. Since 1928 Hoffmann–La Roche has had its U.S. headquarters in Nutley (340 Kingsland St.); the local facility (which includes the pharmaceutical division) employs some 4,300 workers.

The Nutley Historical Society museum* (65 Church St.; 973-667-1528), housed in an attractive brick building (formerly a school), features local history, including exhibits of Annie Oakley memorabilia. Open 1st and 3d Sunday of the month, 2–4; Tuesday evening, 7–9; groups and other times by appointment. Across the street is the Franklin Reformed Church, an attractive wooden building.

Kingsland Manor* (3 Kingsland St.; 973-235-1549, 973-235-1974), a large sandstone structure, most of which dates to the late 18th century (a portion was built earlier, and the structure was altered in the 19th century), has recently been restored as closely as feasible to its original condition. It served as a home for the wealthy Kingsland family between 1790 and 1909; in the 20th century it saw service as a training camp for prizefighters, a speakeasy, a club, and a convalescent home. Long-range plans include operating it as a living museum. Open September–June, 3d Sunday of the month, 2–4, and for various special events throughout the year, including a holiday program in early December. Other times and groups by appointment.

Oakland Bergen 11,997

US 202, NJ 208

Oakland is one of Bergen County's older communities, and several early stone houses remain, particularly along Ramapo Valley Dr. (US 202), to remind us of that past. One of these, the Van Allen House* (Franklin Ave. and Ramapo Valley Rd.; 20I-405-7726, 20I-825-9049), is maintained as a museum by the

Oakland Historical Society. This 18th-century structure, which for a brief period served as George Washington's headquarters when he was traveling from Morristown to West Point and other northern spots, and for another brief period functioned as the Bergen County courthouse, has exhibits of clothing and colonial furnishings intended to convey the atmosphere of a Dutch colonial household. The society also conducts educational programs for children. Open by appointment. (A former architectural attraction, Oakland's diner, was transported to Baltimore, where it served as the principal set for the movie *Diner*.)

Northwest of Oakland (take W. Oakland Ave. to Skyline Dr.; turn right; you can park near the creek) is Ramapo Mountain State Forest (973-962-7031), a 2,900-acre preserve that includes Rotten Pond and Ramapo Lake Natural Area. The forest is open for hiking, horseback riding, mountain-biking, canoeing, and fishing, and, in season, hunting, sledding, and cross-country skiing, but no motorized vehicles are permitted. Trail maps are available at Ringwood State Park (see Ringwood).

Ocean City Cape May 15,512

NJ 52, C 619, 623, 656

Founded in 1879 by three brothers, Methodist ministers looking to create a wholesome year-round family resort, Ocean City is still a dry community that has maintained its reputation as a familyoriented place. With its well-kept look, eight miles of beach and more than two miles of boardwalk, including a late-1920s music

pier (Moorlyn Terrace) on which summer concerts are given, Ocean City can find its population swelling to 150,000 during the summer months. The community sponsors many special events in the summer, including a hermitcrab beauty contest (to say nothing of a hermit crab who looks for his shadow each spring), a baseball card show, an antique car show, a sand-sculpting contest, and what is billed as the oldest baby parade in the country. Brochures for a self-guided tour of the city's historic district (Atlantic to Asbury aves. and 3d–7th sts.) are available at the Chamber of Commerce Information Center (9th St. causeway, NJ 52; 609-399-2629). Open May–Labor Day, Monday–Saturday, 9–5, Sunday, 10–2; Labor Day–April, Monday–Saturday, 10–5, Sunday, 10–2.

The Ocean City Historical Museum (1735 Simpson Ave.; 609-399-1801)

features artifacts, apparel, and other items related to the history and the natural history of Ocean City. Included among these are mementos of John Fulton Short, said to be America's only matador. Of particular interest is the Sindia Room, with mementos of the four-masted bark that went aground on the Ocean City beach in 1901. (Rumors of contraband still in the hull have led to periodic talk of salvage operations; a recent rumor included the installation of an amphitheater so the public-for a fee-could watch the operation.) The Sindia Pavilion (17th St. and the boardwalk) marks the location of the wreck: the ship's dimensions are traced on the boardwalk. The museum's library contains many early deeds and other papers relating to Ocean City and Cape May County. Open May–October, Monday–Saturday, 10–4; November–April, Tuesday-Saturday, 1-4; groups by appointment. Also run by the Friends of the Ocean City Historical Museum is the Seashore Cottage (1139 Wesley Ave.), a c. 1920 house set up to show what life in Ocean City was like in the 1920s and '30s. Open June–Labor Day, Tuesday, Friday, and Saturday, 1-4; groups and other times by appointment. Admission fee. The Friends sponsor various special events, including a house tour in early December.

On the second floor of the same building is the Ocean City Arts Center (609-399-7628). The center's gallery exhibits change roughly every month; the center also offers a variety of classes and other programs. Open Monday–Thursday, 9–9; Friday, 9–4; Saturday, 9–12.

Corson's Inlet State Park (Ocean Dr.; 609-861-2404) is off the southern end of Ocean City. The park's 300-odd acres offer opportunities for fishing, boating, and hiking. This is a popular park in the summer, although flies and poison ivy can be problems. The inlet is surrounded by the Cape May Wetlands Wildlife Management Area, more than 11,000 acres, most of it salt marsh, with excellent opportunities for boating and bird-watching.

About five miles from Ocean City in Palermo (take Bay Ave. to Roosevelt Blvd. to US 9 and turn left) is the Friendship School (Ocean Ave. and Shore Rd.; 609-628-3041). A reconstruction and restoration of an 1830s school, school privy, and coat and storage shed, the complex is run by the Historic Preservation Society of Upper Township. Open June–October, 1st Sunday of the month, 1–4; other times by appointment.

Ocean Grove Monmouth [Neptune Township]

NJ 33, 71

Founded in 1869 by Methodists as a religious summer colony, the town of Ocean Grove was for 100 years run by the Methodist Camp Meeting Association. In 1979 the state supreme court declared Ocean Grove's government unconstitutional, and Ocean Grove became part of Neptune Township. At that point most of

the community's strictly enforced blue laws, which included Sunday prohibitions against driving (the gates leading into the community were closed at midnight Saturday), bicycle riding, boating, swimming, and hanging laundry outside, no longer applied. The land still belongs to the association, however, and it is still the case that no alcoholic beverages can be sold or served, and that no one is allowed on the beach on Sundays until the church service is over. Many residents of the community, which has a population of about 7,000 in winter and 20,000 in summer, are supporting movements either to secede from Neptune or to get the township to issue special ordinances that apply only to Ocean Grove.

Ocean Grove's historic district* (the area between Main St., the Atlantic Ocean, and Wesley and Fletcher lakes) is distinguished by its generally homogeneous Victorian look. Permanent tents (actually houses extended in the summer by tents) are clustered around the Great Auditorium; there are fine old hotels with porches on Ocean Ave.; the street signs are made of tile. The auditorium (54 Pitman Ave.; 732-988-0645), a magnificent pile built in 1894 (President Grant attended the dedication ceremonies) and now a national landmark, seats over 7,000; each summer a series of concerts ranging from classical to popular to barbershop quartets is held there. The Historical Society of Ocean Grove sponsors a house tour each summer. Tours of the town can also be arranged; for information call 732-774-1869.

For beach information, call 732-988-5533.

Oceanville Atlantic [Galloway Township]

US 9

About one mile east of the center of Oceanville are the headquarters of the Edwin B. Forsythe National Wildlife Refuge (Great Creek Rd.; 609-652-1665), named in honor of a conservationminded congressman. This is the refuge's Brigantine unit, founded in 1939, primarily to protect the Atlantic Flyway. Its 40,000 acres

contain a variety of habitats: marshes (salt, brackish, and fresh water), creeks, ponds, upland fields, shrubby areas, and torests. Over 200 species of birds are known to frequent this spot. Some 1,600 acres have been impounded, creating freshwater habitats. One of the high points of this popular refuge (some 300,000 people visit it each year) is an eight-mile car trail along the impoundment dikes that gives you a view of the freshwater ponds, the salt marshes, and the mud flats (not to mention an eerie view of the Atlantic City skyline across the bay). There are 14 stops along the auto trail, and many of the birds have become accustomed to the cars so that they go about their business (cracking clam shells on the highway, leading their young across the road) as if you weren't there. There are also two short self-guided nature trails through the fields and woods and limited hunting, fishing, and crabbing. For leaflets describing the auto trail and the two nature trails, stop at the visitor center; for information on hunting permits, go to the headquarters building across the road, which also contains some natural history exhibits. The refuge is open daily, dawn to dusk; the office, 8-4 weekdays. Group orientation programs by appointment. Admission fee.

Mid-March to mid-April is the peak of the northbound waterfowl migration. To see young birds, come in mid-April through May for the Canada geese and mid-June to mid-July for the ducks. (The end of May is also a good time to see a major display of dragon's mouth orchid and grass pink on Great Creek Rd., about half a mile west of the entrance to the refuge.) The first 10 days in November usually produce spectacular concentrations of ducks, geese, and brant in the pools—over 100,000 birds congregate on 1,600 acres. Mid-November to mid-December is the best time to see snow geese.

The other side of Lily Lake is southern New Jersey's first art museum, the Noyes Museum (Lily Lake Rd.; 609-652-8848). Opened in 1983, this lovely building is beautifully situated. The museum features contemporary fine and folk art and presents rotating exhibits in three of its galleries, devoting the fourth to changing displays of decoys. The museum also sponsors several concerts a year and various other special events. Open Wednesday–Sunday, 11– 4; closed national holidays. Admission fee except on Friday.

North of Oceanville is Smithville (us 9 and Moss Mill Rd.; 609-652-4040), once touted as a reconstruction of a colonial village. Some of the buildings are genuinely old, but the emphasis now is entirely on the stores and restaurants, not history.

West of Smithville (continue on Moss Mill Rd. to Vienna Ave. and turn right) is Sylvin Farms (24 N. Vienna Ave.; 609-965-1548 weekends, 973-778-1494 weekdays), a winery that grows all its own grapes. Open for tours by appointment Friday and Saturday.

Oldwick Hunterdon [Tewksbury Township]

Oldwick, situated in the rolling hills of northeastern Hunterdon County, was settled by German immigrants in the mid-18th century. Originally called New Germantown, the town changed its name during the World War I days of pervasive anti-German sentiment. Strikingly untouched by the 20th century, Oldwick

today is a beautiful village set in the midst of beautiful agricultural country.

In the center of the village is the Zion Lutheran Church, said to be the state's oldest Lutheran church in continuous use. Built in 1749, but altered considerably during the course of the 19th and 20th centuries, the church housed what was apparently New Jersey's first organ. On the west side of High St., a bit farther south, is the Oldwick Methodist Church; it dates from the mid-1860s. The community center and town library (west side of High St., opposite Joliet St.) dates from 1807 and was given to the town by Dr. Oliver Barnet (his house, built in 1771, lies on the eastern continuation of Church St.) to serve as a classical academy and meetinghouse. It remained in the public school system until 1951 and has served as the community center since the mid-1950s.

Just north of Church St. on C 517 is the Cold Brook Preserve (Old Turnpike Rd.; 908-782-1158), formerly the Van Doren farm. The 298 acres of rolling fields,

orchards, and old pastures are administered by the county park system as a natural area. Part of the land is still being farmed, and it is hoped that this unusual combination of farm area and adjoining conservation easements will help preserve some of Hunterdon County's rural heritage. You are welcome to walk in the park, but you are asked to respect the farmer's fields. Open to limited hunting.

Also just north of town are the facilities of the Somerset Hills Handicapped Riders Club (C 517; 908-234-0290); visitors are welcome to observe the lessons. Call for information.

Oradell Bergen 8,024

GARDEN STATE PKWY EXIT 165, C 503

One of Bergen County's many Dutch settlements, Oradell still has some of its early stone houses, particularly along Kinderkamack and Paramus roads. On Midland Rd. you can also see an example of a Stickley house. The Edward W. Vaill house* (863 Midland Rd.) was built in 1911 according to one of the plans published in the

Craftsman and furnished completely in arts and crafts style. The railroad station* (400 Maple Ave.) dates to 1890. In a converted late-19th-century firehouse, the Bergen County Players (298 Kinderkamack Rd.; 201-261-4200), a community group founded in the early 1930s, presents eight shows each season, including a minimusical for children each December. Tours of the theater can be arranged by writing the theater.

The hometown of Walter Schirra, the astronaut who orbited around the earth six times in 1962, Oradell is also the home of the Hiram Blauvelt Art Museum (705 Kinderkamack Rd.; 201-261-0012), an unusual museum devoted to a personal collection focusing on wildlife. Housed in the former carriage house of the late-19th-century Blauvelt mansion (the dark house with turrets and towers that looks like a haunted house in a Grade B movie), the collection includes examples of animals from around the world as well as paintings and sculpture related to animal themes. Among the holdings is a rare Audubon edition. Open Wednesday–Friday, 10–4; weekends, 2–5; groups by appointment.

Before the Revolution, a mill stood on the site on which the former Hackensack Water Company built a pumping station (1882) and other facilities (in the New Milford Ave., Elm and Grove sts. area, often referred to as van Buskirk's Island). Now that the water company no longer uses this location, a controversy has developed over whether to keep the area for open space and a nature center or let it be used for development.

Just south of Oradell, in New Milford, is the Art Center of Northern New Jersey (250 Center St.; 201-599-2992). Housed in a former church built in the 1890s, the center sponsors exhibits in its gallery and offers classes in all media. Exhibits change several times a year. Open Monday–Friday, 9:30–5:30; Saturday, 10–2; Sunday by appointment.

Oxford Warren 1,790

Situated on the slopes of Scotts Mountain, Oxford (originally known as Oxford Furnace) became an important iron town in the 1740s, producing cannonballs for the revolutionary army. It was the first ironworks in the United States to use the hot blast method (1834), which revolutionized iron making in this country.

A variety of iron products was made here, including railroad wheels and firebacks. until the furnaces were blown out in the 1880s (another furnace, built later, did continue operations until the early 1900s). The mines continued to be worked until 1964, and ore from these mines went into munitions for both world wars. The remains of the original Oxford Furnace* can be seen on the west side of Washington Ave. (between Belvidere Ave. and Cinder St.); there are explanatory plaques at the site. Farther up the hill is the Shippen Manor* (1744; 8 Belvidere Ave.; 908-453-4381), now serving as a house museum and home to the Warren County Cultural and Heritage Commission. During one period in the mid-18th century, the Oxford ironworks were owned by the Shippen brothers from Philadelphia; their niece Peggy Shippen, who became Benedict Arnold's wife, visited Oxford frequently to take part in its active social whirl of balls and hunts. Shippen Manor is open for tours, 1-4, 1st and 2d Sunday of the month; groups Wednesday by appointment. Oxford's industrial historic district* includes parts of NJ 31; Belvidere, Buckley, and Washington aves. and the area around them; Jonestown and Mine Hill rds.; and Academy and Church streets.

North of Oxford on the south side of us 46, a little less than three miles east of the intersection with NJ 3I (the approach is well marked), is the Pequest Trout Hatchery and Natural Resource Education Center (605 Pequest Rd.; 908-637-4125). The facility is located within the Pequest Wildlife Management Area, an area chosen for the hatchery because of the exceptionally high quality of the water in the Pequest Valley. The hatcheries produce some 600,000 brook, brown, and rainbow trout each year for stocking the roughly 200 streams and lakes open for public fishing. (Some 350,000 people fish for trout in New Jersey waters each year.) This is basically a put-and-take operation, as few New Jersey streams can support trout naturally. Visitors can look into the nursery rooms and watch the upper raceways from an observation ramp. Many of the exhibits in the handsome educational center, which relate to the management of natural resources generally, as well as to fishing, forestry, and the Jersey shore, are hands-on and interactive. Occasionally, there are changing exhibits-fly tying was the subject of one-and the annual open house the week before trout season opens includes a living history encampment and can draw as many as 8,000 people. The center operates programs for school groups, conservation organizations, camps, and casual visitors. A popular facility, the center can become crowded except in the winter months. A 15-minute video

showing the behind-the-scenes operations (how the eggs are collected, for example) runs continuously, and there is a self-guiding tour. On the grounds are also a fishing education pond, a butterfly garden, nature trails, and facilities for picnicking. Open daily, 10–4; groups by appointment. Fishing courses, taught April–October. Some of the wildlife management area land is leased to local farmers who grow small grain and corn to attract game birds and deer; within designated areas you can hike, hunt, and fish.

Paramus Bergen 25,067

GARDEN STATE PKWY EXITS 163, 165, NJ 4, 17

Settled in the mid-17th century by Dutch emigrants, Paramus may have derived its name from the Indian word "permessing," for "abundance of turkeys." Over 50 years ago the town was described by the WPA guide to New Jersey as "an old Dutch farm community... growing vegetables for the city markets." You can

still find scattered about the town a half-dozen or so old Dutch stone houses (drive along Paramus and E. Ridgewood aves.), but any sense of being in anything as compact as a farm community is gone (and the turkeys, of course, disappeared long ago).

In fact, Paramus is noted among historians of the city for having led in the development of the post–World War II shopping mall. (It has even been described as the mecca of malls.) The Garden State Plaza (NJ 4 and I7), which opened in 1957, was an early example of the open mall that served several regional community functions (it has since been converted to a closed mall), and the Paramus Park Mall (Garden State Pkwy and NJ I7) is an early example of the newer type of enclosed mall that for many has taken over some of the functions of the city's downtown. Paramus Park Mall is architecturally interesting: the exterior is severe, yet the interior, with its waterfall, fountain, hanging shrubs, and diagonally intersecting skylights, is open and light.

The Bergen County Museum of Arts and Science (327 E. Ridgewood Ave. at Fairview in the Bergen County Community Services building; 201-265-1248) is housed in a mid-19th-century brick building, once the Bergen County Almshouse (1852–1930) and the County Old Folks Home (1930–67). The museum's science exhibits feature a well-known mastodon skeleton unearthed nearby, Lenape artifacts, minerals, fossils, and a nature room. Art exhibits change every eight weeks and usually consist of one-person shows by artists from northern New Jersey and metropolitan New York City. The museum also has a youth gallery devoted to work by students in the Bergen County schools; here the exhibits change roughly every six weeks. Occasionally items from the permanent collection are on display, and the museum has an active schedule of children's educational programs and workshops. Open Tuesday–Saturday, 10– 5; Sunday, 1–5; groups and gallery tours by appointment. Donation requested.

Behind the museum in the same county complex is the award-winning Norman Bleshman State Regional Day School for the Handicapped, designed so that everything will be not only convenient but pleasurable for someone in a wheelchair. The horticultural center in the same area, part of the county's vocational and technical school facilities, includes an old barn, a modern airplanetype windmill, buildings with solar panels, greenhouses, and a wood silo.

West of this complex, off Ridgewood Ave. on the other side of the Garden State

PARAMUS PARK MALL

Parkway, is the New Jersey Children's Museum (599 Industrial Ave.; 201-262-5151). Intended for children up to eight and adults, the facility features a variety of interactive and educational exhibits and activities. Open May–September, weekdays, 9–5, weekends, 10–5; October–April, weekdays, 9–5, weekends, 10–6. Admission charge.

Paramus's oldest extant building, the Midland School* (239 W. Midland Ave.), was built in 1876. In 1924 the one-room schoolhouse became the borough hall. It later housed the police department and the entire library. Recently restored and tastefully enlarged, it is now the Charles E. Reid branch library. Also on Midland note the Mount Saint Andrew Villa, a retirement home run by the Sisters of Saint Elizabeth in Convent Station, and across the street the Church of the Annunciation.

Van Saun Park (Forest, Continental, and Howland aves.; 201-262-2627), one of Paramus's two county parks (it shares Van Saun with River Edge), is one of the county's most popular parks. Van Saun can be crowded in the summer, and two of the parking lots are reserved for county residents. Its 10-acre 200 features some 200 animals representing 65 species from North and South America. The zoo is involved in an endangered species program and has managed to use its small space so that the animals do not appear crowded. A 4,000-square-foot aviary constructed like a circus tent and covered with netting replicates the environment of the Meadowlands. A boardwalk goes through the aviary over a 9,000-gallon artificial pond, which contains native fish, turtles, and waterfowl. (The aviary is closed when it is too cold to hose down the walks.) The zoo offers a wide range of educational programs-some 10,000 children a year take part in the formal programs-as well as seasonal events like sheep-shearing. An 1860s Bergen County farmyard, complete with appropriate animals, has been re-created, and during the summer months (April-October) a miniature train with a replica of an 1866 locomotive runs around the 200 and the farmyard. At Washington Spring Park (between Van Saun's areas M and L), so called because Washington's army camped near here in 1780 and according

to legend took water from the natural spring, is a shade garden. There are also picnic grounds, a lake and boat basin, a bicycle-pedestrian path, sledding slopes, and a tennis center (201-265-1028). Open May–September, 9–5; October–April, 9–4:30. Tours by appointment (201-262-3771).

One section of Saddle River County Park is on Dunkerhoof Rd. (off Paramus Rd.; 201-444-1117); here are a wooded picnic area and one section of the five-mile trail that links several recreation areas along the Saddle River. Bergen County Community College, on the site of a former golf course, is a compact campus joined by covered walks. Along the Saddle River at the southwestern corner of the borough (Red Mill Rd., just south of 4 and east of Saddle River Rd.) is the Easton tower and waterwheel, reconstructed in the 1960s to replace the original complex built in 1899 on the site of an 18th-century mill that produced blankets for the army in the Civil War.

Park Ridge Bergen 8,102

GARDEN STATE PKWY EXIT 172S

Richard Nixon's home for the last years of his life, Park Ridge is also the hometown of the singing group the Roche sisters and, since the late 1980s, home base for the Hertz Corporation, the world's largest rental-car company. Like much of Bergen County, Park Ridge was settled by Dutch farmers, and there are old Dutch

stone houses to be seen on Pascack and Rivervale roads. At 13 Pascack Rd., for example, is the Wortendyke Dutch Barn* (201-646-2780, 201-930-0124). This 18th-century barn has been closed for restoration but is expected to reopen in the spring of 1997. Exhibits focus on the history of the family whose farm it was and on farming in the northern part of Bergen County. Open May–October, Wednesday and Sunday, 1–5; groups by appointment. Directly across the road (12 Pascack Rd.) is the mid-18th-century Frederick Wortendyke house.*

From about 1775 until 1889 Park Ridge was the site of a wampum mint. Wampum, manufactured here by John W. Campbell and his descendants, was used by the U.S. government and by fur traders (John Jacob Astor bought wampum from the Campbells) in their dealings with Native Americans in the West. Most wampum was manufactured by hand, but the Campbells invented a machine that could drill holes in six shells at once. They are reputed to have given picnics at which one could eat all the shellfish one wanted without charge as long as the shells were not broken. Their machine, thought to be unique in the world, is on exhibit at the Pascack Historical Society Museum (19 Ridge Ave.; 201-573-0307, 201-664-4934, 201-664-3350), along with other tools from the mint and collections of old instruments, cabinetmakers' tools, paperweights, and many other items. The museum, housed in an 1873 Congregational church built "under the guidance of" Henry Ward Beecher, concentrates on exhibits that highlight life in the Pascack valley. The central exhibit generally changes every year or two. The society also sponsors occasional lectures and slide programs that are open to the public. Ordinarily open May-September, Sunday, 2–5, with groups and other times by appointment. The museum, closed for repairs in 1997, was expected to reopen in the summer of 1998.

Parsippany-Troy Hills Morris 48,478

I 287, I 80, US 202, NJ 10, 46, 53

Parsippany is known to have been settled since at least the early 18th century; at that time the area was considered the "most notable in the state for grazing." In the 19th century dairy products replaced hay and wood, and in the 20th truck gardening and poultry farming were dominant. The area was also popular as a

resort from the 19th century into the 1920s and '30s, and some of the local lakes were created for that market. Like many other townships, Parsippany–Troy Hills is made up of smaller settlements, some of which grew in an uncontrolled way after World War II, and the remnants of their past are often hard to find among the corporate offices and superhighways. (Four superhighways—I 287, I 80, US 202, and NJ 46—slice through the township, often making it awkward to get from one part to another.) Parsippany is far and away the county's largest municipality; it also boasts over 9 million square feet of office space. Among the corporate tenants is Tiffany's, and the Vince Lombardi silver Superbowl trophy is crafted in Parsippany.

One of the township's remaining late-18th-century buildings, the Bowlsby House* (320 Baldwin Rd.; 973-263-4397), is being used as the township's historical museum. Here you can see a variety of artifacts, memorabilia, and photographs relating to the town, including, for example, the wagon and high chair belonging to John Grimes, head of the Underground Railroad in Morris County. Open weekdays, 12–4.

Old Troy Park (Reynolds Ave.; 973-326-7600) is a recently refurbished county park, with playing fields, picnic facilities, a wooden train for children, and trails suitable for hiking, cross-country skiing, and snowshoeing.

In the western part of the township is Craftsman Farms* (2352 NJ 10 W. at Manor La.; 973-540-1165), a national historic landmark designed and built by Gustav Stickley (on land that had been farmed since the 18th century). From 1908 to 1912 he worked to build his home and a farm school that would further the arts and crafts movement, but by 1918 he was bankrupt. Eventually, the property was rescued from the jaws of a developer, and of the 650 acres Stickley had purchased, 26 remain. The main house, sometimes described as the biggest log cabin in the eastern United States, has been lovingly restored and serves as a museum of the arts and crafts movement with changing exhibits (generally three each season), crafts demonstrations, and lectures and tours. Grounds open daily; house open April–October, Thursday, 12–3, weekends, 1–4. Groups by appointment.

In the southwestern part of the township (off NJ 53) is the community of Mount Tabor. Formed as a camp meeting in the late 1860s (by a committee that included Stephen Crane's father), it gradually evolved from a tent camp to

a more permanent summer religious colony to its present condition as a distinctive section of the larger township. The Mount Tabor Golf Club is on land that was part of the colony, and the colony's past is distinguishable in the Victorian gingerbread that characterizes many of the houses.

Passaic Passaic 58,041

NJ 2I

Passaic at one time was a center of the country's textile industry it was once the country's leading manufacturer of linen and linen thread, in 1910 it was first in the state and fourth nationally in the production of worsted, and at one point over half the country's handkerchiefs were manufactured here. Botany Worsted Mills

claimed to have the largest complete textile manufacturing facility in the world, and the Botany Worsted Mills Historic District* can be seen at 80–82 and 90 Dayton Ave. and 6–32 Mattimore Street. The city was also an important producer of rubber, and the first pre–World War II TV sets were manufactured here by the Du Mont company. The mills began to move south after World War II, and today the remaining large industrial buildings are occupied by a mix of small companies.

As industry developed after the Civil War, the original Dutch and Irish farmers in the area were joined by European immigrants. In the 1910 census, Passaic had the largest percentage of foreign-born residents in the state, and in the 1930s about one-third of the residents were foreign born. Poles were then the largest single group, although there were large numbers from Hungary, Italy, Russia, and elsewhere. The tradition continues: today, for example, there are so many Peruvians in Passaic and Paterson that Peru has opened a consulate in the county.

There were some hopes that the mid-19th century Ayerigg Mansion* (15 Temple Pl.), named for Passaic's first mayor and until recently the Masonic temple, could be converted to a museum that would feature artifacts and mementos relating to the city's history and stress the city's wide variety of cultures. For now, in the heart of the old Hungarian district, now primarily Hispanic, you can visit a museum devoted to one of those cultures: the American Hungarian museum is housed on the second floor of the Reid Memorial Library (80 Third St.; 973-473-0013, 201-836-4869). The permanent exhibit has examples of folk and fine art, historical artifacts, and photographs, from the old country and from the Hungarian American community. The museum also sponsors concerts, lectures, and videos. Open October–May, by appointment during library hours; special programs Sunday, 1–5.

Paterson Passaic 140,891

180, NJ 4, 20

First settled by the Dutch in the late 17th century, Paterson remained an agricultural community until late in the 18th century. It was an unusually early tourist attraction—the 77-foot-high Great Falls of the Passaic River drew visitors from as far away as New York when it took three days to get to the site. During the

Revolution, George Washington, Alexander Hamilton, and the marguis de Lafayette had stopped to eat lunch at the Great Falls, and Hamilton had been struck by the power that lay in them. He believed that the success of the young country depended on its establishing its own industrial base, and 12 years after his visit to the Great Falls, as secretary of the treasury, he proposed to Congress the establishment of an industrial district. When Congress was unenthusiastic about funding the project, he arranged private support for what was in effect the country's first planned industrial city. Thus was the Society of Usefull Manufactures (S.U.M.) born in 1791. Pierre L'Enfant, later to design Washington, D.C., was hired to design the city. His scheme proved too expensive, although the raceways were laid out according to his plan, and the work was taken over by Peter Colt, a member of a family that had much to do with the S.U.M. and Paterson's development. The area surrounding the falls was named Paterson in honor of the then governor of the state and signer of the Declaration of Independence, William Paterson. The society, which was granted many financial and legal privileges by the state, continued to operate until after World War II.

Over the course of the 19th century Paterson became a leading industrial city, known as the home of the Colt revolver ("The gun that won the West") and the submarine, as a leading producer of cotton and the home of cotton duck sails, as Silk City, as a major producer of locomotives and then airplane engines, as the scene of momentous labor struggles. It was also a major stop on the Underground Railroad. By 1900 it had become the 15th-largest city in the United States. Many famous people were Paterson natives, among them Nicholas Murray Butler, the president of Columbia University for over 40 years; Garret A. Hobart, vice-president during McKinley's first term; Albert Sabin, discoverer of the oral polio vaccine; Larry Doby, the first African American in the American Baseball League; Allen Ginsberg, the poet; and Lou Costello, the comedian (in 1992 a statue was erected in his honor in Federici Park). Perhaps less well remembered today is Sam Patch, a cotton spinner who jumped into the falls when drunk one night. He survived and started a second career as "the Great Descender," achieving a successful jump at Niagara Falls. (He died in the Genessee Falls.) Although not a native (he came from Rutherford), the poet William Carlos Williams is forever associated with Paterson because of his long poem of that name.

The first factory was in operation by 1794, producing calico goods, and

cotton was Paterson's first important product. In the 1830s Sam Colt began manufacturing his revolver in what came to be known as the Gun Mill (the walls of the first two stories are still to be seen at Van Houten St.). The venture was not successful, and he sold the factory. When the government decided it wanted to order the revolver (apparently because of a recommendation from the Texas Ranger Sam Walker, who had used it in 1838), Colt had no model at hand. In one version of the story, he paid an exorbitant price to buy someone else's gun; in another, he redesigned the gun. In either case, there is agreement that he made his fortune from the revolver, but this time it was manufactured in Connecticut.

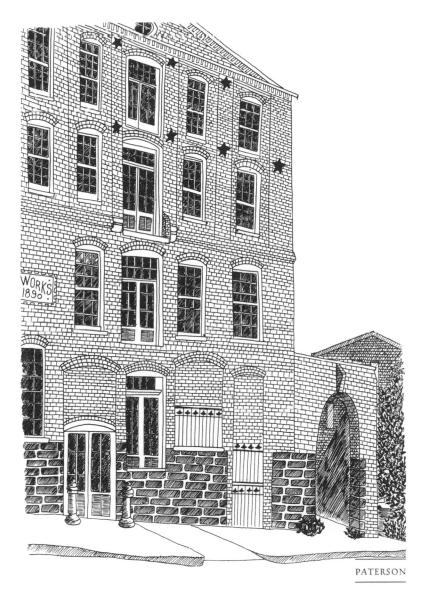

At about the same time that Colt first made his revolver, Thomas Rogers manufactured the country's first steam locomotive, the Sandusky. Over the next 50 years four companies were manufacturing locomotives in Paterson and among them produced roughly 40 percent of the nation's locomotives. Paterson also produced most of the rotary snowplows used on locomotives.

The silk industry began in Paterson in the 1840s, cotton by then having moved to New England, and by the 1880s Paterson was called Silk City. Every stage of production, except growing the silkworms, took place in Paterson, and unlike the other industries mentioned, silk continued as a prominent industry into the 20th century. In fact, the famous silk workers strike of 1913 (see Haledon) took place when the industry was still vital to the city. Silk ceased being important to the city when synthetic fibers were developed.

A Paterson schoolteacher, John P. Holland, developed the first successful submarine in 1878 and tested it in the Passaic River. Although Holland's ideas lie behind today's atomic submarines, for years the navy did not take him seriously, even when he surprised a navy ship on a secret maneuver. When he won a contest sponsored by the navy, the navy decided to sponsor another contest.

After World War I the Wright Aeronautical Corporation, manufacturers of airplane motors, moved to an old silk factory in Paterson, where they made the engine for Charles Lindbergh's *Spirit of St. Louis*. For a time this was Paterson's dominant industry, but it moved elsewhere after World War II.

Although Paterson is no longer a leading industrial city, it has found creative ways to reuse its remaining 19th-century industrial buildings and is experiencing new vitality as a different sort of city. The S.U.M. historic district* (encompassing W. Broadway; Ryle, Wayne, and McBride aves.; Grand, Morris, Barbour, Spruce, Market, Mill, Van Houten, Curtis, River, Oliver, and Reservoir sts.; Stoney Rd.; and the Passaic River) is a national historic landmark. The buildings have been converted to a variety of uses. In the Rogers Locomotive Erecting Shop (1874), for example, is the Paterson Museum (2 Market St.; 973-881-3874), dedicated to preserving the industrial, technological, and geological history of Paterson. There are both changing and permanent exhibits: among the displays are ones relating to the aircraft engine industry, locomotives, Colt guns, local rocks and minerals, and textiles, as well as two of Holland's submarines. Open Tuesday–Friday, 10–4; weekends, 12:30–4:30.

The Great Falls Visitor Center (65 McBride Ave.; 973-279-9587) is located in a converted 1930s gas station (itself a retrofitted mid-19th-century boarding house). Here you can see photographs of the falls and orientation videos and pick up a map for a self-guided tour, as well as other material. Open year-round weekdays, 9–4; April–September, Sunday, 12–4, but it is advisable to call first.

Wandering through the district you will see not just old mills but workers' houses, the raceways, churches, even the bar (Cianci and Van Houten sts.) that served as I.W.W. headquarters during the silk strike. Some of the mills have been converted to living quarters: the Phoenix Mill complex (Van Houten St.),

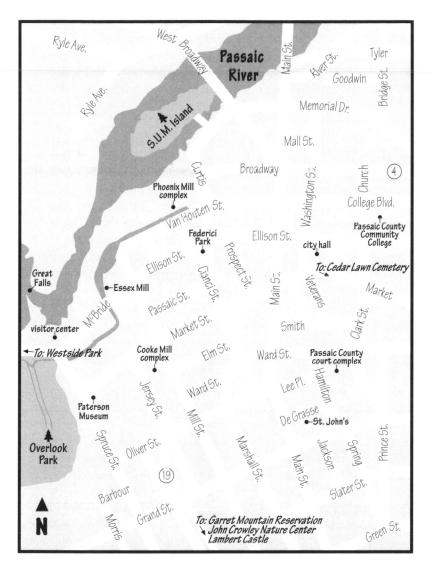

1815–70, has been turned into cooperative apartments; the Essex Mill (Mill St.), 1807–72, which used to manufacture mosquito netting, into subsidized apartments for artists. The Cooke Mill Complex (Mill St.) has been converted to apartments and a family health center. In the mid-'80s the People's Republic of China even purchased an old paper mill to manufacture cardboard.

The falls, 77 feet high and 280 feet wide, have been declared a national natural landmark, and their energy is once again being harnessed. They are best observed from Overlook Park (McBride); from there you can also see much of Paterson's geological history in the rocks. Another attractive option is to walk on the recently restored foot trail that follows an old Native American trail (Stoney Rd.) and travels along the ridge.

A visit to downtown Paterson, which is close to the Great Falls district, is

also rewarding. Note particularly the Cathedral of St. John the Baptist* (Main and Grand sts.), 1865, a national historic landmark; the Passaic County courthouse annex, originally the post office (Hamilton St.), built at the turn of the century as a copy of the medieval Haarlem Guild house (to honor the first settlers of Paterson); the late-19th-century city hall (155 Market St.), modeled on that in Lyons, France (also a silk-producing city); and the county courthouse, 1903 (Clark St.).

Another aspect of the silk industry can be seen in Lambert Castle,* also known as Bella Vista (Valley Rd.; 973-881-2761), a pretentious late-19th-century stone mansion built by one of the leaders of the industry, Catholina Lambert. The house, which has recently undergone extensive renovation, serves as a museum run by the Passaic County Historical Society. Although Lambert was forced to sell his art collection (it included works by Rembrandt, El Greco, Renoir, and Monet), a few pieces remain. The first floor is decorated to reflect life as someone in Lambert's social class would have lived it in Victorian times. with an attempt to have each room reflect the purpose it served when the Lamberts lived there. In some cases, Lambert's actual furnishings are available (the dining room set, for example). The second floor is devoted to local history more generally, with exhibits that change two to three times a year. The house itself is striking: note the hand-carved oak structure that places anyone descending the steps in a picture frame, and be sure to take in the view from the terrace. The grounds have also been restored to reflect the 1930s landscaping designed by the Olmsted Brothers (a noted landscaping firm run by the sons of Frederick Law Olmsted). The house is scheduled to reopen in the fall of 1997. Call for information. Admission charge.

Lambert Castle is located in Garret Mountain Reservation, a county park with open fields, a fishing pond, a three-mile cross-country track, an overlook, and picnic areas. Garret Mountain has an unusual number and variety of rare minerals and is in fact a national natural landmark because of the volcanic activity associated with its creation. It is also a good place to watch for hawks.

South of Garret Mountain, in Rifle Camp Park (Rifle Camp Rd.), is the John Crowley Nature Center (973-523-0024). The center, which includes an observatory, a seismograph, and a weather station, has changing nature and mineral displays and sponsors a variety of programs for children and adults. There are hiking trails and a fitness course in the park, and public evenings at the observatory usually take place twice a month. Open daily, 9–5, except New Year's Day, Thanksgiving, and Christmas. Group tours by reservation. The picnic areas include one suitable for handicapped visitors.

Many of Paterson's distinguished citizens, including Lambert, Rogers, Hobart, and Butler, are buried in the Cedar Lawn Cemetery (McLean Blvd., NJ 20), opened in 1867. This cemetery, which includes a Greek Revival temple for Hobart designed by Henry Bacon, who designed the Lincoln Memorial, is rich in examples of Victorian funerary architecture. North of Cedar Lawn (take McLean Blvd.), in what was Paterson's wealthy area, is Eastside Park, laid out in the 1890s. There is a splendid view here, and some of the mansions from Paterson's days of glory surround the park. At Westside Park* (112–242 Totowa Ave.), you can see the 19th-century Van Houten house.

At Passaic County Community College (College Blvd.) is a large mural depicting the history of the city from Hamilton to the visit of Martin Luther King in 1968. (King's visit took place shortly before his assassination.) Also on the campus is a life-size brass-and-copper statue of King. The poetry center sponsors readings, workshops, conferences, and contests. Exhibits at the LRC Gallery are open to the public weekdays, 9–9; Saturday, 9–5. A theater series for young people also takes place at the college. For information on all cultural events that are open to the public, call *973-684-6555*.

Paulsboro Gloucester 6,577

NJ 44

Settled in the 1680s, Paulsboro is named for one of the first families to arrive in the area. Fort Billings Park (Delaware River, Billingsport Rd. at 3d St., Clonmell Rd., N. Delaware St.), listed on the state historic register, commemorates the fort, which was built by the U.S. government in 1776 to keep the British from getting to

Philadelphia. The land bought for Fort Billings represented the new government's first land purchase (the Pauls were the sellers), and the fort was designed by Tadeusz Kosciuszko, the Polish patriot. The Gill Memorial Library (Broad and Commerce sts.) is in a stone house built c. 1810 by John Clark and named in honor of Matthew Gill, a prominent 19th-century Paulsboro man who, among other charitable activities, in the 1870s gave the land on which the Episcopal Church stands. (The current church building dates to 1910; the original one burned.) The Samuel Philip Paul house (212 E. Broad St.), like the library, dates to 1810, although the back portion may be much older. The Mobil refinery just south of the park (known as the Paulsboro plant, it is actually in Gibbstown) opened in 1917; the refinery on the Paulsboro side, completed in the early 1990s, is said to be the country's largest producer of lubricating oil.

Southwest of Paulsboro, in Gibbstown, is the C. A. Nothnagle log house* (406 Swedesboro Rd.; 609-423-2883), a mid-17th-century structure that may well be the oldest log house in the country. Inside the 16 x 22 square foot house are an 18th-century cabinet and various artifacts. Open by appointment.

Also in Gibbstown is Greenwich Lake Park (Tomlin Station Rd; 609-468-0100). The 40-acre spring-fed lake is stocked with trout, and you can fish yearround. The boat launch is open weekends from the start of the trout season to Labor Day; the lake is open for swimming June–Labor Day. Picnic tables are also available, and a variety of wildlife is to be seen in the wetlands surrounding the lake. Open April–October, sunrise–sunset.

Peapack and Gladstone Somerset 2,111

US 202, 206, C 512

Situated in an area of rolling hills and large estates, Peapack and Gladstone (together they form a single borough) are both attractive villages. Many of the estates have been converted to other uses—the former Blair mansion, for example, a French chateau built in 1903 that overlooks Ravine Lake, was for many

years St. Joseph's Villa, a religious retreat. Thirty-eight acres from that estate and some of the other buildings-the stables, the carriage barn, and three brick houses employees of the estate had lived in-became the nucleus for the current campus of the Matheny School, an institution that has pioneered in the effort to provide severely learning disabled children and young adults with an education that will enable them to live independently. The former Ladd estate was bought by King Hassan II in 1983 in what was then the largest domestic real estate transaction in the state's history (\$7.5 million). Hamilton Farms, a former estate with stables that were characterized when they were built in 1916 as "the most lavish" in the country, now serves as the headquarters of the USET (United States Equestrian Team; Pottersville Rd., 512, just west of us 206; 908-234-1251). Here the team trains for international events, and master classes and competitions are held. Open to the public weekdays, 8:30-4:30, and for special events. From May to October, there are generally one or two special events or competitions each month, including the Festival of Champions in June; admission may be charged on these occasions.

A little north of Gladstone are two Morris County facilities, both on former, albeit more modest, estates—Willowwood Arboretum and Bamboo Brook Outdoor Education Center (continue on 512 past Hamilton Farms to Union Grove Rd., right on Union Grove, left on Longview; about a half-mile to your left is the driveway leading to Willowwood; another half-mile to your left the driveway to Bamboo Brook; 973-326-7600). On 130 acres of rolling farmland in the Hacklebarney Hills, Willowwood contains some 3,500 kinds of plants, both native and exotic, as well as one section of undisturbed forest. There are impressive collections of lilacs, ferns, magnolias, and hollies, and a hillside of pink lady slippers. Near the house, which dates from 1792, are two small formal gardens, but most of the paths meander through open areas and woodland.

Bamboo Brook, formerly Merchiston Farm, was for many years the home of Martha Brookes Hutcheson, one of the first women to be trained as a landscape architect in the United States. On the center's 100 acres are fields, forest, and a five-acre formal garden designed by Hutcheson. The earliest section of the house dates from the 1720s; the lecture hall is a music room added in the 1920s. The house is now used by the New Jersey Conservation Foundation. The gardens include a cedar arbor, pool garden, and ha-ha. As in the Willowwood Arboretum, trails here wind through the fields and along the brook. Classes, tours, and workshops are held at both facilities. The grounds in both parks are open dawn–dusk; tours by appointment.

Because the two facilities are in different geological sections—Willowwood is in the Piedmont and much of Bamboo Brook in the Highlands—the contrast between the two adjacent sites is of interest. The wooded area between them contains examples of Roxbury pudding stone.

Near Peapack-Gladstone on US 206 are the Beneficial Management Corporation headquarters. Seen from the highway, they look something like an Italian hill village. Occupying 30 acres of an 850-acre tract, the buildings are linked by arcades, there are formal gardens and landscaped courts, and dominating all is the 88-foot campanile.

Pemberton Burlington 1,367

C 530

This small Pinelands community, just a few miles west of Fort Dix and McGuire Air Force Base, was settled by Quakers in the late 17th century and named in the 19th century for James Pemberton, a Philadelphia merchant. An early-19th-century house and mill* can still be seen where Rancocas Creek crosses Hanover St.; note

also the North Pemberton railroad station,* also on Hanover Street. An 18thcentury Quaker meetinghouse* still stands in Arneys Mount, north of Pemberton.

Burlington County College is south of the borough on the Pemberton– Browns Mills Rd. (c 530; 609-894-9311, ext. 7289). In the Lewis Parker College Center are two galleries. Exhibits in the Creation Gallery are devoted to works by students and local artists and change monthly; in the student lounge is a permanent collection. Most of the pieces in the sculpture gallery change annually. The exhibits are open to the public during normal college hours; call for information. The Foundation Theatre (609-894-2138), a professional company, performs at the college.

If you continue on c 530 and turn right on New Lisbon Rd. (c 646), after about four miles you will enter Lebanon State Forest (609-726-1191). The state began acquiring this forest early in the century; it now covers some 32,000 acres and contains 400 miles of road. Two units of the CCC (Civilian Conservation Corps), one all African American, were active here in the 1930s, developing 60 miles of road; building shelters and cabins, three of which are still in use; creating Pakim Pond out of a former cranberry reservoir (the pond is near the site of the Lebanon Glass Works, active for a few years in the 1860s, which gave the forest its name); and planting more than 3 million seedlings. Today, on occasion trees from that planting are harvested and taken to Batsto (see Hammonton) to be sawn into lumber to use in the forest for repairs and signs. Among the many attractions of this Pinelands tract is the Cedar Swamp Natural Area, an Atlantic white cedar swamp surrounded by a pitch pine forest, in which can be found many of the unusual plants that thrive in the Pinelands. This is the northern limit of commercially useful Atlantic white cedar. Hikers can find many miles of unmarked sand roads as well as marked trails and a section of the Batona Trail, which begins in the forest at Ong's Hat and ends in Wharton State Forest (see Hammonton). Horseback riders will also enjoy the sand roads. The forest is open for picnicking, camping, fishing, and hunting. Nature programs, ranging from plant hikes to motor tours in search of deer, are offered during the summer. For information and trail maps, stop at the office (the entrance is off NJ 72, one mile south of the NJ 70-72 intersection).

If you continue on c 530, past New Lisbon Rd. (at Browns Mills, 530 turns right and becomes Lakehurst Rd.), about 41/2 miles east of Browns Mills, you will reach Whitesbog Road. Turning left here takes you to the community of Whitesbog,* developed in the 1860s by Joseph J. White, a cranberry cultivator who discovered the value of flooding cranberry bogs and became known as the cranberry king. His eldest daughter, Elizabeth C. White, was responsible for developing the commercial blueberry from native huckleberries. In 1916, five years after she began working with a U.S. Department of Agriculture scientist, she marketed her first commercial crop. White maintained her interest in the development of the blueberry all her life and donated land for further work. (She also maintained a lifelong interest in and concern for those who tended the plants.) New Jersey now leads the nation in the production of blueberries for consumption fresh (25 million pounds in 1995) and is second in overall production (35 million pounds in 1995) and acreage (7,700 acres in 1995). (The acidic soil of the Pinelands, combined with the blueberry's low fertility requirements, make this the ideal place to grow them.) At one time the White plantation employed 80 full-time and 600 migrant workers. Although cranberries and blueberries are still grown commercially around Whitesbog (some of the land is leased to the White company, which has been modernizing some of the bogs), many of the buildings suffered from neglect. The Whitesbog Preservation Trust (609-893-4646) is working on the remaining buildings, including the packing house, the old general store, the workers' cottages, and a Sears catalogue house.* The Whitesbog Trust's Seasonal Series features moonlight walks, nature walks, and other educational programs.

The Pineland Institute for Natural and Environmental Studies (referred to as Pines; 609-893-1765) has been located in Whitesbog since 1968. Run by Rowan University, the institute, which operates out of the old general store, sponsors daylong educational programs. Attended by some 10,000 people a year, the programs focus on the natural resources of the Pinelands and the environmental impact of human activity. This is a wonderful area to walk in, but as in all hikes on unmarked Pinelands roads, it is easy to get lost unless you take care to watch for distinguishing landmarks.

East of the borough of Pemberton (take 616 north to 630, Pointville Rd., and turn right) is Emmons Dairy (201 Pointville Rd.; 609-894-2305), the last dairy farm in the state to bottle and process its own milk. Tours of the farm, including a petting zoo, can be arranged by appointment weekdays.

Pennington Mercer 2,537

NJ3I

First settled late in the 17th century, Pennington was named Queenstown in honor of Queen Anne, but came to be called Penny Town, possibly because it was so small (less than one square mile). By the mid-18th century, the name had solidified as Pennington. In 1776 the town was occupied by British and Hessian

troops, who apparently used it as a base for raids on Trenton. Lord Cornwallis had his headquarters here for a time, and members of the British cavalry are said to have jumped their horses over the wall in front of the First Presbyterian Church. (The present building on Main St. dates to 1875; the earlier building burned.)

Pennington today is much admired for its well-preserved look. The Pennington School (112 W. Delaware Ave.), founded in 1838, is the oldest Methodist secondary school in the United States. Established as a Methodist Episcopal male seminary, in 1854 it became coeducational. Reverting to a boys' school in 1910, it went coed again in 1972. Among Pennington's many attractive buildings note the 18th-century John Welling house* (52 E. Curlis Ave.), with its fish-scale shingles, and the railroad station* at the corner of Green St. and Franklin Ave. (c. 1882).

East of the center of town is the Stony Brook–Millstone Watershed Association (31 Titus Mill Rd.; 609-737-3735), a conservation organization that operates out of a farmhouse on 585 acres. Also on the property are the Buttinger Nature Center, an organic farm, a pondhouse, and eight miles of trails suitable for hiking and cross-country skiing. Maps are available for selfguided tours. The nature center (609-737-7592) has two discovery rooms and a nature gallery; exhibits change every six weeks. The farm (609-737-8899) is used as an experimental and demonstration farm. The association is involved in an active educational program for children and adults; it also sponsors a day camp in the summer and frequent special events. The nature center is open Monday– Saturday, 10–5; the reserve daily, dawn–dusk; and the office weekdays, 9–5.

About two miles east of the center of town (take E. Delaware Ave. to Federal City Rd.) is Rosedale Park (609-989-6530), a 472-acre county facility. The lake is stocked with trout, and you can boat (no gasoline engines) and canoe; there are family and group picnic areas (the latter by reservation only; call 609-989-6536). Environmental tours of the park for groups by reservation (609-989-6532). The county's equestrian facility (609-730-9059) recently opened for boarders; a cow barn on the property is being renovated so that the facility can begin offering lessons as well. In the meantime, you are welcome to ride on the the trails. The park is open daily until dusk.

Just north of Pennington (take N. Main St.) is the Baldwin Lake Wildlife Management Area, a small protected area with a popular 18-acre fishing lake, notable for bass and sunfish.

Pennsauken Camden 34,738

US 130, NJ 90, C 543

3

The township of Pennsauken lies on the Delaware River (it is in fact bisected by the approach to the Betsy Ross Bridge) and is bounded on the north by Pennsauken Creek. The area was inhabited by Native Americans, and this is the only town in Camden County with a Native American name (Pennsauken

means "place where tobacco was traded"). It is also the site of the first recorded English settlement in West Jersey: in the 1630s a group of English colonists built a fort here, which they named after a Native American chicf. The fort was abandoned after four years, but the Griffith Morgan House* (Griffith Morgan La. off River Rd., c 543, by the Esther Williams plant; 609-665-1948), built c. 1693, is still standing. This stone house, the oldest house in Camden County, is furnished with pieces dating primarily from the early 1700s to around 1820; on the top floor is a museum that concentrates on life in the area. A variety of memorabilia and artifacts, including fossils from southern New Jersey, as well as the work of local artists, is featured. Open houses are held several times a year, and groups can arrange for tours by appointment.

The Burrough-Dover House^{*} (9201 Burrough-Dover La.; 609-662-9175, 609-662-0873), an early-18th-century stone house (c. 1710) with a late-18th-century addition (1793), serves as headquarters of the Pennsauken Historical Society. The society opens the house several times a year and gives tours by appointment.

Near the Esther Williams plant is a company that apparently constructed the largest aluminum scaffolding ever built; it was used in the repair of the Statue of Liberty.

Pennsville Salem 13,794

NJ 49

The first area in Salem County to be settled, Pennsville was founded by Swedes and Finns around 1640. It later became a center for shad (and some sturgeon) fishing and the terminal for ferry service to Delaware. (At the foot of Church Landing Rd. is a marker showing where the early Scandinavian settlers crossed the

river to Wilmington, Delaware, to worship on Sunday.) Today the Delaware Memorial Bridge crosses at Pennsville, and many from the township use it to commute to Delaware or even Philadelphia. A large township, Pennsville still retains a few prerevolutionary homes.

St. George's Episcopal Church (NJ 49 and Church Landing Rd.) was founded by the Church of Sweden in 1714. When the Swedish missionaries left, the log-cabin church became Episcopal. It was replaced in 1802 by the present structure (now minus its second story, which was removed in 1860 because it was too heavy). In the parish house are various artifacts from the Swedish settlers. Tours for groups can be arranged by calling 609-678-7979.

Toward the end of Church Landing Rd. is the Church Landing Farm Museum (86 Church Landing Rd.; 609-678-4453). This Gothic Revival farmhouse (c. 1860) has recently been restored by the Pennsville Township Historical Society and has been furnished to show what life would have been like in a mid-19th-century farmhouse. The society also sponsors a Victorian tea Thanksgiving weekend and a day-at-the-farm fair in June. Open Sunday and Wednesday, 12–4; other times and groups by appointment. Closed February.

Riverview Park, a municipal park at Broadway between Lakeview Ave. and Pittsfield St., occupies the site of an amusement park that closed in 1967. Artifacts from the amusement park can be seen at the Church Landing Museum.

If you continue south on Broadway, turning right at Fort Mott Rd., you will see to your left the Finn's Point Rear Range Light* (Harrisonville-Lighthouse Rd.; 609-935-1487), a 115-foot lighthouse with a Greek doorway, built in 1876, a rare surviving example of a wrought-iron lighthouse. The view from the lighthouse, which was decommissioned in 1950, is spectacular. Open April–October, 3d Sunday of the month, 12–4; groups by appointment. The lighthouse is part of the Supawna Meadows National Wildlife Refuge, and an interpretive display at the site has information about the light on one side and the refuge on the other. The refuge, close to 3,000 acres, is of interest to naturalists because it is less saline than the ocean and a good spot for glossy ibis, cattle and snowy egrets, red-winged blackbirds, and mute swans.

Continuing south on Fort Mott Rd. will bring you to Fort Mott* State Park (609-935-3218), a 104-acre waterfront park with buildings and concrete gun embattlements dating to the Spanish-American War. Acquired by the state in 1947, the park has a splendid view of the Delaware, facilities for picnicking and fishing, and playing fields. At the welcome center, housed in a former ordnance building, there is an exhibit that interprets the history and fortifications of Fort Mott, and you can pick up a walking-tour brochure that will explain the fortifications. The park is a stop on the New Jersey Coastal Heritage Trail, and the center also contains exhibits relating to maritime life and history. The welcome center is open year-round (except Thanksgiving, Christmas, and New Year's Day), 8–4; the park is open the same hours during the winter (Labor Day–Memorial Day) and 8–7:30 in the summer (Memorial Day–Labor Day).

On the same spit of land is Finn's Point National Cemetery* (609-935-3628), where many Confederate soldiers (and several German World War II prisoners) are buried. The lodge dates to the late 19th century, as does the marble monument to the Union dead (the cupola was added in 1936); the Confederate obelisk dates to 1910. Civil War buffs generally hold memorial services at the cemetery shortly before Memorial Day. Open daily, 8–5.

The roads around Fort Mott traverse salt marshes and wild rice marshes, but it is often difficult to see the marshes because of the tall phragmites that line the roads. Also in this area is the Killcohook Coordination Area. This is where army engineers, engaged in a never-ending battle to keep the Delaware River open to navigation, dump the sludge from their dredging. Fifty years of dumping have produced hills that are 30–40 feet high. If you drive around the perimeter of this desolate area, you will pass into the state of Delaware, even though you will still be on the east side of the Delaware River. This is because the original deed for Wilmington included the land within a 12-mile radius of a particular point, and since this was all swamp at the time, no one paid the anomaly much mind.

Perth Amboy Middlesex 41,967

NJ 35, 440

Perth Amboy, situated at the mouth of the Raritan River, was established in 1683 by William Penn and 11 other men, the Proprietors of East New Jersey, who had purchased the East Jersey tract from the estate of Sir George Carteret, the original grantee, in 1682. Their aim was to set up East Jersey's principal

town on what was described as "a sweet, wholesome, and delightful place," and the town plan they developed, with its central green, survives more or less intact today. The town was actually settled by a group of Scottish proprietors, but their attempt to name the settlement New Perth, in honor of the earl of Perth, was unsuccessful, and eventually their choice merged with the community's original name, Ambo Point, to form today's Perth Amboy.

The community did indeed serve as the capital of East Jersey from 1686 to 1702 and then as one of the twin capitals of New Jersey; in 1718 it became the first incorporated municipality in the colony. Because of its strategic position at the mouth of the Raritan River, Perth Amboy suffered in the Revolution—it was occupied by the armies of both sides—and in 1790 the capital was moved to Trenton. Three years later the county seat was moved to New Brunswick, and for a while the city stagnated.

In the early 19th century, Perth Amboy became a fashionable resort and began to develop an oyster industry. The arrival of the railroad in the 1830s encouraged increased industrial activity; the town's rich clay deposits led to a flourishing brick, ceramic, and terra cotta industry. It was also a leading center of copper and silver refining, and at one point had the second largest copper refinery in the world. The Raritan Copper Works (Elm and Market sts.) are listed in the state register of historic places, but the giant American Smelting and Refining Company plant is gone.

The increased pace of industrialization after the Civil War resulted in a wave of immigration; by the 1930s close to three-quarters of the inhabitants of Perth Amboy were foreign born. Slavs predominated, followed by Danes, Italians, and Poles; now a large portion of the residents are from Puerto Rican, other Hispanic, and Caribbean backgrounds. In the mid-1980s, for example, there were more Anguillans living in Perth Amboy than lived on the island of Anguilla, and in 1977 the Anguillan Sons and Daughters Benevolent Society (founded in 1921) took over the former union hall of the American Smelting and Refining Company (State St. and Pulaski).

The heterogeneity of Perth Amboy's population is reflected in the town square (intersection of Market and High sts.). In this spacious square the weekly markets were held; from the 1740s to the 1840s the market house, a large brick shed, stood in the middle of the square. Now the square has been converted to a park; the statue of George Washington, by Nils Alling, a local sculptor, was given to the town in 1896 by the local Scandinavian community. Scattered about the park are plaques commemorating trees planted in honor of George Washington in 1932 (the town's 250th birthday) by Perth Amboy's various ethnic associations, including those of Italians, Poles, Germans, Scandinavians, Hungarians, Ukrainians, and Greeks.

At 260 High St. are the city hall^{*}—the oldest public building in continuous use in the United States—and the surveyor general's office.^{*} Begun in 1713, the city hall, which is painted white to hide the scars of numerous fires and alterations, served as the county courthouse until the county seat moved to New Brunswick; it also housed the state assembly until 1790. It was in this building that New Jersey became the first state to ratify the Bill of Rights and Thomas Mundy Peterson the first African American to vote under the auspices of the 15th Amendment. The surveyor general's office, built in 1860, houses the records of the Board of Proprietors of Eastern New Jersey, the oldest active corporation in the state.

The houses around the square generally date to the 18th and 19th centuries; in the one at 83–85 Market St. (1730) William Dunlap (1766–1839), sometimes called the father of American drama, who was also a painter (he studied with

Benjamin West) and a historian of the theater and design, received his early education. The Gothic Revival First Presbyterian church (1902) was built on the site of an 1802 church; its manse (1887) is at 236 High Street.

The Proprietary House* (149 Kearny Ave.; 973-826-2100) is the country's only remaining official royal governor's house. Built in the 1760s, this imposing brick Georgian mansion originally sat on 11 acres. Occupied first by Chief Justice Frederick Smyth, it was Governor William Franklin's home from 1774 until his arrest for supporting the English cause in 1776. (His father, Benjamin Franklin, visited him here in an unsuccessful attempt to persuade him to change his allegiance.) In 1809 it was converted to a resort hotel, the Brighton, and the third floor and south wing were added. (The wing involved the first use of structural cast iron in the United States.) It has also served as a retire-

ment home for Presbyterian clergymen, a hotel, a private residence, and a rooming house. There were once even rumors that Joseph Bonaparte might live here (see Bordentown). The property was subdivided in 1904, and the house began a long decline. The state bought the house in 1911 and used it primarily as a rooming house until 1967. The Proprietary House Association, formed in 1966, has been working on the house for many years. The upper floors have been rented out, but the association runs a museum on the ground floor and basement. It is now engaged in a major restoration, which is being done room by room. Most of the rooms will be unfurnished and used for changing exhibits that will show the character of the house over the years. The two least-altered rooms will be restored to their period appearance. Open Sunday, 1–4, and by appointment. The association also sponsors a variety of special events, including an annual Yuletide celebration and a reenactment of William Franklin's arrest in June.

The Kearny Cottage* (63 Catalpa St.; 973-826-1826) dates from the 1780s and was the home of Elizabeth Lawrence Kearny—the poet Madame Scribblerus and half-sister of Captain James Lawrence of "Don't give up the ship" fame (see Burlington)—and her husband, Michael Kearny. Their son, Lawrence Kearny (1789–1868), who was born in the house and lived there all his life, was a naval officer who was in large part responsible for the open-door policy in China. Operated as a house museum by the Kearny Cottage I listorical Society, the cottage's four rooms contain displays reflecting the nautical background of the house's owners and the history of Perth Amboy; the colonial garden has plant specimens that go back to the first half of the 19th century. Open Tuesday–Thursday, 2–5; guided tours by appointment.

At the foot of Smith St. is the Perth Amboy ferry slip (973-672-0100). Service between Perth Amboy and Staten Island began in 1684 and continued until 1963. The present structure, a shed* containing a wooden lift mechanism, was built in 1904 by the Staten Island Railroad and is presently being restored to serve as a maritime museum. Guided tours by appointment. There is some talk of restoring the Staten Island service.

At the intersection of Rector and Gordon sts. is St. Peter's Episcopal Church, the oldest Episcopal parish in the state (first service 1685, organized 1698). The present Gothic Revival building, on the site of one begun in 1719, dates from 1849, the cemetery from 1722. William Dunlap and Thomas Mundy Peterson are both buried here. The rectory (222 Rector St.) is a Tudor Revival building built in 1914. From Water St. there are fine views of the harbor and many interesting houses, most from the 19th century, but including Perth Amboy's oldest house (228 Water St.) from the early 18th century. At 160 Water St. the striking house (c. 1875), now occupied by the Raritan Yacht Club, has its original double doors. At 222 Water St. is the old rectory of St. Peter's (1815).

Along the waterfront, at the corner of Front and Gordon sts., is the old United States Naval Armory. Built in 1929, this large brick building has been converted to commercial space. Plans for the waterfront include a new city marina and fishing pier; for now, you can enjoy the harbor walk running from the old ferry slip to the park abutting Sadowski Parkway to S. 2d Street.

Outerbridge Crossing is a cantilevered structure that crosses Arthur Kill to reach Staten Island. Opened in 1928, it was named not for its location but for Eugenius H. Outerbridge, the first chairman of the Port Authority of New York and New Jersey. It carries over 20 million vehicles each year.

Phillipsburg Warren 15,757

178, US 22, NJ 57, C 519, 621, 646

The site of a Native American village known as Chintewink, Phillipsburg was settled by farmers early in the 18th century and, thanks to its location, became a transportation hub in the 19th. The town is situated at the Delaware River just across from the point the Lehigh River joins it. The western end of the Morris

Canal was in Phillipsburg, and a network of railroads reached it as well, making it convenient to both markets and raw materials for a variety of products. Early in the 20th century it became an industrial center—in 1904 Ingersoll-Rand opened a compressed air and hydraulic machinery plant that at one time employed 6,000 workers—and although much of the manufacturing activity is gone, Phillipsburg retains the feel of a city. There are still Victorian homes to be seen up on the hill that rises from the Delaware, there is a river walk to the south of the city, and there is some hope that excursion trains can be started on the surviving tracks.

Northeast of Phillipsburg, in Harmony Township (take 57 to Montana Rd. and turn left), is the Merrill Creek Environmental Resource Center (34 Merrill Creek Rd.; 908-454-1213), a 290-acre environmental preserve with 2,000 additional acres of woods and fields, all surrounding a 650-acre reservoir that a group of utilities built to store water when the Delaware is low. The preserve is open for passive recreation: you can fish and boat (electric motors only) in the reservoir and hike and cross-country ski on the trails. There are two wildlife observation blinds, and one of the trails is barrier free. Along the way you may notice the stabilized remains of late-18th-, early-19th-century houses. At the nature center, which offers a variety of educational programs for children and adults, there are exhibits dealing with the history of the area, its flora and fauna, and the operation of the reservoir. You can also pick up a trail map here. The outdoor areas are open every day during daylight hours; the visitor center is open daily, 8:30–4:30, except New Year's Day, Easter, Thanksgiving, Christmas Eve, and Christmas; the boat ramp's hours are more limited.

Piscataway Middlesex 47,089

1 287, NJ 18, C 514 SPUR, 529

According to one version of Piscataway's history, the community was settled in 1666 by people from the Piscataqua River valley in New Hampshire, which accounts for its name. In other versions, the name derives from various Native American words—the possibilities include "it is getting dark," "place of dark night,"

"great deer river," and "division of the river." Whichever version is correct, it is apparently undisputed that there was a settlement here on the east bank of the Raritan River in the 17th century, that there was for a time a flourishing shipping trade at the community known as Raritan Landing, and that the competitive advantages of the Delaware and Raritan Canal and the greater depth of the river at New Brunswick put an end to Raritan Landing's days as a shipping center. Not that Piscataway has remained stagnant—the population has more than doubled since 1960.

Three of the buildings that date from Raritan Landing's more prosperous days do remain, however, among them the Cornelius Low House* (1225 River Rd.; 732-745-4177, 732-745-3888), also known as Ivy Hall. Built in 1740–41 for Low, a prominent merchant, surveyor, and attorney, the sandstone Georgian manor house now serves as the Middlesex County Museum. The museum focuses on state and local history and offers hands-on educational workshops; exhibits usually change once a year. The museum closed for extensive renovations in 1993 and while it was closed offered workshops on the restoration process and a variety of traveling programs; it reopened in the spring of 1997. Open Tuesday–Friday and Sunday, 1–4; groups and other times by appointment. (The museum parking lot is on Sutphen La. on the Rutgers University Busch campus.)

The Metlar House–Peter Bodine House* (1281 River Rd.; 732-463-8363) is another of the three remaining sites from Raritan Landing (the third is Buccleuch Mansion; see New Brunswick). Its earliest section dates to 1728, and it is now a museum devoted to showing how transportation has affected the development of the area. The museum has a permanent collection of Piscataway memorabilia, rotating exhibits, programs of historical interest, and special tours for children. Open Thursday–Saturday, 12–5; Sunday, 1–4; guided tours and other hours by appointment.

Rutgers University's Busch campus and most of the Livingston campus fall within Piscataway, as does the football stadium. The College of Medicine and Dentistry of New Jersey and the Center for Advanced Biotechnology and Medicine Research are two of the facilities on the Busch campus.

Stretching along the banks of the Raritan for about two miles, with a view of New Brunswick across the river, is Johnson Park (732-745-3900), one of Middlesex County's most popular parks. Established on land donated by the family of Johnson & Johnson, the park contains a small zoo and animal shelter and a wildflower sanctuary, as well as picnic areas, a trail, lakes, playgrounds, and athletic facilities. There are summer concerts at the park, an annual fishing derby, and, in the fall, an old-car show. One of the Piscataway area's many prehistoric sites is located in Johnson Park.

Also within the park is East Jersey Olde Towne (River Rd. and Hoes La.; 732-745-4489), a 12-acre site on which 11 colonial and Revolutionary War buildings have been re-created or moved from other central New Jersey locations, and arranged as they might have been in a real 18th-century village. The buildings include houses, a school, a barn, a church, and a replica of the mid-18th-century Indian Queen Tavern, visited by John Adams and other founding fathers. Brochures are available explaining the history of each building. Since the restoration, the village has inaugurated a series of programs, starting with storytelling. Open to school groups two days during the week and to the general public on Sunday.

At the township municipal building (445 Hoes La.; 732-562-2300), art shows are hung in the council chamber in the central part of the building. These shows, sponsored by the town's Cultural Arts Advisory Commission, change roughly once a month; one show each year is usually devoted to work by senior citizens and one to the high school art department, but the range is wide. Open weekdays, 8:30–4:30; closed holidays. The commission also sponsors performances and concerts in a variety of venues. Call 732-562-2301 for the schedule. You can also often find art shows at the Piscataway libraries.

Northwest of the municipal building is Ambrose Dotys Park (Sidney Rd.), a largely undeveloped county park with playing fields and trails.

At the northern end of River Rd. is the country's first full-scale multiplastics recycling facility. Each year this Union Carbide facility turns 27,000 tons of bags, soda bottles, and water jugs into trash containers, other bottles, and plastic fencing.

Pitman Gloucester 9,365

NJ 47, C 553

Ş

Pitman was founded in 1871 as a summer religious camp and named Pitman Grove Camp Meeting in honor of the Reverend Charles Pitman, a powerful camp-meeting preacher. The community was laid out in the shape of a wheel, with an auditorium at the hub, 160 small frame cottages on spokes radiating from the

center, and a circular road marking the perimeter. (The Pitman Grove historic area* includes East, West, North, South, Webb, S. Oak, Wesley, Embury, and Ist–I2th aves.) Popular in the 1880s and 1890s, the meetings attracted thousands of visitors—I2,000 one day in 1880. Gradually the year-round population began to increase and the cottages were winterized and enlarged; in 1905 the borough of Pitman was incorporated, and in 1910 the Episcopalians built a splendid stone church. Pitman's residents today tend to commute to Camden, Philadelphia, and nearby Rowan University.

Alcyon Lake (Holly and Cedar aves.), once the site of a Native American

village, was known from the 1870s until 1945 as a park and recreation site. Closed for a time when chemicals from a nearby toxic dump polluted the water and made it one of the most severely polluted sites in the United States, the lake has since reopened for boating and fishing. Note also the buildings on Broadway and Pitman Ave., including the Broadway Theater, the two banks, and the Hotel Pitman (1917).

Plainfield Union 46,567

NJ 28, C 531

Plainfield was settled in the 1680s by Scottish families from Perth Amboy who called it Blondyn Plains. After a gristmill was built on the Green Brook in 1760, the town became known as Milltown, and in 1800 it received its current name. During the Revolution, there was a militia post on the east bank of the Green Brook, and

George Washington was in Plainfield often during and after the battle for the Watchungs. In the early 19th century, Plainfield was known for the many hatteries operating along the Green Brook. Rail service to Elizabeth began in the 1830s, and after direct service to New York City (including a ferry at Jersey City) was established in 1869, Plainfield developed as one of the first bedroom communities. It was also one of the wealthier railroad suburbs, as can be seen today from the scale of the houses. (Over 100 millionaires are supposed to have lived in the Van Wyck Brooks historic district* alone.) Some industry had arrived by the 1880s, but the city, though distinctly urban, is still primarily residential. (In the days of the Jack Benny radio show, Plainfield achieved considerable, probably unwanted, publicity in jokes about Mary Livingston's mother.) Its symphony orchestra, founded in 1919, claims to be the oldest in the state, and John Philip Sousa gave his first concert as leader of his own band in Plainfield in 1892, an event celebrated in 1992 with a gathering of bands. Although Plainfield has experienced some of the problems of urban decline, it has held its own, and many of its large late-19th- and early-20th-century houses have been restored or converted to apartments. There are realtors who specialize in publicizing the attractions of Plainfield homes in New York City newspapers.

In Plainfield's historic districts you will find a large variety of buildings, most from the late 19th and early 20th centuries, which reflect many of the building styles popular over those years. Four of these districts are Crescent* (including Crescent Ave.; 1st, 2d, and 3d places; Park Ave. between Crescent and 9th St.; 9th St. between Park Ave. and Watchung Ave.; Watchung Ave. between 7th and 9th sts.; 7th St. between Watchung Ave., 9th St., and Franklin Pl.); Hillside Ave.* (Hillside Ave. from Watchung to Martine Ave.); the North Ave. commercial district* (parts of Park, North, and Watchung aves.); and the Van Wyck Brooks* area (parts of W. 8th and 9th sts., Arlington, Madison, Central, Stelle, and Field aves.), named for the author who lived in the area for a time.

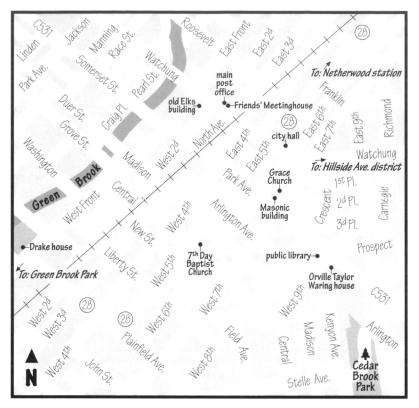

One of Plainfield's earliest structures is the Friends' Meetinghouse (Watchung Ave. and E. 3d St.), which has been in continuous use since 1788. This was the first house of worship in Plainfield, and there are Native Americans buried in the graveyard. The Nathaniel Drake House* (602 W. Front St.; 908-755-5831) was built in 1746 and served as Washington's headquarters in June 1777. In the 1860s, the Drake family sold the house to John Harberger, president of the New York bank that was to become Chase Manhattan. At that time the house was enlarged and altered (the towers were a still later addition). Now operated as a museum, the house has period rooms reflecting both the Drake and the Harberger eras, from the 1740s kitchen to the 1880s library. Upstairs, exhibits change roughly three to four times a year and are usually related to Plainfield history. Open Sunday, 2–4; groups by appointment other times.

Among the many eye-catching buildings, note the Masonic building (525 Park Ave.), which now houses stores; the Netherwood railroad station* Netherwood and South aves.), 1894; the public library (Park Ave. and 8th St.; 908-757-1111), where there are changing exhibits in the front lobby; the Orville Taylor Waring house* (900 Park Ave.), 1881; the old Elks building (116 Watchung Ave.); Grace Church (E. 7th St.), 1892; and the 7th Day Baptist Church* (501 Central Ave.), built in the 1890s. Note also the bronze lampposts (1915) in front of the main post office (201 Watchung Ave.); they were stolen in 1995 but found and returned within a month. Two large Bierstadt paintings hang in the municipal courthouse (325 Watchung Ave.). These can be seen during normal court hours.

Cedar Brook Park (Park, Randolph, and Pemberton aves.; 908-527-4900) is an 86-acre county park built on a former garbage dump and swamp. It has a pond where you can fish and skate, playgrounds, tennis courts, and picnic facilities. The Shakespeare garden includes plants mentioned by Shakespeare and common in his day. Green Brook Park (West End, Myrtle, and Clinton aves.), 100 acres along a stretch of the river, has picnic facilities, athletic fields, and playgrounds.

Pomona Atlantic [Galloway Township]

GARDEN STATE PKWY EXIT 44, US 30, C 575

Pomona is the home of The Richard Stockton College of New Jersey (Jim Leeds Rd.), opcncd in 1971 on 1,600 forested acres (this includes land leased to two hospitals), 400 of which have been set aside as an ecological reserve. The campus is remarkable for its prize-winning architecture; most activities take place in a series of

buildings that are linked by an interior street, and leading architects have been responsible for much of the campus. The college also boasts the world's largest closed-loop geothermal heating and cooling system, by means of which it can air-condition and heat its buildings with significant savings in the consumption of electricity and natural gas and probably in costs as well. The Performing Arts Center (609-652-9000) sponsors guest productions in dance; popular, folk, and classical music; and theater, including children's theater, that are open to the public.

The Atlantic City International Airport is also at Pomona. Built by the federal government during World War II, the airport was bought by the Federal Aviation Administration in 1958 as a test center. The FAA now runs a large research-and-development center (5,000-plus acres, 1,600-plus employees) that studics problems of air traffic control, aircraft safety, and communication and navigation, while Atlantic City uses 80 acres for its airport. The airport also houses what has been described as "the world's most elaborately equipped test heliport."

Port Monmouth [Middletown Township]

NJ 36

Port Monmouth is the site of the first house built on the New Jersey shoreline, the Shoal Harbor Museum^{*} (119 Port Monmouth Rd.; 732-787-1807), often referred to as the Spy House or the Seabrook-Wilson House. Built in 1663 by Thomas Whitlock, the house remained in the hands of his descendants until the early

1900s. It is called the Spy House because, converted to an inn by the time of the Revolution, it served as a clearinghouse for information collected by Americans spying from a nearby hill. Some 39 raids are supposed to have been made possible by information relayed to the house. Now part of a museum complex, Spy House actually consists of three houses joined together, incorporating parts from later in the 17th century and early in the 18th. Also in the complex are a store moved from Lincroft and Port Monmouth's first barbershop. Exhibits include displays devoted to local shipping and fishing, to artifacts of daily life, and to bayshore farming. The museum also sponsors special events, including a harvest festival in October, a Civil War display in November, and a St. Nicholas Day celebration in December. Usually open Sunday, 2–4.

Princeton Mercer 12,016 (borough) 13,198 (township)

US 206, NJ 27, C 526, 571, 583

Once known primarily as a university town of quiet, tree-lined streets, Princeton is showing the effects of the post–World War II growth in the township (referred to locally as the doughnut surrounding the hole of Princeton Borough—the township's population is almost 2¹/₂ times what it was in 1950; the borough's is

virtually unchanged). Settled at the end of the 17th century, principally by Quakers, Princeton was known as Stony Brook until 1724. It grew along the site of an old Native American trail, now Nassau St., which was to prove an important thoroughfare in the Revolution. The town played a significant role in that war, and many historians consider the battles of Trenton and Princeton as turning points in the struggle for independence. For a brief time in 1783, while the Continental Congress sat in the university's Nassau Hall, Princeton was the capital of the country. Midway between New York and Philadelphia, it prospered in the 19th century as a stagecoach stop.

The university, founded by Presbyterians as the College of New Jersey in 1746 in Elizabeth, moved from there to Newark, and settled in its present location in 1756. (The association of the town with the university has been long remarked: according to a late-18th-century visitor from Poland, "Princeton is notable only for its college, which is a building erected before the Revolution and rather large.") Other educational institutions followed, among them the Princeton Theological Seminary, founded in the early 19th century by a group of dissident Presbyterians who felt the university had become too lax. The Institute for Advanced Study was founded over 60 years ago; Abraham Flexner was its first director, Albert Einstein one of its first professors. Also in town are the American Boychoir School and the Westminster Choir College (now part of Rider University; see Lawrenceville). The Gallup Poll has been a Princeton institution since 1935, and Educational Testing Service, although it is actually in Lawrence Township, has a Princeton address.

Corporate research laboratories moving into the area, among them RCA and Cyanamid, changed the character of the town after World War II. More recently, many large corporations have been moving their headquarters or other offices to the so-called Princeton Corridor (us I between Trenton and New Brunswick) or other parts of what is now referred to as Greater Princeton, and even those actually located in neighboring communities often list their addresses as Princeton. The focus of the town is thus increasingly toward the outside. With the resultant increases in population, the town is busier and the buildings in the center are taller, but you can still find a prerevolutionary building on Nassau St., and it is still lined with trees.

Many famous names have been associated with Princeton. Aaron Burr and Grover Cleveland are both buried in the Princeton cemetery (Witherspoon and Wiggins sts.; 609-924-1369), as are most Princeton University presidents and Paul Tulane, the founder of Tulane University. At 112 Mercer St. you can see the 1870s house* (now a national historic landmark) where Einstein lived. T. S. Eliot, a visitor at the Institute for Advanced Study in 1948, wrote much of *The Cocktail Party* at 14 Alexander Street. Thomas Mann lived in the house now owned by the Aquinas Institute at the corner of Stockton St. and Library Pl.; Woodrow Wilson lived at 72 and 82 Library Pl. and at 25 Cleveland La., Grover Cleveland at 15 Hodge Rd.* (Cleveland's house, built in the 1850s, is a national historic landmark.) Other literary names associated with either the university or the town include, of course, F. Scott Fitzgerald and John O'Hara and, of more recent vintage, John McPhee, Toni Morrison, and Joyce Carol Oates.

Although a considerable variety of architectural styles is represented on the Princeton University campus, the tone is set by Collegiate Gothic. As you stroll

through the arches and courtyards, keep an eye out for gargoyles. (Notice, too, the black squirrels, descendants of specimen squirrels released from a private estate, although they may have been native to the area earlier.) Setting off the Gothic atmosphere is a large collection of 20th-century outdoor sculpture by distinguished artists. The Henry Moore, located in the courtyard formed by Stanhope, West College, Alexander Hall, and Nassau Hall, is a special favorite of children; before a controversial cleaning in the early 1990s, the highly polished lower portion attested to that popularity. There are also works by Picasso, Lipchitz, and Nevelson. George Segal's Kent State memorial, rejected by Kent State University, is in the courtyard below the chapel and Firestone Library.

Nassau Hall,* built in 1756 but several times remodeled, is reputed to have been at one time the largest building in the colonies. A national historic landmark, it once housed the entire college and has also served as barracks, hospital, and home of the Continental Congress. It is now used for higher administrative offices and faculty meetings. The Faculty Room contains portraits of past university presidents and a Charles Wilson Peale of George Washington. Note how worn the interior steps are.

Of the fieldstone buildings planned to harmonize with Nassau Hall, Stanhope and West College remain. Stanhope, an early-19th-century building, has a lovely staircase and stairwell and contains public toilets.

Although the stacks of Firestone Library are no longer open to the public, the exhibits in the Rare Books room (609-258-3184) and Graphic Arts gallery (609-258-3197) are worth a visit. (The university library system as a whole contains over 5 million printed works and 5 million manuscripts and grows at the rate of 10,000 volumes a month.) The chapel, considered an outstanding example of Collegiate Gothic, is one of the largest university chapels in the United States. The art museum (609-258-3787), housed in McCormick Hall, features changing exhibits; the permanent collection is particularly strong in early Mediterranean, Oriental, and pre-Columbian art, but do keep an eye out for Pliny's two left feet in Angelica Kauffmann's 1785 *Pliny the Younger and His Mother*. During the spring and fall semesters there are public gallery talks (Friday at 12:30, Sunday at 3:30) and children's talks.

Chancellor Green Library and Alexander Hall are examples of later-19thcentury Ruskinian and Richardsonian architecture. The exuberance of Alexander Hall, which now contains the Richardson concert hall, has won it many ardent devotees.

Prospect House, from 1879 until 1969 the home of the university's presidents and now a faculty club (and a national historic landmark), is one of several examples of John Notman's Italianate buildings to be found in Princeton. Its formal gardens are open to the public, and the splendid trees around the building, like many other trees on the campus, carry identification plaques.

Modern university buildings include Robert Venturi's Lewis Thomas Laboratory (Washington Rd.), the recent reworking of the Woolworth Music Building by Juan Navarro Baldeweg, and the Woodrow Wilson School (Washington Rd.), designed by Minoru Yamasaki (the decorative pool in its courtyard was for a time

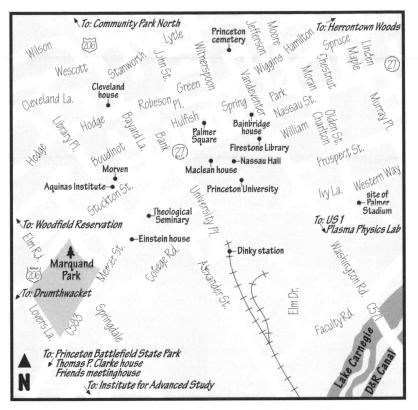

so popular in the summers that it became a public-health problem). The mansions on Prospect St. just east of Washington Rd. belong to the eating clubs; these social clubs at which many students eat their meals were once encouraged as an alternative to fraternities (some of the clubs no longer exist, and their buildings have been converted to serve more academic purposes). The university's Orange Key Guide Service, located in Maclean house* (73 Nassau St.; 609-258-3603), until 1879 home of the university's presidents and itself a national historic landmark, offers walking tours of the campus Monday–Saturday, 10, 11, 1:30, and 3:30; Sunday, 1:30 and 3:30. These last about one hour; they visit Nassau Hall and the chapel and usually go through Prospect gardens, the exact itinerary varying with the size of the group and the weather.

The town also has its outdoor sculpture, much of it the work of Seward Johnson (see Hamilton Township). Note the man reading the *New York Times* in front of Borough Hall, the man reading a book near the kiosk in Palmer Sq., and the fishermen in Community Park North.

Princeton's historic district* includes 18th- to 20th-century buildings on Nassau, Mercer, Prospect, William, Stockton, Wiggins, Alexander, and Olden sts.; Springdale and College rds., Lovers La., and Library Pl., but older houses remain in almost all areas of central Princeton. Bainbridge house (158 Nassau St.; 609-921-6748) is a prerevolutionary building, the birthplace of William Bainbridge, commander of the frigate *Constitution* (better known as *Old Ironsides*). Run as a museum by the Princeton Historical Society, Bainbridge features thematic exhibits (for example, the Italian-American community in Princeton, rites of passage in Princeton families, the history of the African American community here) that usually change twice a year. The society offers a guided walking tour of historic Princeton every Sunday at 2 and arranges guided tours for other times; you can also pick up a brochure for a self-guided walking tour at Bainbridge house. Open March–December, Tuesday–Sunday, 12–4; January and February, weekends only.

Morven* (55 Stockton St.; 609-683-4495), built c. 1754 for Richard Stockton, a signer of the Declaration of Independence, was for many years the governor's mansion. The national historic landmark is now a museum run by the New Jersey State Museum. Recently renovated, the museum focuses on interpreting life in Morven during different periods of occupancy, from colonial days to its years as the governor's mansion. Open September–June, Wednesday, 11–2; groups by appointment (609-683-1514).

Today Drumthwacket* (354 Stockton St.; 609-683-0057) serves as the governor's mansion. Built in the 1830s by Charles Smith Olden and considerably enlarged in the 1890s by Moses Taylor Pyne (he is responsible for the black squirrels mentioned above), Drumthwacket was restored in the 1980s and furnished with 19th-century pieces. Tours Wednesday, 12–2, September–July; groups by appointment. Also on the property is the Olden house,* built in the mid-18th century by Thomas Olden. Recently restored, it houses the offices of the Drumthwacket Foundation and a gift shop, which is open when Drumthwacket is open for tours.

The Friends meetinghouse (Quakerbridge Rd. and Mercer St.), 1760, is thought to resemble closely the original building (1724), destroyed by fire.

Two particularly attractive concentrations of houses from a single period are the row of white frame houses on upper Alexander St. built by Charles Steadman in the 1830s and 1840s and the 18th-century group at the crossroads known as Queenston or Jugtown (Nassau and Harrison sts.; this is part of the Jugtown historic district,* which also includes Evelyn Pl.).

Princeton Battlefield State Park* (Mercer St.; 609-737-0623), the site of the Battle of Princeton and a national historic landmark, is about 1½ miles west of the center of town. At the southwest end of the battlefield, its back to the field, is the Thomas P. Clarke house (500 Mercer St.; 609-921-0074), a prerevolutionary farmhouse that has been converted to a museum of 18th-century life. The oldest part of the house is furnished as it would have been during the revolutionary era; the 1840s wing contains maps, paintings, and weapons having to do with the Revolutionary War. Future plans include establishing a working farm on the property, planting gardens, and adding a visitor center. Open Wednesday–Saturday, 10–12 and 1–4; Sunday, 1–4. Special events are scheduled at various times throughout the year, including around 4 July and the December holidays. The columns across the road in the northern portion of the field are not related to the battle; they come from a stately home that was torn down in the 20th century.

If you follow the trails southeast from the park, you will enter the "institute woods," a 250-acre portion of the more than 550 acres of woodlands, wetlands, and farmlands owned by the Institute for Advanced Study (Olden Ave.; 609-734-8000; you can also park on Olden La. and enter from behind the central building of the institute). These woods connect to the Charles Rogers wildlife sanctuary to the east, and the entire area is beloved of bird-watchers—close to 200 species have been observed here, close to 100 nest here, and the spring warbler migration is particularly impressive. The woods also contain an unusual diversity of tree species and have been described as "a virtual laboratory for studies of forest succession." A swaying suspension bridge, according to legend built by visiting scholars, is a favorite of children.

Across US I from town, on the university's Forrestal campus, is the Princeton Plasma Physics Laboratory, where scientists, working to produce energy by fusion, which unlike fission does not leave radioactive waste products, have already produced enough electricity to light a small city or two, albeit only for extremely short periods. (Commercial production of energy by fusion isn't expected for another 50 years or so.) Tours by appointment (call Patricia Wieser at 609-243-2757).

North of the center of town is the Herrontown Woods Arboretum (Snowden La. and Herrontown Rd.; 609-989-6532). This 142-acre woodland was donated to the county by Oswald Veblen, a professor at the Institute for Advanced Study (and a nephew of the economist Thorstein Veblen). The arboretum contains a range of habitats that provide a clear illustration of succession; its 3¹/₂ miles of trails are well marked. Open daily until dusk. Tours by appointment.

Community Park North (us 206 north of the center) has hiking trails, a fitness course, and a pond. Concerts are given in the amphitheater in the summer. Directly to its west is Mountain Lake Nature Preserve (609-921-2772; the park and the preserve share a parking lot off Mountain Ave.). There are trails through its 90 acres, and in February and March, lectures are given on Sunday afternoon. Woodfield Reservation (take Elm Rd. north to the Great Rd. W.) also has trails that go through hilly woods. Access to the Delaware and Raritan Canal State Park (see Kingston) is possible at Basin Park (Alexander St.), Washington Rd., and Harrison Street.

Rahway Union 25,325

NJ 27, 35

Possibly named for the Native American chief Rahwack, Rahway is one of the oldest settlements in New Jersey. The first houses date from the mid-17th century and the first sawmills from the 1680s. Rahway was a transportation center, first as a stop on the stagecoach line between New York and Philadelphia; then, after

the Revolution, as a port; and, after 1835, as a stop on the railroad. In later years the town became an industrial center: Three-in-One oil was developed in

Rahway in the late 19th century, and a few years later the Merck company, one of the world's largest producers of prescription drugs, bought land in Rahway (in 1993 Merck moved its headquarters to Whitehouse Station, but there are still some 3,800 employees here, occupying 125 buildings on over 200 acres and working in the company's research and development headquarters as well as in manufacturing). Rahway possesses what is reputed to be the nation's first solar-heated city hall (Main St. and E. Milton). Among its best-known native sons are the sculptor John Frazee, the economist Milton Friedman, the former senator Clifford Case, and the scientist and author Carl Sagan. Abraham Clark, a signer of the Declaration of Independence, is buried in the Rahway cemetery (St. Georges Ave. near Westfield Ave.).

The Merchants and Drovers Tavern* (St. Georges and Westfield aves.; 732-381-0441) probably dates from the 1780s. The township of Rahway was created in this tavern in 1804. The frame building, now four stories tall (it was enlarged once late in the 18th century and again early in the 19th), continued in use as a tavern until 1932. Now owned by the Rahway Historical Society, this museumin-process will eventually contain permanent exhibits in the second-floor common room and appropriately furnished bedrooms on the third floor, and will be interpreted to show what tavern life was like. On the property is another tavern (Rahway once boasted seven), the much smaller Terrill Tavern (c. 1763), now at its third location. George Washington was a guest here on one of his trips through the area. A museum shop is in the Terrill Tavern. The society holds educational programs for schoolchildren in the tavern and sponsors a variety of special events. Both taverns are open for special events and by appointment.

At the junction of Central Ave. and Main and Irving sts. is the Union County Arts Center* (732-499-8266), housed in a 1,300-seat theater built as a vaudeville house in 1927–28. The gold-leaf decor has been restored, and the original Wurlitzer organ is in place. The center sponsors a variety of events, among them classical, jazz, country, and pop concerts; plays; films (including silent films accompanied by the organ); and dance.

The Rahway River Parkway (St. Georges Ave. and River Rd.), designed by the Olmsted firm, has places where you can fish, as does Milton Lake Park (W. Lake and Madison aves.), both county facilities. Along the river off Lawrence Ave. is the Riverfront Park Conservation Area, a small park created when the county incinerator opened nearby. The area is rich in wildlife, and you can walk along the river, much of the time on a floating boardwalk.

Ramsey Bergen 13,228

NJ 17, C 507

Now primarily a commuters' town, Ramsey was originally settled by the Dutch. In one of their early stone houses (c. 1745) is the Old Stone House Museum* (538 Island Rd.; 201-327-2208). Three rooms on the main floor are furnished to show how a prerevolutionary Dutch household would have looked. A junior museum with toys

and other items from the turn of the century is upstairs. There are also changing exhibits. The house is only scheduled to be open a few Sundays of the year, so it is best to call for the exact schedule. Groups and other times by appointment.

Other 18th- and early-19th-century stone houses can be found at 171 Lake St., 245 Shadyside Rd., and 37 W. Crescent Ave.* Part of Darlington County Park (see Mahwah) extends into Ramsey.

Red Bank Monmouth 10,636

Situated at the mouth of the Navesink River, Red Bank began as a transportation center, deriving its prosperity from trade with New York City. By the late 1820s, 13 sloops and schooners were in regular service between Red Bank and New York City, taking vegetables, wood, and ovsters to New York and coming back with

manufactured goods. Regular steamship service began in the 1830s and continued until the 1920s, after which Red Bank's career as a port was over. The once-prized local oysters have also disappeared, casualties of polluted water. One of Red Bank's water-related activities, ice-boating, has continued. Farm sled races, presumably the ancestors of ice-boat races, were recorded here as early as 1879, the same year the Monmouth Boat Club^{*} (31 Union St.) was founded. The club is still active; among its other activities is frostbite racing. Also still active is the North Shrewsbury Iceboat and Yacht Company, founded in 1880. Some members of both clubs have taken up renovating and occasionally racing late-19th-century boats.

Red Bank (the name can be found in a 1734 log and presumably derives from the clay in the riverbanks) can boast at least two famous native sons: Edmund Wilson, the author and critic, was born here in 1895; Count Basie, the jazz musician, was born here in 1904 and began his career playing piano to accompany films at the Palace Theater. The musical tradition continues: Red Bank today is home to the East Coast's largest bagpipe band.

The town has a distinctly late-19th-century appearance, partly the result of a fire that led to the complete rebuilding of Broad St. in the late 19th century. But red brick and other 19th-century features are found on other streets as well: note, for example, the borough hall* (1892; 51 Monmouth St.), once the Shrewsbury Town Hall; the railroad station* (1878; Bridge Ave. and

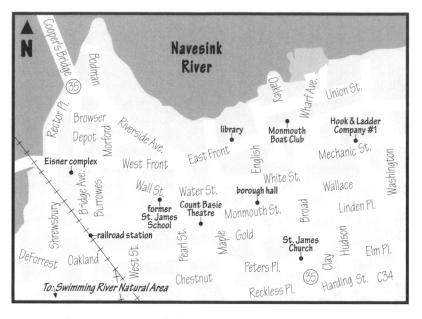

Monmouth St.); the Navesink Hook & Ladder Company #1 (1872; Mechanic St.); the library (84 Front St.), once the Red Bank Seminary and for a time at the turn of the century the home of bandmaster and composer John Philip Sousa; the lumber company that was once the St. James School (1879; 9 Wall St.); St. James Church (1894; Broad St. at Peters Pl.).

The largest uniform-manufacturing company in the world was started in Red Bank by Sigmund Eisner in 1885. Specializing in military and Boy Scout uniforms, the company stopped manufacturing in the late 1940s. Its five buildings on Bridge Ave. and W. Front St. have been converted into a commercial complex with offices, shops, restaurants, and art galleries. The clock tower was added in 1986.

At 99–101 Monmouth St. is the Count Basie Theatre (732-842-9000). Built as a vaudeville theater (it opened in 1926), it was later converted to a movie house. In 1973 it was purchased by the Monmouth County Arts Council, making the council the only one in the state to own and operate a performing arts center. Plans call for a thorough renovation to begin in the late '90s. Programs at the 1,400-seat theater (the seats from the old Carnegie Hall were installed in the mid-'80s) include dance, drama, jazz, classical and folk music, and a family entertainment series; performers range from members of the Monmouth County Arts Council to international stars. Call for the schedule.

Up the Swimming River, a mile or two from Red Bank, is the Swimming River Natural Area (908-936-2371). Located at the confluence of the Swimming River and Pine Brook, these 100-plus acres contain a variety of habitats. There are wetlands and uplands (there was once a farm here), forests, and steep slopes, and the area is a good one in which to hike and look for birds and other animals.

Ridgewood Bergen 24,152

GARDEN STATE PKWY EXIT 166, NI 17, C 507

Because the Dutch Reformed Church in Ridgewood, built in 1735, was situated at a strategic crossroads, it was used steadily for military purposes during the Revolution and fell into disrepair. Although it may have served as George Washington's headquarters for a few days, and had witnessed Aaron Burr's marriage and

part of Charles Lee's court-martial (Lee's court-martial was held in several places to avoid taking army officers away from their wartime duties; see Freehold), the congregation decided to replace it and in 1800 built the Old Paramus Reformed Church* (660 E. Glen Ave.). The bell ordered from London for the 1800 church is still in use.

On the church grounds, in an 1873 schoolhouse, is the Schoolhouse Museum (650 E. Glen Ave.; 201-262-8711), run by the Paramus Historical & Preservation Society and devoted to local history. Among the exhibits are a Dutch room containing a 1690 Dutch Bible and other items from the Netherlands that the Dutch settlers, preponderant in this area, might have brought with them; a Victorian schoolroom containing old school equipment; an early-18th-century kitchen; and a church exhibit containing items from both the 1735 and 1800 churches. Each year there is a thematic exhibit, changed to coordinate with the society's annual antiques and colonial crafts show in February. Open May–October, Sunday, 2:30–4:30; other times and tours of the church by appointment.

In the center of Ridgewood, in Van Neste Sq., is a World War I memorial column designed by Henry Bacon, the architect of the Lincoln Memorial. There are in Ridgewood several examples of early Dutch stone houses. Note, for example, the David Ackerman house* (415 E. Saddle River Rd.); most of it was built in the 1720s and 1730s, but the earliest portion may be late 17th century. Other old houses are to be seen on E. Glen, Lincoln, Doremus, N. Maple, and E. Ridgewood aves., Grove and Prospect sts., and E. Saddle River Road.

At the Stable (259 N. Maple Ave.; 201-670-5560), the headquarters of the Ridgewood Parks and Recreation Department, you can see a small collection of 19th-century farm equipment. The late-19th-century building was once a stable, and after a fire destroyed the house on the farm it was part of, it was rescued by a citizens' group. There are also art exhibits in the Stable (except in July and August); they change each month. Open weekdays, 8:30–4:30. Helen Nearing, who with her husband, Scott Nearing, was an influential social activist and proponent of a return to the land, was a native of Ridgewood and a graduate of the high school.

Ringoes Hunterdon [East Amwell Township]

US 202, NJ 31, 179, C 579

The log hut that John Ringo built at the intersection of two Native American trails in 1720 was the nucleus around which today's attractive town of Ringoes developed. The hut became not just Ringo's house but a tavern as well, and the tavern prospered after 1769, when it became a stop for the Swift-Sure Stagecoach line.

According to one legend, Ringo made a fortune, but fearing robbery, he buried it and died without revealing its location.

The Amwell Academy (NJ 179, the Old York Rd.), now an inn, was built as a school in 1811 and bought by Dr. C. W. Larison in 1868. Well known as an educator in the 19th century, Larison believed strongly in phonetic spelling and in 1885 published *Geografy: A Text Buk in Fonic Orthografy*. On the other side of the road, about a half-mile closer to town, is the Landis house, possibly the oldest house in Hunterdon County. The marquis de Lafayette is supposed to have recuperated from an illness here.

The Black River & Western Steam Railroad (C 579; 908-782-6622), which runs an old-fashioned steam train between Ringoes and Flemington, has its yards and depot in Ringoes. The station dates to the 1870s, and the engine house and yard started life as a creamery. From April through December, there are several round-trips to Flemington on weekends; in July and August, trips also run Thursday and Friday; on Sunday afternoon, May–October, and Saturday evening, June–Labor Day, trains run to Lambertville as well. Fee charged.

There are two wineries in Ringoes, both with lovely views out over the Amwell valley. Unionville Vineyards (9 Rocktown Rd.; 908-788-0400) occupies a mid-19th-century farm that began with a peach orchard, switched to apples when the peach blight hit, became a dairy farm, and then grew grain. Open for winery tours and tasting, Thursday–Sunday, 11–4; vineyard tours by appointment. Amwell Valley Vineyard (80 Old York Rd.; 908-788-5852) was one of the first wineries to be established when New Jersey laws changed to allow an increase in the number of wineries, provided they grew their own grapes. Tours and tasting weekends, 1–5; other times by appointment.

Ringwood Passaic 12,623

C 511

Located near the New York border, the borough of Ringwood developed first as an iron-mining town and then as a summer resort (there are many lakes in the area). Between 1950 and 1980, it was a rapidly growing commuter town; since 1980 that growth seems to have slowed. Almost two-thirds of Ringwood's land is

open space, including much of the Ringwood Manor,* Skylands Manor,* and

Shepherd Lake sections of Ringwood State Park. The Ringwood Manor section can be reached from Sloatsburg Rd. (off c 511); the other two sections are to the east; the park as a whole occupies over 5,000 acres.

Ringwood Manor (973-962-7031), a national historic landmark, is a rambling mansion of 50-odd rooms, with 24 fireplaces and 250 windows, situated on spacious grounds. It too owes its existence to the iron industry. The Ringwood Company was active in this area from the 1740s to the early 1930s, and during the American Revolution the ironworks were important suppliers to the Continental troops. At that time the works were run by Robert Erskine, surveyor general to the Continental army and known for the accuracy of the maps he drew for George Washington (a frequent visitor to Ringwood). Although ironmasters first lived on this site in the mid-18th century, the earliest part of the present mansion dates to 1810, when Martin Ryerson was the ironmaster (a Ryerson steel company still exists in Jersey City; it manufactures aluminum). In the mid-19th century, the works and house were owned by Peter Cooper, a versatile inventor, entrepreneur, and philanthropist, perhaps best known as the founder of Cooper Union in New York City. His daughter and son-in-law, the Abram S. Hewitts, decided to make Ringwood their permanent summer home, and most of the present house was built by them between the 1850s and the 1870s. Among the noteworthy features are the wood-paneled great hall and dining room and the Delft tile fireplace in the library. The furnishings, 95 percent of which belonged to the former owners or are original to the period, reflect the occupants' lives over the 120 years from 1810 to 1930 and include many fine pieces. Various mementos of the iron industry lie about the grounds, including links from a chain similar in type to the one stretched across the Hudson during the Revolution as a barrier to British ships. The columns in the garden come from the New York Life Insurance building in New York City. Within this section of the park there are picnic tables, fishing ponds, and hiking trails. The area is also suitable for crosscountry skiing. Manor house open May-October, Wednesday-Sunday, 10-4, and for winter holiday tours; park open sunrise to sunset; office open daily, 10-4. Parking charge Memorial Day weekend-Labor Day weekend (weekends only at Ringwood and Skylands manors).

At the Skylands Manor section of the park (973-962-7031) is New Jersey's first official botanic garden (973-962-7527). Originally designed in the 1920s for Clarence McKenzie Lewis, an investment banker who was also a trustee of the New York Botanical Garden, the 300 acres of gardens were neglected for many years and only saved with the help of volunteers. There is almost always something blooming here amid the variety of formal and less formal layouts, which include a crab apple vista, a magnolia garden (unusual this far north), a bog garden, and a winter garden. The 40-room mansion, also built by Lewis in the 1920s (of stone quarried on the estate), is rented out by the state for various functions, and the Skylands Association (973-962-7527) gives tours of the house once a month spring–fall. The gardens are open daily from sunrise to sunset. There are also hiking trails and hunting in season.

Ringwood 269

The Shepherd Lake section (973-962-6526) is north of Skylands Manor and centers around the lake where you can swim, fish, boat, and picnic. Some of the trails can be used by horseback riders, cyclists, mountain bikers, and cross-country skiers.

At the southwestern corner of the borough, adjacent to the Norvin Green State Forest (973-962-7031), is the Weis Ecology Center (150 Snake Den Rd.; 973-835-2160), founded in the 1970s and since 1995 a New Jersey Audubon Society sanctuary. The center building, originally part of a 1930s working-class rural getaway, contains displays, and the center sponsors a variety of programs, from mushroom hunts to autumn hawk watches to cross-country skiing instruction. The office is open Wednesday–Sunday, 8:30–4:30. The close to 4,000 acres of state forest have one of the most extensive trail systems in the state and, with elevations up to 1,300 feet, splendid views of the area and the New York City skyline. The birding is good, and you can fish here and in season hunt, crosscountry ski, and sled. Trail maps are available at the Weis Center.

Some three miles west of Ringwood Manor (take Margaret King Ave., which becomes Greenwood Lake Tnpk), along the Wanaque River, are the remains of the 18th- and 19th-century Long Pond Ironworks.* These works, which were run by the same ironmasters who were active at Ringwood, were last operated in the 1880s; they take their name from the former name of nearby Greenwood Lake. The site, now part of the Long Pond Ironworks State Park (973-962-7031), includes remains of the ironworking complex and its surrounding village. This is said to be the only site in the United States where you can still see three generations of technology. There are monthly tours of the historic area; for information call Ringwood State Park (973-962-7031). Revolutionary War enactments take place in the spring and summer, and sailing instruction is offered June–September. There are hiking trails, and the park's 1,700 acres provide facilities for boating, fishing, ice-fishing, cross-country skiing, and sledding.

River Edge Bergen 10,603

NJ 4, C 503

River Edge played a crucial part in the Revolution when George Washington, in November 1776, led his army over the Hackensack New Bridge after the surprise attack by the British at Fort Lee. At that spot is Steuben House* (1209 Main St., just north of NJ 4; 20I-487-1739), a state historic site that houses the museum of the

Bergen County Historical Society. The oldest portion of the sandstone house was probably built in 1713, making this the oldest extant house in the county, but there had been a gristmill on the site for several years before that. During the Revolution the house was owned by Jan Zabriskie, a leading merchant and a Tory. It was confiscated and offered to Major General Baron von Steuben in gratitude for his work in training the American troops. The house had suffered considerable abuse during the war: because of its strategic location at the bridge it was used for various military purposes, including serving as a fort, throughout the Revolution. According to one legend, Steuben declined the offer because he didn't want to displace the Zabriskies; according to another, its condition made it undesirable. Actually, Steuben did live in the house for a time and, according to an advertisement for its sale, repaired the damage. At one point he rented the house to the Zabriskies, who entertained him there and charged the costs of the entertainment to the general's account. Eventually Steuben sold the house to Zabriskie's son for a handsome sum.

Most of the items on display in the Steuben House, including, for example, the furniture and pottery, were manufactured or used in the area. A Native American dugout canoe found in Hackensack in the mid-19th century is also to be seen. Various special events take place at the Steuben House, including an annual Christmas exhibit that traces the evolution of the holiday from ancient to modern times. Open Wednesday–Saturday, 10–12 and 1–5; Sunday, 2–5; groups by appointment.

The Steuben House has an idyllic setting, known as New Bridge Landing Historic Park.* There are other buildings in the park, including the Campbell Christie House* (120 Main St.; 201-343-9492, 201-646-2780), a colonial sandstone house moved from New Milford, and restored as a tavern by the Bergen County Historical Society. The society expects to establish regular hours soon; for information call 201-646-2780. To arrange individual and group tours, call the Steuben House (201-487-1739). The Demarest House* (1209 Main St.; 201-261-0012), an early stone house, was also moved here from New Milford. Once thought to have been built in the late 1670s by the Huguenot settler David des Marest, it is more likely a late-18th-century successor on that site. Its two rooms are furnished with period pieces. Open Sunday, 2–5. A late-19th-century barn and an 1880s iron-truss swing bridge,* probably the oldest extant highway swing bridge in the state, are also in the park. The houses and the barn are often open for visits during special events at the park.

Riverton Burlington 2,775

C 543

Situated on the Delaware River and founded in 1851 as a resort by a group of wealthy businessmen from Philadelphia, Riverton has lovely views of the river along Bank Avenue. Several of the mansions built by the founders remain, as does the Riverton Yacht Club (Bank Ave. at the foot of Main St.), built in 1880 at the end of

an 1869 iron pier. A walk or drive along Bank Ave., Main St. (note the public library), Lippincott St., and Carriage House La. (where many of the Victorian carriage houses have been converted to residences) is a pleasant way to see what kind of a community its founders must have intended.

There were farms in this area in the 18th century, and some of the early farmhouses are reputed to have been stops on the Underground Railroad. The Taylor Wildlife Refuge (Taylor's La. off 130; 609-829-4992, 609-829-7034) is a 90-

acre preserve that is part of an organic farm that has been in the same family since the early 18th century and is now the only working farm along the river; the two houses date to the 1830s and the 1880s. The preserve contains swamp, woodlands, and open pasture and is particularly attractive to birders. There are marked trails. Open dawn to dusk.

Rockaway Morris 6,243 (borough) 19,572 (township)

1 80 EXIT 37, US 46, NJ 15, C 513

Rockaway Borough (incorporated in 1894) and Township (incorporated in 1844) lie in the heart of a region that once supported a flourishing iron industry. Four-fifths of the iron mined in New Jersey came from a narrow strip running through this area southwest to northeast. The Mount Hope mine, the largest in the

state, has been in almost continuous operation since 1710. Although the iron mine did shut down in 1959 (it had a brief revival in the '70s), road-building material is being excavated at the site (this is the seventh largest such operation in the country; in 1990 there were 2,000 truck trips a day at Mount Hope).

The Ford-Faesch house* (Mt. Hope Rd., a little over a mile north of interchange 35 on 1 80; 973-366-6730) was built in 1768 by Jacob Ford Jr., who went on to build himself a mansion in Morristown, used by Washington as his headquarters in 1779–80 (see Morristown). The Faesch in question is John Jacob Faesch, a Swiss who came to this country in 1764 to run the Ringwood mine (see Ringwood). In 1770 he moved to Rockaway Township to supervise the Mount Hope mines and eventually bought the business and the house. The house is being restored by the Historical Society of the Rockaways.

The whole area is rich in history: these mines supplied raw material for weapons crucial to the Revolutionary War. Mt. Hope Historical Park (Teabo Rd.; 973-829-8666), which opened in June 1997, includes three formerly independent properties: the Richard, Allen, and Teabo mines. Trails here are open for hikers, and as you hike through these beautiful woods, you will see the effect of 200 years of mining on the landscape. It will also be obvious why park regulations forbid leaving the marked trails: the deep subsidence pits are a clear danger. You can pick up brochures for self-guided tours in the parking lot. Trails open daily, 9–dusk. The Mount Hope Conservancy, in cooperation with the Morris County Park Commission, offers guided tours of the area throughout the year. For information on other mine tours see Ringwood.

Long-range plans for the area include establishing a visitor center in the Mt. Hope Methodist Church (Mt. Hope Rd.) and opening some 800 acres to the public as a park with an environmental center. These plans are contingent on a project that would reuse the old site by building a pumped-storage hydroelectric plant. During periods of slack demand, water would be pumped from an underground to an above-ground reservoir; during periods of peak demand the water would be released to run turbines and generate electricity. This will be one of the biggest pumped-storage plants in the world; the hope is that construction will begin before the turn of the century. Further plans include restoring some of the old mine machinery so that you will be able to watch the actual production process. (For information, call Mt. Hope Hydro, 973-361-1072.)

If you take exit 37 from 180 and go north on C 513 toward Hibernia, another of the iron towns within Rockaway Township, you will pass through the Wildcat Ridge Wildlife Management Area. Here are almost 4,000 acres in which you can hike (the mines in this area are all secured, some by a developer who had hoped to build houses and a golf course on top of the ridge), watch for birds (at migration time you should be able to spot hawks from the ridge), and fish. There are spectacular views from the top of the ridge, and this area is home to New Jersey's largest collection of bats, some of them endangered, which took over some of the caves that resulted when the mines were abandoned. At the moment, there is more concern to protect the bats from the people than vice versa.

Farther north is Farney State Park (Durham Rd.; 973-962-7031), more than 1,200 noncontiguous acres. This is an undeveloped park with woodlands, streams, ponds, and a reservoir, with facilities for hiking (there are trails and an old logging road), fishing, ice-fishing, bird-watching, and cross-country skiing.

Rocky Hill Somerset 693

C 518, JUST EAST OF US 206

This small town (less than a square mile in area) served as George Washington's headquarters in the fall of 1783 while the Continental Congress was meeting in Princeton. Here Washington entertained, among others, Alexander Hamilton, John Witherspoon, Thomas Jefferson, Thomas Paine, and James

Madison, and here he wrote the address that has come to be known as "Washington's Farewell to the Troops" (he could not have delivered a farewell to the troops here because there weren't many around). Washington's house, Rockingham* (c 518 c. half a mile east of the Delaware and Raritan Canal; 609-921-8835), is now a state-run historic-house museum. The house was moved from its original site in the late 1890s and moved again in the 1960s because it was threatened by blasting from the nearby Trap Rock Industries quarry. The Rockingham Association plans to move it to a larger site close to the Millstone River, near where the house originally sat, by the spring of 1999. The house is furnished with pieces from 1783 or earlier and includes reconstructed outbuildings and a colonial herb garden. Annual events include a candlelight tour in December and a celebration of Washington's birthday. Open Wednesday– Saturday, 10–12 and 1–4; Sunday, 1–4; closed New Year's Day, Thanksgiving, and Christmas. Groups by appointment. The restored washhouse now serves as a hands-on museum for young children; open by appointment only.

Rocky Hill is a well-preserved and attractive village. Its historic district* includes 19th- and 20th-century buildings on Washington St. and Montgomery, Crescent, and Princeton avenues. The prerevolutionary mill at 200 Washington St., now a potter's studio and gallery, was once owned by John Hart, one of New Jersey's five signers of the Declaration of Independence.

The Millstone River and the Delaware and Raritan Canal* come through Rocky Hill, and you can walk (or bicycle or horseback ride) along the towpath here (see Kingston). The remains of a well-known terra cotta plant, now a private house, are visible from the towpath. The firm supplied the tiles for the Woolworth Building in New York City, and you can also see examples of the terra cotta work in the Rocky Hill firehouse, 156 Washington Street.

Each December for over 30 years the Pacific Southern Model Railway (26 Washington St.; 609-921-9276) has put on a show to benefit the fire department and first aid squad. Several shows a day take place on the first two complete December weekends.

North of Rocky Hill, in Montgomery Township (take Montgomery Ave. until it becomes Montgomery Rd. or pick up Montgomery Rd. from us 206 north), is the 1860 House (124 Montgomery Rd.; 609-921-3272), the home of the Montgomery Cultural Center. Connected to the mid-19th-century house by a glass breezeway is an early-20th-century wood-paneled library, moved from a northern New Jersey house by a member of the Ballantine brewery family. The center sponsors concerts, lectures, and classes. Exhibits in the house change roughly every six weeks. Open Tuesday–Thursday, 9–5; Saturday, 10–2; at times the hours are extended, so it is best to call first.

Continuing north on us 206 to Belle Mead brings you to the LaFollette Vineyard & Winery (64 Harlingen Rd.; 908-359-8833). Located within 15 miles of the 18th-century home of the LaFollette ancestors, LaFollette specializes in growing and producing only one type of wine. The winery was once a sheep hut, and the Wine Hut, where wines can be tasted, a 150-year-old lambing shed. Open for tours Thursday–Sunday, 12–5.

The Van Harlingen Historical Society of Montgomery Township maintains the Dirck Gulick house (c 601, the Belle Mead–Blawenberg Rd., at the point c 604, the Dutchtown-Harlingen Rd., intersects it from the east; 908-359-3498), a stone Dutch house dating to 1752. Part of the ground floor may be seen by appointment. The society also maintains the Bedensville Schoolhouse (Burnt Hill Rd., behind the elementary school; 908-359-3498), a one-room schoolhouse built in 1853 and moved to this site after it closed. Open by appointment (when school is in session, someone at the school can take you through; call 908-874-5200).

If you continue north on 601 and turn left on E. Mountain Rd., you will come to the Sourland Mountain Preserve (908-722-1200), a Somerset County preserve of over 1,600 acres. This is rocky and hilly terrain with a wide range of habitats and consequently of birds and wildflowers. Open for passive recreation daily, dawn–dusk.

Roebling Burlington [Florence Township]

DELAWARE RIVER BETWEEN BORDENTOWN AND BURLINGTON, JUST WEST OF US 130

Roebling was founded as a company town in 1904, when the Roebling Company, famous for making the wire rope used in suspension bridges, decided to make for itself the steel that went into the rope. The plant was built on the site of a 115-acre peach and potato farm that bordered the Delaware River; it turned out a

variety of products, including the cable used in the George Washington Bridge. The town was designed by Charles G. Roebling, the third son of the famous John Roebling, who had invented steel cable, had created the Roebling company, had built his first cable suspension bridge in Pittsburgh in 1846, and had designed and begun construction of the Brooklyn Bridge. The younger Roebling envisioned a model community for the workers in the new plant. He laid out the town on a rectangular grid, with Main St. a boulevard that expanded into a circle at the intersection with 5th Ave., and provided a park, an auditorium, and a variety of shops. Those higher up in the company lived in the larger houses along Riverside Ave., but the workers' brick row houses were solidly built, and the view of the river from the park is lovely. In the 1950s the plant was sold. The town is now part of Florence Township, many of the original structures are gone, and the buildings are privately owned, but the distinctive quality of the community is still apparent. The Roebling historic district* includes 2d-8th, Alden, Norman, and Amboy avenues. In the library (Hornberger and 6th aves.), formerly the union meeting hall, are pictures and artifacts relating to the history of Roebling from its founding to the present. Open weekdays, 12-4 and 6-8; other times by appointment (call 609-499-2415 or 609-499-2379). St. Nicholas Byzantine Catholic Church (191 Norman Ave.) has a picnic grove at the end of the street where ethnic festivals sponsored by the church are held several times a year.

Roosevelt Monmouth 884

C 57I

Conceived as a utopian community that would be a self-sufficient agricultural and industrial unit, Roosevelt,* founded in the 1930s and known as Jersey Homesteads until the death of President Franklin Delano Roosevelt, was actually owned by the federal government. The early community, a project of the Federal

Resettlement Administration, contained a cooperative factory (the Workers Aim Cooperative Factory on N. Valley Rd., dedicated in 1936, now housing a packaging manufacturer, art studios, and a woodworking shop) and a cooperative store. Communal farms were also part of the original conception.

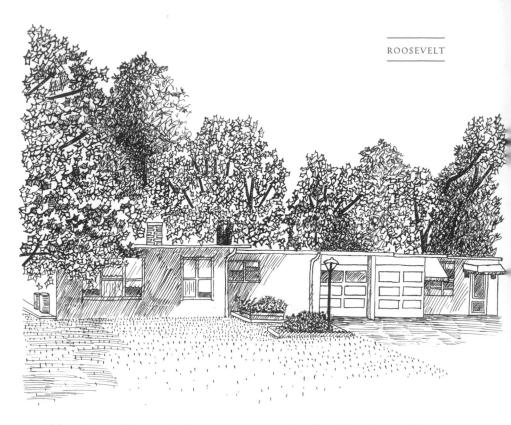

Although 151 of the original structures remain, the farms have been sold, the cooperatives are long since gone, and the government sold the town to the residents in the late 1940s. But underneath the extensive architectural alterations, you can still see the boxlike houses and rational layout of the original Bauhausinspired scheme, the work of Alfred Kastner (his assistant was Louis Kahn).

Most of the residents are now commuters, but the town has long been a haven for artists and writers, of whom Ben Shahn is probably the best known. His large mural, depicting incidents and people involved in the history of labor, immigration into the United States, and the founding of Roosevelt, is to be found in the elementary school (School La., just west of c 571; 609-448-2798). Visitors are welcome to come see the mural during school hours (8–3:30), as well as the photography exhibit on permanent loan from the state museum, but you are asked to stop by at the front office first.

Shahn is buried in the community cemetery (Eleanor La.); the memorial he designed himself. The cemetery is still free to residents. In the park with the amphitheater on the west side of c 571 (N. Rochdale Ave.) is a monumental bust of Roosevelt, modeled by Shahn's son Jon. Other Roosevelt residents have included Jacob Landau and Gregorio Prestopino.

At the corner of N. Valley Rd. and Homestead La. is Britton House, one of the farmhouses predating the foundation of Jersey Homesteads. And at the foot of Farm La. is a prize-winning project from the 1980s, Roosevelt Solar Village, a low-income solar housing project for the elderly, modeled on an English village.

276 Roosevelt

To the south and west of Roosevelt, off c 571 (and also accessible from c 524, c 539, and many lesser roads) is the Assunpink Wildlife Management Area, 5,600 acres containing three lakes, open fields, marsh, lowland forest, upland woods, and hedgerows. Some of the land is leased to farmers. The area is reputed to be one of the best spots for bird-watching in central New Jersey, with over 250 species having been seen here. Fishing is possible along most of the shore of all three lakes, one can hike, and there is limited hunting.

The Horse Park at Stone Tavern (609-259-0170) occupies 147 acres within the wildlife management area and has facilities for international equestrian events of all kinds. Shows, festivals, and other events take place here almost every weekend, March–October.

For an inside look at the world of harness racing you can visit nearby Showplace Farms (505 NJ 33; 732-446-3100); from the Horse Park take 571 north to Perrineville Rd. and turn right; turn left on Prodelin Way and right on 33). This large (more than 20 barns stabling more than 400 horses), well-groomed training and therapy facility welcomes visitors, but you are asked to call first. Groups by appointment.

Roseland Essex 4,847

I 280, C 527

What is apparently the oldest (founded in 1847) and largest flag maker in the world, Annin & Co., has had its headquarters in Roseland since the 1980s. The 60 x 90 foot American flag that flies from the George Washington Bridge on patriotic holidays (and weighs 500 pounds) was made by Annin, as are flags of all the

other countries of the world, to say nothing of American states, Swiss cantons, and innumerable organizations.

The Harrison House* (126 Eagle Rock Ave.; 973 228 1029), a white clapboard house with its original beehive oven and walk-in fireplace, dates to the 1820s and serves as the headquarters for the Roseland Historical Society. The society holds several open houses during the year, and the house is open other times by appointment. You are welcome to visit the attractive garden any time. The society also owns a portion of the former Becker Dairy Farm (35 Livingston Ave.) and hopes eventually to develop space there to exhibit its collection of dairy and farm tools, milk sleigh, and the like. For the moment, it uses the Becker Center (which once housed the dairy's delivery wagons and later its trucks) for fund-raisers and meetings.

Green Meadows Farm (610 Eagle Rock Ave., ¹/₄ mi. west of Eisenhower Pkwy; 973-228-6966) gives two-hour guided tours of its collection of 500 farm animals. The tour includes close contact with the animals, pony rides, and hayrides. Open daily, 9:30–6, late September to early November and late April– mid-June; weekday tours 9:30–1; weekend tours 9:30–3; groups by appointment. Admission charge.

Roosevelt, Roseland 277

Roselle Union 20,314

NJ 27

The first city in the world to be lit by incandescent bulbs (and the first in the United States to be lit by electricity), Roselle was settled in the late 1670s by Abraham Clark, who migrated here from Long Island and was the great-grandfather of the Abraham Clark who signed the Declaration of Independence. The town remained

basically rural for almost 200 years until John C. Rose, after whom it is named, began buying up farms and developing the area. Today Roselle has an attractive, lived-in look and many interesting buildings, including, for example, the oldest building in town, the Federal-style Cavalier Jouet house (238 E. 2d Ave.).

A replica of the Abraham Clark house, which burned in the early years of this century, has been built at 9th Ave. and Chestnut St. (908-245-1777, 908-486-1783). The house, not that distinguishable from its neighbors, sits a few hundred feet from the site of the original house on land that once belonged to Clark. The museum wing features a small collection of items primarily related to the history of the Clark family and the history of Roselle, including for example, some early light bulbs. Open by appointment only.

The First Presbyterian Church (5th Ave. and Chestnut St.) dates from the 1890s and was the first church in the United States to be lit by incandescent light. The original Electrolier, still in use, is a brass chandelier with milk-glass reflectors that was designed and installed by Edison; damaged by fire, it was restored in the 1960s. (A plaque marks the site of Edison's laboratory at Locust St. and 1st Ave.) The Second Baptist Church (2d Ave. and Locust St.) also dates from the 1890s.

In the southeastern corner of the borough (Thompson and St. Georges aves.) is Warinanco Park, best known for its indoor skating rink (201-298-7849, 201-298-7850). The 210-acre park, one of Union County's many Olmsted-designed parks, was named for one of the three chiefs of the Lenape. In the spring its Chatfield Garden has a sensational display of tulips. The park has facilities for boating (201-289-1899), fishing, and picnicking, as well as bicycle paths, a fitness trail, tennis courts (201-245-2288), a playground, and athletic fields.

North of Roselle, in Roselle Park, is the Roselle Park Museum (9 W. Grant Ave.; 908-245-1776). Housed in an apartment building said to date from the 1890s, the museum has a collection of photographs and other memorabilia relating to the history of the borough, which will celebrate its centennial in 2001. Open Monday, 7–9 P.M.; Wednesday, 10–2. On the same block is the Robert Gordon school, the first public building to use Thomas Edison–designed cement. Roselle Park's high school has a prize-winning band, soon to be seen in a Disney TV show.

Rutherford Bergen 17,790

NJ 3, 17

Once a settlement known as Boiling Springs (there is a Boiling Springs Ave. just over the border in East Rutherford), Rutherford was developed in 1862 on land that had belonged to John Rutherford, a patriot and friend of George Washington. There are still early-18th-century houses to be seen in Rutherford: the oldest

portion of the Nathaniel Kingsland house (245 Union Ave.), where Washington rested on his journey from Newburgh to Princeton, dates from 1670, making it one of the oldest houses in the state. (The adjoining Richard Outwater house dates from 1821.) Washington also visited the Kip Homestead* (12 Meadow

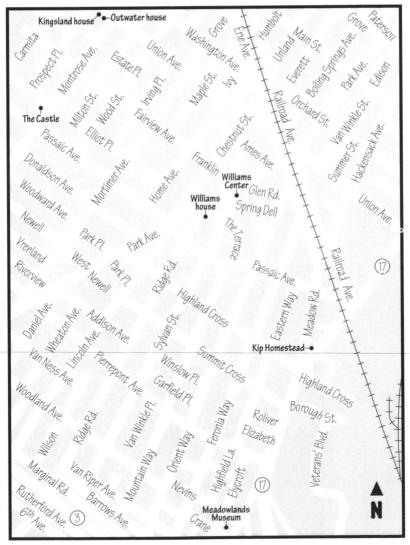

Rutherford 279

Rd.). Another old Dutch stone house, the Yereance-Berry house,* contains the Meadowlands Museum (91 Crane Ave.; 201-935-1175), which specializes in area history but also exhibits fine and decorative art and crafts. Permanent exhibits include New Jersey minerals, antique toys and dolls, and early kitchens; there are also changing exhibits. Open September–July, Monday and Wednesday, 1–4; Sunday, 2–4; group tours by appointment.

Rutherford is the birthplace of the poet William Carlos Williams, and until 1996 his house* (9 Ridge Rd. at Park Ave.) remained in the hands of his family. One block from his house is the William Carlos Williams Center (Park Ave. between Glen Rd. and Spring Dell; 201-939-6969), built around the Rivoli, a 1922 vaudeville theater that was converted into a movie house but burned in 1977. Claiming to be one of the few arts centers in the United States to be named after a poet, the Williams Center has had several changes of focus; at the end of 1995 the center announced it would concentrate on concerts, ballet, opera, and theater for children.

Fairleigh Dickinson, which now has its campuses in Madison and Teaneck, opened in Rutherford in 1942 as a junior college. The Castle (Passaic and Montrose aves.), the building the college purchased when it first opened, was built as a summer home in the 1880s and was inspired by the French chateaux of Chaumont and Amboise.

Salem Salem 6,883

NJ 45, 49

In 1675 a group of Quakers led by John Fenwick settled on the banks of the Delaware River and named their community Salem, from "shalom," the Hebrew word for peace. Immigrants from other countries had preceded them—the Swedes and Finns, for example, had established a settlement at Fort Elfsborg (also

known as Fort Myggenborgh because of the mosquitos, located near today's Point Elsinboro) in 1643, and there had also been Dutch and Puritans from New Haven in the area—but their communities did not last (Fort Elfsborg was abandoned in 1653), and Salem became the first permanent English settlement in West Jersey.

Salem thrived as a shipping center (it was designated an official port in 1682) until the Revolution, when shipping activity moved to Camden and Philadelphia. The port fell into disuse, but in 1982, some 300 years after its founding, it was officially reopened, and a load of grain was shipped out of the harbor for the first time in 100 years. The port has prospered, and in 1995 almost 38,000 tons, largely containerized shipping and used vehicles, left Salem, much of it heading for the Caribbean.

Improvident farming practices depleted the soil around Salem, and in the early 1800s many of its citizens headed west, among them Zadock Street, who left in 1802 and founded the towns of Salem, Ohio, and Salem, Indiana. His son Aaron Street was responsible for Salem, Iowa, and Salem, Oregon.

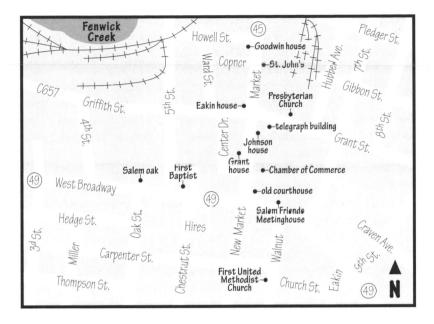

The discovery of marl nearby made it possible to replenish the soil, and agriculture prospered again. Salem, in fact, has a footnote in agricultural history. Robert Gibbon Johnson, a wealthy local landowner, is credited with importing the first tomato plants from South America. On 15 September 1820, he is supposed to have stood on the courthouse steps and eaten a tomato, which most people believed to be poisonous. Tomatoes are now, of course, an important crop in New Jersey, and many of them are grown in Salem County.

Johnson was also one of the founders of the New Jersey Historical Society (1845) and its first vice-president. His elegant house (90 Market St.), built in 1806 with additions dating from 1850, now serves as a county building and is one of the many brick buildings that, with the wide streets, help give Salem its distinctly West Jersey look.

At Market St. and Broadway is the old Salem County Courthouse. Portions date from 1735, but the courthouse was almost completely rebuilt in 1817 and extensively remodeled again in 1908. The outside now dates basically from 1817, the inside from 1908. To visit the courthouse, stop in at the Chamber of Commerce (104 Market St.; 609-935-1415). Open weekdays 9–3, weekends 9–4.

Next to the Johnson house is the mid-19th-century Presbyterian Church, which has a Tiffany window over the pulpit in the sanctuary. Farther along Market St. (north of Grant) is St. John's Episcopal Church, originally Church of England. The present building dates from 1836.

At 79–83 Market St., in the Alexander Grant house, part of which dates from 1721, are the headquarters, museum, and library of the Salem County Historical Society (609-935-5004). Furnished to show how the occupants of such a house would have lived, the museum exhibits antiques that reflect the county's heritage, as well as various special collections, including glass from Wistarburg, the first glassworks in the colonies (1739); Native American relics; and dolls. Behind the Grant house, on the historical society's property, is the John Jones law office, a tiny octagonal brick building, c. 1735, believed to be the oldest surviving law office in the country. There is also a re-creation of a South Jersey stone barn built in 1957 that contains some of the larger items owned by the society as well as some of the specialized collections. Open Tuesday–Friday and the 2d Saturday of the month, 12–4. Admission charged. The society is also restoring the Alfonso L. Eakin house (89 Market St.), a late-18th-century house that was remodeled in 1841, as a Victorian house museum.

On the north side of E. Broadway, at Walnut St., is the Salem Friends Meetinghouse. Dating from 1772, it has the longest record of continuous service of any religious building in New Jersey. Built of brick in a Flemish-bond pattern, its walls are 16–18 inches thick, much of its glass may be from Wistarburg, and its fences are made of New Jersey bog iron.

On W. Broadway, opposite Oak St., is the Friends burial ground. Here you will find the famous Salem oak, a massive white oak tree believed to be over 500 years old. Under this tree in October 1675 John Fenwick signed a treaty with the Native Americans. The tree has been heavily braced, and there is hope that it will be around for some time.

If possible, walk up and down Market St. and along Broadway (a large section of Market St. and E. Broadway is in the Market St. historic district,* and many buildings have identifying plaques). The house at 47 Market St. served as a stop on the Underground Railroad when Elizabeth and Abigail Goodwin lived there. Many of the houses in the area were derelict or had been vandalized, and the renovation efforts have been heroic. The Greek Revival house at 28 Market St. (c. 1800) is one of those renovated. It stands taller than its neighbors because it was built by a tailor who had his shop in the basement (the basement windows and doorway have been removed). See also the small frame saltboxes at 18 Market. The First United Methodist Church (Walnut St., opposite Church St.) dates from 1888, the First Baptist church (130 W. Broadway) from 1846. At 185 Grant St. is the former telegraph building; built in 1856 and used by Western Union from 1917 to 1955, it is being restored by Preservation Salem to serve as an office and resource center.

Scotch Plains Union 21,160

US 22, NJ 28, C 509

Scotch Plains was settled in 1684 by Scottish Dissenters from Perth Amboy who were soon followed by Quakers. By the 1740s there were more Baptists than Quakers or Scottish Dissenters. An agricultural community, Scotch Plains grew slowly (by refusing to let the railroad come through the town, it stayed rural longer), but

after World War II it doubled in size and became a commuter town. James Manning, the founder of Brown University, came from Scotch Plains, and Arthur Brisbane, the journalist and editor, was a resident. Scotch Plains's first substantial building, the Stage House Inn* (Front St. and Park Ave.; 908-322-4224), built c. 1737, and from roughly 1769 to 1829 a stagecoach stop on the Swift-Sure Stagecoach line, is now the cornerstone for Stage House Village, in which various older buildings, some from other sites, have been converted to shops and restaurants. Nearby is the Cannonball Osborn House (1840 Front St.; 908-232-1199), c. 1720, so named because it was hit by a cannonball (fired by a Continental soldier) during the Revolution. Maintained as a museum by the Scotch Plains and Fanwood Historical Society, the house has its original kitchen, complete with a beehive oven. One parlor is furnished with colonial pieces, the other with Victorian ones. The society's collection includes antique clothing; exhibits change frequently and tend to be thematic (historic bridal gowns in June, for example). Open the 1st Sunday of the month, 2–4. Tours by appointment.

The Ruskinesque-Gothic Baptist church (311 Park Ave.) dates from the 1870s, but the parsonage* (Park Ave. and Grand St.) is almost 100 years older (1786, with a later addition). Built of boulders from the Green Brook, supposedly because the new parson was from Pennsylvania and accustomed to stone, it was the first stone parsonage in the area. The Second Baptist Church (Grand and Union), now the YMCA, dates from c. 1817. Note also the Romanesque All Saints' Episcopal Church (559 Park Ave.), 1882.

The Ephraim Tucker farmhouse (Jerusalem Rd. near Plainfield Ave.; 908-322-6700, ext. 220; 908-232-9748), c. 1740, enlarged in the 19th century and considerably altered in the 20th, now serves as the clubhouse for the Scotch Hills Golf Club. Founded as the Westfield Golf Club in the 1890s, it became the Shady Rest Country Club in the 1920s (apparently the first African American country club in the state). Purchased by the township in the 1960s, it is now one of the few municipally owned clubs in New Jersey. John Shippen, the first African American pro in the PGA and the first American-born golf professional to compete in a U.S. Open, was the pro at Shady Rest for over 40 years. His portrait hangs in the lobby (note the fireplace), and each year the John Shippen Memorial Tournament raises money for student scholarships.

East of Raritan Rd. are the Ash Brook Reservation and the Ash Brook golf course (see Clark). Part of the Watchung Reservation also falls within Scotch Plains (see Mountainside).

Seaside Park Ocean 1,871

Z

NJ 35

The tiny beach community of Seaside Park is nestled between Seaside Heights to the north—with its boardwalk and nightlife, reputed to have more people per square inch in the summer than any other community—and Island Beach State Park (732-793-0506) to the south—to miles of one of the last completely unspoiled

beaches in New Jersey and one of the last undeveloped barrier islands along the North Atlantic. Because there are no jetties or groins on Island Beach, the natural forces shaping the beach are unimpeded. Actually, Island Beach is no longer an island, its name dating to the time it was, from the mid-18th to the early 19th century.

Owned in the 1920s by Henry Phipps, a partner of Andrew Carnegie, who planned to convert the area into a luxurious seaside resort, Island Beach was purchased by the state and turned into a park in the 1950s. One of the Phipps houses saved by the state now serves as the governor's summer home. The former carriage house (and later municipal garage) has been converted to a nature center. There is a short self-guided tour here, and you can pick up trail maps. The lifesaving station* dates from the 1890s.

With the ocean on one side and Barnegat Bay on the other, the park offers visitors a wide variety of activities. Over half the acreage consists of natural areas, but there are recreation areas as well. There is only one road into the park, and when the parking lots are full (in high season as many as 15,000 may visit daily), no more cars are let in. (There is no limit on four-wheel-drive vehicles driven by those planning to fish.)

At the nature center, displays focus on barrier islands—their history and bird life, and the environment of barrier beaches—and include a diorama that transects a barrier island. You can take a self-guided tour behind the nature center, and on Saturday morning in spring (April–June) and fall (Labor Day– October), theme nature walks are scheduled. Canoe tours and a wide range of nature programs are offered in the summer months. Educational programs for groups can be arranged; call for details on all the programs. The nature center is open daily the 4th weekend in June–Labor Day, 8:30–4:30, weekends the 1st weekend in April–4th weekend in June and Labor Day–October.

The bay side is generally closed, but tours can be arranged. The park naturalists conduct tours through the northern natural area, and you are free to walk in the wildlife sanctuary to the south. The southern area has a bird blind and launching areas for canoes and kayaks. The north bathhouse has a 180gallon saltwater tank display. From the third week in June to Labor Day some areas of the beaches are protected by lifeguards, and it is also possible to fish, scuba dive, and surf in designated areas. The bird-watching is excellent, and although there are no tables or fireplaces, you are welcome to picnic on the beach; you can build a fire (except in the bathing areas) as long as you keep your fire at least 50 feet east of the dunes. Even at the height of the summer season, you can find empty stretches of beach to walk along if you leave the guarded areas. From October through April you can bring a horse onto the beach (advance reservations are necessary). Parking charges for most areas year-round, for all areas in summer.

Secaucus Hudson 14,061

NJ TNPK EXITS 16E, 17, NJ 3

Secaucus, which must once have had one of the worst reputations of any city in the state, was settled in the early 1680s by a few hardy souls willing to cross the damp meadowland to reach high ground. The name comes from a Native American word meaning "where the snake hides," and the Native Americans are said to

have avoided the area. Laurel Hill, the nearly leveled mineral-rich rock formation familiar to those who travel by train, bus, or car to or from New York City, was once known as Snake Hill and is said to have been used by George Washington's troops as a lookout during the Revolution. The county has recently opened a park in this area, its first new park in over 80 years. A boat launch is open now, and eventually the park will contain playgrounds, ballfields, and nature trails.

Part of Secaucus's bad reputation came from its pig farms—until about 35 years ago, there were some 50 of them—and slaughterhouses. When the New Jersey Turnpike was built, several of the farms were destroyed, and the town forbade the establishment of new ones. One pig farmer, Henry Krajewski, ran for president as an Independent Populist in 1952 and 1960.

Known also as an area of warehouses and freight yards, Secaucus may have suffered from the idea, accepted until fairly recently, that marshland was waste land, good only for pig farms and freight yards. In recent years, however, Secaucus has attracted so much industrial, commercial, and residential development that there is considerable concern about overbuilding on the marshland. Among the projects from the 1980s are the immense Harmon Cove and Harmon Meadow developments, which contain housing, marinas, office and hotel space, child-care facilities, shops and restaurants, a cinema and a health club.

One of the newest projects is a rail transfer station, which will bring together the state's major rail lines and presumably cut travel time to New York City as well as encourage more people to use the trains. A light rail line to the Meadowlands Sports Complex (see East Rutherford) is part of the project, expected to open by the end of the '90s.

When the studios of WOR-TV (9 Broadcast Plaza; 201-330-2105) opened in the mid-'80s, they were in one of the few buildings in the country built specifically as a television facility. One-hour tours of the facility are available weekdays by appointment. Lincoln Towers (County Ave. near Dorigo La.) is a striking, barrier-free housing project for the elderly and handicapped, the last subsidized project to be approved by HUD before funds were cut in 1981. Note also the dramatic municipal building (1203 Paterson Plank Rd.).

Secaucus today is a popular stop for shoppers because of the abundance of factory outlets. What is interesting about these outlets is that they are located among working warehouses, so that to go from one store to another shoppers

must negotiate around 18-wheelers, driving down streets with names like Enterprise Ave. and Venture Way. Among the companies to be found in Secaucus is the 60-year-old Goya Foods, one of the largest Hispanic-owned companies in the country.

Sergeantsville Hunterdon [Delaware Township]

c 523, 604

First settled around 1700, Sergeantsville (pronounced sir'-gentsville) is named for Charles Sergeant, a Revolutionary War soldier. (Before the 1830s it was known as Skunktown.) This tiny village at the intersection of county routes 523 and 604 (the Stockton-

Flemington Rd. and the Rosemont-Ringoes Rd.) lies in as yet largely undeveloped, rolling land characteristic of Hunterdon County. From Sergeantsville came Dr. George Larison, the founder of Hunterdon County's peach industry. He first planted his orchards in the 1850s; by 1890 there were 2 million peach trees in Hunterdon County, yielding some million bushels of peaches a year. An infestation of San José scale in the 1890s resulted in the destruction of most of the trees.

Roughly a mile southwest of the crossroads on the Rosemont-Ringoes Rd. as it crosses the Wickecheoke Creek, is Green Sergeant's Covered Bridge,* the last of New Jersey's 75 pre-20th-century covered bridges (one was built in the 1950s in Cherry Hill, almost a century after the state's last wooden covered bridge). Built in 1872 on the site of one dating to 1750, the bridge was threatened with a modern replacement in the 1950s. Saved by concerned citizens, it was rebuilt on a steel frame, retaining over half of the original trusses and members.

Sergeantsville has applied for designation as a historic district, and there are many 18th- and 19th-century buildings to be seen. The inn was actually built as a private house in the 18th century and greatly enlarged in 1835. The fieldstone and stucco house on the southeast side of c 604 at the creek dates from around 1740. At the intersection of c 604 and Headquarters Rd. is the mid-18th-century Headquarters Farm, so named because George Washington is believed to have camped here on his way to Trenton. Included on the property are a stone mansion, a tenant house, slave quarters, and a four-story gristmill. Well into the 20th century there was a community here with a store and post office. Since 1973 Sergeantsville has held a November house tour (609-397-8337, 908-996-4677); it is possible then to see some of the many remaining 18th- and 19thcentury houses and farms. On 4 July you can take part in the town's Great Crate Race, in which children and adults race in home-made coaster cars.

About three miles north of the bridge on the Locktown-Sergeantsville Rd. (at the intersection with Locktown School Rd.) you will come to the Locktown Baptist Church* (1819). The community is supposed to have gotten its name during a dispute among the Baptists. One faction put a lock on the door to keep the other out, but the other added a lock of its own, thereby keeping everyone out. To visit the handsome stone church, call 908-996-2254.

Shrewsbury Monmouth 3,096 (borough) 1,098 (township)

NJ 35, C I 3A

Shrewsbury is one of New Jersey's oldest settlements (the first buildings date to 1664; the township was incorporated in 1667), and over 40 of its buildings are at least 100 years old, but because its historic center is at the intersection of two broad, heavily traveled highways, much of the feeling of the past is obscured by the noise

of the traffic. (Much of the traffic is generated by Fort Mommouth; sec Eatontown.) Part of the Monmouth Patent of 1665, Shrewsbury was settled by Quakers, Anglicans, and Scotch Presbyterians, many of whom came to the area by way of Rhode Island and Long Island. The spot put its settlers to mind of Shrewsbury in England, and they named it accordingly. (During World War II, Monmouth County's Shrewsbury raised a considerable amount of money to help England's Shrewsbury, and the contact continued; in the mid-'80s, the vicar of the abbey in Shrewsbury, England, preached in Christ Church in Shrewsbury, New Jersey, while Christ Church's vicar was visiting in Shrewsbury, England.)

Sycamore Ave., one of Shrewsbury's two main crossroads (Broad St. is the other), follows the Burlington Trail, an old Native American path that ran from Freehold to the sea; Broad St. was once the Kings Highway; together they define Shrewsbury's historic district.* At their intersection are an old house, a meetinghouse, a church, and an old estate. On the northwest corner is the Allen House* (732-462-1466), built in 1667; at various times it has served as a private residence, a tavern, a tea room, and an antiques shop. Since 1968 the Allen House has belonged to the Monmouth County Historical Association, which now operates it as a museum. Restoring the house to look as it had in the 1750s and 1770s, when it was said to be "the most noted tavern in Shrewsbury," the historical association gathered and arranged the furnishings to show what a tavern would have been like in the mid-18th century. Outside is a colonial herb garden. Open May–September, Tuesday, Thursday, Sunday, 1–4, Saturday, 10–4. Admission charged.

At the northeast corner is the Friends Meeting House (1816). Shrewsbury's first Quaker meetinghouse was built in 1672; it was the town's first public building. In 1727 bricks were imported from Holland to build another meeting-house, and some of those bricks were used again in the present building.

At the southeast corner stands Christ Church (732-741-2220), erected in 1769 with funds raised largely by a lottery. (In 1879 President Ulysses S. Grant attended the church's centennial celebration.) Among the curiosities of the church are its crown, its Bible, and the canopied pew for the colonial governor. The crown sits atop the tower (added in 1874) above a gilt ball and the weather vane; during the Revolution soldiers tried to destroy this symbol of the English monarchy, and the scars from their shots are apparently still to be seen on the ball. The Bible is a Vinegar Bible (a Bible printed at Oxford in 1717, full of

typographical errors, including the substitution of "vinegar" for "vineyard" in the heading of Matthew 20). Tours by appointment (732-741-2220).

On the fourth corner are Borough Hall^{*} and the Shrewsbury Historical Society (732-530-7974), the former on an estate that can be traced back to the 1600s, the latter in a new building (1982) built for it on the site of the estate's carriage house, which burned. The society runs a library and a small museum. Of particular interest are scale models of Shrewsbury's churches, which enable you to see what the interiors of the churches look like even when it is not possible to enter them. There are also memorabilia from the Broadmeadow family (James Broadmeadow began canning tomatoes in a factory on Sycamore St. in 1863). Open Tuesday and Thursday, 1–4; Saturday, 10–4.

The Presbyterian Church (1821) stands east of Christ Church on Sycamore Ave. and replaces an early-18th-century building. On Sycamore near Broad St. is Paddington Farms, a housing development built on the former 80-plus-acre Chalmar horse farm, an early-19th-century estate that once served as a summer retreat for Louis V. Bell. (Bell was a wealthy New Yorker who, contrary to legend, was probably not related to Alexander Graham Bell.) The estate later became the home of David H. Marx, president of the Louis Marx Toy Company, at one time the world's largest toy manufacturer; Dwight Eisenhower visited the estate when Marx owned it. The 22-room Georgian mansion (1910) has been preserved, as has the 19th-century farmhouse.

North of the four corners is the gallery of the Guild of Creative Art (620 Broad St.; 732-74I-I44I). Exhibits change monthly and are primarily of paintings and drawings, though they do include some sculpture and photography. The guild also sponsors public classes. Gallery open Tuesday, Thursday, Saturday, 12–4:30.

Somers Point Atlantic 11,216

GARDEN STATE PKWY EXITS 29, 30, US 9, NJ 52, C 559

This rapidly growing community is the oldest settlement in today's Atlantic County. Formerly known as Somerset Plantation, it was founded in 1693 by seven men (four of English, two of Dutch, and one of Swedish extraction), most of whom came from Long Island. Once a stagecoach stop, the port of entry for Great

Egg Harbor (1791–1913), and the site of the county's first post office (1806), Somers Point was an active shipbuilding center in the 19th century. By the mid-19th century it was known as a resort. Today it is a popular spot for fishing and boating. It is also the home of the South Jersey Regional Theatre (738 Bay Ave.; 609-653-0553), the first Equity theater to have had a full season in southern New Jersey. Because developers must now provide a public-access boardwalk around any new developments or marinas, you can walk along the shore here, despite all the new condominiums.

The Richard Somers Mansion* (Shore Rd. at Somers Pt. Circle; 609-927-2212), built in the 1720s, is Atlantic County's oldest surviving building. Made of brick in a Flemish-bond pattern with an unusual roof (thought to have been built by a shipwright, it looks like an inverted hull), the house was built for Richard Somers, the harbormaster. Somers was a descendant of one of the town's original settlers and the grandfather of Somers Point's most illustrious native son, Richard Somers, commander of the *Intrepid*, blown up in Tripoli in 1804. The Somers family continued to live in the house until 1937. Now owned by the state and partially furnished to look much as it would have when the Somers family lived there in the 18th century, the house is due for further restoration (it was partially restored by the Works Progress Administration [WPA] in the late 1930s). Open Wednesday–Friday, 9–12 and 1–6; Saturday, 10– 12 and 1–6; Sunday, 1–6. Closed New Year's Day, Thanksgiving, and Christmas.

Just north of the Somers Mansion is the Atlantic County Historical Society library and museum (907 Shore Rd.; 609-927-5218). The museum contains artifacts dating from precolonial days to the early 20th century as well as material relating to Richard Somers and to Somers Point's nautical role. Of particular interest are the explorer dolls, a local WPA project. Open Wednesday–Saturday, 10–12, 1–4, and by appointment on the 1st Sunday afternoon or 1st Friday evening of each month (call 609-641-4607). Closed legal holidays.

North of Somers Point (take c 585), in the town of Northfield, is the Risley Homestead* (8 Virginia Ave.; 609-642-8976), a late-18th-century house that was home to many generations of oyster fishers. The Atlantic County Historical Society takes guided tours through the house April–November, Saturday, 10–4, Sunday 1–5.

West of the Risley Homestead, on the site of a former brick factory, is Birch Grove Park (Burton Ave. between Mill and Tilton rds.; 609-64I-3778). On its 280 acres are 21 small lakes (made by the brickworkers excavating clay) where you can fish (the lakes are stocked with trout), campgrounds, a playground and picnic area, nature trails, a fitness course, and a small zoo. Special events at the park include fishing tournaments, art shows, and summer concerts. Open daily, 9–5, mid-March–mid-October; 9–4, the rest of the year.

Southwest of Northfield (take the Northfield–English Creek Rd., which becomes Zion Rd., and turn right on Asbury Rd.) is the Atlantic Riding Center for the Handicapped (214 Asbury Rd.; 609-926-2233). The public is welcome to watch the regular program; call for the schedule.

West of Northfield, in Cardiff, is Story Book Land (Black Horse Pike; 609-64I-7847), a 40-year-old theme park based on children's stories, with live animals, a picnic area, and festive lighting for the winter holiday season. Open mid-March–December; call for the schedule.

Somerville Somerset 11,632

US 202, 206, NJ 22, 28, C 567

The seat of rapidly growing Somerset County, Somerville is changing from the center of an agricultural region to a city supporting professional and commercial services. Somerville is the birthplace of the opera singer Frederica von Stade and the home of the Memorial Day Somerville 50-mile bicycle race, the oldest

continuously run bicycle race in the country. A bicycle under glass at West End and Mountain aves. is a memorial for two young men who won the race in its first years and died in World War II. The event, which draws some 40,000 spectators each year, has several parts, including 300-meter sprints and a 35-mile road race. At the U.S. Bicycling Hall of Fame (166 W. Main St.; 908-722-3620, 800-242-9253) the inductees' plaques line the walls, but also on display are bicycle memorabilia, including historic bicycles, the first stars-and-stripes jersey made for an American rider, officials' ribbons, and the like. Open weekdays, 9– 12 and 1–3, but it is advisable to call ahead. Groups, weekends, and other times by appointment.

The Somerset Courthouse Green,* Main St. between Grove and N. Bridge sts., reflects the late 19th and early 20th centuries. The white marble Palladian courthouse, built in 1908 and recently restored and rededicated, is famous as the site of the Hall-Mills murder trial (1922), in which Mrs. Hall and her brothers were acquitted of the charge of murdering her minister husband and one of his married choristers. At the county's new administration building (20 Grove St.) the County Cultural and Heritage Commission (908-231-7110) hangs exhibits that are open to the public. The exhibits, which tend to focus on artists from the county, change roughly every other month. Open weekdays, 8:30– 4:30. Around the courthouse and the railroad station, the signs of new downtown growth are obvious (a second courthouse, the new administration building, among others).

Two of Somerville's historic buildings are, however, of particular interest. The Old Dutch Parsonage* (65 Washington Pl.; 908-725-1015), built in 1751 by the congregation of the First Reformed Dutch Church, is a state-run historichouse museum. The country's first Dutch Reformed Theological Seminary was established here in the 1750s by John Frelinghuysen; eventually it was to become Queen's College, which in turn became Rutgers University. Frelinghuysen died three years after coming to Somerville. His widow married one of his students, Jacob Hardenbergh, who in time became the first president of Queen's. The house has been furnished to show what the building would have been like when the Hardenberghs lived in it. Farther along and across the street is the Wallace House* (38 Washington Pl.; 908-725-1015), also a state historic-house museum. The house, which belonged to John Wallace, a Philadelphia merchant, was used by George Washington as his headquarters in the winter of 1779 while his troops were encamped at Middlebrook. It is furnished to reflect what a house would have looked like at the time of Wallace's ownership. Both houses have special events, including Middlebrook Day in the spring, a holiday diversion in the winter, and a country fair. Both are open Wednesday–Saturday, 10–12 and 1–4; Sunday, 1–4. Closed New Year's Day, Thanksgiving, and Christmas. Groups by appointment.

Somerville has many attractive buildings. Note the public library (35 West End Ave.) across Mountain Ave. from the bicycle monument and the mid-19thcentury Speer Van Arsdale funeral home (10 West End Ave.). In one of the city's handsome older residential districts is St. John's (W. High St. and Doughty Ave.), an 1890s stone church with a stone rectory.

South of town on us 206 (just past the Raritan River), on what is left of the Duke estate, are the Duke Gardens (908-722-3700), 11 display gardens representing various geographical and historical gardening styles, from 18th-century French and 19th-century Italian to 18th-century Japanese, from a succulent garden to a rain forest. The estate itself, built by the founder of the American Tobacco Company and the benefactor of Duke University in Durham, and until the mid-'90s lived in much of the year by his daughter, Doris, was created out of flat farmland by building hills and importing trees. You can get some sense of its former extent simply by following the stone wall, supposedly built of stone from Schooley's Mountain, on the western side of 206. Open October– May, daily, 12–4. Admission by reservation only. Fee charged.

North of Somerville (adjacent to Station and River rds. in North Branch Station; take NJ 28 north to US 22 west, or US 202 west) is the Ralph T. Reeve Cultural Center, 35 acres of county land dedicated to promoting the arts, and the home since the 1970s of the Printmaking Council of New Jersey (440 River Rd.; 908-725-2110). The building houses studios, a library, and two galleries; the council offers classes and workshops here and has an active educational

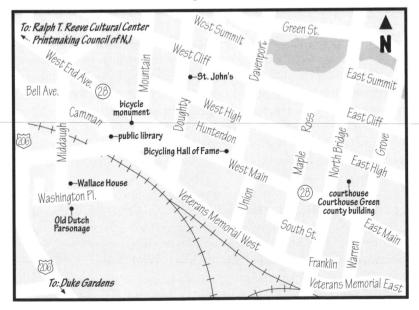

outreach program, taking portable presses into the community so that people can learn how prints are actually made. Exhibits at the galleries are open to the public Wednesday–Friday, 11–4; Saturday, 1–4. For a look at a stone house built in 1725 and in 1995 still in the hands of a descendant of the builder, continue north (take Station Rd. to the end, turn right on NJ 28 and left on Vanderveer Ave.), where you will see on your right the Jacob Ten Eyck house.

South Brunswick Middlesex 25,792

US I, I30, C 522

George Segal, the noted sculptor, makes his home in the township of South Brunswick, where the population has been growing at a rapid rate for the last 40 years (it increased over 50 percent in the last 10). A township with large industrial parks, South Brunswick also has some undeveloped areas, among them the county's

Davidson's Mill Pond Park (us 130 and Davidson's Mill Rd.; 732-745-3995), 400 acres with a pond, trails, picnic areas, and fishing. At Davidson's Mill the county grows the food it feeds the animals that live in its three zoos (see Jamesburg, Piscataway, and Woodbridge). Pigeon Swamp State Park (Fresh Ponds and Rhode Hall rds.) is a large (more than 600 acres) undeveloped area, much of which is rented to farmers.

South River Middlesex 13,692

C 527, 535

First settled in the early 18th century by Samuel Willett, South River for many years was an active port, serving the clay and fruit industries located nearby. Borough Hall in South River (64–66 Main St.) is located in the former Old School Baptist Church,* built in 1785. The church's foundation was made from rocks used

as ballast by cargo ships, and the walls were of local cedar. Among the stones in the cemetery behind the building is an urn by John Frazee in memory of his wife, who died in the 1832 cholera epidemic. Frazee was the first sculptor in the United States to receive patronage from the federal government: in 1831 he was commissioned by Congress to do a bust of John Jay for the Supreme Court chambers. The cemetery is locked, but stop in at the clerk's office (732-257-1999), weekdays, 9–5, for a key.

The local historical society is hoping to establish a permanent home in which to display its collection of historical South River artifacts; in the meantime, you can see two 18th-century portraits of the Willett sisters at the library (55 Appletree Ave.; 732-254-2488), which also puts on changing exhibits. The fact that some 40 percent of South River's population is of Polish descent is one reflection of the town's ethnic variety; another can be seen in the recently restored Sts. Peter and Paul Russian Orthodox Church (Whitehead Ave.), built in 1916.

Sparta Sussex 15,157

NJ 15, 181, C 517, 605, 613

Sparta was first settled in the late 18th century, and by the mid-19th was known as a resort area. Now on the shores of Lake Mohawk, which was created by developers in the mid-1920s, Sparta boasts an unusual commercial area built to serve the wealthy visitors to the town. The historic White Deer Plaza and

Boardwalk district^{*} (1926–35) includes the boardwalk, West Shore Trail, and Winona Parkway. Other parts of the downtown in this fast-growing community date from the same period. The First Presbyterian Church (32 Main St.), listed on the state register of historic buildings, was started in the 1780s. Each spring the Sussex County Arts and Heritage Council sponsors the Skylands Art Show at the Lake Mohawk Country Club (12 Boardwalk). This is a juried show that runs for a long weekend; call 973-383-0027 for the schedule.

The Ehrengart Museum at the Sparta Public Library (22 Woodport Rd.; 973-729-3101) features displays on Plains and Woodlands Native Americans and the history of the county. Open by appointment.

Springfield Union 13,420

178, US 22, NJ 24, 124, C 509 SPUR

Located at the head of the Rahway River and named for its springs, Springfield was first settled in the early 18th century by colonists from Hackensack. Only four colonial buildings remain, however, since the British burned the town in 1780 after losing the Battle of Springfield. It was during this battle that the Reverend James Caldwell, minister

at Elizabethtown (the fighting parson to the Americans, the high priest of the Revolution to the British), broke into the church, grabbed the Watts hymnals, and took them to the troops, who were running out of wadding for their cannon. "Give 'em Watts, boys, give 'em Watts!" he is supposed to have cried, and just two weeks after his wife had been murdered by the British (see Union), he rallied the troops and helped spur their victory in the last major engagement on New Jersey soil. A monument to the battle is at Washington Ave. and the river.

The Cannonball House* (126 Morris Ave.; 973-379-2624), one of the buildings that survived the fire, derives its name from the cannonball that lodged in its northwest gable during the battle. General Jonathan Dayton, from the family that founded Dayton, Ohio (James Caldwell was chaplain to his unit), lived here after the war. The house is now a historic-house museum run by the Springfield Historical Society. Open by appointment.

The new First Presbyterian Church (210 Morris Ave.) was built in 1791. The present parsonage (41 Church Mall) was built in the 1840s on the foundations of the earlier building, which had served as George Washington's headquarters for a time in June 1780.

Spring Lake Monmouth 3,499

NJ 71, C 524

Developed as a seaside resort for the wealthy in the 1870s (note the stone gate at the northern entrance on Ocean Ave.), Spring Lake* is named for a serene lake in the center of town. A family resort that once had the reputation of being the gathering place for wealthy Irish (well over half the residents are of Irish descent),

Spring Lake is increasingly becoming a year-round town. Although many of its buildings are being converted to other uses—(some of the older houses, for

example, have become bed-and-breakfasts—the structures themselves are well preserved and the town has an old-fashioned prosperous look. It is not surprising that croquet tournaments are held in Spring Lake.

One of Spring Lake's splendid hotels, the Essex-Sussex beach hotel, built in 1914 and designed by Philadelphia architect Guy King, was used as a set for the movie *Ragtime*. After the hotel closed, various developers came forth with projects that would save the building. Whether the latest plan, converting the hotel to luxury housing for senior citizens, will be realized should be known by the end of 1997.

The park by the lake is attractive, and along Tuttle, Jersey, Mercer, Sussex,

Spring Lake 295

Monmouth, Atlantic, and Union aves., among others, you can see some of the buildings from the golden era of the late 19th century, to say nothing of the lawns in front of many of them. Note also the railroad station and the statue in front of St. Catharine's. On the top floor of the municipal building is the historical society's museum (5th Ave. and Warren St.; 732-449-0772), devoted to local history. Open Thursday, 10–12; Sunday, 1–3; groups and other times by appointment; closed holidays. The society also sponsors an annual house tour. During the summer months, a trolley (732-449-1416) makes a loop through the town and around the lake; you can pick up a brochure describing the historical sites on its route at the museum.

Spring Lake has two miles of ocean beach and a commerce-free boardwalk as well. Forced to replace the boardwalk after the nor easter of December 1992, Spring Lake became one of the first communities to try a plastic and wood compound that won't rot, be eaten by insects, or, best of all, splinter. For information on beach fees, call 732-449-0577.

Stanhope Sussex 3,393

US 206, NJ 183, C 601, 602

Like the other iron towns in New Jersey, Stanhope, the site of the country's first anthracite furnace (c. 1841), stopped growing when the iron industry shifted westward. The borough did, however, see its population double between 1960 and 1980.

Southwest of Stanhope is another mid-18th-century iron town, Waterloo Village* (west on c 604 off us 206; this is well marked; 973-347-0900). Once known as a deserted village, and threatened with destruction by a developer, it was restored and has been open to the public since 1964. Situated on the Musconetcong River, Waterloo (before 1815 and Napoleon's defeat in Belgium, it was known as Andover Forge) lies within Allamuchy Mountain Park (see Hackettstown). In 1760 it could boast a gristmill, sawmill, forge, and mansions for the ironmaster and forgeman (the furnace was north of the village). Their owners being loyalists, the ironworks were seized by the revolutionary government, and Andover Forge supplied cannonballs for the revolutionary army. When the Morris Canal opened in 1831, the village became a canal port and entered its period of greatest prosperity. A general store was built that year and continued in business for over a century. By the mid-19th century, the railroad had also come to Waterloo, and over the years various members of the Smith family, important as landholders in Waterloo since late in the 18th century, built mansions for themselves. Competition from the railroads put the canal out of business, and when the iron industry moved west, Waterloo lost its economic raison d'être.

As a restored village, Waterloo has often drawn tens of thousands of visitors a year. Some of the buildings are house museums, others are used by working craftsmen. There is an exhibit of Lenape culture (Native Americans once lived in this area) as well as a re-created Lenape village, there are working mills, the canal association has its museum here, the mid-19th-century Methodist Church still holds services, and the locks and inclined planes are being restored. Open Wednesday–Sunday, 10–6, April–September; 10–5, October– December. Admission charge. The Waterloo Festival for the Arts (973-347-4700) takes place on frequent weekends June–December and features a wide variety of music, ethnic festivals, and other special events. In the mid-'90s, the village was undergoing various changes, so be sure to call ahead.

Just east of Stanhope off 206 is Wild West City (Lackawanna Dr., c 607; 973-347-8900), a reproduction of an 1880s frontier town, with picnic grounds, a petting zoo, museums, and shops. Open 10:30–6, daily, mid-June–Labor Day; weekends, May–mid June and Labor Day–Columbus Day. Groups by appointment other times. Admission charged. During the winter trails are sometimes open for cross-country skiing; call ahead for details.

Just beyond Wild West City, off 607 in the Byram Municipal Complex, is the Roseville School (Mansfield Dr.; 973-347-3243). Built in the 1870s or '80s, the school closed in 1928 and for over 35 years functioned as an Episcopal church. It has been restored to its original appearance and decorated to show how a school of that time would have looked. The collection also includes memorabilia relating to local history. Tours by appointment.

Stockton Hunterdon 629

NJ 29, C 523

Stockton, located on the Delaware River roughly three miles north of Lambertville, started as a ferry town in the early 18th century. Colonel John Reading, believed to be the first settler of Hunterdon County and a major force in laying out the Old York Road, ran the ferry until his death in 1717. Because the main road

from New York to Philadelphia ran through Lambertville, attempts to revive the ferry were not successful. A bridge was built early in the 19th century (it lasted until the 1920s and its replacement, the bridge you see today, was built on the piers and abutments of the earlier one).

Stockton was the home of John Deats, who in the mid-18th century invented the Deats plow and corn sheller. His son Hiram set up a factory in 1852 that made threshers, reapers, mowers, and corn shellers. Another Stockton man, Joseph Wilson, was involved in Hunterdon County's famous egg industry; Wilson was the first man to ship day-old chickens.

Stockton may be best known today as the site of the Stockton Inn (formerly Colligan's) made famous by Lorenz Hart and Richard Rodgers's song, which contains the lines "There's a small hotel, with a wishing well." Built around 1710 as a private home, the building may have been converted to a hotel in the 1830s; the wishing well is still there, and the murals were painted during the Depression. The Woolverton Inn, also first intended as a private home, was built in the late 18th century by John Prall; from 1957 to 1972, it was owned by St. John Terrell, producer of the now-defunct Music Circus in Lambertville.

The Prallsville industrial district* (NJ 29; 609-397-3586) is a complex of buildings that includes Prallsville Mills (sometimes referred to as Smith's Mills after the last owner) and a few houses across the road. The district is now part of the Delaware and Raritan Canal State Park (see Kingston). The first mill was built at this beautiful spot in the early 1700s; John Prall, for whom the area was named, bought the property in 1794. The mill area includes a gristmill (1877), an attached granary (c. 1900), a stone linseed-oil mill (1794), a sawmill, and a stable (which houses the canal commission offices). The gristmill is used for special events like art exhibits, crafts shows, and folk concerts, and in the stable is an exhibit dealing with the Hunterdon section of the park. The Delaware River Mill Society hopes to renovate the sawmill soon. Plans also call for opening the buildings to the public one Sunday a month during the summer. Office open weekdays, 10–4; tours by appointment. From the mill you can hike or bicycle on the canal path past Bull's Island to north of Frenchtown.

A mile or two north of Stockton, in the community of Rosemont, is Academy Books and Bindery (829 Rosemont-Ringoes Rd.; 609-397-4035). Here you will find an outdoor sculpture garden, Sculpture to Go; eventually the art exhibits that were a prominent feature of the bindery when it was located in Stockton will be reinstituted. Rosemont itself is attractive, and despite the encroaching sprawl, you will see many old houses and lovely views.

Stone Harbor Cape May 1,025

c 619, 629

Situated on a barrier beach island (which it shares with Avalon), Stone Harbor is the only municipality in the United States to run a heronry. Registered as a national landmark, the Stone Harbor Bird Sanctuary occupies over 20 acres between 111th and 117th sts. and 2d and 3d avenues. The birds are attracted by thickets of cedar,

holly, sassafras, and bayberry and feed on the adjacent marshes. They return from their wintering grounds around mid-March, and nesting is usually well under way by early April. The number of birds occupying the sanctuary has varied considerably over the years—some years as many as 10,000 birds occupied the sanctuary at the height of the nesting season. The flights are most spectacular at dawn as the day feeders leave and the night feeders return home, and again at dusk when the pattern is reversed. At the parking area on the 3d Ave. side, you will find a good view of the birds; coin-operated binoculars are available.

The Wetlands Institute (1075 Stone Harbor Blvd.; 609-368-1211), founded in 1969, occupies 6,000 acres of protected salt marsh interspersed with tidal creeks. Dedicated to education and research, the institute contains saltwater aquariums; changing exhibits on, for example, ospreys or other raptors; and wonderful views of the surrounding marsh from the observation tower and lecture room. Outside there are bird and butterfly gardens, hiking trails through the marsh (a brochure for a self-guided tour is available and an audioguide may also be available), a boardwalk that goes by a tidal pool, and a pier that goes over a tidal creek. The research programs include a permanent camera that records the nesting behavior of a pair of ospreys; inside the center you can watch what the camera is recording as it happens. Over 50,000 people a year participate in the institute's programs, which include field trips, nature classes, kayak trips, workshops, and lectures, as well as the annual mid-September Wings 'n' Water Festival. Guided group tours by appointment. Open Tuesday– Saturday, 9:30–4:30, year-round; also Monday, 9:30–4:30, and Sunday, 10–4, mid-May–mid-October. Admission charged.

Beach tags, good for Avalon's beaches too, may be purchased at Borough Hall (95th and 2d Ave) during the week and at the beach at 95th St. on weekends. At 95th and 3d Ave. note St. Mary's by the Sea (1911). For beach information, call 609-368-5102.

This is generally a good area for bird-watchers, and both Stone Harbor Point (follow 2d or 3d Ave. to the end) and Nummy Island (take 3d Ave. to Ocean Dr. and cross the bridge) are favored spots. Stone Harbor Point is one of the last nesting sites in the state for the least tern and piping plover.

North of Stone Harbor and Avalon (take 619 or exit 17 of the Garden State Pkwy) is Sea Isle City, a town laid out by Charles K. Landis (see Vineland). Housed in an early-20th-century house, the Sea Isle City Historical Museum (4208 Landis Ave.; 609-263-3195, 609-263-4461) features a variety of artifacts and memorabilia and an extensive collection of 19th- and 20th-century photographs. Open July and August, Monday–Saturday, 10–1; other times by appointment. The Environmental Commission sponsors guided beachcomber walks June–August; for information, call 609-263-8687.

Summit Union 19,757

NJ 24, 124, C 512, 527

Known before the Revolution as Turkey Hill, Summit began to change into a suburb when the Morris and Essex Railroad was put through the town in the 1830s. It was popular as a resort in midcentury, and in the 1880s many of the wealthy visitors became permanent residents and commuters.

What is probably the oldest building in Summit is the Carter House (90 Butler Pkwy; 908-277-1747), now a house museum and the headquarters of the Summit Historical Society. Originally located on River Rd., the house was moved to its present location in 1986. The oldest part dates to the mid-18th century. Enlarged over the years, the house still retains many of its 18th-century features. Furnished with pieces appropriate to its period, the house also contains artifacts and memorabilia relating to the history of Summit. Open Tuesday, 9:30–12; Wednesday, 1:30–4; the 1st Sunday of the month, 2–4; and by appointment. The society also sponsors four public lectures each year.

Summit has long had a reputation as a culturally active town. The Summit Chorale developed from a singing group founded in 1909; the Summit Play-

house has occupied the old Summit library (10 New England Ave.), a Romanesque Revival structure from the 1890s, since 1918. The New Jersey Center for Visual Arts (68 Elm St.; 908-273-9121), founded in 1933 and housed in an interesting new building (1973), specializes in contemporary American painting and sculpture. There are two galleries, and new exhibits open every four to six weeks. The center has an extensive program of art classes, teaching everything from drawing and painting to ceramics, papermaking, and Chinese brush painting. Special events, including concerts, are scheduled frequently. Galleries open weekdays, 12–4; weekends, 2–4. The office and gift shop are open daily, 9–5. The center is closed the last two weeks of August. Group tours by appointment.

In the northern part of Summit is the Reeves Reed Arboretum* (165 Hobart Ave., near NJ 24; 908-273-8787), 12¹/2 acres that were once part of a Revolutionary War farm. The arboretum, a wildlife habitat, includes a natural hardwood forest, native and imported trees, open fields, lawns, formal gardens, a rose garden, and an herb garden. Trails go through the woods. On the property are several kettles from the Wisconsin glacier; in one large kettle in the front, thousands of daffodils are planted, forming a carpet in spring (the daffodils usually peak sometime in April). Educational programs for children and adults are offered, and the Elephant Tree Day Camp (named for a huge gray beech much beloved of children) is offered for children in the summer. In the Colonial Revival house, which dates from the late 1880s, are the arboretum's administrative offices and the horticultural library; the house is also used for lectures, meetings, and occasional concerts. You can pick up a self-guided-tour brochure there. Most educational activities, particularly those with a hands-on component, take place in the former carriage house. Grounds open daily, yearround; office open Monday, Tuesday, Thursday, and Friday, 9-3; garden shop (908-277-1190) open Monday–Saturday, 10–4.

Briant Park (Springfield Ave. and Briant La.; 908-352-8431) has facilities for fishing and ice-skating, a fitness course, and a picnic area. You can also fish and picnic at the Passaic River Park (Passaic Ave.; 908-352-8431), which has a nature trail as well. Part of the Watchung Reservation (see Mountainside) falls at the southern edge of Summit.

Sussex Sussex 2,201

NJ 23, 284, C 639

Sussex, in the heart of the county's dairy country, used to be known as Deckertown, in honor of Peter Decker, who built a cabin here in the 1730s. About one mile southwest of Sussex on c 565 (head south out of Sussex on Loomis Ave., c 639) is Sussex Airport, site of the annual air show (973-875-0783). Held the last

weekend in August, the show features stunt flying, balloon rides, model airplanes, parachute-jumping, wing-walking, and the like. The airport also has three shows a year for those who build their own planes.

About four miles west of Sussex, on NJ 23, is the Elias Van Bunschooten

Museum^{*} (1097 NJ 23; 973-875-4610), a late-18th-century house built by the local Dutch Reformed minister. The house, which stayed in the same family until the late 1920s, contains both 18th- and 19th-century furnishings, some dating back to the original owner. Open mid-May–mid-October, Thursday and Saturday, 1–4.

Another four miles north and west on 23 (and picking up c 519) will bring you to the entrance to High Point State Park (1480 NJ 23; 973-875-4800), over 14,000 acres in the Kittatinny Mountains. Given to the state in 1923 by Colonel and Mrs. Anthony R. Kuser, the park encompasses the highest point in New Jersey (1,803 feet above sea level). At this point, accessible by car or foot, is a monument from which there are spectacular views out over New Jersey, New York, and Pennsylvania.

The Kusers had used this area as their summer home, converting the High Point Inn (1888) into their summer mansion. The building was allowed to deteriorate and is now gone; the Gatehouse (1912), however, is occupied by a member of the maintenance staff.

Within the park is the state's first natural area, the John Dryden Kuser Natural Area (in honor of the former senator and noted conservationist, the son of Anthony Kuser), dedicated in 1965 and now containing some 800 acres. The area's 200-acre cedar swamp is an excellent example of a mature bog, with a stand of Atlantic white cedar unusual at 1,500 feet. The Cedar Swamp trail loops around the bog, which contains a wide variety of plants and animals, including insectivorous plants.

The extensive trail system, which includes a stretch of the Appalachian Trail, offers a wide range of possibilities, from Sunday strolls to strenuous upand-down hikes. Many of the trails were developed by the CCC (Civilian Conservation Corps), which also constructed shelters and dams. Lake Marcia is a spring-fed glacial lake. No hunting is allowed in the park, but you can fish,

swim, camp, boat, picnic, and cross-country ski (732-702-1222; snow is made when necessary, and the trails are groomed). Trails lead directly to Stokes State Forest (see Branchville). The park is open year-round, though weather conditions in winter sometimes make it impossible to get in. Open daily, 8–8 in summer (Memorial Day weekend–Labor Day), 8–4:30 the rest of the year; admission charged in summer.

Swedesboro Gloucester 2,024

c 538, 551, 605

Swedish farmers settled along Raccoon Creek in the mid-17th century, and Swedesboro, first known as Raccoon, was for many years the Swedish center of the area. It later became a transportation center for the surrounding agricultural region. Trinity Episcopal Old Swedes Church* (Church and Main sts.), familiarly

known as Old Swedes, is the oldest deeded church property in Gloucester County and was the first Lutheran congregation in the state (it became Episcopal in 1786 when the Swedes stopped sending ministers to the colonies). Among its ministers was Peter Kalm, the noted Swedish naturalist whose journal is a mine of information about 18th-century New Jersey. Today's Flemish-bond brick building, which dates from the 1780s, replaced a log-cabin church that burned in the Revolution; the tower and steeple were added in the 1830s. The congregation still uses, on special occasions, a beaten silver communion service dating to 1730. Many Revolutionary War heroes are buried in the churchyard, among them Colonel Bodo Otto. Tours of the recently restored building may be arranged by calling 609-467-1227 or 609-467-0440.

On the church grounds is the Schorn log cabin (also known as the Vanleer cabin or the Mortonson-Schorn cabin), which was moved from the banks of the Raccoon Creek west of Swedesboro. This early-18th-century cabin, which may well be one of the oldest original cabins of Swedish-Finnish design, was probably used as a granary and is reputed to have served as a stop on the Underground Railroad.

The Hatton house (935 Kings Highway) is a mid-18th-century house that belonged to John Hatton, a customs collector who tried to enforce the Stamp Act. He fled to England during the Revolution, and the house was confiscated by the county. The original lion's-head door knocker, a symbol of the British crown, remains on the front door. Records indicate that what is today called the Old Swedes Inn (301 Kings Highway) was operating as a tavern in the 1770s. There are also interesting 19th-century buildings in Swedesboro, and at the intersection of the Kings Highway and Lake Ave. note the early-20th-century borough hall.

Just north of Raccoon Creek on the Kings Highway is Stratton Hall,* built in the 1790s. Charles C. Stratton, governor of the state from 1845 to 1848, was born in the brick house in 1796 (he died there in 1858). Stratton was the first governor from Gloucester County and the first elected by popular vote rather than by the legislature. North of Swedesboro (take Locke Ave. out of town to the Swedesboro-Bridgeport Rd. and continue on Oak Grove Rd., c 671) is Adams Methodist Episcopal Church* (Oak Grove and Stone Meeting House rds.), the oldest Methodist church building in the county. Note how the even stones are in front, the uneven ones in back.

Three miles south of Swedesboro, on Sharptown Rd. (take 605 to the fork and bear right) at Oliphant's Mill, is the Moravian Church,* built in the 1780s of brick in a Flemish-bond pattern. The church is open for services once each June and September. Tours may be arranged by calling the Gloucester County Historical Society (609-845-4771).

Teaneck Bergen 37,825

I 95 EXIT 70, NJ 4

Bergen County's largest community, Teaneck was settled by the Dutch in the 17th century. Some stone houses remain, particularly on Teaneck and Riverneck roads. The 18th-century Brinkerhoff-Demarest house* (493 Teaneck Rd.) is a national historic landmark. The source of the town's name is obscure: perhaps from

"Tekene," a Native American word for "the woods," perhaps from the Dutch "Tekene," a Native American word for "the woods," perhaps from the Dutch "Tee Neck," referring to a curved piece of land alongside a stream. In 1949 the town was chosen by the Army Corps of Engineers as a model American community, and material on Teaneck was used as part of the army's program to explain American democracy to the Japanese. The town has since developed a reputation as a multi-ethnic community. The mosque on Fabry Ct. was the first in the county, the Bahai Center (130 Evergreen Pl.) was visited by the grandson of the religion's founder in the early 20th century, and in 1992 Teaneck elected the country's first Indian-born mayor.

At Fairleigh Dickinson's Teaneck-Hackensack campus (the Hackensack River flows through the campus, putting it in both communities) is the county's first Equity theater. The American Stage Company (River Rd. and NJ 4; 201-692-7744), founded in 1985 by Paul Sorvino, presents four American plays each season.

Tenafly Bergen 13,326

US **9**W, C 501

One of Bergen County's Dutch settlements whose name may be derived from the Dutch words for "Garden Valley," Tenafly developed in the 1870s when the railroad reached the town. Service ended in the 1960s, but the sandstone station* (1872–74; Hillside Ave.) with its Venetian Gothic details, thought by some to

have been designed by Cleveland Cady, has been converted to retail purposes. (In the mid-'90s the town won a state preservation award for its work on the

Swedesboro, Teaneck, Tenafly 303

station's exterior.) While downtown note Ye Olde Tenafly Diner (1926; "Stop for . . . a bite, day or nite"). The feminist Elizabeth Cady Stanton came from Tenafly, and her house* (135 Highwood Ave.) is a national historic landmark.

At 23 Bliss Ave. is the S.M.A. Fathers African Art Museum (off Engle St., 501, at the southern edge of Tenafly; 201-567-0450). Founded in France in the mid-19th century, the S.M.A. (Society of African Missions) Fathers collected and preserved West African artifacts. In addition to its exhibits of pieces in wood, ivory, brass, bronze, and other metals, the museum sponsors crafts, educational, and outreach programs. Open weekdays, 9–5; tours and other hours by appointment.

The Tenafly Nature Center (313 Hudson Ave.; 201-568-6093) is an environmental education center that abuts the Lost Brook Preserve. The two parcels together contain 380 acres of woodlands, including one of the few remaining stands of northeastern deciduous woodland near the New York metropolitan area. There are six miles of trails here, a pond rich in ducks and herons, heavy spring and fall songbird migrations, and some hawks. You can pick up a booklet for a self-guided tour of the trail at the center. Cross-country skiing and ice-skating are also possible here. The center offers a wide range of programs and workshops and attracts some 15,000 visitors a year. Trails open dawn–dusk. Center open Monday–Saturday, 9–5; Sunday, 10–5; closed major holidays.

Greenbrook Sanctuary (US 9W; 201-768-1360), run by the Palisades Nature Association, is a 165-acre nature preserve on top of the Palisades. The sanctuary contains a 5-acre pond and adjoining bog, the 250-foot Greenbrook Falls, hemlock ravines with 150- to 250-year-old trees, and seven miles of self-guided trails. Since 1946 the association has been conducting research and field studies; it offers weekend field trips and programs about flora, fauna, geology, and ecology. Trails open to members; programs and tours by appointment only.

Teterboro Bergen 22

180, US 46, NJ 17

New Jersey's second-smallest municipality (only Pine Valley in Camden County, population 19, is smaller, though if plans to build a small apartment complex go through, the population could easily double), Teterboro is home to New Jersey's third busiest airport. Owned by the Port Authority of New York and New

Jersey and operated by Johnson Controls World Service, Teterboro cannot serve scheduled aircraft, and the planes that use it are subject to weight limits; nevertheless, it remains one of the busiest in the country for private craft (in 1995, over 150,000 takeoffs and landings were logged; each day more than \$15 billion in canceled checks move through this airport). It has been in more or less constant use since 1920, and many of the nation's leading pilots, among them Floyd Bennett, Admiral Richard E. Byrd, Amelia Earhart, and Charles A. Lindbergh, trained at Teterboro. The astronauts Buzz Aldrin and Walter Shirra got their first flying experience at this airport. Gates's Flying Circus operated out of Teterboro, and Anthony Fokker (who designed the Red Baron's plane) manufactured aircraft here. Most of the borough is taken up by the airport and plants belonging to some 90 companies, among them the Bendix Aerospace Division of Allied Corporation, the borough's largest employer and the owner of all the houses in town (there are nine).

Located at the airport is the Aviation Hall of Fame & Museum of New Jersey (201-288-6344), dedicated to "preserving the history of aviation in New Jersey and honoring those who made it." The Aeronautical Educational Center, which opened a major addition to its space in the summer of 1997, is on the east side of the field. On the second floor you can look out over the field and listen while the controllers guide planes on and off the field. The collection includes memorabilia from the early days of New Jersey's flying history and Arthur Godfrey's aviation collection, historic engines and wooden propellers, a model plane collection, helicopters, and airplanes. There are displays on space flight, lighter-than-air flight, and women in aviation, all with an emphasis on the state. The museum shows films on the history of aviation in New Jersey, old-time stunt flyers, the destruction of the *Hindenburg*, and the history of the airport. Private parties can be arranged; there is also a small picnic area. Open Tuesday–Sunday, 10–4. Admission charged.

Titusville Mercer [Hopewell Township]

NJ 29

This tiny Delaware River community lies near the spot where George Washington crossed the ice-choked river on 25 December 1776 to begin the famous Battle of Trenton, generally believed to be a turning point in the Revolutionary War. Volunteers have reenacted the event every Christmas afternoon for close to 50 years.

Titusville's 19th-century historic district* lies along River Drive. West of the historic district is Washington Crossing State Park (bounded by NJ 29, Church Rd., c 546, and c 579; 609-737-0623). The 850-acre park is a national historic landmark, and its visitor center (off 546; 609-737-9304) concentrates on the events that occurred in the crucial 10 days between 24 December 1776 and 3 January 1777. A memorable collection of Revolutionary War artifacts is on display at the center, and there are changing exhibits as well.

Also at the park is the restored Johnson Ferry House (609-737-2515). Built in 1740, the house served briefly as Washington's temporary headquarters during the crossing. The house is furnished as it might have looked when the Johnson family lived there (1740–70), and special living-history programs are regularly scheduled. Open Wednesday–Saturday, 10–4:30; Sunday, 1–4:30; groups by appointment.

The park's nature center moved into a new building, constructed specifically as a nature house, in the summer of 1997. The building has exhibit, classroom, and workshop spaces and a wildlife observation area; the center offers regularly scheduled educational programs. Open Wednesday–Saturday, 9–4:30; Sunday, 11:30–4:30. Formerly the site of the state tree nursery (see Cassville), the park boasts over 80 species of trees and shrubs. It also includes the George Washington Memorial Arboretum, a 100-acre natural area, picnic areas, and an open-air theater. Park open daily. Admission charge summer weekends and holidays. Visitor center open daily, 9–5, Memorial Day–Labor Day; Wednesday–Sunday, 9–4:30, the rest of the year. Tours by appointment (609-737-0609).

The park was also formerly the site of a dairy farm, whose owner developed the automatic egg candler and sorter, establishing his first factory in a converted cannery in Titusville. Egomatic continued to produce egg-sorting machines for a worldwide market until the 1980s.

About three miles north of Titusville, on 29, is the Mercer County Wildlife Center (609-883-6606), located on the grounds of the county corrections center, where injured and orphaned wild animals are treated and rehabilitated. The center also engages in off-site educational program and hopes eventually to modify its facilities so that the public can be invited in (too much exposure to humans can make it harder to return an animal to the wild). The center, which has a release rate of 65 percent, in 1995 treated some 1,800 animals. Messages about animals needing help can be left 24 hours a day.

At the northern boundary of the corrections center is the road leading to the Belle Mountain public ski area (Valley Rd.; 609-883-0007; off-season, 609-989-6538), a county-run ski area with seven trails, a main slope of 1,200 feet, beginner and intermediate slopes, a snowboard park, a chair lift and tows, a rental shop, and a ski school. Open December–March, weather permitting, 9–5 and 6–10 P.M. An adjacent picnic area, with a small fishing pond, is open daily until dusk.

Farther east on Valley Rd. is the 19-acre Valley Rd. group picnic area (609-989-6536), with playing fields as well as picnic facilities. Open April–October, 10– dusk, by reservation only.

Still farther east (turn left on Woodens La.) is the Howell Living History Farm (609-737-3299), a county park located on what was once the 18th-century Phillips Farm.* This is a working farm dedicated to farming as it was done c. 1900–1910. Saturday programs include demonstrations of various aspects of horse-drawn farming, such as haying, sowing, harvesting, and cultivating. There are also demonstrations of blacksmithing, sheep-shearing, ice-harvesting, and maple-sugaring, as well as hayrides for children and nature walks. The farm is open to the public Tuesday–Friday, 10–4, February–November, Sunday, 12–4, mid-April–mid July and September–November. Saturday programs and workshops take place from the end of January to the beginning of December. Food raised on the farm is sold Wednesday and Saturday, July–October. Groups by appointment.

Some of the area around Howell Farm—along Woodens La. and Hunter, Pleasant Valley, and Valley rds.—forms the Pleasant Valley Historic District.* Here you can still see some of the outbuildings, barns, farmhouses, and fencing that characterized a Delaware Valley agricultural community at the turn of the century.

306 Titusville

Toms River Ocean [Dover Township]

GARDEN STATE PKWY FXIT 82, NJ 37, C 549, 571

Situated on the northern bank of the river from which it takes its name, Toms River has been a fishing and boat-building community; a yachting center (the Toms River Cup is said to be the "oldest continually raced-for trophy in yachting"); the site during the Revolution of an important saltworks; and, since the county

was founded in 1850, the Ocean County seat. The central portion of the courthouse* (Hooper Ave.), built in 1850, was planned as a more modest imitation of Hudson County's (the wings date from 1950). Since the mid-1950s Toms River has been the home of the Garden State Philharmonic (732-349-6277), a 45-member orchestra founded as a community orchestra in Lakewood over 40 years ago. Although the city may no longer be as financially dependent on water-related activities as it once was, much of its interest for visitors still lies along the river.

The town's connection with the water is celebrated in the Toms River Seaport Society Museum (Hooper Ave. and E. Water St.; 732-349-9209). The museum is housed in the carriage house (1868) from Joseph Francis's estate (Francis invented the "Lifecar," an early maritime rescue boat). On display inside are artifacts relating to local marine history, historic boats and models, a library, and a restoration workshop. Outside you will find some of the many boats owned by the society, with an emphasis on those particularly tied to the Barnegat Bay area. The society sponsors a variety of programs and events, including an annual wooden-boat festival and classes in decoy-carving and boat- and model-building. Open Tuesday and Saturday, 10–2, or by appointment.

The Ocean County Historical Society Museum (26 Hadley Ave.; 732-341-1880), located in a Victorian house, features a variety of displays, including a Victorian kitchen, a music room, a child's room with old dolls and toys, Victorian crafts, early local industries, and Native American artifacts. There are also rotating exhibits. Open Tuesday and Thursday, 1–3; Saturday, 10–1; groups by appointment.

The Robert J. Novins Planetarium at Occan County College (College Dr., off Hooper Ave.; 732-255-0343, 732-255-0342) has programs for the general public (the main features are not suitable for children under six). These are usually scheduled for Friday and Saturday evening at 8 and Saturday and Sunday at 2, although in the summer there are afternoon shows Tuesday–Friday and evening shows Thursday as well. (The planetarium is closed for cleaning for about eight weeks in late spring.) Groups by appointment. Admission charged.

The art gallery at the college (College Dr.; 732-255-0340) is also open to the public. Shows change roughly every six weeks and include an annual Senior Citizens of Ocean County exhibit. When the college is in session, the gallery is open until 10 P.M. weekdays; for weekends and vacation time it is best to call first.

Cattus Island Park (1170 Cattus Island Blvd., off c 571, north of the center of town; 732-363-8712) is a 500-acre county park with a variety of habitats, including salt marshes, maple-gum lowland, pine-oak upland forest, a white cedar swamp, and a mature pitch pine stand. The park is named for John V. A. Cattus, who, in 1895, built a mansion on Cattus Island as a hunting and fishing lodge. (The mansion was destroyed by an arsonist in the 1970s.) The park has some 10 miles of hiking trails, including a boardwalk path through the swamp; open playing fields; and facilities for picnics. At Cattus Island Park is the Cooper Environmental Center (732-270-6960), named for Betty and A. Morton Cooper, who helped preserve this section of the shore. Among the innovations at the center, which draws two-thirds of its energy needs from a passive solar system, is a porous parking lot, which allows water to drain. A dinosaur and animal tracking garden contains copies in cement of actual dinosaur tracks as well as those of local animals. In the center is a nature display, including a fossil exhibit, as well as live reptiles and fish; the exhibits change from time to time. This popular center (75,000 people made use of it in 1995) sponsors a variety of programs for children and adults, including nature walks and boat trips. Open daily (except New Year's Day, Easter, Thanksgiving, and Christmas), 10-4. The park grounds are open dawn to dusk. Groups by appointment.

Sightseeing cruises on a reproduction of a paddle-wheel riverboat are available three days a week, May–September. For information, call 732-349-8664.

A few miles toward the ocean, on the south bank of the river, is the Ocean Gate Historical Society's museum (Cape May and Asbury aves.; 732-269-3468). Housed in a 1909 railroad station, the museum has a railroad ambiance, with a ticket window and a 1909 hose cart that was formerly owned by the Pennsylvania Railroad. The exhibits also include area artifacts and a hand-pumper fire engine. Open Wednesday, 6:30–8, and Saturday, 10–12, June–September; by appointment, October–May. The road to Ocean Gate passes through Pine Beach, once the home of the Admiral Farragut Academy (Riverside Dr.), the country's first naval preparatory school, founded in 1933. When the school closed in 1994, the contents of its memorable marine museum were sold at auction.

Trenton Mercer 88,675

US 1, 206, NJ 29, 31, 33, 129, C 579, 583

Located at the navigable head of the Delaware River, New Jersey's capital was almost the nation's: the Continental Congress, meeting in Trenton in 1784, voted money for the construction of federal buildings in Trenton, but for various reasons, including, apparently, George Washington's opposition, it never came to

pass. A thriving community with about 100 houses, several churches, and considerable economic activity at the time of the Revolution, Trenton became a major manufacturing center in the 19th century. The city was known the

world over for steel (the Roebling Company that made the cables that support suspension bridges was located here; see Roebling); pottery, both fine (Lenox, the first American company to make china for the White House, was founded in 1889; Greenwood Pottery, the first to make china for restaurant use, in the mid-19th century) and sanitary (the oversize bathtub ordered by President William Howard Taft for the White House because he kept getting wedged in the one that was there was made by Motts in Trenton); and rubber goods. Like other industrial cities, Trenton suffered after World War II, but unlike some, the decline was largely downtown, and many neighborhoods survived almost intact. In addition, extensive construction of various state offices and facilities has injected a considerable amount of money into the city's economy, and many people who were relocated into the area because of the corporate boom along us 1 discovered Trenton as a city with housing bargains. These factors have made optimistic statements about Trenton's renaissance seem believable.

In 1679 Mahlon Stacy, Trenton's first white settler, built a house and gristmill near the falls of the river, and in 1714 his son sold some 800 acres of his land along the Assunpink Creek to William Trent, a Philadelphia merchant and later New Jersey's first chief justice. Trent subdivided the parcel for sale in 1721 and established Trent's Town. The town prospered: it became a shipping center for communities up the Delaware, and regular ferry service across the Delaware was inaugurated in 1727, simplifying travel between New York City and Philadelphia. Two important Revolutionary War battles were fought in Trenton, the first on 26 December 1776, after George Washington had crossed the Delaware some eight miles upstream (see Titusville). Although the Hessians may not have been in the post-Christmas drunken stupor commonly ascribed to them, the Americans did surprise them and did win the battle, taking close to 1,000 prisoners and, of greater importance, taking the initiative away from the British. The second battle, on 2 January 1777, was again a victory for the Americans.

Trenton became the state's capital in 1790, and by 1792 construction of the State House had begun. It is today the second oldest state capitol still in use, although little of the current building dates from the 18th century, and much that does has been remodeled and looks Victorian.

Trenton's importance as a transportation center was encouraged by the work of John Fitch, who had a steam-powered boat running on the Delaware in 1786, 20 years before Fulton. By 1789 there was regular steamship service on the Delaware, but Fitch, who during the Revolution had been expelled from his church for repairing Continental guns on Sunday, did not remain in Trenton. The road along the Delaware behind the State House honors him.

In 1806 the first permanent bridge across the Delaware was built, and today Trenton's most famous bridge—the one at Bridge St. with the "Trenton Makes, the World Takes" sign—rests on those original piers and abutments. The sign resulted from a contest sponsored by the Chamber of Commerce in 1910, and the slogan won out over almost 1,500 other entries. The bridge is now owned and maintained by the Delaware River Joint Toll Bridge Commission,

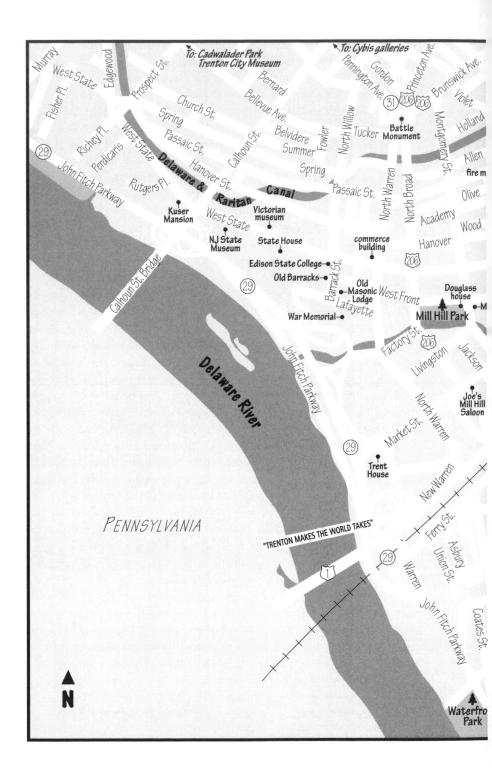

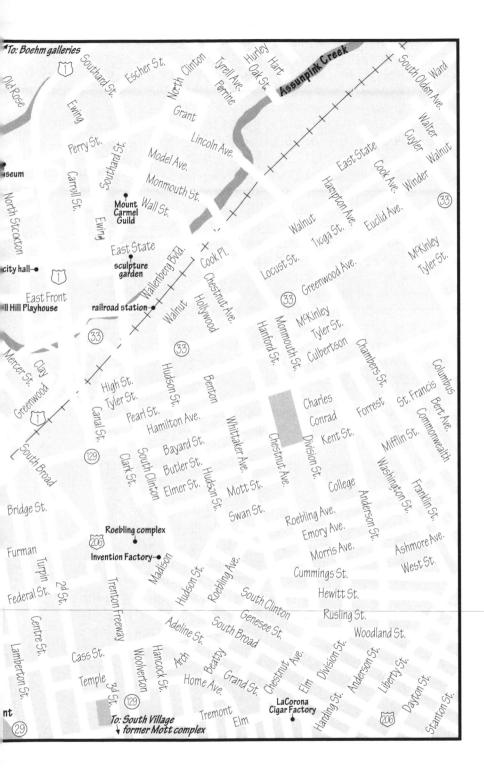

no easy task, for heavy winds and the vibration from traffic can knock out letters. The oldest bridge across the Delaware still used for vehicular traffic is the Calhoun St. Bridge*; the current (1884) span was placed on the original (1861) piers and abutments.

Despite all the massive new state buildings, you can still find some survivors from Trenton's colonial past. William Trent's House* (15 Market St.; 609-989-3027), the oldest in the city (1719) and a national historic landmark, now belongs to the city. Built of bricks brought from England as ballast, this elegant house, conceived as a summer estate on the Delaware, has been restored to its colonial appearance. Most of the furnishings are from 1680–1740; the oldest item in the house is probably the Dutch game board dating from 1590. Open daily, 12:30–4; closed major holidays; groups and tours by appointment.

Another 18th-century national historic landmark is the Old Barracks* (Barrack St.; 609-396-1776), built c. 1758. It is the only barracks remaining of the five built in New Jersey to house soldiers fighting in the French and Indian wars. Many of the Hessians captured in the first Battle of Trenton were quartered here; at various times it also housed British troops, Continental troops, and prisoners of war, and served as a military hospital. After independence, it was sold; considerably altered, it was put to a variety of uses. It has now been restored to its colonial appearance and is set up as a museum. When the restoration plans have been completed, the north wing will be devoted to period rooms and the south to a "history lab," with exhibits, some interactive, dealing with the field of history and the restoration of the Barracks. This is one of the state's most popular sites with students-over 22,000 visit each yearand the Barracks also runs a day camp for children in the summer. The collection includes firearms, prints, and mementos of Washington. Special events take place throughout the year, and there are special holiday exhibits. Open daily, 10-5; groups by appointment. Admission charge.

Close by the Old Barracks is the Old Masonic Lodge (Barrack St. and W. Lafayette), built in 1793 with a mid-19th-century brick addition. In the 1830s the state's first free school opened in this building. The lodge was replaced by a new one in the mid-1860s, but this building was returned to masonic control, restored, and moved to this site c. 1915. The lodge is now occupied by the Trenton Convention & Visitors' Bureau (609-777-1771), but in the upstairs room the ceiling designs have been restored, and you can also see what is believed to be some of the lodge's original furniture. At the visitors' center you can pick up information on places of interest not just in Trenton but throughout the state. Open daily, 10–4. Walking tours of the city arranged through Walk This Way (609-396-9419) leave from the center April–October, Sunday at 1; other days by appointment.

The successful stand against the British in the second Battle of Trenton took place in what is now the Mill Hill historic district* (E. Front, Mercer, Jackson, Market, Livingston, Clay, and Broad sts. and Greenwood Ave.). After the battle Washington met with his advisers in the Douglass house,* which dates from 1766, and planned the next day's battle of Princeton. The Douglass house (Front and Montgomery sts., moved from S. Broad; 609-394-1965) serves as the headquarters for the Trenton Historic Society. The society sponsors monthly programs open to the public; the house is open other times by appointment only. The Mill Hill Playhouse (Front and Montgomery sts.) was

once a Lutheran Saloon (300 S. Broad) microbrewery. Each mid-1960s the Old 989-8977) has spon-June the society spon-

Marking the spot tal artillery pounded the Battle Monu-Warren sts., Brunsand Princeton aves.; 1891, the tower is over base are copies of by Thomas Eakins the battle (the origithe New Jersey State elevator takes you to tion platform. Open Saturday, 9–12 and 1–4;

THE STATE HOUSE

church; Joe's Mill Hill is also a

December since the Mill Hill Society (609sored a house tour; in sors a garden tour. where the Continenthe British garrison is ment* (Broad and wick, Pennington, 609-737-0623). Built in 150 feet high. At its bronze plaques done depicting scenes from nals are on display in Museum). An the observa-Wednesday-Sunday, 1-4. sculpture garden (S. Clin-

In 1996 the Station Plaza ______ sculpture garden (S. Clir ton Ave.) opened next to the Trenton railroad station. Here over 15 works, some created for the spot, are displayed in a carefully landscaped project.

Among the large complex of state buildings is the New Jersey State Museum (205 W. State St.; 609-292-6308), devoted to both the arts and the sciences. In the main building are exhibits of fine arts; decorative arts, with emphasis on local porcelain and other household items; natural science; and archaeology and ethnology, which includes artifacts of Native American and other world groups. The adjacent 150-seat planetarium (609-292-6333) has shows for the general public on weekends (some of the shows have age requirements for children). The auditorium is used by the museum for a variety of programs, including films, concerts, lecture-demonstrations, and plays. Open Tuesday– Saturday, 9–4:45; Sunday, 1–5; groups by appointment (609-292-6347).

The State House historic district* includes W. State and Barrack. Tours of the statehouse (125 W. State St.; 609-633-2709), recently renovated, take place on the hour Tuesday, Wednesday, and Friday, 10–3, Saturday, 12–3. Note the Edison chandelier in the Assembly Room. The state house annex, built in the early 1930s, has also been renovated and boasts a new stained-glass skylight made at Wheaton Village (see Millville) depicting important historical figures and geographical features of the state. Another building of interest is the Contemporary Victorian Museum (176 W. State St.; 609-392-9727), an Italianate townhouse from the 1840s, owned by the Contemporary Club, with high

ceilings, detailed woodwork, etched glass, a handsome square piano, and a Victorian grand piano. Open 3d Sunday in the month, 2–4, and by appointment. One day in spring the club runs four tours of the city, each focusing on a specific area or historical theme.

Edison State College (I0I W. State St.; 609-984-II00) occupies the Kelsey building, built in 1911. Kelsey, a local banker and philanthropist, commissioned the building as a memorial to his wife and donated it to the Trenton School of Industrial Arts. It was modeled on the Palazzo Strozzi in Florence and designed by Cass Gilbert. The Prudence Townsend Kelsey Memorial Room houses Mrs. Kelsey's collection of ceramics. Open by appointment (call 609-984-II9I). The college also occupies the five adjacent historic brownstones. Chartered in 1972, Edison State, which caters to older students and is known for its off-campus degree possibilities, now offers graduate programs as well.

In the 200 block note the seven brick buildings, dating from the 1870s, known as the Pride of Lions because of the reliefs of lions on the facades. Note also the detail on the facade of the Kuser Mansion* (315 W. State St.), from 1910. George Segal's 23-foot-high sculpture of construction workers among interlocking steel I-beams and other paraphernalia of a building site stands in front of the new commerce building (W. State and Warren sts.). Farther east is Trenton City Hall* (309 E. State), built in 1907.

Trenton's War Memorial* (between the State House and the river; 609-984-8484), finished in 1932, has recently been closed for extensive restoration. Scheduled to reopen at the end of 1997, it is used for concerts and operas, including a regular series by the New Jersey Symphony Orchestra. Two of Trenton's most famous musical citizens, the tenor Richard Crooks and the composer George Antheil, were classmates at Trenton High School.

West of the state buildings, in Cadwalader Park (Parkside and Stuyvesant aves.), is the Trenton City Museum (609-989-3632). Housed in Ellarslie,* a mansion built in the 1840s for Henry McCall, a Philadelphia industrialist, the museum displays on its upper floor items from its permanent collection, which focuses on the city's porcelain and ceramic art industries, the Roeblings, and home furnishings with Trenton associations. On the first floor are changing exhibits of works by local artists. Open Tuesday–Saturday, 11–3; Sunday, 2–4. The park itself was laid out by the Frederick Law Olmsted firm in the 1890s; among its other attractions is its deer park. It honors Dr. Thomas Cadwalader, a pioneer in smallpox inoculation and the donor of the state's first public library. The Cadwalader Heights residential area (Parkside Ave. between Bellevue and Stuyvesant aves.) was developed from 1910 to 1930 and was also designed by the Olmsted firm.

South of Cadwalader Park is the Berkeley Square historic district* (Parkside, Riverside, and Overbrook aves. and W. State St.), an area built up c. 1890–1910, notable for its solid houses with stained-glass windows, chestnut and oak woodwork, marble fireplaces, and the like. West of the park is the Trenton Psychiatric Hospital, founded in the 1840s under the influence of Dorothea Dix, who lived her last years in an apartment at the hospital.

North of the state buildings in the headquarters of the fire department is the Meredith Havens Fire Museum (244 Perry St.; 609-989-4038). The collection includes equipment and other items related to the history of fire fighting, with special emphasis on Trenton's fire departments. The museum also has a collection of Civil War material. Closed for renovation, the museum expects to reopen by the turn of the century.

Many of Trenton's old buildings are being put to other uses. The headquarters of the Mount Carmel Guild (73 N. Clinton), for example, were once the home of the head of Greenwood Pottery. The turn-of-the-century Stokely-Van Camp cannery complex* (Lalor St. at Stokely Ave.) has become part of South Village I and II, a public-housing development and senior citizen residence; the Millhouse Residential Center (325 Jersey St., off Lalor St.) was once part of the J. L. Mott complex, where sanitary porcelain products were manufactured; the Spanish-looking 1930s LaCorona Cigar Factory* (507 Grand St.) has been converted to apartments. By far the most ambitious project, though, is taking place at the 45-acre historic Roebling complex, which includes 40 buildings dating from the 1850s through the 1950s that belonged to the Roebling Company and the Trenton Iron Company. (The Trenton Iron Company, founded by Peter Cooper [see Ringwood] in 1850, eventually became a subsidiary of U.S. Steel and continued operating until 1987.) The new headquarters for the New Jersey Housing Mortgage Finance Agency are in the former Physical Testing House and South Rope Shop from the late 1920s; next door is a large retail complex; a county administration building is in the same block; the former mill vard has been converted to a small urban park. The Invention Factory Science Center (650 S. Broad St.; 609-396-2002), an innovative museum and educational facility, is being built in stages. In the former machine shop, the visitor center, scheduled to open in 1998, will have changing interactive exhibits focusing on six themes: biotechnology, communication, energy, the environment, material sciences, and transportation. Other projects under construction, on the drawing board, or as visions in many people's minds are a senior citizen housing complex, a performing arts center, a hotel and convention center, and a sports arena. Along the river (south of the us I bridge) is a new executive park as well as Waterfront Park Stadium, where the Trenton Thunder (1 Thunder Rd.; 609-394-8236), the city's popular minor-league baseball team, plays.

Although sanitary pottery may no longer be as important to the city, the production of art porcelain continues; Boehm, Cybis, and Ispanky are all currently active. The Boehm galleries (25 Fairfacts St.; 609-392-2207) are open weekdays, 9–4:30; groups by appointment. Among the pieces on display at the Cybis galleries (65 Norman Ave.; 609-392-6074) are items sent to heads of state on various historic occasions. Tours by appointment.

The first weekend in June Trenton celebrates its past with Heritage Day on the Trenton Commons. Other annual events include a professional bicycle race in early summer and the reenactment of the Battle of Trenton the first Saturday after Christmas.

Tuckerton Ocean 3,048

US 9, C 539, 603

Settled in the late 1690s, Tuckerton was an important port in colonial days, later serving as the shopping center for the surrounding region. In 1912 the country's tallest radio tower was built just south of Tuckerton in what is now Mystic Island (take Radio Rd. south out of town); at the time this was the only transmitter

that could broadcast to Europe without a relay. The transmitter was built in Germany for a French company and assembled here under the supervision of a German engineer, and although it was taken over by the government during both world wars, rumors swirled around its German connection. Today Tuckerton is the western terminus of the world's first fiber-optic transatlantic cable (located in an underground building on Cable Rd.), completed in 1988 and able to carry some 40,000 simultaneous telephone conversations.

The Barnegat Bay Decoy and Baymen's Museum (137 W. Main St.; 609-296-8868), temporarily located at the county's Tip Seaman Park, features historic hunting decoys, fishing artifacts, and photographs. Open Wednesday–Sunday, 10–4:30. Admission charged. The Baymen's Museum represents the first phase of the Tuckerton Seaport, an ambitious plan to re-create a working village that would show some of the port-related activities that occupied Tuckerton's residents in the 18th and 19th centuries. (According to local legend, Tuckerton in 1791 was the colonies' third port of entry, after New York and Philadelphia.) The facility will include a mix of historic buildings and replicas and will feature demonstrations of such crafts as clamming and boat-building. Ground breaking was scheduled for July 1997, and the seaport expected to be in its new location by the end of the '90s.

Many of Tuckerton's older houses have been restored, and the Bartlett Mansion, possibly the oldest house in the county, is being restored and should eventually be open to the public. West of Tuckerton, just south of us 9, is the Giffordtown Schoolhouse Museum (Wisteria La. and Leetz Blvd.; 609-296-2394), an 1880s school building, run as a museum by the Tuckerton Historical Society. Its two rooms contain artifacts related to various aspects of local history, including wireless transmission, the Tuckerton railroad, and the early Quakers. Open mid-June–September, Saturday, 2–4. Donations accepted. In September the society runs the Clamtown antique flea market (Tuckerton used to be known as Clamtown).

South of Tuckerton is the Great Bay Boulevard Wildlife Management Area (Great Bay angles south off us 9 just west of the intersection with Green St.), one of the largest (over 5,000 acres) and least-disturbed stretches of marshland in the state. The area is heavily used by waterfowl and nesting shorebirds and is much favored by bird-watchers. It is also favored by those who like fishing, boating, waterskiing, clamming, and crabbing, although the insects can be fierce in summer. Parking and launching ramps are available off Great Bay Boulevard.

About five miles northwest of the US 9–Green St. intersection is Bass River State Forest (609-296-1114), more than 25,000 acres with facilities for picnicking, swimming, boating (electric motors only), hiking, and hunting. A short nature trail in the Lake Absegami region gives a vivid depiction of the Pinelands as it moves through various types of forest to a cedar bog and back. Office open 9–4 in winter, extended hours in summer.

Union Union 50,024

178, GARDEN STATE PKWY EXITS 139, 140, US 22, NJ 82, 124

Settled in 1667 by several families from Connecticut, Union (known at first as Connecticut Farms) claims to have the tallest water sphere in the world—familiar to many motorists on the Garden State Parkway. Union's Connecticut Farms Presbyterian Church* (Stuyvesant Ave. at Chestnut St.) was the first building in

New Jersey to be placed on the national register of historic places. The church was built in 1788 to replace the 1730 church burned by the British during the Revolution. The Reverend James Caldwell, the fighting parson (see Springfield), then minister at Elizabethtown, had moved his family here, apparently believing they would be safer. Versions of what happened differ, but his wife was killed by British snipers as she sat in the parsonage in June 1780. A later parsonage, built c. 1783 on the foundations of the earlier one, is now the Union Township Historical Society Museum* (909 Caldwell Ave.; 908-964-9047). It is decorated to show what life might have been like in a 19th-century parsonage; many of the objects came from Connecticut Farms' original settlers. Tours by appointment. The society's meetings, generally held the 3d Sunday of the month, are also open to the public; call for the schedule.

On Morris Ave., just north of North Ave., is Liberty Hall* (1772), also known as the Livingston-Kean house, a national historic landmark built by William Livingston, New Jersey's first elected and very popular governor (he served until 1790). George and Martha Washington both stayed in Liberty Hall, as did Alexander Hamilton, and Livingston's daughter Sarah married John Jay (before he became the first Supreme Court chief justice) in the house. Liberty Hall remained in the Kean family (John Kean, a member of the Second Continental Congress, married Livingston's niece Susan) until 1986, when plans were announced to develop the property. There has been talk of converting the main house and some of the outbuildings, which include a small smokehouse, a large icehouse, a stable, and some older frame houses, into a miniature Williamsburg-style museum dedicated to preserving the state's colonial history. For now, though, the chief change has been the addition of offices and townhouses.

Across Morris Ave. from Liberty Hall is Kean College (908-527-2000), founded in 1855 as Newark State College. In 1958 the college moved onto 120 acres that were also once part of the Kean estate. A complex of French Norman buildings, once part of the Kean family farm and later known as Kean Library, houses the nursing department, and the 1790 James Townley house* is used by the first-aid squad. Most of the campus buildings, however, are new. Exhibits in the James Howe Gallery, which is located in the striking Vaughn Eames Building, are open to the public Monday–Thursday, 10–2 and 5–7; Friday, 10–12. The students' art gallery in the Campus Center is open when the college is open. At the theater (908-527-2337) you can see college productions as well as a variety of professional theatrical, musical, and dance events. The college's Holocaust Resource Center is also open to the public Monday and Tuesday, 8– 4:30; Wednesday, 8–7; Thursday, 8–4; and Friday, 9–2. Guided tours of the campus start from Hutchinson Hall Friday at 10. Just east of the campus, in Hillside, on the old grounds of the Pingry School, one of the nation's oldest country day schools, is Kean College's east campus (take North Ave., NJ 439).

At Ingersoll Terrace (south off Morris Ave. just west of the Garden State Pkwy) are the Thomas Edison Houses, poured concrete houses made by a process invented by Edison in 1908. Fewer than a dozen of the unusually shaped houses remain, and some have been bricked over.

At the Model Railroad Club (Jefferson Ave. off us 22 just east of the Cedar Lawn Cemetery; 20I-964-8808) are both HO- and N-scale layouts. The larger HO is roughly 40 x 40 feet with a heavy-duty main line, a I920s-style interurban trolley line, and a short line. The club is planning a substantial increase in the size of the exhibit (when complete it will be one of the largest in the world). The smaller N layout, as well as a second HO layout, runs along three walls of an upstairs meeting room. Open Saturday, I-4 (club members are usually working on the trains at this time, although some equipment is running). A holiday show is held on the first three weekends following Thanksgiving, at which time the trains are run as an exhibit. Visitors can watch from a viewing balcony as theatrical lighting illuminates the trains and a tape describes what is

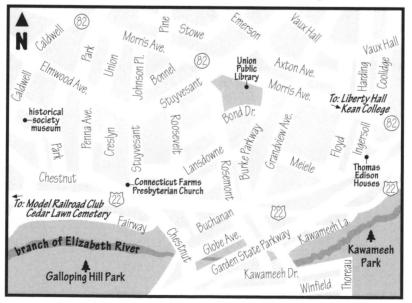

happening. The club also offers a series of hands-on educational classes on various Saturdays. Admission charged.

The Les Malamut Gallery in the Union Public Library (Morris Ave. next to the municipal building; 908-686-0420) features fine art exhibits in many media. Exhibits change every six to seven weeks. Open Monday, Wednesday, Thursday, 9–9; Tuesday and Friday 9–6; Saturday 9–5; but hours are sometimes cut back in the summer.

Vernon Township Sussex 21,211

NJ 94, C 515, 517, 565

Vernon Township's location in the mountains of the Highlands has determined the character of its two largest industries: satellite telecommunications (microwave transmission is least disturbed in mountains) and recreational skiing. With the country's highest concentration of microwave transmitters, the residents of this

large (68 sq. mi.) and rapidly growing (the population increased almost tenfold between 1960 and 1990) township are concerned about the effects of these transmitters on their health.

Vernon's mountains apparently served as a source of rock for Native Americans 6,000 years ago—what looks like the remains of two mines have been found—and Native American artifacts turn up frequently. Matilda, a mastodon skeleton unearthed here in the 1950s, is on display at the State Museum in Trenton.

Among the historic buildings still standing in the township is the Price's Switch School (Prices Switch, c 515, and Meadowburn rds.), built c. 1840, moved and enlarged in the late 1800s, and finally closed in 1958, the last one-room schoolhouse in the county. Tours by appointment (973-875-9562). Also on Meadowburn Rd. is Meadowburn Farm, listed on the state register of historic places. Started c. 1760 by William Willet DeKay, one of Vernon's earliest settlers, it maintains the gardens designed by Helena Rutherfurd Ely, a well-known writer on gardening, who lived in the house from 1880 to 1920. Also in the township is High Breeze Farm, a working mid-19th-century farm that remains relatively untouched by the 20th century (see Highland Lakes).

Within the township is the Hamburg Mountain Wildlife Management Area (NJ 23, C 517), 2,400 acres of mountainous, heavily forested land. Access to the area is limited, but it is open for hiking, skiing, fishing, and hunting. Within the management area is the Vernon Valley–Great Gorge ski facility (973-827-2000), which is converted to an amusement park in the spring. Call for hours and rates.

North of the Hamburg Mountain area is the Hidden Valley ski area (973-764-6161). Open weekdays, 9 A.M.–10 P.M.; weekends and holidays, 8:30 A.M.–10 P.M. Snowboarding is allowed on all the trails here.

The Wallkill River National Wildlife Refuge (973-702-7266), the state's newest (it was dedicated in 1992), lies partially in Vernon Township (it is also in

Wantage and Hardyston townships). The first river-floodplain refuge in the Northeast, it may in the future encompass 7,500 acres. The refuge supports an unusually high number of species, some of them on the state's endangered list. Fishing, hiking, canoeing, and bird-watching will all be possible here, but because the refuge is still a work-in-progress, it is advisable to call ahead to find out which areas are open. Headquarters for the refuge will eventually be in a late-19th-century farmhouse at 1547 Glenwood Rd. (C 565 about 1¹/₂ miles northeast of NJ 23).

Vineland Cumberland 54,780

NJ 47, 55, C 540, 552, 555

Physically New Jersey's largest city, Vineland is also one of New Jersey's first planned cities. It was founded in 1861 by Charles K. Landis, a 28-year-old, who envisioned businessmen and industrialists living in the center of his city, while artisans with farms and orchards surrounded the core. To prevent speculation he stipu-

lated that anyone who bought land had to build a house and till the soil. Each homeowner also had to plant shade and fruit trees and follow Landis's sanitary codes. Recruiting Italians to come as farmers, he encouraged workers to buy property, offering them long-term loans to build houses on their own land. Within 20 years the population had reached 6,000.

Landis had hoped the community would prosper by growing grapes (hence the name), but in the 1880s a blight destroyed the vines. Agriculture did flourish, however, and Vineland is now the dandelion capital of the world (though production has declined over the years, over \$200,000 worth of dandelions still passes through the produce auction); an annual dandelion dinner is held in March (609-691-7400). Vineland is also a major center for eggplant (New Jersey is second to Florida as an eggplant producer) and asparagus seed (the state is fourth nationally in asparagus production). It was once a major egg center, but, like the rest of the New Jersey egg industry, Vineland's is declining in importance. Vineland's produce auction (N. Main Rd.) is one of the largest in the country and the largest of its kind on the East Coast. Almost all the produce sold at the 65-year-old auction is for consumption fresh, not for canneries, and most of it is being picked while the auction is going on (sample cases are brought in for the auction). Open daily, late April–November.

Welch's grape juice was a 19th-century Vineland creation. T. B. Welch, a Vineland dentist and staunch Methodist, objected to the use of fermented grape juice in the church. He introduced unfermented juice, and by the time he moved his company from Vineland in the 1890s, it was on the way to becoming a major firm. Because of the sandy soil, many cities in Cumberland County are centers of glass manufacturing, and this is one of Vineland's primary industries. (John Mason patented his lid for the Mason jar, familiar to home canners, in 1858.) Other local industries include textile manufacturing, food processing, water-purification systems (the world's third-largest manufacturer of these systems recently moved to Vineland), construction, and truck-related operations.

The Vineland Training School (Landis Ave., c 540, between Main and Spring rds.) was founded in 1888 to serve the mentally retarded. The institution was the first in the country to use the Binet intelligence scales; it also drafted the first army IQ tests. Its research and therapy programs have won it an international reputation.

You can still see some of the logic of Landis's plan as you drive through town. The streets are straight, the intersections at right angles. The railroad, which runs through the center of town (and ran through the center of Landis's property when he bought it), has been integrated into a boulevard. Notice also the rows of brick houses, some with interlaced color at the corners, on Chestnut St., east of the railroad. And for a splendid example of another era, note the white marble building built for the Vineland Trust Company in 1913, with its stained glass, ceramic tiles, brass, and mahogany.

Another example of another era is the Landis Theater (834 E. Landis Ave.; 609-692-4553), a 1937 art deco movie palace threatened with demolition but saved by concerned citizens. The man who built the Landis broke the moviemakers' monopoly on the showing of first-run movies (he also managed to build the Garden State Park Racetrack in 1942; see Cherry Hill). The Landis was scheduled to reopen in 1997 as a multiscreen theater.

The Vineland Historical and Antiquarian Society (108 S. 7th St.; 609-691-1111) is one of the oldest historical societies in the state. Founded in 1864, it is housed in a building specially built for it in 1910. The collection focuses on local history and includes Lenape artifacts, local glass (some connected to Welch's grape juice), paintings of local interest, a fire department display, and furnishings from Landis's house. Changing exhibits also focus on items of local historical interest. Open Saturday, 1–4 (the office is open for research Tuesday–Saturday, 1–4); groups by appointment.

Five miles northwest of Vineland is Parvin State Park (Centerton-Norma Rd., C 540; 609-358-8616). Within its 1,125 acres is a variety of terrain—including woodland, swamps, lakes, and streams-and of species-including those from the Pinelands, the Piedmont, and the Inner Coastal Plain. Much of Parvin, which dates from 1933, was developed by the CCC (Civilian Conservation Corps), which had a camp there. The CCC dug mud out of the lakes and replaced it with sand, cleared trails, built roads, built bridges over swamps, and dug a new lake, all without power equipment. It constructed buildings out of bricks salvaged from structures that were being torn down in Philadelphia. Its barracks (now gone) were used during World War II to house German POWs, Japanese from the West Coast, and Kalmuks exiled from the Soviet Union. The park, open all year, includes 15 miles of hiking and biking trails, a 3-mile blacktop trail for bicycles, a 400-acre natural area, picnic tables, and facilities for boating, swimming, fishing, camping, ice-skating, and cross-country skiing. The park sponsors a variety of special programs, including nature walks, nature crafts, and migratory-bird walks. The protected swimming area is staffed from

Memorial Day to Labor Day. Admission charged Memorial Day–Labor Day. Guided hikes by reservation.

The road from Vineland to Parvin passes through Norma, one end of the 19th-century Jewish settlement of Alliance. The other end (turn right on Gershel Ave.) is at Brotmanville (named for a Mr. Brotman, who established a factory here). Very little is left of the settlement, but at the Alliance Cemetery (Gershel Ave. less than a mile from 540) is a brick chapel, which contains artifacts, old documents, and photographs showing what life was like in these settlements in the 1880s. A synagogue, open annually for the High Holidays, is across the street, and an old house or two can be seen. The cemetery is open except on Saturdays; for information on visiting the chapel, call the Cumberland County Jewish Federation (609-696 4445).

Just north of Vineland, in Newfield, is the Matchbox Road Museum (Pearl St.; 609-697-2800), featuring a collection of some 15,000 Matchbox items. Open weekdays, 9–4; weekends by appointment.

Walpack Township Sussex 67

C 615

A township with a population density of 2.8 people per square mile, Walpack is located within the Delaware Water Gap National Recreation Area (see below), where you can find some of the state's most spectacular mountain scenery. It is an area that is also rich in history, although how much of the physical evidence of

that history will be around for people to look at depends on what the National Park Service decides should be the future of the recreation area.

For now, you can still visit the mid-19th-century Walpack Center historic district^{*} and explore the remaining old houses along the Old Mine (see Blairstown) and other roads. The Old Mine Road Historic District^{*} extends into the townships of Montague, Sandyston, and Hardwick (which in 1997 absorbed Pahaquarry). The Walpack Historical Society has a small museum in the First Rosenkrans House (Main St.; 908-948-6171) with local and Victorian artifacts. Open mid-May–mid-October, 3d Sunday of the month, 1–5.

Southwest of Walpack Center, the 19th-century village of Millbrook (908-84I-953I) has been restored; it contains a blacksmith's, a weaver's, and a shoemaker's shop, a store, a church, and a school. Long-range goals include restoring the mill, a project complicated by the fact that its water power came from what is now a protected trout stream. The buildings are open mid-Maymid-October, Friday–Sunday, 9–5; occasionally volunteers demonstrate crafts. You are free to wander around other times, and you will find in the brochure box a pamphlet with a self-guided tour.

The Isaac Van Campen Inn (Old Mine Rd., 2 miles north of the intersection with Pompey Rd.; 717-588-2451) was built in the mid-18th century as a farm-house. The solid stone structure served as a fortress during times of trouble with Native Americans, and because it was frequented by travelers, has come

to be known as an inn. John Adams was among its visitors, George Washington mentioned it by name in correspondence, and Count Pulaski used the house as his headquarters for three months during the Revolution. Although much altered over the years, the house retains many of its original features (doors, hinges, stair structure, paneling). Open Sunday, 1–5, mid-May–mid-October, and by appointment. The stretch of the Old Mine Rd. north of Pompey Rd. runs along the river; it is beautiful, but it is not maintained, and to save your car you may prefer to approach from the other direction (take Kuhn Rd. west out of Peters Valley [see Bevans] and turn left on the Old Mine Rd., driving south for about 2½ miles). Near the inn in an old cemetery is the grave of Anna Symmes, mother-in-law of William Henry Harrison (she died in 1777).

About five miles southwest of Walpack Center is the Walpack Wildlife Management Area. It is one of the earliest such areas (begun in 1932) and is located on over 350 acres of woodlands and fields. The Big Flatbrook, which goes through the tract, is one of the state's best-known trout streams, and the area is also open for hiking, bird-watching, and hunting. The office is on c 521 at Bevans in the Flatbrook-Roy Wildlife Management Area.

The Delaware Water Gap, where the river has carved out a channel through the Kittatinny Mountains some 1,300 feet deep (the river itself is only 900 feet wide at this point), is a breath-taking site, long an attraction to tourists and painters. In pursuit of its plan to build a huge dam and recreation area at Tocks Island, the federal government came to own some 70,000 acres on both sides of the river, most of it north of the gap. To the relief of many, the project stalled, and the government converted the area into the Delaware Water Gap National Recreation Area. (The project was formally canceled late in 1993.) Although the army engineers destroyed many of the old buildings, they are not all gone, and some of the villages, like Walpack Center and Millbrook (see also Bevans), have been converted to tourist attractions or are being used for environmental education programs. Recreational opportunities in the park abound: you can hike, fish, rock climb, canoe, hunt, and bicycle. In winter, designated sections are open for ice-fishing, ice-skating, cross-country skiing, and snowmobiling. Information and trail maps are available at the Kittatinny Point Visitor Center (off 1 80; 908-496-4458). Center open daily, May-October, 9-5; most weekends, November-April, 9-4:30. Interpretive tours for groups by appointment (717-588-6637).

Washington Warren 6,429

NJ 31, 57

For some time the marketing center for a large area, Washington, with its broad main streets, looks larger than it actually is. First a stop on the Morris Canal, then on the railroads, Washington was once a major producer of pianos and organs—for a time, in fact (until the advent of the phonograph), it was known as the organ

capital of the world. It has also been a center of hosiery manufacturing; that

industry has also faded, and the Pohatcong Mills, for example, have been converted to apartments.

The Doll Castle Doll Museum (37 Belvidere Ave.; 908-689-7042, 908-689-6513) grew out of a private collection. The small museum, on the second floor of a downtown office building, displays dolls of many materials and from many countries, with a few from the 19th century, some from the 1930s and 1950s, many of recent vintage, and many made by doll artists rather than manufacturers; there is also a small library. Open by appointment. Admission charge.

Wayne Passaic 47,025

US 202, NJ 23, C 502, 504

Even when it was incorporated in the 1840s (and named in honor of Mad Anthony Wayne), the township of Wayne did not have a single center but was made up of a collection of settlements. Now, as the population increases (some 60 percent since 1960), the spaces between the communities are shrinking.

Wayne was the home of Albert Payson Terhune (1872–1942), best known for his tales of the collies he raised at Sunnybank. His house was destroyed, but the land (on the Terhune Dr. section of US 202 at the northern end of the township) now forms Terhune Memorial Park (sometimes referred to as Sunnybank Park), with gardens and a picnic ground. Terhune's great-grandfather can be seen in Emanuel Leutze's famous painting of George Washington crossing the Delaware (he's the near bow oarsman). Cecil B. De Mille's childhood home was near Sunnybank Park.

In Preakness Valley Park is the Dey Mansion (199 Totowa Rd.; 973-696-1776). Built c. 1740–50, this beautiful Georgian house was the home of Theunis Dey, a revolutionary patriot, and served as Washington's headquarters in July, October, and November of 1780. Here he heard the news of Rochambeau's arrival, and here he came after Benedict Arnold's treachery. The county has restored the house to its 18th-century appearance and furnished it with pieces appropriate to the first three-quarters of the 18th century, some on loan from the Metropolitan Museum in New York City. In the attic is a sort of catch-all museum, and on the grounds near the house replicas of various outbuildings, including a cottage modeled on the 18th-century Doremus house in Towaco (and built from old stones), an herb garden, and a picnic grove. Open Wednesday-Friday, 1-4:30; weekends, 10-noon and 1-4; closed major holidays. Admission charged. Groups by appointment. Special events are scheduled at the house, including lectures, demonstrations of colonial crafts on many Sunday afternoons, a Revolutionary War encampment in the fall, and an annual Christmas holiday exhibit. Also in Preakness Valley Park (973-742-6373), one of Passaic County's most heavily used parks, are a golf course, shag field, and tennis courts.

The Wayne Museum (533 Berdan Ave.; 973-694-7192) is in the Van Riper– Hopper house, built in 1776 by descendants of 17th-century Dutch settlers; their descendants were active as farmers until 1920. The house is furnished with period furniture but also features a few Terhune memorabilia. Special events, including, for example, classes in colonial fireplace cooking, are scheduled at the museum. The view across the grounds to the Point View Reservoir (which serves as a bird sanctuary supervised by the Audubon Society) is lovely, and on the grounds are the early-18th-century Mead–Van Duyne house, * an archaeological research laboratory, an herb garden, and an orchard. The Mead–Van Duyne house, threatened by highway construction, was moved to this spot in 1975; the laboratory is filled with artifacts excavated at the house's former site. The Mead–Van Duyne house has been restored and can be visited. It and the museum are open by appointment.

The oldest house in Wayne is the Schuyler-Colfax house,* c. 1696 (2343 Paterson-Hamburg Tnpk), which remained in the same family until quite recently. George and Martha Washington visited the house, and the father of Ulysses S. Grant's vice-president was raised here. It is hoped that the house can become a museum. Other historic houses in Wayne include the Van Saun house (23 Laauwe Ave.), an 18th-century house that may have been Lafayette's headquarters in 1780, and the Demarest house (Fairfield Rd.).

On a wooded hilltop in the northeast corner of the township, with views over the surrounding metropolitan area, is William Paterson University. (Access to parking lots is from Pompton Rd., c 504.) Most of the buildings on the 250-acre campus are new, but the administrative offices are in Hobart Manor, a neo-Tudor building erected in the 1870s and expanded to 40 rooms in 1915 by John McCollough, a Scottish immigrant who had made a fortune in wool. At the Shea Center for the Performing Arts (973-720-2371), a variety of music events occurs, including a jazz series, a new music series, lunch concerts, and concerts by the Wayne Chamber Orchestra. This is also home base for the internationally renowned New Jersey Percussion Ensemble. During the school year, exhibits at the Ben Shahn Galleries (973-720-2654) are open to the public. As you walk about the campus, note the outdoor sculpture.

North of the college (off the Paterson-Hamburg Tnpk between Valley Rd. and Duncan La.) is High Mountain Wilderness Park, the largest remaining tract of forest land in this part of the state. In it are many rare and endangered plant and animal species. As yet undeveloped, it is open for walking and bird-watching.

The famous Breyer horses are manufactured in Wayne. Many of these miniature horses, much beloved of children, have become collectors' items.

Weehawken Hudson 12,385

I 495, C 505

From about 1799 to 1835 Weehawken, situated on the bluffs overlooking the Hudson, was notorious for its "infamous dueling ground," a grassy shelf some 20 feet above tidewater. The most famous duel to take place there was, of course, that between Alexander Hamilton and Aaron Burr. A monument to Hamilton

can be found in Weehawken, but not at the actual site. (An earlier monument

on the site was destroyed in the 1820s by citizens outraged by the practice of dueling; the grassy shelf itself was later swallowed by the railroads.) Today's monument is on Hamilton Ave. (off Blvd. East as it makes a right-angle turn). A bust of Hamilton rests atop a stone on which, according to the inscription, "rested the head of Alexander Hamilton." The inscription replaces a bronze plaque, several times stolen; the four holes are sometimes seen as bullet holes. The semicircular stone wall is supposed to have been built by a friend to keep Washington Irving, who used to fall asleep while viewing the Hudson, from falling over the edge.

Just north of the monument, on Blvd. East, is Hamilton Plaza, a popular scenic overlook maintained by the town of Weehawken. Stop here for a spectacular view of Manhattan and the river. Awareness of Wcchawken as a viewing spot goes back to the 18th century, and the town was once a resort town, the bluffs occupied by estates, beer gardens, and large, Adirondack-style wooden hotels. Ferry service ran from New York City, and elevators carried the visitors up to the buildings on the cliff.

The New Jersey entrance to the Lincoln Tunnel, the world's only threetube tunnel though not the world's busiest (apparently a tunnel in Japan has that distinction), is in Weehawken. The first tube opened in 1937; today's three tubes carry close to 20 million vehicles a year from Weehawken to Manhattan.

Many drivers entering and leaving the tunnel are aware of the Richardsonian gray stone Weehawken Public Library. There are other splendid late-19th-century stone buildings to be seen on the bluffs; for a coherent Victorian neighborhood, walk through the Kingswood section near the Hamilton monument. (Walk along Hamilton and King aves., Bonn Pl., Bellevue St., and Kingswood Rd.; much of this area was built by a single developer around 1900.) Blvd. East Promenade connects Hamilton Plaza, Hamilton Monument, Soldiers and Sailors Monument, and Old Glory Park; eventually it will be one of the alternative routes for the river walk running from the George Washington Bridge to the Bayonne Bridge.

The Hackensack Water Company's brick tower* (4100 Park Ave.), dating from 1883, is all that remains of a large complex where the Tower Plaza Mall now sits. Modeled on the Palazzo Vecchio in Florence, the 175-foot tower formerly held the water company's offices in its base and a 150,000-gallon water tank at its top; it is listed in the navigation guides for river boats and blimps.

Marinas, condominiums, office buildings, hotels, an all-weather driving range, and restaurants have sprouted on the former freight yards and nolonger-active piers (when one of the first restaurants opened in May 1985 the International Longshoremen's Association picketed on the grounds that it had the right to control the waterfront). Ferry service to New York City was restored in 1986, and some 30,000 riders a day now take the ferry from Weehawken, Hoboken, or Jersey City. Harbor cruises are available mid-March–November (call 800-533-3779 for information).

Westfield Union 28,870

NJ 28, C 509

Westfield was founded in the 17th century—West Fields meant the western fields of Elizabethtown (now Elizabeth)—and remained primarily a farm community until the railroad came through in the 1860s. The Revolution intruded in 1777 when the British camped in and plundered Westfield and again in the 1780s

when James Morgan, an American sentry, killed the Reverend James Caldwell (also known as the fighting parson; see Elizabeth and Springfield). The circumstances of the murder are unclear, but Morgan was tried and condemned in the Presbyterian Church on Mountain Avenue. (The church now standing on the site dates from the 1860s.) He was hanged a few blocks from the church on Gallows Hill Road. The cemetery contains a substantial number of 18thcentury tombstones (the date and nature of many of the graves have been color coded by the D.A.R.).

At 614 Mountain Ave. is the Miller-Cory House* (908-232-1776), a living museum of early American farm life. With the help of an early-19th-century inventory, the house has been decorated to reflect life at the time it was built (c. 1740). On the grounds are a colonial rose garden, kitchen gardens, a utility garden, and the like. Among the crafts demonstrated at the museum are openhearth cooking, sheep-shearing, candle-making, and maple-sugaring; the museum is also involved in extensive educational programs. Open mid-September–mid-June, Sunday, 2–5 (in January and February the hours are 2–4), except on major holiday weekends. Groups by appointment other times. Admission charged.

Cartoonist Charles Addams was born here (at 522 Elm St.), and there is some feeling that the house at 314 Elm St. may have been the model for the Addams Family mansion. The Stoneleigh Park Historic District* includes buildings from 1904–29, but there are also an unusual number of revolutionaryera buildings. Westfield is a prosperous community with an attractive downtown. Among the interesting buildings downtown, note in particular the Spanish Revival fire headquarters* (404 North Ave.), and the railroad stations. Among the events that take place at the Westfield Armory (500 Rahway Ave.) are the Tristate Cat Fanciers of America's annual show (973-379-2816) and the Westfield Craft Market (914-355-2400). Westfield is also known for its professional symphony orchestra.

Part of Echo Lake Park (see Mountainside) is in Westfield. Mindowaskin Park (E. Broad next to the municipal building) has ice-skating in the winter and concerts in the summer. Tamaques Park (Lamberts Mill Rd.) has trails as well as athletic facilities.

West Long Branch Monmouth 7,690

NJ 71, C 32

Monmouth University (Cedar and Norwood aves.; 732-571-3400) in West Long Branch was founded in 1933 as Monmouth Junior College, one of six Depression-era colleges created in New Jersey with funds from the Federal Emergency Relief Administration. Today the university is situated on two former estates, and much

of its 138-acre campus retains the formal landscaping of another era. Woodrow Wilson Hall* (1929), formerly Shadow Lawn, is a 128-room limestone mansion modeled on Versailles. This national historic landmark was built on the site of Woodrow Wilson's 1916 Summer White House, which burned; among the many features of this extraordinary building (Daddy Warbucks's mansion in the movie version of Annie) are a three-story great hall and a Venetian stainedglass skylight, believed to be the largest of its kind in the world. You are welcome to walk around the campus weekdays, 9-5; walking-tour brochures are available on the first floor of Wilson Hall. The art galleries (one in a former barn, one in a former icehouse; 732-571-3428) feature some six to eight exhibits during the academic year; when exhibits are in place, they are open to the public, weekdays, 2:30-4:30. Performing arts series, featuring programs of music, theater, and dance, are presented at the Guggenheim Theater (732-571-3483), housed in the former carriage house of the Murry Guggenheim estate, and in the larger Pollak auditorium (732-571-3483). Garret A. Hobart, the state's only vice-president (see Paterson), once lived where the Guggenheims built their estate. Across Cedar Ave. from Shadow Lawn and the theater is the Murry and Leonie Guggenheim Mansion* (1903), which contains the school's library.

The public library (95 Poplar Ave.; 732-222-5993) sponsors art exhibits concentrating on living local artists and work of local interest. The exhibits are usually up for two months. Open July and August, Monday, Wednesday, 9:30–3 and 6:30–8:30, Tuesday, Thursday, 9:30–1 and 6:30–8:30, Friday, 9:30–3, Saturday, 9:30–1:30; September–June, Monday, Wednesday, 10–5 and 6:30–8:30, Tuesday, Thursday, 1–8, Friday, 10–5, Saturday, 10–2.

Directly south of West Long Branch (take Monmouth Ave., NJ 15) in the community of Oakhurst is the Ocean Township Historical Museum (163 Monmouth Rd.; 732-531-2136). Housed in the old Oakhurst school (1900), the museum specializes in memorabilia related to the area, including vintage clothing, old toys, and photographs. The society also sponsors centenary plaques for local houses. Open Tuesday, 1–4 and 7:30–9.

West Orange Essex 39,103

I 280, NJ 10, C 508, 577

In 1887 Thomas Alva Edison settled in West Orange, buying a house in Llewellyn Park* and setting up his laboratory*—an invention factory he called it—on Main Street. From 1887 until his death in 1931 Edison developed a steady stream of inventions; his years in West Orange yielded over half the 1,093 patents he

received in his lifetime (more than any other individual has received). New ideas or improvements stemming from the West Orange years involved the phonograph, motion pictures, storage batteries, poured concrete, the fluoroscope, and the extraction of rubber from goldenrod. The laboratory itself was an invention, the prototype of today's industrial research lab, where large groups work simultaneously on assigned projects. The laboratory included a physics laboratory, a chemistry laboratory, and a metallurgical laboratory, and since Edison built his own machines to run his experiments, a machine shop and a pattern shop. The labs were surrounded by factory buildings; at one time T. A. Edison Inc. employed some 6-7,000 people in manufacturing operations here, in nearby Bloomfield, and in Warren and Sussex counties. Although only one of the factory buildings still stands (the reinforcement of these concrete structures was so much stronger than government regulations require that dynamite was used to demolish them), most of the laboratory buildings remain and are now a national historic landmark (Main St. between Alden St. and Lakeside Ave.; 973-736-0550). Some 50,000 people visit the site each year.

The visitor center (in the former powerhouse) is open daily, 9–5, and has on display samples of most of Edison's major inventions. The labs themselves can be seen only by guided tours, which are offered Wednesday–Sunday, 10:30–3:30. As late as 1984, one of the tour guides had worked in the labs when Edison was alive, but even without such a direct human link, the physical arrangements of the labs convey a strong sense of what this organization, which was so influential in shaping American life today, was like in its heyday. Groups by appointment (973-736-1515). Closed New Year's Day, Thanksgiving, and Christmas.

Llewellyn Park (1857), where Edison bought his home, was one of the country's earliest planned residential developments and the site of the first large-scale naturalization of crocus, narcissus, and jonquils. When Edison moved there, the houses were all large, as was their acreage (Edison's house has 22 rooms and was then on 11 acres). Only those who lived there or their authorized visitors could enter Llewellyn Park, and that is still true today. Edison, who apparently did not like fussing about such things, bought Glenmont (Park Way and Glen Ave., less than half a mile west of Main St.) completely furnished and ready to move into from an executive who had embezzled money to pay for the house. Arrangements to tour the building can only be made at the laboratory, and it is assumed that once inside the gates, you will drive only to Glenmont. Glenmont tours Wednesday–Sunday, 11–4. Part of the South Mountain Reservation (973-268-3500), a 2,000-acre county park designed by the Olmsted firm, which West Orange shares with South Orange, Maplewood, and Millburn, is at the southwestern edge of West Orange (take Main St. south to Northfield and head west on Northfield). At this end of the park is Turtle Back Zoo (560 Northfield Ave.; 973-731-5800), which has some 300 animals representing 100 species. The zoo, which has recently had a facelift, engages in outreach and other educational programs and has been involved in a program to reintroduce endangered species to the wild; it also features a petting zoo and arranges birthday parties for children. The county is looking into developing new operating partnerships that will enable the zoo, a popular spot with families and as an educational resource, to remain open. Open Monday–Saturday, 10–5; Sunday, 10:30–6. Also at this end of the park is the South Mountain Arena (973-731-3828), two ice-skating rinks that together provide 12 time slots open to the public each week from Labor Day to mid-June. Mid-June to mid-August, the arena is open Tuesday and Thursday; call for the schedule.

South Mountain Reservation is on a ridge that protected Washington's army when it was quartered at Morristown in the winter of 1779–80, for from the ridge the soldiers could keep an eye on the British troops on Staten Island. The reservation contains many miles of carriage roads and paths suitable for jogging, walking, hiking, horseback riding, and cross-country skiing. Picnicking and fishing (with a permit) are also possible.

At the northern end of West Orange is another county park, Eagle Rock Reservation (Eagle Rock Ave.; take Prospect, c 577, north out of West Orange; 973-268-3500), also designed by the Olmsted firm, which West Orange shares with Verona and Montclair. Its overlook is considered one of the state's most spectacular spots for viewing the New York City skyline. Casino in the Park, an early-20th-century Italian Renaissance structure next to the overlook, has been converted into a restaurant. Eagle Rock also has picnic tables and fireplaces, bridle and foot trails, and a wildlife reservation.

The Francis A. Byrne golf course (Pleasant Valley Way and Mount Pleasant Ave.; 973-736-2306) is also a county facility.

At Seton Hall University in South Orange (400 S. Orange Ave.; 800-843-4255), the state's third largest and the first diocesan college in the United States (founded in 1856, it moved here in 1860), exhibits at the Walsh Library Gallery (973-275-2033) are open to the public weekdays, 10–4:30, and by appointment. For information on theater programs, call 973-761-9098; for information on public lectures, 973-761-9739. Seton Hall's preparatory school, whose original campus is now the site of St. Elizabeth's in Convent Station (see Madison), is housed in the former West Orange high school (Northfield Ave.). The university's art and music center is in the former Eugene Kelley carriage house* (1887). There are many striking houses and public buildings in this hilly town, said to be the first in the country to issue its own credit card. Note the late-19thcentury South Orange Village Hall* (S. Orange Ave. and Scotland Rd.), the Mountain railroad station* from 1915 (449 Vose Ave.), and the South Orange station* built a year later (19 Sloan St.).

West Windsor Township Mercer 16,021

US 1, C 526, 533, 535, 571

Like many of New Jersey's other townships, West Windsor Township is made up of several small communities that were formerly separated by farmland. Parts of West Windsor were settled in the 18th century (it celebrated the bicentennial of its incorporation in 1997), and it remained an agricultural community

until fairly recently. Between the 1980 and 1990 censuses, however, its population almost doubled. Nevertheless, some 38 percent of the land remains undevcloped, including a 3,000-acrc protective greenbelt, and the township has won awards for its zeal in planting trees and for its planning—linking development to highway construction. The growth in commercial activity has been equally striking; us 1 between New Brunswick and Trenton has seen a rapid expansion of corporate centers, corporate headquarters, other forms of office space, and shopping malls, and a fair amount of this expansion falls within West Windsor. At one of these office parks, 2.5 acres are devoted to sweet corn, harvested each summer by those who work there.

The earliest mill in the area was at Grovers Mill, a community made famous in 1938 by Orson Welles's radio adaptation of H. G. Wells's *The War of the Worlds*, in which Martians landed on Grovers Mill Pond (Clarksville and Cranbury rds.), now part of Van Nest Park and recently restored. The broadcast was so realistic that telephone switchboards all over the country were jammed by frightened callers. Other older communities that retain some coherence and charm include Dutch Neck and Edinburg. Another older community, Penns Neck, at least retains its Baptist Church* (us 1 and Washington Rd.), built in 1812 and altered in the 1870s, although noise, vibrations, and CB radios from the truck traffic can intrude on the services and may threaten the structure.

The West Windsor Historical Society is restoring the Zaitz-Schenck property on Southfield Rd. (between c 571 and Village Rd. across from the golf course; 609-452-8598), with its farmhouse (c. 1790, c. 1830), barn, and tenant house. Eventually the house will serve as museum, library, and headquarters, and the society will establish regular hours.

Mercer County Park (access from Hughes Dr. and Edinburg and S. Post rds.; 609-989-6530) occupies 2,500 acres in the southwestern corner of the township. One hundred of these acres are devoted to playing fields, but the park also has a fair-size boating lake (swimming and gasoline motors are not permitted), a five-mile bicycle path, two picnic groves, an ice-skating rink (609-371-1669), and tennis courts (609-448-8007). There are unpaved trails, and you are welcome to walk north of the lake and Assunpink Creek, although here you must be careful to respect the private homes and the fields that have been rented to farmers. The brick house on the hill near the marina is the mid-18thcentury John Rogers House* (S. Post Rd.), a rare example of a Flemish-bond house of the type seen more frequently in South Jersey, which is unfortunately being left to deteriorate. The park is open year-round, the marina (609-448-4004, off-season 609-989-6538) May–October (weather permitting), the tennis courts April–October, and the ice-skating rink mid-November–mid-March. Tours by appointment (609-989-6532).

The Trenton Kennel Club (609-396-3647) holds its annual show in the park the first weekend in May. Running almost every year since 1926 (the club itself was first formed in 1911), the show is one of the biggest on the East Coast close to 4,000 dogs were entered in 1996—and one of the most important for competitors. When their dogs are not being judged, handlers and owners are usually happy to answer spectators' questions.

Adjacent to the park is Mercer County Community College. Art exhibits can be seen at the gallery on the second floor of the Communications Center (609-586-4800, ext. 589). Open weekdays, 11–3; Thursday evening, 6–8. There is also an art gallery at the Summit Bancorp headquarters (US 1; 609-987-3200). Exhibits change roughly once a month. Open weekdays, 9–5. For a really striking building, drive east on c 571 to the former PA Consulting Services Inc. headquarters (just east of the intersection with c 535, in East Windsor Township). This architectural tour de force has an exposed structure, a roof suspended from cables with the heating and ventilating equipment hung from its center, and translucent walls that glow at night like a lantern.

North of Grovers Mill (take Millstone Rd., which becomes Grovers Mill Rd., jog right, take the first left, and continue on Edgemere Rd. to Plainsboro Rd.), in Middlesex County, is the township of Plainsboro. Once part of both South Brunswick and Cranbury, but dissatisfied with the schools, the township was founded in 1919. One of its first acts was to build a school. At one time Walker-Gordon was the largest employer in town, and the Rotolactor, its rotating milking machine that could milk 1,400 cows in less than six hours, was a popular tourist attraction. Elsie the cow was also a Plainsboro resident.

In the Wicoff House (641 Plainsboro Rd.; 609-799-0909), which dates to the 1880s, the Plainsboro Historical Society has installed a museum of local history. Included are artifacts and memorabilia from Native Americans, local families, Walker-Gordon, and the Princeton University Forrestal campus (see Princeton). The society expects to open the museum and establish regular hours in May 1998. Until that happens, displays of local history can be seen at the library (641 Plainsboro Rd.; 609-275-2897). While in town, note also Bethel Cemetery (Plainsboro Rd. just west of the train tracks).

Whippany Morris [Hanover Township]

NJ 10, C 511

Once known as a center of paper manufacturing, Whippany is also the site where the concept of the cellular car phone was developed (in the Bell Systems laboratory here in the 1940s). In the depot yard of the old Morristown & Erie Railway is the Whippany Railway Museum (I Railroad Plaza, at the intersection of NJ 10

West and Whippany Rd.; 973-887-8177). On display are rolling stock and locomotives, and you can sit at the controls of a steam locomotive. In the former freight house (c. 1904) are toy trains, scale models, and railroad memorabilia. Open April–October, Sunday, 12–4. Donations requested. The museum also offers special holiday excursions to Morristown and back on a train pulled by one of the Morristown & Erie diesels.

Among the buildings of interest on Whippany Rd. note particularly Our Lady of Mercy Chapel* (1853; 100 Whippany Rd.) and the green Queen Anne part of the Crestwood Nursing Home (Whippany Rd. and Eden La.). There are interesting buildings on NJ 10 as well, but the traffic moves so quickly it is hard to see them.

The Wildwoods Cape May 4,484 (Wildwood) 5,017 (North Wildwood) 3,631 (Wildwood Crest)

NJ 47, C 621

The Wildwoods—Wildwood, North Wildwood, and Wildwood Crest—share some five miles of Atlantic beach. These areas were frequented by Native Americans in the summer and, before they were developed as resorts, were used by mainland farmers to graze their animals, creating a problem with feral animals that continued

into the 20th century. Fishermen settled here in the 1870s, about the time the lighthouse was built (see below), and commercial fishermen are still at work in this arca. Known both as family resorts and for their nightlife, the communities today are basically summer resorts (the population of the three soars from its wintertime total of just over 13,000 to as high as 85,000 on a summer weekday, not to speak of 250,000 on a major holiday, and in North Wildwood the meters are removed from the municipal parking lot in the fall). In Wildwood there are several amusement piers (the tallest roller coaster on the shore is on one of them) and some 14,000 hotel and motel rooms. Wildwood expects to have a minor-league baseball team by 1998, and there is talk of opening a casino.

The George Boyer Historical Museum (Holly Beach Mall, 3907 Pacific Ave.; 609-523-0277), run by the Wildwood Historical Society, features local history and memorabilia, and includes the National Marbles Hall of Fame. Open May–October, weekdays, 9:30–2:30, weekends, 10–2; November–April, Thursday–

Sunday, 10:30–2:30, with groups by appointment. The national marbles tournament, which dates to 1923 and claims to be the oldest regularly occurring tournament for children, has been held in Wildwood for over 40 years. Other annual events include water-slide and kite-flying championships and a Labor Day Craft Show. For information on special events, call 609-523-0100.

In North Wildwood, originally a fishing village known as Anglesea, the Hereford Inlet Lighthouse* (Central Ave.; 609-522-1407, 609-522-2030) has been restored and is being converted to a maritime museum. Built in 1874, the lighthouse, unusual in that it looks more like a house than a tower, continued in use until 1964. A light was reinstalled in the 1980s, and you can climb to the top and see it. The lighthouse's prize-winning gardens were established in the 1980s. Open for tours daily, March–September, 9–4:45; Thursday–Sunday, October–November, 10–4; Thursday–Saturday, December–February, 10–3; groups by appointment. During the summer months, there are regular concerts at the lighthouse.

The Wildwood information center (609-522-1407) is on the boardwalk at Shellinger Ave., the North Wildwood center (609-729-8686) at 22d St. and the boardwalk, and the Wildwood Crest center (609-522-0221) at Rambler Rd. and the beach. All three centers are open daily during the summer.

Winfield Union 1,576

GARDEN STATE PKWY EXIT 136

Union County's smallest municipality in both population and size (0.2 square mile), Winfield began as Winfield Park, a community built by the federal government in 1941 to house shipyard defense workers and their families. Enclosed within a bend of the Rahway River, Winfield, which was named for General Winfield Scott,

purchased itself from the government after the war and paid off its mortgage in 1984. Somewhat similar to a cooperative apartment, the town is actually a mutual housing corporation, with the residents as shareholders. The street names—Gulf Stream, Seafoam, Wavecrest—reflect its nautical origins, and the houses, despite the additions of gabled roofs, decks, porches, and extra rooms, still betray their barrackslike origins as defense workers' housing.

Woodbine Cape May 2,678

C 550, 557

One of South Jersey's 15 path-breaking 19th-century Jewish settlements, Woodbine dates from the 1890s, when several hundred Russian refugees established over fifty 30-acre farms here. Woodbine was the largest of these settlements, with 2,500 residents by the turn of the century. Incorporated in 1903, it was

the first community in the country in which Jews filled all the official posts.

The Baron De Hirsch Agricultural School, opened in Woodbine in 1894, is said to be the country's first agricultural technical high school. Although little of Woodbine's past remains, you can still see the Woodbine Brotherhood Synagogue* (612 Washington Ave.), built in 1896.

North of Woodbine, on Webster Ave. (c 550), is the largest segment of Belleplain State Forest (609-861-2404), close to 13,000 noncontiguous acres of swamp hardwood forest. The CCC (Civilian Conservation Corps) was active here from 1937 to 1941, and in addition to doing a great deal of tree work, the corps built roads, bridges, maintenance buildings, dams, and the nature center, mostly by hand. It also created Lake Nummy (by hand), named for the last Native American chief to rule in this part of the state, out of an abandoned cranberry bog. There are lifeguards at the lake in the summer, a self-guided nature trail, and a fitness trail. The forest is also open for hikers, campers (including tent and trailer sites, group sites, lean-tos, and a cabin), horseback riders, cross-country skiers, and hunters. Trail maps are available from the park warden

West of Woodbine (and another section of Belleplain) is the Dennis Creek Wildlife Management Area, 5,400 acres of salt marsh open for hiking, boating, bird-watching, fishing, crabbing, and hunting. Shingles made from Dennis Creek cedar windfalls (healthy trees knocked over by the wind) are apparently extremely durable, and shingles from Dennis Creek cedars were used on the roof of Independence Hall in Philadelphia. Although some people are still mining cedar from the swamps in this area, the industry is no longer as important as it once was. This is also a good place to see eagles in winter, and sometimes otters in spring, but it can be ferociously buggy in summer. It is also a good spot to observe migrating shorebirds.

Woodbridge Middlesex 93,086

NJ TNPK EXIT 11, I 95, US 1, 9, NJ 27, 35, C 514

The oldest original township in the state (settled in 1664, chartered in 1669), Woodbridge remained relatively small until the Garden State Parkway was built in the 1950s (its population doubled between 1950 and 1960). The colony's first gristmill was crected in 1670 by Jonathan Dunham, and his house, built in 1670 from bricks

brought from Holland as ballast, is now the rectory of Trinity Church (see below).

Woodbridge was settled largely by New Englanders, most of them from Newbury, Massachusetts (among them Captain John Pike, an ancestor of Zebulon Pike). According to one theory, the town was named for the assistant pastor of the Newbury church, one John Woodbridge, but he spent very little time in Woodbridge; others say it was named for a town in Suffolk, England. The settlers built their first sawmill in 1682 and their first tavern in 1683. In 1730, they drank the first cup of tea in the colonies. In 1751, the first permanent printing press and publishing house in New Jersey were established by James

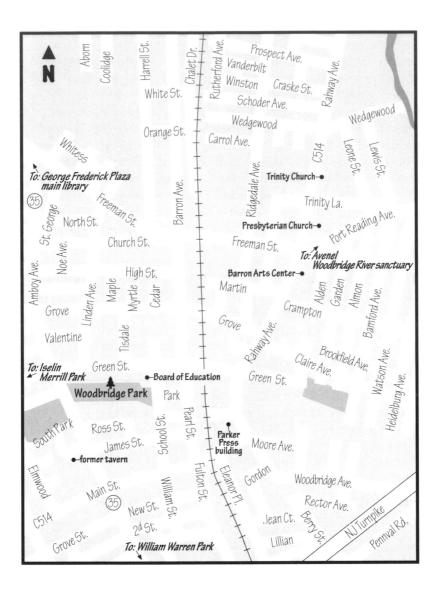

Parker (1714–70). Parker, who had served as an apprentice to Benjamin Franklin and William Bradford and was the official printer for New Jersey until his death, in 1758 printed the first magazine in today's meaning of the word: the *New American Magazine* contained articles on current events and history, essays, and short stories. (An earlier periodical, the *Independent Reflector*, printed in 1752, was unsuccessful.) Joseph Bloomfield is the only Woodbridge-born citizen to become governor of New Jersey. Much later, in 1877, at a graduation ceremony at the Union Town school, Thomas Alva Edison demonstrated the telephone. And, later still, in 1928, Woodbridge became the first community in the United States to have a cloverleaf highway intersection (at US I and NJ 35, scheduled to be replaced by 2001).

Although the first Episcopal service in Woodbridge took place in 1698 and

the first building dates to 1713, today's Trinity Church (650 Rahway Ave.) dates to 1860. Contrary to popular belief, Richard Upjohn did not design the building, although he did draw up some plans for it and the church possesses one of his renderings. The church owns many 18th-century artifacts, including its royal charter, a silver chalice, and a first edition of the American Book of Common Prayer. The cemetery dates to 1714, although the earliest existing stone is from 1750. The rectory, Woodbridge's oldest remaining documented building, was considerably altered some 300 years after Dunham built it, but you can still see its original Flemish-bond brickwork, and the adze-hewn beams remain.

In Barron Library* (1877) Woodbridge had one of the first free public libraries in the state. This small but wonderfully detailed Romanesque Revival stone structure, designed by J. Cleveland Cady, who designed the old Metropolitan Opera House, now houses the Barron Arts Center (582 Rahway Ave.; 732-634-0413). The building has a massive clock tower, ornamented cornices, a Delft-tiled fireplace, and an elaborately foliated foyer. The center's exhibits range from the fine arts to local history to theater design and change roughly once a month. The center also presents monthly poetry readings, a train show during the winter holiday season, and occasional concerts and lectures. Open weekdays, 11–4; Sunday 2–4; large groups by appointment.

The Parker Press building (Rahway Ave.; 732-634-9397, 732-382-6168) is a reconstruction of Parker's shop, which was burned by the British in 1777. Inside are two old iron-frame letterpresses and some type. There are still hopes that these can be restored to working condition and the building made available for tours.

Although there is little left of Woodbridge's earliest history, you will still feel a sense of community in the center of town, and Woodbridge has several times been designated an all-American or typical American city. Other buildings you might want to look at include the tavern George Washington slept in (it was the last night before he was sworn in as president). Originally located where the Knights of Columbus building now stands (Amboy Ave. and Main St.), it has been moved back to 142 James Street. Converted to apartments (during a reenactment Washington had tea with the residents), the building may also have served as a post office (Woodbridge was one of the country's original 10 post office sites). The Presbyterian Church (600 Rahway Ave.; 732-634-1024), known locally as the White Church, has been remodeled and covered with white brick so that you would be hard-pressed to guess its age (it was built in 1803). The interior, however, did not suffer the same fate, and in the cemetery is a stone dating to 1692. Tours by appointment. Note also the main library (George Frederick Plaza; 732-634-4450), which has changing exhibits in its lobby, and the Board of Education administration building (School St.), an 1876 school.

West on Green St. into Iselin will take you to Merrill Park (Middlesex-Essex Tnpk; 732-381-3555), 179 acres that include walking and nature trails, playing fields, tennis courts, fishing and picnic areas, and a small zoo that features farm animals. There are free concerts in the summer and ice-skating in the winter. At the library in Iselin is the Garden for the Blind and Physically Handicapped (1081 Green St.; 732-283-1200). The garden is open daily, dawn-dusk, with the peak bloom time in spring and summer.

South of the center of town (take NJ 35) is William Warren Park (Florida Grove Rd.; 732-636-5423), a county park that also offers concerts in the summer. Much of this 126-acre park, which has athletic fields, picnic groves, and woods with foot trails, is built on reclaimed clay pits. In the 19th century, clay mining and brick manufacturing were Woodbridge's principal industries; the clay from these pits was used to make fire bricks.

In the Avenel section of Woodbridge is Kullman Industries, New Jersey's oldest extant diner-construction company, one of three left in the state (50 years ago there were about 20). The company started building only diners; now diners represent only about 20 percent of its business.

East of Avenel is the township's 40-acre Woodbridge River sanctuary (north side of Port Reading Rd. and east of Rahway Ave.). Woodbridge won an award for cleaning up this wetlands area, which now provides a home for wildlife. Open for hiking and bird-watching.

Woodbury Gloucester 10,904

NJ 45, C 534, 551, 553

Founded in 1683 by Henry Wood, a Quaker from Bury in England,

Woodbury has been the seat of Gloucester County since 1785. Located near the confluence of the Delaware River and Woodbury Creek (originally called Pescozackasing, a Lenape word possibly meaning "place of black burrs"), it was once something of a manufac-

turing center, with lively traffic in patent medicines, glass, and other products. Today's residents tend to work in county offices, the hospital, at the nearby Mobil facility, and in Philadelphia and Camden. Broad St., the major north-south thoroughfare and once part of the old Kings Highway from Burlington to Cape May, is, as so often happens in South Jersey, appropriately named. There is an interesting mix of buildings in Woodbury, many preserved in their original 18thand 19th-century form, others adapted, often gracefully, to contemporary uses, and large portions of the town have been placed on the state register of historic places.

Among the early buildings is the Friends Meeting House* (120 N. Broad St.), the west side of which dates from 1715 and the east from 1785. The building was used as a barracks and hospital for British troops after the nearby Battle of Red Bank in 1777 (see National Park). Furthermore, in Woodbury the Hicksite-Orthodox split did not produce two meetinghouses, as happened in so many other Quaker communities; instead, the two groups continued to use the same meetinghouse, simply dividing it with movable partitions. From 1827 to 1927 they shared the building, and in 1954 the two groups rejoined. Another Quaker building from the 18th century now forms the easternmost part of the city hall (33 Delaware St.); this is the Deptford Free School building, dating from 1744 (the second story was added in 1820).

In 1783, the country's first airborne trip ended in Woodbury, when Jean-

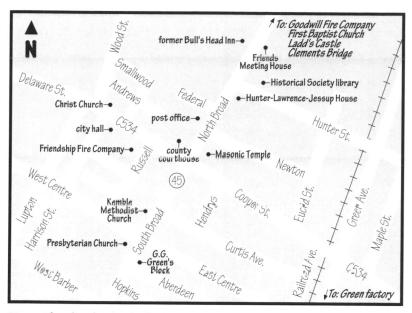

Pierre Blanchard, who had taken off in Philadelphia, landed his hot-air balloon in a farmer's field a few miles northwest of town (near Clements Bridge off NJ 42 near the Deptford Mall). In that same year the Gloucester County Abolition Society was formed, one of the first in the nation.

The county courthouse (Delaware and Broad sts.) is a splendid stone building, completed in 1887. Its white-columned neighbor dates from 1926, as does the Masonic Temple across the street.

At 58 N. Broad St. is the Hunter-Lawrence-Jessup House* (c. 1765; 609-845-4771). The Hunter refers to Reverend Andrew Hunter, a chaplain in the revolutionary army and a participant in the Greenwich tea party (see Greenwich), who was head of the town's distinguished Woodbury Academy (founded 1791); the Lawrence to John Lawrence, older brother of James Lawrence, the naval hero (see Burlington), who lived with his brother while attending the Woodbury Academy; and the Jessup to John S. Jessup, a late-19thcentury judge and civic leader. The house is maintained as a museum by the Gloucester County Historical Society, which bought it in 1924. The society's collections include period furniture, guns, toys, and other artifacts. Among the society's holdings are a walnut desk and bookcase that had belonged to Elizabeth Haddon (see Haddonfield) and an audience chair (#425) that was in Ford's Theater the night Lincoln was shot. The society has reconstructed in its basement the fireplace from Hugg's Tavern near Gloucester where Betsy Griscom, known as the designer of the American flag, and John Ross were married. A copy of their license hangs over the mantel (the original is in the society's library). Built into the library is one wall from the Cooper house, used by Cornwallis as his headquarters (bayonet marks made by British soldiers trying to force a door are still visible). Exhibits change four times a year. Open Wednesday, Friday, the 1st and 3d Monday of the month, and at exhibit

openings, the 1st Sunday of the month, 1–4; groups by appointment. Admission fee. Closed in August. Around the corner from the museum is the historical society's library (17 Hunter St.; 609-845-4771). Open weekdays, 1–4; Tuesday and Friday evening, 6–9:30; last Sunday of the month, 2–5. Donation requested.

Opposite the meetinghouse is the former Bull's Head Inn (III N. Broad St.), possibly built c. 1720 (the earliest records date to 1737), supposedly from bricks left over from the construction of the meetinghouse. This building has functioned continuously as a tavern and restaurant for over 250 years.

At the corner of S. Broad and W. Centre sts. is the Presbyterian Church (1833). The congregation was founded in 1721, and this building replaces an earlier one, supposedly abandoned because it had been used by British troops in 1777 and was thought to be haunted. This odd-shaped building does not look its age. In 1906 the church was connected to its stone chapel (1895), and the entire structure was faced in stone. Then, in 1965, the stone was removed, new bricks were used, and the front was extended. At that time a cupola was built to house the church's 12th-century bell, cast in Bordeaux and brought to Woodbury in the late 18th century from Santo Domingo, when the French Revolution caused upheaval on the islands.

Next door to the city hall is the Friendship Fire Company No. 1, founded in 1799, though its present building dates from 1891. The Goodwill Fire Company (N. Broad St.), with its round window and cupola, was built in 1889. Other buildings of interest include the post office (1928), the First Baptist Church (1857), and the Kemble Methodist Church (1888), all on Broad Street. Also on Broad St., between Centre and Hopkins sts., are the remains of the splendid red brick G. G. Green's Block (1880). Green was perhaps Woodbury's most successful entrepreneur, making a fortune from patent medicines and associate businesses. His former factory (122 Green Ave.) has been used by other companies over the years. On the north side of Delaware is Christ Church Episcopal Church (1856), with two hitching posts still in place. Brochures for a self-guided walking tour are available in city hall. Open weekdays, 9–4.

About one mile north of town (take NJ 45 north to Colonial Ave. and turn left, or west) is Ladd's Castle (1337 Lafayette Ave.), also known as Candor Hall. Built in 1688 by John Ladd, who is said to have surveyed Philadelphia for William Penn and to have been thrown out of the Society of Friends for marrying non-Quaker couples, it is now a private home.

Woodstown Salem 3,154

US 40, NJ 45

A Quaker settlement dating back to the early 1700s, Woodstown retains many of its old buildings, and a string of 18th-century structures can be found along Main and Marlton streets. There are also many striking Victorian buildings, both domestic and commercial. Among the earlier buildings is the Joseph Shinn

house* (68 N. Main St.); its central section was built in 1742, and its southern

section may have been a 17th-century Native American trading post moved from another location. The Woodstown Friends meetinghouse is also on N. Main, as is the Samuel Dickeson house (42 N. Main; 609-769-4588), the home of the Pilesgrove-Woodstown Historical Society. The house dates to 1749; in it the society runs a museum that concentrates on genealogy and items of local history, such as marl equipment and grandfather clocks manufactured in the area. Open Saturday, 1–3. Behind the museum is the Eldridges Hill School, a one-room schoolhouse dating to 1840 that was moved in from Pilesgrove township. The schoolhouse is furnished as a mid-19th-century schoolhouse would have been. Tours by appointment. The society also sponsors a house tour the first Friday in December.

Roughly two miles west of Woodstown, just west of Sharptown (a stop on the Underground Railroad) is the Cowtown Rodeo (US 40; 609-769-3200), which has been in existence since the mid-1950s. An outgrowth of the local livestock auctions, the rodeo is the oldest on the East Coast and is run by a family that has lived within a few miles of Sharptown for 11 generations. It is sanctioned by the Professional Cowboys Association and draws riders from all over the country. Open Memorial Day–September, Saturday, 7:30 P.M. Admission charged. The auctions, which take place Tuesday at noon, are also open to the public, as is the year-round farmers' market, Tuesday and Saturday, 8–4.

South of Woodstown (take S. Main south to Eastlake Rd. and turn right) is Joy Farm (87 Eastlake Rd.; 609-769-1526). In the early 20th century there was a chicken farm on this property; the chicken waterer was developed here. It is now a fiber farm dedicated to preserving the Jacob sheep, an unimproved breed that is thought to descend from the sheep mentioned in Genesis. Spinning lessons are offered at the farm, which also raises merino sheep and colored angora goats. A sheep and yarn festival takes place at the Salem County Fairgrounds (us 40 across the road and just west of the rodeo) the fourth weekend in September. Call Joy Farm for information.

Roughly two miles northeast of Woodstown in Pilesgrove Township (take Main St., the Old Kings Highway, to the intersection with Woodstown-Auburn Rd.) is the Seven Stars Tavern.* The earliest portion dates to 1762, and the tavern may well be one of the oldest drive-ins in the country, for a window off the tap room was set up so that riders could have their drinks without dismounting. In the 19th century the building was used as a farmhouse.

Wyckoff Bergen 15,372

NJ 208, C 502

Bergen County's James A. McFaul Wildlife Center (Crescent Ave. south of c 502; 201-891-5571) is in Wyckoff. This 81-acre wildlife sanctuary has outdoor displays of native mammals and birds, a nature trail (a trail guide is available), an ornamental grass garden, an herb garden, a butterfly and hummingbird garden, and an old-

fashioned-roses garden. Inside the exhibit hall are live native animals, natural

history displays (including a demonstration beehive with a glass viewing panel), an observatory overlooking the pond, and a changing art exhibit. The center sponsors nature education programs for schools and other groups. The building is open weekdays, 8–4:45; weekends and holidays (except Thanksgiving, Christmas, and New Year's Day), 1–4:45. The park is open until sunset. Groups by appointment.

Wyckoff was originally a Dutch settlement, and some of the early Dutch stone houses remain (try Wyckoff and Franklin aves.). One of these, the Van Voorhees-Quackenbush-Zabriskie House* (421 Franklin Ave.; 201-891-0057), is now a house museum. Started in the mid-18th century (the larger section dates from 1824), the house was occupied almost entirely by direct descendants of the original builder until 1973, when it was given to the township. Its furnishings, which reflect the Dutch colonial heritage, are period pieces collected by the last inhabitant. Open Friday, 9–3 (the museum is closed when the schools are closed, except in July), and for an annual December open house. Admission charge. Note also the Wyckoff Reformed Church (E. Wyckoff Ave.), which dates from 1806.

pened in November 1951, the New Jersey Turnpike is the most heavily traveled toll road in the United States. In 1995 over 190 million paying customers used some of the turnpike's 148 miles, which averages out to over half a million vehicles a day (each doing an average of almost 24 miles a trip). On holiday weekends, traffic can reach 700,000 cars a day (traditionally, the Wednesday before Thanksgiving has been the heaviest single day).

The turnpike is also one of the nation's safest highways. Its 1,200-foot acceleration and deceleration lanes, median dividers capable of stopping an eighteen-wheeler doing 55 miles per hour (and still effective even at the speeds too many eighteen-wheelers actually go), and full shoulder lanes on all bridges help contribute to its safety record. (Such features also contribute to its cost the eight-mile Newark Bay-Hudson County extension, opened in 1956, was one of the most expensive stretches of toll road in the United States.) Other safety features include computerized traffic control: electronic detectors that monitor traffic have been placed under the roadbed; these relay information to the administration building in New Brunswick. Information coming from these sensors can provoke automatic adjustments to the message signs and thereby change posted speed limits or divert traffic from one part of the road to another. (These adjustments can be overridden by the human beings in the control room at the headquarters in New Brunswick.) A highway advisory telephone and a highway advisory radio are also in use, and the turnpike's reputation as a well-run highway attracts highway administrators from all over the world.

All 148 miles are limited-access highway, ranging in width from 4 to 14 lanes (the Turnpike Authority refers to the 12- and 14-lane portions as the dual-dual). They consist of a 117¹/₂-mile mainline; the Hudson County and Pennsylvania Turnpike extensions, which together total 14 miles; a westerly alignment that adds 10 miles; and a 4¹/₂-mile section running from what was once the end of the westerly alignment to the George Washington Bridge. (The eastern and western alignments rejoin as express and local lanes.) Tolls provide over 90 percent of the turnpike's revenue (it uses no municipal, state, or federal tax funds), and the cards themselves provide a good deal of information. Received opinion has it that the turnpike is simply an efficient means of connecting Philadelphia and New York City, but some studies have suggested that over half the trips begin and end within the state. Nevertheless, for many people the turnpike has created a negative impression of the state as a whole. Presumably this is because those entering from the north at the Lincoln Tunnel immediately pass into an industrial area, which most people find unattractive and which at times does smell (usually of mercaptan, a harmless by-product of various chemical processes). For many years, though, pig farms were numerous at the northern end, and they smelled all the time. And many people remember when the landfills, still visible, smoldered, producing, with the pig farms, a pungent combination. There are no more pig farms and the landfills no longer smolder (some are being converted to parks and artworks), but the

unfortunate reputation lingers on. The southern end has its industrial stretches too, but land is cheaper at that end, and more of it has been used for plantings that screen the factories.

The Turnpike Authority hopes that its plan for widening the highway, which has not been without controversy, will make the road able to handle traffic easily to the year 2050. The mileage of the dual-duals has increased; some sections now have 14 lanes, in some cases with an HOV (high-occupancy vehicle) lane during rush hour; and some of the toll plazas have been realigned or expanded. In addition, a fly-over bridge has been built to improve conditions at the Southern Mixing Bowl (between interchanges 14 and 15E), once highly congested and the most dangerous section of the road. The authority has also engaged in projects intended to improve the appearance of the turnpike (although it is also increasing the number of billboards). Planting trees along the roadway is not an easy task: roadside conditions are not ideal for a young tree, maintenance workers mowing the grass sometimes decapitate the young trees, and in some areas construction plans forestall planting. The authority claims a high success rate for its plantings, and the amount of screening has increased dramatically. Some of the screening today, though, is done by sound barriers, which unfortunately are neither as attractive as trees nor as diverting as observing what's off the roadway. To prevent the theft of evergreen trees during the holiday season, the turnpike authority coats likely victims with a compound that releases a disagreeable odor when it hits room temperature, an odor that lasts well beyond the Christmas season.

This tour is meant for those who are going to be using the turnpike anyway and assumes that if you know what you are looking at as you speed by, you will find it more interesting. The tour may not convince the doubters that the turnpike is attractive, but it may make the time pass more quickly. To help you identify sites, the turnpike authority's mileage markers are used (they are the numbers on the small green stakes along the edges of the roadway). The numbers start in the south and increase as you go north, so if you are traveling south, you will have to begin at the end of the tour. Each entry begins with a mileage number. The letter following that number tells you which side of the road is being talked about: N means the right side when you are traveling north (toward New York City), S the right side when you are traveling south (toward Philadelphia and Delaware). Mainline mileage is given without a prefix; the western alignment is prefixed by a W, the Hudson extension by an H. Thus, W 115 S tells you to look to the right when you are traveling south on the western alignment (away from the George Washington Bridge), to the left when you are traveling north on that stretch.

Unfortunately, the mileage indicators cannot tell you exactly when to look. The particular mileage marker at which you see something depends on how fast you are traveling, which part of the dual-dual you are in (the all-car or the car, truck, and bus section), how much traffic there is, which lane you are using, and what kind of vehicle you are traveling in. If traffic is heavy, you may be able to see very little to your left, particularly if you are in the right half of

the dual-dual. This tour, unlike other entries in this guide, recognizes that you cannot stop the car and turn around to get a second look, or park it and get out for a closer one. Most of the items described in the tour, however, are large enough that you will not miss them if you don't look at precisely the right moment unless you are traveling way over the speed limit.

The entries come thicker and faster for the northern, more industrial parts of the tour; the southern stretch is more like other high-speed roads—in fact, people even complain to the Turnpike Authority that the southern stretch is boring. Although southern New Jersey is developing rapidly, large areas are still rural, and, as mentioned before, it is often harder to see what borders the highway in the south because of the screening (this is true for farms and stables, not just the industrial parts). Because many of the trees are deciduous, the southern stretch is particularly attractive in the fall (and you can see more in the winter).

The tour starts near Deepwater in Salem County. In the first 20 miles you will find many farms that raise Holsteins, vegetables, and grain, yet much of the state's chemical industry is along the Delaware River just north of the Delaware Memorial Bridge.

I N,S—Interchange I to the Delaware Memorial Bridge. The toll booths at this interchange are still the original 1952 booths, but the interchange, congested on summer and holiday weekends, is scheduled to be relocated and enlarged. The highway here crosses Game Creek. The concrete guard rails often prevent you from seeing the many rivers crossed by the turnpike. You may notice Game Creek again at 3 S.

2–4. N,S—There are farms and stables on both sides of the highway here, though most of them are obscured by trees. At 3 N,S the road crosses Penny Run.

5 N,**S**—John Fenwick (N) and Clara Barton (S) service areas. All the turnpike's service areas are named for individuals with ties to the state, generally with ties that are geographically close to the service area. Barton and Fenwick are both associated with southern New Jersey (for Fenwick, see Salem; for Barton, Bordentown).

7 N,S—The road crosses Oldman's Creek, which divides Salem and Gloucester counties. There are farms visible for the next two miles.

II N,S—The road crosses Narraticon Run. Lake Narraticon (S) and the old community of Swedesboro (S) are nearby; you can see a church steeple in Swedesboro.

I 2 N,S—Interchange 2. One of the turnpike's smallest interchanges (3 toll booths), 2 is the one you should take to visit Swedesboro or to get to US 322, which goes west to the Commodore Barry Bridge over the Delaware and east to Glassboro. The road crosses Raccoon Creek, which flows along the northern edge of Swedesboro, itself first known as Raccoon.

34.6 New Jersey Turnpike Tour

I 3-18 N,S—You can see the radio tower at one of the turnpike's maintenance yards (N). Each year litter crews pick up over 7,000 bags from the roadway alone (if you add in litter from the service areas, it comes to over 90,000 bags). The road crosses Still Run, Edwards Run, and Mantua creeks. Mantua Creek is particularly lovely. At 18 N you can see the Martin Luther King Memorial Gardens. Note the rumble strips in the shoulder; they were introduced in 1993 to cut down accidents caused by vehicles running off the road. By 1995, 75 miles were in place, and this kind of accident had decreased 45 percent; look for more rumble strips in the future.

19–21 N,S—The turnpike passes through Woodbury Heights, crossing Woodbury Creek.

23–25 N,S—The turnpike crosses first a tributary of and then Big Timber Creek itself, the boundary between Gloucester and Camden counties. Walt Whitman used to spend his summers near here (see Laurel Springs). In Camden County the road also crosses Beaver Branch and goes through Runnemede and Bellmawr.

26 N,S—Interchange 3. This is where you get off for Woodbury, South Camden, and NJ 168. The road continues through Barrington and Lawnside.

27 N—The next few miles are an industrial area; at this point a large fiberglass plant is visible.

29 N,S—The highway crosses the Lindenwold high-speed line.

2.9 N—The Hussman Corporation's water tower is clearly visible. This company, which began manufacturing supermarket equipment at this spot in the late 1950s, was the first major industry in the area.

29 S—In this mile are a Ryder truck rental maintenance depot and the Melitta Filter company, which makes coffee makers and filters.

30 S—The Walt Whitman Service Area. Whitman lived his last years in Camden. The mushroom-shaped Cherry Hill water tower is 133 feet tall and holds 2 million gallons of water.

3.3 N,S—The road crosses Pennsauken Creek, which divides Camden and Burlington counties, and goes through an area of small industrial establishments and housing developments.

34 N,S—Interchange 4. This exit takes you to Camden and to NJ 73 (to the Tacony-Palmira Bridge, a drawbridge notorious for its effect on rush-hour traffic). On both sides of the turnpike there are hotels serving the Camden area.

35 N—The tanks of the Colonial Pipeline Company are visible.

 $35\,$ S—The large industrial buildings here include a Martin Marietta facility (see 38 S).

38 S—What appears to be a landlocked ship belongs to Martin Marietta's Missile and Surface Radar division; since 1977 the "cruiser in the cornfield" has been the center for land-based testing and training for the U.S. Navy's Aegis combat weapons system. Seen from a little closer, the cruiser looks less like a warship and more like what it is: a 122-foot superstructure, bristling with radar antennas, perched on the roof of a three-story building. The radio tower is also visible. Some 3,500 of the 4,500 employees at this plant work on the Aegis system, designed to protect ships from missile threats. In the fall a "Beat Army" banner often hangs from the superstructure. I 295 can be seen running parallel to the turnpike.

39 N,S—The turnpike crosses Parkers Creek; those heading north will find the James Fenimore Cooper Service Area. Cooper was born in Burlington. A farmers' market opened at the service area in 1996.

41 N,S—The turnpike crosses Rancocas Creek. A boardwalk goes into a nature area (N), but if you want to walk here, approach it from off the turnpike. For Rancocas State Park, see Mount Holly.

43 N,S—The road crosses Mill Creek. This is an area of large dairy farms.

44 N,S—Interchange 5: use this exit for Burlington and Mount Holly.

47–49 N,S—Farms, stables, fields, and woods continue. The road crosses Assiscunk Creek.

51 N,S—Interchange 6 takes you to the Pennsylvania Turnpike spur, interchange 6A to Florence. A new configuration is planned for this interchange. Trees screen the highway for most of the spur's six miles; in some cases the woods are reclaimed pastures.

54 N,S—Interchange 7, for Bordentown, Trenton, and us 206. For a while a beaver who took up residence at the wetlands mitigation pond here was threatening the authority's trees. The highway is close to the Old York Road, which crosses it. The road goes over Blacks Creek.

56 N,S—The highway crosses Crosswicks Creek, which divides Burlington from Mercer County and flows into the Delaware at Bordentown.

56 S—The road skirts the New Jersey State Prison Farm.

58 N,S—Here are the Woodrow Wilson (N) and Richard Stockton (S) service areas. Both these men are associated with Princeton. Farms are still visible on both sides of the highway.

60 N,S—Interchange 7A: here you can get to 1 195, taking you north to Trenton and Hamilton Township and south to the shore.

61-63 N,S—There are farms on both sides of the road. The highway crosses Assunpink Creek and goes through a portion of the Assunpink Wildlife

Management Area (see Roosevelt). At 62 S, a billboard, partially obscured, welcomes you to Mercer County.

66 N,5—Cedar Brook is crossed.

66 S—A sign lets you know that the Peddie School golf course lies beyond the woods (see Hightstown).

67 N,S—Interchange 8, taking you to Hightstown, Freehold, and NJ 33. Between here and interchange 8A are many chemical companies. The highway crosses Rocky Brook.

67 S—At the Turnpike Authority's large maintenance depot here, you can sometimes see the green roadway signs being worked on. The road passes Local 827 of the AFL-CIO International Brotherhood of Electrical Workers' building.

68 N,S—The highway crosses the Millstone River, which divides Mercer from Middlesex County. At 68 N is the turnpike's only variable traffic sign (the others are only changeable); a satellite dish makes it possible to have the sign flash any message the authority chooses so that it can suggest alternative routes.

69 N,S—The highway crosses a tributary of the Millstone River and Conrail tracks. Over the next 10 miles, much of the land adjoining the turnpike is owned by housing developments.

70 N,S—Cranbury Brook is on both sides of the highway.

70 S—The Jamesway Distribution Center abuts the highway here.

71 N—Carter-Wallace, a large manufacturer of pharmaceuticals, diagnostic kits, and over-the-counter products, has a facility here.

7I S—The Molly Pitcher Service Area. Molly Pitcher is associated with the Battle of Monmouth (see Freehold). This recently renovated and expanded service area is the busiest on the turnpike, serving some 150,000 travelers each month. A sprinkling of historical material relating to Molly Pitcher is on exhibit in the lobby of the food-services building. A farmers' market opened here in the summer of 1996.

72 N—Rhone-Poulenc warehouses dominate here.

73 N,S—Interchange 8A takes you to Jamesburg and Cranbury. This interchange will be rebuilt to accommodate NJ 92.

73 N—The turnpike's neighbors here are Forsgate Country Club and Rossmoor (see Jamesburg). A Shop Right warehouse, said to be equipped with over a mile of computer-controlled conveyor belts, is visible across the field.

73 S—The Monroe Township municipal water facility is here; the tower is clearly visible. This is a growing industrial area.

74 N,S—The highway crosses the former Jamesburg branch of the Pennsylvania Railroad.

75 N—A Canon warehouse is visible in this mile.

74 S—A large BASF facility that once manufactured a Styrofoam product sits largely empty, most of it for rent. There are several empty warehouses in this general area.

76 S—The heavy equipment belongs to Local 825 of the International Union of Operating Engineers (AFL-CIO), which runs a training school here. Each year more than 1,000 carefully screened union members (including many who have already spent years in the construction industry) come to this school to learn to operate more than a dozen kinds of equipment: bulldozers, front-end loaders, pans, graders, combination backhoes, cranes. The center works with the Occupational Safety and Health Administration (OSHA) and the state's Department of Environmental Protection, offering, for example, a course in hazardous waste removal. The center serves all of New Jersey and part of New York State. The pond belongs to the Dallenbach Sand Co. and gets deeper and lighter in color as more sand is removed.

 $77\,$ N,S—The turnpike crosses Ireland Brook. Middlesex County is developing a park along the brook.

78 N—The Joyce Kilmer Service Area. Kilmer was born in New Brunswick.

 $78\,$ S—Much of the land in this mile belongs to the Tamarack County Golf Club.

80 N,S—Crossing the road here is a turnpike service road. The Milltown Water Tower and a Home Depot are visible to the east.

81 N,S—The turnpike crosses the Saw Mill Brook and the (freight only) Raritan River railroad.

83 N,S—Interchange 9 for New Brunswick, NJ 18, and the shore. The highway crosses Lawrence Brook.

83 S—Tower Center, visible for many miles along the turnpike, consists of two 16-story towers with offices (said to be the tallest in central New Jersey), a 360-room hotel, and parking for 4,200 cars. The turnpike's administration building can be seen above the road.

84 N,S—In this mile the highway crosses the Raritan River and the old Lehigh Valley railroad tracks.

84 N—The ferryboat in the Raritan River is the *Mary Murray*, christened in 1938, and active on the Staten Island run until 1975. Its current owner had apparently hoped to convert it to a restaurant. Slowly deteriorating, the boat evidently frequently inspires passers-by to call and either let the Turnpike

Authority know it is there or ask why it is. Public Service Electricity and Gas Company has a generating station here.

84. S—Raritan Center is one of the largest industrial parks in the East. More than 10,000 people work on its 2,350 acres, once part of the Raritan Arsenal, an army supply depot. Middlesex Community College and Thomas A. Edison Park (see Edison) are also on the site. At this point the river is deep enough to accommodate medium-sized ocean-going ships.

85 N—This is an area of warehouses, industrial parks, and garden apartments, although in summer trees screen much of the view. The United States Army Reserve's 78th Division armory is visible.

86–8/ N,5—The road crosses Bridge-Mill Brook and the old Bonhampton branch of the Pennsylvania Railroad and passes through an area of warehouses and garden apartments.

87 N—Here you can see the *New York Times*'s state-of-the-art color printing plant and distribution facility, opened in 1992. In a space big enough to hold 22 football fields (1.3 million square feet), stands an army of high-speed presses (70,000 impressions an hour) that can turn out well over 1 million copies of the Sunday paper, several hundred thousand of the daily.

88 N,S—Interchange 10, taking you to 1 287, Metuchen, and Perth Amboy. The highway goes under 1 287 and crosses Conrail's Perth Amboy branch.

89 S—There are Tudor condominiums and a municipal playground on this side.

90 N,S—The road going over the turnpike is the Garden State Parkway, and interchange 11 will take you to it, as well as to Woodbridge and the Amboys. This is the busiest interchange on the turnpike and, with 26 toll booths, the second-largest single interchange. Between this exit and interchange 12 you will notice many oil-storage terminals.

QO S—The New Jersey National Guard and a racquet club are visible here.

91 N—The clay pits here once provided the material used to produce millions of bricks; Middlesex County has reclaimed much of this land as part of William Warren Park (see Woodbridge). The Turnpike Authority stores salt at the maintenance facility. In 1994, a particularly snowy winter, it used over 61,000 tons of rock salt (18,000 tons is more usual, but in 1995 only 7,400 were needed). The igloos you see from time to time along the turnpike are used for storing salt. The building with the cupola is St. Joseph's Convent, in Woodbridge, the American headquarters for an order of nuns founded in Poland (most of the sisters are Polish). The house was built in 1856 by a brick magnate as a wedding present for his daughter; it was later used as an orphanage. The house has beautiful woodwork and other fine details, and there are hopes that eventually it can be opened for tours. Because of the sound barriers, it is harder to see St. Joseph's after you've passed the crest of the hill.

91 S—The Hess Oil office building, over 10 stories high, was the first high-rise building in Woodbridge. Its luxurious interior has solid teak walls and Italian and Vermont marble floors.

92 N—The Grover Cleveland Service Area is named for the only president of the United States to serve two nonconsecutive terms (see Caldwell). The road crosses the Woodbridge River, currently being cleaned up.

92 S—The Thomas Edison Service Area (see Edison and West Orange).

93 N—You can see the Hess storage tanks and refinery. The red and white stacks in the distance belong to the Chevron refinery on the Arthur Kill. There's a good view of the New York City skyline.

94 N—The Hess Wetlands, so named because of the Hess sign nearby, are part of a wetlands mitigation project. (When the turnpike was widened between interchanges 11 and 15, some wetlands were filled in.) The sticks are there to protect the planted wetlands vegetation from predators until it is established. You can often see waterfowl, including some threatened species, on the two ponds.

94 S—The Colonial Pipeline Company stores heating oil and liquid petroleum products here.

95 N,S—Interchange 12 to Carteret and Rahway, formerly one of the least busy interchanges. Now that the area is attracting more industry, it is likely to become busier.

95 N—There are garden apartments here and small companies.

95~S—Several businesses are here, including Wiz warehouses. The Public Service high-tension lattice tower is visible.

96 N,S—The highway crosses the Rahway River, which divides Middlesex from Union County.

96 N—Conrail tracks are to the side of the road.

96 S—The white Colonial Pipeline Company's tanks are visible here. Joseph Medwick Memorial Park, a Middlesex County Park honoring a member of the baseball Hall of Fame who grew up in Carteret, is along the river.

97 N—The Allied Chemical plant here dates from World War I. The company's first plant, it was one of the state's first chemical factories. Now part of GAF, it makes a wide range of products, at one time including fluoro-carbons. From here you can see the Northville storage tanks, Mobil tanks, and Staten Island. During the gasoline shortages in the 1970s, most of the oil companies along the turnpike painted out their identification signs.

98 N—Public Service Electric and Gas Company's Linden generating station, with its three steam turbines and six gas turbines, has half the capacity of the

generators at Boulder Dam. In 1974 a natural-gas plant was added to the site; it is turned on during periods of peak demand in the winter.

98~S – Cogen Technologies and the Linden cogenerating plant across the turnpike occupy the site once occupied by the Exxon Bayway refinery, formerly the world's largest catalytic cracking plant and the country's third-largest refinery.

 $99\,$ N,S—Interchange 13, taking you to 1 278, Elizabeth, and the Elizabeth seaport.

99 N—The Goethals Bridge over the Arthur Kill to Staten Island provides a direct connection between the turnpike and the Staten Island Expressway. Opened in 1928, this cantilevered structure has a center span of more than 650 feet. Its four lanes carry almost 12 million castbound cars a year. The road crosses the Elizabeth River. You can sometimes see ships on the Arthur Kill.

100 N,**5**—The highway passes through the eastern part of Elizabeth, the state's fourth-largest city (see Elizabeth).

IOO N—More good views of the New York City skyline come in this mile. The Conrail tracks once belonged to the Central Railroad Co., and you can still see the Elizabeth Gas Company's production plant. Several interesting buildings are visible. The black triangular steeple belongs to Greystone Presbyterian church, built in 1893 from stones blasted from the bottom of New York's East River. The gold Byzantine dome belongs to St. Peter and St. Paul's Greek Catholic Church, built in 1919. The church with the green copper roof and the clock tower is St. Adalbert's Roman Catholic Church, built in 1905. Its congregation, once largely Polish, is now becoming Hispanic. The twin Gothic spires belong to St. Patrick's. Built in 1887, apparently by Irish Catholics weary of walking to Newark, St. Patrick's is modeled on various French cathedrals and is so big it's hard to heat.

IOO S—For part of this mile the houses are extremely close to the turnpike. From the street it is clear that the highway has sliced right through a neighborhood, and the elevated roadway casts a shadow over the remaining houses.

IOI N,S—Interchange 13A takes you to Newark Airport, Elizabeth, and Elizabeth seaport.

IOI N—Until 1994, this was the site of the William F. Halsey Service Area. Admiral Halsey, commander of U.S. naval forces in the Pacific during World War II, was born in Elizabeth. (The inn at the site of his birthplace is also gone.) Note the igloos in the turnpike maintenance yard.

IOI S—A Vintage warehouse is visible here.

IO2 N—Ikea's busiest American store is here, as is Toys-R-Us's largest. Several big box stores are being added in this complex, and an enclosed super outlet mall is being built to the north. **IO2–IO3** S—This is Newark Airport, the metropolitan area's only airport until just before World War II, when La Guardia Airport opened. Legend has it that Fiorello La Guardia, at the time mayor of New York City, refused to get off a plane when it arrived at Newark Airport, saying he had bought a ticket to New York and this was not New York, and thus was born La Guardia Airport. As it happens, the future La Guardia Airport was by then already under construction and reporters had been tipped off in advance. This very busy airport belongs to the city of Newark and is run by the Port Authority of New York and New Jersey. (For more information on Newark Airport, see Newark.) The dividing line between Union and Essex counties runs through the airport and into the Elizabeth Channel.

IO3 N,S—I lere you can see four modes of transportation cheek by jowl. Starting from the east, you have Ports Elizabeth and Newark, Conrail yards, the turnpike, and Newark Airport. The two ports make up one of the world's largest facilities for container shipping, Port Elizabeth having been built in 1958 specifically as a container port. (Port Newark dates to 1915.) Together the ports occupy over 2,100 acres and have roughly 5 million square feet of warehousing and distribution space. With their combined 36,000 linear feet of berth space, they handle not just containers but break-bulk cargo. The buildings include a facility for storing and blending orange juice concentrate and a high-tech plant that produces copper rod. Bananas and cars are two of the major imports. Keeping the channels deep enough to accommodate modern cargo ships requires considerable dredging, and disposing of the silt has environmental and political ramifications.

103 N—Shipping lines and associated industries dominate this mile; the most obvious landmarks are the Sea-Land warehouse, Cargill, and the giant Maersk cranes.

 IO_4 N,S—Interchange 14, taking you to 178, US 1 and 9, Newark Airport, and the Hudson County extension. (For the Hudson County extension, see H 1–8 at the end of the tour.) This interchange, with 27 toll booths, is the largest.

 $104\,$ N—A deepwater inlet and the Port Authority's Port Newark administration building are here.

IO4 S—The DHL plane you almost always see here stays in this spot precisely so that people will notice it. At this point the highway begins to split, the eastern branch going to the Lincoln Tunnel and the western to the George Washington Bridge.

105 N,S—This is an area of container storage, auto wreckers, small plants, trucking companies, and warehouses.

105 N-The Passaic Valley Sewer Commission has a pumping station here.

105 S—An Englehard facility occupies much of this mile.

106 N,S—Interchange 15E to Newark, Jersey City, and US 1 and 9. Oak trees were planted at this interchange in the 1980s as part of the governor's beautification program. This mile contains more warehouses, chemical companies, container storage, car dumps, and a good view of the Newark skyline.

106 N—The Newark police have a car pound and pistol range here.

106 S—The multiplex theater here replaced one of the last of the state's drive-in theaters.

107 N,S—The Pulaski Skyway crosses the turnpike. Built in the 1920s and named for the Polish general who fought with the Continental army, it soars 145 feet over the Passaic and Hackensack rivers. A daring design for its day, it cut the travel time between New Jersey's two biggest cities, Newark and Jersey City, from 25 minutes to 5. It now carries US I and 9 over the Passaic River. The turnpike crosses the Passaic River.

108 N,S—The road crosses the Hackensack River.

IO8 N—The hill you see here is a former landfill, closed in accordance with the latest environmental principles. A plan to create an artwork on the site had to be put on hold until the dump finishes settling, although some of the plantings are already in place. In the meantime, methane is being pumped from the fill, processed, and sold to Public Service. At night you can see the illuminated Newark Cathedral.

108 S—At this point you can cross over to Exit 15W.

109 N—This is Public Service Electric and Gas Company's Essex generating station. AM radio towers are visible here (see W III–II4), as are the western extension of the turnpike and the Hackensack Meadowlands Development Commission's Environment Center (see Lyndhurst).

109 S—The remains of a fallen AM tower can still be seen in the marsh.

I IO S—The dark rock, sometimes decorated with graffiti, is Snake Hill, a volcanic mass that the County of Hudson used to lease to mining interests. (For a while there were rumors that the hill would be completely mined away; that didn't happen—the turnpike, it seems, is structurally dependent on Snake Hill.) A lookout point for Continental soldiers during the Revolution, it has also been the site of a poor house, insane asylum, sanitarium, and communicable diseases hospital. In the late 19th century, it served as the inspiration for the Prudential Insurance Company's Rock of Gibraltar advertising slogan: an advertising executive on his way home from a meeting with the Prudential company struck on the idea as his train passed the hill. Cedar trees once grew in the Hackensack Meadowlands, but salt water entered the area, killing them off. Hudson County is building a park in this area; the boat launch is open, and eventually there will be playing fields and nature trails.

III S—The Alexander Hamilton Service Area. Hamilton met his future wife in New Jersey (see Morristown), he was responsible for founding the city of Paterson (see Paterson), and he met his death in New Jersey (see Weehawken).

II2 N,S—Here are interchanges 16E to the Lincoln Tunnel, Secaucus, and NJ 3, and 18E to the George Washington Bridge, 1 80, 1 95, and us 46.

II2 S—Interchange 17 is a limited-access interchange. If you are coming from the north you can exit here and head for the Lincoln Tunnel. You can also enter at 17, but only if you want to head north. In this mile are a state motor vehicle inspection station, a Public Service transformer, Meadowview Hospital, a UPS facility, and an industrial park.

II3 N—A large Meadowlands development project is here.

II4-II5 N—This is an area of warehouses.

II5 S—Note the phragmites, a tall, aggressive reed grass that is relatively tolerant of pollution. Phragmites have taken over large portions of New Jersey's wetlands, but, unfortunately, they are not as nourishing for birds and animals as some of the vegetation they have driven out. Four AM radio towers, arranged in a rectangle, can be seen, as can the bridge from the turnpike's western alignment, which looks particularly graceful.

II6 N,S—The Vince Lombardi Service Area. Early in his career Lombardi coached at an Englewood high school. There used to be a display of Lombardi memorabilia at the food-service building, but his widow removed the collection after a drug bust at the service area. Wildlife preserves border this service area (created by the turnpike to compensate for areas destroyed in construction).

117 N,S—The western alignment joins the main branch, and the turnpike ends shortly thereafter.

II7 S—This is Public Service's Bergen generating plant. The western alignment was built in 1966. It took almost a year to dredge and fill the Hackensack Meadowlands so that the road could be built. Attitudes toward building on wetlands were different then, and the Turnpike Authority was praised for its leadership in the development of engineering methods for building on swamps.

W 107 N,S—The turnpike goes under the Pulaski Skyway (see 107 N,S) and crosses the Passaic River.

W 107 N—Note the vertical-draw railroad bridge. In the next few miles there are several drawbridges.

W 107 S—Here you can cross over to exit 15E.

W 108 N,S—Interchange 15W to Newark, the Oranges, and 1 280. There are plantings of native trees and shrubs in this area.

356 New Jersey Turnpike Tour

W 109 N,S—The highway crosses the main Amtrak line.

W 109 S—In this mile there's a good view of the Newark skyline and a landfill mesa.

W IIO S—A sanitary landfill is visible here, as is the environmental and visitor center of the Richard W. DeKorte State Park (see Lyndhurst), named after a state assemblyman. Eventually the landfill will become part of the park, and gas from bacteriological decomposition will heat indoor facilities. At the park you will be able to ski, hike, camp, boat, and play tennis, softball, and football. In the meantime, the center, which concentrates on environmental concerns, is open and well worth a visit.

W III-II4 N,S In this stretch you will see a good many radio transmitters, often in groups of three or four. Salt marsh provides an efficient medium for AM radio waves, which is why so many of New York City's AM stations have their towers here.

W III N—Harmon Cove, Harmon Plaza, Meadowlands Hilton, and the Tiger Racquet Club are along this stretch. This is a Hartz Mountain development (the company used to be known for its pet products; it is now also a major real estate developer). Included in this 800-acre development, which began in the late 1960s, are townhouses, condominiums, research facilities, offices, warehouses, retail stores, a hospital, hotels, movie theaters, marinas, and industrial space.

W II2 N,S—Interchange 16W takes you to Secaucus, Rutherford, the New Jersey Sports Complex, and NJ 3.

W II2 S—This is the New Jersey Sports Complex. What is now called the Continental Airlines Arena is the building closest to the highway, but the complex also includes a racetrack and a stadium (see East Rutherford).

W II3 N,S—Interchange 18W to the George Washington Bridge, 1 80, 1 95, and us 46. More money is taken in here than at any other interchange. The highway also crosses Cedar Creek.

W 114 N,S—The road crosses Moonachie Creek. Note the poplars.

W II5 N,S—Another entrance to the Vince Lombardi Service Area (see 116 N,S). The road crosses the Hackensack River.

W II7 S—Public Service's Bergen station is here. The turnpike's western alignment joins the mainline, and the turnpike formally ends in Ridgefield Park, although the $4\frac{1}{2}$ miles to the George Washington Bridge are now owned by the Turnpike Authority. The authority in 1992 bought the $4\frac{1}{2}$ miles from the state for more than it had cost to build the first stretch of the road 40 years earlier.

Even when the Hudson County extension is not actually going north or south,

the suffix N means what is to the right as you are driving toward New York City, the suffix S what is to the right as you are driving toward Philadelphia.

H 1–2, N,S—The turnpike crosses Newark Bay. Bayonne is visible to your right as you head toward New York City, Jersey City to your left.

H I N—There are usually an impressive number of new cars unloaded on the dock here, awaiting shipment elsewhere. Oil tanks are also visible.

H ${\tt I}\,$ S—At the Newark Industrial Center you can see the Toys-R-Us warehouse.

H 2 N—A city park is along the water.

H 2 S—The Society Hill development (on totally flat land) sits on the site of the old Roosevelt Stadium (see Jersey City).

H 3 N,S—Interchange 14A to Bayonne.

H 3 N—The tracks belong to Conrail's Greenville Yards. From here on there are often good views of the New York City skyline.

H 3 S—According to one story, in one of Jersey City's dirtier election campaigns, someone jammed the elevators in this public housing project to keep its residents from voting.

H 4 N—Caven Point is a recognized birding area and a popular fishing spot. Until recently, a U.S. Army Reserve Center was here. There are good views of the Statue of Liberty.

H 4 S—Auto wreckers are prevalent in this section.

H 5 N,S—Interchange 14B takes you to Jersey City and Liberty State Park; interchange 14C, about a half-mile north of 14B, to the Holland Tunnel and eventually to a park-and-ride facility. As you come down to street level and the entrance to the tunnel, you can see Jersey City to your right (as you head toward New York City) and Hoboken to your left.

H 5 N—Liberty State Park (see Jersey City) and the Statue of Liberty are visible now. The Morris Canal basin is at the northern end of the park.

H 6-8, N,S—As the road goes through Jersey City, you may see some of the new riverside office towers and various municipal parks and other facilities. The building with the stepped side next to the three tall buildings at 7 S is part of the Jersey City Medical Center.* The very large yellow-and-white building with classical elements on the hill at 7 S is Dickinson High School.*

Index

The index is divided into the following categories:

Art exhibition spaces 359 Cemeteries 360 Churches that offer tours 360 Cultural and performing arts centers 360 Historic-house and school museums 361 Historic sites 362 Lighthouses 362 Miscellaneous attractions and tours 362 Museums 363 Natural and wildlife-management areas 366 Nature centers and animal refuges 368 Parks, gardens, and forests 368 Planetariums and observatories 370 Restored communities 371 Sports facilities 371 Theme and amusement parks 371 Towns and other communities without their own entries 371 Wineries 372 Zoos 372

Art exhibition spaces

Academy Books and Bindery: Stockton Art Center of Northern New Jersey: Oradell Artspace: Jersey City Atlantic City Art Center: Atlantic City Atlantic Community College: Mays Landing Barron Arts Center: Woodbridge Bayonne Public Library: Bayonne Ben Shahn Galleries: Wayne Boehm galleries: Trenton Bristol-Myers Squibb: Lawrenceville Camden County College: Blackwood Cape May County Art League: Cape May College Center and Presidential Galleries: Edison Township Conant Hall: Lawrenceville Courtney Gallery: Jersey City Cybis galleries: Trenton Dana Library: Newark Educational Testing Service: Lawrenceville Extension Gallery: Hamilton Township Ferry Gallery: Hackettstown Firestone Library: Princeton Fort Lee Library: Fort Lee Gallery One: Montclair Gardner A. Sage Library: New Brunswick Gateway Pub: Newton

Grounds for Sculpture: Hamilton Township Guild of Creative Art: Shrewsbury Henry T. Chauncy Conference Center: Lawrenceville Holman Hall Art Gallery: Ewing Township Hunterdon Arts Center: Clinton James Howe Gallery: Union Johnson Atelier: Hamilton Township Judicial Center: Newton Kean College: Union Korn Gallery: Madison Les Malamut Gallery: Union Lewis Parker College Center: Pemberton LRC Gallery: Paterson Main Gallery: Montclair Mariboe Art Gallery: Hightstown Mason Gross School of the Arts: New Brunswick Master's Octave: Keyport Mercer County Community College: West Windsor Township Michael Gilligan Student Union Building Gallery: Jersey City Monmouth University: West Long Branch Montclair State University: Montclair Montgomery Cultural Center: Rocky Hill

Nabisco headquarters building: East Hanover Newark Public Library: Newark New Jersey Center for Visual Arts: Summit New Jersey Designer Craftsmen Gallery: New Brunswick Ocean City Arts Center: Ocean City Ocean County College: Toms River Piscataway municipal building: Piscataway Polish Cultural Foundation: Clark Princeton University art museum: Princeton Quietude Sculpture Garden: East Brunswick Paper Mill Playhouse: Millburn Paul Robeson Center Gallery: Newark Performing Arts Center of Middle Township: Cape May Court House Prallsville industrial district: Stockton Ralph T. Reeve Cultural Center: Somerville Ramapo College Art Galleries: Mahwah Rider University Student Center: Lawrenceville Sage Library: New Brunswick Schering-Plough: Madison

Index 359

S.M.A. Fathers African Art Museum: Tenafly Somerset Art Association: Far Hills Somerset County administration building: Somerville South River library: South River Stedman Art Gallery: Camden Thompson Park: Lincroft Tomasulo Gallery: Cranford Visceglia Art Gallery: Caldwell Walsh Library Gallery: West Orange Walt Whitman Cultural Arts Center: Camden Westby Art Gallery: Glassboro West Long Branch public library: West Long Branch Westminster Arts Center: Bloomfield Woodbridge main library: Woodbridge Cemeteries Alliance Cemetery: Vineland Cedar Lawn Cemetery: Paterson Christ Episcopal Church: New Brunswick Colestown Cemetery: Cherry Hill Community cemetery: Roosevelt Ewing Church Cemetery: Ewing Township Evergreen Cemetery: Hillside Finn's Point National Cemetery: Pennsville First Reformed Church of New Brunswick: New Brunswick Fisher family cemetery: Millstone Flower Hill Cemetery: North Bergen Friends Meeting House cemetery: Barnegat Friends Meetinghouse cemetery: Haddonfield Hancock's Bridge cemetery: Hancock's Bridge Harleigh Cemetery: Camden Lafayette cemetery: Branchville Moravian cemetery: Hope Mt. Pleasant Cemetery: Newark

360

Index

Oak Summit cemetery: Frenchtown Old School Baptist Church cemetery: Hopewell Old Stone Union Church cemetery: Long Valley Old Tennent Church cemetery: Freehold Old Burial Ground: Bordentown Peters Valley cemetery: Bevans Presbyterian Church cemetery: Westfield Presbyterian Church cemetery: Woodbridge Princeton cemetery: Princeton Rahway cemetery: Rahway South River cemetery: South River St. Mary's Episcopal Church cemetery: Burlington St. Peter's Episcopal Church cemetery: Perth Amboy Trinity Church cemetery: Woodbridge Ukrainian Orthodox Memorial Church cemetery: Millstone Churches that offer tours Christ Church: Shrewsbury First Presbyterian Church: Elizabeth First Reformed Church of New Brunswick: New Brunswick Moravian Church: Swedesboro Old Paramus Reformed Church: Ridgewood Presbyterian Church: Woodbridge St. George's Episcopal Church: Pennsville St. John's Episcopal Church: Elizabeth St. Vladimir: Cassville Trinity Episcopal Old Swedes Church: Swedesboro Cultural and performing arts centers Atlantic Community College: Mays Landing Barron Arts Center: Woodbridge Battleground Arts Center: Freehold Brookdale Community College performing arts center: Lincroft

Cape May County Art League: Cape May Centenary College Performing Arts Guild: Hackettstown College of New Jersey: **Ewing Township** Count Basie Theatre: Red Bank Darress Theater: Boonton Fine Arts Center: Camden Glassboro Center for the Arts: Glassboro John Harms Center for the Arts: Englewood Long Beach Island Foundation of the Arts and Sciences: Barnegat Light Mid-Atlantic Center for the Arts: Cape May Middlesex County College: Edison Township Monmouth University: West Long Branch Montclair State University: Montclair Montgomery Cultural Center: Rocky Hill New Brunswick Cultural Center: New Brunswick New Jersey Center for Visual Arts: Summit New Jersey Performing Arts Center: Newark Nicholas Music Center: New Brunswick Oakeside-Bloomfield Cultural Center: Bloomfield Ocean City Arts Center: Ocean City Ocean County Center for the Arts: Lakewood Old Baptist Church Cultural Center: Manahawkin Old Church Cultural Center: Alpine Paramount Theater: Asbury Park Passaic County Community College: Paterson Performing Arts Center of Middle Township: Cape May Court House Perkins Center for the Arts: Moorestown Peters Valley Crafts Center: Bevans PNC Bank Arts Center: Holmdel Polish Cultural Foundation: Clark Ralph T. Reeve Cultural Center: Somerville

The Richard Stockton College of New Jersey Performing Arts Center: Pomona Rowan University School of Fine and Performing Arts: Glassboro Shea Center for the Performing Arts: Wayne Somerset Art Association: Far Hills Sony-Blockbuster Music Entertainment Centre: Camden Strand Theatre: Lakewood Union County Arts Center: Rahway Walt Whitman Cultural Arts Center: Camden Watchung Arts Center: Green Brook William Mount-Burke Theatre: Hightstown William Carlos Williams Center: Rutherford Historic-house and school museums Abbott House: Hamilton Township Abraham Clark House: Roselle Abram Demaree Homestead: Closter Acorn Hall: Morristown Adolph Strauss house: Atlantic Highlands Alexander Grant House: Salem Alfonso L. Eakin house: Salem Allen House: Shrewsbury Allgor-Barkalow Homestead Museum: Neptune Bainbridge House: Princeton Ballantine House: Newark Barclay Farmstead: Cherry Hill Bard-How House: Burlington Bedensville Schoolhouse: Rocky Hill Belcher-Ogden House: Elizabeth Benjamin Temple house: Ewing Township Blackledge-Kearney House: Alpine Blackwells Mills Canal House: Griggstown Bonnell house: Elizabeth Bowlsby House: Parsippany-Troy Hills

Boxwood Hall: Elizabeth Bridget Smith-Ida McConnell House: Dover Buccleuch Mansion: New Brunswick Buckelew's Mansion: Jamesburg Burrough-Dover House: Pennsauken **Burrowes Mansion** Museum: Matawan C. A. Nothnagle log house: Paulsboro Cadmus House: Fair Lawn Campbell Christie House: **River** Edge Cannonball House: Springfield Cannonball Osborn House: Scotch Plains Carter House: Summit Clara Barton schoolhouse: Bordentown Clarke House: Princeton Clark House: Roselle Compton house: Mauricetown Cornelius Low House: Piscataway Covenhoven House: Freehold Craftsman Farms: Parsippany-Troy Hills Craig House: Freehold Crane-Phillips house: Cranford Deacon Hetfield house: Mountainside Demarest House: River Edge Dey Mansion: Wayne Dickeson House: Woodstown Dirck Gulick house: Rocky Hill Doric House: Flemington Drake House: Plainfield Dr. Robinson's Plantation: Clark Eldridges Hill School: Woodstown Elias Van Bunschooten Museum: Sussex Elizabeth Compton House: Mauricetown Ely house: Hightstown Emlen Physick House: Cape May First Rosenkrans House: Walpack Township Fleming Castle: Flemington Force Homestead: Livingston Foster-Armstrong house: Montague

Ford Mansion: Morristown Frankford Plains Octagon Schoolhouse: Branchville Gabreil Daveis Tavern: Blackwood Gibbon house: Greenwich Gilder House: Bordentown Glenmont: West Orange Grant House: Salem Greenfield Hall: Haddonfield Griffith Morgan House: Pennsauken Guest House: New Brunswick Hancock House: Hancock's Bridge Harrison House: Roseland Henry S. Guest House: New Brunswick Hermitage: Ho-Ho-Kus Hoboken Historical Museum: Hoboken Holmes-Hendrickson house: Holmdel Hopper-Goetschius house: Mahwah Hunter-Lawrence-Jessup House: Woodbury Indian King Tavern House Museum: Haddonfield Isaac Van Campen Inn: Walpack Township Isaac Watson house: Hamilton Township Israel Crane House: Montclair James and Ann Whitall house: National Park James Fenimore Cooper House: Burlington James Lawrence House: Burlington John Holmes House: Cape May Court House John Rosencrantz house: Ho-Ho-Kus Johnson Ferry House: Titusville Joyce Kilmer's birthplace: New Brunswick Kearny Cottage: Perth Amboy Kingsland Manor: Nutley Kuser Farm Mansion: Hamilton Township Lambert Castle: Paterson Littell-Lord Farmhouse Museum: Berkeley Heights Low House: Piscataway Macculloch Hall Historical Museum: Morristown

Marlpit Hall: Middletown Marshall House: Lambertville Mead-Van Duvne house: Wayne Merchants and Drovers Tavern: Rahway Metlar House-Peter Bodine House: Piscataway Miller-Cory House: Westfield Montrose Schoolhouse: Colts Neck Morven: Princeton Nathaniel Bonnell house: Elizabeth Nathaniel Drake House: Plainfield Neldon-Roberts Schoolhouse: Montague Oak Summit School: Frenchtown Old Dutch Parsonage: Somerville Old Monroe Schoolhouse: Branchville Peachfield: Mount Holly Peter Mott house: Haddonfield Physick House: Cape May Pomona Hall: Camden Port Mercer Canal House: Lawrenceville Potter's Tavern: Bridgeton Price's Switch School: Vernon Township Proprietary House: Perth Amboy Richard Somers Mansion: Somers Point Ringwood Manor: Ringwood **Risley Homestead: Somers** Point Robinson Plantation: Clark Rockingham: Rocky Hill Roseville School: Stanhope Samuel Dickeson House: Woodstown Schuyler-Hamilton House: Morristown Seashore Cottage: Ocean City Shippen Manor: Oxford Shoal Harbor Museum: Port Monmouth Skylands Manor: Ringwood Smith-Cadbury Mansion: Moorestown Somers Mansion: Somers Point Steuben House: River Edge Strauss house: Atlantic Highlands

Temple House: Ewing Township Thomas P. Clarke House: Princeton Trent House: Trenton Tunis-Ellicks House: Morristown Union House: Millville Van Allen House: Oakland Van Bunschooten Museum: Sussex Van Campen Inn: Walpack Township Van Riper-Hopper House: Wavne Van Veghten House: Bridgewater Van Voorhees-Ouackenbush-Zabriskie House: Wyckoff Village Inn: Englishtown Wallace House: Somerville Whitall House: National Park Whitebriar Farmhouse: Burlington Whitman House and Library: Camden Whitman Stafford Farmhouse: Laurel Springs Wicoff House: West Windsor Township William Trent's House: Trenton Woodruff House: Hillside Zaitz-Schenck farmhouse and tenant house: West Windsor Township Historic sites Alliance: Vineland Batsto: Hammonton Battle Monument: Trenton Easton Tower: Paramus Feltville: Berkeley Heights, Mountainside Fort Nonsense: Morristown Jockey Hollow: Morristown Long Pond Ironworks: Ringwood Monmouth Battlefield: Freehold Pahaquarry copper mines: Blairstown Prallsville industrial district: Stockton Princeton Battlefield: Princeton Red Bank Battlefield: National Park Woolman Memorial: Mount Holly

Lighthouses Absecon Lighthouse: Atlantic City Cape May Point lighthouse: Cape May Point East Point Lighthouse: Mauricetown Finn's Point Rear Range Light: Pennsville Hereford Inlet Lighthouse: The Wildwoods Navesink Light Station: Highlands Old Barney: Barnegat Light Sandy Hook Lighthouse: I lighlands Twin Lights Historic Site: Highlands Miscellaneous attractions and tours Academy of Culinary Arts: Mays Landing A. J. Meerwald: Mauricetown Alliance for a Living Ocean: Beach Haven Battle Monument: Trenton Bill Healy Crystal: Flemington Black River & Western Steam Railroad: Flemington, Lambertville, Ringoes Cape May Whale Watch and Research Center: Cape May Catacombs: Newark Clevenger Glassworks: Clayton Cowtown Rodeo: Woodstown Drumthwacket: Princeton Emmons Dairy: Pemberton Englishtown Auction Sales: Englishtown Ford Motor Company: Edison Township Georgian Court College: Lakewood Great Falls: Paterson Green Meadows Farm: Roseland Historic Preservation Committee: Beach Haven Holocaust Resource Center: Union Johnson Atelier: Hamilton Park Library Company of Burlington: Burlington Life Safety Complex: Mahwah

Lucy, the Margate elephant: Margate City Marimba Productions: Asbury Park Mcadowlands Sports Complex: East Rutherford Model Railroad Club: Union Mount Hope mine tours: Rockaway Naval Air Engineering Station: Lakehurst Newark Airport tours: Newark New Jersey State Aquarium: Camden New Jersey marine terminals: Newark New York harbor cruises: Weehawken Oyster Creek Nuclear Generating Station: Forked River Pacific Southern Model Railway: Rocky Hill Peters Valley Crafts Center: Bevans Philip Alampi Beneficial Insect Rearing Laboratory: Ewing Township Raccoon Ridge: Blairstown Radburn: Fair Lawn Reeds Beach: Cape May Court House Rockport Pheasant Farm: Hackettstown Rova Farms: Cassville Salem County Courthouse: Salem Skylands Park: Branchville Soclair Music Festival: Clinton Solberg Airport: Bridgewater Stanley Theater: Jersey City Terhune Orchards: Lawrenceville United States Coast Guard training station: Cape May U.S. Bicycling Hall of Fame: Somerville USET headquarters: Peapack and Gladstone Vineland produce auction: Vineland Visiting Nurse Association of Central New Jersey: Middletown Waterfront Park Stadium: Trenton William J. Brennan Court House: Jersey City WOR-TV: Secaucus

Museums Abbott House: Hamilton Township Abraham Clark House: Ruselle Acorn Hall: Morristown Adolph Strauss house: Atlantic Highlands Afro-American Historical and Cultural Museum: Jersey City Alexander Grant House: Salem Allaire Village: Farmingdale Allen House: Shrewsbury Allgor-Barkalow Homestead Museum: Neptune American Hungarian Museum: Passaic American Labor Museum: Haledon ARDEC Museum: Dover Armstrong museum: Alpine Army Communications-Electronic Museum: Eatontown Atlantic City Historical Museum: Atlantic City Atlantic County Historical Society museum: Somers Point Aviation Hall of Fame & Museum of New Jersey: Teterboro Bainbridge House: Princeton Ballantine House: Newark Barclay Farmstead: Cherry Hill Barnegat Bay Decoy and Baymen's Museum: Tuckerton Barnegat Historical Society Heritage Center: Barnegat Barnegat Light Museum: Barnegat Light Batsto: Hammonton Belcher-Ogden House: Elizabeth Bell Telephone Laboratories: Berkeley Heights Belskie Museum of Art and Science: Closter Benjamin Temple House: Ewing Township Bergen County Museum of Arts and Science: Paramus Bergen Fire Department Museum: Bayonne Blackledge-Kearney House: Alpine Blauvelt Art Museum: Oradell

Bloomfield Historical Society Museum: Bloomfield Bonnell House: Elizabeth Bordentown Historical Society Museum: Bordentown Boxwood Hall: Elizabeth Bover Historical Museum: The Wildwoods Buccleuch Mansion: New Brunswick Buckelew's Mansion: Jamesburg **Burlington County Prison** Museum: Mount Holly Burrough-Dover House: Pennsauken **Burrowes Mansion** Museum: Matawan Cadmus House: Fair Lawn Campbell Christie House: River Edge Cannonball House: Springfield Cannonball Osborn House: Scotch Plains Cape May County Historical and Genealogical Society museum: Cape May Court House Cape May Fire Museum: Cape May Carter House: Summit C.A.S.E. Museum of Russian Contemporary Art in Exile: Jersey City Chesterfield Township Historical Society museum: Crosswicks Chief John T. Brennan Fire Museum: Bayonne Church Landing Farm Museum: Pennsville Church of the Presidents: Long Branch Civil War and Native American Museum: Hamilton Township Clarke House: Princeton Clark House: Roselle Cleveland birthplace: Caldwell Clinton Historical Museum Village: Clinton Cold Spring Village: Cape May Compton House: Mauricetown Contemporary Victorian Museum: Trenton Cooper Mill: Chester

Cornelius Low House: Piscataway Corson Poley Center: Burlington Covenhoven House: Freehold Craftsman Farms: Parsippany-Troy Hills Craig House: Freehold Cranbury Museum: Cranbury Crane House: Montclair Crane-Phillips House: Cranford Croydon Hall: Middletown Culver Brook Restoration Foundation Museum: Branchville Deacon Hetfield House: Mountainside Demarest House: River Edge Dey Mansion: Wayne Dickeson House: Woodstown Discovery House: East Brunswick Displayworld Stone Museum: Jamesburg Doll Castle Doll Museum: Washington Doric House: Flemington Drake House: Plainfield Dr. Robinson's Plantation: Clark East Brunswick Museum: East Brunswick East Jersey Olde Towne: Piscataway Eatontown Museum: Eatontown Edison laboratories: West Orange Edison Memorial Tower: Edison Township Ehrengart Museum: Sparta Elias Van Bunschooten Museum: Sussex Elizabeth Compton House: Mauricetown Ellarslie: Trenton Ely House: Hightstown Emlen Physick House: Cape May Eureka Fire Museum: Milltown Finn's Point Rear Range Light: Pennsville Firefighters Museum of Southern New Jersey: Absecon First Presbyterian Church: Elizabeth

First Rosenkrans House: Walpack Township Fleetwood Museum of Art and Photographica: Green Brook Fleming Castle: Flemington Flemington Speedway museum: Flemington Force Homestead: Livingston Ford Mansion: Morristown Fort Hancock Museum: Highlands Fosterfields Living Historical Museum: Morristown Franklin Mineral Museum: Franklin Friendship School: Ocean City Garden State Discovery Museum: Cherry Hill Garretson Forge and Farm Restoration: Fair Lawn George Boyer Historical Museum: The Wildwoods George Woodruff Indian Museum: Bridgeton Gibbon House: Greenwich Giffordtown Schoolhouse Museum: Tuckerton Glenmont: West Orange Gloucester County Historical Society museum: Woodbury Grant House: Salem Greenfield Hall: Haddonfield Griffith Morgan House: Pennsauken Griggstown Mule Tenders Barracks Museum: Griggstown Guest House: New Brunswick Hackensack Meadowlands Environment Center: Lyndhurst Hackettstown Historical Society museum: Hackettstown Haddon Fire Company museum: Haddonfield Haddon Heights Historical Society museum: Haddonfield Hall of Fame: Bridgeton Hammonton Historical Society museum: Hammonton Hancock House: Hancock's Bridge Harrison House: Roseland Havens Homestead Museum: Lakewood

Henry S. Guest House: New Brunswick Hereford Inlet Lighthouse: The Wildwoods Heritage Glass Museum: Glassboro Hermitage: Ho-Ho-Kus Hiram Blauvelt Art Museum: Oradell Historic Cold Spring Village: Cape May Historic Speedwell: Morristown Holcombe-Jimison Farmstead Museum: Lambertville Holmes-Hendrickson House: Holmdel Hope museum: Hope Hopewell Museum: Hopewell Howell Living History Farm: Titusville Hungarian Heritage Center: New Brunswick Hunterdon Historical Museum: Clinton Hunter-Lawrence-Jessup House: Woodbury Indian King Tavern House Museum: Haddonfield Isaac Van Campen Inn: Walpack Township Israel Crane House: Montclair Jackson Township schoolhouse museum: Cassville James and Ann Whitall House: National Park James Fenimore Cooper House: Burlington Jane Voorhees Zimmerli Art Museum: New Brunswick Jersey City Museum: Jersey City John Dubois Maritime Museum: Greenwich John Holmes House: Cape May Court House John Taylor house: Boonton Joyce Kilmer's birthplace: New Brunswick Kearny Cottage: Perth Amboy Kearny Museum: Kearny Kilmer's birthplace: New Brunswick Kingsland Manor: Nutley Kirby's Mill Museum: Medford Kuser Farm Mansion and Park: Hamilton Township Lake Hopatcong Historical

Society museum: Hopatcong Lakehurst Historical Society Museum: Lakehurst Lakeview: Jamesburg Lambert Castle: Paterson Liberty Science Center: Jersey City Littell-Lord Farmhouse Museum: Berkeley Heights Little Red Schoolhouse Museum (Bergen County): Lvndhurst Little Red School House Museum (Morris County): Madison Long Beach Historical Society Museum: Beach Haven Longstreet Farm: Holmdel Low House: Piscataway Lower Alloway Historical Museum: Hancock's Bridge Macculloch Hall Historical Museum: Morristown MacKenzie Museum and Library: Farmingdale Marine Mammal Stranding Center: Brigantine Marlpit Hall: Middletown Maritime Traditions of Delaware Bay Museum: Mauricetown Marshall House: Lambertville Matchbox Road Museum: Vineland Meadowlands Muscum: Rutherford Merabash: Bordentown Merchants and Drovers Tavern: Rahway Merchantville Historical Society collection: Cherry Hill Meredith Havens Fire Museum: Trenton Metlar-Bodine House: Piscataway Middlesex County Museum: Piscataway Middletown Township Historical Society museum: Middletown Millbrook Village: Walpack Township Millburn-Short Hills Historical Society museum: Millburn Miller-Cory House: Westfield

Milltown Museum: Milltown Millville Army Airfield Museum: Millville Millville Historical Society museum: Millville Monmouth County Historical Association museum: Freehold Monmouth Museum and Cultural Center: Lincroft Montclair Art Museum: Montclair Moorestown Historical Society museum: Moorestown Morris County Historical Society museum: Morristown Morris Museum: Morristown Morven: Princeton Mount Holly Schoolhouse museum: Mount Holly Museum of Early Trades and Crafts: Madison Nail Mill Office Museum: Bridgeton Nathaniel Bonnell House: Elizabeth Nathaniel Drake House: Plainfield Neptune Historical Museum: Neptune Newark Museum: Newark New Jersey Children's Museum: Paramus New Jersey Firemen's Museum: Boonton New Jersey Historical Society museum: Newark New Jersey Museum of Agriculture: New Brunswick New Jersey Naval Museum: Hackensack New Jersey State Museum: Trenton New Providence Historical Society Museum: Berkeley Heights New Sweden Farmstead Museum: Bridgeton Newton Fire Museum: Newton Northlandz:Flemington North Plainfield Exempt Firemen's Museum: Green Brook Noves Museum: Oceanville Nutley Historical Society museum: Nutley

Ocean City Historical Museum: Ocean City Ocean County Historical Society Museum: Toms River Ocean Gate Historical Society museum: Toms River Ocean Township Historical Museum: West Long Branch Old Ardena Schoolhouse: Farmingdale Old Barracks: Trenton Old City Hall: Bordentown Old Dutch Parsonage: Somerville Old Forge Museum: Millstone Old Masonic Lodge: Trenton Old Millstone Forge Association blacksmith museum: Millstone Old Monroe Schoolhouse: Branchville Old Schoolhouse and Firehouse Museum: Franklin Old Schoolhouse Museum: Forked River Old Station Museum: Mahwah Old Stone House Museum: Ramsey Old Town Hall Museum: Mullica Hill Old Vincentown Town I Iall: Medford Parsippany-Troy Hills historical museum: Parsippany-Troy Hills Pascack Historical Society Museum: Park Ridge Passaic County Historical Society museum: Paterson Paterson Museum: Paterson Peachfield: Mount Holly Perth Amboy ferry slip: Perth Amboy Pilesgrove-Woodstown Historical Society museum: Woodstown Pomona Hall: Camden Port Mercer Canal House: Lawrenceville Post Office Museum: Little Silver Princeton Historical Society museum: Princeton Princeton University Art Museum: Princeton

Proprietary House: Perth Amboy Ralston museum: Mendham Rancocas Indian Reservation museum: Mount Holly Richard Somers Mansion: Somers Point Ridge and Valley Conservancy: Blairstown Ringwood Manor: Ringwood Ripley's Believe It or Not Museum: Atlantic City **Risley Schoolhouse** Museum: Mays Landing Robinson Plantation: Clark Rockingham: Rocky Hill Roebling Historical Society display: Roebling Roselle Park Museum: Roselle **Rutgers University** Geological Museum: New Brunswick Salem County Historical Society museum: Salem Samuel Dickeson House: Woodstown Schoolhouse Museum: Ridgewood Schuyler-Hamilton House: Morristown Seabrook Educational and Cultural Center: Bridgeton Sea Isle City Historical Museum: Stone Harbor Shippen Manor: Oxford Shipwreck museum: Long Branch Shoal Harbor Museum: Port Monmouth Shrewsbury Historical Society museum: Shrewsbury S.M.A. Fathers African Art Museum: Tenafly Smith-Cadbury Mansion: Moorestown Smithville County Park museum: Mount Holly Somers Mansion: Somers Point Space Farms Zoo and Museum: Beemerville Speedwell: Morristown Springfield Historical Society museum: Springfield Spring Lake Historical Society museum: Spring Lake State police museum: Ewing Township

Steamboat Dock Museum: Keyport Steam-engine museum: Hackensack Sterling Hill Mining Museum: Franklin Steuben House: River Edge Stillwater Museum: Newton Stone Store and Museum: Manahawkin Strauss house: Atlantic Highlands Sussex County Historical Society museum: Newton Temple House: Ewing Township Terrill Tavern: Rahway Thomas A. Edison laboratories: West Orange Thomas A. Edison Memorial Tower: Edison Township Thomas Force House: Livingston Thomas P. Clarke House: Princeton Thomas Warne Historical Museum and Library: Matawan Toms River Seaport Society Museum: Toms River Township of Lebanon Museum: Glen Gardner Trent House: Trenton Trenton City Museum: Trenton Tunis-Ellicks House: Morristown Twin Lights Historic Site: Highlands Ukrainian Orthodox Memorial Church Museum: Millstone Union Township Historical Society Museum: Union United States Golf Association museum: Far Hills University of Medicine and Dentistry: Newark Van Allen House: Oakland Van Bunschooten Museum: Sussex Van Campen Inn: Walpack Township Van Riper-Hopper House: Wavne Van Voorhees-Quackenbush-Zabriskie House: Wyckoff Vincentown Schoolhouse museum: Medford Vincentown-Tabernacle

Telephone Museum: Medford Vincentown two-cell lockup: Medford Vineland Historical and Antiquarian Society museum: Vineland Volendam Windmill Museum: Milford Wallace House: Somerville Warren County Historical and Genealogical Society Museum: Belvidere Washington Township Historical Society museum: Long Valley Waterloo Village: Stanhope Wayne Museum: Wayne Wetlands Institute and Museum: Stone Harbor Wheaton Village: Millville Whippany Railway Museum: Whippany Whitall House: National Park Whitebriar Farmhouse: Burlington White Township Museum: Belvidere Whitman House and Library: Camden Whitman-Stafford Farmhouse: Laurel Springs Wicoff House: West Windsor Township William Trent's House: Trenton Woodruff House: Hillside Woolman Memorial: Mount Holly Wortendyke Dutch Barn: Park Ridge Zimmerli Art Museum: New Brunswick Natural and wildlifemanagement areas Absecon Wildlife Management Area: Absecon Absegami Trail Natural Area: Tuckerton Assunpink Wildlife Management Area: Roosevelt Baldwin Lake Wildlife Management Area: Pennington Batsto Natural Area: Hammonton Bear Creek Reserve: Egg Harbor City

Bearfort Mountain Natural Area: Highland Lakes Bear Swamp Wildlife Management Area: Branchville Beaver Swamp Wildlife Management Area: Cape May Court House Bennett Bogs Preserve: Cape May Bevan Wildlife Management Area: Millville Black River Wildlife Management Area: Chester Butterfly Bogs Wildlife Management Area: Cassville Buttermilk Falls: Mendham Cape May National Wildlife Refuge: Cape May Court House Cape May Wetlands Wildlife Management Area: Ocean City Capoolong Creek Wildlife Management Area: Clinton Cedar Ridge Trail: Hopewell Cedar Swamp Natural Area: Pemberton Cheesequake Natural Area: Matawan Clarks Pond Wildlife Management Area: Bridgeton Clinton Wildlife Management Area: Clinton Cold Brook Preserve: Oldwick Colliers Mills Wildlife Management Area: Cassville Cook Natural Area: Kingston Dennis Creek Wildlife Management Area: Woodbine Dismal-Harmony Natural Area: Mendham Dismal Swamp: Metuchen Dix Wildlife Management Area: Bridgeton Drvden Kuser Natural Area: Sussex Edward G. Bevan Wildlife Management Area: Millville Edwin B. Forsythe National Wildlife Refuge: Oceanville Fairview Farms: Far Hills

Fairview Lake YMCA camp: Newton Fisherman's Cove Conservation Area: Manasquan Flatbrook-Roy Wildlife Management Area: Bevans Glassboro Wildlife Management Area: Clayton, Glassboro Great Bay Boulevard Wildlife Management Area: Tuckerton Great Swamp National Wildlife Refuge: Basking Ridge Greenbrook Sanctuary: Tenafly Greenwood Forest and Pasadena Wildlife Management Area: Forked River Hainesville Wildlife Management Area: Branchville, Montague Hamburg Mountain Wildlife Management Area: Vernon Township Higbee Beach Wildlife Management Area: Cape May Point Jockey Hollow Environmental Studies Center: Mendham John Dryden Kuser Natural Area: Sussex Ken Lockwood Gorge Wildlife Management Area: Glen Gardner Killcohook Coordination Area: Pennsville Liberty Park Natural Area: Jersey City Little Brook Sanctuary: Bernardsville Lost Brook Preserve: Tenafly McBurney Woods Preserve: Hopewell Mad Horse Creek Wildlife Management Area: Hancock's Bridge Manahawkin Wildlife Management Area: Manahawkin Manasquan River Wildlife Management Area: Manasquan Mashipacong Bogs: Montague Medford Wildlife Management Area: Medford Menantico Ponds Wildlife Management Area: Millville

Merrill Creek Environmental Resource Center: Phillipsburg Mountain Lake Nature Preserve. Princeton Musconetcong Gorge Nature Preserve: Milford Peaslee Wildlife Management Area: Millville Pequest Wildlife Management Area: Oxford Pleasant Valley Open Spaces: Hopewell Prospertown Lake Wildlife Management Area: Cassville Pyramid Mountain Historic Area: Kinnelon Ramapo Lake Natural Area: Oakland Rancocas Natural Area: Mount Holly Saw Mill Creek Wildlife Management Area: Lyndhurst Schulman Tract: Cassville Sourland Mountain Preserve: Rocky Hill Sourland Mountain Reservation: Hopewell Sunfish Pond Natural Area: Blairstown Supawna Meadows National Wildlife Refuge: Pennsville Swimming River Natural Area: Red Bank Taylor Wildlife Refuge: Riverton Tillman's Ravine Natural Area: Branchville Troy Meadows: East Hanover Turkey Swamp Wildlife Management Area: Freehold Wallkill River National Wildlife Refuge: Vernon Township Walpack Wildlife Management Area: Walpack Township Wanaque Wildlife Management Area: Highland Lakes, Ringwood Wawayanda Hemlock Ravine Natural Area: Highland Lakes Wawayanda Swamp Natural Area: Highland Lakes Whittingham Wildlife Management Area: Newton Wildcat Ridge Wildlife

Index 367

Management Area: Rockaway Winslow Wildlife Management Area: Hammonton Woodbridge River Sanctuary: Woodbridge Woodfield Reservation: Princeton Nature centers and animal refuges Bergen County Wildlife Center: Wyckoff Cape May Bird Observatory: Cape May Point Cape May Migratory Bird Refuge: Cape May Point Closter Nature Center: Closter Cooper Environmental Center: Toms River Cora Hartshorn Arboretum and Bird Sanctuary: Millburn Crowley Nature Center: Paterson Elizabeth D. Kay Environmental Center: Chester Estell Manor nature education center: Mays Landing Flat Rock Brook Center: Englewood Forest Resource Education Center: Cassville Great Swamp Outdoor Education Center: Chatham Hackensack Meadowlands **Environment Center:** Lyndhurst Hartshorn Arboretum: Millburn Huber Woods environmental center: Highlands Island Beach State Park nature center: Seaside Park James A. McFaul Wildlife Center: Wyckoff lockey Hollow Environmental Studies Center: Mendham John Crowley Nature Center: Paterson Lord Stirling Environmental Education Center: Basking Ridge Lorrimer Sanctuary and Nature Center: Franklin Lakes McFaul Wildlife Center: Wyckoff

Marine Mammal Stranding Center: Brigantine Mercer County Wildlife Rehabilitation Center: Titusville Merrill Creek Environmental Resource Center: Phillipsburg Mohican Outdoor Center: Blairstown Montclair Hawk Lookout: Montclair Nature Center of Cape May: Cape May Overpeck County Park: Fort Lee Owl Haven: Freehold PAWS Farm Nature Center: Mount Laurel Pequest Trout Hatchery and Natural Resource Education Center: Oxford Poricy Park Nature Center: Middletown Raccoon Ridge: Blairstown Rancocas Nature Center: Mount Holly Raptor Trust: Basking Ridge Ridge and Valley Conservancy: Blairstown St. Hubert's Giralda: Madison Scherman-Hoffman Sanctuaries: Bernardsville Stone Harbor Bird Sanctuarv: Stone Harbor Stony Brook-Millstone Watershed Association: Pennington Tenafly Nature Center: Tenafly Trailside Nature and Science Center: Mountainside Washington Crossing State Park nature center: Titusville Weis Ecology Center: Ringwood Wells Mills Nature Center: Barnegat Wetlands Institute: Stone Harbor Wharton Forest Nature Center: Hammonton Woodford Cedar Run Wildlife Refuge: Medford Parks, gardens, and forests Abram S. Hewitt State Forest: Highland Lakes Allaire State Park: Farmingdale

Allamuchy Mountain Park: Hackettstown, Stanhope Alonzo F. Bonzal wildlife preserve: Montclair Ambrose Dotys Park: Piscataway A. Paul King County Park: Manahawkin Ash Brook Reservation: Clark, Scotch Plains Bamboo Brook Outdoor Education Center: Peapack and Gladstone Barnegat Lighthouse State Park: Barnegat Light Bass River State Forest: Tuckerton Bayonne Park: Bayonne Baysholm Conservation Area: Freehold Birch Grove Park: Somers Point Belleplain State Forest: Woodbine Bonzal wildlife preserve: Montclair Bovd Park: New Brunswick Branch Brook Park: Newark Briant Park: Summit Brookdale Park: Bloomfield, Montclair Buccleuch Park: New Brunswick Buck Hill Park: Mendham Bull's Island: Kingston, Stockton Cadwalader Park: Trenton Campgaw Mountain County Reservation: Mahwah Cape May County Park: Cape May Court House Cape May Migratory Bird Refuge: Cape May Point Cape May Point State Park: Cape May Point Cattus Island Park: Toms River Cedar Brook Park: Plainfield Charles Rogers Wildlife Sanctuary: Princeton Cheesequake State Park: Matawan City of Bridgeton Park: Bridgeton Colonial Park: Millstone Community Park North: Princeton Cora Hartshorn Arboretum and Bird Sanctuary: Millburn Corson's Inlet State Park:

Ocean City

Cross Estate Gardens: Bernardsville Crosswicks Creek Park: Allentown Darlington County Park: Mahwah, Ramsey Davidson's Mill Pond Park: South Brunswick Deep Cut Park: Middletown Deer Path Park: Clinton DeKorte State Park: Lyndhurst Delaware and Raritan Canal State Park: Griggstown, Kingston, Lambertville, Princeton, Rocky Hill, Stockton Delaware Water Gap National Recreation Area: Bevans, Blairstown, Walpack Township Dorbrook Recreation Area: Colts Neck Double Trouble State Park: Forked River Dr. Ulysses S. Wiggins Waterfront Park: Camden Duke Gardens: Somerville Duke Island Park: Bridgewater Durand Conservation Area: Freehold Eagle Rock Reservation: West Orange East Brunswick Community Park: East Brunswick East Freehold Park: Freehold Eastside Park: Paterson Echo Lake Park: Mountainside Edwin B. Forsythe National Wildlife Refuge, Brigantine Division: Oceanville Estell Manor Park: Mays Landing Etra Lake Park: Hightstown Farney State Park: Rockaway Flat Rock Brook Center: Englewood Forsythe National Wildlife Refuge, Brigantine Division: Oceanville Fort Billings Park: Paulsboro Fort Lee Historic Park: Fort Lee Fort Mott State Park: Pennsville Frelinghuysen Arboretum: Morristown Garden for the Blind and Physically Handicapped: Woodbridge

Garret Mountain Reservation: Paterson Gaskill Park: Mays Landing Gateway National Recreation Area: Highlands Gilder Field: Bordentown Great Swamp National Wildlife Refuge: Basking Ridge, Chatham Green Brook Park: Plainfield Greenbrook Sanctuary: Tenafly Greenwich Lake Park: Paulsboro Hackensack River park: Hackensack Hacklebarney State Park: Chester Hamilton Plaza: Weehawken Hartshorne Woods Park: Highlands Hedden County Park: Dover Helen Hartley Jenkins Woods: Morristown Hemknoll Farm: Hope Herrontown Woods Arboretum: Princeton High Mountain Wilderness Park: Wavne High Point State Park: Sussex Holmdel Arboretum: Holmdel Holmdel Park: Holmdel Hopatcong State Park: Hopatcong Howard A. Van Vleck Arboretum: Montclair Howell Park and Golf Course: Farmingdale Huber Woods Park: Highlands Hunterdon County Arboretum: Clinton Hutcheson Memorial Forest: Millstone Institute for Advanced Study woods: Princeton Ireland Brook Park: East Brunswick Island Beach State Park: Seaside Park Jamesburg County Park: Helmetta Jenny Jump State Forest: Hope Jockey Hollow Encampment Area: Morristown John A. Roebling Park: Hamilton Township Johnson Park: Piscataway Kill van Kull Park: Bayonne

Lake Shenandoah Park: Lakewood Learning's Run Gardens and Colonial Farm: Cape May Court House Lebanon State Forest: Pemberton Lenape Park: Mays Landing Leonard J. Buck Garden: Far Hills Lewis Morris Park: Morristown Liberty State Park: Jersey City Lincoln Park: Jersey City Little Brook Sanctuary: Bernardsville Loantaka Brook Reserva tion: Morristown Long Pond Ironworks State Park: Ringwood Lord Stirling Park: Basking Ridge McConnell Park: Cranford Mahlon Dickerson Reservation: Jefferson Township Manasquan Reservoir: Farmingdale Mercer County Park: West Windsor Township Merrill Park: Woodbridge Mill Creek Park: Burlington Millington: Basking Ridge Mills Reservation: Montclair Milton Lake Park: Rahway Mindowaskin Park: Westfield Monmouth Battlefield State Park: Freehold Montclair Hawk Lookout: Montclair Monument Park: Freehold Morristown National Historical Park: Morristown Mount Paul Memorial Park: Mendham Mountainside Park: Montclair Mt. Mitchill Scenic Overlook: Atlantic Highlands Musconetcong Gorge Nature Preserve: Milford New Bridge Landing Historic Park: River Edge New Jersey Brigade Area: Bernardsville, Morristown New Jersey seedling nursery: Cassville Nomahegan Park: Cranford North Branch Park: Bridgewater

North Hudson Park: North Bergen Norvin Green State Forest: Ringwood Ocean County Park: Lakewood Old Troy Park: Parsippany-Troy Hills Overlook Park: Paterson Overpeck County Park: Fort I ee Pakim Pond: Pemberton Palisades Interstate Park: Alpine Parvin State Park: Vineland Passaic River County Park: Berkeley Heights Passaic River Park: Summit Patriots County Park: Cassville Patriots' Path: Mendham, Morristown Penn State Forest: Hammonton Pequannock Watershed: Highland Lakes Pigeon Swamp State Park: South Brunswick Pine Park: Lakewood Poricy Park Nature Center: Middletown Preakness Valley Park: Wayne Presby Iris Gardens: Montclair Princeton Battlefield State Park: Princeton Prospertown Lake: Cassville Rahway River Parkway: Rahway Ramapo Mountain State Forest: Oakland Ramapo Valley County Reservation: Mahwah Rancocas State Park: Mount Holly Reeves Reed Arboretum: Summit Richard W. DeKorte Park: Lvndhurst Rifle Camp Park: Paterson Riker Hill Art Park: Livingston Ringwood State Park: Ringwood Riverfront Park Conservation area: Rahway Riverside County Park: Lyndhurst Riverview Park: Pennsville Rogers Wildlife Sanctuary: Princeton

Roosevelt Park: Edison Township Rosedale Park: Pennington Round Valley Recreation Area: Clinton Rutgers Gardens: New Brunswick Saddle River County Park: Paramus Sandy Hook: Highlands Sayen Park Botanical Gardens: Hamilton Township Schooley's Mountain Park: Long Valley Scotland Run Park and Wilson Lake: Clayton Seven Presidents Oceanfront Park: Long Branch Shakespeare Garden: Madison Shark River Park: Neptune Shepherd Lake: Ringwood Silas Condict Park: Kinnelon Skylands Manor: Ringwood Smithville County Park: Mount Holly South Mountain Reservation: Millburn, West Orange Sperry Park: Cranford Spruce Run Recreation Area: Clinton Stafford Township Historical Society Heritage Park: Manahawkin Stokes State Forest: Branchville Stony Brook-Millstone Watershed Association: Pennington Sunset Beach: Cape May Point Supawna Meadows National Wildlife Refuge: Pennsville Swartswood State Park: Newton Tamaques Park: Westfield Tatum Park: Middletown Telegraph Hill Park: Holmdel Thomas A. Edison Park: Edison Township Thompson Park (Middlesex County): Jamesburg Thompson Park (Monmouth County): Lincroft Tourne Park: Boonton Troy Meadows: East Hanover Turkey Swamp Park: Freehold

Union Lake: Millville Van Saun Park: Paramus, River Edge Veterans Park: Hamilton Township Voorhees State Park: Glen Gardner Walnford Village: Allentown Warinanco Park: Roselle Warren Park: Woodbridge Washington Crossing State Park: Titusville Washington Park: Jersey City Washington Rock State Park: Green Brook Washington Spring Park: Paramus Washington Valley Park: Bridgewater Watchung Reservation: Berkeley Heights, Mountainside, Scotch Plains, Summit Watsessing Park: Bloomfield, East Orange Wawayanda State Park: Highland Lakes Weequahic Park: Newark Wells Mills County Park: Barnegat West Essex Park: Roseland West Hudson Park: Harrison Westside Park: Paterson Weymouth County Park: Mays Landing Wharton State Forest: Hammonton Wiggins Park: Camden William Warren Park: Woodbridge Willowwood Arboretum: Peapack and Gladstone Woodfield Reservation: Princeton Worthington State Forest: Blairstown Planetariums and observatories John Crowley Nature Center: Paterson Newark Museum: Newark New Jersey State Museum: Trenton Paul Robinson Observatory: Glen Gardner Robert J. Novins Planetarium: Toms River Sperry Observatory: Cranford

Trailside Nature and Science Center: Mountainside

Restored communities Allaire Village: Farmingdale Barnegat Historical Society Heritage Center: Barnegat Batsto: Hammonton East Jersey Olde Towne: Piscataway Feltville: Berkeley Heights, Mountainside Historic Cold Spring Village: Cape May Historic Speedwell: Morristown I lunterdon Historical Museum: Clinton Long Pond Ironworks: Ringwood Millbrook Village: Walpack Township Prallsville industrial district: Stockton Smithville County Park: Mount Holly Walnford Village: Allentown Waterloo Village: Stanhope Wheaton Village: Millville Whitesbog: Pemberton Sports facilities (many parks not listed below also maintain sports facilities) Ash Brook Golf Course: Scotch Plains Atlantic Riding Center for the Handicapped: Somers Point Belle Mountain ski area: Titusville Fairview Lake ski area: Newton Francis A. Byrne Golf Course: West Orange Green Knoll Golf Course and Tennis Center: Bridgewater Hasty Acres Farm: Kingston Hidden Valley ski area: Vernon Township Horse Park at Stone Tavern: Allentown, Roosevelt Howell Park and Golf Course: Farmingdale Lord Stirling Park Riding Center: Basking Ridge Mennen Sports Arena (iceskating): Morristown Oak Ridge Golf Course: Clark Overpeck Riding Center: Fort Lee

Preakness Valley Park (golf and tennis): Wayne Riding High Farm: Allentown Rossmoor Golf Course: Jamesburg Saddle Ridge horseback riding area: Franklin Lakes Scotch Hills Golf Club: Scotch Plains Seaton Hackney Stables: Morristown Senator Frank S. Farley marina: Atlantic City Shark River Golf Course: Neptune Somerset I lills I landicapped Riders Club: Oldwick South Mountain Arena (iceskating): West Orange Spooky Brook Golf Course: Millstone Tamarack Golf Course: East Brunswick Vernon Valley–Great Gorge ski area: Vernon Township Warinanco Park (iceskating): Roselle Watchung Riding Stable: Mountainside Weequahic golf course: Newark William G. Mennen Sports Arena (ice-skating): Morristown Theme and amusement parks Clementon Amusement and Splash World Water parks: Blackwood Land of Make Believe: Hope Six Flags Great Adventure: Cassville Story Book Land: Somers Point Wild West City: Stanhope Towns and other communities without their own entries Alliance: Vineland Augusta: Branchville Avalon: Stone Harbor Bedminster: Far Hills Belle Mead: Rocky Hill Bivalve: Mauricetown Bonhampton: Edison Township Branchburg Township: Bridgewater Township Brick Township: Lakewood Bridgeville: Belvidere

Brotmanville: Vineland

Browns Mills: Pemberton Canton: Hancock's Bridge Cardiff: Somers Point Chatsworth: Hammonton Clementon: Blackwood Convent Station: Madison Demarest: Alpine Denville: Boonton East Amwell: Hopewell East Millstone: Millstone Edgewater Park: Burlington Estell Manor: Mays Landing Finesville: Milford Florence Township: Roebling Florham Park: Madison Free Acres: Berkeley Heights Gibbstown: Paulsboro Glendora: Blackwood Glen Ridge: Bloomfield Grovers Mill: West Windsor Township Haddon Heights: Haddonfield Harmony Township: Phillipsburg Hewitt: Ringwood Imlaystown: Allentown Iselin: Woodbridge Jackson Township: Cassville Lafayette: Branchville Lawnside: Haddonfield Loveladies: Barnegat Light Merchantville: Cherry Hill Millington: Basking Ridge Mine Hill: Dover Monmouth Beach: Long Branch Monroe Township: Jamesburg Montgomery Township: Rocky Hill Mountain Lakes: Boonton Mount Tabor: Parsippany-Troy Hills Newfield: Vineland New Hampton: Glen Gardner New Milford: Oradell New Providence: Berkeley Heights New Vernon: Morristown Norma: Vineland North Branch Station: Somerville Northfield: Somers Point North Plainfield: Green Brook North Wildwood: The Wildwoods Oakhurst: West Long Branch

Ocean Gate: Toms River Ogdensburg: Franklin Old Bridge Township: Matawan Palermo: Ocean City Pilesgrove Township: Woodstown Pine Beach: Toms River Piscatawaytown: Edison Township Plainsboro: West Windsor Pleasantville: Absecon Port Norris: Mauricetown Radburn: Fair Lawn Ralston: Mendham Roselle Park: Roselle Rosemont: Stockton Seabrook: Bridgeton Sea Isle City: Stone Harbor Smithville (Atlantic County): Oceanville Smithville (Burlington County): Mount Holly South Bound Brook: Millstone South Orange: West Orange

Stillwater: Newton Tavistock: Haddonfield Twin Rivers: Hightstown Upper Saddle River: Mahwah Vincentown: Medford Wall Township: Neptune Watchung: Green Brook Whitesbog: Pemberton Wildwood Crest: The Wildwoods Willingboro: Burlington

Wineries

Alba Vineyard: Milford Amwell Valley Vineyard: Ringoes Cream Ridge Winery: Allentown Four Sisters Winery: Hope King's Road Winery: Milford LaFollette Vineyard & Winery: Rocky Hill Poor Richard's Winery: Frenchtown Renault Winery: Egg Harbor City Sylvin Farms: Oceanville Tamuzza Vineyards: Hope Tomasello Winery: Hammonton Unionville Vineyards: Ringoes Zoos

Birch Grove Park: Somers Point

Cape May County Park: Cape May Court House Cohanzick Zoo: Bridgeton Emmons Dairy: Pemberton Johnson Park: Piscataway Merrill Park: Woodbridge Popcorn Park Zoo: Forked River Space Farms Zoo and Museum: Beemerville

Thompson Park: Jamesburg Turtle Back Zoo: West Orange

Van Saun Park Zoo: Paramus, River Edge Wild West City: Stanhope

To the Users of This Book

o matter how careful one tries to be, errors are bound to creep into a guidebook of this kind, to say nothing of unintentional omissions. To give just a few examples: in the Cape May Court House entry, no mention is made of the new Audubon research and education facility that opened in the spring of 1997 (600 NJ 47 north; 609-861-0700). Nor will you find mention of the Fort Dix museum (609-562-6983) or the Well-Sweep Herb Farm in Port Murray (201-852-5390).

If you do come across mistakes or other omissions, I hope you will send them to me at 40 Pine Street, Princeton 08542. I would also welcome suggestions for other ways to improve possible future editions. Thank you.

Barbara Westergaard